CULTURE
&VALUES

To Clark Baxter
Slim customer, cherished friend

CULTURE & VALUES

A SURVEY OF THE HUMANITIES

VOLUME II

NINTH EDITION

LAWRENCE S. CUNNINGHAM

John A. O'Brien Professor of Theology
University of Notre Dame

JOHN J. REICH

Syracuse University
Florence, Italy

LOIS FICHNER-RATHUS

The College of New Jersey

✳ Cengage

Australia · Brazil · Canada · Mexico · Singapore · United Kingdom · United States

Cengage

Culture & Values:
A Survey of the Humanities, Volume II,
Ninth Edition
Lawrence S. Cunningham, John J. Reich,
Lois Fichner-Rathus

Product Director: Monica Eckman

Product Manager: Sharon Adams Poore

Content Developer: Rachel Harbour

Product Assistant: Danielle Ewanouski

Senior Marketing Manager: Jillian Borden

Senior Content Project Manager: Lianne Ames

Senior Art Director: Cate Rickard Barr

Manufacturing Planner: Julio Esperas

IP Analyst: Christina Ciaramella

IP Project Manager: Kathryn Kucharek

Production Service: Thistle Hill Publishing
Services, LLC

Compositor: Cenveo® Publisher Services

Text and Cover Designer: Chrissy Kurpeski

Cover Image: © mvlampila/Alamy Stock Photo

For product information and technology assistance, contact us at
Cengage Customer & Sales Support, 1-800-354-9706
or support.cengage.com.

For permission to use material from this text or product, submit all
requests online at **www.copyright.com**.

Library of Congress Control Number: 2016945332

Student Edition:
ISBN: 978-1-337-10266-7
Loose-leaf Edition:
ISBN: 978-1-337-11659-6

Cengage
200 Pier 4 Boulevard
Boston, MA 02210
USA

Cengage is a leading provider of customized learning solutions
with employees residing in nearly 40 different countries and sales in more
than 125 countries around the world. Find your local representative at:
www.cengage.com.

To learn more about Cengage platforms and services, register or access
your online learning solution, or purchase materials for your course,
visit **www.cengage.com.**

Printed at CLDPC, USA, 08-22

Contents

18

Africa 603

19

The Eighteenth Century 625

20

Europe and America: 1800–1870 663

Toward the Modern Era:
1870–1914 723

The World at War: 1914–1945 777

23

The Contemporary Contour 817

Reading and Playlist Selections

ⓘ MindTap for *Culture & Values*, Ninth Edition, provides direct links to the unabridged versions of these literary excerpts in the Questia online library.

Preface to the Ninth Edition

The ninth edition of *Culture & Values* continues its mission to inform students of the history of humankind through the lens of the humanities—language and literature, art and architecture, music, philosophy, and religion. Through the study of the humanities, we aim not only to *know* but to *understand*—to consider what humans across time and lands have thought about; how they have felt or acted; how they have sought to come to terms with their relationship to the known and the unknown; and how culture has influenced them to develop and express their ideas, ideals, and their inner selves. *Culture & Values* encourages students to place their own backgrounds and beliefs in context and to consider how understanding both their own and other heritages contributes to becoming a citizen of the world in the 21st century.

WHAT'S NEW IN THE NINTH EDITION

Professors who have taught with earlier editions of the book will find that the ninth edition is familiar, yet, in many respects, quite new. Readers of the ninth edition will discover a new chapter on the Americas, three new types of features, and new works throughout, including numerous new maps.

New Chapter: Cultural Centers of the Americas

The new Chapter 16 provides comprehensive coverage of various cultures of the Americas, from the Olmec civilization to the Post-Columbian period. It covers:

- The migration of humans from Asia across the land bridge from present-day Siberia to North America some 23,000 years ago.
- The development of civilizations and cities in Mesoamerica and South America, and the cultures of migrants who remained north of Mexico.
- The polytheistic religions of these cultural centers, how they explained the origins of the universe, and how they governed the rituals of daily life.
- Achievements in architecture, including the construction of monumental pyramids; sculpture; earthworks; crafts; and fine poetry.

- Scientific achievements in astronomy and the creation o[f] calendars.
- The consequences of the European conquest of these territories, including the destruction of native cultures and belief systems and the introduction of new languages and religions.

New Chapter Organization

The new Chapter 16, "Cultural Centers o[f] the America[s] inspires a new organization for Volume II of *C[u]lture & Value[s]*. The new chapter follows Chapter 15, "The Se[ve]nteenth Ce[n]tury," because it is during that era that the prep[o]nderance [of] European exploration and colonization of the A[m]ericas a[nd] other parts of the world—such as Africa—took [p]lace. T[he] ancient history of South Asia, China, and Japan is pr[e]sented [in] Chapter 5 of the first volume; in Chapter 17 of the se[co]nd v[ol]ume, "South Asia, China, and Japan: From Medieval to [M]ode[rn] Times," we revisit these regions just as east–west enco[u]nte[rs] became more prevalent. Chapter 18, "Africa," complete[s] th[is] cluster of non-European civilizations.

The 17th century and the years directly before and aft[er]ward—despite their impact—comprise but a small part of the f[ull] history of these regions. Rich cultural developments hark back [to] ancient times in the Americas, the East, and Africa. Moreove[r,] cultural developments in these regions, as in the West, continu[e] to impact the wider world today, often in directions that wou[ld] have been impossible to predict.

New Features

The ninth edition has three new features designed to engage stu[-] dents and to demonstrate the relevance of the humanities to th[eir] contemporary world:

THE NEW CULTURE AND SOCIETY FEATURE hig[h]lights relationships between cultural and social development[s,] both ancient and modern. A sampling of topics includes:

- "The Maya Ball Game," a Mesoamerican "sport" connecte[d] with Maya beliefs concerning life, death, resurrection, an[d] transformation.
- "The Works Progress Administration," Franklin Delan[o] Roosevelt's expansive Great Depression employment rel[ief]

program that funded a spectrum of projects ranging from public works to works of art and literature.

"Liberation" discusses various kinds of liberation, from liberation from totalitarian regimes to gay liberation.

THE NEW CONNECTIONS FEATURE draws parallels between works of art and literature, relays contemporary responses to ancient events, and offers engaging new perspectives on cultural figures and monuments. Examples include:

Chapter 17, "South Asia, China, and Japan: From Medieval to Modern Times," includes a feature on action painting, east and west, which relates Japanese artist's Kazuo Shiraga's painting with his feet while suspended over his canvases to the American Jackson Pollock's method of drip painting.

Chapter 18, "Africa," contains a feature on Gustavus Vassa, who wrote the first slave autobiography.

A feature in Chapter 22, "The World at War: 1914–1945," illustrates collaboration between art forms such as ballet, writing, and the visual arts.

THE NEW RELIGION FEATURE presents essential aspects and tenets of belief systems past and present, including:

The Puritans

Gods and Goddesses in the Aztec Pantheon

WHAT'S NEW IN THE NINTH EDITION—CHAPTER BY CHAPTER

The High Renaissance and Mannerism in Italy

New illustrations, including new views of the Sistine Chapel, the Tempietto, and the Villa Rotunda

Connections feature: Papermaking and Leonardo's experimental sketches and drawings

Connections feature: The mutilation and restoration of Michelangelo's *Pietà*

The High Renaissance in Northern Europe and Spain

New illustrations, including Madrid's El Escorial and Seville's La Casa De Pilatos

Culture and Society feature: "Principal Discoveries and Inventions in the Sixteenth Century"

Connections feature: The preservation of Cordoba's Mezquita after the Catholic monarchs drove the Muslims from Spain in 1492

15 The Seventeenth Century

- New illustrations, including Carracci's ceiling fresco *The Loves of the Gods* and the Palace of Versailles

- New coverage of John Winthrop, including an excerpt from *A Model of Christian Charity*

- Connections feature: Velasquez and the Knights of Santiago

- Connections feature: Rubens's royal patrons

- Culture and Society feature: "Principal Scientific Discoveries of the Seventeenth Century"

- Connections feature: Pisa's Galileo and Jupiter's Ganymede

- Religion feature: "The Puritans"

16 Cultural Centers of the Americas

- New works of architecture and art, including the Temple of the Feathered Serpent, Teotihuacán, Mexico; Moche pottery; a Nazca geoglyph; Machu Picchu; a Chilkat blanket; the Serpent Mound in Ohio; and works by Diego Rivera and Frida Kahlo

- New coverage of the Olmecs; Teotihuacán; the Maya; the Aztecs and Tenochtitlán; the Nazca, Moche, and Inka cultures of South America; Oceania; the native cultures of North America; and the European conquest

- Five new readings, including excerpts from the *Florentine Codex*; the recounting of the conquest of Mexico from the Aztec point of view and from the Spanish viewpoint (as related by a soldier of Cortes, Bernal Diaz del Castillo); and metaphysical poetry by Nezahualcoyotl

- Religion feature: "The Feathered Serpent"

- Culture and Society feature: "The Maya Ball Game"

- Religion feature: "Some Gods and Goddesses in the Aztec Pantheon"

- Culture and Society feature: Mexican Nationalism in the 20th century

17 South Asia, China, and Japan: From Medieval to Modern Times

- New illustrations of "hybrid" art and architecture from the British colonial period, including Mumbai's Victoria Terminus

- New coverage of Indian artists known as the Progressives

- Expanded coverage of the Chinese transition from monarchy to Republican to Communist rule

- Expanded coverage of the development of modern Japan

- New coverage of the Japanese Gutai Art Association

- Connections feature: Jackson Pollock, Kazuo Shiraga, and action painting

18 Africa

- Revised chapter preview featuring Neolithic rock painting
- Connections feature: The *Catalan Atlas* and a pilgrimage to Mecca by Mansa Musa I, the 14th-century king of Mali
- Connections feature: The slave biography of Gustavus Vassa
- Connections feature: Celebrity, identity, and impersonation in the art of Cameroonian photographer Samuel Fosso

19 The Eighteenth Century

- New illustrations, including Thomas Jefferson's Monticello, Panini's *Interior of the Pantheon*, and Gilbert Stuart's iconic portrait of George Washington
- Connections feature: The 18th-century Grand Tour of Europe
- Connections feature: Representing George Washington

20 Europe and America: 1800 to 1870

- New illustrations and discussions of art and war in the Romantic era
- Connections feature: Beethoven, Goya, Wilde, and hearing loss
- Connections feature: The photographic documentation of war

21 Toward the Modern Era: 1870–1914

- New illustrations, including works by Gaudí, Kandinsky, Picasso, Braque, and others
- Connections feature: Portraying the fourth dimension in art
- Connections feature: The phenomenon of World's Fairs
- Connections feature: La Sagrada Familia

22 The World at War: 1914–1945

- New illustrations, including a discussion of the artistic collaboration between Picasso, Satie, Cocteau, and Diaghilev for the 1917 ballet, *Parade*
- Connections feature: Surrealism, André Breton, and Frida Kahlo
- Connections feature: Contrasting visions of America in Walt Whitman's poem "I Hear America Singing" and Langston Hughes's "I, Too"
- Culture and Society feature: "The Works Progress Administration"

23 The Contemporary Contour

- New illustrations and discussions of the depth and breadth of postwar art and architecture
- Expanded coverage of rock and roll legend Elvis Presley, including a Connections feature on Elvis
- Culture and Society feature: "Liberation"
- Connections feature: Revisiting and revising Richard Hamilton's 1956 collage *Just What Is It That Makes Today's Homes So Different, So Appealing?*

Familiar Features in the Ninth Edition

A DYNAMIC, ELEGANT, AND ACCESSIBLE DESIG that features brilliant, accurate color reproductions of works art along with large-format reproductions of original pages of l erary works. Students will be able to fully appreciate the visu impact of these works and may be inspired to seek out art museums and to visit historic site.

CHAPTER PREVIEWS draw students into the material each chapter by connecting intriguing works of art and oth images with the ideas and ideals that permeate the eras und discussion. From the opening chapter—in which students di cover how contemporary technologies are used to reconstru the human past—to the last—in which the emergence of ne media charts multiple cultural and artistic directions in th 21st century—students are encouraged to face each new perio with curiosity and anticipation. At the same time, the previev reinforce connections to the knowledge students have accum lated from previous chapters.

COMPARE + CONTRAST features present two or mor works of art or literature side by side and encourage students t focus on stylistic, technical, and cultural similarities and differ ences. The features promote critical thinking by encouraging stu dents to consider the larger context in which works were create honing their interpretive skills and challenging them to probe fc meaning beyond first impressions. Compare + Contrast featu parallel the time-honored pedagogy of analyzing works of a texts, and ideas by describing their similarities and differences

TIMELINES in each chapter give students a broad framewo for the periods under discussion by highlighting seminal dat and events.

END-OF-CHAPTER GLOSSARIES provide students with an efficient way to access and review key terms and their meanings.

THE BIG PICTURE feature at the end of each chapter summarizes the cultural events and achievements that shape the character of each period and place. Organized into categories (Language and Literature; Art, Architecture, and Music; Philosophy and Religion), the Big Picture reinforces for students the simultaneity of developments in history and the humanities.

ACKNOWLEDGMENTS

We first acknowledge the reviewers—our colleagues who, as instructors in the humanities survey, collectively have shaped student encounters with art, music, religion, philosophy, and literature over generations. The extent to which *Culture & Values*, Ninth Edition, meets their pedagogical needs and inspires their students—and yours—is a direct result of their willingness to share—and our commitment to learn from—their expertise and experiences. They have had the enduring patience to read the text meticulously to inform us of any shortcomings, and they have inspired us with their unique pedagogical visions. Sincere gratitude and thanks to the reviewers for the ninth edition: Subraj Aryal, Purdue University; Terri Birch, Harper College; Steven Cartwright, Western Michigan University; Erin Devin, Northern Virginia Community College; Taurie Gittings, Miami Dade College; Charles Hill, Gadsden State Community College; Sean Hill, Irvine Valley College; Garry Ross, Texas A&M University—Central Texas; Arnold Schmidt, California State University, Stanislaus; Teresa Tande, Lake Region State College; and Scott Temple, Cleveland Community College.

The authors acknowledge that an edition with revisions of this magnitude could not be undertaken, much less accomplished, without the vision, skill, and persistent dedication of the superb team of publishing professionals at Cengage Learning. First and foremost is Sharon Adams Poore, our Product Manager, who, as always, guides a project with steady and collegial hands, seamlessly meshing author and publisher, needs and desires, idea and reality. She is our touchstone, our champion, our trusted friend; Rachel Harbour, our Content Developer, worked intensely day by day, bringing her grasp of cultural matters and her global insights to the evaluation and enhancement of nearly every word and phrase in the manuscript—all for the better; Danielle Iwanouski, Product Assistant; Lianne Ames, our veteran Senior Content Project Manager, the enviable master of all she surveys, who guarantees that all of the pieces fit and that everything keeps moving along consistently and coherently, and who always finds a way to marry pedagogy, aesthetics, and quality of production in spite of crushing deadlines; Cate Barr, our Senior Art Director, whose splendid taste, acumen, and flexibility resulted in the exceptional print or digital text you find before you—without Cate as our design "rudder," we would never bring the ship of our dreams to port; Christina Ciaramella, Intellectual Property Analyst; Kathryn Kucharek, Intellectual Property Project Manager; and, last but not least, Jillian Borden, our Senior Marketing Manager—without Jillian's strategic and boundlessly creative mind, her enthusiasm and energy, and belief in the authors and products in her keeping, our efforts to support the teaching of humanities might never come to fruition.

We can only list the others involved in the production of this edition, although they should know that we are grateful for their part in making *Culture & Values* a book we are proud to present: Chrissy Kurpeski, interior and cover designer; Angela Urquhart, editorial project manager at Thistle Hill Publishing; and Corey Smith and Kristine Janssens, photo and literary permissions researchers at Lumina Datamatics.

Lois Fichner-Rathus would also like to thank Spencer Rathus, her husband, silent partner, and true-to-life "Renaissance man" for the many roles he played in the concept and execution of this edition.

ABOUT THE AUTHORS

Lawrence Cunningham is the John A. O'Brien Professor of Theology at the University of Notre Dame. He holds degrees in philosophy, theology, literature, and humanities. John Reich, of Syracuse University in Florence, Italy, is a trained classicist, musician, and field archaeologist. Both Cunningham and Reich have lived and lectured for extended periods in Europe.

Lois Fichner-Rathus is Professor of Art and Art History at The College of New Jersey. She holds degrees from the Williams College Graduate Program in the History of Art and in the History, Theory, and Criticism of Art from the Massachusetts Institute of Technology. In addition to being co-author of *Culture & Values*, she is the author of the Cengage Learning textbooks *Understanding Art* and *Foundations of Art and Design*. She teaches study-abroad programs in Paris, Rome, Spain, and Cuba and resides in New York.

RESOURCES

For Faculty

MINDTAP® FOR INSTRUCTORS Leverage the tools in MindTap for *Culture & Values*, Ninth Edition, to enhance and personalize your course. Add your own images, readings, videos, web links, projects, and more to your course Learning Path. Set project due dates, specify whether assignments are for practice or a grade, and control when your students see these activities in

their course. MindTap can be purchased as a stand-alone product or bundled with the print text. Connect with your Learning Consultant for more details via www.cengage.com/repfinder.

FULL READINGS IN QUESTIA This edition's MindTap includes free access to Questia, an online research library with tens of thousands of digital books and millions of academic journal articles. Links to the full versions of many of the literary works excerpted in the ninth edition appear within the MindTap version of the text. Look for the Questia icon next to individual readings on pages x–xiii of the print book to see which readings are available and linked within MindTap.

For Students

MINDTAP FOR STUDENTS MindTap for *Culture & Values* helps you engage with your course content and achieve greater comprehension. Highly personalized and fully online, the MindTap learning platform presents authoritative Cengage Learning content, assignments, and services, offering you a tailored presentation of course curriculum created by your instructor.

MindTap guides you through the course curriculum via an innovative Learning Path Navigator where you will complete reading assignments, annotate your readings, complete homework, and engage with quizzes and assignments. This edition's MindTap features a two-pane e-reader, designed to make your online reading experience easier. Images discussed in the text appear in the left pane, while the accompanying discussion scrolls on the right. Highly accessible and interactive, this new e-reader pairs videos, Google Map links, and 360-degree panoramas with the matching figure in the text.

WRITING AND RESEARCH TOOLS IN QUESTIA The MindTap for this edition of the text includes free access to Questia, a digital research library replete with tips and instruction on how to complete research- and writing-based activities for your course. You can view tutorials and read how-to advice on the steps of completing a research paper, ranging from topic selection to research tips, proper citation formats, and advice on how to structure a critical essay. Look for links to many of the resources available through Questia right in the Learning Path of your course.

CULTURE
&VALUES

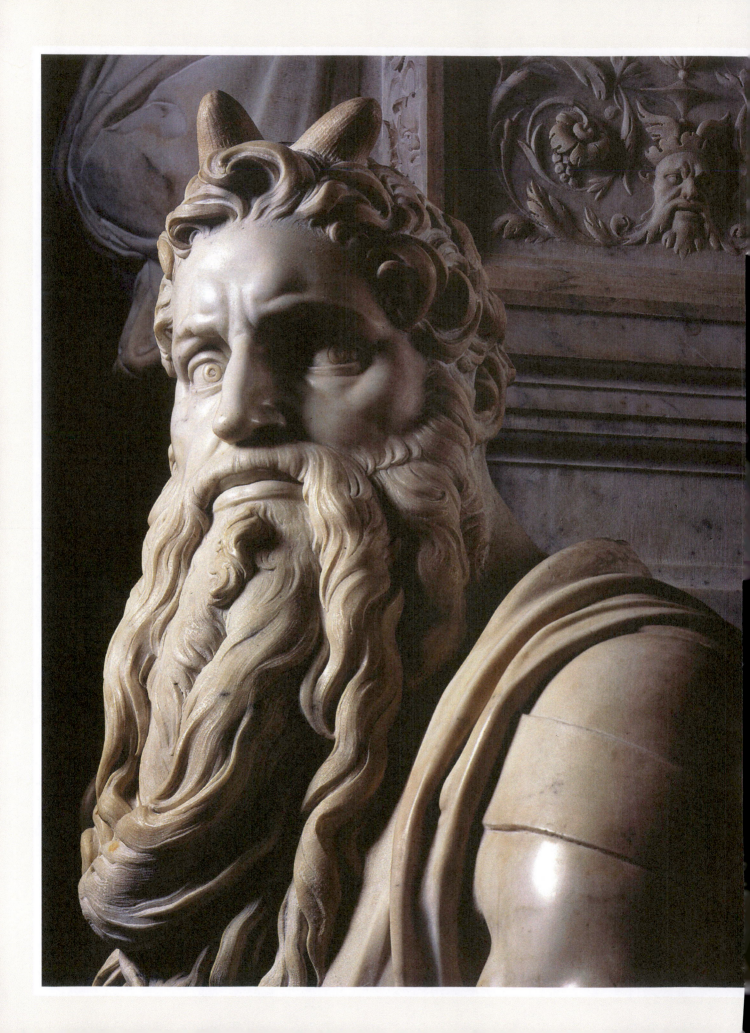

The High Renaissance and Mannerism in Italy

13

PREVIEW

The Italians had a word for awe-inspiring power and grandeur, overwhelming emotional intensity, intractable will, and incalculable rage: *terribilità*. That they used the word to describe two outsized personalities—Pope Julius II and Michelangelo Buonarroti—whose intertwined destinies shaped both history and the history of art and give us insight into the Renaissance papacy, patronage of the arts, and the lust for legacy.

On his fourth attempt to secure the papacy, Giuliano della Rovere, called "il Terribilis," was elected almost unanimously in 1503 by a conclave of cardinals, several of whom he most certainly bribed—heavily. He took the name Julius II, not in honor of the canonized fourth-century pope by the same name but in emulation of Julius Caesar, the great Roman statesman, conqueror, and architect of the future empire. Julius II would become known as the Warrior Pope who brought the Papal States back under control of Rome after the Avignon papacy and who waged military campaigns against the Republic of Venice in partnership with the Holy Roman emperor and the kings of France and Aragon.

Like Caesar, Julius II would aim to glorify Rome, using art and architecture conspicuously to assert his power and wealth and to ensure his legacy. He directed his energies—and funds from the papal treasury—toward several pet projects that would reflect his authority, influence, and personal taste. They included the construction of a new Saint Peter's on the site of Constantine's fourth-century basilica and major works of art for the Vatican. An advocate for and patron of contemporary artists, Julius II was, in the words of the author R. A. Scotti, "a one-man MoMA."[1] In every way, he was larger than life. A Venetian ambassador to the Vatican said: "No one has any influence over him, and he consults few or none....It is almost impossible to describe how strong and violent and difficult to manage he is....Everything about him is on a magnificent scale, both his undertakings and his passions."[2] As it happened, Julius II might have spoken those very words in describing Michelangelo, for their relationship was anything but smooth.

By the time he was 30, the Florentine sculptor Michelangelo had secured his position as the hottest artistic commodity in Italy. With at least two significant, attention-getting works under his belt—the *Pietà* in a chapel in Old Saint Peter's Basilica and the *David* in the Piazza della Signoria in Florence—Michelangelo was destined for work in Rome. That was where power and the money were. And that is where Julius II would use him to realize his grand plans—beginning with his own funerary monument, a massive freestanding pyramidal structure with 40 carved figures to be placed in none other than the basilica of Saint Peter's. It was the commission of a lifetime,

◀ **13.1** Michelangelo, *Moses*, detail, 1513–1515. Marble, 92 ½" (235 cm) high. San Pietro in Vincoli, Rome, Italy.

1. MoMA is the acronym for the Museum of Modern Art in New York City.
2. Quoted in R. A. Scotti, *Basilica: The Splendor and the Scandal; Building St. Peter's* (New York: Penguin, 2006), p. 4.

and Michelangelo threw himself into the project with passion and zeal. But while the sculptor was away from Rome choosing perfect, creamy-white marble from the quarries in Carrara (his favorite material), Julius turned his attention to something even grander: a new Saint Peter's. Julius's choice of the architect Donato Bramante—a longtime bitter rival of Michelangelo—and sporadic provision of adequate funds for the tomb project caused tension and, eventually, outright conflict. Worst, perhaps, was the fact that Michelangelo was not getting the attention from the pope to which he was accustomed, and Julius II made a habit of adding insult to injury by granting several important commissions to his competitors. Michelangelo's rage, obstinacy, and moodiness—and the legendary temper of Julius II—amounted to a clash of titans.

Completion of the tomb plagued Michelangelo throughout Pope Julius II's reign (Julius's other "side projects" for the artist included the Sistine Chapel ceiling fresco), and things would not improve after the pontiff's death. Subsequent popes wanted to harness Michelangelo's talent for their own projects and purposes; very few were interested in glorifying their dead predecessor, particularly with a mammoth monument-tomb in as high profile a place as Saint Peter's. In the end, a completed work—much diminished from its first, grand design—was erected in the church of San Pietro in Vincoli (that is, "Saint Peter in Chains") where it can still be seen today. Julius, who always intended to have his remains interred in Saint Peter's, is indeed buried there—alas, beneath the floor, his grave marked by a simple inscription carved in marble.

The masterwork of the monument to Pope Julius II is Michelangelo's *Moses* (**Fig. 13.1**), a portrait of the great Hebrew prophet and lawgiver fresh from his communion with God, gripping the tablets inscribed with the Ten Commandments, glowering in fury at the idolaters about to be destroyed. A figure of awesome might, uncompromising will, fearsome temperament,

and unwavering belief—he is the artistic embodiment of *terribilità*. In his face, we see Julius; we see Michelangelo.

THE SIXTEENTH CENTURY IN ITALY: POLITICS, POPES, AND PATRONAGE

Culturally, one could argue that the Renaissance in Italy affected the daily lives of only the few. Pope Martin V returned the papacy to Rome in 1420, but much of the city was poor and in ruins from its history of invasions, the loss of its position as the seat of the papacy during the "Babylonian Captivity," and the fallout of the Great Schism. But the century between Pope Martin's move back to Rome and the Holy Roman Emperor Charles V's (r. 1519–56) sack of Rome in 1527 was a period of growth and renewal and the return of power to the hands of the papacy.

That said, the 16th century witnessed a continuation of wars among the city-states, the most prominent among them Milan, Florence, Siena, Genoa, Venice, Naples, and the Papal States—territories in central and northern Italy as well as France that were directly controlled by the pope (see **Map 13.1**). As leader of the faith, the pope held ecclesiastical power but, as a head of state, he also held temporal power. The papacy had governed territories in central Italy from the Middle Ages (ca. 756) and securing and defending these holdings was a priority; Pope Julius II led armies to do so over and over again. Territories under the control of the papacy in Rome continued into the 19th century; the last Papal State, which we know as Vatican City, was established in 1929. Although the territory is located within the geographical boundaries of the city of Rome, it is a separate country.

The High Renaissance and Mannerism in Italy

1471 CE	1501 CE	1520 CE	160 CE
Reign of Pope Sixtus IV (della Rovere)	Michelangelo sculpts *David*	Reign of Pope Clement VII (de' Medici)	
Columbus lands in the Americas	Leonardo da Vinci paints *Mona Lisa*	Sack of Rome by Charles V	
Foreign invasions of Italy begin	Reign of Pope Julius II (della Rovere)	Churches of Rome and England separate	
Leonardo da Vinci paints *The Last Supper*	Michelangelo paints the ceiling of the Sistine Chapel	Titian paints *Venus of Urbino*	
	Venetian trade declines as a result of new geographic discoveries	Council to reform the Catholic Church begins at Trent	
	Reign of Pope Leo X (de' Medici)		
	Reformation begins in Germany with Luther's 95 Theses challenging the practice of granting indulgences		

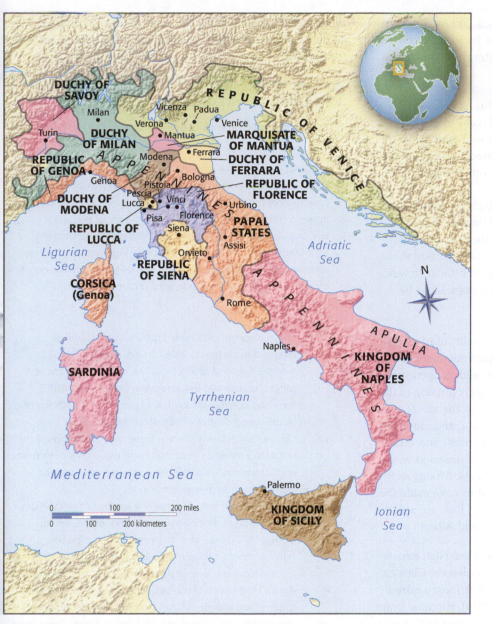

coffers of papal patronage in Rome. Pope Sixtus IV (r. 1471–1484) had commissioned many eminent Florentine artists—among them Ghirlandaio, Botticelli, and Perugino—to paint the walls of a new Papal Chapel (the Sistine) named after himself, as well as to work on other projects that caught his artistic fancy. Not the least of these was the enlargement and systematization of the Vatican Library.

The period known as the High Renaissance really began, however, in 1503, when a cardinal nephew of Sixtus IV, Giuliano della Rovere, succeeded the Spanish pope, Alexander VI (Borgia) to become Pope Julius II. As we noted in the opening of this chapter, Julius was a fiery man who did not hesitate to don full military armor over his vestments to lead his papal troops into battle. But he also summoned both Michelangelo and Raphael to Rome to glorify the Church—and his papal reign—in art and architecture.

It should be noted that although the papal court of the Vatican in Rome became the preeminent center of arts and culture in 16th-century Italy, patronage—and power politics—did not stop elsewhere. In Florence, the Medici dynasty's political influence waned but was far from over. The territory of Florence expanded, becoming the Grand Duchy of Tuscany in 1569. Between 1523 and 1605, the Medici family produced four popes and a queen of France (Catherine de' Medici,

The papacy in the 15th and 16th centuries was awash in powerful family names who used their influence—and often, money—to secure the papal seat: Colonna (Martin V), della Rovere (Sixtus IV and Julius II), Farnese (Pope Paul III), Medici (Leo X, Clement VII). Starting with Julius II, Michelangelo worked for all of them—and others. As Rome proceeded to claim its position as the capital of a unified church and Christendom's most important (and lucrative) pilgrimage destination, the Renaissance popes projected their power as patrons of the arts and letters. Inspired by classical architecture, the discovery and collection of ancient art, and the classics of Greek and Latin literature, under their leadership, Rome became a center of artistic excellence, humanist learning, and the revival of all things antiquity. If you were an intellectual or an artist in the 16th century, Rome was the place to be.

By the second half of the 15th century, artists already were chasing opportunity as it shifted from the generous and refined **patronage** of powerful Florentine families to the even deeper

who reigned from 1547 to 1559). Their second queen of France, Marie de' Medici, reigned at the beginning of the 17th century, from 1600 to 1610. They remained serious patrons of the arts, competing with the Sforza and Visconti families in Milan, the Gonzagas in Mantua, and foreign monarchs for the services of Italy's most renowned artists. But the twin gravitational fields of patronage and the Church were inexorably pulling the center of the art world toward Rome.

THE VISUAL ARTS

The High Renaissance ushered in a new era for the most sought-after artists—one of respect, influence, fame, and, most important, the power to shape their circumstances. Here is an example: Sometime in 1542, Julius II and Michelangelo were in the midst of one of their many conflicts, and the artist was feeling the brunt of the pope's rage. Julius seemed to be backing out of the tomb project and was refusing to pay Michelangelo

for the materials he had already purchased. When the artist sought to redress these grievances, Julius had him removed from the Vatican. Michelangelo let his outrage be known—as well as his suspicions:

> A man paints with his brains and not his hands, and if he cannot have his brains clear he will come to grief. Therefore I shall be able to do nothing well until justice has been done me.... As soon as the Pope [carries] out his obligations towards me I [will] return, otherwise he need never expect to see me again.
>
> All the disagreements that arose between Pope Julius and myself were due to the jealousy of Bramante and of Raffaello da Urbino; it was because of them that he did not proceed with the tomb,...and they brought this about in order that I might thereby be ruined. Yet Raffaello was quite right to be jealous of me, for all he knew of art he learned from me.[3]

This passage offers us a good look at the personality of an artist of the High Renaissance. He was in demand, independent, and indispensable—and could be arrogant, aggressive, and competitive.

In Italy at the end of the 15th century and beginning of the 16th, three artists dominated the discourse on the visual arts: Leonardo da Vinci, a painter, scientist, inventor, and musician; Michelangelo, a painter, sculptor, architect, poet, and enfant terrible; and Raphael, a painter whose classical-inspired works were thought to have rivaled those of the ancients. Among architects, it is Donato Bramante who is deemed to have made the most significant contributions of this period. These are artistic descendants of Giotto, Donatello, Masaccio, and Alberti.

LEONARDO DA VINCI If the Italians of the High Renaissance could have nominated a counterpart to what the Classical Greeks referred to as the "four-square man," it most assuredly would have been Leonardo da Vinci (1452–1519). He came from Vinci, a small Tuscan town near Florence, but lived in Florence proper until the 1480s when he left for Milan. From there, he moved from place to place until his death in France—the country in which he is buried.

Leonardo's capabilities in engineering, the natural sciences, music, and the arts seemed unlimited, as he excelled in everything from solving mundane drainage problems (a project he undertook in France just before his death) and designing prototypes for airplanes and submarines, to creating some of art history's most iconic paintings.

We know that in about 1481, Leonardo looked for work with Ludovico Sforza, the son of the Duke of Milan. Just as we sometimes tailor our résumés to coincide with the job we are seeking, so too did Leonardo write his letter of introduction stressing those talents that he felt might be of greatest interest to Sforza—designing instruments of war—and mentioning just briefly his

artistic abilities. Leonardo's application (see Reading 13.1) was accepted, and he left Florence for Milan in 1482 where he stayed for the next 17 years.

READING 13.1 LEONARDO DA VINCI

Letter of Application to Ludovico Sforza (ca. 1481)

Most Illustrious Lord, Having now sufficiently considered the specimens of all those who proclaim themselves skilled contrivers of instruments of war, and that the invention and operation of the said instruments are nothing different from those in common use: I shall endeavor, without prejudice to any one else, to explain myself to your Excellency, showing your Lordship my secrets, and then offering them to your best pleasure and approbation to work with effect at opportune moments on all those things which, in part, shall be briefly noted below.

1. I have a sort of extremely light and strong bridge, adapted to be most easily carried, and with it you may pursue, and at any time flee from the enemy; and others, secure and indestructible by fire and battle, easy and convenient to lift and place. Also methods of burning and destroying those of the enemy.
2. I know how, when a place is besieged, to take the water out of the trenches, and make endless variety of bridges, and covered ways and ladders, and other machines pertaining to such expeditions.
3. If, by reason of the height of the banks, or the strength of the place and its position, it is impossible, when besieging a place, to avail oneself of the plan of bombardment, I have methods for destroying every rock or other fortress, even if it were founded on a rock, etc.
4. Again, I have kinds of mortars; most convenient and easy to carry; and with these I can fling small stones almost resembling a storm; and with the smoke of these cause great terror to the enemy, to his great detriment and confusion.
5. And if the fight should be at sea I have kinds of many machines most efficient for offense and defense; and vessels which will resist the attack of the largest guns and powder and fumes.
6. I have means by secret and tortuous mines and ways, made without noise, to reach a designated spot, even if it were needed to pass under a trench or a river.
7. I will make covered chariots, safe and unattackable, which, entering among the enemy with their artillery, there is no body of men so great but they would break them. And behind these, infantry could follow quite unhurt and without any hindrance.
8. In case of need I will make big guns, mortars, and light ordnance of fine and useful forms, out of the common type.
9. Where the operation of bombardment might fail, I would contrive catapults, mangonels, trabocchi,

3. Michelangelo Buonarroti, *Michelangelo: A Record of His Life as Told in His Own Letters and Papers*, trans. Robert W. Carden (Boston and New York: Houghton Mifflin Company, 1913), p. 201.

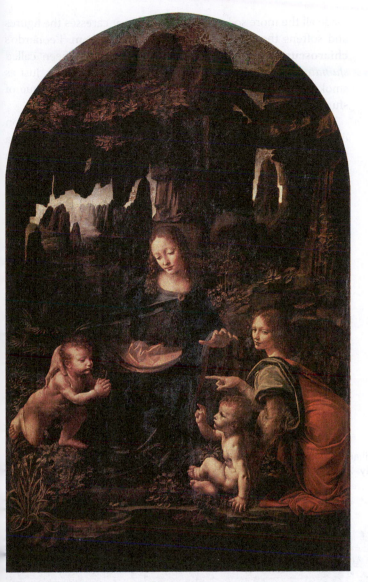

▲ **13.2A** Leonardo da Vinci, *Madonna of the Rocks*, ca. 1483–1490. Oil on panel, transferred to canvas, 78 ¼" × 48" (199 × 122 cm). Musée du Louvre, Paris, France. The *Madonna of the Rocks* was commissioned as the central painting for an altarpiece for a church in Milan. Leonardo did not comply with the deadline, and lawsuits followed.

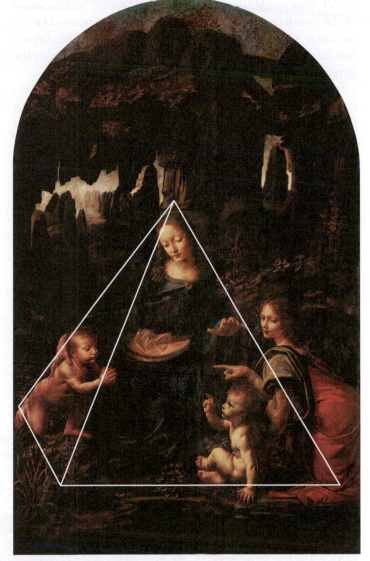

▲ **13.2B** The pyramidal structure of Leonardo da Vinci's *Madonna of the Rocks*. The favorite compositional device of the Renaissance painter was the triangle (or pyramid). It provided a focal point as well as stability to figural groups.

and other machines of marvelous efficacy and not in common use. And in short, according to the variety of cases, I can contrive various and endless means of offense and defense.

10. In times of peace I believe I can give perfect satisfaction and to the equal of any other in architecture and the composition of buildings public and private; and in guiding water from one place to another.

11. I can carry out sculpture in marble, bronze, or clay, and also I can do in painting whatever may be done, as well as any other, be he who he may. Again, the bronze horse may be taken in hand, which is to be to the immortal glory and eternal honor of the prince your father of happy memory, and of the illustrious house of Sforza.

And if any of the above-named things seem to anyone to be impossible or not feasible, I am most ready to make the experiment in your park, or in whatever place may please your Excellency—to whom I commend myself with the utmost humility, etc.

Leonardo only left us about 30 paintings—an exceptionally small number for a Renaissance artist of such stature. One of his earliest was completed in Milan soon after his arrival. *Madonna of the Rocks* (**Fig. 13.2A**) was commissioned as part of an altarpiece for the chapel of the Confraternity of the Immaculate Conception in the church of San Francesco Grande. In it we

detect what would become Leonardo's signature *humanization* of the characters in Christianity's dramatic narrative: Mary is no longer portrayed as the venerated Queen of Heaven (as she had been during the Middle Ages and the early years of the Renaissance); she is a mother, she is human, she is "real."

But the visual representation of Mary as a mother in a grotto on an outing with her son and his cousin, John the Baptist, is not the only aspect of this painting that creates a more human vision of the Madonna. The dramatic tableau that Leonardo stages is the thing that makes the painting remarkable. We cannot be sure of the actual meaning of the painting, but the action and interconnected gestures compel us to interpret what may be going on. Mary is the centerpiece of the composition (see **Fig. 13.2B**). She extends her arms outward toward the two boys, placing her arm around John (on the left, kneeling and praying) and reaching for Jesus (in the right foreground, sitting with one hand raised in an attitude of blessing). Her left hand might have reached her son were it not for the hand of an angel that interrupts the contact with a pointed finger. The boys look at one another, the angel looks at us, and Mary looks downward, her head cocked to one side. How do we read her expression? Sadness? Resignation? Perhaps both. Does the angel's gesture represent the Word of God that will prevent Jesus's mother from protecting him as he fulfills his destiny as Redeemer? The moment is a tender one, made all the more so by the warm light that caresses the figures and softens the atmosphere that surrounds them. Leonardo's **chiaroscuro**—his use of light and shadow—has been called *sfumato*, from the Italian word "fumo" meaning smoke. Just as smoke obscures the edges of things, so does the technique of sfumato create a blurry, soft, or vague effect.

Leonardo's compositional scheme emerged as a common one during the High Renaissance. The figures are placed in a triangular (or pyramidal) configuration: Mary's head is in the apex of the triangle, her arms and, in extending the line therefrom, the backs of John and the angel, form the two sides of the triangle, and the horizontal of the ground line at the water's edge forms the base. These actual lines are complemented by implied lines that connect Mary's sideward glace toward John, her left hand to the top of Jesus's head, the glances of the two cousins, and the angel's glance toward us—the viewers—outside of the picture space. These implied lines create the action—the movement, the energy—in the piece and are balanced by the stabilizing (actual) lines of the compositional triangle.

The *Last Supper* (**Fig. 13.3**), commissioned by Ludovico Sforza for the refectory (dining room) of the convent of the church of Santa Maria delle Grazie in Milan stands as one of Leonardo's greatest works. The condition of the work is poor because of his experimental fresco technique—although the

▼ **13.3** Leonardo da Vinci, *The Last Supper*, ca. 1495–1498. Fresco (oil and tempera on plaster), 15' 1" × 28' 10" (460 × 880 cm). Refectory, Santa Maria delle Grazie, Milan, Italy. There had been many paintings on the subject of the Last Supper, but the people in Leonardo's composition are individuals who display real emotions. They converse with one another animatedly, yet most heads are turned toward Jesus, focusing the viewer's attention of the center of the composition.

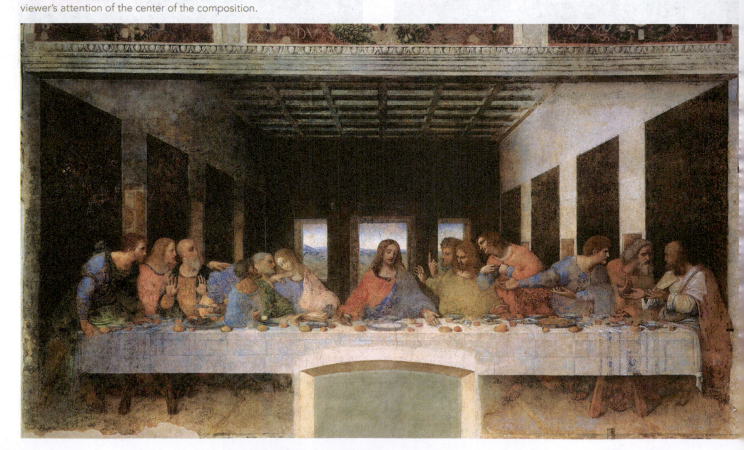

humidity in Milan certainly has been a contributing factor in its deterioration over time. A 21-year-long restoration of the mural (1978–1999) was undertaken to remove centuries of grime and overpainting and to stabilize what was left of Leonardo's brushwork. Unlike the fresco paintings you have seen in previous chapters, the *Last Supper* was painted not on wet plaster (*buon fresco*) but on dry plaster (*fresco secco*). An advantage of buon fresco is that the paint is absorbed into the plaster and the two dry simultaneously. Leonardo chose to paint on dry plaster, in all likelihood to duplicate the spontaneous effect of painting on wood, but the mural began to flake not long after it was completed. In spite of its condition, however, we can perceive the Renaissance ideals of Classicism, humanism, and technical perfection that came to full fruition in the hands of Leonardo. The composition is organized through the use of one-point linear perspective. Solid volumes are constructed from a masterful contrast of light and shadow. A hairline balance is struck between emotion and restraint.

The composition of the *Last Supper* is one of near absolute symmetry, with Jesus positioned as the fulcrum to the left and right of which are six animated—one could say agitated—apostles. All of the lines in the composition (**orthogonals**) converge at a single point on the horizon, seen in the distance through the center of three windows behind Jesus. Our attention is held by His isolation; the apostles lean away reflexively at His accusation that one among them will betray Him. Incredulous, they gesture expressively and turn to one another—and to Jesus—for answers. "Who can this be?" "Is it I?" It is a testament to Leonardo's convincing portrayal of human reaction and emotion that we find ourselves imagining their dialogue. The guilty one, of course, is Judas, shown, elbow on the banquet table, clutching a bag of silver pieces at Jesus's left. The two groups of apostles are subdivided into four clusters of three, pacing the eye's movement along the strong horizontal line of the table. At the ends, left and right, the "parenthetic" poses of the men coax the viewer back inward to Jesus at the center. Leonardo's exacting use of perspective and his subtle balance of motion and restraint represent two significant aspects of Renaissance composition.

The misty, hazy atmosphere and mysterious landscape of the *Madonna of the Rocks*, deftly handled chiarsoscuro, and the cryptic expression on the face of the Virgin Mary, were still in Leonardo's pictorial repertory when he created what is arguably the most famous portrait in the history of art—the *Mona Lisa* (**Fig. 13.4**). It is a portrait of Lisa di Antonio Maria Gherardini, commissioned by her banker-husband, Francesco del Giocondo. The portrait, which is sometimes referred to as "La Gioconda" takes its name from the Italian contraction of the words "ma donna (*my lady*) Lisa." What is it about this portrait that has contributed to its iconic status? To begin with, it is one of his relatively few completed paintings. With his *Mona Lisa*, Leonardo modernized portraiture: he replaced the typical profile view of a sitter with a natural three-quarter-turned body position by which a visual dialogue could be established between the sitter and all of us outside of the picture space. He departed from convention by fixing the sitter's confident eyes on the viewer when it would have been considered inappropriate for a woman to look directly into the eyes of a man. For Leonardo, the face (particularly the eyes) and the hands (their placement and gestures) conveyed much about the personality of the sitter, inviting us to "know" them rather than just to see them. That invitation is accepted by about 6 million people per year who see her

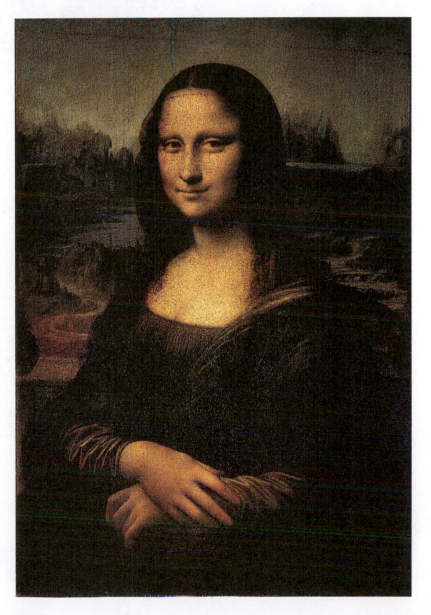

▶ **13.4 Leonardo da Vinci, *Mona Lisa*, ca. 1503–1505. Oil on wood panel, 30¼" × 21" (77 × 53 cm). Musée du Louvre, Paris, France.** *Mona Lisa* has been called the most famous portrait in the world, even the most famous painting. The sitter's face, subtly modeled with gradations of color, has been called inscrutable. Is her gaze engaging the viewer or perhaps the artist? The gentle repose of her hands has been considered exquisite. The scenic backdrop is fantasy.

at Paris's Louvre museum who may wonder about who might be the object of her glance or what conversation brings a mysterious smile to her lips. Leonardo was a master of the fine line between revealing and concealing, and thus our interpretation of the painting is limited only by our capacity to imagine. The American singer-songwriter Bob Dylan wrote that "Mona Lisa must have had the highway blues; you can tell by the way she smiles."

If we had been bequeathed nothing but Leonardo's *Notebooks*, we would still say that he had one of humanity's most fertile minds. By means of his sketches, one could say that he "invented" flying machines, submarines, turbines, elevators, ideal cities, and machines of almost

CONNECTIONS Leonardo's *Notebooks* were comprised of leaves of paper, a relatively new drawing material that was introduced to Italy in the late 15th century, fast on the heels of Gutenberg's first printing press. Until that time, artists made drawings on either parchment or vellum—both derived from animal skins. The material was expensive to produce and thus drawings were made with great attention and precision; the idea of quick, experimental sketches would have been out of the question. But in the late 15th century, the process of creating paper from pulp in great quantities made the material affordable and, with that, drawings became extremely common—a vital part of the artist's conceptual and creative process.

Papermaking came late to Europe. Archaeologists date the invention of papermaking to China some 2000 years ago. The Chinese closely guarded the secret of paper manufacturing, but it eventually spread to the rest of the world via the Silk Road. Arabs, who learned papermaking from the Chinese and created a paper industry in Baghdad as early as 793, also kept the process secret. It was not until 1150 that paper arrived in Spain from North Africa as a result of the Crusades.

every description. His knowledge of anatomy was unsurpassed (he came close to discovering the circulatory path of blood), and his interest in the natural worlds of geology and botany was keen. The *Notebooks*, in short, reflect a restlessly searching mind that sought to understand the world and its constituent parts. Leonardo's investigations were driven by an obsession with science and mathematics, a deep respect for the natural world, explorations into the psychology of human behavior, and a love for beauty—interests that were part and parcel of the Renaissance spirit. A page from Leonardo's *Notebooks* (**Fig. 13.5**) shows one of the first drawings of a human fetus and lining of the uterus. Typical for his notebook pages are copious annotations that fill virtually every square inch of space, along with myriad smaller drawings of different things and thoughts.

RAPHAEL SANZIO Raphael Sanzio (1483–1520) was born in Urbino, a center of humanist learning east of Florence dominated by the court of the Duke of Urbino. His precocious talent was first nurtured by his father, a painter, whose death in 1494 cut short the son's mentoring. The young Raphael then went to Perugia as an apprentice to

◀ **13.5 Leonardo da Vinci, anatomical drawing, medical studies of the human body, 1509–1514. Black and red chalk, pen and ink wash on paper, 12" × 8⅝" (30.5 × 22 cm). Royal Library, Windsor Castle, London, United Kingdom.** Leonardo's anatomical drawings show great drafting skill, but the slight scientific inaccuracies reflect the state of knowledge of his day.

◀ **13.6** Raphael, *Madonna of the Meadow*, 1508. Oil on panel, 44½" × 34⅝" (113 × 88 cm). Kunsthistorisches Museum, Vienna, Austria. Like Leonardo in his *Madonna of the Rocks*, Raphael organizes his figures in a pyramidal shape. Unlike Leonardo, he opts for a vivid backdrop, a bright palette, and crisp contours.

his use of chiaroscuro was more delicate than dramatic, and his brushwork was more tightly controlled.

Raphael left Florence for Rome in 1508. Within a year, at Pope Julius II's behest, he began painting the walls of the Stanza della Segnatura in the Vatican Palace and, after completing that project, he painted a portrait of his employer in 1511. According to Vasari, it was "so true and so lifelike, that the portrait caused all who saw it to tremble as if it had been the living man himself" (**Fig. 13.7**).

Raphael died at the early age of 37 but had amassed an extensive list of projects and responsibilities under both Julius II and his successor, Pope Leo X, including assorted administrative posts for the papacy, overseeing the construction of the new Saint Peter's, and serving as superintendent of the Vatican's collection of antiquities. At Raphael's request, he was buried in the Pantheon; the inscription on his tomb reads "Here lies that famous Raphael by whom Nature feared to be conquered while he lived, and when he was dying, feared herself to die."

▼ **13.7** Raphael, *Portrait of Pope Julius II* (mid-1511). Oil on poplar, 108.8 × 81 cm. National Gallery, London.

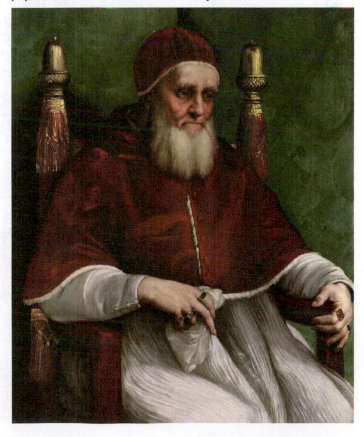

the painter Perugino where his talents were quickly recognized. In 1505, at the age of 22, he moved on to Florence, where he worked for three years.

While in Florence, Raphael painted many compositions featuring the Virgin Mary and Jesus in an outdoor setting. The *Madonna of the Meadow* (**Fig. 13.6**) features a typical format for Raphael: Mary, Jesus, and, in this case, John the Baptist are arranged in a pyramidal configuration similar to that which we see in Leonardo's *Madonna of the Rocks*, a format that produces a rationally ordered composition. The group is placed in the extreme foreground against a fertile landscape that fades to a misty blue at the **horizon line**, and the even compositional lighting (as opposed the sfumato Leonardo preferred) adds clarity to the forms and colors. Raphael's precise drawing, subtle modeling of the figures, and placid smiles contribute to a feeling of sweetness and overall peacefulness in the composition that seems a bit at odds with the visual narrative he constructs. The child, John the Baptist, genuflecting on one knee before the baby Jesus, hands Him a thin wooden staff in the shape of a cross. Jesus grasps it and, at the same time, His mother seems to gently keep Him from advancing toward John. As in Leonardo's *Madonna of the Rocks*, even though the relationship between the boys seems playful, their gestures may be interpreted as a premonition of Jesus's sacrifice on the cross to come.

Raphael's approach to painting was, in most ways, markedly different from Leonardo's. Raphael's style was more linear—more reliant on meticulous drawing—than Leonardo's,

One of Raphael's most outstanding works—and certainly one of the most important for defining the meaning of the 16th-century Renaissance in Rome—is a fresco painted in 1510–1511 on a wall of the Stanza della Segnatura, a room in the papal apartments that was originally used by Julius as a library and private office. The iconographic program of the frescoes concerns the education of a contemporary pope; *The School of Athens* (Fig. 13.8A), which occupies one full wall of the square room, represents philosophy; the others symbolize law, theology, and poetry.

Philosophy (The School of Athens) portrays an imagined gathering of the great minds of antiquity in an immense vaulted space that must have been inspired by the impressive ruins of Roman baths and basilicas, and perhaps the work new Saint Peter's, then under construction. The central figures, framed by the most distant of a succession of arches, are the two giants of Classical-era philosophy—Aristotle (on the right) and his mentor, the elder Plato (on the left). On a par with one another as they stride toward us, the two are flanked to either side by those whose views of the world and accomplishments were framed by their distinct philosophies: Plato's theory of Forms and concern with the mysteries that transcend human experience, and Aristotle's belief that knowledge is rooted in empirical observation. By virtue of their attributes, some of the figures have been identified, and several feature portraits of contemporary artists who allied with these competing philosophies. In the left foreground—on Plato's side—we see Pythagoras making notes while a younger man, standing before him, displays the harmonic scale. Sprawled on the steps in a blue garment is the Cynic philosopher, Diogenes, and the pendant figure to Pythagoras on the opposite side—Aristotle's side—is Euclid, who bends over a slate with a compass to demonstrate a theorem. This is thought to be a portrait of the architect, Bramante, a great supporter of Raphael's. Above his head, echoing its round,

▼ **13.8A** Raphael, *Philosophy (The School of Athens)*, 1509–1511. Fresco, 25' 3" × 18' (770 × 548 cm). **Stanza della Segnatura, Stanze di Raffaello, Vatican Palace, Vatican City State, Italy.** The central figures represent Plato and Aristotle. The man in the forefront is believed to be Michelangelo resting his head on his fist. This is no static portrait: people move about in all directions, some with their backs turned to the viewer. One tries to scribble in a notebook held precariously on his raised knee.

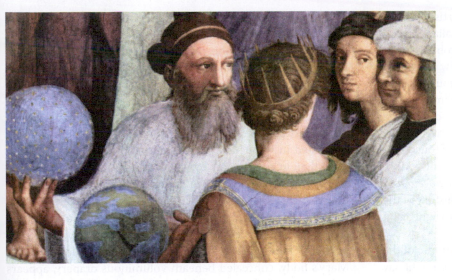

◀ **13.8B** Raphael, *Philosophy (The School of Athens)*, 1509–1511. Fresco (detail), 25'3" × 18' (770 × 548 cm). Stanza della Segnatura, Stanze di Raffaello, Vatican Palace, Vatican City State, Italy. Raphael included a self-portrait in the lower right corner of the fresco, placing himself firmly within the rationalist tradition of Aristotle.

That such a fresco should adorn a room in the Vatican, the center of Christian authority, is not difficult to explain. The papal court of Julius II shared the humanist conviction that philosophy is the servant of theology and that beauty, even if derived from a pagan civilization, is a gift from God and not to be despised. To underscore this point, Raphael's homage to theology across the room, his fresco called the *Disputà*, shows in a panoramic composition similar to *Philosophy (The School of Athens)*, the efforts of theologians to penetrate divine mystery.

balding pate, are the two astronomers, Zoroaster and Ptolemy (see detail, **Fig. 13.8B**), both holding globes. Just beyond their right, tucked into the corner and staring out at us in a black velvet hat, is Raphael himself—soundly placed in the company of the Aristotelians.

Raphael's *Philosophy (The School of Athens)* could be seen as a textbook exercise in linear perspective (**Fig. 13.8C**), with all of the compositional lines above and below the horizon converging at a single point, waist-level, between Plato and Aristotle. The compulsively ordered space acts as a stable foil for the myriad gestures and body positions of the assembly of humanist celebrities.

Finally, in the lower center of Raphael's *Philosophy (The School of Athens)* is a lone figure leaning an elbow on a block of marble and scribbling, taking no notice of the exalted scene about him. Strangely isolated in his stonecutter's smock, the figure has recently been identified, at least tentatively, as Michelangelo. If this identification is correct, this is the younger artist's homage to the solitary genius who was working just a few yards away from him in the Sistine Chapel.

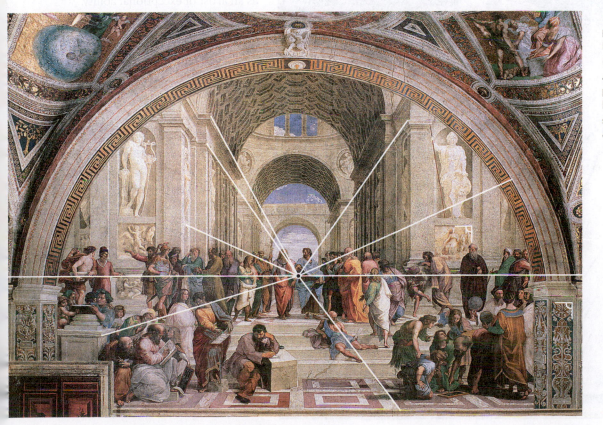

◀ **13.8C** One-point perspective in Raphael's *Philosophy (The School of Athens)*. In one-point perspective, parallel lines converge at a single vanishing point on the horizon.

MICHELANGELO BUONARROTI Of the artists considered to be the three great figures of the arts of the Italian Renaissance, Michelangelo Buonarroti (1475–1564) is probably most familiar to us. During the 1964 World's Fair in New York City, hundreds of thousands of culture seekers and devout pilgrims were trucked along a moving walkway for a brief glimpse of his *Pietà* at the Vatican Pavilion. A year later, Hollywood captured the saga of the Sistine ceiling and the relationship between Pope Julius II and Michelangelo in a film version of Irving Stone's 1961 biographical novel, *The Agony and the Ecstasy* (1961). More recently, Ross King's impeccably researched *Michelangelo and the Pope's Ceiling* (2003) brought the complicated history of the project and the relationship between the two men to light again in his definitive book.

Michelangelo's first apprenticeship was in the studio of the Florentine painter, Domenico Ghirlandaio, but one might say that his education as an artist began in earnest when he was brought into the circle of Lorenzo de Medici. It was through this lofty connection that he first studied sculpture. He might have stayed in Florence for a while but, with Lorenzo's death in 1492 and the subsequent demise of Medici supremacy, Michelangelo left the city for Venice. He made his way to Rome in 1496. Two years later, he created the **Pietà** (**Fig. 13.9**), his first work for a Roman patron—a French cardinal living in Rome.

The subject, the Virgin Mary holding her dead son in her lap, was a common theme in French and German art. Yet Michelangelo's rendering of the subject displays a profound sensitivity and as yet unparalleled mastery of textural effects in his handling of the marble. But beyond technique, Michelangelo introduced an aspect of his approach to the human form that digressed from both Leonardo's and Raphael's calculated ideal. He was more interested in practice than theory—more interested in what his eyes told him about the totality of the form than in any systems by which he might perfect it. How is this evident in the *Pietà*? An exacting observer might wonder how it is that Mary, so slight in frame, can believably cradle a fully grown man in her lap as if she were holding a sleeping child. The answer is that Michelangelo manipulated the proportions of the figure to make it work visually. The lower part of Mary's body, concealed beneath voluminous drapery, appears to have expanded to accommodate the body of Christ.

If Leonardo's *Mona Lisa* is one of the best-known paintings in Western art, in the medium of sculpture, Michelangelo's *David* (**Fig. 13.11**) is certainly one of the best-known sculptures—if not the best-known. It was commissioned upon Michelangelo's return to Florence in 1501, and the artist worked on a massive piece of Carrara marble that had lain abandoned behind the cathedral in Florence since the middle of the preceding century. For Michelangelo, as he described his creative process, the task was to see the form within the block of stone and to liberate it—to remove the material that surrounded and "imprisoned" it. He succeeded in doing just that with *David*, cementing his reputation as an artist of exceptional ability.

By the time Michelangelo crafted his own *David*, earlier versions of the biblical hero had been on display in Florence for several years—one by Donatello (see Fig. 12.16) and the other by Verrocchio (see Fig. 12.17). Michelangelo departed from these forerunners in many ways. His David is older, more mature—someone who does not simply fulfill his destiny but writes it. Donatello and Verrocchio depict him after he fells the giant with his slingshot and beheads him with a sword; the severed head lies at the youth's feet. Michelangelo gives us

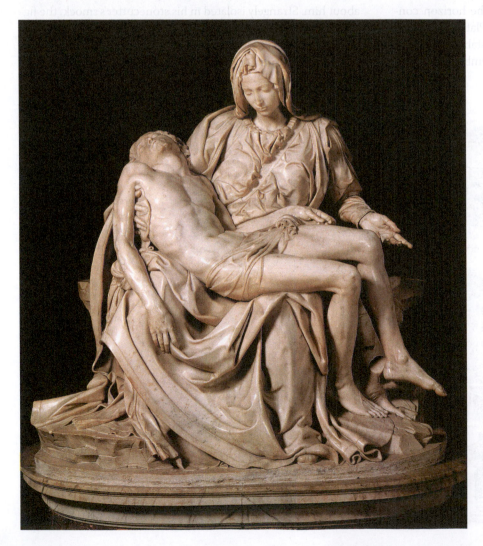

◄ **13.9 Michelangelo, *Pietà*, 1498–1499. Marble, 69" (175 cm) high. Saint Peter's, Vatican City State, Italy.** Michelangelo's *Pietà*, like those that preceded it, shows the Virgin Mary holding her dead son, Jesus, in her lap. Although it is an intensely religious work, it stirred controversy because Mary is portrayed as beautiful and not mature enough to have an adult son. Michelangelo countered that her beauty represented her purity. Julius II endorsed the sculpture by commissioning Michelangelo to create several other works after viewing the *Pietà*.

CONNECTIONS Forty-one years after Laszlo Toth jumped over a railing in Saint Peter's Basilica and attacked Michelangelo's *Pietà* with a hammer, the Vatican Museums held a seminar on the statue and on the controversies that arise over how (and why) damaged works of art should be restored. Toth had struck the figure of the Madonna 12 times, knocking off her left hand and arm completely and smashing her nose and the back of her head. At least 100 marble fragments had lain strewn on the floor of the chapel where the *Pietà* was displayed. One would think that restoring it would have been a simple, uncontested decision, but it was not. Some felt that the statue should remain in its damaged state as a reminder of the attack. Some thought that it should be repaired but that the missing pieces should be filled in with a material that would make them obvious. In the end, the *Pieta* was restored to the look of the original (using so-called integral restoration), reattaching pieces that remained and infilling the missing pieces with their equivalents, which were created from molds of an existing, full-scale copy of the statue. A Reuters reporter wrote, "restorers painstakingly pieced together the chunks and fragments, including one that arrived anonymously from the United States. A tourist who was in the basilica picked up a piece in the confusion as the police were arresting Toth. The tourist later apparently felt guilty and mailed it back [to the Vatican]."*

▲ **13.10** Michelangelo's *Pietà*, shown after the attack.

* Philip Pullella. (2013, May 21). Vatican marks anniversary of 1972 attack on Michelangelo's Pieta. http://www.reuters.com/article/us-vatican-pieta-idUSBRE94K0KU20130521.

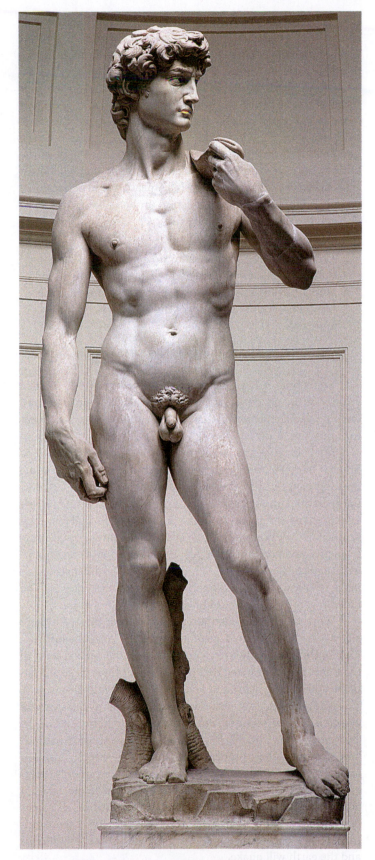

▲ **13.11** Michelangelo, *David*, 1501–1504. Marble, 14'3" (434 cm) high. Galleria dell'Accademia, Florence, Italy. David's weight is shifted to his right leg, causing a realignment of his body and lending to the realism of the sculpture. True, he stands there, but he is certainly not inert. He is contemplating his attack on the giant Goliath, and we imagine him pulling the sling from his shoulder and unleashing its missile.

David before the deadly encounter. He stares intently at his enemy, his knitted brows reflecting the inner workings of his razor-sharp mind. Michelangelo captures David caught in the moment between choice and action with what would become a signature physical and emotional tension. The sculptor's portrayal of the body at rest (with flawless contrapposto) compels our eyes to linger, to take in the details of David's splendid form. Michelangelo's version of David is a perfect reflection of the humanist notion that human beings are at the center of the universe, the "measure of all things." A century after Michelangelo carved his *David*, William Shakespeare would pen some of his most famous lines in a reflection on humankind conveyed through the character of Hamlet:

> "What a piece of work is man! How noble in reason, how infinite in faculty! In form and moving how express and admirable! In action how like an angel, in apprehension how like a god! The beauty of the world. The paragon of animals."

WILLIAM SHAKESPEARE, *HAMLET*, ACT 2, SCENE 2

The statue was placed outside the Palazzo Vecchio as a symbol of the civic power of the city, where it remained until ongoing damage from weather and pollution led to its transfer to a museum in 1873.

Michelangelo was called back to Rome in 1505 by Pope Julius II to create the monumental tomb we spoke about in the opening pages of this chapter. According to Ascanio Condivi, the artist's biographer, it was to be a three-story structure replete with perhaps 47 figures glorifying Julius's spiritual and temporal power: Victory, bound captives, allegorical figures representing the active and contemplative life, and larger-than-life-size statues such as *Moses* (**Fig. 13.12**), the only one by Michelangelo's hand to make it into the final, much-diminished design. The crowning glory likely would have been the Pope's effigy.

Work on *Moses* began after Julius's death in 1513, a mere eight years after Michelangelo accepted the commission from the Pontiff. Originally to be positioned on the second level of the tomb, it was intended that the statue of Moses be seen from below rather than at ground level as in its current placement.

Michelangelo is a master of restrained energy and pent-up emotion, and we see it in *Moses* just as we do in his *David*. His awesomeness is palpable. From the carefully modeled particulars of musculature, drapery, and hair to the fiercely inspired look on his face, Moses has the appearance, we can only imagine, of one who has seen God. His face radiates divine light but also divine fury toward the idolaters he spies when he comes down from Mount Sinai after receiving the Ten Commandments. He looks as though he will rise to judge the unrighteous and the earth will quake.

Michelangelo had hardly begun work on the Pontiff's tomb when Julius directed him to paint the ceiling of the Sistine Chapel to complete the work done in the previous century under Sixtus IV. Michelangelo fiercely resisted the project (he actually fled Rome and had to be ordered back by papal edict). Nevertheless,

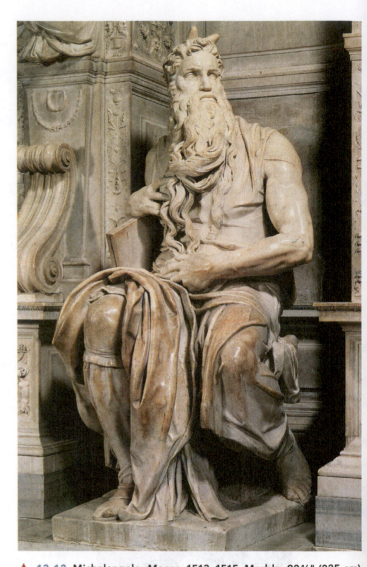

▲ **13.12** Michelangelo, *Moses*, 1513–1515. Marble, 92½" (235 cm) high. San Pietro in Vincoli, Rome, Italy. Moses has brought the commandments from Mount Sinai, and now he sits—momentarily—with his face twisting into a terrible wrath as he views idolaters. The "horns" on his head represent rays of light; the use of horns instead of rays is based on a mistranslation in the Latin Vulgate Bible.

he relented and, in spite of numerous technical problems and a steep learning curve for the artist in the art of fresco, he finished the ceiling in just under four years (1508–1512) (**Fig. 13.13**). He signed it "Michelangelo, Sculptor" to remind Julius of his reluctance and his own true vocation.

The vault measures some 5800 square feet and is almost 70 feet above the floor. After much anguish and the abandonment of a first design that would have populated the ceiling with a variety of colossal religious figures (eventually more than 300 in all), Michelangelo took command of the space by dividing it into painted, architectural "frames" into which he would place scenes from Genesis and other vignettes, biblical prophets and sibyls (female prophets), and *ignudi*—20 seated male nudes. In the four corners of the vault are scenes that depict heroic action in the Hebrew Bible (Judith beheading Holofernes, David slaying Goliath, Haman being punished for his crimes, and the rod

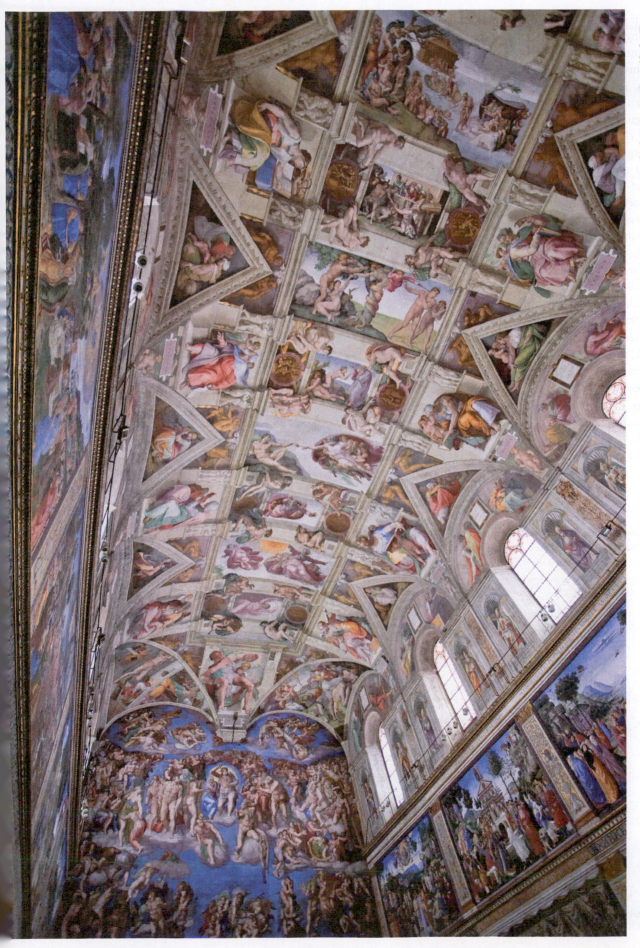

◀ **13.13**

Michelangelo, ceiling of the Sistine Chapel, 1508–1511. Fresco, 44' × 128' (13.44 × 39.01 m). Sistine Chapel, Vatican Palace, Vatican City State, Italy. The more than 300 figures painted by Michelangelo contain biblical scenes of the creation and fall of humankind. The fresco cycle took the artist some four years. Michelangelo would suffer the physical effects of working on the project for the rest of his life.

of Moses changing into a serpent). The other eight triangles—four on each long side of the rectangular space—are devoted to the biblical ancestors of Jesus Christ. Sandwiched between them are ten figures representing, alternately, Hebrew prophets and pagan sibyls. Ten major intermediate figures are alternating portraits of pagan sibyls (female prophets) and Hebrew prophets. The rectangular central panels that fill the vault from the entrance to the chapel to the altar wall on the opposite end, feature scenes beginning with God's creation of the world (closest to the altar) and ending with the Drunkenness of Noah (Genesis 9:20–27) after the great flood (closest to the entrance). Michelangelo started with the last scenes and, moving the scaffolding as each segment was completed, worked his way backwards in time to the creation, getting better and more confident as he went along.

Arguably the most famous of these scenes is *The Creation of Adam* (**Fig. 13.14**) and, in viewing the fresco, it becomes clear why Michelangelo saw himself more as a sculptor than as a painter. In translating his sculptural techniques to a two-dimensional surface, he conceived his figures in the round and used the tightest, most expeditious line and modeling possible to render them in paint. The fresco, demonstrating Michelangelo's ability to combine physical bulk with linear grace and a powerful display of emotion, well exemplifies the adjective *Michelangelesque*, applied to many later artists who were influenced by his style.

In this fresco panel, Michelangelo imagined the most dramatic moment in God's creation of the first human. Adam lies listless for lack of a soul on a patch of fertile green and looks directly at God the Father as He rushes toward him amidst a host of angels nestled under billowing drapery. The entire composition pulls toward the left, echoing the illuminated diagonal of empty sky that provides a backdrop for the very moment of creation. The atmosphere is electric; the hand of God reaches out to spark spiritual life within Adam—but does not touch him! In some of the most dramatic negative space in the history of art, Michelangelo has left it to the spectator to complete the act.

The full force of Michelangelesque style can be seen in the artist's second contribution to the Sistine Chapel: *The Last Judgment*, painted on the wall behind the main altar between the years 1534 and 1541 (**Fig. 13.15**). An enormous fresco marking the end of the world when Christ returns as judge, *The Last Judgment* shows the enthroned Messiah in the top-center of the chaotic scene, the world beneath Him being divided into the damned to His lower left (our right) and those who are called to glory above. Into that great scene, Michelangelo poured both his own intense religious vision and a reflection of the troubled days during which he lived. It was painted after the Holy Roman Emperor Charles V had sacked Rome in 1527 and after the Catholic Church had been riven by the Protestant Reformation following Martin Luther's posting of his 95 Theses in 1517. It is a fearsome representation of the wrath of God and trembling souls that resided in Michelangelo's imagination and was, in this fresco, made real. His own anxiety and dread did not escape representation. To the right of Jesus, just below and along an

▼ **13.14** Michelangelo, *The Creation of Adam*, 1508–1512. Fresco (detail), ca. 9' 2" × 18' 8" (280 × 570 cm). Sistine Chapel, Vatican Palace, Vatican City State, Italy. The spark of life is passed from God to Adam. The composition of the work unifies the figures, but they do not actually touch.

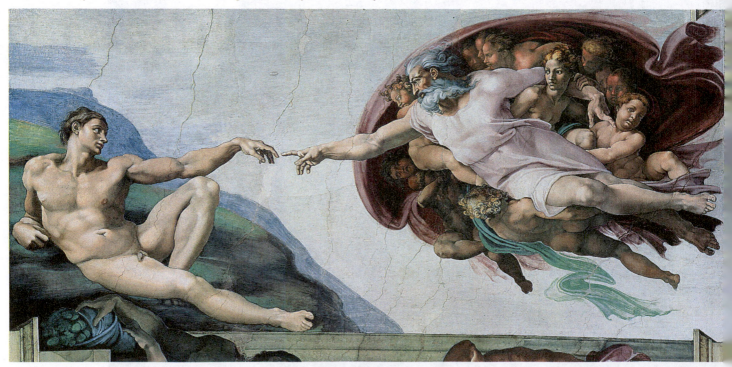

▶ **13.15**

Michelangelo, *The Last Judgment*, **1534–1541. Fresco (restored), 44' 11" × 40' (13.7 × 12.2 m). Sistine Chapel, Vatican Palace, Vatican City State, Italy.** The loincloths on the figures were added later to appease the prudish sensibilities of post-Reformation Catholicism. The flayed skin of Saint Bartholomew below and to the right of Christ is a self-portrait of the painter.

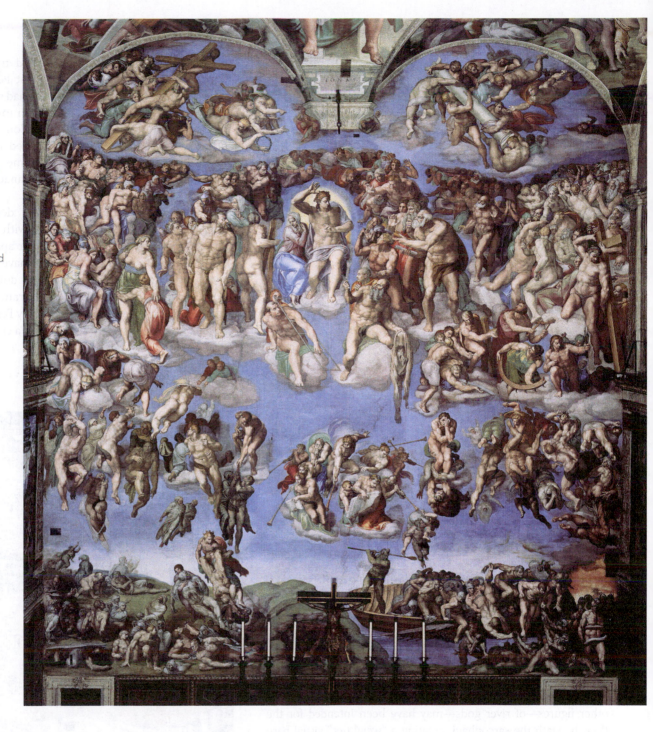

implied diagonal line, is the martyr Saint Bartholomew who holds, in his left hand, a flayed human skin representing the horrific method by which he was slain. The head on the limp remains bears Michelangelo's self-portrait.

Between the two projects for the Sistine Chapel, Michelangelo accepted a commission by Pope Leo X and the future Pope Clement VII—both from the Medici family—to design a funerary chapel in the Florentine Church of San Lorenzo to house the tombs of Medici dukes, Lorenzo di Piero and Giuliano di Lorenzo, and their more illustrious forbearers, Lorenzo the Magnificent and Giuliano de' Medici, one-time co-rulers of Florence. Although Michelangelo first conceived the project in 1519, he

worked on it only in fits and starts from 1521 to 1534 when he departed for Rome permanently. He never personally saw it to completion, the final realization left to the hands of his Florentine pupils.

The interior of the Medici Chapel—the New Sacristy (**Fig. 13.16**)—echoes Brunelleschi's design for the Old Sacristy, also part of the Church of San Lorenzo, and his Pazzi Chapel in its dramatic contrast of white stucco and grayish "pietra serena" stone, Corinthian pilasters, arches, and other classical architectural motifs. The tombs of Giuliano and Lorenzo sit across from one another in the space, their figural groups arranged in a triangular shape above the **sarcophagi** that house their remains.

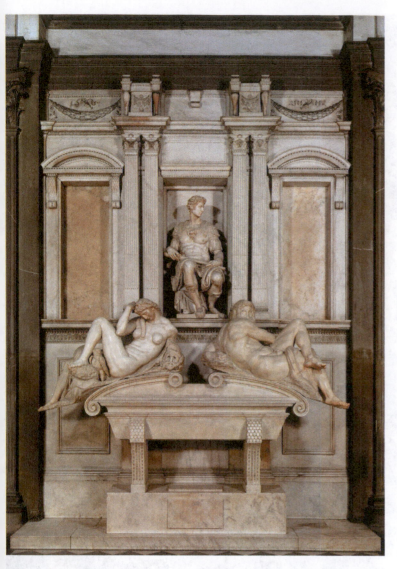

▲ **13.16** Michelangelo, **Medici Chapel with tomb of Giuliano de' Medici,** 1519–1534. Church of San Lorenzo, Florence, Italy.

Scholars have suggested that, in addition to what we see, two other figures—of river gods—may have been intended for the floor beneath the sarcophagi, creating a "weightier" visual base and completing what they believe was a complex iconographic scheme based on Neo-Platonic philosophy. The statues of Lorenzo and Giuliano are a study in contrasts; Lorenzo is portrayed as introspective and meditative, Giuliano imposing and confident. The photograph in Figure 13.16 shows Giuliano's tomb, and the pendant figures beneath his statue are Night (on the left) and Day (on the right); Lorenzo's tomb includes figures of Dawn and Dusk. Both the stark decoration of the chapel and the positioning of the statues (Duke Lorenzo seems always turned to the dark with his head in shadow, whereas Duke Giuliano seems more readily to accept the light) form a mute testament to the rather pessimistic and brooding nature of their creator.

The New Saint Peter's

In 1506, Pope Julius II commissioned the architect Donato Bramante (1444–1514) to rebuild Saint Peter's Basilica in the Vatican (**Figs. 13.17**). Old Saint Peter's had stood on Vatican Hill since it was first constructed more than 1000 years earlier, during the time of the Roman emperor Constantine. By the early 16th century, it had repeatedly suffered roof fires, structural stresses, and the general ravages of time. In the minds of the Renaissance "moderns," it was a shaky anachronism.

BRAMANTE'S PLAN Bramante's design envisioned a domed, central-plan featuring a cross with arms of equal length that each terminated in a semicircular apse (**Fig. 13.18A**) and portal. Access to the interior would have been possible from any of the four portals and the central dome equidistant from each. The plan was not executed in Bramante's lifetime, but a small chapel in Rome commissioned by Ferdinand and Isabella of Spain and begun in 1502 may give us a clue to what Bramante

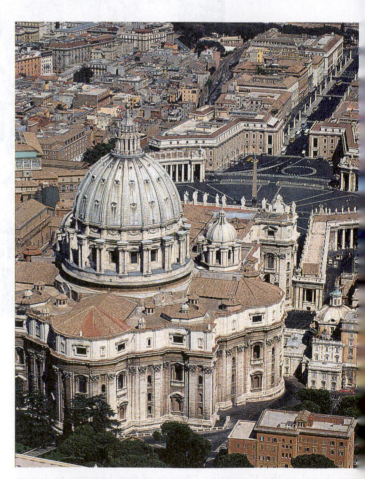

▲ **13.17** Michelangelo, **Saint Peter's Basilica (looking northeast),** 1546–1564 (dome completed in 1590 by Giacomo della Porta). Vatican City State, Italy. Length of church, ca. 694' (212 m); diameter of dome, 138' (42 m); height of nave, 152' (46 m); height from nave floor to summit of cross on dome, 435' (133 m).

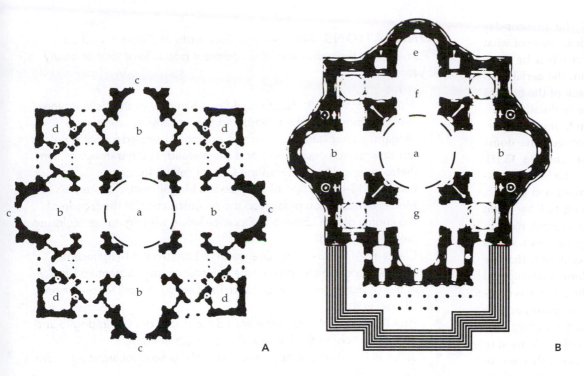

◀ **13.18** Floor plans for the new Saint Peter's Basilica, Rome, Italy, 1506–1564. Bramante's plan, part A (1506–1514), shows a compact plan of a Greek cross with arms or transepts (b) of equal length meeting at a central altar (a) set under a dome, with each arm ending in a semicircular apse (e) opening to a portal or entrance (c), and including several chapels (d) for smaller services. Michelangelo's plan, part B (1547–1564), shows a centralized domed Greek cross inscribed within a square but retained the vestibule (c), now fronted by a portico with giant columns. Artwork by Cecilia Cunningham.

had in mind for the dome. The so-called *Tempietto* ("little temple," **Figure 13.19**) has elements that are similar to the image of Bramante's proposed St. Peter's on a 1506 coin minted to commemorate the new building (**Fig. 13.20**).

MICHELANGELO'S PLAN After Bramante's death, other architects—including Raphael—worked on the massive project, and in 1547, Michelangelo was appointed chief architect. He returned to Bramante's plan for a central-domed church (see **Fig. 13.18B**) and envisioned a ribbed dome somewhat after the manner of the cathedral in Florence, but on a far larger scale.

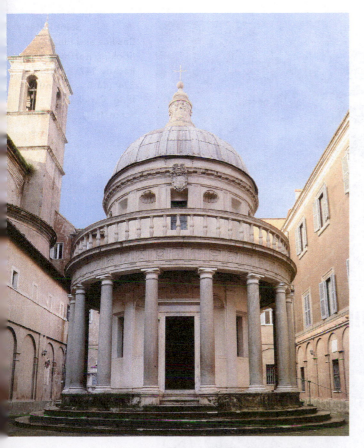

▲ **13.19** Donato D'Angelo Bramante. Tempietto, San Pietro in Montorio, Rome, Italy, begun 1502. The image is similar to the design of Bramante's vision for St. Peter's.

▲ **13.20** Cristoforo Foppa Caradosso, attributed, cast bronze medal of Pope Julius II commemorating the building of St Peter's. Rome, Italy, 1506. British Museum, London, Great Britain.

The main façade of the present-day Saint Peter's gives us no clear sense of what Michelangelo had in mind when he drew up his plans. It is only from the aerial view looking eastward at the back of the basilica that we can appreciate the undulating contours, multiple apses, and, most importantly, the relationship between the dome and the rest of the structure (see Fig. 13.17). Michelangelo's central plan included a vestibule and an extended columned portico, which was eventually elongated by Carlo Maderno, who added the present nave in the early 17th century. **Figure 13.21** shows the façade, designed by Maderno, that we see today, as well as the colonnaded elliptical piazza in front of the basilica that was completed under the direction of Gian Lorenzo Bernini in 1656–1667, almost a century after Michelangelo's death. Michelangelo lived to see the completion of the drum that was to support his dome, which was raised some 25 years after his death by Giacomo della Porta.

CONNECTIONS Michelangelo Buonarotti of Florence worked in Rome under the patronage of six different popes for a total of nearly 60 years.

- Julius II (1503–1513): Nephew of Pope Sixtus IV of the della Rovere family; commissioned his tomb and accompanying sculpture (a gargantuan freestanding structure originally planned for Saint Peter's but downsized considerably and set, instead, in the transept of San Pietro in Vincoli) and the Sistine Chapel ceiling frescoes
- Leo X (1513–1521): Son of Lorenzo the Magnificent of Florence's Medici dynasty; commissioned the reconstruction of the façade of the church of San Lorenzo in Florence along with figurative sculpture (never completed)
- Clement VII (1523–1534): Grandson of Lorenzo the Magnificent; commissioned the Medici tombs in Florence, the Laurentian Library in the church of San Lorenzo, and *The Last Judgment* for the Sistine Chapel in Rome
- Paul III (1534–1549): Commissioned the Piazza del Campidoglio and the upper floor of the Farnese Palace, both in Rome
- Julius III (1550–1555): Appointed Michelangelo chief architect of Saint Peter's in Rome
- Pius IV (1559–1565): Commissioned the Porta Pia gate in Rome's ancient Aurelian Walls

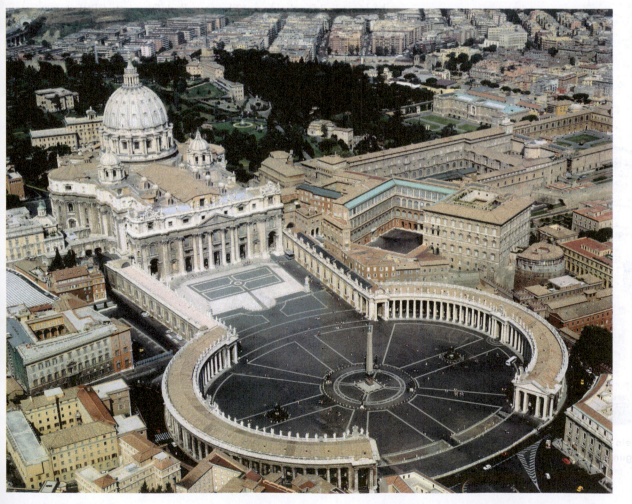

◀ **13.21** **Saint Peter's Basilica and Piazza (looking northwest). Façade 147' high × 374' (44.8 × 114 m) long. Vatican City State, Italy.** The building combines Renaissance and Baroque elements. The nave and façade were finished by Carlo Maderno (1556–1629) between 1606 and 1612, and the colonnades around the square were built between 1656 and 1663, according to Bernini's design.

The High Renaissance in Venice

The brilliant and dramatic outbreak of artistic activity in 16th-century Rome and Florence found its counterpart in the Republic of Venice to the north. While Rome produced renowned examples of architecture, sculpture, and fresco painting, Venice (and its territory) became famous for its revival of Classical architecture and for its oil paintings. Venice's impressive cosmopolitanism derived from its position as a maritime port and its trading tradition.

ANDREA PALLADIO The leading architect of the whole of northern Italy in the High Renaissance, the only one to rival the achievements of Tuscan architects of the caliber of Alberti and Michelangelo, was Andrea di Pietro della Gondola (1508–1580)—better known as Palladio. Coined by his first patron, Gian Giorgio Trissino of Vicenza, the name derives from that of the ancient Greek goddess Pallas Athena and indicates the main source of Palladio's inspiration: the architecture of Classical Greece as he saw it reflected in the buildings of ancient Rome. The young Palladio and his patron made several visits to Rome, studying both High Renaissance buildings and the ruins of the ancient city. His designs for villas, churches, and palaces stressed the harmonic proportions and Classical symmetry that the Romans had inherited from the Greeks. His *Four Books of Architecture* (1570) spread his style throughout Europe. The Palladian style became particularly popular in 18th-century England and in due course was exported to North America, where it inspired much of the "Greek Revival" architecture of the Southern United States.

Whether Palladio was born in Vicenza is uncertain, but it is this city that contains the largest number of his buildings, both public and private. As a result, Vicenza is one of the most beautiful and architecturally interesting cities of Renaissance Venetian territory, and indeed of Italy as a whole. The Villa Rotunda is perhaps the finest example of Palladio's style (Fig. 13.22). Built for a monsignor of the Papal court who retired from service, the plan owes much to prototypes from antiquity—particularly the Pantheon in Rome (see Fig. 4.33)—in its symmetry and temple-front porticos. But Palladio was not just an imitator, his work not just derivative. He internalized the mathematical systems and structural vocabulary of the Classical era and composed his own, highly original architectural essays, as it were. The plan of the Villa Rotunda is essentially a circle within a square within a cross. From the center of the villa—the domed space—one can look in four directions that culminate in beautifully framed views of the surrounding landscape. The sense of harmony and balance of proportion is a perfect example of the Renaissance revival of Classical ideals.

Painting in Venice

Renaissance art in Florence and Rome was based, first and foremost, on the study of form. From Masaccio to Michelangelo, whether with line or light (chiaroscuro), artists endeavored to convincingly portray the substance of form through meticulous drawing and the illusion of space using mathematical systems. But for the Venetians, color—not sculptural form—was the primary focus, and oil painting—not drawing—was the vehicle for capturing vibrant, intense hues and the brilliance and subtlety of Venetian light. First popularized in the north, oil painting provided the artist unparalleled opportunities to enrich and deepen color with applications of multiple, translucent layers of paint. Venetian painters, like their counterparts in Northern Europe, also had an eye for detail and a passion for landscape (an ironic interest, since Venice had so little land).

TITIAN Tiziano Vecellio (ca. 1488/1490–1576), called Titian, was the master of the colorist methods and painting techniques for which Venice was renowned. His work had an impact not

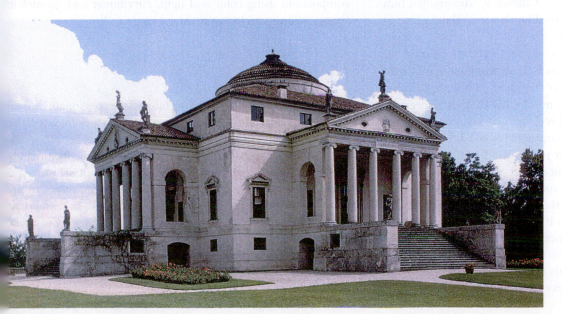

◀ **13.22 Andrea Palladio, Villa Rotunda (looking southwest), near Vicenza, Italy, ca. 1550–1570.** The villa revives Classical ideals. Parts of it resemble Roman temples, yet it is also highly innovative.

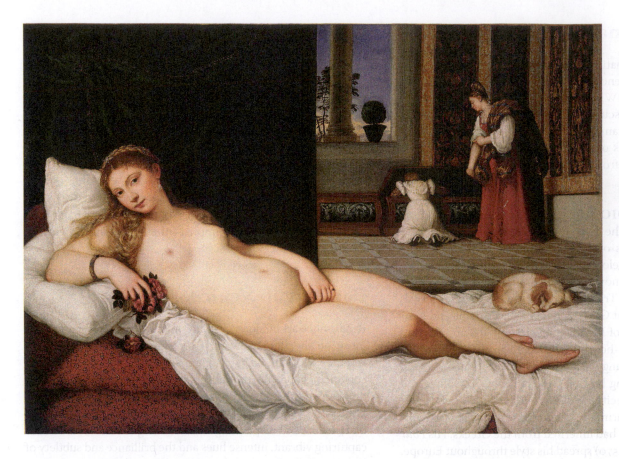

◄ **13.23** Titian, *Venus of Urbino*, 1538. Oil on canvas, ca. 47" × 65" (119 × 162 cm). Galleria degli Uffizi, Florence, Italy. The artist created the radiant golden tones of Venus's body through the application of multiple glazes over pigment.

only on his contemporaries but also on later, Baroque painters in other countries—Peter Paul Rubens in Antwerp and Diego Velasquez in Spain. He had more in common with the artists who would follow him than with his Renaissance contemporaries in Florence and Rome. Titian's pictorial method differed from those of Leonardo, Raphael, and Michelangelo; he constructed his compositions by means of color, brushwork, and **glazing** rather than with line and chiaroscuro.

Titian's artistic output during 70 years of activity was vast. He was lionized by popes and princes and was a particular favorite of Holy Roman Emperor Charles V, who granted him noble rank after having summoned him on several occasions to work at the royal court.

Titian's *Venus of Urbino* (**Fig. 13.23**), likely painted for the Duke of Urbino, Guidobaldo II, is a reclining nude woman in a bedchamber in the guise of the goddess of love. Inspired by a painting of a sleeping Venus by his teacher, Giorgione, Titian's goddess lounges on a red, upholstered couch draped in pure white linens. She is thoroughly relaxed, legs crossed, arm draped discretely over her pelvis, hand gently clutching a small cluster of roses. Venus meets our gaze and blushes, ever so slightly, her rosy cheeks mirrored in the pink-tinged glow of her luminescent flesh created through extremely subtle gradations of pigment blended into transparent glazes. Titian's virtuoso brushwork seems to dance across the canvas, delighting in a display of textural contrasts: the smooth flesh and soft tendrils of hair against delicate folds of drapery, the silky coat of the little pet dog curled up at Venus's feet, the delicate flower petals against rich brocade fabric.

Titian's use of color as a compositional device is also significant. A square block of green velvet drapery provides a stark backdrop for Venus's head, shoulders and torso, encouraging our eyes to linger on the most important part of the scene. At the same time, the strong contrast between that drapery and the light in the distant part of the room draws our attention to the action occurring in the right background. The patch of red in the upholstery and the red dress of the servant—diagonally opposed—capture the eye and shift it from foreground to background and back again. Titian thus subtly balances the composition using color and light, curvilinear and geometric shapes, stillness and movement.

Mannerism

There is no doubt that powerful artistic personalities like Leonardo, Raphael, Michelangelo, and Titian dominated the Italian art scene during the High Renaissance. So extraordinary were their accomplishments that one might legitimately wonder, "What was there to do next?" Works of art emerged among the next generation of artists—termed *Mannerist* by art historians—that were distinct in style from one another but had in common a rejection of many of the artistic tenets of these "Old Masters." Collectively, **Mannerist** artists set a different course, one that often seems in direct opposition to the High Renaissance styles of Florence, Rome, and Venice.

Characteristics of Mannerist art include distortion and elongation of figures; flattened and ambiguous space; lack of

13.24 Jacopo Pontormo (born Carucci), *Entombment*, 1525–1528. Oil on panel, 123" × 76" (312.4 × 193 cm). Capponi Chapel, Santa Felicità, Florence, Italy. The figures do not possess the substantial realism of those of Michelangelo and Raphael. Instead, we find nearly weightless figures with elongated limbs.

compositional balance and defined focal point; and discordant pastel hues. In general, the pursuit of naturalism that preoccupied painters since Giotto was abandoned as Mannerist artists took pleasure instead in highlighting the "artmaking" aspect of their work—the artifice.

JACOPO DA PONTORMO In the *Entombment of Christ* (**Fig. 13.24**) by Jacopo da Pontormo, we witness this strong shift from the typical High Renaissance style. The sculpturesque figures of Michelangelo and Raphael and the ideal proportions of Leonardo have been replaced with figures that seem to float, almost weightless. Their bodies and limbs are elongated, and their heads, much smaller in proportion, are dwarfed by their billowing, pastel-colored robes. There is a certain innocent beauty in the common facial features, haunted expressions, and nervous glances. The movement swirls around an invisible vertical axis; the figures press forward to the picture plane and outward toward the borders of the painting, leaving a void space in the center of the composition.

The weightlessness, distortion, and ambiguity of space create an almost otherworldly aspect—an atmosphere in which objects and people do not come under an earthly gravitational force. The artist proffers this strangeness with no apology, and we find ourselves taking the ambiguities in stride. In fact, it really is not clear whether the subject is the descent from the cross or the entombment of Christ; for Pontormo and other Mannerists, conventional narratives and **iconography** are irrelevant.

BRONZINO Agnolo di Cosimo di Mariano Tori (1503–1572), known as Bronzino, was a student of Pontormo. Bronzino's 16th-century masterpiece *Venus, Cupid, Folly, and Time (The Exposure of Luxury)* (**Fig. 13.25**) is a classic example of a work in which there is much more than meets the eye. On the surface, it is a fascinating jumble of mostly

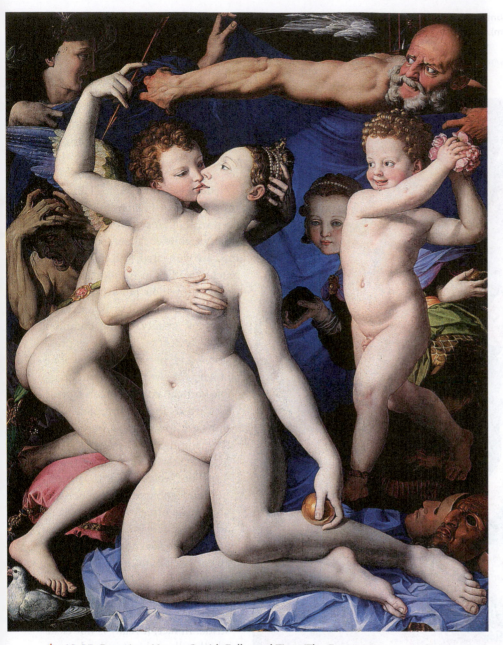

▲ **13.25** Bronzino, *Venus, Cupid, Folly, and Time (The Exposure of Luxury)*, ca. 1546. Oil on wood, 57 ½" × 45 ⅝" (146.1 × 116.2 cm). National Gallery, London, United Kingdom. Along with its eroticism, the painting has the ambiguity of meaning and obscurity of imagery that are considered characteristic of Mannerism.

pallid figures, some of which possess body proportions that, as in the Pontormo painting, do little to convince us that they would exist in the real world. Over the years, the work has alternately titillated and intrigued viewers because of the manner in which it weaves an intricate allegory, with many actors, many symbols. Venus, undraped by Time and spread in a languorous diagonal across the front plane, is fondled by her son Cupid. Folly prepares to cast roses on the couple, while Hatred and Inconstancy (with two left hands) lurk in the background. Masks, symbolizing falseness, and other objects, with meanings known or unknown, contribute to the intricate puzzle. What is symbolized here? Is Bronzino saying that love in an

environment of hatred and inconstancy is foolish or doomed? Is something being suggested about incest? Self-love? Can one fully appreciate Bronzino's painting without being aware of its iconography? Is it sufficient to respond to the elements and composition, to the figure of a woman being openly fondled before an unlikely array of onlookers? No simple answer is possible, and a Mannerist artist such as Bronzino would have intended this ambiguity. Certainly one could appreciate the composition and the subject matter for their own sake, but awareness of its meaning would enrich the viewing experience.

LAVINIA FONTANA The daughter of an accomplished painter in Bologna, Lavinia Fontana (1552–1614) trained in her father's studio and traveled to Rome to study the works of Michelangelo and Raphael. There she found patronage, primarily as a portrait painter, even at the level of the Papal court. Her husband, Gian Paolo Zappi, gave up his own career after they married in 1577 to manage her prolific one.

Fontana's painting *Noli Me Tangere* (*Do Not Touch Me*) (Fig. 13.26) is noteworthy in that women artists of the era were far less likely to acquire commissions for religious paintings than were male artists. Yet Fontana painted altarpieces as well as the usual portraits. *Noli Me Tangere* refers to the words attributed to the risen Christ in the Gospel of John (20:11–18). Mary Magdalene visits Jesus's tomb on the third day following his execution (pictured in the left background) and finds it empty. Soon thereafter, she has a chance encounter with a man disguised as a gardener (her figure now repeated in the foreground) and comes to realize his true identity. Jesus has risen from the dead. She drops to her knees and reaches for Him, but He rejects her touch.

The subject was not unusual, but Fontana's presentation is. Artists typically placed the visual emphasis on Jesus but Fontana, in positioning the Magdalene's plaintive face front and center, focuses our attention on her and the emotions that she must be experiencing—joy that Jesus is risen but confusion and melancholy when He keeps her away. Recalling the way in which Renaissance artists humanized their religious figures to draw feelings of empathy, it is imaginable that Fontana tapped into her viewers' own experiences with personal loss to create a dialogue between them and her subject.

SOFONISBA ANGUISSOLA In 1556, Giorgio Vasari traveled to Cremona to see the "marvels" of six sisters, children of the Anguissola family, who were "excellent in painting, music

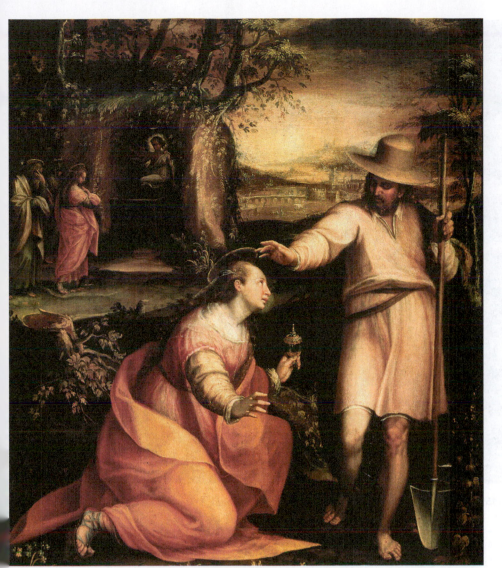

◀ **13.26** Lavinia Fontana, *Noli Me Tangere*, 1581. Oil on canvas, 31 ½" × 25 ¾" (80 × 65.5 cm). Galleria degli Uffizi, Florence, Italy. Fontana was an important portrait artist in Bologna whose father Prospero, himself a painter, had taught her to paint in the Mannerist style. But Fontana also made a number of religious paintings, with *Noli Me Tangere* considered to be among her best.

and *belles artes*." The beneficiary of a humanist education at home, the most famous of these sisters was Sofonisba (ca. 1532–1625), who enjoyed a great degree of fame in her own lifetime. As a young woman, she traveled with her father to Rome, where she most likely met Michelangelo. Anguissola also spent time in Milan and, in 1560, traveled to Spain on the invitation of King Philip II to serve as a court portraitist. She remained in Spain for most of the next decade, moving back to Italy after her marriage to a Sicilian nobleman. She died in Palermo in 1625.

Anguissola was enormously successful. Most of her large body of work reflects the regional, realistic style of Cremona rather than the Mannerist stylizations that were popular elsewhere in Italy. Her taste for meticulous detail was certainly influenced by Flemish portrait painters, including Anthony van Dyck, who painted Anguissola's portrait. *A Game of Chess* (**Fig. 13.27**), painted in 1555 when the artist was only 23, is a group portrait of three of the artist's sisters playing chess while a nanny-servant looks on. The brocade fabric of their elaborate dresses and the patterned tablecloth attest to the family's affluence and gentility, although the girls are anything but stilted in their behavior. The oldest, Lucia, looks up from

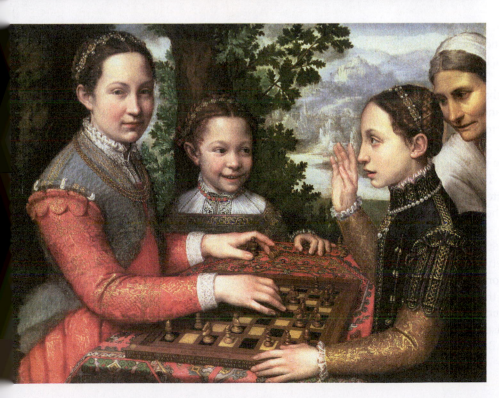

◀ **13.27** Sofonisba Anguissola, *A Game of Chess*, 1555. Oil on canvas, 28 ¼" × 38 ¼" (72 × 97 cm). National Museum in Poznan, Poland. Anguissola was one of the earliest women artists to be internationally renowned. Her father was influenced by Castiglione's *The Book of the Courtier* and saw to it that Anguissola attained a proper education.

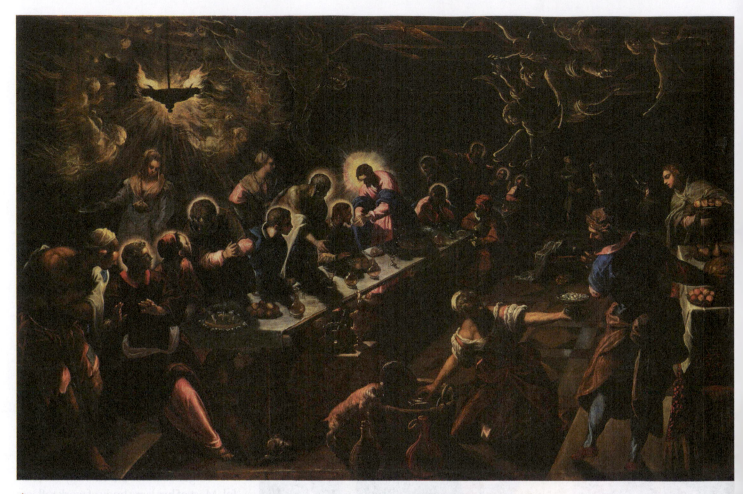

▲ **13.28** Tintoretto, *The Last Supper*, 1592–1594. **Oil on canvas, 12' × 18'8" (366 × 569 cm). Chancel, San Giorgio Maggiore, Venice, Italy.** Tintoretto's impassioned application of pigment lends energy to the painting. Although Tintoretto was a student of Titian, he constructed his forms in a more linear fashion, foregoing layer upon layer of glazing. A comparison with Leonardo's *Last Supper* quickly reveals Tintoretto's creation of a sense of motion and his dramatic use of light—both characteristics of the Baroque era to come.

the game to meet our gaze, self-assured and poised. Her sister Minerva seems to try to catch her attention, her hand raised and her lips slightly parted as if about to speak. The youngest looks on, her face brimming with joy, it seems, that Minerva appears to be losing the game. Animated gestures and facial expressions combine to create a work that is less a formal portrait than an absolutely natural and believable scene. Anguissola pushes beyond mere representation to suggest the personalities of her sisters and the relationships among them. This easy, conversational quality will become a familiar characteristic of group portraiture in the 17th century, particularly in the north.

TINTORETTO The last of the giants of 16th-century Venetian painting was Jacopo Robusti, called Tintoretto (1518–1594)—"little dyer," after his father's trade. His style combined the color of Titian, the drawing of Michelangelo, and the devices of Mannerism. His dynamic compositional structure and arrested momentary action, along with dramatic use of light and darkness, though, set the stage for the Italian Baroque style of the 17th century.

A comparison between Tintoretto's *Last Supper* (**Fig. 13.28**) and Leonardo's *Last Supper* (see Fig. 13.3) will illustrate the dramatic changes that had taken place in both the concept and style of art over almost a century. The depiction of time and motion are added to that of space, light has a drama all its own, and theatricality is the dominant aspect. In Tintoretto's painting, everything and everyone is set into motion. The space, sliced by a sharp, rushing diagonal that goes from lower left to upper right, seems barely able to contain all of the commotion, but this cluttered effect enhances the energy of the event.

Leonardo's obsession with symmetry, along with his balance between emotion and restraint, yields a composition that appears static in comparison to the asymmetry and overpowering emotion in Tintoretto's canvas. Leonardo's apostles seem posed for the occasion when seen side by side with Tintoretto's spontaneously gesturing figures. A particular moment is captured; we feel that if we were to look away for a fraction of a second, the figures would have changed position by the time we looked back.

The moment that Tintoretto has chosen to depict—when Jesus shares bread and wine with His apostles and charges them to repeat this in memory of Him—also differs from Leonardo's—the moment when Jesus announces that one among them will betray Him. Leonardo chose a moment signifying death, Tintoretto a moment signifying life, depicted within an atmosphere that is teeming with life.

GIOVANNI DA BOLOGNA Mannerist elements are not exclusive to painting; we detect them in sculpture and architecture as well. Giovanni da Bologna (1529–1608) was born Jean de Boulogne in Flanders, under Spanish rule at the time, and moved to Italy, where he assumed the Italian form of his name. He settled in Florence in 1552 where he attracted the attention of Francesco de' Medici. He became one of the most significant court sculptors of the Medici family, who kept him in their employ for life, fearful that another royal family would recruit him.

His *Abduction of the Sabine Women* (**Fig. 13.29**), assigned this title only after the work had been exhibited, has a complex spiral composition that encourages the viewer to walk around the statue and take it in all from all angles. This movement reveals different combinations of line and shape, solid and void so that no single perspective is the same as another. It is the viewer who constructs the entirety of the action by virtue of his or her "participation" in the piece.

MICHELANGELO'S VESTIBULE FOR THE LAURENTIAN LIBRARY Aspects of the mannerist style show up in some of Michelangelo's later art, specifically in his *Last Judgment*. They can also be seen in his design for the vestibule and staircase for the Laurentian Library (**Figure 13.30**) connected to the church of San Lorenzo in Florence and built by the Medici pope, Clement VII. The contrast of creamy white stucco and pietra serena has become familiar to us in Florentine architecture, but that Renaissance stylistic tradition is about the only one that Michelangelo adhered to in his design. If we see the Mannerist artist as one who subverts, one by one, established conventions, then Michelangelo is here a Mannerist artist. The vestibule is an eclectic adaptation of familiar architectural elements that serve the overall form rather than function in the literal sense of the word: columns and corbels support nothing; pilasters taper toward the base, inverting their visual weight; windows appear to be boarded up; the frames of pediments are broken. The result is a more active, spirited iteration of the at times pedantic classical references in Renaissance architecture.

◀ **13.29 Giovanni da Bologna,** *Abduction of the Sabine Women,* ca. 1581–1583. Marble, 13' 5" (409 cm) high. Loggia dei Lanzi, **Florence, Italy.** The work was sculpted in the *figura serpentina* style— an upward spiral movement intended to be viewed from all sides.

▶ **13.30** **Michelangelo Buonarroti, vestibule of the Laurentian Library, Florence, Italy, 1525–1534; staircase, 1558–1559.** With this architectural endeavor, Michelangelo broke tradition with established conventions and any notion that form need be connected with function.

The show-stopping part of the design, however, is the staircase that connects the vestibule to the reading library. Here, Michelangelo breaks stride from the geometry of the vestibule walls and switches, unpredictably, to curving lines and organic shapes for the central part of the staircase. The steps seem to ripple like wavelets from the doorway of the reading room to the foot of the staircase, as if to suggest that the knowledge contained therein must flow out into the world.

It is fitting to open and close our discussion of the High Renaissance and Mannerism in Italy with Michelangelo. His life was long and his legacy was never ending.

MUSIC

Much of the painting, sculpture, and architecture we see during the Renaissance was intended for the service of Roman Catholic worship. Fine music was also subsidized and nurtured in Rome at the papal court.

Music at the Papal Court

The patronage of the popes for the creation and the performance of music dates back to the earliest centuries of the papacy. Gregorian chant, after all, is considered a product of the interest of Pope Gregory and the school of Roman chant. In 1473, Pope Sixtus IV established a permanent choir for his private chapel, which came to be the most important center of Roman music. Sixtus's nephew Julius II endowed the choir for Saint Peter's, the Julian Choir.

The Sistine Choir used only male voices. Preadolescent boys sang the soprano parts, while older men—chosen by competition—sang the alto, tenor, and bass parts. The number of voices varied then from 16 to 24 (the choir eventually became, and still is, much larger). The Sistine Choir sang a cappella (without accompaniment), although we know that the popes enjoyed instrumental music outside the confines of the church. Benvenuto Cellini, for example, mentions that he played instrumental motets for Pope Clement VII.

JOSQUIN DES PREZ While Botticelli and Perugino were decorating the walls of the Sistine Chapel, the greatest composer of the age, Josquin des Prez (ca. 1450–1521), was in the service of the Sistine Choir, composing and directing music for its members from 1486 to 1494. From his music, we can get some sense of the quality and style of the music of the time.

Josquin, who was Flemish, spent only those eight years in Rome, but his influence was widely felt in musical circles. He has been called the bridge figure between the music of the Middle Ages and the Renaissance. Although he wrote **madrigals** and many masses in his career, it was in the motet for four voices—a form not held to traditional usage in the way masses were—that he showed his true genius for creative musical composition. Josquin has been most praised for homogeneous musical structure, a sense of balance and order, and a feel for the quality of the lyrics. These are all characteristics common to the aspirations of the 16th-century Italian humanists. In that sense, Josquin combined the considerable musical tradition of Northern Europe with the new intellectual currents of the Italian south.

The Renaissance motet uses a sacred text sung by four voices in **polyphony**. Josquin split his texts into clear division

but disguised them by using overlapping voices, so that one does not sense any break in his music. He also took considerable pains to marry his music to the obvious grammatical sense of the words while still expressing their emotional import by the use of the musical phrase.

PALESTRINA The 16th-century composer most identified with Rome and the Vatican is Giovanni Pierluigi da Palestrina (1525–1594). He came from the Roman hill town of Palestrina as a youth and spent the rest of his life in the capital city. At various times in his career, he was the choirmaster of the choir of Saint Peter's (the Julian Choir), a singer in the Sistine Choir, and choirmaster of two other Roman basilicas (Saint John Lateran and Saint Mary Major). Finally, from 1571 until his death, he directed all music for the Vatican.

Palestrina flourished during the rather reactionary period in which the Catholic Church, in response to the Protestant Reformation, tried to reform itself by returning to the simpler ways of the past. It should not surprise us, then, that the more than 100 masses he wrote were conservative. His polyphony, while a model of order, proportion, and clarity, is closely tied to the musical tradition of the ecclesiastical past. Rarely does Palestrina move from the Gregorian roots of church music. For example, amid the polyphony of his Missa Papae Marcelli (Mass in Honor of Pope Marcellus), one can detect the traditional melodies of the Gregorian Kyrie, Agnus Dei, and so on. Despite that conservatism, he was an extremely influential composer whose work is still regularly heard in the Roman basilicas. His music was consciously imitated by the Spanish composer Vittoria (or Victoria, ca. 1548–1611), whose motet "O Vos Omnes" is almost traditional at Holy Week services in Rome, and by William Byrd (ca. 1539/40–1623), who brought Palestrina's style to England.

GO LISTEN!
PALESTRINA
Missa Papae Marcelli, Credo

In this listening selection, we hear Palestrina's successful return to earlier traditions of church music, a return that satisfies the Counter-Reformation requirement of keeping the text clearly audible. Indeed, he may have composed the mass to illustrate the musical seriousness and textual intelligibility laid down as requirements by the Council of Trent.

Nevertheless, for all Palestrina's conservatism, his work is clearly more complex and advanced than that of Machaut (see Chapter 11). The richness of harmony and the perfect balance of the voices produce a smoothness of texture and beauty and a variety of line that break new ground in the history of Western music. Note the entrance of one voice immediately after another, and the decorative ornamentation of many of the phrases that by the addition of shorter notes adds musical interest without blurring the text.

In the purity of his style, his return to the ideal values of the past, and the inventiveness of his own musical contributions, Palestrina is a perfect example of a Renaissance artist. His music has remained widely admired, and a 19th- and 20th-century composer, Hans Pfitzner (1869–1949), wrote the opera Palestrina to pay homage to the inner certainties of artistic genius.

Venetian Music

The essentially conservative character of Palestrina's music can be contrasted with the far more adventuresome situation in Venice, a city less touched by the ecclesiastical powers of Rome. In 1527, a Dutchman—Adriaan Willaert—became choirmaster of the Saint Mark's Basilica. He in turn trained Andrea Gabrieli and his more famous nephew, Giovanni Gabrieli, who became the most renowned Venetian composer of the 16th century.

The Venetians pioneered the use of multiple choirs for their church services. Saint Mark's regularly used two choirs, called split choirs, which permitted greater variation of musical composition in that the choirs could sing to and against each other in increasingly complex patterns. The Venetians were also more inclined to add instrumental music to their liturgical repertoire. They pioneered the use of the organ for liturgical music. The independent possibilities of the organ gave rise to innovative compositions that highlighted the organ. These innovations in time became standard organ pieces: the prelude, the music played before the services began (called in Italy the *intonazione*), and the virtuoso prelude called the toccata (from the Italian *toccare*, "to touch"). The toccata was designed to feature the range of the instrument and the dexterity of the performer.

Both Roman and Venetian music were deeply influenced by the musical traditions of the north. Josquin des Prez and Adriaan Willaert were, after all, both from the Low Countries. In Italy, their music came in contact with the intellectual tradition of Italian humanism. Without pushing the analogy too far, it could be said that Rome gave musicians the same Renaissance sensibility that it gave painters: a sense of proportion, Classicism, and balance. Venetian composers, much like Venetian painters of the time, were interested in color and emotion.

LITERATURE

The High Renaissance in Italy not only marked the achievement of some of the most refined artistic accomplishments, but, as in other times and in other places, it was also a period of great upheaval. The lives of Raphael and Leonardo ended at precisely the time Luther was struggling with the papacy. In 1527, Rome was sacked by Emperor Charles V's soldiers in an orgy of rape and violence the city had not seen since the days of the Vandals in the fifth century.

Writing continued. Some of it was in the form of notebooks, as we see with Leonardo da Vinci. Some was in the form of poetry, as we see in the sonnets of Michelangelo and Vittoria Colonna. Some of it was philosophizing, as in Castiglione's fictionalized dialogues in *The Book of the Courtier*. And some of it was autobiography, as we find in the self-serving work of Cellini.

LEONARDO DA VINCI When we think of Leonardo da Vinci, paintings such as the *Mona Lisa* and *The Last Supper* may spring into mind. And they should. But so ought we to contemplate his 13,000 pages of notes, replete with well-known drawings. They were made throughout his travels and daily

undertakings, mostly written from right to left, as seen through a mirror. Leonardo was left-handed, and it has been speculated that it might have been easier for him to write "backwards."

Some of the notes were published, or intended for publication, during his lifetime: notes on mathematics with geometric drawings; treatises on anatomy, focusing on the skeleton, muscle, and sinews; observations on landscape and the nature of light. Many of his writings and illustrations seem as though they would be the science fiction of his day: fanciful inventions that presage our own times with just enough detail to suggest that they were, in fact, plausible. Included among these are helicopters and hang gliders, submarines, a 720-foot-long bridge, and war machines such as the tank, which would resist defensive measures and protect land forces following behind. (In 2006, the Turkish government decided to build the bridge.)

MICHELANGELO BUONARROTI If Leonardo had never held a paintbrush, we would know him today because of the richness of his written works. It is difficult to know whether we would know of Michelangelo's poetry if he had never held a brush or a chisel. The poems have received a mixed review, yet many of them show the vitality of an artist more than occasionally at odds with his patrons and society.

The following sonnet, written to his longtime (platonic) friend Vittoria Colonna, compares the artist's quest for forms residing in dumb blocks of stone to his search for certain properties in the woman—"Lady, divinely proud and fair." It is of interest that Michelangelo's poems to Tomasso de'Cavalieri, a male friend, are more erotically charged—one of the suggestions that Michelangelo might have been gay.

> **READING 13.2 MICHELANGELO**
>
> The master-craftsman hath no thought in mind
> That one sole marble block may not contain
> Within itself, but this we only find
> When the hand serves the impulse of the brain;
> The good I seek, the harm from which I fly,
> Lady, divinely proud and fair, even so
> Are hid in thee, and therefore I must die
> Because my art is impotent to show
> My heart's desire; hence love I cannot blame,
> Nor beauty in thee, nor thy scorn, nor ill
> Fortune, nor good for this my pain, since life
> Within thy heart thou bearest at the same
> Moment as death, and yet my little skill
> Revealeth death alone for all its strife.

VITTORIA COLONNA Colonna (1492–1547) was a member of an affluent Roman family that patronized Petrarch, so it is fitting that she wrote mainly in Petrarchan sonnets (see Chapter 11). She numbered Michelangelo and the epic poet Ludovico Ariosto among her friends. Her social life seems to have largely come to a halt when her husband died in battle in 1525. Nearly all of the more than 400 poems that have come

down to us idealize her husband. They look back to love and the promise of a rich life; they look forward to emptiness and darkness. Although her writings became reasonably predictable, Michelangelo refers to them as composed in "sacred ink." Ariosto said of her poetry that it "rescued her triumphant spouse from the dark shore of the Styx." Her spouse was triumphant in seizing the poet's heart unto perpetuity, not on the battlefield.

> **READING 13.3 VITTORIA COLONNA**
>
> Sonnet IX
>
> Once I lived here in you, my now blest Light,
> With your soul joined to mine, for you were kind;
> Each, to the dearer one, had life resigned,
> And dead to self, there only lived aright.
> Now that, you being in that heavenly height,
> I am no longer graced such joy to find,
> Your aid deny not to a faithful mind,
> Against the World, which arms with us to fight.
> Clear the thick mists, which all around me lie,
> That I may prove at flying freer wings,
> On your already travelled heavenward way.
> The honour yours, if here, midst lying things,
> I shut my eyes to joys which soon pass by,
> To ope them there to true eternal day.

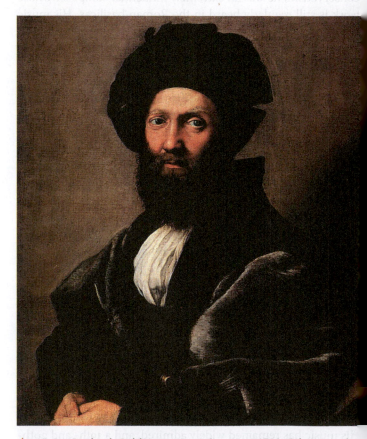

▲ **13.31** Raphael, *Baldassare Castiglione*, ca. 1514. Oil on panel, transferred to canvas, 32¼" × 26¼" (82 × 67 cm). Musée du Louvre, Paris, France. Raphael would have known the famous humanist through family connections in his native Urbino.

BALDASSARE CASTIGLIONE Baldassare Castiglione (1478–1529) served in the diplomatic corps of Milan, Mantua, and Urbino. He was a versatile man—a person of profound learning, equipped with physical and martial skills, and possessed of a noble and refined demeanor. Raphael's portrait of Castiglione (Fig. 13.31) faithfully reflects Castiglione's aristocratic and intellectual qualities.

While serving at the court of Urbino from 1504 to 1516, Castiglione decided to write *The Book of the Courtier*, a task that occupied him for a dozen years. It was finally published by the Aldine Press in Venice in 1528, a year before the author's death. Castiglione's work was translated into English by Sir Thomas Hoby in 1561. It exerted an immense influence on what the English upper classes thought an educated gentleman should be. We can detect echoes of Castiglione in some of the plays of Ben Jonson as well as in Shakespeare's *Hamlet*.

> Oh, what a noble mind is here o'erthrown!
> The courtier's, soldier's, scholar's eye, tongue, sword:
> The expectancy and rose of the fair state,
> The glass of fashion and the mould of form,
> The observed of all observers…

The most common criticism of Castiglione's courtier is that he reflects a world that is overly refined, too aesthetically sensitive, and excessively preoccupied with the niceties of decorum and decoration. The courtier's world, in short, is the world of the wealthy, the aristocratic, and the most select of the elite.

In *The Book of the Courtier*, cast in the form of an extended dialogue, Castiglione has his learned friends discuss a range of topics: the ideals of chivalry, Classical virtues, the character of the true courtier. Castiglione insistently pleads that the true courtier should be a person of humanist learning, impeccable ethics, refined courtesy, physical and martial skills, and fascinating conversation. He should not possess any of these qualities to the detriment of any other. The *uomo universale* (well-rounded person) should do all things with *sprezzatura*, or effortless mastery. The courtier, unlike the pedant, wears learning lightly, while his mastery of sword and horse has none of the fierce clumsiness of the common soldier in the ranks. The courtier does everything equally well but with an air of unhurried and graceful effortlessness.

Book 3 deals with the position of women in the courtly life of Renaissance Italy. We find one strikingly modern note in this selection when the Magnifico argues that women imitate men not because of masculine superiority but because they desire to "gain their freedom and shake off the tyranny that men have imposed on them by their one-sided authority."

The Magnifico argues that women are as capable as men of understanding worldly affairs. Signor Gaspare counters with the "wisdom" of various philosophers and says that he is astonished that the Magnifico would allow that women are capable of understanding social and political issues as are men:

READING 13.4 BALDASSARE CASTIGLIONE

From *The Book of the Courtier*, Book 3, "The Perfect Lady"

"Leaving aside, therefore, those virtues of the mind which she must have in common with the courtier, such as prudence, magnanimity, continence and many others besides, and also the qualities that are common to all kinds of women, such as goodness and discretion, the ability to take good care, if she is married, of her husband's belongings and house and children, and the virtues belonging to a good mother, I say that the lady who is at Court should properly have, before all else, a certain pleasing affability whereby she will know how to entertain graciously every kind of man with charming and honest conversation, suited to the time and the place and the rank of the person with whom she is talking. And her serene and modest behavior, and the candor that ought to inform all her actions, should be accompanied by a quick and vivacious spirit by which she shows her freedom from boorishness; but with such a virtuous manner that she makes herself thought no less chaste, prudent and benign than she is pleasing, witty and discreet. Thus she must observe a certain difficult mean, composed as it were of contrasting qualities, and take care not to stray beyond certain fixed limits."

…

The Magnifico laughed and said:

"You still cannot help displaying your ill-will towards women, signor Gaspare. But I was truly convinced that I had said enough, and especially to an audience such as this; for I hardly think there is anyone here who does not know, as far as recreation is concerned, that it is not becoming for women to handle weapons, ride, play the game of tennis, wrestle or take part in other sports that are suitable for men."

Then the Unico Aretino remarked: "Among the ancients women used to wrestle naked with men; but we have lost that excellent practice, along with many others."

Cesare Gonzaga added: "And in my time I have seen women play tennis, handle weapons, ride, hunt and take part in nearly all the sports that a knight can enjoy."

The Magnifico replied: "Since I may fashion this lady my own way, I do not want her to indulge in these robust and manly exertions, and, moreover, even those that are suited to a woman I should like her to practice very circumspectly and with the gentle delicacy we have said is appropriate to her. For example, when she is dancing I should not wish to see her use movements that are too forceful and energetic."

…

The Magnifico Giuliano…remarked:

"It appears to me that you have advanced a very feeble argument for the imperfection of women. And, although this is not perhaps the right time to go into subtleties, my answer, based both on a reliable authority and on the simple truth, is that the substance of anything whatsoever cannot receive of itself either more or less; thus just as one stone cannot, as far as its essence is

(continued on p. 448)

COMPARE + CONTRAST

Courtesans, East and West

Baldassare Castiglione's most famous work, *The Book of the Courtier*, was written one year before he died, at age 50, from the plague. The funerary monument dedicated to him informs posterity that he was "endowed by nature with every gift and the knowledge of many disciplines" and that "he drew up *The Book of the Courtier* for the education of the nobility." Castiglione's book lays out the model for the perfect Renaissance gentleman—a virtuous, noble, and devoted public servant, educated in the classics, skilled in rhetoric, able to converse knowledgeably on all subjects including the humanities and history, and gifted in poetry, music, drawing, and dance. Above all, these wide-ranging talents ought to come naturally to the ideal courtier, or at least give the appearance of authenticity; this is the quality Castiglione calls *sprezzatura*—an apparent effortlessness, or "art that conceals art."

Although the setting that inspires *The Book of the Courtier* is the court of the duke of Urbino, the philosophical conversation "recorded" by Castiglione offers a good barometer of the social climate in early-16th-century Italy—including contemporary views on the role of women, their capabilities and gender disadvantages, and their contribution to the life and intellectual discourse of the court. In fact, Elisabetta Gonzaga, the duchess of Urbino, was the moderator of the four-day-long salon (a gathering meant to educate and inspire participants through conversation on subjects such as politics, art, literature, poetry, and scholarship) described by Castiglione in his book. Gonzaga was an educated noblewoman and was regarded as one of the most cultured and virtuous women (she remained loyal to her invalid husband) in Renaissance courtly circles.

The role of courtier was not, then, exclusive to males. On the contrary, in some places where less rigid and more tolerant views prevailed—like the Republic of Venice—female courtesans were an important part of the social fabric. The most renowned courtesan of Renaissance Venice was Veronica

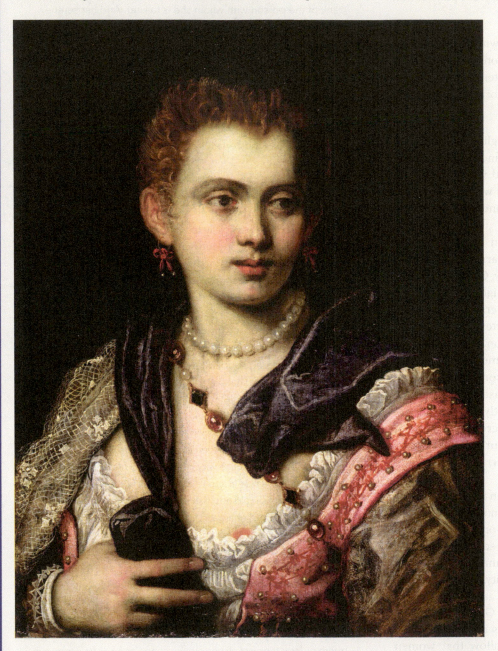

◀ **13.32** Tintoretto, *Veronica Franco*, late 16th century. Oil on canvas, 18" × 24" (46 × 61 cm). Worcester Museum of Art, Worcester, Massachusetts.

Franco (1546–1591), a complex woman of great prestige and many talents whose mantle as a public servant included the creation of a charitable institution for women involved in prostitution and their children.

Franco (**Fig. 13.32**) was the daughter of what Venetians called a *cortigiana onesta* (an honest, upstanding, virtuous courtesan), trained by her mother to be a proper consort of nobility and princes. She was well educated, a skilled musician, a poet, and a brilliant conversationalist. Courtesans like Franco were sought-after companions and entertainers who may or may not have engaged in sexual liaisons. In Venice, a lower class of courtesans—the *cortigiane di lume*—comprised women for whom prostitution was a means of financial survival or security. *Cortigiane oneste* could rise from modest backgrounds to the upper rungs of society, their profession providing one way to gain influence within a patriarchal oligarchy that otherwise suppressed the status of women.

Versions of courtesanship have existed in many cultures, including Japan (**Fig. 13.33**), China, and Turkey, but physical beauty is certainly a common denominator (it is also an important quality of the ideal woman in Castiglione's book). The history of Japanese courtesans, like their European counterparts, has run the gamut from poor young women selling sexual services and high-class prostitutes to *geisha*—erudite companion-entertainers (*geisha* means "entertainer" in Japanese) trained in classical music, dance, vocal performance, conversation, and traditional Japanese rituals such as serving tea.

Although the term *geisha girl* entered common parlance after World War II among American soldiers stationed in Japan to describe women working as prostitutes, these women were not geisha in the true definition of the term. In geisha society, which was highly structured and cloistered, authentic geisha were not associated with clients paying for sex; their business lives and love lives were entirely separate.

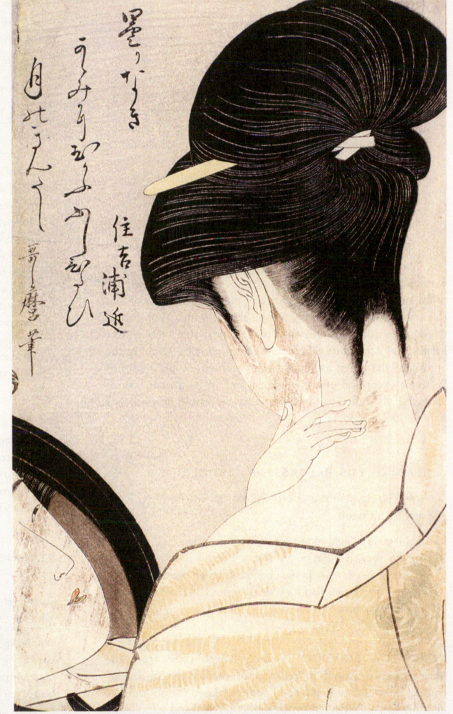

▲ **13.33** Kitagawa Utamaro, *White make-up*, 1795–1796. Color woodblock print, 14½" × 8¾" (37.0 × 22.3 cm). Musée national des arts asiatiques Guimet, Paris, France.

(continued from p. 445)

concerned, be more perfectly stone than another stone, nor one piece of wood more perfectly wood than another piece, so one man cannot be more perfectly man than another; and so, as far as their formal substance is concerned, the male cannot be more perfect than the female, since both the one and the other are included under the species man, and they differ in their accidents and not their essence. You may then say that man is more perfect than woman if not as regards essence then at least as regards accidents; and to this I reply that these accidents must be the properties either of the body or of the mind. Now if you mean the body, because man is more robust, more quick and agile, and more able to endure toil, I say that this is an argument of very little validity since among men themselves those who possess these qualities more than others are not more highly regarded on that account; and even in warfare, when for the most part the work to be done demands exertion and strength, the strongest are not the most highly esteemed. If you mean the mind, I say that everything men can understand, women can too; and where a man's intellect can penetrate, so along with it can a woman's."

There follows a discussion of what Nature "intended" with women and men, and how neither can be perfect in the absence of the other. The Magnifico jests that philosophers believe that those who are weak in body will be able in mind. Therefore, if women are in fact weaker than men, they should have greater intellectual capability. Signor Gaspare, intent on winning the argument that men are superior to women, finally responds "without exception every woman wants to be a man," which leads the Magnifico to reply with what we would now see as a feminist point of view:

READING 13.5 **BALDASSARE CASTIGLIONE**

From *The Book of the Courtier*, Book 3, "The Perfect Lady," continued

The Magnifico Giuliano at once replied:
 "The poor creatures do not wish to become men in order to make themselves more perfect but to gain their freedom and shake off the tyranny that men have imposed on them by their one-sided authority."

VERONICA FRANCO Veronica Franco (1546–1591), the most famous courtesan in Venice, was schooled in Classical literature, knew the ins and outs of politics, played various musical instruments, and was renowned for her learned and scintillating conversation. She wrote letters to the elite of Venice and Europe, letters that have survived because the recipients valued them. She also wrote poems in **terza rima**, the difficult verse used by Dante in his *Divine Comedy*. Franco's collected poems in terza rima include pieces that are seductive, poetic dialogues with her suitors, and many that challenge the patriarchal status quo in Venice:

READING 13.6 **VERONICA FRANCO**

From *Poems in Terza Rima*, chapter 2, lines 34–39 and 154–171

Since I will not believe that I am loved,
nor should I believe it or reward you
for the pledge you have made me up to now,
win my approval, sir, with deeds:
prove yourself through them, if I, too,
am expected to prove my love with deeds.

. . .

So sweet and delicious do I become,
when I am in bed with a man
who, I sense, loves and enjoys me,
that the pleasure I bring excels all delight,
so the knot of love, however tight
it seemed before, is tied tighter still.
Phoebus, who serves the goddess of love,
and obtains from her as a sweet reward
what blesses him far more than being a god,
comes from her to reveal to my mind
the positions that Venus assumes with him
when she holds him in sweet embraces;
so that I, well taught in such matters,
know how to perform so well in bed
that this art excels Apollo's by far,
and my singing and writing are both forgotten
by the man who experiences me in this way,
which Venus reveals to people who serve her.

Franco's efforts to help and protect Venetian women who were working as prostitutes through her charitable institution, Casa del Soccorso, acknowledged the dangers and indignities of life as a courtesan—particularly among the *cortigiane di lume*. Franco warns the mother of a young woman of the sordid side of courtesan life in a letter:

READING 13.7 **VERONICA FRANCO**

From letter 22, "A Warning to a Mother Considering Turning Her Daughter into a Courtesan"

Where once you made [your daughter] appear simply clothed and with her hair arranged in a style suitable for a chaste girl, with veils covering her breasts and other signs of modesty, suddenly you encouraged her to be vain, to bleach her hair and paint her face. And all at once, you let her show up with curls dangling around her brow and down her neck, with bare breasts spilling out of her dress, with a high, uncovered forehead, and every other embellishment people use to make their merchandise measure up to the competition.

. . .

I'll add that even if fate should be completely favorable and kind to her, this is a life that always turns out to be a misery. It's a most wretched thing, contrary to human reason, to subject one's body and labor to a slavery terrifying even to think of. To make oneself prey to so many men, at the risk of being stripped, robbed, even killed, so that one man, one day, may snatch away from you everything you've acquired from many over such a long time, along with so many other dangers of injury, and dreadful contagious diseases; to eat with another's mouth, sleep with another's eyes, moving according to another's will, obviously running toward the shipwreck of your mind and your body—what greater misery? What wealth, what luxuries, what delights can outweigh all this? Believe me, among all the world's calamities, this is the worst. And if to worldly concerns you add those of the soul, what greater doom and certainty of damnation could there be?

BENVENUTO CELLINI Benvenuto Cellini (1500–1571) was a talented Florentine goldsmith and sculptor whose life, frankly chronicled, was a seemingly never-ending panorama of violence, intrigue, quarrel, sexual excess, egotism, and political machination. His autobiography, much of it dictated to a young apprentice who wrote while Cellini worked, is a vast and rambling narrative of Cellini's life from his birth to the year 1562. We read vignettes about popes and commoners, artists and soldiers, cardinals and prostitutes, assassins and artists, as well as a gallery of other characters from the Renaissance demimonde of Medicean Florence and papal Rome.

Above all, we meet Benvenuto Cellini, who makes no bones about his talent, his love of life, or his taste for violence. Cellini is not one of Castiglione's courtiers. He fathered eight children in and out of marriage; was banished from Florence for sodomy; was imprisoned for assault; fled Rome after murdering a man; and fought on the walls of the Castel Sant'Angelo in Rome during the siege of 1527, in defense of the Medici pope Clement VII. Anyone who thinks of the Renaissance artist solely in terms of proportion, love of the classics, Neo-Platonic philosophy, and genteel humanism is in for a shock when encountering Cellini's autobiography.

One particular part of Cellini's book is interesting not for its characteristic bravado or swagger but for its insight into the working methods of an artist. In a somewhat melodramatic account, Cellini describes the process of casting the bronze statue of Perseus that turned out to be his most famous work (**Fig. 13.34**). Completed in 1554 for Duke Cosimo I de' Medici, it is a highly refined work, all the more interesting for Cellini's record of its genesis.

In the extract from his autobiography shown in Reading 13.8 on page 450, Cellini recalls his casting of the statue. The casting of bronze statues is a complex process in which a model of the statue, made of a material such as wax or clay, is translated into the more durable bronze. Bronze has been used most frequently because of its appealing surface and color characteristics. It involves the use of a kiln, and accidents occur quite often. Cellini's casting of the bronze Perseus involved a series of such accidents, some of which could have been quite dangerous. As

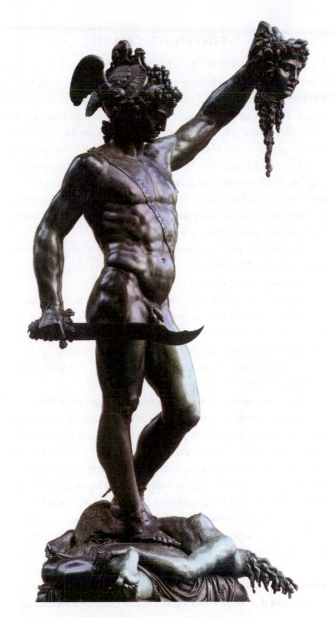

▲ **13.34 Benvenuto Cellini, *Perseus Holding the Head of Medusa*, 1545–1554. Bronze, 126" (320 cm) high (after restoration). Loggia dei Lanzi, Florence, Italy.** Earlier models of this statue, including a first effort in wax, are preserved in the Bargello Museum in Florence.

the reader encounters the process, she or he comes across much more than delays, illness, masterly skill, and perseverance; the ego of the artist is also inescapable. Here the artist is attempting to explain the difficulties of the process to the duke—his patron.

Despite his skepticism of the process and his impatience with the manner of the artist, the duke asks Cellini to explain matters to him, which he does, at the same time asking for more money. We are then led through the complicated casting process, including an illness during which Cellini is certain he will die. But upon hearing that his work is in danger of being destroyed, the "selfless" Cellini springs out of bed and summons all of his assistants and all of his skills to the achievement of the task. Once the statue is complete, Cellini journeys to Pisa to inform his patron, in effect, that he—the artist—was correct in his predictions.

READING 13.8 BENVENUTO CELLINI

From *The Autobiography*, Casting Perseus

I had cast the Medusa [whose severed head is held high by the victorious Perseus]—and it came out very well—and then very hopefully I brought the Perseus towards completion. I had already covered it in wax, and I promised myself that it would succeed in bronze as well as the Medusa had. The wax Perseus made a very impressive sight, and the Duke thought it extremely beautiful. It may be that someone had given him to believe that it could not come out so well in bronze, or perhaps that was his own opinion, but anyhow he came along to my house more frequently than he used to, and on one of his visits he said:

"Benvenuto, this figure can't succeed in bronze, because the rules of art don't permit it."

I strongly resented what his Excellency said.

"My lord," I replied, "I'm aware that your Most Illustrious Excellency has little faith in me, and I imagine this comes of your putting too much trust in those who say so much evil of me, or perhaps it's because you don't understand the matter."

He hardly let me finish before exclaiming: "I claim to understand and I do understand, only too well."

"Yes," I answered, "like a patron, but not like an artist. If your Excellency understood the matter as you believe you do, you'd trust in me on the evidence of the fine bronze bust I made of you: that large bust of your Excellency that has been sent to Elba. And you'd trust me because of my having restored the beautiful Ganymede in marble; a thing I did with extreme difficulty and which called for much more exertion than if I had made it myself from scratch: and because of my having cast the Medusa, which is here now in your Excellency's presence; and casting that was extraordinarily difficult, seeing that I have done what no other master of this devilish art has ever done before. Look, my lord, I have rebuilt the furnace and made it very different from any other. Besides the many variations and clever refinements that it has, I've constructed two outlets for the bronze: that was the only possible way of ensuring the success of this difficult, twisted figure. It only succeeded so well because of my inventiveness and shrewdness, and no other artist ever thought it possible.

"Be certain of this, my lord, that the only reason for my succeeding so well with all the important and difficult work I did in France for that marvelous King Francis was because of the great encouragement I drew from his generous allowances and from the way that he met my request for workmen—there were times when I made use of more than forty, all of my own choice. That was why I made so much in so short a time. Now, my lord, believe what I say, and let me have the assistance I need, since I have every hope of finishing a work that will please you. But if your Excellency discourages me and refuses the assistance I need, I can't produce good results, and neither could anyone else no matter who."

The Duke had to force himself to stay and listen to my arguments; he was turning now one way and now another, and, as for me, I was sunk in despair, and I was suffering agonies as I began to recall the fine circumstances I had been in [when] in France.

All at once the Duke said: "Now tell me, Benvenuto, how can you possibly succeed with this beautiful head of Medusa, way up there in the hand of the Perseus?"

Straight away I replied: "Now see, my lord: if your Excellency understood this art as you claim to then you wouldn't be worried about that head not succeeding; but you'd be right to be anxious about the right foot, which is so far down."

At this, half in anger, the Duke suddenly turned to some noblemen who were with him and said:

"I believe the man does it from self-conceit, contradicting everything."

. . .

Seeing that the work was so successful I immediately went to Pisa to find my Duke. He welcomed me as graciously as you can imagine, and the Duchess did the same. Although their majordomo had sent them news about everything, it seemed to their Excellencies far more of a stupendous and marvelous experience to hear me tell of it in person. When I came to the foot of the Perseus which had not come out—just as I had predicted to his Excellency—he was filled with astonishment and he described to the Duchess how I had told him this beforehand. Seeing how pleasantly my patrons were treating me I begged the Duke's permission to go to Rome.

GLOSSARY

Chiaroscuro (p. 420) From the Italian for "light–dark"; an artistic technique in which subtle gradations of value create the illusion of rounded, three-dimensional forms in space; also called *modeling*.

Glaze (p. 436) In painting, a semitransparent coating on a painted surface that provides a glassy or glossy finish.

Horizon line (p. 423) In linear perspective, the imaginary line (frequently where the earth seems to meet the sky) along which converging lines meet; this spot is known as the vanishing point.

Iconography (p. 437) A set of conventional meanings attached to images; as an artistic approach, representation or illustration that uses the visual conventions and symbols of a culture. Also, the study of visual symbols and their meaning (often religious).

Madrigal (p. 442) A song for two or three voices unaccompanied by instrumental music.

Mannerism (p. 436) A style of art characterized by distortion and elongation of figures; a sense of flattened space rather than depth; a lack of a defined focal point; and the use of clashing pastel colors.

Orthogonal (p. 421) In perspective, a line pointing to the vanishing point.

Patronage (p. 417) In the arts, the act of providing support for artistic endeavors.

Pietà (p. 426) In artistic tradition, a representation of the dead Christ, held by his mother, the Virgin Mary (from the Latin word for "pity").

Polyphony (p. 442) Music with two or more independent melodies that harmonize or are sounded together.

Sarcophagus (p. 431) A coffin; usually cut or carved from stone, although Etruscan sarcophagi were made of terra-cotta.

Terza rima (p. 448) A poetic form in which a poem is divided into sets of three lines (*tercets*) with the rhyme scheme *aba*, *bcb*, *cdc*, and so on.

THE BIG PICTURE THE HIGH RENAISSANCE IN ITALY

Language and Literature

- Leonardo da Vinci began to write his treatises on art and science ca. 1490–1495.
- The Aldine Press was established in Venice ca. 1494.
- Strozzi wrote his poem on Michelangelo's *Night* ca. 1531.
- Vittoria Colonna began writing poems in memory of her husband in 1525.
- Castiglione published *The Courtier* in 1528.
- Michelangelo and Colonna began exchanging letters and poems in 1538.
- Cellini wrote his autobiography ca. 1558–1566.
- Sir Thomas Hoby translated *The Book of the Courtier* into English in 1561.

Art, Architecture, and Music

- Sixtus IV establishes the Sistine Choir in 1473.
- Leonardo da Vinci painted his *Madonna of the Rocks* in 1483, *The Last Supper* in 1495–1498, and *Mona Lisa* ca. 1503–1505.
- Josquin des Prez composed masses and motets for the Sistine Choir ca. 1486–1494.
- Raphael painted *Madonna of the Meadow* in 1508 and *Philosophy (The School of Athens)* in 1509–1511.
- Michelangelo sculpted the *Pietà* in 1498–1499, *David* in 1501–1504, and *Moses* in 1513–1515.
- Michelangelo painted the ceiling of the Sistine Chapel in 1508–1511 and *The Last Judgment* ca. 1534–1541.
- Pope Julius II established the Julian Choir for Saint Peter's Basilica in 1512.
- Adriaan Willaert became the choirmaster of Saint Mark's in Venice in 1527.
- Palladio began the construction of the Villa Rotunda ca. 1550.
- Titian painted *Venus of Urbino* in 1538.
- Tintoretto painted his *Last Supper* in the Mannerist style in 1592–1594.
- Pontormo painted *Entombment* in 1525–1528.
- Bronzino painted *Venus, Cupid, Folly, and Time (The Exposure of Luxury)* ca. 1546.
- Palestrina composed *Missa Papae Marcelli* in 1567.
- Fontana painted *Noli Me Tangere* in 1581.
- Anguissola painted *A Game of Chess* in 1555.
- Bologna sculpted *Abduction of the Sabine Women* ca. 1581–1583.
- Cellini sculpted *Perseus Holding the Head of Medusa* ca. 1545–1554.

Philosophy and Religion

- Luther presented his 95 Theses, triggering the Reformation in Germany in 1517.
- Castiglione published *The Book of the Courtier*, a philosophical treatise on the courtly life in 1528.
- The churches of Rome and England separated in 1534.
- The Council of Trent initiated the Counter-Reformation in 1545–1564.

The High Renaissance in Northern Europe and Spain

PREVIEW

The website of London's Royal Shakespeare Company cites *Hamlet* as the most often performed of William Shakespeare's plays. Its earliest documented performance took place in 1607 on a ship called *The Dragon* anchored off the coast of Sierra Leone in West Africa; some 400 years later, the actor David Tennant (**Fig. 14.1**) played the title role in a production that included a human skull that had been bequeathed in a will for use as a prop in a play.

It is estimated that every minute of every day, *Hamlet* is staged somewhere in the world. To what does the play owe such fascination, such relevance, such longevity as a work of art? Why have Shakespeare's writings outlived many of "the gilded monuments of princes" of which he wrote? Steven Greenblatt, in his important book, *Will in the World: How Shakespeare Became Shakespeare*, observed:

> One of the prime characteristics of Shakespeare's art is the touch of the real. As with any other writer whose voice has long ago fallen silent and whose body has moldered away, all that is left are words on a page, but even before a gifted actor makes Shakespeare's words come alive, those words contain the vivid presence of actual, lived experience. The poet who noticed that the hunted trembling hare was "dew-bedabbled" or who likened his stained reputation to the "dyer's hand," the playwright who has a husband tell his wife that there is a purse in the desk "That's covered o'er with Turkish tapestry," or who has a prince remember that his poor companion owns only two pairs of silk stockings, one of them peach-colored—this artist was unusually open to the world and discovered the means to allow the world into his works.[1]

This careful observation of the mundane, the stuff of everyday life rendered vivid, against which unfold symbolic narratives, describes Shakespeare's plays just as it does the visual art of Northern Renaissance painters. The illusion of reality based on mimicking the experience of the physical world on a two-dimensional surface, made more convincing by the depiction of the psychological states of the characters—this was the contribution of the Italian Renaissance artist. It finds its analogy in Shakespeare's haunting realism on stage and his penetration into the hearts and

◄ 14.1 British actor David Tennant as Hamlet. Royal Shakespeare Company, The Courtyard Theatre, London, United Kingdom.

1. Stephen Greenblatt. *Will in the World: How Shakespeare Became Shakespeare* (New York: W. W. Norton & Company, 2004), pp. 13–14.

anguishes of his characters. He knew psychology before there was a science called *psychology*.

Self-knowledge and self-reflection are also key components of humanist thought, and in Shakespeare's famed soliloquies, they are explored to great dramatic effect. In what is perhaps the most familiar of these speeches, "To be or not to be," Hamlet confronts the fear of death and dilemmas of conscience that plague him—and humankind. In another, recited in a graveyard where he comes upon the skull of his father's court jester, he ponders the transitory nature of human existence and the fate of death that knows no privilege. He asks his confidante, Horatio, "Dost thou think Alexander looked o' this fashion?" and muses on the inglorious ends of two of history's most famed figures: "Alexander was buried, Alexander returneth into the dust; the dust is earth; of earth we make loam; and why of that loam, whereto he was converted, might they not stop a beer-barrel" (that is, use the mix of dirt and human remains to stop it from leaking); and "Imperious Caesar, dead and turn'd to clay, Might stop a hole to keep the wind away: O, that the earth, which kept the world in awe, Should patch a wall to expel the winter flaw!"

In the 16th century, the spirit of humanism spread from Italy to Northern Europe, including England, where William Shakespeare was born in 1564—the same year that the High Renaissance master, Michelangelo, died in Rome. Shakespeare would become the most famous of Elizabethan writers, his work a hallmark of an era of great cultural achievement that accompanied the almost half-century-long reign of Queen Elizabeth I.

HUMANISM TRAVELS NORTH AND WEST

The ideas and artistic styles that developed in Italy during the 15th and 16th centuries produced immense changes in the cultural life of England, France, Germany, and the Netherlands. As the Renaissance spread beyond the Alps, the new humanism roused Northern Europe from its conservative intellectual patterns and offered an alternative to traditional religious doctrines. The infusion of Italian ideas produced a breadth of vision that contributed not only to a humanist aesthetic in Northern Renaissance painting and to important developments in music but also to a more global enthusiasm for Classical literature and philosophy, which led to considering the tenets of Christianity from a humanist perspective.

France

The spread of Italian Renaissance ideas to the North was in many respects political rather than cultural. Throughout most of the 16th century, the monarchs of Northern Europe vied with one another for political and military control over the states of Italy. In the process, they came in contact with the latest developments in Italian artistic and intellectual life and often based their own courts on Italian models. Francis I, who ruled France from 1515 to 1547, made a deliberate attempt to expose French culture to Italian influences; he attracted Italian artists to the

The Renaissance in Northern Europe and Spain

1500 CE	1525 CE	1550 CE	1575 CE	1620 CE
GENESIS OF THE REFORMATION	**SPREAD OF THE REFORMATION**	**GROWTH OF THE COUNTER-REFORMATION**	**RELIGIOUS AND NATIONALISTIC UNREST**	
Reign of Henry VIII in England	Charles V defeats Francis I at Pavia	Lutheran and Catholic wars in Germany end with the Peace of Augsburg	The Netherlands declares independence from Spain	
Reign of Francis I in France	Charles V sacks Rome	Charles V abdicates	England sends troops to support the Netherlands against Spain	
Luther presents his 95 Theses, triggering the Reformation in Germany	Execution of Thomas More	Reign of Philip II in Spain and the Netherlands	Philip II's Spanish Armada is defeated by England	
Reign of Charles V as Holy Roman emperor	Execution of Anne Boleyn	Reign of Mary Tudor in England	The English found the East India Company	
Peasants' War in Germany	Copernicus publishes *On the Revolution of Celestial Bodies*, and Vesalius publishes *Seven Books on the Structure of the Human Body*	Reign of Elizabeth I in England	The English found the colony of Jamestown	
		St. Bartholomew's Day Massacre in France	Spain recognizes the independence of the Netherlands	
			Francis Bacon publishes *Novum Organum*	

French court, among them Leonardo da Vinci, Andrea del Sarto, and Benvenuto Cellini. Francis and his successors also esteemed literature and scholarship. Francis's sister, Marguerite of Navarre, was a writer of considerable gifts and became the center of an intellectual circle that included many of the finest minds of the age.

Spain

In 1492, Christopher Columbus (1451–1506) set sail for the East Indies on an expedition funded by the Catholic monarchs of Spain, Ferdinand II of Aragon and Isabella I of Castile. It was the first of his three voyages under the Spanish flag, but his were not the only explorations made possible by Spain's deep financial coffers. As the 16th century began, Francisco Pizarro (ca. 1470–1541), Vasco Nunez de Balboa (ca. 1475–1517), Ferdinand Magellan (1480–1521), and Hernan Cortes (1485–1547) and others did their part to conquer the New World for Spain (and Portugal), enriching the country with plunder and launching widespread colonization. As the 16th century drew to a close, Spain controlled territories in Europe and the Mediterranean as well as North Africa and the New World. It was the wealthiest, most powerful, and most Catholic country in Europe.

Germany and the Holy Roman Empire

The modern-day country of Germany lies at the core of what was the Holy Roman Empire (see **Map 14.1**). The history of Germany is intimately bound up with that of the Habsburg family. The House of Habsburg, one of the most powerful royal houses in Europe, held the throne of the Holy Roman Empire continuously from 1438 to 1740. From the 16th century onward—as a result of the politically expedient marriage in 1496 of Philip the Handsome, son of the Holy Roman Emperor Maximilian I, and Joanna of Castile, daughter of Ferdinand II and Isabella I of Spain—the Habsburg dynasty consisted of two branches: Austrian and Spanish.

Charles V, who inherited the Spanish throne after his mother, Joanna, was declared insane and unfit to rule in the wake of Philip's death, ruled as King Carlos I. Upon the death of his paternal (Habsburg) grandfather in 1519, Charles inherited the Habsburg Monarchy and succeeded Maximilian I as Holy Roman Emperor. He was 19 years old.

Charles was the principal competitor of Francis I for political domination of Italy, and although his interest in the arts was less cultivated than that of his rival, his conquests brought Italian culture to both Spain and the North. On his abdication

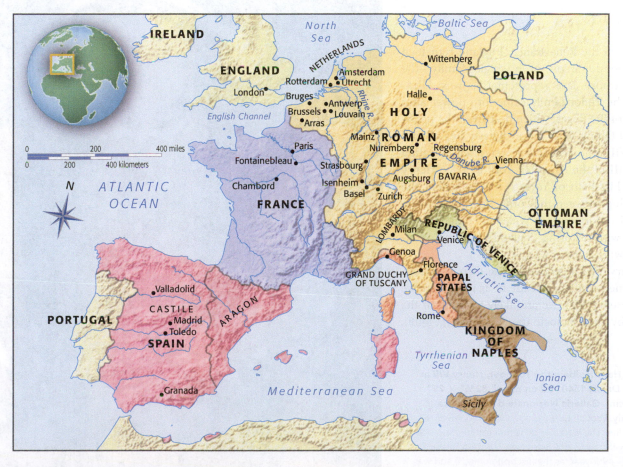

▲ **MAP 14.1 Europe in the early 16th century.**

in 1556, he divided his territories between his brother Ferdinand and his son Philip. The Austrian and Spanish branches of the Hapsburg family remained the principal powers in Europe until the 1650s.

The Netherlands

Spain reached the height of its power in the 16th century, controlling territories in the Americas, parts of France and Germany, and the Netherlands. Catholic Spain came into conflict with Northern Europe not only because of a desire to increase and maintain wealth and power, but also because Northern Europe was turning Protestant. In 1566, there were Calvinist-led riots in the Spanish Netherlands, which caused the Spanish to militarily restore order and conduct a reign of terror. The Eighty Years' War followed, leading to the eventual independence of the Netherlands. In 1586, Queen Elizabeth I of England supported the Protestant Netherlands. (In 1587, the English admiral Sir Francis Drake attacked the Spanish port of Cádiz, destroying many of the harbored **galleons** and delaying the Spanish Armada from attacking England for a year.) Despite all the turmoil, excellent art was produced in the Netherlands—as it apparently is in many or most societies undergoing transformations.

England

For most of the Renaissance, England remained under the dominion of a single family—the Tudors—whose last representative was Elizabeth I. The Tudor family came into power after the War of the Roses, which destroyed the previous royal family. The Tudor dynasty began with Henry VII, who rose to power after defeating Richard III of the House of York in 1485. Henry married Elizabeth of York to try to cement the relationship between the conflicting families and extended Tudor power to Wales and Ireland. He is credited with restoring England's financial security following ruinous wars.

Henry VIII ascended to the throne in 1509 and reigned until his death in 1547. When we picture Henry VIII, we are likely to think of the portrait by Hans Holbein the Younger (**Fig. 14.2**),

showing a corpulent but confident king with a rakish demeanor and a flattering beard. He is wearing wedding apparel, attired for a not-uncommon event in his life. He is remembered for having six wives and disposing of them all in one way or another, but he also beheaded tens of thousands of actual and potential political opponents. Nor did matchmakers fare well; Henry also beheaded a couple of ministers who had recommended failed marital unions—albeit for different reasons.

Henry VIII's marriage to his first wife, Catherine of Aragon, failed because the couple could not produce a male heir to the throne. The king sought a papal dispensation that would permit divorce, but the pope refused the petition. Parliament enacted laws breaking ties with the pope and establishing Henry VIII as the governor of the Church of England, along with his secular title as king. He then married Anne Boleyn, who gave birth in 1533 to Elizabeth, who would become Queen Elizabeth I. Thomas Cromwell, a minister of the king from 1532 to 1540, accused Anne of adultery. She was tried for treason, witchcraft, and incest, found guilty, and executed in 1536. (Cromwell was executed four years later.) Henry married again, and again, and again—and again.

Elizabeth I became queen after much intrigue and rivalry in claims to the throne. Her predecessor and half-sister, Mary Tudor—nicknamed Bloody Mary because of her burning of

▶ **14.2** Hans Holbein the Younger, *Henry VIII in Wedding Dress*, 1540. Oil on panel, 32 ½" × 29" (83 × 74 cm). Galleria Nazionale d'Arte Antica, Rome, Italy. Weddings were not uncommon events in Henry's life. The wedding he is dressed for here—to his fourth wife, Anne of Cleves (see Fig. 14.17)—took place in his 49th year (as the inscription reads) and was annulled within the year.

Protestant dissenters at the stake—had sought to return England to the Catholic faith from which Henry VIII had broken. But Elizabeth was a Protestant, and when she assumed the throne, she required clergy to swear an oath recognizing the independence of the Church of England from the Catholic Church.

The question of marriage for Elizabeth was a problem without an easy solution. Had Elizabeth married an English nobleman, she would have disturbed the delicate balance of power that maintained the loyalty of England's leading aristocratic families. Marriage to a foreign ruler could have compromised England's status as a leading European power, just at the moment when she was intent on strengthening it. Elizabeth avoided the dilemma by choosing to remain the "Virgin Queen," although gossips during her reign and since have questioned the accuracy of the moniker.

In the course of her long reign (1558–1603), Elizabeth established her court as a center of art and learning. Although the influence of Italian models on the visual arts was less marked in England than elsewhere, revived interest in Classical antiquity and the new humanism it inspired is reflected in the works of Shakespeare and other Elizabethan writers.

Toward the end of her life, a protracted war with Spain and a series of poor harvests weakened England's economy. For a while, Elizabeth's authority seemed to falter, but by the end of her reign, she had regained the love of her people. As she proclaimed in 1601, "Though God hath raised me high, yet this I count the glory of my crown, that I have reigned with your love, and you never shall have any on this throne who will love you better."

Although the art of the great Northern centers drew heavily on Italy for inspiration, the 16th century was also a period of intellectual tumult in which traditional ideas on religion and the nature of the universe were shaken and changed. Many of the revolutionary movements of the age were Northern in origin, and they had a profound effect on the arts. While Northern artists were being influenced by the styles of their fellow artists south of the Alps, their cultural world was also being shaped by theologians and scientists closer to home.

THE REFORMATION

On the eve of All Saints' Day in 1517, a German Augustinian friar, Martin Luther (1483–1546; **Fig. 14.3**), tacked on the door of the collegiate church of Wittenberg a parchment containing 95 **theses** (academic propositions) written in Latin—the usual procedure for advertising an academic debate. Luther's theses challenged the Roman Catholic doctrine of **indulgences** (forgiveness of punishment for sins, usually obtained either through good works or prayers along with the payment of an appropriate sum of money; see Reading 14.1). This was a timely

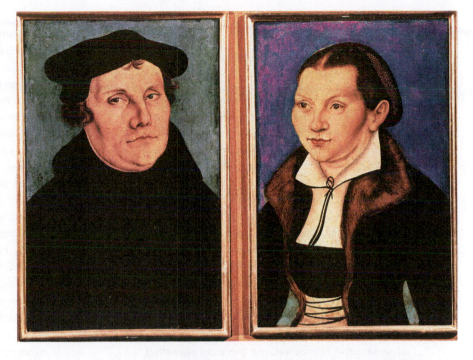

▲ **14.3** Lucas Cranach the Elder, *Martin Luther and His Wife Katherina von Bora* (double portrait), 1529. Oil on wood, 14⅜" × 9"; 14⅝" × 9" (36.5 × 23; 37 × 23 cm). Galleria degli Uffizi, Florence, Italy. Luther and von Bora, a former nun, were married at about the time this portrait was painted. They had six children.

topic because an indulgence was currently being preached near Wittenberg to help raise funds for the rebuilding of Saint Peter's in Rome.

Consequences of Luther's Challenge

Luther's challenge touched off a controversy that extended far beyond academia. For the next few years, theologians debated, and Luther received emissaries and directives from the Vatican as well as official warnings from the pope. Luther did not waver in his criticisms. He also advocated the abolition of statues and images and the right of the clergy to marry (abolishing celibacy). On June 15, 1520, Pope Leo X (Giovanni de' Medici, son of Lorenzo the Magnificent) condemned Luther's teaching as heretical; and, on January 3, 1521, he excommunicated him from the Catholic Church, unintentionally birthing the Protestant Reformation.

ANABAPTISM Luther's reformation principles began to be applied in churches throughout Germany, and a rapid and widespread outbreak of other reforming movements was touched off by his example. By 1523, reformers called **Anabaptists**, who were more radical than Luther, agitated for a purer Christianity, one free of any trace of "popery." *Anabaptism* means being baptized again, reflecting the group's insistence on adult baptism even if baptism had been performed in infancy. Anabaptists

READING 14.1 MARTIN LUTHER

From *Disputation on the Power and Efficacy of Indulgences* (1517)

Out of love for the truth and the desire to bring it to light, the following propositions will be discussed at Wittenberg, under the presidency of the Reverend Father Martin Luther, Master of Arts and of Sacred Theology, and Lecturer in Ordinary on the same at that place. Wherefore he requests that those who are unable to be present and debate orally with us, may do so by letter.

...

32. They will be condemned eternally, together with their teachers, who believe themselves sure of their salvation because they have letters of pardon.

33. Men must be on their guard against those who say that the pope's pardons are that inestimable gift of God by which man is reconciled to Him;

34. For these "graces of pardon" concern only the penalties of sacramental satisfaction, and these are appointed by man.

35. They preach no Christian doctrine who teach that contrition is not necessary in those who intend to buy souls out of purgatory or to buy confessionalia.

36. Every truly repentant Christian has a right to full remission of penalty and guilt, even without letters of pardon.

37. Every true Christian, whether living or dead, has part in all the blessings of Christ and the Church; and this is granted him by God, even without letters of pardon.

...

43. Christians are to be taught that he who gives to the poor or lends to the needy does a better work than buying pardons;

44. Because love grows by works of love, and man becomes better; but by pardons man does not grow better, only more free from penalty.

45. Christians are to be taught that he who sees a man in need, and passes him by, and gives [his money] for pardons, purchases not the indulgences of the pope, but the indignation of God.

...

50. Christians are to be taught that if the pope knew the exactions of the pardon-preachers, he would rather that St. Peter's church should go to ashes, than that it should be built up with the skin, flesh and bones of his sheep.

51. Christians are to be taught that it would be the pope's wish, as it is his duty, to give of his own money to very many of those from whom certain hawkers of pardons cajole money, even though the church of St. Peter might have to be sold.

52. The assurance of salvation by letters of pardon is vain, even though the commissary, nay, even though the pope himself, were to stake his soul upon it.

...

75. To think the papal pardons so great that they could absolve a man even if he had committed an impossible sin and violated the Mother of God—this is madness.

76. We say, on the contrary, that the papal pardons are not able to remove the very least of venial sins, so far as its guilt is concerned.

believed that baptismal candidates must be able to understand and make their own declarations of faith. Many of these Anabaptist groups had radical social and political ideas, including pacifism and the refusal to take oaths or participate in civil government, which appealed to the discontent of the lower classes. One outcome was the Peasants' War in Germany, which was put down with ferocious bloodshed in 1525.

The Amish, Hutterites, and Mennonites are descendants of the Anabaptist movement. The Baptist churches in the United States arose independently, but Baptists share the belief that only people who understand the meaning of baptism are candidates for the ceremony. The concept of being "born again" refers to the experience of conversion to Christianity by means of water and one's confession of faith.

CALVINISM In 1523, Zürich, Switzerland, accepted the reformation ideal for its churches. Under the leadership of Ulrich Zwingli (1484–1531), Zürich—and later Berne and Basel—adopted Luther's reforms, including the abolition of statues and images and the abolition of clerical celibacy. The list of **sacraments** was reduced and modified to include only baptism and **communion** (the Lord's Supper).

In Geneva, John Calvin (1509–1564) preached a brand of Protestantism that has come to be seen as more extreme than that of Luther or Zwingli, but one could argue that it developed logically enough from certain beliefs about the nature of God. The Judeo-Christian God is defined as **omnipotent** (all-powerful) and **omniscient** (all-knowing). God, seeing the past, present, and future, knows what people will do and who will be saved. In that sense, one's selection for salvation is predestined; God knows who will be saved before they are born. Therefore, life on earth is not an opportunity to earn salvation by good deeds, as it is in Lutheranism. Nevertheless, Calvin and his followers preached that it is essential to live as though one is among the elect (those who are to be saved).

Consider the core beliefs of Calvinism. The first is *total depravity*, the idea that all people are depraved because of the original fall into sin. Second is *unconditional election*, the idea

that God will save some through mercy, despite all of humanity's fall into sin. Third is *limited atonement*, the view that Jesus's atonement serves to save only those who are among the elect. Fourth is *irresistible grace*, a saving grace instilled by God among the elect. Fifth is *perseverance of the saints*—the maintenance of faith among the elect despite hardship or temptation. Among those who bear some conceptual lineage from Calvinism are members of the Reformed Church in America, Presbyterians, and the Puritans who settled the shores of Massachusetts.

Calvin's major theological work is the *Institutio Christianae religionis* (*Institutes of the Christian Religion*) in which he declares the tenets of his belief system. Reading 14.2 describes some of his views on **predestination**. The conflict about predestination essentially has to do with whether humankind obtains salvation through works—that is, good deeds and righteous living—or by the grace of God. Calvin expresses the view that it must be one or the other; it cannot be both.

READING 14.2 JOHN CALVIN

From *Institutes of the Christian Religion*, on predestination

[Many] consider nothing more unreasonable, than that, of the common mass of mankind, some should be predestinated to salvation, and others to destruction....But [we] shall never be clearly convinced as we ought to be, that our salvation flows from the fountain of God's free mercy, till we are acquainted with His eternal election, which illustrates the grace of God....Ignorance of this principle evidently detracts from the Divine glory, and diminishes real humility. But according to Paul, what is so necessary to be known, never can be known, unless God, without any regard to works, chooses those whom He has decreed. "At this present time also, there is a remnant according to the election of grace. And if by grace, then it is no more of works; otherwise, grace is no more grace. But if it be of works, then it is no more grace; otherwise, work is no more work...." In ascribing the salvation of the remnant of the people to the election of grace, Paul clearly testifies, that it is then only known that God saves whom upon which there can be no claim. They who shut the gates to prevent anyone from presuming to approach and taste this doctrine, do no less injury to man than to God; for nothing else will be sufficient to produce in us suitable humility, or to impress us with a due sense of our great obligations to God.

Calvin's doctrine spread north to the British Isles, especially Scotland, under the Calvinist John Knox, and west to the Low Countries, especially Holland. It also crossed the Atlantic to Massachusetts in the 17th century and flavored the beliefs of the Puritans.

Reading 14.3 is one of the most famous, or infamous, sermons ever delivered. The preacher, Jonathan Edwards, was a Puritan; he gave this sermon two centuries after Calvin's lifetime to what he saw as a resistant congregation in Enfield, Massachusetts. Edwards's goal was to convince the congregation to live more righteously. The theological justification for the sermon is the Calvinist tenet that all humankind is totally depraved and deserving of eternal damnation. The irony, of course, is that within that denomination, only God's grace can save people, and the outcome is predestined. What then, one might ask, could congregants really do on their own to deliver themselves from hellfire? Because of this problem, such sermons are rare, and Calvinists "in large numbers have drifted away from [attempting to frighten congregations]."[2]

READING 14.3 JONATHAN EDWARDS

From "Sinners in the Hands of an Angry God," 1741

The God that holds you over the pit of hell, much as one holds a spider, or some loathsome insect, over the fire, abhors you, and is dreadfully provoked; his wrath towards you burns like fire; he looks upon you as worthy of nothing else, but to be cast into the fire; he is of purer eyes than to bear to have you in his sight; you are ten thousand times so abominable in his eyes as the most hateful venomous serpent is in ours. You have offended him infinitely more than ever a stubborn rebel did his prince: and yet 'tis nothing but his hand that holds you from falling into the fire every moment; 'tis to be ascribed to nothing else, that you did not go to hell the last night; that you was suffered to awake again in this world, after you closed your eyes to sleep: and there is no other reason to be given why you have not dropped into hell since you arose in the morning, but that God's hand has held you up; there is no other reason to be given why you han't gone to hell since you have sat here in the house of God, provoking his pure eyes by your sinful wicked manner of attending his solemn worship: yea, there is nothing else that is to be given as a reason why you don't this very moment drop down into hell.

. . .

It would be dreadful to suffer this fierceness and wrath of almighty God one moment; but you must suffer it to all eternity: there will be no end to this exquisite horrible misery. When you look forward, you shall see a long forever, a boundless duration before you, which will swallow up your thoughts, and amaze your soul; and you will absolutely despair of ever having any deliverance, any end, any mitigation, any rest at all; you will know certainly that you must wear out long ages, millions of millions of ages, in wrestling and conflicting with this almighty merciless vengeance; and then when you have so done, when so many ages have actually been spent by you in this manner, you will know that all is but a point to what remains. So that our punishment will indeed be infinite.

2. Benjamin B. Warfield, "Calvinism Today," Princeton, NJ. http://www.the-highway.com/caltoday_Warfield.html.

THE CHURCH OF ENGLAND In England, King Henry VIII broke with Rome in 1534 because the pope refused to grant an annulment of his first marriage, to Catherine of Aragon. In that same year, Henry issued the *Act of Supremacy*, declaring the English sovereign head of the Church of England, also known as the Anglican Church. In 1559, Parliament made Elizabeth I the supreme governor of the church, and a new Book of Common Prayer was introduced in the same year. Elizabeth I was excommunicated from the Catholic Church in 1570, possibly because the papacy had finally surrendered any expectation of reunion. After ascending to the throne in 1603, James I commissioned English scholars to translate the Bible into English and free it from papal and Calvinist influences. The King James Version of the Bible is still considered authoritative by many millions.

The church created a threefold order of clergy: bishops, priests, and deacons. The term *Anglican Communion* refers to the worldwide congregation of Anglican churches. However, unlike in Catholicism, there is no central authority. The archbishop of Canterbury is the titular head of the Church of England and the worldwide Anglican Communion, but the position holds more symbolic than actual authority. The Episcopalian and Methodist churches have their ancestry in the Church of England.

By the middle of the 16th century, Europe—for centuries solidly under the authority of the Church of Rome—was divided in a way that has remained essentially unaltered. Spain and Portugal, Italy, most of France, southern Germany, Austria, parts of Eastern Europe (Poland, Hungary, and parts of the Balkans), and Ireland remained Catholic, whereas most of Switzerland, Great Britain, all of Scandinavia, northern and eastern Germany, and other parts of Eastern Europe gradually switched to Protestantism.

Causes of the Reformation

What conditions permitted this rapid and revolutionary upheaval in Europe? The standard answer is that the medieval church was so riddled with corruption and incompetence that it was like a house of cards waiting to be toppled. However, this answer does not explain why the Reformation did not occur a century earlier, when similar or worse conditions prevailed. Why did the Reformation not take place during the 14th century, a time of plague, schisms, and wars as well as reformers clamoring for change? The exact conditions that gave birth to the Reformation are difficult to pinpoint, but any explanation must take into account several elements that were emerging in the 16th century.

First, there was a rising sense of nationalism in Europe, but many of the economic and political demands of the papacy ignored the rights of individual countries. Thus, Luther's insistence that the German rulers reform the church because the church was impotent to do so appealed to both economic and nationalistic self-interests.

Second, the idea of reform in the church had been maturing for centuries, with outcries against abuses. Some of the great humanists who were contemporaries of Luther—including Desiderius Erasmus of Rotterdam, Thomas More in England, and Jacques Lefèvre d'Étaples in France—had also pilloried the excesses of the church. Their followers and devoted readers yearned for a deeper, more interior piety, free from the excessive pomp and ceremony that characterized medieval religion. Luther's emphasis on personal conversion and his rejection of much of the ecclesiastical superstructure of Catholicism thus appealed to many people.

Third, the low moral and intellectual condition of much of the clergy was a scandal; the wealth and lands of the monastic and episcopal lords were envied.

In 1528, with the Reformation underway, Luther toured villages in Saxony (a region of Germany) and was appalled at the people's lack of knowledge about their religion. In response, he wrote *The Small Catechism*, which was meant for ordinary people to read as a handbook of the tenets and rituals of their faith. Reading 14.4 is from the preface to the catechism and reveals Luther's concerns:

READING 14.4 MARTIN LUTHER

From *The Small Catechism*, preface

Grace, mercy, and peace in Jesus Christ, our Lord, from Martin Luther to all faithful, godly pastors and preachers.

The deplorable conditions which I recently encountered when I was a visitor constrained me to prepare this brief and simple catechism or statement of Christian teaching. Good God, what wretchedness I beheld! The common people, especially those who live in the country, have no knowledge whatever of Christian teaching, and unfortunately many pastors are quite incompetent and unfitted for teaching. Although the people are supposed to be Christian, are baptized, and receive the holy sacrament, they do not know the Lord's Prayer, the Creed, or the Ten Commandments, they live as if they were pigs and irrational beasts, and now that the Gospel has been restored they have mastered the fine art of abusing liberty.

How will you bishops answer for it before Christ that you have so shamefully neglected the people and paid no attention at all to the duties of your office? May you escape punishment for this! You withhold the cup in the Lord's Supper and insist on the observance of human laws, yet you do not take the slightest interest in teaching the people the Lord's Prayer, the Creed, the Ten Commandments, or a single part of the Word of God. Woe to you forever!

...

In the first place, the preacher should take the utmost care to avoid changes or variations in the text and wording of the Ten Commandments, the Creed, the Lord's Prayer, the sacraments, etc. On the contrary, he should adopt one form, adhere to it, and use it repeatedly year after year. Young and inexperienced people must be instructed on the basis of a

uniform, fixed text and form. They are easily confused if a teacher employs one form now and another form—perhaps with the intention of making improvements—later on. In this way all the time and labor will be lost.

Renaissance Humanism and the Reformation

The relationship between Renaissance humanism and the Protestant Reformation is significant, if complex. Luther had no early contact with the "new learning," even though he utilized its fruits. Nevertheless, humanism as far back as the time of Petrarch shared many intellectual and cultural sentiments with the Reformation.

The reformers and the humanists shared several religious aversions. They were both fiercely critical of monasticism, the decadent character of popular devotion to the saints, the low intellectual preparation of the clergy, and the general venality and corruption of the higher clergy, especially the papal **curia**—the body of tribunals and assemblies through which the pope governed the church.

Both the humanists and the reformers felt that the scholastic theology of the universities had degenerated into quibbling arguments, meaningless discussions, and dry academic exercises bereft of intellectual or spiritual significance. They preferred Christian writers of an earlier age. John Calvin's reverence in the 16th century for the writings of Saint Augustine (354–430) echoed the devotion of Petrarch in the 14th century.

Humanists and reformers alike spearheaded a move toward a better understanding of the Bible—one based not on the authority of theological interpretation but on close, critical scrutiny of the text, preferably in the original Hebrew and Greek. Mastery of the three biblical languages (Latin, Greek, and Hebrew) was considered so important in the 16th century that schools—including Corpus Christi College, Oxford; the University of Alcalá, Spain; and the Collège de France in Paris—were founded for instruction in them. Luther's own University of Wittenberg emphasized the study of biblical languages.

We can see the connection between humanist learning and the Reformation more clearly by noting some aspects of Luther's translation of the Bible into German. Although there had been many earlier vernacular translations into German, Luther's, which he began in 1521, was the first produced entirely from the original languages; and the texts he used illuminate the contribution of humanist learning. For the New Testament, he used the critical Greek edition prepared by Erasmus. For the Book of Psalms, he used a text published in Hebrew by the humanist printer Froben at Basel in 1516. The other Hebrew texts were rendered from a Hebrew version published by Italian Jewish scholars who worked in the Italian cities of Soncino and Brescia. His translations of the Apocrypha (books not found in the Hebrew canon) utilized the Greek edition of the Apocrypha printed in 1518 by Aldus Manutius at his press in Venice.

As an aid for his labors, Luther made abundant use of grammars and glossaries published by the humanist scholar Johannes Reuchlin.

Luther's achievement was possible only because much of the groundwork had been laid by a generation of humanist **philologists**. Similarly, in 1611, when the translators of the King James Bible wrote their preface, they noted that they had consulted commentaries as well as translations or versions in Chaldee, Hebrew, Syriac, Greek, Latin, Spanish, French, Italian, and Dutch.

Although there were similarities and mutual influences between humanists and reformers, there were also differences. For example, the humanist program was rooted in the notion of human perfectibility. This was as true of the Florentine humanists with their strong Platonic bias as it was of Northern humanists such as Erasmus. The humanists emphasized the Greek (or, more accurately, Socratic) notion that education can produce a moral person. Humanist learning and humanist education had a strong ethical bias: learning improves and ennobles. The reformers, by contrast, felt that humanity was hopelessly mired in sin and could only be raised from that condition by the freely offered grace of God. For the reformers, the humanists' position that education could perfect a person undercut the notion of a sinful humanity in need of redemption.

LUTHER AND ERASMUS The contrast between these two points of view is evident in a debate between Luther and Erasmus on the nature of the human will. In a 1524 treatise called *De libero arbitrio* (*On Free Will*), Erasmus defended the notion that human effort cooperates in the process of sanctification and salvation. Luther answered in 1525 with a tract denying free will—*De servo arbitrio* (*On the Bondage of the Will*).

Many humanists also believed that a universal truth underlay all religious systems and could be detected by a careful study of religious texts. Pico della Mirandola, for example, believed that the essential truth of Christianity could be detected in Talmudic, Platonic, Greek, and Latin authors. He felt that a sort of universal religion could be constructed from a close application of humanist scholarship to all areas of religion. The reformers, on the other hand, held to a simple yet unshakable dictum: *Sola Scriptura* ("the Bible alone"). While the reformers were ready to use humanist methods to investigate the sacred text, they were adamant in their conviction that only the Bible held God's revelation to humanity.

As a result of the translation of the Bible into the vernacular languages of Northern Europe, Reformation theologians were able to stress the scriptures as the foundation of their teachings. Luther and Calvin further encouraged lay education, urging their followers to read the Bible for themselves and find there—and only there—Christian truth. In interpreting what they read, individuals were to be guided not by religious authorities but by their own judgments on what they read, and by their own consciences. This doctrine is known as "universal priesthood," because it denies a special authority to the clergy. All of these teachings, although primarily theological, were to have profound and long-range cultural impacts.

CULTURE AND SOCIETY

Reform

The predominant value that energized Western Europe in the first half of the 16th century was the desire for religious reform. This impulse was manifested in different ways, but the acting out of the reform impulse would have great sociopolitical effects in Europe and in the newly discovered lands of the New World.

This desire for reform motivated Northern humanists who believed that their scholarly labors of biblical translation and the recovery of early Christian classics would invigorate Christian life in Europe. They believed in reform by scholarship.

The Protestant reformers did not undertake to found new churches. They sought to return to an earlier, less corrupt, Christianity. The Catholic response to Protestantism is often called the Counter-Reformation, but it was also an internal reformation in which the Church clarified its own beliefs and experienced religious impulses anew. The reactive strategies of Catholicism to the rise of Protestantism derived from the sense that the church itself needed reformation.

Early 16th-century reforming impulses solidified into discrete church bodies: the Anglicans in England; Presbyterians in Scotland; Calvinists in parts of Switzerland and Holland; Catholicism in the Mediterranean countries; and Lutheranism in parts of Germany and Scandinavia.

Also evident in this period was a new spirit in scientific investigation, which would sweep away the older authority-based approach to scientific questions in favor of an empirical, investigative mode. In the rise of the experimental sciences, we find another kind of reformation, of intellectual life.

There was an intense positive and negative interaction between humanism and the Reformation—a movement energized by books in general and the Bible in particular. The intensely literary preoccupations of 14th- and 15th-century humanism provided a background and impetus for the 16th-century Reformation. As a philosophical and cultural system, however, humanism was, in general, too optimistic and ecumenical for the more orthodox reformers. In the late 16th century, humanism as a worldview found a congenial outlook in the Christian humanism of Cervantes and the gentle skepticism of Montaigne, but in Reformation circles, it was used as an intellectual instrument for other ends.

The Cultural Significance of the Reformation

Cultural historians have attributed a great deal of significance to the Reformation. Some have argued, for example, that with its strong emphasis on individuals and their religious rights, the Reformation was a harbinger of the modern political world. (However, with equal plausibility, one could make the case that with its strong emphasis on social discipline and its biblical authoritarianism, the Reformation was the last great spasm of the medieval world.) Likewise, in a famous thesis developed in the early 20th century by the German sociologist Max Weber, Calvinism was seen as the seedbed and moving force of modern capitalism. Weber's proposition has lingered in our vocabulary in phrases such as "the work ethic" and "the Puritan ethic."

The Reformation also gave impetus to the already growing use of books in Europe. The emphasis on Bible study suggested a need for more widespread literacy. Luther wanted free education for children of all classes in Germany. Luther's Bible in Germany and the King James Bible in England exercised an inestimable influence on the very shape of the languages spoken by their readers. In other countries touched by the Reformation, the literary influence of the translated Bible was fundamental. In the Scandinavian countries, vernacular literature began with translations of the Bible. Finnish was used as a written language for the first time in translating the Bible.

The Bible was not the only book to see widespread diffusion in this period. Books, pamphlets, and treatises crisscrossed Europe as theological battles were waged on one position or another. It is not accidental that the Council of Trent (1545–1564), a prime instrument of the Catholic Counter-Reformation, legislated the manner in which copies of the Bible were to be translated and distributed. The fact that the infamous index of forbidden books was instituted by the Catholic Church at this time is evidence that the clerical leadership recognized the power of books. The number of books circulating during this period is staggering. Between 1517 and 1520 (even before his break with Rome), Luther's various writings sold about 300,000 copies in Europe.

None of this would have been possible before the Reformation because printing did not exist in Europe. The invention of the printing press and moveable type revolutionized Renaissance culture north and south of the Alps in the same way that film, radio, television, and the Internet changed the

20th century. There were important side effects. The availability of "book learning" undermined the dominance of universities, which had been the principal gatekeepers and disseminators of knowledge. Latin began to lose its position as the sole language for scholarship because many new readers could not read or write it. Luther grasped the implications of the spread of literacy and used it to advance his cause.

The reformers also placed great emphasis on the word. Besides reading and listening there was also singing, and the reformers—especially Luther—stressed vernacular hymns. Hymns were seen as a means of praise and as an instrument of instruction. Luther was a hymn writer of note. The famous "Ein' feste Burg ist unser' Gott" ("A Mighty Fortress Is Our God"), one of the best-loved hymns in Christianity, is generally attributed to him.

On the other hand, the 16th-century reformers had little need or sympathy for painting and sculpture. They were in fact militantly **iconoclastic**. One of the hallmarks of the first reformers was their denunciation of paintings, statues, and other visual representations as forms of papist idolatry. The net result of this iconoclastic spirit was that, by the beginning of the 17th century, patronage for the sacred visual arts had virtually died out in countries where the Reformation was strong. With the exception of Rembrandt, it is difficult to name any first-rate painter or sculptor who worked from a Reformation religious perspective after the 16th century, although much secular art was produced.

The attitude of the 16th-century reformers toward the older tradition of the visual arts may best be summed up by the Church of Saint Peter in Geneva, Switzerland. Formerly a Romanesque Catholic cathedral of the 12th century, Saint Peter's became Calvin's own church. The stained glass was taken out, the walls whitewashed, the statues and crucifixes removed, and a pulpit placed where the high altar once stood. The Church of Saint Peter is a thoroughly reformed church, a building for hearing the Word of God preached and read. Gone is the older notion (represented, for example, by the Chartres Cathedral) of the church as reflecting the otherworldly vision of heaven in the richness of its art. Reformation culture was in short an *aural*, not a *visual*, culture.

THE GROWTH OF SCIENCE

The period of the Renaissance in the North was not merely a turning point in the history of religion. It was also a decisive age in the history of science. In earlier times, a scientist was likely enough to be an ingenious tinkerer with elaborate inventions

CULTURE AND SOCIETY

Principal Discoveries and Inventions in the Sixteenth Century

1486	Diaz rounds the Cape of Good Hope
1492	Columbus discovers North America
1513	Balboa sights the Pacific Ocean
1516	Portuguese ships reach China
1520–1522	First circumnavigation of globe by Magellan
ca. 1530s	Paracelsus pioneers the use of chemicals to treat disease
1530–1543	Copernicus refutes the geocentric view of universe
1533	Gemma Frisius invents the principle of triangulation in surveying
1542	Leonhard Fuchs publishes an herbal guide to medicine
1543	Vesalius publishes his anatomical treatise
1546	Agricola publishes a guide to metallurgy
1569	Mercator devises his system of mapmaking
1572–1598	Tycho Brahe observes a supernova (1572) and produces the first modern star catalog (1598)
1582	Pope Gregory XIII reforms the calendar
ca. 1600	The first refracting telescope is constructed in Holland
1600	William Gilbert publishes his treatise on magnetism

who dabbled in alchemy, astrology, and magic. The new Renaissance scientist, a person of wide learning with a special interest in mathematics and philosophy, would develop bold and revolutionary ideas but subject them to the test of practical experience.

The age produced many advances in science. In England, William Gilbert (1544–1603) discovered that the earth was a large magnet whose pole points approximately north. William Harvey (1578–1657) solved the problem of how the blood could circulate—get from the arteries to the veins and return to the heart—by postulating the existence of the then-undiscovered channels we now call capillaries. John Napier (1550–1617) discovered the practical mathematical tool called the *logarithm*, which reduced the time and effort needed to solve difficult equations.

Elsewhere in Europe, the German Paracelsus (1493–1541) laid the foundations of modern medicine by his rejection of traditional practices. Although his own theories were soon rejected, his insistence on observation and inquiry had important consequences, one of which can be seen in the work of Andreas Vesalius (1514–1564), who was born in Brussels and studied in Padua. Vesalius's *De humani corporis fabrica libri septem* (*Seven Books on the Structure of the Human Body*), published in 1543, comprises a complete anatomical treatise, illustrating the human form with minute detail and impressive accuracy (**Fig. 14.4**).

The philosophical representative of the "new science" was Francis Bacon (1561–1626), who combined an active and somewhat disreputable political career with the writing of works intended to demolish traditional scientific views. The chief of these books was the *Novum Organum* (*New Organon*, 1620), which aimed to free science from the 2000-year-old grasp of Aristotle while at the same time warning against the unrestrained use of untested hypotheses. Science and religion came into direct conflict in the work of the Polish astronomer Nicolaus Copernicus (1473–1543), who studied at the universities of Kraków and Bologna. In 1543, the same year in which Vesalius's work appeared, Copernicus published *De revolutionibus orbium coelestium* (*On the Revolutions of Celestial Bodies*), a treatise in which he denies that the sun and the planets revolve around the Earth, and reverts to a long-dead Greek theory that the Earth and planets orbit the sun. Catholic and Protestant theologians for once found themselves united in their refusal to accept an explanation of the universe that seemed to contradict the teaching of the Bible, but Copernicus's work provided stimulus for Galileo's astronomical discoveries in the following century.

Additionally, the general principle behind Copernicus's method had important repercussions for the entire history of science. Up until his time, scientists had taken the position that, with certain exceptions, reality was as it appeared to be. If the sun appeared to revolve about the Earth, that appearance was a "given" in nature, not to be questioned. Copernicus showed that it was equally plausible to take the Earth's mobility as a given, because his view explained why it might seem that the Earth lay in the center of the solar system and also explained other astronomical events more powerfully and extensively.

▲ **14.4** **Andreas Vesalius, Third Musculature Table from** *De humani corporis fabrica libri septem*, **1543. Published in Basel, Switzerland. National Library of Medicine, Bethesda, Maryland.** Although the work was chiefly intended to have a scientific value, Vesalius has set his anatomic drawing into a scene showing a landscape and, in the distance, evidence of human construction. By placing the human in the foreground, towering over the rest of the scene, Vesalius emphasizes the humanists' view of the central importance of humanity.

THE VISUAL ARTS IN NORTHERN EUROPE AND SPAIN

The conflict between religion and humanism—and the attempt to reconcile them in the North—affected the outcomes of developments in the visual arts. Some artists traveled to Italy and absorbed themselves in the art of antiquity as well as its interpretation by Italy's contemporary artists. Some were influenced by the writings of Martin Luther, others by the Christian

humanism of Erasmus. The art of the 16th century in the North reflected, as it always does, the current streams of thought as well as the market for commissions. Of particular importance, however, was the role that the invention of the printing press played in the dissemination of international styles and of copies of works.

Germany

It might be said that the intellectual and religious battles of the era stimulated German art to its highest achievements, for both Albrecht Dürer (1471–1528) and Matthias Grünewald (ca. 1470–1528), who are, in very different ways, towering figures in the development of Northern European painting. Despite his sympathy with Luther's beliefs, Dürer was strongly influenced by Italian artistic styles and, through Italian models, by Classical ideas. Grünewald, on the other hand, rejected almost all Renaissance innovations and turned instead to traditional Northern religious themes, treating them with new passion and emotion. Other artists, it seems, chose not to wrestle with these theological and cultural problems. Albrecht Altdorfer (1480–1538), for example, stood apart from the dueling ideological discourses and created a worldview of his own.

ALBRECHT DÜRER Dürer was born in Nürnberg, the son of a goldsmith who trained him in the craft and also arranged an apprenticeship for him with a wood engraver. This technical background accounts for Dürer's proficiency in handling the printmaking medium as well as for his reputation as a printmaker; in his day, he was more famous for his prints than his paintings. Dürer's education as an artist expanded with two visits to Italy. There he saw for the first time the new technique of **linear perspective** (in which parallel lines converge at vanishing points as they recede from the viewer) and came into contact with artists studying human anatomy. As important as these technical discoveries were to his own art, what truly impressed him in Italy was the reshaping of artistic identity by humanist thought. The traditional German—indeed, medieval— view of the artist was as an artisan whose task was to humbly, if expertly, reproduce God's creations. Dürer would adopt the humanist view that

the artist is an inspired genius endowed with potential by God but whose exceptional achievements reflect conscientious work and study and the will to excel.

It is not by chance that a first glance at Dürer's *Self-Portrait* of 1500 (**Fig. 14.5**) suggests a Christlike figure rather than a prosperous German painter of the turn of the century. The effect is intentional. The lofty gaze underlines the solemn, almost transcendent nature of the artist's vision, while the positioning of the fingers of his hand vaguely recall the sign of blessing seen in icons and other representations of Christ (see Fig. 7.6 and Fig. 7.17). Our focus is drawn to the artist's penetrating eyes and his hand, symbolizing the important connection between the artist's vision and his skill.

In his paintings, Dürer shows a fondness for capturing form with precise detail and strong, linear draftsmanship rather than the suppler modeling using light and shade that was characteristic of Italian art. This reflects his training as a goldsmith and his commitment to printmaking. One of his most accomplished

▶ **14.5** Albrecht Dürer, *Self-Portrait*, 1500. Oil on lime panel, 25⅝" × 18⅞" (65 × 47.9 cm). Alte Pinakothek, Munich, Germany. The frontal pose and solemn gaze convey Dürer's belief in the seriousness of his calling. The artist's characteristic monogram stands to the upper left, with the date, 1500, above it.

▲ **14.6** Albrecht Dürer, *Adam and Eve*, 1504. Engraving, 9⅞" × 7⅝" (25.1 × 19.4 cm). Metropolitan Museum of Art, New York, New York. The engraving reveals Dürer's fascination with the ideal human form. Adam and Eve are depicted in symmetrical poses. Each is supported on one leg; each bends an arm upward. The fig held by Eve represents the Tree of Knowledge; Adam holds a branch representative of the Tree of Life. Four animals symbolize the basic temperaments of the ancient Greek physician Hippocrates: the elk, melancholic; the cat, choleric; the rabbit, sanguine; and the ox, phlegmatic.

works in the medium is *Adam and Eve* (**Fig. 14.6**), an **engraving** that combines an admiration for the Classical style with the attention to realistic detail that is the signature of Northern art. Dürer's Adam and Eve arise from the idealism of Greek and Roman prototypes; Adam's young, muscular body could have been drawn from a live model or from Classical statuary. Eve reflects a standard of beauty very different from that associated with representations of the female nude in works by other Northern artists: the familiar slight build and refined facial features are replaced with a plumper, more well-rounded figure and a Classical profile. Elsewhere in the composition, however,

Dürer's Northern roots are visible in the carefully drawn trees with their leaves and hanging fruit, detailed renderings of the animals, and symbolism. The ox, cat, rabbit, and elk are associated with the four humors, or fluids of the body, derived from medieval medical theories about human temperament: phlegm, yellow bile, blood, and black bile.

Dürer brought unsurpassed subtlety and expressiveness to engraving, a challenging print-making medium in which the artist incises lines into a metal plate (such as copper or zinc) with a sharp-pointed steel instrument called a *burin*. When the drawing is complete, the plate is smeared with a paste-like ink that is forced into the crevices made by the burin. The excess ink is wiped away, a damp piece of paper is laid on top of the plate, and both are passed through a press. The fibers of the paper, under many pounds of pressure, sink into the ink-filled crevices and pick up the ink. The resulting print is a mirror image of the drawing that was made on the plate.

Knight, Death, and the Devil (**Fig. 14.7**) is one of three prints Dürer made during 1513 and 1514, known collectively as his *Meisterstiche*—master engravings (in German, *stechen* means "to stab" or "to prick"). The theme of the work is moral virtue, symbolized by the Christian knight who remains stalwart despite the temptation toward sin (the devil with a pig snout follows closely behind) and the recognition of the brevity of life (Death, holding an hourglass, stares directly into the knight's face). We do not know whether Dürer had read Erasmus's *Instructions for the Christian Soldier* (1503), but the content of the print seems to be inspired by his words: "In order that you may not be deterred from the path of virtue because it seems rough and dreary…and because you must constantly fight three unfair enemies—the flesh, the devil, and the world—this third rule shall be proposed to you: all of those spooks and phantoms which come upon you as if you were in the very gorges of Hades must be deemed for naught after the example of Virgil's Aeneas….Look not behind thee."[3] Indeed, the knight, beset by "spooks and phantoms" looks neither behind nor to the side—rather, steadfastly straight ahead.

Dürer was acknowledged as one of the great artists of his era during his lifetime. Like Luther, he used the new possibilities of the printing press to disseminate his ideas. At the time of his death, Dürer was working on *Libri IV De Humani Corporis Proportionibus* (*Four Books on Human Proportions*). This work (in Latin) aimed to accomplish for art what Vesalius's did for

3. "Albrecht Dürer: *Knight, Death, and the Devil* (43.106.2)." *Heilbrunn Timeline of Art History*, Metropolitan Museum of Art, October 2006, http://www.metmuseum.org/toah/works-of-art/43.106.2.

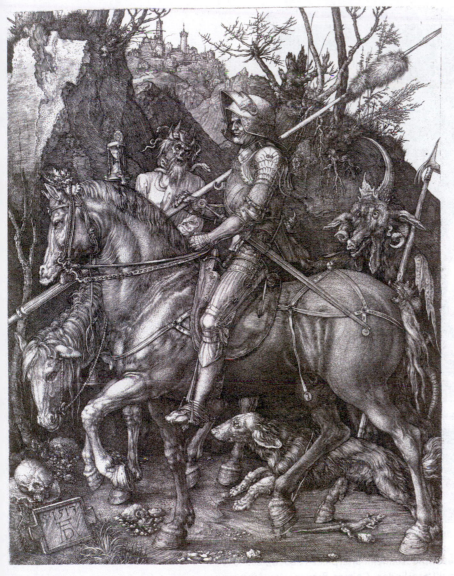

▲ **14.7** Albrecht Dürer, *Knight, Death, and the Devil*, 1513. Engraving, 9⅝" × 7⅝" (24.4 × 18.1 cm). British Museum, London, United Kingdom. The knight's steadfast sense of purpose may have been inspired by Erasmus's *Instructions for the Christian Soldier*.

medicine. It was inspired by two of the great intellectual concerns of the Renaissance: a return to Classical ideals of beauty and proportion, and a new quest for knowledge and scientific precision.

MATTHIAS GRÜNEWALD

If Dürer's art illustrates the impact that humanist thought, imported from Italy, had on the North, the work of Matthias Grünewald exposes the Northern artists' characteristic synthesis of realism, religion, symbolism, and passionate emotion. Grünewald, whose actual name was Matthias Neithardt, worked for a while at the court of the archbishops of Mainz, important figures in the Holy Roman Empire. Some scholars believe that he sided with the peasants in their complaint against the Catholic Church—which contributed to the Peasants' War of 1524–1525—and embraced some of the teachings of Martin Luther. In any event, Grünewald moved northeast from Mainz to Halle, where he stayed until his death.

What we know about his political and religious sympathies—his support for the oppressed and for the ideals of the Reformation—is borne out by the characteristics of his paintings. Grünewald did not share the Renaissance quest for ideal beauty and the humanist interest in Classical antiquity. Instead, he turned repeatedly to the traditional religious themes of German medieval art, bringing to them a passionate, almost violent intensity.

Grünewald's Isenheim altarpiece (completed in 1515) was commissioned for the church of a hospital run by members of the monastic Order of Saint Anthony. The folding panels are painted with scenes and figures appropriate to its location, including saints associated with the curing of disease and events in the life of Saint Anthony. In particular, the patients who contemplated the altarpiece were expected to meditate on Christ's Crucifixion and Resurrection and derive from them comfort for their own sufferings.

In his painting of Christ in the *Crucifixion* panel (see **Fig. 14.8** on p. 468), Grünewald uses numerous details to depict the intensity of Christ's anguish—from his straining hands frozen in the agony of death, to the thorns stuck in his festering body, to the huge iron spike that pins his feet to the cross. It is difficult to imagine anything further from the Italian Renaissance and its concepts of ideal beauty than this tortured image. Nor does Grünewald adhere to Renaissance or Classical theories of proportion or perspective. The figure of Christ, for example, is not related in size to the other figures—it dominates the panel—as a glance at the comparative size of his gnarled hands will reveal. Those hands reach painfully upward, stretching for salvation from the blackened sky. We do not find such impassioned portrayals outside Germany during the Renaissance.

With the Protestant Reformation, the market for works like the Isenheim altarpiece would change as reformers like Luther and Calvin equated prayer before images of Christ, the Virgin Mary, and saints with idol worship.

ALBRECHT ALTDORFER

Like his contemporaries, Albrecht Altdorfer painted his share of religious subjects, but in his case, landscape elements dominated the compositions, sometimes to the point that they seem to be the main subject. Such is the case in his *Battle of Alexander at Issus* (see **Fig. 14.9** on p. 469), a history painting commissioned by Wilhelm IV, the duke of Bavaria (from 1508 to 1550). The subject is Alexander the Great's defeat of the Persian king Darius III on the battlefield at Issus in 333 BCE. The sweeping panorama is a study in creating depth within

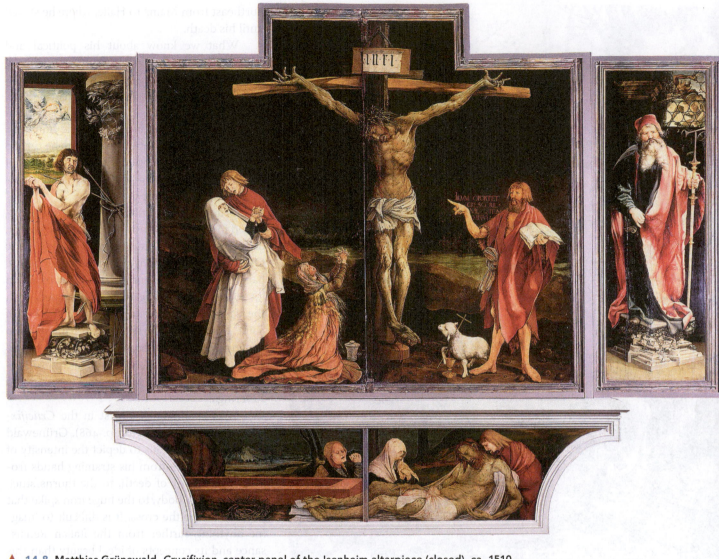

▲ **14.8** Matthias Grünewald, *Crucifixion*, center panel of the Isenheim altarpiece (closed), ca. 1510–1515. Oil on panel, 106" × 121" (269 × 307 cm). Musée d'Unterlinden, Colmar, France. Mary Magdalene kneels, wringing her hands in grief, as Mary and John the Evangelist stand behind her. John the Baptist points to Jesus while the sacrificial lamb pours its blood into the chalice.

pictorial space. Like a river wending and surging toward the horizon, the cavalries of both armies clash along a similar path; Alexander's troops drive their enemy toward the encampment adjacent to a town on the Pinarus River. Across the water are the island of Cyprus, the Nile River, and the Red Sea farther beyond. A brilliant sunset represents the reward that awaits the victorious troops, while the vanquished are met by the crescent of a waxing moon; the contrast of the celestial bodies symbolizes Alexander (who was represented as the sun god) and Persia (whose symbol was the crescent moon). The Latin inscription suspended in the sky declares the subject as the Battle of Issus as well as the names of the victor and vanquished; the armor that is worn by the soldiers, however, is of the 16th century rather than the fourth century BCE. The occasion for the commission was the duke's military campaign against invading Turks; the subject was clearly chosen because it resonated with the Duke's own ambitions.

Almost half of the area of the painting of the *Battle of Alexander at Issus* is given over to landscape elements—craggy mountains, serene seas, and a turbulent sky that seems, only at this moment in the battle, to be calming. Masses of humanity—and their squabbles—are dwarfed by the awesome power of nature.

The Netherlands

The numerous provinces of the Netherlands (including present-day Holland and Belgium), under the rule of the Spanish crown during the second half of the 16th century, rebelled in 1579 and formed two separate unions: one to the south, closer to France, remained Catholic, and the other, to the north, was Protestant. Art commissions in the two territories reflected these religious differences.

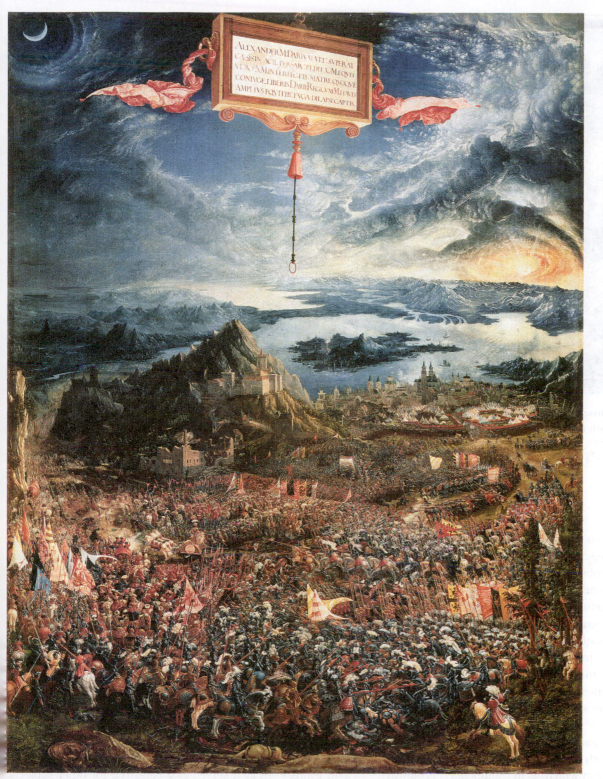

◄ **14.9** Albrecht Altdorfer, *Battle of Alexander at Issus*, 1529. Oil on wood, 62" × 47" (158 × 120 cm), Alte Pinakothek, Munich, Germany. Although the cavalry is appareled in 16th-century armor, the title of the painting—and the inscription in the sky—refers to Alexander the Great's defeat of the Persians at the town of Issus in 333 BCE. Wilhelm IV of Bavaria had just undertaken a campaign against invading Turks and wished, as Alexander before him, to drive the enemy back across the seas. The panorama takes the eye as far as Cyprus, the mouth of the Nile, and the Red Sea.

HIERONYMUS BOSCH Hieronymus Bosch (ca. 1450–1516) was a Dutch painter known for using fantastic and erotic imagery to illustrate moral concepts. His *Garden of Earthly Delights* (see **Fig. 14.10** on p. 470) is one of the most intriguing works of art that a reader will encounter in this book; it is certainly one of the most ambiguous in terms of meaning and purpose. On the one hand, its form—a triptych—likens it to an altarpiece; on the other, some of the content, which is quite sexually explicit, would suggest that the work was a secular rather than religious commission. Some scholars have suggested that it might have been painted as a wedding picture because of imagery relating to sex and procreation. The *Garden of Earthly Delights* may never be accurately deciphered, but it will always be mesmerizing.

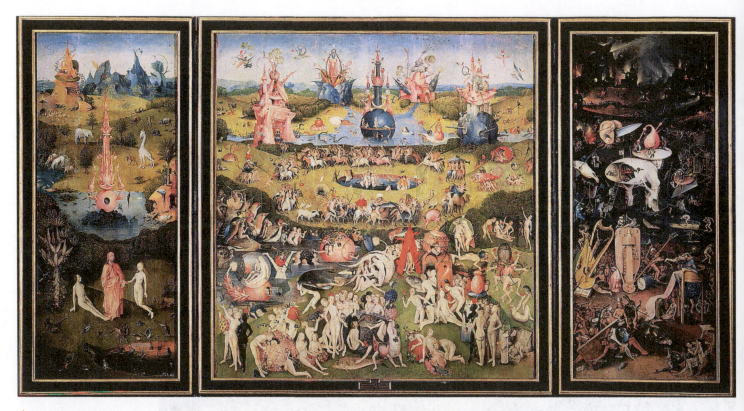

▲ **14.10** Hieronymus Bosch, *Garden of Earthly Delights*, 1505–1510. Oil on wood, center panel 86" × 76¼" (220 × 194 cm), each wing 86" × 38¼" (220 × 97 cm). Museo del Prado, Madrid, Spain. God presents Eve to an apparently questioning Adam in the left panel. The center panel is an orgy of sex and procreation. The right panel shows hellfire and punishment for sinners. The overall meaning of the triptych is somewhat puzzling, but the impression is fascinating.

Reading the triptych from left to right, the first panel features a fanciful landscape with plants, animals, and landforms generated not from the observation of nature but from the mind. It is an imagined Eden in which, at the bottom in the extreme foreground, God introduces Adam and Eve to one another. The central panel continues the theme of the garden, this time populated by the generations who seem to have inherited the bliss of Adam and Eve in their state of innocence before the Fall. They live, cavort, and love freely; nothing they do causes shame. An outright joyousness, however bizarre, permeates the panel, enhanced by the vibrant colors, frolicking nudes, and fantastic hybrid structures along the horizon. How grim then, by contrast, is the last panel. Here all the light and air evaporate, and we are left with the murky darkness of a forbidding, perverted, hellish scene in which, as in Dante's *Inferno*, punishment is meted out to souls (or here, people) according to their sins. The most prominent image is of a creature with a cracked, egg-shaped body and a man's head, crowned with a bagpipe—a symbol of lust—to the left of which is a cannon-like object assembled from two severed ears and a knife blade poised like a phallus. Elsewhere a glutton retches up his excesses, and a miser excretes coins. Lust, gluttony, and greed are three of the seven deadly sins.

The sources of Bosch's inspiration in this and his other works are unknown. Many of his demons and fantastic animals seem related to similar manifestations of evil depicted in medieval art, but no medieval artist ever devised a vision such as this or possessed the technique—or the courage—to execute it. To modern eyes, some of Bosch's creations, like the human-headed monster on the right-hand panel turning both face and rear toward us, seem to prefigure the surrealist art of the 20th century. Bosch stands as one of the great originals in the history of painting.

PIETER BRUEGEL THE ELDER With increased prosperity in the Netherlands, a more diverse market of art buyers took shape. The church and nobility did not alone define patronage, and religious art was only one of many genres in which artists were working. Landscape emerged as an important genre, even as it served as a backdrop for other subjects. Portraiture also became popular, as did scenes of daily life. As with Northern art in general, Dutch painting often harbored symbolism and continued to be chock-full of realistic detail.

Pieter Bruegel the Elder (ca. 1525–1569), the most important Netherlandish painter of the second half of the 16th century, combined a love of landscape and genre scenes (slice-of-life subjects), occasionally with moralizing tales or proverbs. In *The Triumph of Death* (**Fig. 14.11**), Bruegel looks with uncompromising honesty at the indiscriminate nature of death, which comes eventually to all: rich and powerful, poor

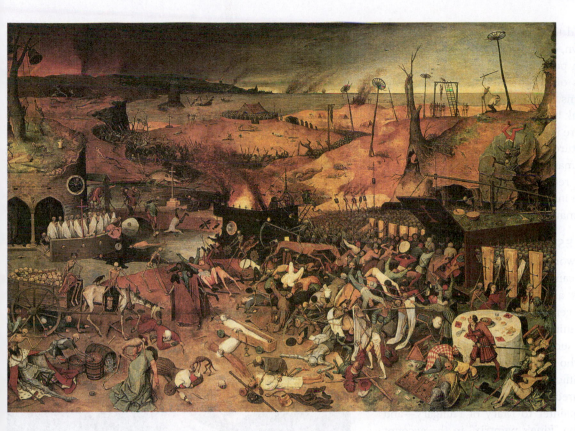

◄ **14.11** Pieter Bruegel the Elder, *The Triumph of Death*, ca. 1562–1564. Oil on panel, 46" × 63 ¾" (117 × 162 cm). Museo del Prado, Madrid, Spain. Note the huge coffin on the right into which the dead are being piled, guarded by rows of skeleton soldiers. Nobody is spared, not even the king in the lower left-hand corner.

and hopeless. Like the hell panel in Bosch's *Garden of Earthly Delights*, *The Triumph of Death* is rife with horrific images. An army of skeletons besieges all living things, from a king (in the lower left corner) and nobles to soldiers and peasants; nothing is spared. The animals are emaciated or dead, and the landscape is burning or scorched. It is about as grim and eerie a picture as is imaginable. Bruegel offers no escape, no hope.

How serene and benign then, by contrast, is *Hunters in the Snow* (**Fig. 14.12**), one of a series of paintings by Bruegel depicting scenes associated with the seasons of the year. We join the

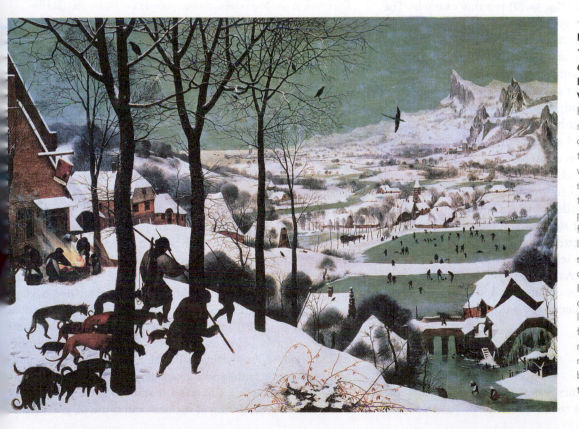

◄ **14.12** Pieter Bruegel the Elder, *Hunters in the Snow*, 1565. Oil on wood, 46" × 64" (116.8 × 162.6 cm). Kunsthistorisches Museum, Vienna, Austria. Note Bruegel's careful use of color to suggest a cold, clear, sunless day. From his first crossing of the Alps in the 1530s, Bruegel was inspired by mountain scenery, and it reappeared throughout his work. In this painting, the panoramic sweep from the foreground to the lofty peaks behind makes the scene appear a microcosm of human existence. Thus Bruegel's "world landscapes" or *Weltlandsschaften* are both literal depictions of scenes from nature and symbolic representations of the relationship between human beings and the world around them.

painting among hunters and their hounds on a hillside overlooking a snow-covered town, our eyes following an imaginary path down toward a frozen pond full of skaters and back up again toward the icy peaks of distant mountains. The minimal palette of white, browns, and cool blues communicates the essence of winter, a bleak backdrop against which humans huddle, work, and play. There is inevitability—even beauty—in the way that people and nature are bound together by a sense of order and purpose. Humanism—encountered by Bruegel during his trip to Italy and reinforced by philosophers active in Antwerp—seems to have inspired him to create works that have a similar regard for human dignity.

CATERINA VAN HEMESSEN The Northern European art market was kinder to women artists than was Italy's. A burgeoning middle class became almost as likely as the nobility to commission paintings, and their taste was for portraits, still-life compositions, and genre paintings. As opportunities for formal training were minimal for women who aspired to be artists, the best path to success was through one's father's studio; for women artists who were not daughters of painters, getting started at all was difficult if not impossible. Very successful women artists acquired court patrons, as did Caterina van Hemessen—who was painter to Mary of Hungary—and Levina Teerlinc, listed as the "king's paintrix" in the account books of the court of England's Henry VIII.

Caterina van Hemessen was trained by her father, one of Antwerp's most sought-after painters, and it is believed that she worked on some of his commissions. Realistically rendered detail and sensitive, thoughtful expressions are a hallmark of her portraiture, arguably the genre in which she was most prolific. Her *Portrait of a Lady* (**Fig. 14.13**) is a fine example. The three-quarter-profile, three-quarter-length format provides a more complete, poised, and natural portrait likeness. The sitter's head is subtly cocked, and her expression is warm and open, as if she is listening with interest to a conversation. The tiny dog, lush, crimson velvet sleeves, heavy brocade dress, and delicate lace inset over the lady's shoulders provide a vehicle for van Hemessen's virtuoso brushwork.

The first self-portrait of a Northern woman artist shown working at her profession was created by van Hemessen. In that work—in a collection in Basel, Switzerland—she sits before an easel on which we see a portrait in progress. Her right hand holds a fine brush—the bristles of which touch the surface of the canvas—and in her left she deftly manages a selection of brushes and a painter's palette. It is worth noting that women painters frequently used the self-portrait to assert their authenticity as practicing artists. As if to be doubly sure to convey her authorship, van Hemessen inscribed her portrait thus: "Caterina van Hemessen painted me/1548/her age 20."

France

French art of the 16th century was strongly influenced by the Italianate style due in part to the presence of Italian artists,

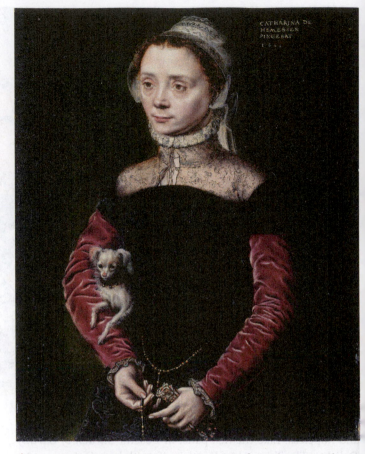

▲ **14.13** Caterina van Hemessen, *Portrait of a Lady*, 1551. Oil on oak, 9" × 7" (22.9 × 17.8 cm). National Gallery, London, United Kingdom. The sitter is unidentified, but the painting is one of a pair of signed portraits. Caterina van Hemessen moved to Spain with the court of Mary of Hungary after Mary abdicated her regency of the Low Countries. When Mary died, she bequeathed van Hemessen and her husband enough money to live on for the rest of their lives.

including Leonardo da Vinci, at the French court. Leonardo had entered the service of Francis I in 1516, one year after the king captured Milan, and remained in the country for the rest of his life. The great Italian Renaissance artist was buried by the French king in the chapel of his royal residence, the Château d'Amboise.

JEAN CLOUET Francis I was an avowed patron of the arts, setting the standard for French taste in art and architecture for generations of successors. He retained as his official portrait painter Jean Clouet (ca. 1485–1541). In Clouet's portrait of Francis (**Fig. 14.14**), the king fills the space, indeed spilling beyond the frame as if his greatness cannot be contained. Francis's facial expression is at the same time imperious and suave, supporting his dual reputation as a man of uncompromising authority (he declared Protestantism illegal in France and persecuted adherents to the faith) and a legendary lover (he was known as the "merry monarch"). Clouet's attention to detail, particularly the illusionistic rendering of surfaces and textures, gives visual

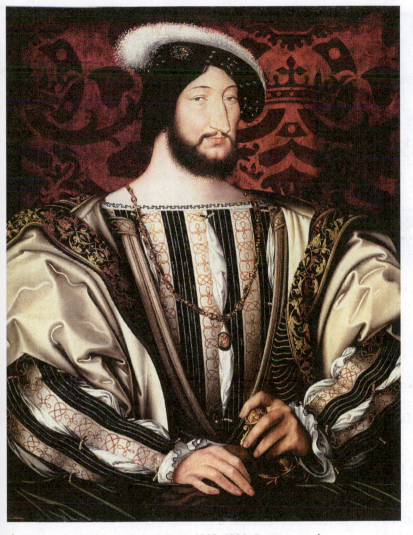

▲ **14.14** Jean Clouet, *Francis I,* ca. 1523–1530. Tempera and oil on wood, 37¾" × 29" (96 × 74 cm). Musée du Louvre, Paris, France. The portrait reveals a sophisticated and calculating king in a nation aspiring to great wealth. The silken brocade is sumptuous, and the hat provides a rakish air.

roofline over a large, square, central module marked by cylindrical towers at the corners. Assertive horizontal moldings that run the length of the building balance the bit of Gothic verticality in the center and in the conical roofs that serve as endpoints for the château's symmetrical wings. The precise delineation of the floors and the rhythmic placement of windows—one aligned atop the other—are reminiscent of the design of Italian palazzi (see Fig. 12.34).

THE LOUVRE Many consider the Louvre to be the world's foremost repository of art. Its renowned courtyard, the Square Court, is a central piece of the design by Pierre Lescot (ca. 1510–1578) for Francis I. The king died in 1547, a year after the renovation began, but it was continued by his successor, Henry II (who reigned from 1547 to 1559). Lescot's design synthesized aspects of Italian Renaissance architecture with characteristically Northern elements. The result created the foundation for a signature French Classical style. The façade of the west wing (see **Fig. 14.16** on p. 474) is a compendium of Classical references—from the arcade on the lowest level and curved and triangular pediments over the windows to engaged columns and pilasters with Corinthian capitals. As in the Château de Chambord (and its Italian precedents), the three stories are accentuated by strong horizontals, but the steep roofline (also seen at Chambord) and the tall windows counterbalance the earthbound quality with their vertical thrust. Also uniquely French are the two-story pavilions that project from the plane of the façade as well as the sculptural ornamentation.

prominence to the king's costume and suggests his flair for fashion. Francis's face and neck, disproportionally small, are defined by strong lines; as in Botticelli's figures (see Fig. 12.27 and Fig. 12.28), chiaroscuro is virtually absent.

CHÂTEAU DE CHAMBORD During the reign of Francis I, a number of luxurious châteaus were built along the valley of the Loire River, combining the airiness of the earlier French Gothic style with decorative motifs imported from Italian Renaissance architecture. The châteaus were castle-like country residences, sometimes complete with moats, built as hunting lodges for the royalty and nobility (the famed palace at Versailles—see Figure 15.29—began as such a getaway). The Château de Chambord (see **Fig. 14.15** on p. 474) is a good example of a hybrid design. An assortment of Gothic-style spires, turrets, chimneys, and other structures rise at the

England

Throughout the 16th century, English political and cultural life followed a path notably different from that of continental Europe, as it had done so often in its previous history. The social unrest that had marked the Late Middle Ages in England was finally ended in 1485 by the accession of Henry VII, the first king of the Tudor dynasty. For the entire 16th century, England enjoyed stability and commercial prosperity, on the basis of which it began to play an increasingly active role in international politics. Henry VIII's final break with the Catholic Church in 1534 led to the development of ties between England and the other countries of the Reformation, particularly the Netherlands. When years of tension between the Netherlanders and their Spanish rulers finally broke out into open rebellion, England (then ruled by Queen Elizabeth I) supplied help secretly. Relations between Elizabeth and the Spanish king Philip II were already strained—in part because Philip had been briefly married to Elizabeth's predecessor, Mary—and English interference in the Spanish Netherlands was unlikely to help. In 1585, a new Spanish campaign of repression in the

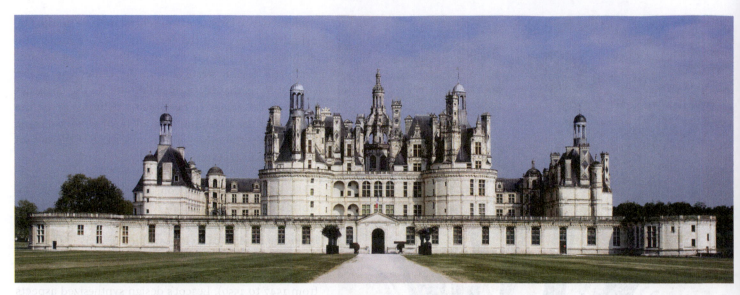

▲ **14.15 Château de Chambord, Loire Valley, France, begun 1519.** The turrets and pinnacles are reminiscent of French medieval architecture, but the central block and much of the decorative detail suggest Italian Renaissance models.

Netherlands, coupled with the threat of a Spanish invasion of England, drove the queen to resort to more open action—she sent 6000 troops to fight alongside the Netherlanders. Their presence proved decisive.

Philip's anger at his defeat and at the progress of the campaign for an independent Netherlands was converted to fury against England. The massive Spanish Armada—the largest fleet the world had ever seen—was ready early in 1588 and sailed majestically north, only to be met by a fleet of lighter, faster English ships commanded by Sir Francis Drake. The rest

is part history, part legend. Even before the expedition sailed, Drake had "singed the beard of the King of Spain"[4] by sailing into Cádiz harbor and setting fire to some of the Spanish galleons anchored there. What was left of the Armada reached the English Channel, where it was destroyed, partly by superior English tactics and partly by a huge storm promptly dubbed (by the victors, at least) the Protestant Wind. The subsequent tales

4. From a poem by Henry Wadsworth Longfellow.

▼ **14.16 Pierre Lescot, west wing of the Cour Carrée (Square Court) of the Louvre, Paris, France, begun in 1546.** The architectural and sculptural decoration are Italian in origin but are used here as typically French elaborate ornamentation. On the first floor, the use of arches is reminiscent of ancient Roman architecture.

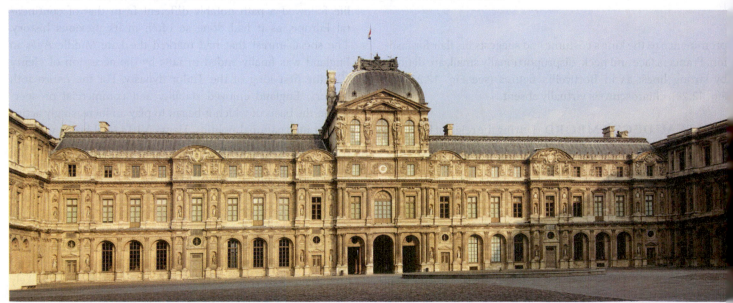

of English valor and daring brought a new luster to the closing years of the Elizabethan Age.

In view of England's self-appointed position as the bulwark of Protestantism against the Catholic Church in general and Spain in particular, it is hardly surprising that Renaissance ideas that developed south of the Alps took some time to affect English culture.

Few Italian artists were tempted to work at the English court or, for that matter, were likely to be invited. Furthermore, England's geographic position inevitably cut it off from intellectual developments in continental Europe and produced a kind of psychological insularity that was bolstered in the late 16th century by a wave of national pride. The finest expression of this is probably to be found in the lines William Shakespeare put into the mouth of John of Gaunt in *Richard II*, a play written some six years after the defeat of the Spanish Armada:

READING 14.5 WILLIAM SHAKESPEARE

Richard II, act 2, scene 1, lines 40–50

This royal throne of kings, this scepter'd isle,
This earth of majesty, this seat of Mars,
This other Eden, demi-paradise,
This fortress built by Nature for herself
Against infection and the hand of war,
This happy breed of men, this little world,
This precious stone set in the silver sea,
Which serves it in the office of a wall
Or as a moat defensive to a house
Against the envy of less happier lands,
This blessed plot, this earth, this realm, this England. . . .

On the other hand, the same spirit of nationalism was bound to produce a somewhat narrow-minded rejection of new ideas from outside. In comparison to those of Italy and the Netherlands, English sculpture and painting remained provincial.

NETHERLANDISH ARTISTS IN THE TUDOR COURT: HANS HOLBEIN THE YOUNGER AND LEVINA TEERLINC

One of the few foreign painters to work in England was the Northerner Hans Holbein the Younger (1497/1498–1543), a court painter to Henry VIII who was enlisted to travel to prospective brides and paint their likenesses for the king's approval. Holbein's *Anne of Cleves* (**Fig. 14.17**) is an example; after viewing the portrait (and that of her sister, Amalia), Henry sent for Anne and made her his fourth queen. Six months later, the marriage between Henry and the woman he called his "Flanders Mare" was annulled. The formal frontal pose and exquisite though understated detail of Anne's costume convey her poise. A French ambassador to the English court described her as "of middling beauty, and of very assured and resolute countenance."

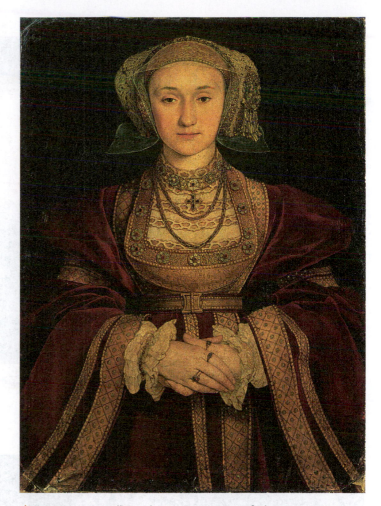

▲ **14.17 Hans Holbein the Younger,** *Anne of Cleves,* **ca. 1539–1540. Vellum applied to canvas, 25⅝" × 18⅞" (65 × 48 cm). Musée du Louvre, Paris, France.** After viewing this portrait, Henry VIII sent for Anne of Cleves and made her his fourth queen. Note the formal pose and suitably modest downturned gaze.

For the most part, women artists of the era, both in the North and in Italy, earned their reputations locally by working steadily on small private commissions. As such, they were able to earn a living in their professions. Some, however, like Levina Teerlinc (1515–1576) were held in such high esteem that they garnered international attention. Henry VIII brought Teerlinc to his court as his official portrait miniaturist, and she stayed in England to serve three Tudor monarchs who succeeded him, including Elizabeth I, the daughter of Henry VIII and Anne Boleyn (executed by Henry's order when Elizabeth was not yet three years old). Attributions of Teerlinc's portraits are not definitive, although it is believed that she created nine of Elizabeth alone. Her miniature portrait of Elizabeth's cousin Lady Catherine Grey (see **Fig. 14.18** on p. 476), only one and three-eighths inches in diameter, shows us Teerlinc's extraordinary skill, the level of which is matched only by the court portraits by her contemporary (and, some say, rival) Holbein.

Like Caterina van Hemessen, Teerlinc came from a family of practicing artists: her grandfather and father were portrait

▶ **14.18** Levina Teerlinc, *Lady Catherine Grey*, ca. 1555–1560. Watercolor on vellum mounted on plain card, 1 ⅜" (3.49 cm) diameter. Victoria and Albert Museum, London, United Kingdom. Teerlinc was a renowned miniaturist.

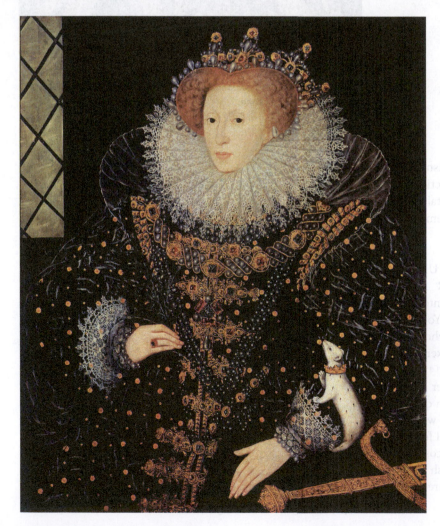

miniaturists, and her father trained her. As far as we know, she was the only female artist working in England from 1550 to 1576.

NICHOLAS HILLIARD

English artists were virtually cut off from contemporary art on the European continent. The only English-born painter of note during the 16th century was Nicholas Hilliard (1547–1619), best known for his miniature portraits, often painted in watercolor. Hilliard's *Ermine Portrait of Queen Elizabeth I* (**Fig. 14.19**), as sumptuous and meticulously detailed as it is, was intended to symbolize the queen's wealth

and power rather than to accurately record her appearance. Her diminutive, delicate hands seem to hover against a constellation of beads that embellish an inky black gown; the stiff pleats of her starched lace collar appear to emanate, as the rays of the sun, from her luminous complexion and flame-red hair. As queen of England and Ireland in her own right, Elizabeth is the picture of transcendent authority.

Spain

The Spanish Golden Age in art and literature coincided with defining events of the late 15th and early 16th centuries: the unification of Spain with the marriage of Ferdinand and Isabella in 1469; the *Reconquista*—the reconquest of Spanish lands ruled by Muslims following the fall of Granada in January of 1492; the expulsion of Jews from Spain in March of 1492; and the rise of the Habsburgs (brought into the Spanish monarchy by marriage) under Charles V and his son, Philip II.

SPANISH ARCHITECTURE IN THE SIXTEENTH CENTURY Fulfilling the wishes of his father, Philip II constructed a vast, Italian Renaissance-style complex in Madrid that contained—within a fortified, regimented grid-plan—a palace, church, monastery, and mausoleum. Called El Escorial (**Fig. 14.20**), it stands as testimony to the era of Spanish supremacy—and Philip's fervent Catholicism. The austere design of the Escorial buildings stands in marked contrast to Moorish style that had a continued presence in Spain in spite of the Reconquista.

La Casa de Pilatos (Pilate's House, **Fig. 14.21**), an Andalusian palace constructed between the 15th and 16th centuries, blends elements of Italian Renaissance architecture and *mudejar* style—a hybrid form of architecture and interior decoration that emerged from Muslim and Christian cultures living side by side in Spain and Portugal. The intricately embellished

◀ **14.19** Nicholas Hilliard, *Ermine Portrait of Queen Elizabeth I*, 1585. Oil on canvas, 41 ¾" × 35" (106 × 89 cm). Hatfield House, London, United Kingdom. The ermine on the queen's sleeve is a symbol of virginity. The portrait as a whole is a symbol of her majesty, not intended to show her actual appearance.

CONNECTIONS The Great Mosque of Córdoba (in Spanish, the *Mezquita*, meaning "mosque") featured a courtyard framed by colonnades and planted with orange trees, a minaret, and a hypostyle prayer hall, which could be expanded in any direction as the congregation grew. Here, we see part of the prayer hall with its red and white arches. After Christians drove the Muslims out of Spain in 1492, many mosques and other Muslim buildings were destroyed, but because the Mezquita was held in high esteem, rather than raze it, King Charles V granted permission for a cathedral to be constructed inside it in the early 16th century. We still see the literal intersection of Islam and Christianity in parts of the Mezquita-Catedral.

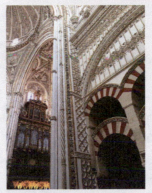

▲ **Intersection of the Cathedral and the Mosque of Córdoba (Fig. 8.12)**

tiled walls of the Casa de Pilatos reveal an aesthetic that is very different from the pristine surfaces of the Escorial.

Mudejar is the word given to Muslims who remained in Iberia (Spain and Portugal) after the Reconquista but who did not convert to Christianity. Muslims and Jews who remained in Iberia and were forced to convert to Christianity are called, respectively, *morisco* and *marrano*). Some—perhaps many—continued to practice their faiths in secret.

EL GRECO The Late Renaissance brought many different styles. Spanish painting polarized into two stylistic groups of religious painting: the mystical and the realistic. One painter was able to pull these opposing trends together in a unique pictorial method. El Greco (1541–1614), born Domenikos Theotokopoulos in Crete, integrated many styles into his work. As a young man, he traveled to Italy, where he encountered the works of the Florentine and Roman masters, and he was for a time affiliated with Titian's workshop. The colors that El Greco incorporated into his paintings suggest a Venetian influence, and the distortion of his figures and use of an ambiguous space speak to his interest in Mannerism.

These pictorial elements can clearly be seen in one of El Greco's most famous works, *The Burial of the Count of Orgaz* (see **Fig. 14.22** on p. 478). In this single work, El Greco combines mysticism and realism. The canvas is divided into two halves by a horizontal line of white-collared heads, separating "heaven" and "earth." The figures in the lower half of the composition are somewhat elongated, but well within the bounds of realism. The heavenly figures, by contrast, are extremely attenuated and seem to move under the influence of a sweeping, dynamic atmosphere. It has been suggested that the distorted figures in El Greco's paintings might have been the result of astigmatism in the artist's eyes, but there is no convincing proof of this. For example, at times El Greco's figures appear no more distorted than those of other Mannerists. Heaven and earth are disconnected psychologically but joined convincingly in terms of composition. At the center of the rigid, horizontal row of heads that separates the two worlds, a man's upward glance creates

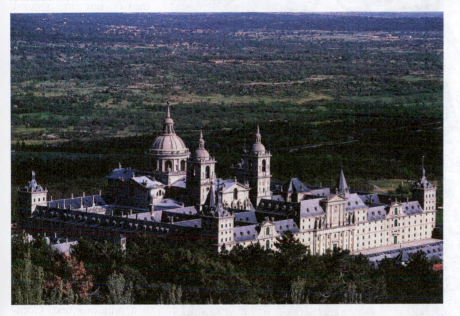

▲ **14.20** Juan de Herrera and Juan Bautista de Toledo, aerial view of El Escorial, near Madrid, Spain, 1563–1584.

▼ **14.21** Casa De Pilatos, staircase, Seville, Andalusia, Spain.

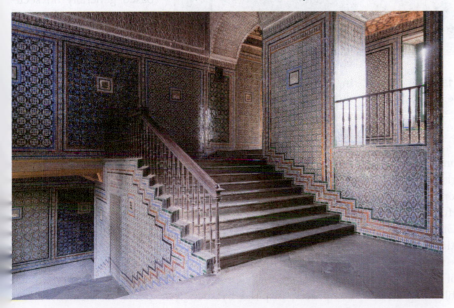

▲ **14.22** El Greco, *The Burial of the Count of Orgaz*, 1586. Oil on canvas. 15' 9" × 11' 10" (480 × 360 cm). Santo Tomé, Toledo, Spain. A horizontal line formed by the progression of white-collared heads separates "heaven" and "earth."

otherworldly nature of the upper canvas. The emotion is high pitched and exaggerated by the tumultuous atmosphere. This emphasis on emotionalism links El Greco to the onset of the Baroque era. His work contains a dramatic, theatrical flair, one of the hallmarks of the 17th century.

MUSIC

As in the visual arts, the Renaissance produced major stylistic changes in the development of music, but in general, musical development in the Renaissance was marked by a less severe break with medieval custom than was the case with the visual arts. Although 16th-century European composers began to increase the complexity of their style, frequently using polyphony, they continued to use forms developed in the High Middle Ages and the Early Renaissance. In religious music, the motet remained popular, set to a religious text. Composers also continued to write *madrigals* (songs for three or more solo voices based generally on secular poems). For the most part, these were intended for performance at home, and elaborate, interweaving polyphonic lines often tested the skill of the singers. The difficulty of the parts often made it necessary for the singers to be accompanied instrumentally. This increasing complexity produced a significant change in the character of madrigals, which were especially popular in Elizabethan England. Nonetheless, 16th-century musicians were recognizably the heirs of their 13th- and 14th-century predecessors.

Music in France and Germany

The madrigal form was originally devised in Italy for the entertainment of courtly circles. By the early 16th century, French composers, inspired by such lyric poets as Clément Marot

a path for the viewer into the upper realm. This compositional device is complemented by a sweeping drape that rises into the upper half of the canvas from above his head, continuing to lead the eye between the two groups of figures, left and right, up toward the image of the resurrected Christ. El Greco's color scheme also complements the worldly and celestial habitats. The colors used in the costumes of the earthly figures are realistic and vibrantly Venetian, but the colors of the upper half of the composition are of discordant hues, highlighting the

(1496–1544), were writing more popular songs known as **chansons**. The best-known composer of chansons was Clément Janequin (ca. 1485–ca. 1560), who was famous for building his works around a narrative program. In "La Guerre" ("The War"), the music imitates the sound of shouting soldiers, fanfares, and rattling guns; other songs feature street cries and birdsong. Frequently repeated notes and the use of nonsense syllables help give Janequin's music great rhythmic vitality, although it lacks the harmonic richness of Italian madrigals.

The tendency to appeal to a general public also characterized German and Flemish songs of the period, with texts that were romantic, military, or sometimes even political in character. Among the great masters of the period was the Flemish composer Heinrich Isaac (ca. 1450–1517), who composed songs in Italian and French as well as in German. His style ranges from simple chord-like settings to elaborately interweaving lines that imitate one another. Isaac's pupil, the Swiss Ludwig Senfl (ca. 1486–ca. 1542), was, if anything, more prolific than his teacher; his music is generally less complex, and graceful—almost wistful—in mood.

Elizabethan Music

English music suffered far less than the visual arts from the cultural isolationism of Elizabethan England; the Elizabethan Age, in fact, marks one of the high points in its history. Almost 200 years earlier, the English musician John Dunstable (ca. 1385–1453) had been one of the leading composers in Europe. By bringing English music into the mainstream of continental developments, Dunstable helped prepare the way for his Elizabethan successors. Several other factors were also responsible for the flourishing state of English music.

To begin with, in England there had always been a greater interest in music than in the visual arts. Also, the self-imposed ban on the importation of foreign artworks and styles did not extend to printed music, with the result that by the early years of the reign of Elizabeth, Italian secular music began to circulate in English musical circles. A volume of Italian songs in translation was published in 1588 under the title *Musica transalpina* (*Music from Across the Alps*).

As for sacred music, when Henry VIII broke away from the pope, he was not at all ready to convert wholeheartedly to Lutheranism or Calvinism and to discard those parts of the liturgy that were sung. The services, psalms, and hymns that the new Anglican Church had to devise generally (although by no means invariably) used English rather than Latin texts, echoing Luther's use of the vernacular, but continued for the most part to follow Catholic models. Thus, when the first official version of the English litany was issued in 1544 by Thomas Cranmer, archbishop of Canterbury, it used the traditional Gregorian chant, simplified so that only one note was allocated to each syllable of the text. This innovation preserved the flavor of the original music while making it easier for a listener to follow the meanings of the words and thereby participate more directly in the worship. In more elaborate music, the effects of the Reformation were even less evident. Most of the professional composers of the day had, after all, been brought up in a Catholic musical tradition, and while the split with Rome affected religious dogma (and permitted Henry to marry and divorce at will), it did not alter composers' freedom to create religious music as they wished. They continued to write pieces that alternated and combined the two chief styles of the day: blocks of chords in which every voice moved at the same time and the elaborate interweaving of voices known as **counterpoint**.

The musical forms also remained unchanged except in name. Among the most popular compositions throughout Europe were motets, the words of which were often in Latin. English composers continued to write works of this kind but used English texts and called them **anthems**. A piece that used the full choir throughout was called a *full anthem,* and one containing passages for solo voice or voices was called a *verse anthem.* English musicians nevertheless did not entirely abandon the use of Latin. Some of the greatest figures of the period continued to write settings of Latin texts as well as ones in the vernacular.

THOMAS TALLIS The dual nature of Elizabethan music is well illustrated by the career of Thomas Tallis (ca. 1510–1585), who spent more than 40 years of his life as organist of the Chapel Royal at the English court. Although his official duties required him to compose works for formal Protestant occasions, he also wrote Latin motets and Catholic masses. Tallis was above all a master of counterpoint, bringing the technique of combining and interweaving several vocal lines to a new height of complexity in his motet *Spem in alium* (*Hope in Another*), written for no fewer than 40 voices each moving independently. In his anthems, however, he adopted a simpler style with a greater use of chord passages, so that the listener could follow at least part of the English text. His last works combine both techniques to achieve a highly expressive, even emotional effect, as in his setting of the Lamentations of Jeremiah.

WILLIAM BYRD Among Tallis's many pupils was William Byrd (ca. 1539/1540–1623), the most versatile of Elizabethan composers and one of the greatest in the history of English music. Like Tallis, he produced both Protestant and Catholic church music, writing three Latin masses and four English services, including the so-called Great Service for five voices. Byrd also composed secular vocal and instrumental music, including a particularly beautiful elegy for voice and strings, "Ye Sacred Muses," inspired by the death of Tallis.

Much of Byrd's instrumental music was written for the **virginal**, an early keyboard instrument in the form of an oblong box small enough to be placed on a table or held in the player's lap. It was once believed that the instrument was so called because of its popularity at the court of Elizabeth, the self-styled Virgin Queen, but references have been found to the name before her time, and its true origin is unknown. Forty-two pieces written for the virginal by Byrd were copied down in 1591 in an album known as *My Ladye Nevells Booke.* They include

dances, variations, and fantasias, and form a rich compendium of Byrd's range of style.

Byrd also wrote madrigals. The English madrigal was not intended for an elite audience but for domestic performance by an increasingly prosperous middle class. Less concerned with Renaissance ideas of refinement than with the expression of emotional extremes, some English madrigals were quite serious, even mournful. "Noel, Adieu" by Thomas Weelkes (ca. 1575–1623) is striking for its use of extreme dissonance to express grief.

THOMAS MORLEY Many of the madrigals of Thomas Morley (1557–1602), on the other hand, are lighthearted in tone and fast moving, using refrains such as "Fa-la-la." Among his best known are such settings of popular verses as "Sing We and Chaunt It" and "Now Is the Month of Maying."

**GO LISTEN!
THOMAS MORLEY**
"Now Is the Month of Maying"

Morley's madrigal for five voices is typical of his lighthearted music, the aim of which is to please both listeners and performers. Written for amateur singers who chose to make music for their own pleasure, it demands little technical skill. The setting is divided into three parallel verses, and the words, punctuated by nonverbal refrains, are simple and repetitive.

One reason that Morley's music became so popular was, of course, the new technique of printing, which not only made written music available but also allowed it to circulate widely into private homes (Fig. 14.23). At the same time, the exuberance and grace of his madrigals, together with their sheer energy, won them a wide—and continuing—audience. "Now Is the Month of Maying" was first printed in 1595 and was reprinted several times during the following century.

Morley's work is the perfect illustration of one of the chief aspects of Renaissance music, especially that aimed at domestic consumption. As expressed by a contemporary writer, "as for music, the principal thing we seek in it is to delight the ear."

JOHN DOWLAND The most melancholy works of all Elizabethan music are the **ayres** (simple songs for one voice accompanied by either other voices or instruments) of John Dowland (1562–1626)—the rare example of an Elizabethan musician who traveled widely. Irish by birth, Dowland visited France, Germany, and Italy, and even worked for a while at the court of King Christian IV of Denmark and Norway; ultimately, he settled in England.

Dowland was the greatest virtuoso of his day on the lute (a plucked stringed instrument that is a relative of the guitar), and he used it to accompany his ayres. Dowland's gloomy temperament was given full expression both in the ayres and in his

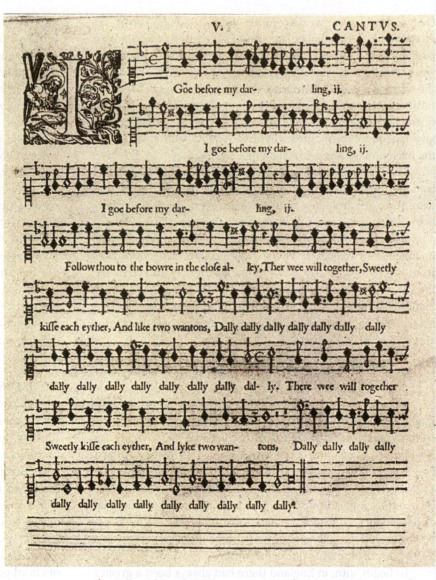

▲ **14.23** Thomas Morley, score page from *The First Booke of Canzonets* [for] *Two Voices*, 1595. Thomas Este, Publisher, London, United Kingdom. This single page could easily have been held and read by two music lovers singing in the privacy of their own home.

solo pieces for lute, most of which are as obsessively depressed and woeful as Morley's madrigals are determinedly cheerful. Popular in his own day, Dowland's music has undergone in more recent times something of a revival, with the growth of interest in the guitar and other similar instruments.

LITERATURE

Renaissance literature in the North took religious and secular turns. There were the writers of the Reformation, such as Martin Luther and John Calvin. There were also essayists, poets, and dramatists who dealt with nonreligious matters, such as the Frenchman Montaigne, with his critique of barbarous behavior in Europe; More, with his *Utopia*; Spenser, in poetry; and Christopher Marlowe and William Shakespeare in drama.

MICHEL EYQUEM DE MONTAIGNE Michel Eyquem de Montaigne (1533–1592) came from a wealthy Bordeaux family. His father, who had been in Italy and was heavily influenced by Renaissance ideas, provided him with a fine early education. Montaigne spoke nothing but Latin with his tutor when he was a child, so when he went to school at age six, he spoke Latin not only fluently but with a certain elegance. His later education (he studied law for a time) was a keen disappointment to him because of its pedantic narrowness. After a few years of public service, in 1571 Montaigne retired with his family to a rural estate to write and study. He remained there, with the exception of a few years traveling and some further time of public service, until his death.

The times were not happy. France was split over the religious issue, as was Montaigne's own family. He remained a Catholic, but his mother and sisters became Protestants. Only a year after his retirement came the terrible Saint Bartholomew's Day Massacre (August 24, 1572), in which thousands of French Protestants were slaughtered in a bloodbath unequaled in France since the days of the Hundred Years' War. In the face of this violence and religious bigotry, Montaigne returned to a study of the classics and wrote out his ideas for consolation.

Montaigne's method was to write on a widely variegated list of topics gleaned either from his readings or from his own experiences. He called these short meditations *essays*. Our modern form of the essay is rooted in Montaigne's first use of the genre in Europe. The large numbers of short essays Montaigne wrote share certain qualities characteristic of a mind wearied by the violence and religious bigotry of the time: a sense of stoic calmness (derived from his study of Cicero and Seneca), a tendency to moralize (in the best sense of that abused word) from his experiences, a generous nondogmatism, and a vague sense of world-weariness.

During the period when Montaigne's essay "On Cannibals" was written, reports of native peoples were pouring into Europe from explorers who wrote of their adventures in the New World. As Montaigne contrasts so-called primitive people to the so-called civilized people of his own time and place, he reflects his horror at the lack of civility in a European culture warring incessantly over religion. Montaigne's somewhat romantic view of cannibals reminds us of the tendency of European culture—especially in the century to follow—to praise the "noble savage" as a vehicle for social and political criticism.

The following reading explores the meaning of the word *barbarous*, as applied to the various "nations" discovered by explorers:

READING 14.6 MICHEL DE MONTAIGNE

From "On Cannibals," the meaning of *barbarous*

These nations, then, seem to me barbarous in this sense, that they have been fashioned very little by the human mind, and are still very close to their original naturalness. The laws of nature still rule them, very little corrupted by ours; and they

are in such a state of purity that I am sometimes vexed that they were unknown earlier, in the days when there were men able to judge them better than we. I am sorry that Lycurgus and Plato did not know of them; for it seems to me that what we actually see in these nations surpasses not only all the pictures in which poets have idealized the golden age and all their inventions in imagining a happy state of man, but also the conceptions and the very desire of philosophy.... This is a nation, I should say to Plato, in which there is no sort of traffic, no knowledge of letters, no science of numbers, no name for a magistrate or for political superiority, no custom of servitude, no riches or poverty, no contracts, no successions, no partitions, no occupations but leisure ones, no care for any but common kinship, no clothes, no agriculture, no metal, no use of wine or wheat. The very words that signify lying, treachery, dissimulation, avarice, envy, belittling, pardon—unheard of. How far from this perfection would he find the republic that he imagined: "Men fresh sprung from the gods" (Seneca).

The following passage discusses warfare among "nations" that practice cannibalism. Montaigne does not view the practice in a positive light, but he notes that these people are somewhat innocent in their outlook, whereas supposedly civilized Europeans have been just as barbaric:

READING 14.7 MICHEL DE MONTAIGNE

From "On Cannibals," on warfare, cannibalism, and other barbaric acts

They have their wars with the nations beyond the mountains, further inland, to which they go quite naked, with no other arms than bows or wooden swords ending in a sharp point, in the manner of the tongues of our boar spears. It is astonishing what firmness they show in their combats, which never end but in slaughter and bloodshed; for as to routs and terror, they know nothing of either.

Each man brings back as his trophy the head of the enemy he has killed, and sets it up at the entrance to his dwelling. After they have treated their prisoners well for a long time with all the hospitality they can think of, each man who has a prisoner calls a great assembly of his acquaintances. He ties a rope to one of the prisoner's arms, by the end of which he holds him, a few steps away, for fear of being hurt, and gives his dearest friend the other arm to hold in the same way; and these two, in the presence of the whole assembly, kill him with their swords. This done, they roast him and eat him in common and send some pieces to their absent friends.

. . .

I am not sorry that we notice the barbarous horror of such acts, but I am heartily sorry that, judging their faults rightly, we should be so blind to our own. I think there is more barbarity in eating a man alive than in eating him dead; and in tearing

by tortures and the rack a body still full of feeling, in roasting a man bit by bit, in having him bitten and mangled by dogs and swine (as we have not only read but seen within fresh memory, not among ancient enemies, but among neighbors and fellow citizens, and what is worse, on the pretext of piety and religion), than in roasting and eating him after he is dead.

English Literature

English literature in the 16th century, unlike the visual arts and to a greater extent even than music, was strongly affected by new currents of Renaissance thought. One reason for this was purely practical. Soon after the invention of printing in Germany, William Caxton (ca. 1421–1491) introduced the printing press into England, and during the first half of the 16th century, books became increasingly plentiful and cheap. With the spread of literature, an increased literacy developed, and the new readers were anxious to keep in touch with the latest ideas of the day. The development of humanism in England undoubtedly influenced Erasmus of Rotterdam, who was brought into contact with humanist ideas during his visits there. In addition to teaching at Cambridge, Erasmus formed a warm personal friendship with the English statesman Sir Thomas More, who became lord chancellor in 1529.

SIR THOMAS MORE More (1478–1535) was an English philosopher, lawyer, author, and statesman. He was a councilor to King Henry VIII and served for three years as lord chancellor. He was an opponent of Martin Luther and did not accept the Reformation in England, which he saw as the king's excuse for divorcing his wives and taking new ones. More accepted Henry VIII as king of England but not as supreme head of the Church of England (the Protestant Anglican Church), a title given the king by Parliament in 1534. More was imprisoned in 1534 because of his refusal to take an oath that disparaged papal power and made the unborn daughter of the king and Anne Boleyn the successor to the throne. That successor, of course, would become Queen Elizabeth I. More was beheaded in 1535 for treason. (There were two more succession acts, one which removed Elizabeth from succession, and the other which placed both Princess Mary—daughter of Catherine of Aragon—and Princess Elizabeth in line for the throne.)

More's execution stunned European statesmen and intellectuals. Erasmus wrote that More's soul was purer than snow and that he possessed a genius heretofore unseen in England and unlikely to be seen again. In the 18th century, Jonathan Swift would write that More was "the person of the greatest virtue this kingdom ever produced." It is not surprising that More became a saint of the Catholic Church, but the Church of England now considers More to have been a Reformation martyr. More also became the tragic hero of Robert Bolt's 1960 play *A Man for All Seasons*, which was made into a film of the same name in 1966.

More's *Utopia*—a term he coined—is a philosophical romance, written in Latin in 1516, about an ideal island nation resembling Plato's *Republic*. *Utopia*, in Greek, means "not a (real) place." It was written under Erasmus's influence and was firmly based on humanistic ideals. Once introduced, these ideas caught on, and so did the use of Classical or Italian models to express them. Sir Philip Sidney (1554–1586), the dashing youth who has been described as Castiglione's courtier come to life, wrote a series of sonnets in imitation of Petrarch, and a romance, *Arcadia*, of the kind made popular in Italy by Ludovico Ariosto (1474–1533).

THOMAS WYATT Thomas Wyatt (1503–1542) was the poet who is credited with bringing the **sonnet** into the English language. His father was a close adviser to King Henry VII and remained in the position when Henry VIII ascended to the throne in 1509. Wyatt attended Cambridge and can be said to then have inherited his father's position, serving Henry VIII as an adviser and an ambassador. One of the perquisites of being in the court at the time was meeting Anne Boleyn. Wyatt was tall and powerfully built, unhappily married, and Boleyn was a red-haired beauty. There is speculation that the two had an affair, and Wyatt was sent to the Tower of London in 1536 on charges of adultery. During his imprisonment in the tower, it is further speculated that he might have witnessed Boleyn's execution from his window, along with those of several other men with whom she was accused of having affairs. These charges were likely trumped up, and the executions were more likely to have been political than personal. In any event, Wyatt managed to be freed due to his father's connections. Wyatt's sister was mother to a man named Henry Lee, from whom descended the Lees of Virginia, including Robert E. Lee.

Following is a sonnet that critics believe was written about Boleyn. "Whoso list to hunt" means "whoever leans toward hunting," as a boat lists to port or starboard when the cargo shifts. A hind is a female red deer. The sense of the poem is that the poet cannot erase the deer from his mind. The English sonnet has three **quatrains** (four lines of verse) and a concluding **couplet**. The couplet here begins with the Latin "Noli me tangere," which translates as "Do not touch me" and represents the words spoken by Jesus to Mary Magdalene (John 20:17) when she recognizes Him following His resurrection. Jesus may have been saying that He now dwelled somewhere in between the human and the divine; the poem may be suggesting that Anne, for Wyatt, also dwelled somewhere beyond natural reality—that perhaps he was spending "his time in vain" if he sought to touch her. The reference to Caesar may be to the king:

READING 14.8 THOMAS WYATT

"Whoso list to hunt?"

Whoso list to hunt? I know where is an hind!
But as for me, alas! I may no more:
The vain travail hath wearied me so sore;

I am of them that furthest come behind;
Yet may I by no means my wearied mind
Draw from the deer; but as she fleeth afore,
Fainting I follow; I leave off therefore,
Since in a net I seek to hold the wind.
Who list her hunt, I put him out of doubt,
As well as I, may spend his time in vain;
And graven with diamonds in letters plain
There is written her fair neck round about:
"Noli me tangere; for Caesar's I am,
And wild for to hold, though I seem tame."

EDMUND SPENSER Edmund Spenser (1552–1599), considered the greatest nondramatic poet of Elizabethan England, was also influenced by Ariosto and by Torquato Tasso (1544–1595), Ariosto's Italian successor in the production of massive epic poems. In *The Faerie Queene*, Spenser combined the romance of Ariosto and the Christian allegory of Tasso to create an immensely complex epic. Its chivalrous hero, the Knight of the Red Cross, represents both Christianity and, through his resemblance to Saint George, England. At the same time, the tests he undergoes make him a Renaissance version of the medieval figure of Everyman. The epic takes place in the imaginary land of Faerie, where the knight's path is frequently blocked by dragons, witches, wizards, and other magical creatures. All of this fantastical paraphernalia not only advances the plot but also provides a series of allegorical observations on moral and political questions of the day.

Spenser also wrote other poems, including sonnets, such as the love poem that is sonnet 79 in his *Amoretti*:

READING 14.9 EDMUND SPENSER

Amoretti, Sonnet 79

Men call you fair, and you do credit it,
For that yourself ye daily such do see:
But the true fair, that is the gentle wit,
And virtuous mind, is much more praised of me:
For all the rest, however fair it be,
Shall turn to nought and lose that glorious hue;
But only that is permanent and free
From frail corruption that doth flesh ensue.
That is true beauty; that doth argue you
To be divine, and born of heavenly seed;
Derived from that fair Spirit, from whom all true
And perfect beauty did at first proceed:
 He only fair, and what he fair hath made;
 All other fair, like flowers, untimely fade.

QUEEN ELIZABETH I Queen Elizabeth I could read Greek and Latin and spoke French, Italian, and Spanish as well as her native English. In addition to her talents of state, she was also an accomplished poet. "On Monsieur's Departure" apparently memorializes her reaction to a heart-wrenching leave-taking. The "monsieur" of the poem may be the French Duke of Alençon and Anjou, with whom Elizabeth had contemplated marriage. It may also be the Earl of Essex, a loyal companion of the queen with whom she may have had a romantic—or nearly romantic—relationship. Elizabeth chose not to reveal his identity. The poem is written in **iambic pentameter**:

READING 14.10 QUEEN ELIZABETH I

"On Monsieur's Departure," ca. 1582

I grieve and dare not show my discontent;
I love, and yet am forced to seem to hate;
I do, yet dare not say I ever meant;
I seem stark mute, but inwardly do prate.
I am, and not, —I freeze and yet am burned;
Since from myself another self I turned.
My care is like my shadow in the sun,
Follows me flying; flies when I pursue it;
Stands, and lies by me; does what I have done;
This too familiar care doth make me rue it.
No means I find to rid him from my breast,
Till by the end of things it be supprest.
Some gentler passion steals into my mind,
(For I am soft and made of melting snow);
Or be more cruel, love, or be more kind;
Let me, or float or sink, be high or low.
Or let me live with some more sweet content,
Or die, and so forget what love e'er meant.

Drama in Elizabethan England

The greatest English cultural achievements in the Renaissance were in drama. The Classical models of English drama were the Latin tragedies of Seneca and the comedies of Plautus and Terence, which, with the introduction of printing, became more frequently read and performed. These ancient Roman plays created a taste for the theater that English dramatists began to satisfy in increasing quantities. At the same time, the increasing prosperity and leisure that created a demand for new madrigals produced a growing audience for drama. To satisfy this audience, traveling groups of actors began to form, often attaching themselves to the household of a noble who acted as their patron. These companies gave performances in public places, especially the courtyards of inns. When the first permanent theater buildings were constructed, their architects imitated the form of the inn courtyards, with roofs open to the sky and galleries around the sides. The stage generally consisted of a large platform jutting out into the center of the open area known as the **pit** or **ground** (Fig. 14.24).

The design of these theaters allowed—indeed encouraged—people of all classes to attend performances regularly, because

▲ **14.24 Replica of Globe Theater, London, United Kingdom.** The theater has 900 seats arranged in tiers and space for 700 groundlings. It is built from what is known of the original Globe Theater, in which Shakespeare's plays were performed.

the price of admission varied for different parts of the theater. The more prosperous spectators sat in the galleries, where they had a clear view of the stage, while the poorer spectators stood on the ground around the stage. Dramatists and actors soon learned to please these so-called **groundlings** by appealing to their taste for noise and spectacle.

Not all performances were given in public before so democratic an audience. The most successful companies were invited to entertain Queen Elizabeth and her court. The plays written for these state occasions were generally more sophisticated in both content and style than those written for the general public. The works written for the court of James I, Elizabeth's successor, are among the most elaborate of all. In general, English drama developed from a relatively popular entertainment in the mid-16th century to a more formal, artificial one in the early 17th century. It is probably no coincidence that the greatest of all Elizabethan dramatists, Shakespeare and Marlowe, wrote their best works at about the midpoint in this development, from about 1590 to 1610. Their plays reflect the increasing appreciation and demand for real poetry and high intellectual content without losing the "common touch" that has given their work its continual appeal.

CHRISTOPHER MARLOWE Born two months before Shakespeare, Christopher Marlowe (1564–1593)—had he not been killed in a fight over a tavern bill at age 29—might well have equaled Shakespeare's mighty achievements. It is certainly true that by the same age, Shakespeare had written relatively little of importance, whereas Marlowe's works included the monumental two-part *Tamburlaine the Great*, a vast tragic drama that explores the limits of human power. It contains some wonderful **blank verse**, nonrhyming lines of iambic pentameter; each of the five feet in a line has two syllables, with the second syllable in each foot generally bearing the accent. Marlowe's use of blank verse for dramatic expression was imitated by virtually every other Elizabethan playwright, including Shakespeare. Marlowe's masterpiece *The Tragicall History of the Life and Death of Doctor Faustus* may reflect the passion and violence of his own life, with heroes striving to achieve the unachievable by overcoming all limits, only to be defeated by destiny.

We know from the title of *Doctor Faustus* that it will not end well. Faustus, a German professor at Wittenberg University, seeks ultimate wisdom and power, and makes a pact with the devil to achieve them. In return for these ends, Faustus will give the devil his body and soul. There are stock

allegorical characters, including the seven deadly sins and Faustus's good and bad angels. In the play, Faustus travels to the Vatican, to the emperor's palace, and through the heavens, and he meets with the beauteous Helen of Troy (who is called Helen of Greece in the play) in a dumb show; that is, she does not speak. When Faustus meets Helen, we hear some of the most beautiful—and familiar—lines that have ever graced the English language:

READING 14.11 CHRISTOPHER MARLOWE

The Tragicall History of the Life and Death of Doctor Faustus, scene 14, lines 88–94

Was this the face that launched a thousand ships
And burnt the topless towers of Ilium[5]?
Sweet Helen, make me immortal with a kiss. [*Kisses her.*]
Her lips suck forth my soul; see where it flies!—
Come, Helen, come, give me my soul again.
Here will I dwell, for Heaven is in these lips,
And all is dross[6] that is not Helena.

Toward the end, Faustus tries to make his peace with God, but there is no turning back. The devil's collection of that which is due is gruesome.

Marlowe was also a fine lyric poet, as we see in some verses from the beloved "The Passionate Shepherd to His Love," which is written in rhyming lines of **iambic tetrameter**:

READING 14.12 CHRISTOPHER MARLOWE

"The Passionate Shepherd to His Love," lines 1–4, 9–12, and 17–20

Come live with me and be my love,
And we will all the pleasures prove
That valleys, groves, hills, and fields,
Woods or steepy mountain yields.

...

And I will make thee beds of roses
And a thousand fragrant posies,
A cap of flowers, and a kirtle
Embroidered all with leaves of myrtle;

...

A belt of straw and ivy buds,
With coral clasps and amber studs:
And if these pleasures may thee move,
Come live with me, and be my love.

WILLIAM SHAKESPEARE Regret at the loss of what Marlowe might have written had he lived is balanced by gratitude for the many works William Shakespeare (1564–1616) bequeathed us. Shakespeare is universally acknowledged as the greatest writer in the English language and one of the greatest in any tongue. His stature is well summarized in the words of his leading contemporary and rival, playwright Ben Jonson (1572–1637): "He was not of an age, but for all time!" A century and a half after the passing of Shakespeare, Doctor Samuel Johnson, a literary critic and an inventor of the dictionary, would further recognize the playwright's humanism and write:[7]

> Shakespeare is above all writers, at least above all modern writers, the poet of nature; the poet that holds up to his readers a faithful mirrour of manners and of life. His characters are not modified by the customs of particular places, unpractised by the rest of the world; by the peculiarities of studies or professions, which can operate but upon small numbers; or by the accidents of transient fashions or temporary opinions: they are the genuine progeny of common humanity, such as the world will always supply, and observation will always find. His persons act and speak by the influence of those general passions and principles by which all minds are agitated, and the whole system of life is continued in motion. In the writings of other poets a character is too often an individual; in those of *Shakespeare* it is commonly a species.[8]

There are gaps in our knowledge of Shakespeare's life. He was born at Stratford-upon-Avon, the son of a successful businessman who also dabbled in local politics; his mother was the daughter of a wealthy man. Stratford was enjoying the economic boom of the Elizabethan Age, and the town hired fine teachers for the grammar school, where Shakespeare presumably began the "armchair travels" that would acquaint him with much of the known Western world, past and present. He left the grammar school in 1578 and married Anne Hathaway in 1582. Over the following three years, the couple had three children. By 1592, Shakespeare had achieved astounding success in London, both as an actor and a budding playwright. Exactly how he became involved in the theater and what he did from 1585 to 1592 remain unclear. From the beginning of his time in London, Shakespeare was associated with the leading theatrical company of the day—the Lord Chamberlain's Men—which changed its name to the King's Men at the accession of James I in 1603. Public records show that Shakespeare would purchase the largest house in Stratford.

Shakespeare's earliest plays follow the example of Classical models in being carefully constructed, although their plots sometimes seem unnecessarily complicated. In *The Comedy of Errors* (1592–1593), for example, Shakespeare combines two plays by the Roman comic writer Plautus (ca. 254–184 BCE) to create a series of situations replete with mistaken identities and general confusion. Some would argue that the careful

5. That is, Troy—as in *The Iliad*.
6. Waste, worthless matter.

7. Samuel Johnson, "Preface to the Plays of William Shakespeare, 1765," in *Works*, ed. Donald Greene, Oxford Authors (Oxford: Oxford University Press, 1984).
8. Representative of all humankind.

CONNECTIONS Who was Shakespeare's "Dark Lady," the enigmatic personality around which a cluster of his sonnets revolved, the object of his obsessive (and often lustful) thoughts? Some scholars, including A. L. Rowse, have argued that she was Amelia Lanier (1570?–1640?), a poet who moved in the court circles of England's monarchs, Elizabeth I, James I, and Charles I, and who was Shakespeare's mistress. According to Sandra M. Gilbert and Susan Gubar, she was known in her own day as a woman "of distinguished learning," although her "origins are obscure" and her "history is shadowy." We do know that she was married to Alphonso Lanier, a royal musician, by whom she had a son who became a court flutist.

The suggestion of Lanier's mysterious "Dark Lady" identity sometimes overshadows her own career as a poet (she was the first Englishwoman to publish a book of poetry and was the author of some radically feminist verse). Her *Salve Deus Rex Judaeorum* (Latin for "Hail King of the Jews") contains "Eve's Apology in Defense of Women," a feminist retelling of the Fall in the Garden of Eden in which Eve is exonerated of perpetrating the sin that would lead to Jesus's execution—the "sacrifice" necessary for the redemption of humanity.

In these excerpts, Lanier submits that Eve's "betrayal" was not instigated by evil intentions but rather was the outcome of unconscious innocence:

> But surely *Adam* can not be excus'd,
> Her fault, though great, yet he was most to blame;
> What Weakness offered, Strength might have refus'd,
> Being Lord of all, the greater was his shame:
> Although the Serpent's craft had her abus'd,
> God's holy word ought all his actions frame:
> For he was Lord and King of all the earth,
> Before poor *Eve* had either life or breath.

> Who being framed by God's eternal hand,
> The perfectest man that ever breathed on earth;
> And from God's mouth received that straight command,
> The breach whereof he knew was present death:
> Yet having power to rule both Sea and Land,
> Yet with one Apple won to loose that breath,
> Which God hath breathed in his beauteous face,
> Bringing us all in danger and disgrace.

> And then to lay the fault on Patience's back,
> That we (poor women) must endure it all;
> We know right well he did discretion lack,
> Being not persuaded thereunto at all;
> If *Eve* did err, it was for knowledge's sake,
> The fruit being fair persuaded him to fall:
> No subtle Serpent's falsehood did betray him,
> If he would eat it, who had power to stay him?

> Not *Eve*, whose fault was only too much love,
> Which made her give this present to her Dear,
> That what she tasted, he likewise might prove,
> Whereby his knowledge might become more clear;
> He never sought her weakness to reprove,
> With those sharp words, which he of God did hear:
> Yet Men will boast of Knowledge, which he took
> From *Eve's* fair hand, as from a learned Book....

> Then let us have our Liberty again,
> And challenge to yourselves no Sovereignty;
> You came not in the world without our pain,
> Make that a bar against your cruelty;
> Your fault being greater, why should you disdain
> Our being your equals, free from tyranny?
> If one weak woman simply did offend,
> This sin of yours, hath no excuse, nor end,...

manipulation of plot in the early plays is achieved at the expense of characterization and that the poetry tends to use artificial literary devices. Even Shakespeare's first great tragedy, *Romeo and Juliet* (1595), is not altogether free from an excessive use of puns and plays on words, although the psychological depiction of the young lovers is convincing and the play contains magnificent passages—including the balcony scene, in which Juliet alludes to the feud between the Montague and Capulet families:

READING 14.13 WILLIAM SHAKESPEARE

Romeo and Juliet, act 2, scene 2, lines 2–6 and 33–44

ROMEO: But, soft! what light through yonder window breaks?
 It is the east, and Juliet is the sun.
 Arise, fair sun, and kill the envious moon,

 Who is already sick and pale with grief,
 That thou her maid art far more fair than she.

 …

JULIET: O Romeo, Romeo! wherefore art thou Romeo?
 Deny thy father and refuse thy name;
 Or, if thou wilt not, be but sworn my love,
 And I'll no longer be a Capulet.
ROMEO: [*Aside*] Shall I hear more, or shall I speak at this?
JULIET: 'Tis but thy name that is my enemy;
 Thou art thyself, though not a Montague.
 What's Montague? it is nor hand, nor foot,
 Nor arm, nor face, nor any other part
 Belonging to a man. O, be some other name!
 What's in a name? that which we call a rose
 By any other name would smell as sweet.

The comedies of the next few years, including both *The Merchant of Venice* (ca. 1596) and *Twelfth Night* (ca. 1600), are more lyrical. *The Merchant of Venice* has been considered Shakespeare's first mature play. The characters are well drawn, and the play is a comedy in the sense that it ends with the union of the young lovers—despite obstacles. Yet the portrayal of the Jewish merchant Shylock, who plans to exact his "pound of flesh" from a youthful lover because of a bad loan, is complex; yes, his demands are troubling, but he also has bitter and real grievances against the social order in which he dwells. Actors over the centuries have feasted on the role, searching out its nuances. And the answer to the question of whether Shakespeare was anti-Semitic seems elusive, since he wrote the play at a time when Jewish characters were typically portrayed as monsters. Despite Shylock's vindictiveness, some find that he is the one character of value in a society of dubious worth.

Twelfth Night is often regarded as Shakespeare's supreme achievement in comedy. Although the plot hinges on a series of well-worn comic devices—mistaken identities, separated twins, and so on—the characters are vivid and individualized. Furthermore, the work's principal subject, romantic love, is shown from an almost infinite number of viewpoints. Yet, at the same time, Shakespeare was attracted to historical subjects—generally drawn from English history, as in *Henry IV*, Parts 1 and 2 (1597–1598), but also from Roman history, as in *Julius Caesar* (1599).

Henry IV, Part 1 has a flamboyant comic character, Sir John Falstaff (**Fig. 14.25**). One tradition has it that Queen Elizabeth herself petitioned the playwright to author another play to continue the ribald nonsense of Falstaff. The "sequel" became *The Merry Wives of Windsor*, set in a town not unlike Stratford. But we meet Falstaff for the first time in act 1, scene 2 of *Henry IV, Part 1*. Prince Hal (Henry) and Sir John enter a London apartment of the prince. Falstaff, portrayed as jolly, rotund, bearded, and often inebriated, asks the prince the time of day. The answer is one of the more jocular retorts in the history of drama and immediately establishes the character, or lack of character, of Falstaff:

▲ **14.25** Eduard Grützner, *Falstaff*, 1910. Oil on canvas, 17¾" × 15" (45 × 38 cm). **Private collection.** Sir John Falstaff, a fictional character in *Henry IV, Part 1*, imagined here by a German artist, has been one of the more popular characters in Shakespeare's plays. He is a knight of questionable moral character, given to drink, "bawds," overeating, and—as it turns out on the battlefield—betrayal. Nevertheless, Shakespeare was urged to write a play with Falstaff as the central character, and Falstaff has inspired many artistic works since, including a 19th-century opera by Giuseppe Verdi.

READING 14.14 WILLIAM SHAKESPEARE

Henry IV, Part 1, act 1, scene 2, lines 1–13

FALSTAFF: Now, Hal, what time of day is it, lad?
PRINCE: Thou art so fat-witted, with drinking of old sack[9]
 and unbuttoning thee after supper and sleeping upon
 benches after noon, that thou hast forgotten to demand
 that truly which thou wouldst truly know. What a devil
 hast thou to do with the time of the day? Unless hours
 were cups of sack and minutes capons and clocks the
 tongues of bawds and dials the signs of leaping-houses[10]

and the blessed sun himself a fair hot wench in flame-colored taffeta, I see no reason why thou shouldst be so superfluous to demand the time of the day.

9. A strong, dry wine.
10. Brothels.

Julius Caesar (1599) is notable for several reasons. It shows that Shakespeare shared the renewed interest of his contemporaries in Classical antiquity. It is, in fact, based directly on the accounts of Caesar, Brutus, and Mark Antony in the *Parallel Lives* of the Greek historian Plutarch (ca. 46–after 119 CE), which had appeared in a new translation by Sir Thomas North in 1579. In the play, Mark Antony is identified by his Latin name, Marcus Antonius. The play illustrates Shakespeare's growing interest in psychological motivation rather than simple sequencing of events. The plot, briefly, covers Caesar's assassination and some of the civil wars that follow, ending with the deaths of the plotters, Brutus and Cassius. Like many of the plays, it mixes the supernatural with the natural world (see Reading 14.15).

READING 14.15 WILLIAM SHAKESPEARE

Julius Caesar, extracts

In act 1, scene 2, line 18, a soothsayer warns Caesar of what is to come.

> Beware the ides of March.

The ides of March is March 15, the date of the assassination. Later, in the same scene, we see Cassius convincing Brutus to join in the assassination for the good of Rome, preventing Caesar from becoming dictator (lines 135–141).

> Why, man, he doth bestride the narrow world
> Like a Colossus, and we petty men
> Walk under his huge legs, and peep about
> To find ourselves dishonorable graves.
> Men at some time are masters of their fates:
> The fault, dear Brutus, is not in our stars,
> But in ourselves, that we are underlings.

In lines 192–195, Caesar sees Cassius standing by and speaks to Antony.

> Let me have men about me that are fat;
> Sleek-headed men and such as sleep o' nights:
> Yond Cassius has a lean and hungry look;
> He thinks too much: such men are dangerous.

The night before Caesar's death, there are warnings enough in the turbulence of nature. Caesar is advised to remain at home on the ides, but he insists to his wife, Calpurnia, that he will venture forth (act 2, scene 2, lines 32–37).

> Cowards die many times before their deaths;
> The valiant never taste of death but once.
> Of all the wonders that I yet have heard,
> It seems to me most strange that men should fear;
> Seeing that death, a necessary end,
> Will come when it will come.

During the assassination in act 3, scene 1, despite knife wounds from others, Caesar sees his loyal and trusted Brutus participating. Caesar says "Et tu, Brute? Then fall, Caesar!" (line 77). (*Et tu* is "and you" in Latin.) Later in the scene, when he is alone, Antony declares his outrage and utters the rallying cry that gave birth to the expression "the dogs of war": "Cry, 'Havoc!' and let slip the dogs of war" (line 273).

In the following scene, we have the well-known conflicting speeches to the Roman crowd by Brutus and Antony. Brutus shows how Caesar was ambitious. Antony ironically refers to Brutus repeatedly as "an honorable man," yet he shows the crowd the bloody garments of Caesar and reads to them from Caesar's will, which has an inheritance for every Roman to show that Caesar had his subjects' best interests at heart. Antony's speech begins (lines 74-77),

> Friends, Romans, countrymen, lend me your ears;
> I come to bury Caesar, not to praise him.
> The evil that men do lives after them;
> The good is oft interred with their bones.

In *Julius Caesar* and many other plays, Shakespeare explains his characters' feelings and motives by using the **soliloquy**—that is, by having the characters utter their thoughts aloud, facing the audience, rather than addressing them to another character in the drama. Antonius's exclamation "let slip the dogs of war" occurs during a soliloquy. The use of this device becomes increasingly common in Shakespeare's supreme achievements, the series of tragedies he wrote between 1600 and 1605: *Hamlet* (ca. 1600), *Othello* (ca. 1604), *King Lear* (ca. 1605), and *Macbeth* (ca. 1605). In dramatic truth, poetic beauty, and profundity of meaning, these four plays achieve an artistic perfection found only in the tragic dramas of Classical Greece. Through his protagonists, Shakespeare explores the great problems of human existence—the many forms of love, the possibilities and consequences of human error, the mystery of death—with a subtlety and yet a directness that remain miraculous through countless readings or performances and continue to provide inspiration to artists and writers.

In *Hamlet,* what could be more in keeping with the humanistic ideal of man as the measure of all things than the following extract from act 2?

READING 14.16 WILLIAM SHAKESPEARE

Hamlet, act 2, scene 2, lines 315–319

What a piece of work is a man! how noble in reason! how infinite in faculty! in form and moving how express and admirable! in action how like an Angel! in apprehension how like a god! the beauty of the world! the paragon of animals!

Yet Hamlet adds that in his present mood—and that is much of what the drama is about: Hamlet's moodiness, his reasons for it, and his inability to extricate himself from it—he cannot appreciate the perfection of man nor, for that matter, woman. The problem is that his mother, Gertrude, has participated in the murder of his father, the king of Denmark, so that she can marry her lover, Hamlet's uncle Claudius, who, through the marriage and the tradition of succession, has become the new king. Hamlet seems to be based on a true story—the pre-Christian story of Horwendil, who was married to Queen Gemuth and had a son with her named Hamlet. Horwendil was killed by his brother, Fengon, who then married

the queen, and Hamlet, to escape the wrath of Fengon, pretended to be insane.

At the beginning of the drama, we again find the interweaving of the supernatural and the natural, with the ghost of the murdered king claiming "murder most foul" and crying out for vengeance. "What a falling off was there," the ghost tells Hamlet of the queen's virtue. The balance of the play has to do with Hamlet's obtaining what he considers solid evidence that Gertrude and Claudius indeed bear the guilt, and whether he is really going to avenge his father's murder. One of the core concepts of Elizabethan drama is that the world has an order, and when that order is broken, it must be reestablished. Hamlet finally acts (a spoiler?[11]), and everyone winds up dead—including Hamlet (another spoiler). A prince from Norway then enters the scene to restore order.

Between the complaint of the ghost and the ghastly scene at the end, we have what many critics refer to as the greatest play ever written. There are plays within the play, which lend a greater sense of reality to the surrounding drama besetting Hamlet. Hamlet observes an actor simulating the grief felt by Hecuba when her husband, Priam, king of Troy, is killed. He is astounded by the apparently true emotions portrayed by the actor, which, one might think, is also a commentary on the power of Shakespeare's own works.

READING 14.17 WILLIAM SHAKESPEARE

Hamlet, act 2, scene 2, lines 555–581

O, what a rogue and peasant slave am I!
Is it not monstrous that this player here,
But in a fiction, in a dream of passion,
Could force his soul so to his own conceit
That from her working all his visage wann'd,
Tears in his eyes, distraction in's aspect,
A broken voice, and his whole function suiting
With forms to his conceit? and all for nothing!
For Hecuba!
What's Hecuba to him, or he to Hecuba,
That he should weep for her? What would he do,
Had he the motive and the cue for passion
That I have? He would drown the stage with tears
And cleave the general ear with horrid speech,
Make mad the guilty and appal the free,
Confound the ignorant, and amaze indeed
The very faculties of eyes and ears.
Yet I,
A dull and muddy-mettled rascal, peak,
Like John-a-dreams, unpregnant of my cause,
And can say nothing; no, not for a king,
Upon whose property and most dear life
A damn'd defeat was made. Am I a coward?

Who calls me villain? breaks my pate across?
Plucks off my beard, and blows it in my face?
Tweaks me by the nose? gives me the lie i' the throat,
As deep as to the lungs? who does me this?
Ha!

Some of this language is unclear to the modern audience. Hamlet has been witness to the invention (the "conceit") of the actor. The actor's face has paled ("his visage wann'd") as fits his role. What would this actor be capable of with Hamlet's true passion? Hamlet argues with himself as to whether his indecision reflects cowardice. He then decides to put on a play which parallels his suspicions about Gertrude and Claudius so that he can observe their reactions for signs of guilt. At the end of the scene, Hamlet voices this couplet:

"The play's the thing
Wherein I'll catch the conscience of the King."
(lines 604–605)

In act 3, scene 1, we find what is probably Shakespeare's best-known soliloquy, which represents more inner conflict over whether Hamlet should act. In this passage, we find familiar expressions such as "to be or not to be," "the slings and arrows of outrageous fortune," "to take arms against a sea of troubles," "the thousand natural shocks that flesh is heir to," "to die, to sleep; to sleep: perchance to dream," "there's the rub," death as "the undiscovered country," and on and on. The passage has been a feast for poets, novelists, dramatists, filmmakers, and professors for four centuries. Note, too, that these plays are written in five acts, and act 3 is the climax—not the end, but the high point, the place to which the earlier story has ascended and from which the final actions fall into place.

READING 14.18 WILLIAM SHAKESPEARE

Hamlet, act 3, scene 1, lines 55–87

To be, or not to be: that is the question:
Whether 'tis nobler in the mind to suffer
The slings and arrows of outrageous fortune,
Or to take arms against a sea of troubles,
And by opposing end them? To die: to sleep;
No more; and by a sleep to say we end
The heartache and the thousand natural shocks
That flesh is heir to, 'tis a consummation
Devoutly to be wish'd.[12] To die, to sleep;
To sleep: perchance to dream: ay, there's the rub;
For in that sleep of death what dreams may come
When we have shuffled off this mortal coil,[13]

11. That is, a piece of information that gives away the plot.

12. If by dying one could end heartache, one might then wish to die.
13. Cast off the concerns of life.

Must give us pause: there's the respect
That makes calamity of so long life;
For who would bear the whips and scorns of time,
The oppressor's wrong, the proud man's contumely,[14]
The pangs of despised love, the law's delay,
The insolence of office and the spurns
That patient merit of the unworthy takes,
When he himself might his quietus make
With a bare bodkin?[15] who would fardels[16] bear,
To grunt and sweat under a weary life,
But that the dread of something after death,
The undiscover'd country from whose bourn[17]
No traveller returns, puzzles the will
And makes us rather bear those ills we have
Than fly to others that we know not of?
Thus conscience does make cowards of us all;
And thus the native hue of resolution
Is sicklied o'er with the pale cast of thought,
And enterprises of great pith and moment
With this regard their currents turn awry,
And lose the name of action.

There is no end to the riches in *Hamlet*. We could also speak of the romance with Ophelia and her suicide. We could speak of Polonius's fabled advice to his son, which includes axioms such as "Give every man thine ear, but few thy voice," "Neither a borrower nor a lender be," and

This above all: to thine own self be true,
And it must follow, as the night the day,
Thou canst not then be false to any man. (lines 78–81)

As Hamlet's final line is "The rest is silence," our discussion of the play must end here.

Shakespeare's later plays explore new directions. *Antony and Cleopatra* (ca. 1603–1608) returns to Plutarch and to ancient Rome but with a new richness and magnificence of language. The conciseness of Shakespeare's great tragedies is replaced by a delight in the sound of words, and the play contains some of the most musical of all Shakespearean verse. His last works examine the borderline between tragedy and comedy with a sophistication that was perhaps intended to satisfy the new aristocratic audience of the court of King James I. *The Tempest* (1611), set on an enchanted island, blends high romance and low comedy to create a world of fantasy unlike that of any of Shakespeare's other plays.

SHAKESPEARE'S SONNETS Shakespeare's early successes on the stage were interrupted by legal restrictions banning actors due to socially unruly behavior and recurrent

plague. During these pauses, Shakespeare wrote poetry, including 154 sonnets that were published in 1609. Sonnet 18 may be the most popular and beloved of Shakespeare's sonnets, with straightforward language that gradually elevates the object of the poet's love into a perfect being—a summer that remains eternal despite the onslaughts of nature. He also asserts that the poem will endure and "give life" to his friend or lover as long as people exist and are capable of reading it:

READING 14.19 WILLIAM SHAKESPEARE

Sonnet 18

Shall I compare thee to a summer's day?
Thou art more lovely and more temperate:
Rough winds do shake the darling buds of May,
And summer's lease hath all too short a date:
Sometime too hot the eye of heaven shines,
And often is his gold complexion dimm'd;
And every fair from fair sometime declines,
By chance or nature's changing course untrimm'd;
But thy eternal summer shall not fade
Nor lose possession of that fair thou owest;
Nor shall Death brag thou wander'st in his shade,
When in eternal lines to time thou growest:
So long as men can breathe or eyes can see,
So long lives this and this gives life to thee.

In sonnet 29, the poet writes that regardless of his moments of despair, his financial reversals, and the disapproval he may find in the eyes of others, his spirits rise when he thinks about his friend or lover. To paraphrase the poet: "Despite all, the memory of your love brings me such psychological wealth that I would not wish to trade my position with those of kings":

READING 14.20 WILLIAM SHAKESPEARE

Sonnet 29

When, in disgrace with fortune and men's eyes,
I all alone beweep my outcast state
And trouble deaf heaven with my bootless cries
And look upon myself and curse my fate,
Wishing me like to one more rich in hope,
Featured like him, like him with friends possess'd,
Desiring this man's art and that man's scope,
With what I most enjoy contented least;
Yet in these thoughts myself almost despising,
Haply I think on thee, and then my state,
Like to the lark at break of day arising
From sullen earth, sings hymns at heaven's gate;
For thy sweet love remember'd such wealth brings
That then I scorn to change my state with kings.

14. Insults.
15. Dagger.
16. Burdens.
17. Boundary.

In sonnet 55, Shakespeare asserts that "this powerful rhyme," his poem, will outlive monuments made of stone and adorned with gold to grant the object of the poem a form of immortality:

READING 14.21 WILLIAM SHAKESPEARE

Sonnet 55

Not marble, nor the gilded monuments
Of princes, shall outlive this powerful rhyme;
But you shall shine more bright in these contents
Than unswept stone, besmear'd with sluttish time.
When wasteful war shall statues overturn,
And broils[18] root out the work of masonry,
Nor Mars his sword nor war's quick fire shall burn
The living record of your memory.
'Gainst death and all-oblivious enmity
Shall you pace forth; your praise shall still find room,
Even in the eyes of all posterity
That wear this world out to the ending doom.
So, till the judgment[19] that yourself arise,
You live in this, and dwell in lovers' eyes.

Sonnet 116 is, in effect, a vow of love based on the marriage of minds. In one interpretation, the sonnet recognizes that there are disagreements and conflicts enough between lovers, but the marriage of "true minds" is not broken by argument or even by the toll taken by time. In another interpretation, the sonnet is a confession of love—presumably platonic[20]—for Shakespeare's mysterious aristocratic male friend:

READING 14.22 WILLIAM SHAKESPEARE

Sonnet 116

Let me not to the marriage of true minds
Admit impediments.[21] Love is not love
Which alters when it alteration finds,
Or bends with the remover to remove:
O, no! it is an ever-fixed mark
That looks on tempests and is never shaken;
It is the star to every wandering bark,
Whose worth's unknown, although his height be taken.
Love's not Time's fool, though rosy lips and cheeks
Within his bending sickle's compass come:
Love alters not with his brief hours and weeks,
But bears it out even to the edge of doom.

18. Disturbances.
19. Judgment Day.
20. Without sexual activity.
21. During a traditional wedding ceremony, the congregations is asked, "If any of you know cause or just *impediment* as to why these persons should not be joined together, speak now or forever hold your peace."

If this be error and upon me proved,
I never writ, nor no man ever loved.

Sonnet 130 is a playful expression of the old adage that love is blind. The speaker's love is actually far from blind in this case, but it is deep and steady. Shakespeare admits that the features of his lover cannot be compared to the wonders of nature. Yet he so adores her that reality matters not:

READING 14.23 WILLIAM SHAKESPEARE

Sonnet 130

My mistress' eyes are nothing like the sun;
Coral is far more red than her lips' red;
If snow be white, why then her breasts are dun[22];
If hairs be wires, black wires grow on her head.
I have seen roses damask'd, red and white,
But no such roses see I in her cheeks;
And in some perfumes is there more delight
Than in the breath that from my mistress reeks.
I love to hear her speak, yet well I know
That music hath a far more pleasing sound;
I grant I never saw a goddess go;
My mistress, when she walks, treads on the ground;
And yet, by heaven, I think my love as rare
As any she belied with false compare.

In the year he wrote *The Tempest*, Shakespeare left London and retired to Stratford to live out the remaining years of his life in comparative prosperity. Although he continued to write, it is tempting to see in lines he gave to Prospero toward the end of *The Tempest* his own farewell to the theater and to the world he created for it:

READING 14.24 WILLIAM SHAKESPEARE

The Tempest, act 4, scene 1, lines 148-158

Our revels now are ended. These our actors,
As I foretold you, were all spirits and
Are melted into air, into thin air:
And, like the baseless fabric of this vision,
The cloud-capp'd towers, the gorgeous palaces,
The solemn temples, the great globe itself,
Yea, all which it inherit, shall dissolve
And, like this insubstantial pageant faded,
Leave not a rack behind. We are such stuff
As dreams are made on, and our little life
Is rounded with a sleep.

22. A dull brownish color.

GLOSSARY

Anabaptist (p. 457) A member of a radical 16th-century reform movement that viewed baptism solely as a witness to the believer's faith; therefore, Anabaptists denied the usefulness of baptism at birth and baptized people mature enough to understand their declaration of faith.

Anthem (p. 479) The English term for a *motet*; a choral work having a sacred or moralizing text; more generally, a song of praise.

Ayre (p. 480) A simple song for one voice accompanied by other voices or by instruments.

Blank verse (p. 484) Unrhymed **iambic pentameter**.

Chanson (p. 479) A song that is free in form and expressive in nature; a French word meaning *song*.

Communion (p. 458) A Christian **sacrament** in which consecrated bread and wine are consumed as memorials to the death of Christ or in the belief that one is consuming the body and blood of Christ.

Counterpoint (p. 479) In music, the relationship between two or more voices that are harmonically interdependent.

Couplet (p. 482) A pair of rhyming lines of poetry.

Curia (p. 461) The tribunals and assemblies through which the pope governed the church.

Engraving (p. 466) An image created by cutting into or corroding with acid the surface of a metal plate or wooden block, such that a number of prints of the image can be made by pressing paper or paper-like materials against the plate or block.

Galleon (p. 456) A ship with three or more masts used as a trader or warship from the 15th through 18th centuries.

Ground (p. 483) In drama, an open area in front of the stage.

Groundling (p. 484) The name given an audience member at a dramatic event who stands in the pit or ground rather than being seated (because admission is generally less expensive).

Iambic pentameter (p. 483) A poetic metrical scheme with five feet, each of which consists of an unaccented syllable followed by an accented syllable.

Iambic tetrameter (p. 485) A poetic metrical scheme with four feet, each of which consists of an unaccented syllable followed by an accented syllable.

Iconoclastic (p. 463) Having to do with the destruction or removal of sacred religious images.

Indulgence (p. 457) According to Roman Catholicism, removal or remission of the punishment that is due in purgatory for sins; the forgiving of sin upon repentance.

Linear perspective (p. 465) A system of organizing space in two-dimensional media in which lines that are in reality parallel and horizontal are represented as converging diagonals; the method is based on foreshortening, in which the space between the lines grows smaller until it disappears, just as objects appear to grow smaller as they become more distant.

Omnipotent (p. 458) All-powerful.

Omniscient (p. 458) All-knowing.

Philologist (p. 461) A person who studies the history of language in written sources; a scholar of the changes in language over time.

Pit (p. 483) In drama, an open area in front of the stage.

Predestination (p. 459) God's foreordaining of everything that will happen, and with Calvinism, including the predetermination of salvation.

Quatrain (p. 482) A verse of poetry with four lines.

Sacrament (p. 458) A visible sign of inward grace, especially a Christian rite believed to symbolize or confer grace.

Soliloquy (p. 488) A passage in a play spoken directly to the audience, unheard by other characters, and often used to explain the speaker's motives.

Sonnet (p. 482) A 14-line poem usually broken into an octave (a group of eight lines) and a sestet (a group of six lines); rhyme schemes can vary.

Thesis (p. 457) An academic proposition; a proposition to be debated and proved or disproved (plural *theses*).

Virginal (p. 479) An early keyboard instrument small enough to be held in the lap of the player.

THE BIG PICTURE THE HIGH RENAISSANCE IN NORTHERN EUROPE AND SPAIN

Language and Literature

- Thomas More published *Utopia* in 1516.
- Thomas Wyatt brought the sonnet into the English language ca. the 1530s.
- Montaigne published his first essays in 1580.
- Queen Elizabeth I penned "On Monsieur's Departure" ca. 1582.
- Marlowe wrote *Tamburlaine the Great* ca. 1587 and staged *Doctor Faustus* ca. 1593.
- Spenser worked on *The Faerie Queene* ca. 1590–1596.
- Shakespeare's plays were written and first performed ca. 1590–1610: *Romeo and Juliet*, ca. 1595; *Julius Caesar*, ca. 1599; *Hamlet*, ca. 1600; *Antony and Cleopatra*, ca. 1603–1608.
- The King James Version of the Bible was translated ca. 1604–1611.

Art, Architecture, and Music

- Bosch painted the *Garden of Earthly Delights* ca. 1505–1510.
- Isaac and Senfl were active ca. 1510.
- Dürer painted a self-portrait ca. 1500 and produced his *Meisterstiche* in 1513 and 1514.
- Grünewald completed the Isenheim altarpiece in 1515.
- The Château de Chambord was begun in 1519.
- Marot and Janequin composed chansons ca. 1520.
- Altdorfer painted the *Battle of Alexander at Issus* in 1529.
- Clouet painted his portrait of Francis I ca. 1523–1530.
- Hans Holbein the Younger painted his wedding portrait of King Henry VIII in 1540; he painted the portrait of Anne of Cleves at about the same time.
- The first English-language litany, based on Gregorian chant, appeared in 1544.
- The renovation of the Louvre into the structure we see today was begun in 1546.
- Bruegel painted his major works ca. 1562–1567.
- El Escorial was constructed between 1563–1584.
- Tallis composed *Lamentations of Jeremiah* ca. 1570.
- Hilliard painted his *Ermine Portrait of Queen Elizabeth I* in 1585.
- El Greco painted *The Burial of the Count of Orgaz* in 1586.
- English madrigals by Byrd, Morley, and Weelkes were sung at the end of the century.

Philosophy and Religion

- Luther presented his 95 Theses, triggering the Reformation in Germany, in 1517.
- Luther was excommunicated by Pope Leo X in 1521.
- Erasmus published *De libero arbitrio* (*On Free Will*) in 1524.
- Luther published *De servo arbitrio* (*On the Bondage of the Will*) in 1525.
- Luther published his translation of the Bible in 1534.
- Henry VIII founded the Church of England in 1534.
- Calvin published *Institutes of the Christian Religion* in 1536.
- The Council of Trent initiated the Counter-Reformation under Jesuit guidance 1545–1564.
- Queen Elizabeth I was excommunicated from the Catholic Church in 1570.

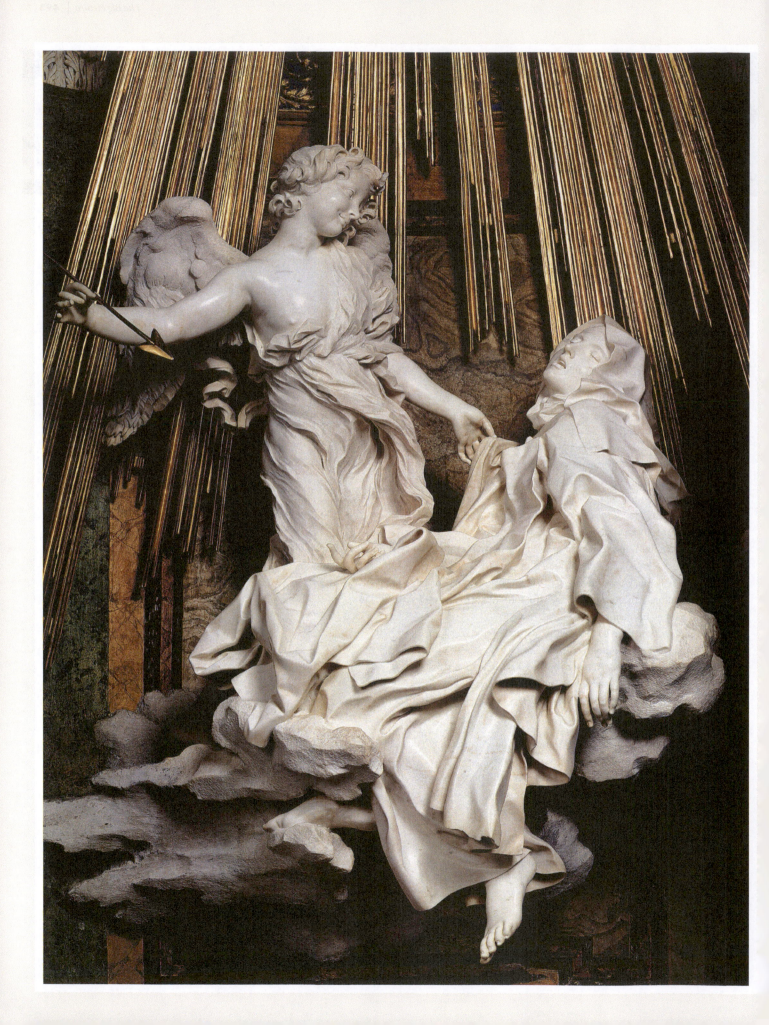

The Seventeenth Century

PREVIEW

Teresa Sánchez de Cepeda y Ahumada was born in the province of Ávila, Spain, on March 28, 1515, just two years before Martin Luther's 95 Theses laid the groundwork for the Protestant Reformation. When she was 30 years old, Pope Paul III convened the Council of Trent in Rome to address Luther's grievances (widespread corruption among the church's elite and the scandal of indulgences) and to reaffirm the basic tenets of Catholic dogma (transubstantiation, the sacraments, veneration of the Virgin Mary and saints, salvation through faith and good works). With these reforms came the institution of new religious orders—the Jesuits, Capuchins, and the Discalced Carmelites among them. They would provide a support system for the Catholic Reformation, or Counter-Reformation, through teaching and missionary work as well as ministries that emphasized personal and private spiritual communion with Jesus Christ achieved through internal prayer. By the time the Council of Trent disbanded in 1563, Teresa Sánchez de Cepeda y Ahumada—Teresa of Ávila—would be 48 years old and would have become one of the most forceful instruments of the Counter-Reformation—a theologian, mystic, writer, and Carmelite nun. The grandchild of a Spanish Jew who had been forced to convert to Christianity during the Inquisition, Teresa of Ávila was canonized by Pope Gregory XV in 1622, just 40 years after her death. In 1970, Pope Paul VI bestowed upon her the honor of doctor of the church—a title granted to only two women in the history of Catholicism.

The central theme of Teresa's writings is the soul's mystical union with God—a process that begins with contemplative mental prayer, followed by progressive states of being in which control of human will and faculties is overtaken by the supernatural, rapturous experience of divine love. The final state in the ascent of the soul and its complete absorption in God was described by Teresa as *ecstasy*, in which the body and the spirit—in a trance sometimes accompanied by levitation—experience sensations of pain and pleasure, stimulation and unconsciousness. Teresa described one particular ecstatic event in her autobiography:

> I saw in his hand a long spear of gold, and at the iron's point there seemed to be a little fire. He appeared to me to be thrusting it at times into my heart, and to pierce my very entrails; when he drew it out, he seemed to draw them out also, and to leave me all on fire with a great love of God. The pain was so great, that it made me moan; and yet so surpassing was the sweetness of this excessive pain, that I could not wish to be rid of it. The soul is satisfied now with nothing less than God. The pain is not bodily, but spiritual; though the body has its share in it. It is a caressing of love so sweet which now takes place between the soul and God, that I pray God of His goodness to make him experience it who may think that I am lying.[1]

◀ **15.1** Gian Lorenzo Bernini, *The Ecstasy of Saint Teresa*, 1645–1652. Marble group, 138" (350 cm) high. Cornaro Chapel, Santa Maria della Vittoria, Rome, Italy.

1. St. Teresa of Avila, *The Life of St. Teresa, Written by Herself*, 5th ed., trans. David Lewis, ed. Benedict Zimmerman (New York: Benziger Brothers, 1916), 266–267.

Thirty years after Teresa's canonization, just as the Counter-Reformation was drawing to a close, Gian Lorenzo Bernini—the most sought-after sculptor in Baroque Italy—captured her words in stone (Fig. 15.1). After the Renaissance, during which teachings of the church were viewed through a humanist, rationalist lens, Teresa's mystical writings reaffirmed the drama and mystery of faith. The re-creation in art of such extremes of emotion as she described fit hand in glove with the Counter-Revolution theory that contemplation of these spiritual experiences would inspire fervent devotion. The new style of the **Baroque** era—a style that embraced theatricality, passion, and human drama—would prove to be a perfect match.

THE SPIRIT OF THE COUNTER-REFORMATION

By about 1600, the intellectual and artistic movements of the Renaissance and Reformation had taken a new turn. Although the cultural activity of the following 150 years was the natural outgrowth of earlier developments, the difference in spirit—already signaled by the middle of the 16th century—was striking.

The chief agent of this new spirit was the Roman Catholic Church. After its initial shock at the success of Protestantism,

the church decided that the best defense was a well-planned offense. It relied in great measure on new religious orders such as the Jesuits to lead the movement known as the **Counter-Reformation**. Putting behind the anxieties of the past, the chief representatives of the Counter-Reformation gave voice to a renewed spirit of confidence in the universality of the church and the authority of its teachings.

The official position of the church was newly stated at the Council of Trent, which met sporadically from 1545 to 1563. Under the leadership of Pope Paul III, the council redefined Catholic doctrines and reaffirmed those dogmas that Protestantism had challenged. Transubstantiation, the apostolic succession of the priesthood, the belief in purgatory, and the rule of celibacy for the clergy were all confirmed as basic to the Catholic system of faith. The pope remained as the monarchical ruler of the church. At the same time, the council tried to eliminate the abuses by the clergy that had fueled Martin Luther and the Reformation, and to tighten discipline. Bishops and priests could no longer hold more than one benefice, and theological seminaries were set up in every diocese to improve the level of education of priests.

One of the key instruments in the campaign to reestablish the authority of the church was the Society of Jesus, an order—founded in 1534 by Ignatius Loyola (1491–1556)—of priests and brothers called Jesuits who dedicated themselves to the defense

The Seventeenth Century

1600 CE	1621 CE	1648 CE	1682 CE	1700 CE
The Dutch dominate global trade	Philip IV is king of Spain	The Peace of Westphalia ends Thirty Years' War; the Counter-Reformation ends	Louis XIV moves the French court from Paris to Versailles	
James VI, king of Scotland, ascends the English throne as James I	Teresa of Ávila is canonized by Pope Gregory XV	England is ruled by Oliver Cromwell	Isaac Newton publishes a monograph describing his laws of motion	
Holland and Flanders achieve independence from Spain in the Twelve Years' Truce	New Saint Peter's is consecrated by Pope Urban VIII, who patronizes the arts on a grand scale	The rings of Saturn are discovered	William of Orange invades England, leading to the deposition of James II; William and his wife Mary become joint sovereigns of England, Ireland, and Scotland	
Galileo invents and improves telescopes	Louis XIV, the Sun King, ascends the French throne in 1643, at the age of five, and reigns until 1715	Cromwell dies, and the English monarchy is restored under Charles II		
Louis XIII of France ascends to throne at the age of nine; the country is ruled by his mother, Marie de' Medici, for seven years as regent	Charles I of England, a supporter of the divine right of kings, rules without Parliament	Most of London is destroyed by a fire that lasts for five days	The Bill of Rights establishes English constitutional government and limits the sovereign's power	
Thirty Years' War	Galileo is found guilty of heresy and forced to recant his discovery that the sun is the center of the solar system	Van Leeuwenhoek discovers bacteria with a microscope	The Salem Witch Trials begin in the Massachusetts Bay Colony in 1692	
Kepler reveals his laws of planetary motion	Massachusetts Bay colony is founded in 1629			
Puritans set sail for North America on the *Mayflower*				

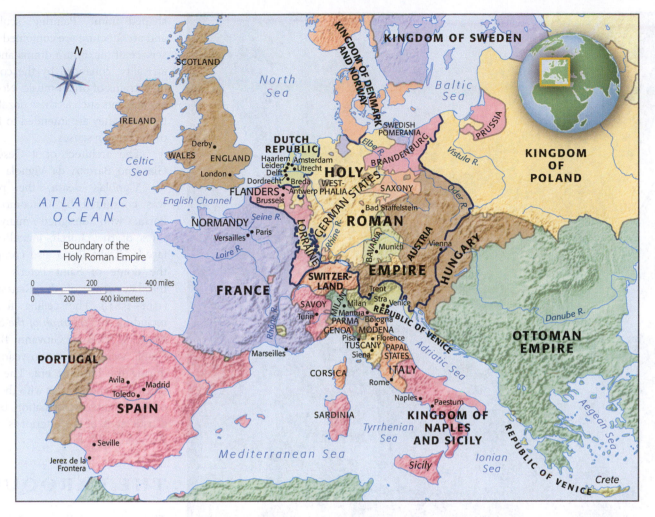

▲ **MAP 15.1 Europe in 1648.**

of the faith. Loyola was a Spanish nobleman and a career soldier who embraced a life of religious devotion after suffering a serious wound. His *Spiritual Exercises* (begun 1522–1523) express a mystical, even morbid spirit of introspection, inspired by visions of Satan, Jesus, and the Trinity. A similarly heightened spiritual sense and attempt to describe mystical experiences occur in the writings of other Spanish Catholics of the Counter-Reformation, most notably, as we saw at the outset of this chapter, Saint Teresa of Ávila (1515–1582) and Saint John of the Cross (1542–1591). Saint John wrote powerfully of the soul's emergence from the "dark night" to attain union with God.

Loyola's Jesuits soon became the most militant of the religious movements to appear during the 16th century. The members were organized on the model of a military company, led by a general as their chief commander and required to exercise iron discipline. The Jesuits led their charge, not with swords or guns, but with eloquence and the power of persuasion. Their duty was simple: to promote the teachings of the church unquestioningly. Loyola taught that if the church ruled that black was white, its followers were obliged to believe it. They reinforced this position by their vigorous missionary work throughout Europe, the Americas, and Asia, while improving educational institutions throughout Catholic Europe.

At the same time, the Council of Trent called on artists to remind Catholics of the power and splendor of their religion by commissioning a massive quantity of works of art dedicated to underlining the chief principles of Counter-Reformation teachings. Now it was the task of religious leaders and, under their guidance, of artists to make this position known to the faithful. New emphasis was placed on clarity and directness. The impression of the church's triumphant resurgence was further reinforced by a new emphasis on material splendor and glory.

Il Gesù

The Jesuits were key figures in the Counter-Reformation strategy of the Catholic Church, so it stands to reason that they would desire worship spaces to accommodate their growing influence and to showcase the spectacle of Counter-Reformation art and ceremony. The Church of Most Holy Name of Jesus in Rome, called il Gesù, is on a familiar basilican plan, designed to accommodate large crowds in its very wide and long nave (**Fig. 15.2**).

One can imagine the elaborate processions of exquisitely clothed clergymen passing through throngs of worshippers as

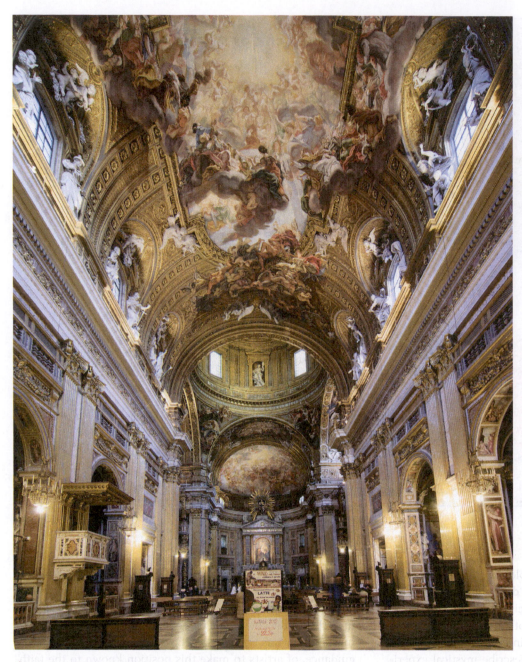

▲ **15.2** Giacomo della Porta, central nave of il Gesù, ca. 1575–1584. Rome, Italy.

shaped frame. Painting, sculpture, and architecture are conjoined in the service of maximum drama and theatricality, enhanced by the compelling strains of organ music. Not only are interiors such as these dazzling to the eyes; they are intended to fire all of the human senses.

The architect of il Gesù was Giacomo Barozzi da Vignola. After da Vignola's death, the project was continued by Giacomo della Porta, who designed many features of the church, including the façade. (Della Porta also completed the dome of Saint Peter's during the late years of the Renassiance (1568–1584.) The ceiling frescoes, including the *Triumph of the Sacred Name of Jesus* by Giovanni Battista Gaulli, were painted 100 years later, during the Baroque era. The Jesuit church is synonymous with the spirit of the Counter-Reformation, but the artistic style of the interior is wholly Baroque.

THE BAROQUE

The origins of the word *baroque* are obscure. It may be related to the Portuguese *barroco*—an irregularly shaped pearl—or to the Italian *baroco*—a term used to describe a complicated problem in medieval logic. The catchall term does convey the multiplicity of artistic styles of the era; the 17th century was filled with artists working all over Europe whose art would be described as anything but uniform. Yet their work reveals some common characteristics: complexity, spontaneity, drama, theatricality, virtuosity, opulence, and monumentality.

Perhaps the most striking, though, is the primacy of emotion. Renaissance art, for example, revisited the perfect balance between emotion and restraint that was central to Classical philosophy and art; Baroque artists, on the other hand, placed extremes of human behavior and emotion front and center. The dramatic nature of their often violent subjects was reinforced by theatrical spotlighting, sanguine palettes, and exaggerated gestures; artists gravitated to such subjects because they provided an opportune vehicle for the artists' edgy, unrestrained styles.

This concern with emotion produced in its turn an interest in what came to be called *psychology*. Baroque artists attempted to analyze how and why their subjects felt as strongly as they did by representing emotional states as vividly as possible.

they pressed toward the altar carrying gold and silver liturgical objects studded with precious stones, music rising around them, incense filling the air. Above it all, there is a spectacular ceiling whose illusion is so complete that the boundaries between heaven and earth seem to be erased (**Fig. 15.3**). It is as if the gilded vault of the church is literally open, creating the sensation that the devout worshipper might be transported to another realm. Within a mesmerizing, brilliant, yellow-white light, a monogram for the Holy Name of Jesus—IHS—hovers, venerated by a host of angels and saints buoyed by clouds. This sublime realm is accessible only to the devout, however. At the same time that the faithful's eyes are drawn heavenward to salvation in Christ, sinners are cast out, their tangled and writhing bodies painted on stucco panels that jut outside the painting's lozenge-

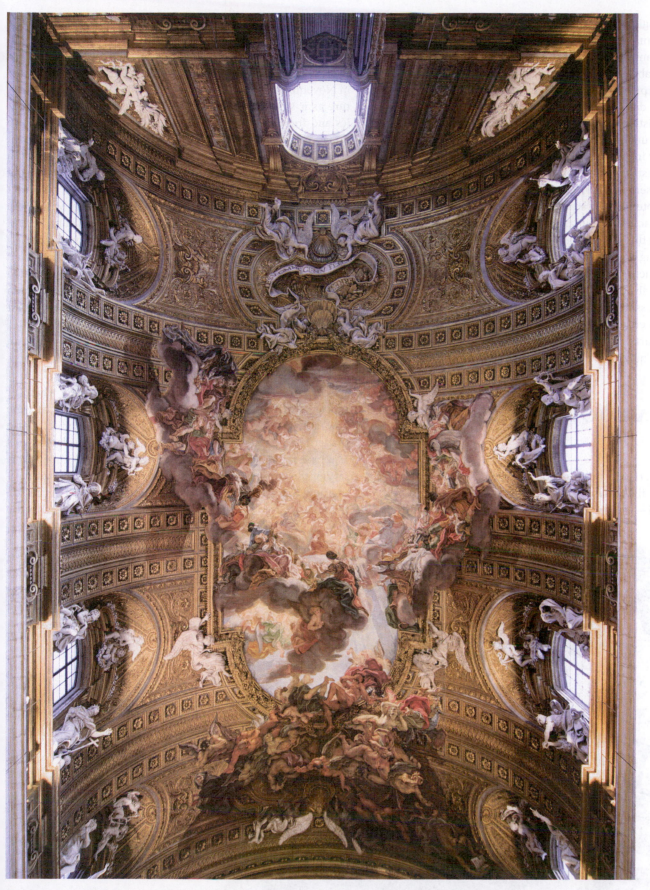

▲ **15.3** Giovanni Battista Gaulli, *Triumph of the Sacred Name of Jesus*, 1676–1679. Nave vault ceiling fresco with stucco figures. The Church of the Most Holy Name of Jesus (il Gesù), Rome, Italy. Baroque ceiling decorations were not partitioned as Renaissance ceilings were. Figures painted on plaster seem to spill out beyond the gilded frame, heightening the illusion of reality.

This psychological exploration is also evident in 17th-century opera and drama, in which musical or spoken passages convey the precise frame of mind of the characters. Baroque writers often used elaborate imagery and complicated grammatical structure to express intense emotional states.

New and daring techniques accompanied these dramatic changes in artistic expression, and Baroque artists gained attention for their unconventional styles and virtuoso handling of their media or instruments. In the hands of Baroque sculptors, stone was transformed into extraordinary illusions of flesh and fabric; composers wrote pieces of increasing complexity whose challenging notes inaugurated the tradition of the virtuoso performer that reached its climax in the 19th century.

Although the term *Baroque* is applied mainly to the visual and performing arts, it is also used to describe the entire cultural achievement of the age. Baroque culture and values were astonishingly diverse, affected by different religious, political, and social pressures in very different parts of Europe. They comprise, indeed, an irregularly shaped pearl. And much of it, at least in the arts, was inspired by the Counter-Reformation of the Catholic Church.

THE BAROQUE ERA IN ITALY

The Baroque era was born in Rome, where a series of powerful popes—Paul V, Gregory XV, Urban VIII, Innocent X, and Alexander VII—wielded power and influence in the realms of religion, politics, and art. This is perhaps nowhere more evident than in the expansion and renovation of Saint Peter's in Vatican City, Rome (**Fig. 15.4**).

Constantine's basilica, Old Saint Peter's, was consecrated in November of 326 CE and was only half the size of the structure as it stands today. Its interior was decorated with mosaics and frescoes and was the site of monuments dedicated to popes and emperors; Charlemagne was crowned Holy Roman emperor in Old Saint Peter's by Pope Leo III in 800 CE. As the most important pilgrimage destination for Christians, the old basilica was deemed inadequate, yet the impetus to do something about it came only in the mid-15th century with Pope Nicholas V. The first significant changes to Old Saint Peter's, however, came with his successor, Julius II—patron of Michelangelo and Raphael. Julius decided on a complete reconstruction of the old basilica and put the architect Bramante in charge of demolishing parts of the old structure and replacing them with a much grander vision. After Julius's death, the "new" Saint Peter's proceeded in fits and starts over a succession of popes—some who supported the arts, at least one who despised them, and some who were so overwhelmed by political disturbances that they were incapable of doing anything else.

It was Pope Paul V who ordered dismantled whatever remained of Old Saint Peter's—and even some parts that were new and just not workable—and hired the architect Carlo Maderno to design a long nave for a Latin-cross plan as well as a new façade. On November 18, 1626—the 1300th anniversary of the consecration of Old Saint Peter's by Constantine—the new Saint Peter's was consecrated by Paul V's successor, Urban VIII. From the beginning of the redesign of St. Peter's in the

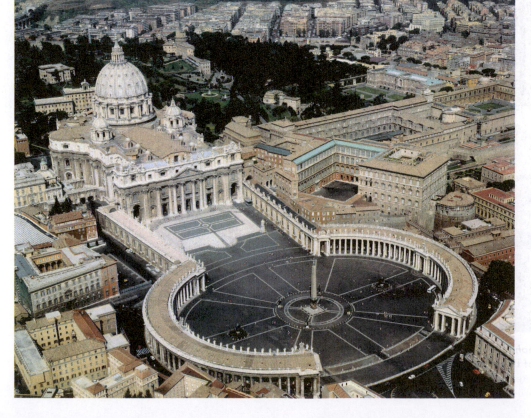

◀ **15.4 Saint Peter's Basilica and Piazza. Façade 147' high × 374' long (44.8 × 114 m). Vatican City State, Italy.** The building combines Renaissance and Baroque elements. The nave and façade were finished by Carlo Maderno (1556–1629) between 1606 and 1612, and the colonnades around the square were built between 1656 and 1663 to Bernini's design.

Bernini's patron for the colonnades was Pope Alexander VII, whose profile can be seen on one side of a commemorative coin marking the construction; the other side of the coin bears an image of a diminutive Saint Peter's against the exaggerated scale (and importance, in Alexander's mind) of the colonnades and piazza (**Fig. 15.5**).

The coin shows a third, center section of the colonnade, which would have obscured a full-frontal view of Maderno's façade, that was never built. Commemorative coins of this type—but with different images—provide a veritable timeline of progress on Saint Peter's and, importantly, connect specific popes with the significant projects they sponsored in Vatican City and in Rome. Another such coin, for example, commemorates the building of Bernini's **baldacchino**, the glorious bronze-columned canopy that stands approximately 100 feet high over the main altar of Saint Peter's, above the saint's tomb and beneath Giacomo della Porta's dome

▲ **15.5** Alberto Hamerani, papal medal showing a bust of Alexander VII wearing a tiara and cope; reverse showing the colonnade and Piazza San Pietro, 1666. Cast-lead, 1⅝" (42 mm). Private Collection.

mid-15th century to its completion, 27 popes had come and gone and almost every Renaissance artist of note was associated in some way with the building: Alberti, Bramante, Raphael, Michelangelo, Giacomo della Porta, and many more. Urban VIII would be known as the first of the Baroque builder-popes. He was also the grand patron of the era's most prolific and accomplished sculptor—Gian Lorenzo Bernini.

Baroque Sculpture and Architecture in Rome

GIAN LORENZO BERNINI Before a visitor encounters the spectacular scale of the nave of Saint Peter's, stands beneath Michelangelo's breathtaking dome over the massive piers of its crossing square, or has an intimate encounter with the heart-rending scene of a mother and her dead child in Michelangelo's *Pietà*—that visitor has passed through an elliptical piazza in front of the basilica and has been caressed by the arms of colonnades that extend from the façade and seem to draw one into the spiritual comfort of the bosom of the church. This is Bernini's piazza—and but one of his many theatrical creations. His seemingly unlimited range of expression and unparalleled technical virtuosity as a sculptor represented one of his artistic dimensions; as the chief architect of Counter-Reformation Rome, he also permanently changed the face of that venerable city.

▼ **15.6** Gian Lorenzo Bernini, Baldacchino, Saint Peter's, 1624–1633. Vatican City State, Italy. The canopy stands nearly 100 feet (30.5 m) above the main altar of Saint Peter's.

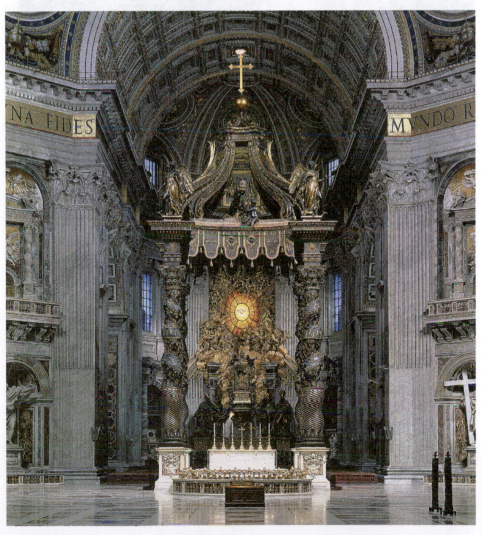

(Fig. 15.6). In the apse, visible through the baldacchino, Bernini combined architecture, sculpture, and stained glass in a brilliant gold setting for the Cathedra Petri, or Throne of Saint Peter. Pope Urban VIII commissioned both of these projects. Bernini also designed the tombs of Urban VIII and Alexander VII in Saint Peter's.

Bernini had another, earlier patron in the upper echelons of the Vatican—Cardinal Scipione Borghese, the nephew of Pope Paul V. Many of Bernini's famed secular sculptures of mythological subjects were created for the Villa Borghese, as was his version of *David* (Fig. 15.7)—at once homage to those of his Florentine predecessors and a sharp departure from them. Bernini's *David* illustrates two of the most dramatic characteristics of Baroque sculpture: time and motion. Bernini does not depict David before or after the fight, but during. We do not

look upon David; we are swept up in the action that unfolds around us with David as the eye of the storm. From his furrowed brow, clenched jaw, and pressed lips to the muscular tension of his arms and the grasping toes of his right foot, this David personifies energy, almost exploding through space. The expressive power of the action is enhanced by deep cuts in the stone that create strong contrasts of light and shadow; slashing diagonals draw the eye around the work along a spiral path. David's body is like a coiled spring. In its violent emotion—a young man on the physical and psychological brink—and its virtuoso technique, Bernini's *David* epitomizes the Baroque style.

The dynamism and drama that we see in the *David* would reach its fullest and most radical expression in works like *The Ecstasy of Saint Teresa* for the Cornaro family chapel in the church of Santa Maria della Vittoria in Rome. Bernini

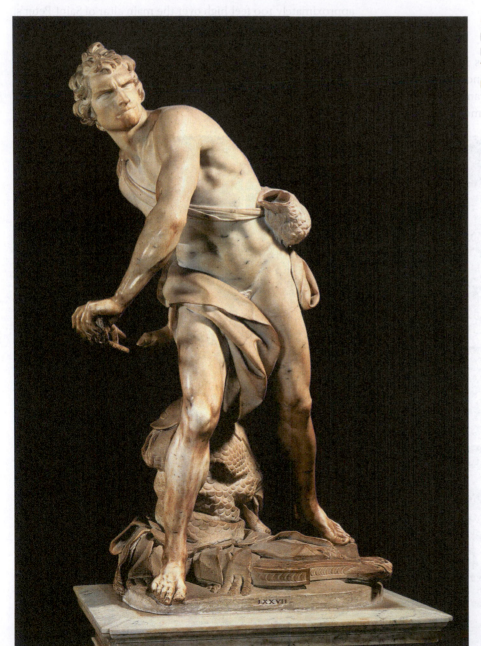

◀ **15.7** Gian Lorenzo Bernini, *David*, 1623. Marble, 66¼" (170 cm) high. Galleria Borghese, Rome, Italy. Bernini's David captures him in action. The facial expression reinforces the tension of the pose with straining leg and foot muscles.

combined architecture, sculpture, and natural light (from a concealed window above the figures) to dramatize the saint's ecstatic vision, which is framed as if on a shallow stage. On the walls of the chapel, left and right, Bernini portrayed members of the Cornaro family observing the event from "box seats" (**Fig. 15.8**). The entire space of the chapel is treated as a theatrical tableau. Perhaps it is not surprising to learn that Bernini also wrote plays and designed stage sets.

We may liken the difference between, say, Michelangelo's *David* and Bernini's *David* to that between Classical and Hellenistic Greek sculpture, the latter of which was marked by an extension of the figure into surrounding space, a strong sense of movement, exaggerated expression, and a large degree of theatricality. The time-honored balance between emotion and restraint coveted by the Classical Greek artist—and adapted in Renaissance works—gave way in the Hellenistic and Baroque periods to unbridled passion.

FRANCESCO BORROMINI Bernini's mother once said of him, "He acts as if he were master of the world." His expansive personality and his resounding success in obtaining high-profile commissions combined to make him the dominant force in the Roman Baroque, but he met stiff competition in Francesco Borromini (1599–1667). Both have been called "stage managers of Baroque theater," and their contentious relationship and obsession with outdoing one another can be described as its own version of theater. They were born within a year of each other but could not have been more different in personality: Bernini was the ultimate insider and showman, a gregarious family man and multifaceted artist, whereas Borromini was a reclusive outsider, a loner, and an "architect's architect." Bernini lived to be 82 and worked up until his death; Borromini committed suicide at the age of 68.

Although the element of motion may seem anathema to architecture, Borromini introduced it as a component in several

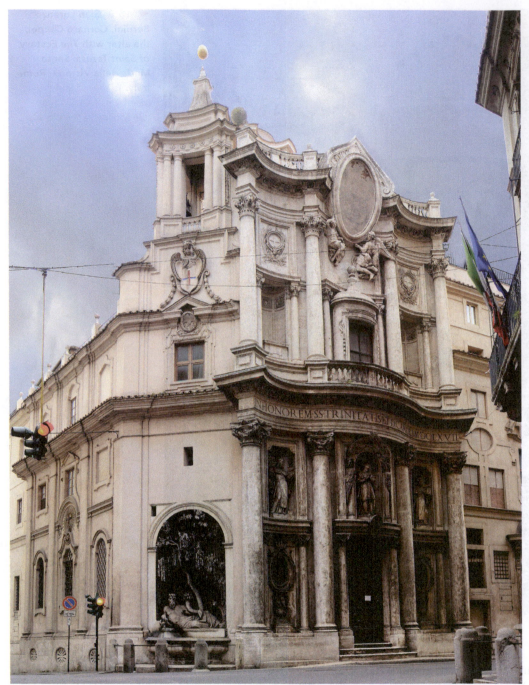

◀ **15.9** Francesco Borromini, San Carlo alle Quattro Fontane, begun 1638, façade finished 1667. Exterior façade 38' (11.58 m) wide. Rome, Italy. The curves and countercurves of the façade, together with the rich decoration, mark a deliberate rejection of the classical style.

of his buildings. Combined with intricately framed space and dramatic lighting, this familiar Baroque characteristic found its equivalent in architectural design. The façade of Borromini's San Carlo alle Quattro Fontane (**Fig. 15.9**), completed the year of his death, undulates with sinuous curves and countercurves. Light plays across the surfaces, bouncing off the projections and plunging the recessed areas into darkness. The stone seems to pulse and breathe, at once joyous and tormented. This organic feeling echoes the interior of the small church, whose rippling concave and convex walls stretch up to an oval-shaped dome with a honeycomb pattern of coffering (**Fig. 15.10**). Perhaps for the first time since the Parthenon (see Fig. 3.3), a building is seen first as sculpture and only second as architecture.

Baroque Painting in Rome

The Baroque interest in combining the arts of painting, sculpture, and architecture found its home in the naves and domes of churches and cathedrals, as artists used the three media to create unsurpassed illusionism. Unlike Renaissance ceiling frescoes, exemplified by Michelangelo's decoration for the Sistine Chapel, the space of Baroque ceilings was not divided into small frames, each with individual scenes. Rather, the space was conceived as a whole, with the center of the vault "open" to the heavens and figures "migrating" from the actual space of the vault to the illusion of space beyond. Giovanni Battista Gaulli's *Triumph of the Sacred Name of Jesus* (see Fig. 15.3) is

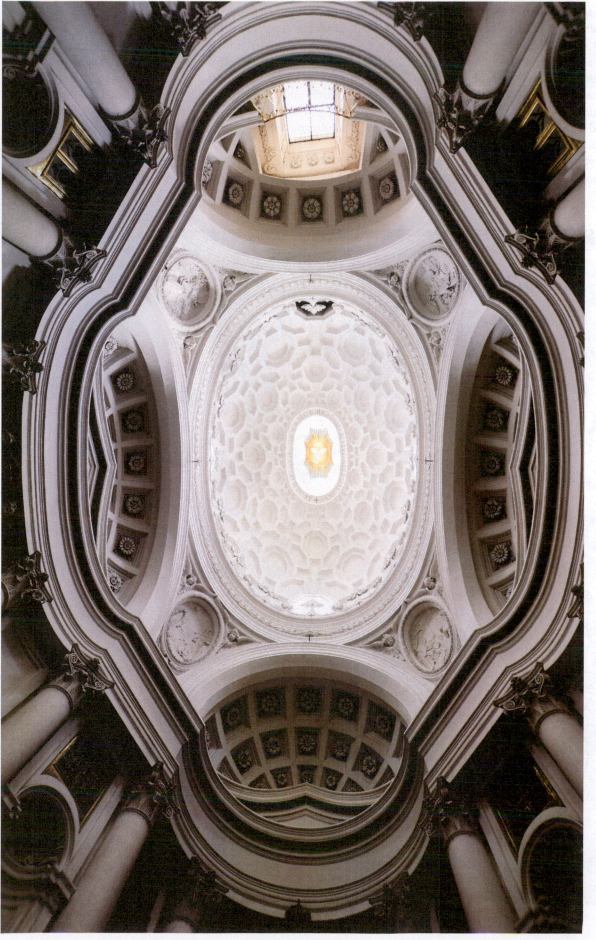

◀ **15.10** Francesco Borromini, the dome of San Carlo alle Quattro Fontane, 1638–1641. Rome, Italy. Borromini used an oval dome rather than a traditional round dome to crown the interior of the church. Some light enters the church from unseen windows around the base of the dome.

an energetic display of figures that spill out beyond the gilded frame of the ceiling's illusionistic opening. The trompe l'oeil effect was achieved by combining these painted figures with white stucco-modeled sculptures and a gilded stucco ceiling. Attention to detail is remarkable, from the blinding light of the heavens to the deep shadows painted on the gilded vault that would be there if the figures were indeed real. Artists like Gaulli and their patrons spared no device—no trick of the eye—to create an utterly believable, mystical atmosphere.

The foundations of Baroque painting were laid around 1600 by two artists whose works, at first glance, have little or nothing in common: Michelangelo Merisi, known as Caravaggio (1571–1610), and Annibale Carracci (1560–1609). That both artists exerted an immense influence on their successors says something about the extreme range of Baroque style. Caravaggio explored the darker aspects of life in some of the most naturalistic and dramatic religious pictures ever painted; Carracci delighted the senses with elegant, colorful, and brilliantly lit landscapes and mythological paintings.

ANNIBALE CARRACCI At first glance, it would seem that the ceiling fresco *The Loves of the Gods* (**Fig. 15.11**) by Annibale

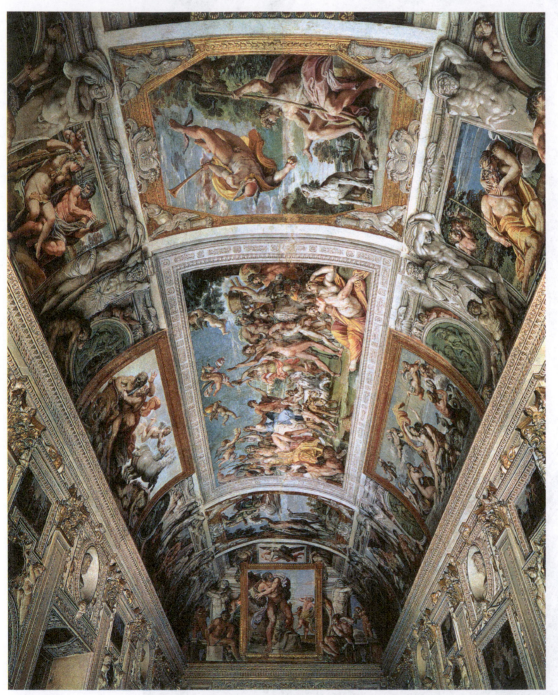

◀ **15.11** Annibale Carracci, *The Loves of the Gods*, 1597–1601. Ceiling frescoes in the gallery of the Palazzo Farnese, Rome, Italy.

Carracci followed the model of Michelangelo's Sistine Chapel with its individually framed paintings, but a closer look reveals a distinct difference. Michelangelo's frames were painted to look like an architectural framework for the vault; his narrative scenes take place within the rectangular bays, and numerous extra figures inhabit assorted spaces between and among the architectural elements. Carracci's ceiling, on the other hand, consists of discrete pictures of the kind that would be painted on an easel, complete with their decorative frames. The sections in the center on either side of the vault feature what appear to be actual separate paintings, with their own internal lighting scheme, propped up on the ledge of a delicately carved entablature. This particular form of illusionism was called *quadro riportato* (transferred frame painting) and was popularized by Carracci. Other figures—the ones outside the frames—are lit differently, creating the illusion that they are separate and three-dimensional. The many scenes in the gallery (formal reception hall) of the Palazzo Farnese were based on Greek and Roman mythology and depict amorous encounters among the gods; Carracci was commissioned by Cardinal Odoardo Farnese to decorate the ceiling on the occasion of the marriage of his brother.

The Loves of the Gods was painted between 1597 and 1601, at the precise moment when another Italian Baroque painter, Caravaggio, was at work on his paintings for the Contarelli Chapel in the Church of San Luigi dei Francesi in Rome. The brilliant, colorful, and idealized world of Annibale Carracci was diametrically opposed to the dark, haunting, emotional world of the Baroque era's most notorious artist.

CARAVAGGIO Caravaggio was an extremely controversial figure in his day—and not just because of his painting. His own lifestyle did little to recommend him to the aristocratic and ecclesiastical patrons on whom he depended. From his arrival in Rome in 1592 until his forced exile in 1606, Caravaggio was in and out of trouble with the law—prone to street brawls, violent outbursts, and a savage temper that alienated potential friends. Although by 1600 his reputation in Rome as a painter had soared, which garnered important commissions, any chances that he had for establishing himself there permanently came to an abrupt end when he (perhaps accidentally) killed a man in 1606. He avoided punishment only by fleeing to Naples and then to Malta, where he was thrown into prison for attacking a police officer. Escaping, he made his way to Sicily and then back again to Naples, where he was involved in yet another violent quarrel, which left him seriously wounded. While in Naples, Caravaggio became aware of the possibility of a papal pardon for the murder in Rome and headed back to that city on a ship with three paintings that he probably thought he could use to secure the pardon. He was detained at a port along the way, and his paintings went on without him; all we know is that Caravaggio died before he could reach Rome. The pardon from the pope arrived a few days later.

The details of Caravaggio's life read like a novel, but nonetheless they offer important clues to unlocking the nature of his style. Whereas Bernini could move in the company of popes and princes, Caravaggio had an affinity for what the French would call the *demimonde*, literally the "half-world"—people who drink, gamble, and live on the edge. After all, he was one of them. Just as he rejected the artifice of decorum and moralistic societal values, so too did he reject traditional, idealized portrayals of religious subjects in favor of something more earthy, more real, more believable. The characters in his stories are not lost amid the splendor of elaborate settings as in so many Counter-Reformation works. Rather, the emphasis is on them—their human anxieties, simple piety, quiet sorrow. Their faces are not the generic, standardized, and often idealized versions typical of other artists; his models were ordinary people—the people around him.

Our attention is drawn to their humanness and individuality, both physical and emotional, as they grapple with their circumstances. As Caravaggio's backgrounds are almost always spare and dark, the atmosphere is close and intimate, and lighting is used to dramatic effect. This technique is called **Tenebrism**, which can be translated as a "dark manner." The effect is harsh and theatrical and was mimicked widely by contemporary Baroque artists in Italy and throughout Europe.

Just five years after Caravaggio came to Rome, he was commissioned by the Contarelli family to paint two works for their chapel in the Church of San Luigi dei Francesi. *The Calling of Saint Matthew* (see **Fig. 15.12** on p. 508) and *The Martyrdom of Saint Matthew* hang on walls opposite one another and thus are connected both spatially and temporally. In one painting, we see Matthew as a young man being called by Jesus to follow him; in the other, he is older, about to be slain for his beliefs. The saint's life story is relayed in two distinct but related dramatic moments. In *The Calling of Saint Matthew*, Jesus enters the room from the right and points in the direction of Matthew, who is surrounded by men and is hunched over the table. It is not clear whether Matthew sees Jesus yet, or hears him, or awed and fearful, tries to shrink back into the darkness—to instinctually preserve himself from the destiny that we know will unfold for him. Of course, Matthew will go.

ARTEMISIA GENTILESCHI One of Caravaggio's foremost contemporaries was Artemisia Gentileschi (1593–ca. 1652). Her father—the painter Orazio Gentileschi, who enjoyed much success in Rome, Genoa, and London—recognized and supported Artemisia's talents. Although one of Orazio's choices for her ended in disaster—an apprenticeship with a man who ultimately raped her—Gentileschi came to develop a personal, dramatic, and impassioned Baroque style. Her work bears similarities to that of Caravaggio, her own father, and others working in Italy at that moment, but it often stands apart in the emphatic rendering of its content or in its reconsideration and revision of subjects commonly represented by 16th- and 17th-century artists.

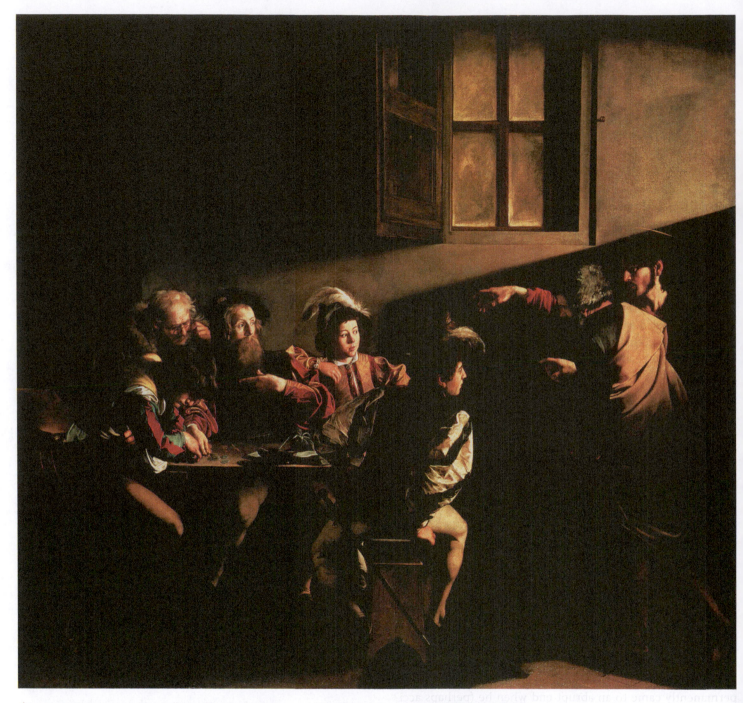

▲ **15.12** Caravaggio, *The Calling of Saint Matthew*, ca. 1600–1602. Oil on canvas, 120⅝" × 132⅞" (322 cm × 340 cm). Contarelli Chapel, Church of San Luigi dei Francesi, Rome, Italy. A bright light comes from a mysterious source to the right of the canvas. Jesus, half-hidden on the right, points at Matthew. The artist dramatically directs the light at Matthew's head, and Matthew draws back in fear.

Consider the roughly contemporary paintings of *Judith and Holofernes* by Caravaggio (**Fig. 15.13**) and *Judith Decapitating Holofernes* by Gentileschi (**Fig. 15.14**). Both works reference a biblical story of the heroine Judith, who rescues her oppressed people by decapitating the tyrannical Assyrian general Holofernes. She steals into his tent under the cover of night and pretends to respond to his seductive overtures. When he is besotted, with her and with drink, she uses his own sword to cut off his head. Both paintings are prime examples of the Baroque style—vibrant palette, dramatic lighting, an impassioned subject heightened to

excess by our coming face-to-terrified-face with a man at the precise moment of his bloody execution. Judith is determined, strong, and physically and emotionally committed to the task. In Caravaggio's painting, Holofernes is caught unaware and falls victim in his compromised, drunken state. Gentileschi's tyrant snaps out of his wine-induced stupor and struggles for his life. He pushes and fights and is ultimately overpowered by a righteous woman. What gender differences, if any, can you interpret in these renderings?

Gentileschi's *Judith Decapitating Holofernes* is one of her most studied and violent paintings. She returned to the subject

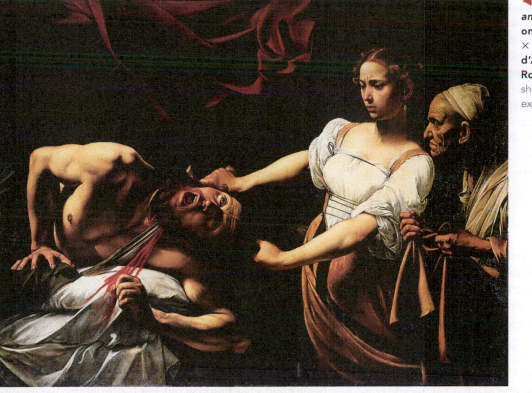

◀ **15.13** Caravaggio, *Judith and Holofernes*, ca. 1598. Oil on canvas, 57" × 77" (145 cm × 195 cm). Galleria Nazionale d'Arte Antica, Palazzo Barberini, Rome, Italy. Caravaggio's painting shows a strangely removed, delicate executioner.

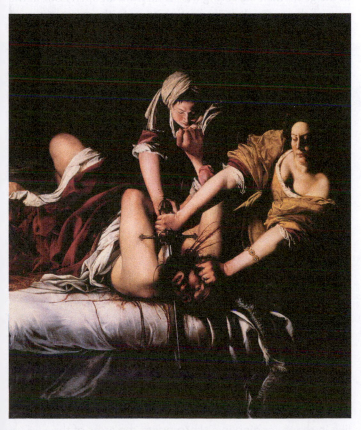

▲ **15.14** Artemisia Gentileschi, *Judith Decapitating Holofernes*, ca. 1620. Oil on canvas, 72½" × 55¾" (199 × 162 cm). Galleria degli Uffizi, Florence, Italy. Gentileschi's Judith is a visually powerful woman who tackles her gruesome task with alacrity.

repeatedly in many different versions, leading some historians to suggest that her seeming obsession with the story signified her personal struggle in the wake of her rape and subsequent trial of her accuser, during which she was tortured in an attempt to verify the truth of her testimony. As with Caravaggio's life and art, do you think that this context is essential to understanding Gentileschi's work?

THE BAROQUE ERA OUTSIDE OF ITALY

During the Renaissance, Italy was the center of virtually all artistic development. Despite the impact of the Counter-Reformation, the Reformation began an irreversible process of decentralization. By the beginning of the 17th century, although Rome was still the artistic capital of Europe, important cultural changes were taking place elsewhere. The economic growth of countries like Holland and England, and the increasing power of France, produced a series of artistic styles that developed locally rather than being imported wholesale from south of the Alps. Throughout Northern Europe, the rise of the middle class continued to create a new public for the arts, which in turn affected the development of painting, architecture, and music.

The irregularity of styles across and even within regions suggested by the term *Baroque* is again apparent. Artists of

Spain and Flanders adopted the Venetian love of color and application of paint in loosely brushed swaths. Northern artists had always been interested in realism, and during the Baroque period, they carried this emphasis to an extreme. Paintings of everyday life and activities became the favorite subjects of Dutch artists, who followed in Bruegel's footsteps and perfected the art of genre painting. The Baroque movement also extended into France and England, but there it often manifested in a strict adherence to classicism. For the first time, European culture began to spread across the Atlantic, carried to the Americas by Counter-Reformation missionaries.

Spain

Spain was one of the wealthiest countries in Europe during the Baroque era—partly because of the influx of riches from the New World—and the Spanish court was lavish in its support of the arts. Painters and sculptors were imported from different parts of Europe for royal commissions, and native talent was cultivated and treasured.

DIEGO VELÁZQUEZ Diego Velázquez (1599–1660) was born in Spain and rose to the position of court painter and confidant of King Philip IV. Although Velázquez relied on Baroque techniques in his use of Venetian colors, highly contrasting lights and darks, and a deep, illusionistic space, he had contempt for the idealized images that accompanied these elements in the

Italian art of the period. Like Caravaggio, Velázquez preferred to use common folk as models to assert a harsh realism in his canvases. Velázquez brought many a mythological subject down to earth by portraying ordinary facial types and naturalistic attitudes in his principal characters. Nor did he restrict this preference to paintings of the masses. Velázquez adopted the same genre format in works involving the royal family, such as *Las Meninas* (**Fig. 15.15**). The huge canvas is crowded with figures engaged in different tasks. *Las meninas*, the maids of honor, are attending the little princess Margarita, who seems dressed for a portrait-painting session. She is being entertained by the favorite members of her entourage, including two little people and an oversized dog. We suspect that they are keeping her company while the artist, Velázquez, paints before his oversized canvas.

Is Velázquez, in fact, supposed to be painting exactly what we see before us? Some have interpreted the work in this way. Others have noted that he would not be standing behind the princess and her attendants if he were painting them. Moreover, on the back wall of his studio, we see what appears to be the mirror images of the king and queen standing next to one another, with a red drape falling behind. Because we do not actually see them in the flesh, we may assume that they are standing in the viewer's position, before the canvas and the artist. Is the princess being given a few finishing touches before joining her parents in a family portrait? We cannot know for sure. The reality of the scene has been left a mystery by Velázquez, as has the identity of the gentleman observing the scene from an open door in the rear of the room. It is interesting to note the prominence of

CONNECTIONS From his position before a monumental canvas, brushes and palette in hand, Velasquez steps back, lists to the side, and looks out toward us. He is tall, strikingly handsome, serious, and self-possessed—at once central to the action and apart from it. In a sea of vivid color and energetic brushwork, the rich velvety black of his tunic and shimmering silver-grey shirtsleeves create a visual pause, concentrating our attention on the artist's head, hands, and chest, emblazoned with the stylized red cross of the Order of Santiago that had been awarded to him by the King in 1659—three years after *Las Meninas* was completed.

The Order of Santiago, also known as "The Order of Saint James of the Sword," was founded in Spain in the 12th century to protect pilgrims along the route to Santiago de Compostela (see Fig. 8.3) and, more broadly, to defend Christendom. Knights of the order followed the rule of the Augustinians, meaning that—unlike the mendicant Franciscans and Dominicans—they did not take a vow of poverty or engage in ministry. It is perhaps for these reasons that the Order expanded rapidly.

The Knights of the Order of Santiago "defended Christianity" in Iberia by participating in the eviction of the Moors, doing battle against them, and collaborating with Spanish royal armies in the *Reconquista*.

The Saint James Cross that appears on Velasquez's tunic may have originated during the Crusades in the Holy Land and may have been adopted by the order as an insignia because their patron saint, Stephen, was executed by the sword for his faith. The body of the cross is sword-like in shape, ending in a sharp point; the arms of the cross culminate in three *fleurs-de-lis* (lilies) that represent "honor without stain."

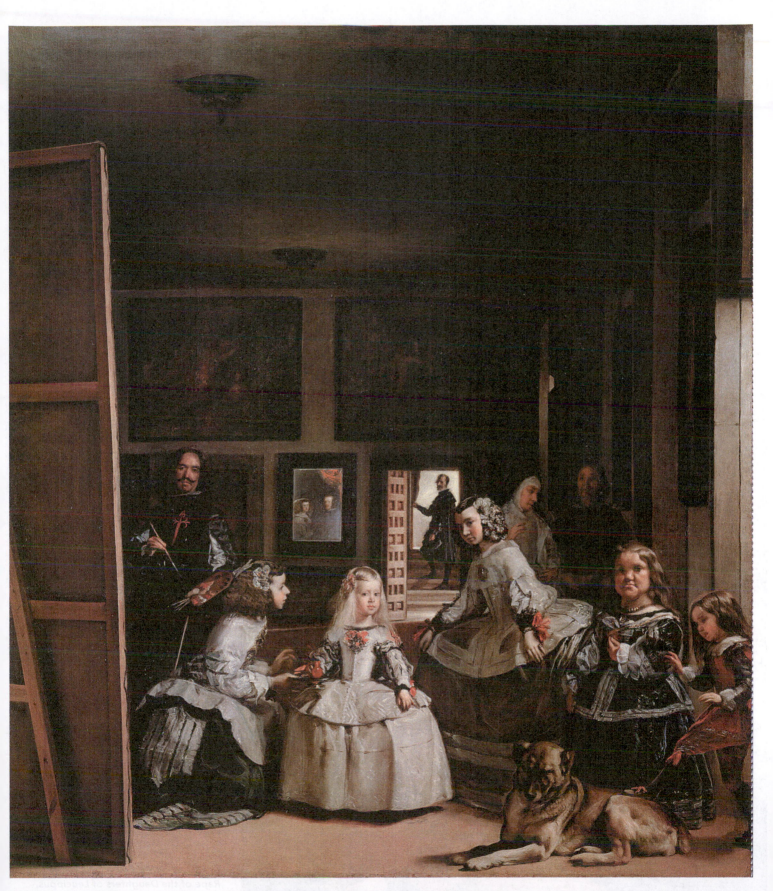

▲ **15.15** Diego Velázquez, *Las Meninas* (The Maids of Honor), 1656. Oil on canvas, 125" × 108¾" (318 cm × 276 cm). Prado Museum, Madrid, Spain. The artist boldly shows himself on the left side of the painting, palette in hand, standing before a huge canvas that is ironically almost lost because of its placement in the composition. The Infanta (princess) stands in the center, surrounded by her maids in waiting. A large dog, a favored symbol of loyalty, occupies the foreground.

the artist in this painting of royalty. It makes us aware of his importance to the court and to the king in particular. Recall the portrait of Raphael in *Philosophy (The School of Athens)* (see Fig. 13.8). Raphael's persona is almost furtive by comparison.

Velázquez pursued realism in technique as well as in subject matter. Building upon the Venetian method of painting, Velázquez constructed his forms from a myriad of strokes that capture light exactly as it plays over a variety of surface textures. Upon close examination of his paintings, we find small, distinct strokes that hover on the surface of the canvas, divorced from the very forms they are meant to describe. Yet, from a few feet away, the myriad brushstrokes evoke an overall impression of silk or fur or flowers. This method would be the foundation of a movement called Impressionism some two centuries later. In his pursuit of realism, Velázquez truly was an artist before his time.

Flanders

After the dust of the Reformation settled, the region of Flanders was divided. The northern sections, now called the Dutch Republic (present-day Holland), accepted Protestantism, whereas the southern sections, still called Flanders (present-day Belgium), remained Catholic. This separation more or less dictated the subjects that artists rendered in their works. Dutch artists painted scenes of daily life, carrying forward the tradition of Bruegel, whereas Flemish artists continued painting the religious and mythological scenes already familiar to us from Italy and Spain.

PETER PAUL RUBENS Even the great power and prestige held by Velázquez were exceeded by the Flemish artist Peter Paul Rubens (1577–1640). One of the most sought-after artists of his time, Rubens was an ambassador, diplomat, and court painter to dukes and kings. He ran a bustling workshop with numerous assistants to help him complete commissions. Rubens's style combined the sculptural qualities of Michelangelo's figures with the painterliness and coloration of the Venetians. He also emulated the dramatic **chiaroscuro** and theatrical presentation of subject matter we found in the Italian Baroque masters. Much as Dürer had, Rubens admired and adopted from his southern colleagues. Although Rubens painted portraits, religious subjects, and mythological themes, as well as scenes of adventure, his canvases were always imbued with the dynamic energy and unleashed passion we link to the Baroque era.

In *The Rape of the Daughters of Leucippus* (**Fig. 15.16**), Rubens recounts a tale from Greek mythology in which two mortal women were seized by the twin sons of Zeus, Castor and Pollux. The action in the composition is described by the intersection of strong diagonals and verticals that stabilize the otherwise unstable composition. Capitalizing on the Baroque "stop-action" technique, which depicts a single moment in an event, Rubens placed his struggling, massive forms within a diamond-shaped structure that rests in the foreground on a single point—the toes of a man and a woman. Visually, we grasp that all this energy cannot be supported on a single point, so we infer continuous movement. The action has been pushed up to the picture plane, where the viewer is confronted with

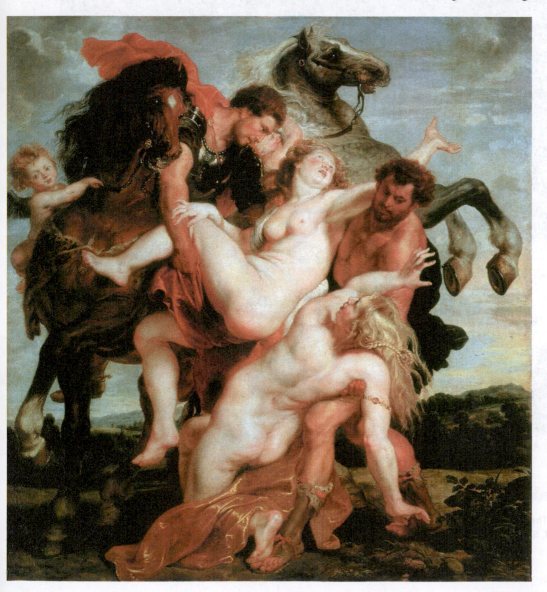

◄ **15.16 Peter Paul Rubens,** *The Rape of the Daughters of Leucippus,* **1617. Oil on canvas, 88¼" × 72⅞" (224 × 211 cm). Alte Pinakothek, Munich, Germany.** Rubens's canvas is flooded with action. As is typical with Rubens, the women have ample, delicately colored flesh.

the intense emotion and brute strength of the scene. Along with these Baroque devices, Rubens used color and texture much in the way the Venetians used it. The virile, suntanned arms of the abductors contrast strongly with the delicately colored flesh of the women. The soft blond braids that flow outward under the influence of all of this commotion correspond to the soft, flowing manes of the overpowering horses.

ANTHONY VAN DYCK Paintings on a large scale required the help of assistants, and there is no doubt that in Rubens's workshop much of the preliminary work was done by his staff. One of the many artists employed for this purpose eventually became as much in demand for portraits of the aristocracy as his former master. Anthony van Dyck (1599–1641) spent two years (1618–1620) with Rubens before beginning his career as an independent artist. Although from time to time he painted religious subjects, his fame rests on his formal portraits, many of which were produced during the years he spent in Italy and England.

Van Dyck's refined taste equipped him for satisfying the demands of his noble patrons that they be shown as they thought they looked, rather than as they actually were. It is certainly difficult to believe that any real-life figure could have had quite the haughty bearing and lofty dignity of Marchesa Cattaneo in van Dyck's portrait of her (**Fig. 15.17**), although the Genoese nobility of which she was a member was known for its arrogance.

International celebrities like Rubens and van Dyck, at home at the courts of all Europe, were far from typical of northern artists. Painters in the Dutch Republic in particular found themselves in a very different situation from their colleagues elsewhere. The two most lucrative sources of commissions—the church and the aristocracy—were unavailable to them because the Dutch Calvinist Church followed the post-Reformation practice of forbidding the use of images in church and because the Dutch Republic had never had its own powerful hereditary nobility. Painters therefore depended on the tastes and demands of the open market.

The Dutch Republic

The grandiose compositional schemes and themes of action executed by Rubens could not have been further removed from the concerns and sensibilities of most 17th-century Dutch artists. Whereas mysticism and religious naturalism flourished in Italy, Flanders, and Spain amid the rejection of Protestantism and the invigorated revival of Catholicism,

artists of the Dutch Republic turned to secular art, abiding by the Protestant mandate that humans not create false idols. Artists turned to scenes of everyday life, and the collectors of art were everyday folk. In the Dutch quest for the establishment of a middle class, aristocratic patronage was lost and artists were forced to peddle their wares in the free market. Landscapes, still lifes, and genre paintings were the favored canvases, and *realism* was the word of the day. Although the subject matter of Dutch artists differed radically from that of their colleagues

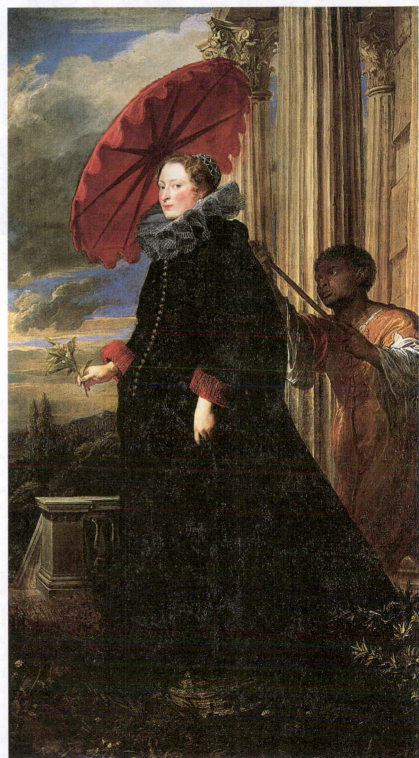

▶ **15.17** Anthony van Dyck, *Marchesa Elena Grimaldi, Wife of Marchese Nicola Cattaneo*, ca. 1623. Oil on canvas, 84⅞" × 48½" (242.9 × 138.5 cm). National Gallery of Art, Washington, DC. The portrait uses generally somber colors and an artificial setting to accentuate the grandeur of van Dyck's subject.

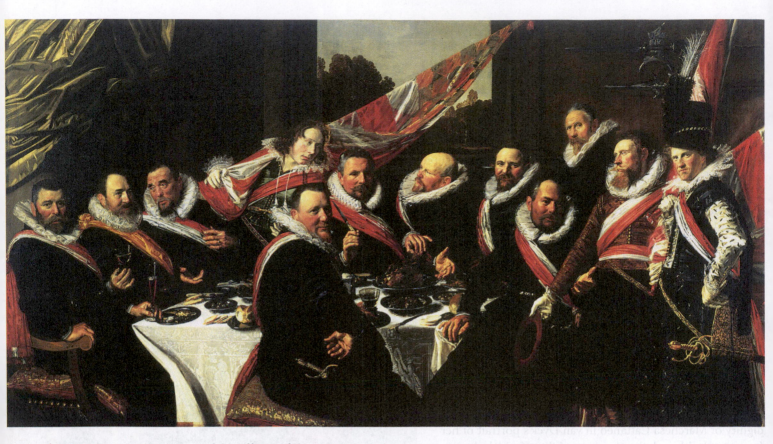

▲ **15.18** Frans Hals, *Banquet of the Officers of the Civic Guard of Saint George at Haarlem*, 1616. Oil on canvas, 60⅞" × 96⅜" (179 × 257.5 cm). Frans Hals Museum, Haarlem, The Netherlands. The "action" of the sitters thrusts from lower left to upper right as the viewer's eye follows the diagonals made by the flag. The sitters are spread out evenly across the canvas and, interestingly, do not all appear to be posing for the painting.

elsewhere in Europe, the spirit of the Baroque, along with many, if not most, of its artistic characteristics, was present in their work.

FRANS HALS One highly profitable source of income for Dutch artists in the 17th century was the group portrait, in particular that of a militia or civic-guard company. These bands of soldiers had originally served a practical purpose in the defense of their country, but their regular reunions tended to be social gatherings, chiefly for the purpose of eating and drinking. A group of war veterans today would hire a photographer to commemorate their annual reunion; the militia companies engaged the services of a portrait painter. If they were lucky or rich enough, they might even get Frans Hals (ca. 1581–1666), whose group portraits capture the individuality of each of the participants while conveying the general convivial spirit of the occasion, as in *Banquet of the Officers of the Civic Guard of Saint George at Haarlem* (**Fig. 15.18**). Hals was certainly not the most imaginative or inventive of artists, but his sheer ability to paint, using broad, dynamic brushstrokes and cleverly organized compositions, makes his work some of the most attractive of that period.

REMBRANDT VAN RIJN The golden-toned, subtly lit canvases of Rembrandt van Rijn (1606–1669) possess a certain degree of timelessness. Rembrandt concentrated on the personality of the sitter or the psychology of a particular situation rather than on surface characteristics. This introspection is evident in all of his works, whether religious or secular in subject, landscapes or portraits, drawings, paintings, or prints.

Rembrandt painted many self-portraits that offer us an insight into his life and personality. In a self-portrait at age 46 (**Fig. 15.19**), Rembrandt paints an image of himself as a self-confident, well-respected, and sought-after artist who stares almost impatiently out toward the viewer. It is as if he has been caught in the midst of working and has but a moment for us. It is a powerful image, with piercing eyes, thoughtful brow, and determined jaw that betray a productive man who is more than satisfied with his position in life. All of this may seem obvious, but notice how few clues he gives us to reach these conclusions about his personality. He stands in an undefined space with no props that reveal his identity. The figure is cast into darkness; we can hardly discern his torso and hands resting in the sash around his waist. The penetrating light in the canvas is reserved for just a portion of the artist's face. Rembrandt gives

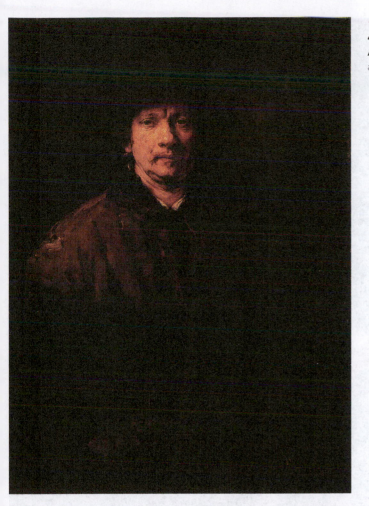

◀ **15.19** Rembrandt van Rijn, *Self-Portrait*, 1652. Oil on canvas, 44" × 32" (112 × 81.5 cm). Kunsthistorisches Museum, Vienna, Austria. This particular self-portrait, painted in early middle age, shows the artist as confident and respected, satisfied with his position in life.

us a minute fragment with which he beckons us to complete the whole. It is at once a mysterious and revealing portrayal that relies on a mysterious and revealing light.

Rembrandt also painted large group portraits, such as *The Anatomy Lesson of Dr. Nicolaes Tulp* (**Fig. 15.20**). In *Banquet of the Officers of the Civic Guard of Saint George at Haarlem* (see again Fig. 15.18), Frans Hals chose to spread his group evenly across his portrait. Rembrandt, however, clustered the doctor's students—members of the surgeon's guild that had commissioned the work—on the left side of the painting. Some of them are caught in the moment of pushing inward for a better view. The doctor gestures with his left hand; he is holding forth. The color of the cadaver makes it look as dead as can be. The student at the center top gazes directly out of the painting, at the viewer, as if to say "We're really here." The cadaver's feet are mercifully shaded so they will not protrude from the painting. The "spotlight" is on his body, especially his dissected arm. Rembrandt, master of light and shade, has much of the outer parts of the painting disappear into blackness. We see what Rembrandt wants us to see.

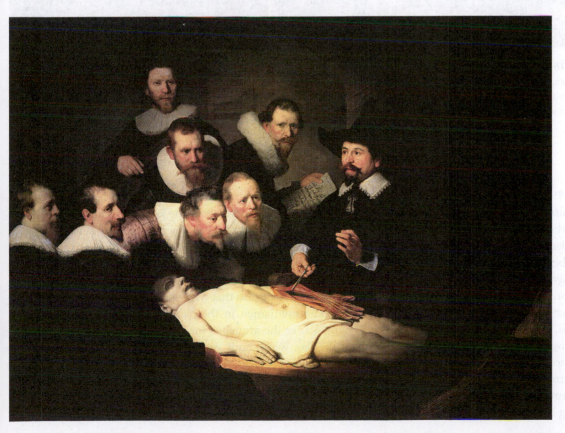

◀ **15.20** Rembrandt van Rijn, *The Anatomy Lesson of Dr. Nicolaes Tulp*, 1632. Oil on canvas, 67" × 85¼" (170 × 217 cm). The Royal Picture Gallery Mauritshuis, The Hague, The Netherlands. The painting, commissioned by the surgeon's guild, groups the onlookers at the left, with some pressing in for a better view.

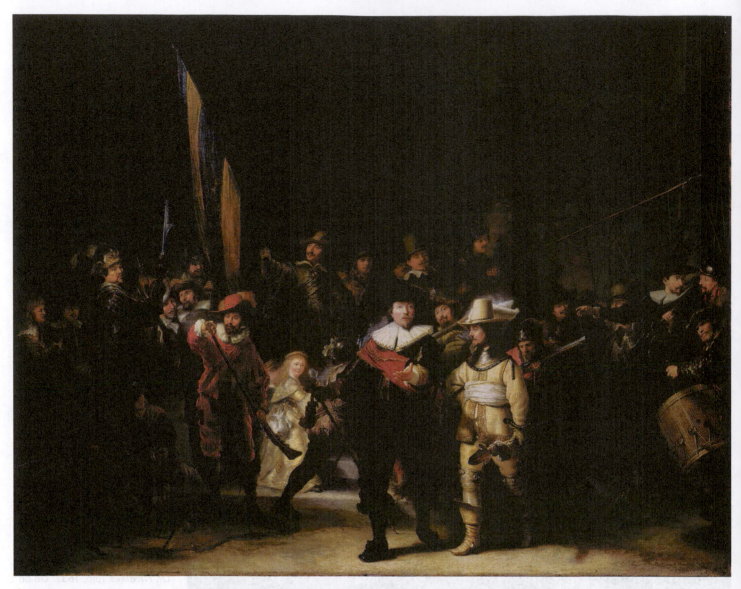

▲ **15.21** Rembrandt van Rijn, *The Company of Frans Banning Cocq and Willem van Ruytenburch (The Night Watch)*, 1642. Oil on canvas, 141 ½" × 170 ½" (363 × 437 cm). Rijksmuseum, Amsterdam, The Netherlands. Recent cleaning has revealed that the painting's popular name, though conveniently brief, is inaccurate. Far from being submerged in darkness, the principal figures were originally bathed in light and painted in glowing colors.

The Night Watch (**Fig. 15.21**), along with Leonardo da Vinci's *Mona Lisa (La Gioconda)* (see Fig. 13.4), is one of the most famous and familiar works in the history of Western art. The Rijksmuseum in Amsterdam, where it hangs today, writes on its website that this is the best-known painting in its collection. But its name is not *The Night Watch*. It is actually called *The Company of Frans Banning Cocq and Willem van Ruytenburch*, and it is a militia painting—that is, another group portrait, this time of a part of the civic guard. In Baroque fashion, Rembrandt did not paint the group in a row or sitting for their annual banquet. Instead, he painted a moment in time, when Cocq has issued the order for the militia to march and they are being organized for action. Rembrandt emphasized movement through a masterful use of foreshortening in which Cocq's left hand seems

to leap out of the painting. Rembrandt used light and shade to focus the viewer's attention on the key figures in the forefront of the painting, Cocq and his lieutenant van Ruytenburch. Although the recesses of implied depth in the painting fall into shade, they are darker than the artist intended, which is how the painting became dubbed *The Night Watch*. Much of the darkness results from layers of varnish that were applied to the surface.

The militiamen in the painting are the Arquebusiers, so named after the arquebus (or *harquebus*), a long-barreled gun of the day. Rembrandt worked the emblem of the group into the painting by having the girl in the foreground carry the symbols of the group, including chicken claws. The painting of the militia was to be hung in the Arquebusiers hall. It was hung alongside other canvases, and since then, it has been moved a

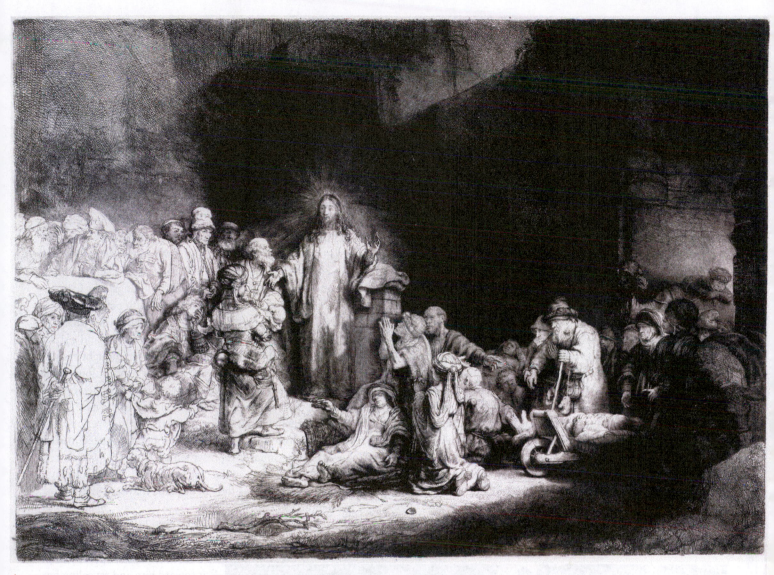

▲ **15.22** Rembrandt van Rijn, *Christ with the Sick around Him, Receiving the Children* (the Hundred-Guilder Print), ca. 1649. Etching, 11" × 15 ¼" (27.9 × 38.8 cm). Pierpont Morgan Library, New York, New York. In this small print, the lame and the blind are scattered all around the Messiah, some bleached in powerful light and others lost in shade.

couple of times. It has not gone without being damaged: it was first moved from the militia's hall to the town hall, where it was cut down, especially on the left side, because it was too large to be hung as it was.

As we saw in the painterly technique of Velázquez, Rembrandt's images are more easily discerned from afar than from up close. As a matter of fact, Rembrandt is reputed to have warned viewers to keep their noses out of his paintings because the smell of paint was bad for them. We can take this to mean that the technical devices Rembrandt used to create certain illusions of realism are all too evident from the perspective of a few inches. Above all, Rembrandt was capable of manipulating light. His is a light that alternately constructs and destroys, bathes and hides from view. It is a light that can be focused as unpredictably, and that shifts as subtly, as the light we find in nature.

We find similar shifts in light in Rembrandt's etching *Christ with the Sick around Him, Receiving the Children* (the Hundred-Guilder Print) (**Fig 15.22**). Despite the details in the etching, it is a small work, only 15 inches wide. The name Hundred-Guilder Print has stuck because that amount of money—the price for which the etching sold—was 10 percent of the price of a decent house in mid-17th-century Holland. The etching shows that Rembrandt also had an interest in religious subjects, which increased as he passed the years. But Rembrandt's piety reveals a human and humane Jesus, preaching to and comforting those most in need—the lame, the blind, and the young. The composition shows a striking arrangement of figures—some standing, some kneeling, some lying down—and a dog who is apparently unconcerned with matters of the soul, because he has presented his behind to the Messiah. Dazzling divine light bathes the

COMPARE + CONTRAST

Vision and Difference: Three Paintings Entitled *Susanna and the Elders*

Artemisia Gentileschi once said, in reaction to being cheated out of a potentially lucrative commission, "If I were a man, I can't imagine it would have turned out this way." The statement might as easily be applied to an analysis—and gendered interpretation—of the subject of Susanna and the Elders, as painted by three different artists: Tintoretto, Artemisia Gentileschi, and Rembrandt.

The story of Susanna is found in the book of Daniel. Susanna was the wife of Joachim, a wealthy Babylonian Jew whose home was frequented by judges and elders of the community. Susanna was as pious as she was enchantingly beautiful. One day, while she was bathing in her garden, two of these elders surreptitiously observed her and then made sexual advances, warning her that if she refused them, they would accuse her publicly of having an affair with a young man. When Susanna did not comply, they made good on their threat and she was put on trial for the fictitious accusations. Just as she was about to be found guilty, Daniel appeared in the court of justice and suggested that the elders be cross-examined out of earshot of one another to determine whether their individual testimonies corroborated each other. They did not. Susanna was found innocent, and her accusers were stoned to death for bearing false witness. Justice was served, and good triumphed over evil.

How might an artist visualize this story? What impression would an artist wish to convey about the protagonists, and what types of pictorial devices might an artist use to skew a narrative? The paintings of Susanna and the Elders offer some contrasting and illuminating answers to these questions. Tintoretto's rendering of Susanna (**Fig. 15.23**) befits her status as the wife of a wealthy man but also suggests that she likes beautiful things. Her hair is elaborately braided, and she is adorned with pearl earrings and golden bracelets. At her feet, which she dries with a sensuous silken cloth, are a silver perfume bottle and a strand of pearls that look as though they have been thoughtlessly tossed aside. Bathing in the surrounds of a sumptuous, fertile garden, Susanna admires herself in a mirror propped up against a privacy screen covered in vines and flowers. Our focus is drawn entirely to her, as are the prying eyes of one of the lecherous old men, peeping around the screen in the lower left. Susanna, as represented by Tintoretto, seems anything but pious. On the contrary, in her wanton display of vanity, it appears as though Susanna may have enticed seduction.

In Rembrandt's *Susanna and the Elders* (**Fig. 15.24**), one of the leering elders grabs at the white cloth wrapped around Susanna's body, pulling it toward him and revealing her naked torso. The physical act, as it unfolds so close to us, is menacing, disturbing. But what first appears to be an empathic rendering of Susanna's plight and a condemning view of her assailants is partially vitiated by other details. We are drawn into the painting by Susanna's eye contact with us, but her facial expression does not beseech us to help her. She perhaps looks

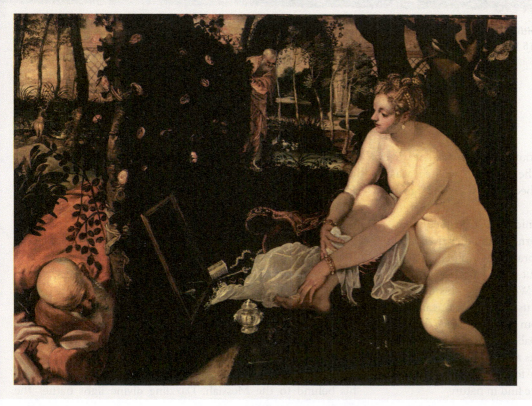

◀ **15.23** Tintoretto, *Susanna and the Elders*, 1555–1556. Oil on canvas, 57¾" × 76¼" (146 × 193.6 cm). Kunsthistorisches Museum, Vienna, Austria. Tintoretto's Susanna is surrounded by jewelry and other stereotypical ornaments of feminine vanity.

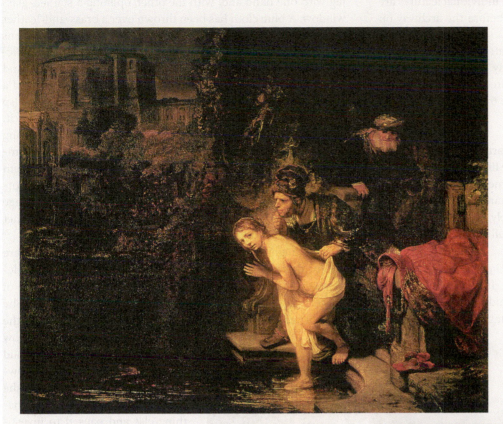

◀ **15.24** Rembrandt van Rijn, *Susanna and the Elders*, 1647. Oil on mahogany panel, 30¼" × 36⅝" (77 × 93 cm). **Gemäldegalerie der Staatlichen Museum, Berlin, Germany.** In Rembrandt's mysterious version of Susanna's plight, the victim looks surprised but not necessarily distressed. A severe light shows her garment being torn from her.

▼ **15.25** Artemisia Gentileschi, *Susanna and the Elders*, 1610. Oil on canvas, 66⅞" × 46⅞" (170 × 119 cm). **Kunstsammlungen Graf von Schönborn, Wiesentheid, Germany.** Gentileschi's Susanna is a victim, a victim who cannot be blamed for the voyeurs' crimes.

surprised, but not distressed. Her cowering body position may lead us to view Susanna as innocent, discreet, ashamed, but Rembrandt placed other things in the painting that may lead us to draw another conclusion about her. She has pearls in her hair and wears a gold bracelet; off to the side are small, satin slippers and a sumptuous red cloak embellished with gold detail.

Artemisia Gentileschi tells the same story but from a dramatically different perspective (**Fig. 15.25**). Her Susanna does not lounge at leisure in a lush garden or dip delicately into a secluded pool. She is trapped in a claustrophobic space, her naked flesh set against hard, cold stone. The men whisper to each other and swoop down on her, threatening her with their proposition. Her body position—a twisting, turning Z shape— is uncomfortable and awkward, even painful to behold. The expression on Susanna's face is undeniably tormented as she pushes them away from her ears. Gentileschi's Susanna wears no jewelry, has no luxurious trappings surrounding her. The cloth draped over her thigh is not a sensuous prop; it simply looks like a towel.

Faced with a narrative to be rendered, artists always make choices. We can assume that the particular elements of a painting are there for a reason. Ask yourself: What are those choices? Why might the artist have made them? Aside from the story, or *text*, of the work of art, is the artist trying to convey some other message (that is, a *subtext*)? What do these choices say about the artist, or the patron, or the gender ideology of the day? And in these works in particular, are there interpretations to be made that reveal gender differences in the representation of familiar subjects?

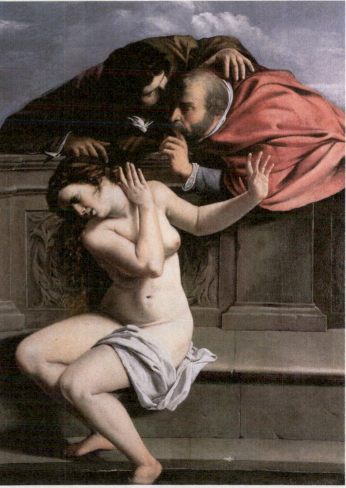

figures on the left, so much so that many individual features are bleached out. In contrast, figures in or before the archway on the right are partly lost in shade.

Although Rembrandt was sought after as an artist for a good many years and was granted many important commissions, he fell victim to the whims of the free market. The grand master of the Dutch Baroque died at age 63, out of fashion and penniless.

JAN VERMEER If there is a single artist who typifies the Dutch interest in painting scenes of daily life, the commonplace narratives of middle-class men and women, it is Jan Vermeer (1632–1675). Although he did not paint many pictures and never strayed from his native Delft, his precisely sketched and pleasantly colored compositions made him well respected and influential in later centuries.

Young Woman with a Water Jug (Fig. 15.26) exemplifies Vermeer's subject matter and technique. In a tastefully underfurnished corner of a room in a typical middle-class household, a woman stands next to a rug-covered table, grasping a water jug with one hand and, with the other, opening a stained-glass window. A blue cloth has been thrown over a brass-and-leather chair, a curious metal box sits atop the table, and a map adorns the wall. At once we are presented with opulence and simplicity. The elements in the composition are perfectly balanced and serene. One senses that their positions could not be moved a fraction of an inch without disturbing the composition. Crisp lines grace the space in the painting rather than interrupt it. The shadows in the painting are rendered in color, displaying the artist's recognition that objects in shadow display a complexity of hues; they are not featureless and black. Every item in the painting is of a simple, almost timeless form and corresponds to the timeless tranquility of the porcelainlike image of the woman. Her simple dress and starched collar and bonnet epitomize grace and peace.

We might not see this as a Baroque composition if it were not for three things: the single source of light bathing the elements in the composition, the genre subject, and the sense of mystery captured by Vermeer. What is the woman doing? She has opened the window and taken a jug into her hand at the same time, but we will never know for what purpose. Some have said that she may intend to water flowers at a window box. Perhaps she was in the midst of doing something else and paused to investigate a noise in the street. Vermeer gives us a curious combination of the momentary and the eternal in this almost photographic glimpse of everyday Dutch life.

France

During the Baroque period, France, under the reign of the Sun King, Louis XIV, began to replace Rome as the center of the art world. The king preferred classicism; so, too, did the country, and painters, sculptors, and architects alike created works in this vein. Louis XIV guaranteed adherence to classicism by forming

◀ **15.26** Jan Vermeer, *Young Woman with a Water Jug*, ca. 1665. Oil on canvas, 18" × 16" (45.7 × 40.6 cm). Metropolitan Museum of Art, New York, New York. The setting is securely upper middle class. Everything is under control. The box on the table lends a minor air of mystery.

academies of art that perpetuated this style. These academies were art schools of sorts, run by the state, whose faculties were populated by leading proponents of the classical style. When we examine European art during the Baroque period, we thus perceive a strong stylistic polarity. On the one hand, we have the exuberant painterliness and high drama of Rubens and Bernini, and on the other hand, a reserved classicism that hearkens back to Raphael.

NICOLAS POUSSIN The most renowned French painter of the 17th century, Nicolas Poussin (ca. 1594–1665), echoed this French preference for restraint when he decisively rejected the innovations of Caravaggio, whose works he claimed to detest. He saw his own work as a kind of protest against the excesses of the Baroque, but a strong dislike of his Roman contemporaries did not prevent Poussin from spending most of his life in Rome. It may seem strange that so French an artist should

have chosen to live in Italy, but what drew him there was the art of ancient, not Baroque, Rome. Poussin's only real and enduring enthusiasm was for the world of Classical antiquity. His friends in Rome included the leading antiquarians of the day, and his paintings often expressed a nostalgic yearning for a long-vanished past.

Poussin's *The Abduction of the Sabine Women* (**Fig. 15.27**) was painted four years before he was summoned back to France by the king. It illustrates the Baroque classicism that Poussin would bring back to his native country. The flashy dynamism of Bernini and Rubens gives way to a more static, almost staged motion in the work of Poussin. Harshly sculptural, Raphaelesque figures thrust in various directions, forming a complex series of intersecting diagonals and verticals. The initial impression is one of chaos, of unrestrained movement and human anguish. But as was the case with the Classical Greek sculptors and Italian Renaissance artists, emotion is always balanced carefully with

▼ **15.27** Nicolas Poussin, *The Abduction of the Sabine Women*, ca. 1636–1637. Oil on canvas, 60⅞" × 82⅝" (154.6 × 209.9 cm). **Metropolitan Museum of Art, New York, New York.** At the time of this painting, Poussin was strongly influenced by the ancient sculptures he had studied in Rome, most notably the careful depiction of the musculature of the figures.

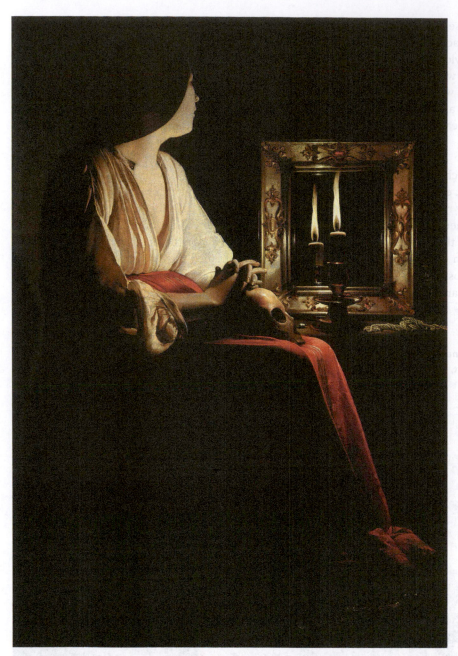

◀ **15.28** Georges de La Tour, *The Penitent Magdalen*, ca. 1640. Oil on canvas, 52½" × 40¼" (133.4 × 102.2 cm). Metropolitan Museum of Art, New York, New York. The symbols in the painting represent a meditation upon loss and death.

have served to glorify that most autocratic and magnificent of monarchs, Louis XIV (born 1638, reigned 1643–1715). For the most part, the king had only second-rate artists available to him at court.

GEORGES DE LA TOUR France was a Catholic country during the Baroque period, and some 17th-century French painters were occupied with religious themes. Among them was Georges de La Tour (1593–1652), whose paintings suggest a familiarity with Caravaggio's depiction of light, particularly Tenebrism. La Tour's works frequently display a single source of light, such that those parts of his subjects who are bereft of that light disappear into the shadows. His *The Penitent Magdalen* (**Fig. 15.28**) shows Mary Magdalene in a pensive mood, reflecting, perhaps, on her carnal sins or on the passing of her beloved Jesus. The symbolism in the painting suggests inner conflict—the mirror symbolizing vanity, the skull symbolizing mortality, and the candle, perhaps, symbolizing spiritual enlightenment. What is signified by the reflection of the candle in the mirror? Although the lighting in the piece may recall Caravaggio, the feeling tone with La Tour here is reflective, not passionate.

VERSAILLES Louis XIV's taste for the Classical extended to architecture, as seen in the Palace of Versailles (**Fig. 15.29**). Originally the site of the king's hunting lodge, the palace and surrounding area just outside Paris were converted by a host of artists, architects, and landscape designers into one of the grandest monuments to the French Baroque. In their tribute to Classicism, the architects Louis Le Vau (1612–1670) and Jules Hardouin-Mansart (1646–1708) divided the horizontal sweep of the façades into three stories. The structure was then divided vertically into three major sections, and these were in turn subdivided into three additional sections. The windows march along the façade in a rhythmic beat, accompanied by rigid pilasters that are wedged between the strong horizontal bands delineating the floors. A balustrade tops the palace, further emphasizing the horizontal sweep while restraining any upward movement suggested by the building's vertical members. The divisions into classically balanced threes and the almost obsessive emphasis on the horizontal echo the buildings

restraint. For example, the pitiful scene of the old woman in the foreground, flanked by crying children, forms part of the base of a compositional triangle that stabilizes the work and counters excessive emotion. If one draws a vertical line from the top of her head upward toward the top border of the canvas, one encounters the apex of this triangle, formed by the swords of two Roman abductors. The sides of the triangle, then, are formed by the diagonally thrusting torso of the muscular Roman man in the right foreground and the arms of the Sabine women on the left, reaching hopelessly into the sky. This compositional triangle, along with the Roman temple in the right background that prevents a radically receding space, are Renaissance techniques for structuring a balanced composition. Poussin used these, along with a stagelike, theatrical presentation of his subjects, to reconcile the divergent styles of the harsh Classical and the vibrant Baroque.

Even had Poussin been prepared to leave Rome and return to the French court, the austere nature of his art would hardly

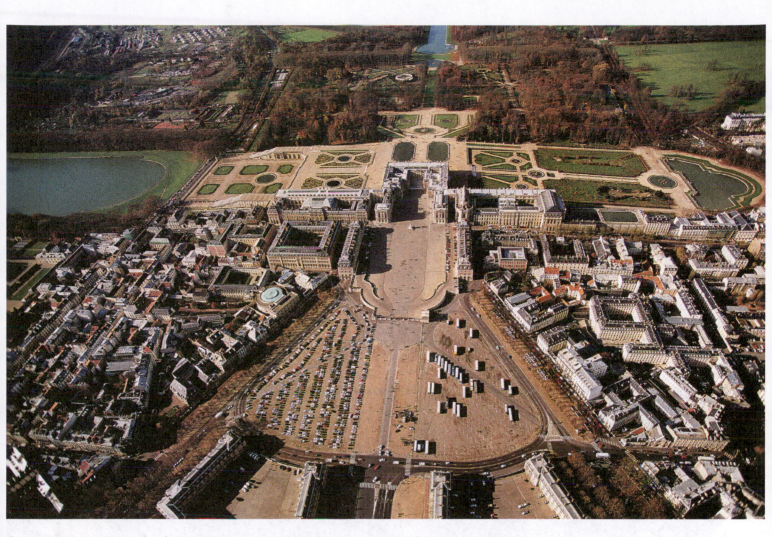

▲ **15.29 Palace of Versailles, begun 1669, and the gardens (looking northwest), Versailles, France.** The chief architects for the last stage of construction at Versailles were Louis Le Vau and Jules Hardouin-Mansart. Although the external decoration of the palace is Classical in style, the massive scale (1935' wide) is characteristic of Baroque architecture.

of Renaissance architects. The French had come a long way from the towering spires of their glorious Gothic cathedrals!

THE HALL OF MIRRORS The Palace of Versailles was conceived by the king in political terms. The architects' task, both inside and out, was to create a building that would illustrate Louis XIV's symbolic concept of himself as the Sun King. Thus, each morning the king would rise from his bed, make his way past the assembled court through the Hall of Mirrors (see **Fig. 15.30** on p. 524), where the 357 mirrors that decorated the 17 arches across from the windows reflected both the daylight and his own splendor, and enter the gardens along the main wing of the palace—laid out on an east–west axis to follow the path of the sun. At the same time, both the palace and its gardens, which extend behind it for some two miles, were required to provide an appropriate setting for the balls, feasts, and fireworks displays organized there.

Given the grandiose symbolism of the ground plan and interior decorations, the actual appearance of the outside of the Palace of Versailles, with its rows of Ionic columns, is surprisingly modest. The simplicity of design and decoration is another demonstration of the French ability to combine the extremes of Baroque art with a more Classical spirit.

England

A scant few years into the 17th century, Queen Elizabeth I died, thereby bringing to a close the Elizabethan era and the Tudor dynasty that had produced five sovereigns for England. Elizabeth's was also the last "singular" reign of England; thereafter, the separate thrones of England and Scotland would be joined under the title of King (or Queen) of the United Kingdom. The first monarch of the United Kingdom was, thus, both James I of England and James IV of Scotland. His was known as the Jacobean era.

At the dawn of the 17th century, Shakespeare had written some of his most famous plays—including *Hamlet* (1600), *Othello* (1604), *King Lear* and *Macbeth* (1605), and *Antony and*

Cleopatra (1606)—for his Globe Theatre (see Fig. 14.24). But dozens of Jacobean era performances were held in the Whitehall Banqueting House, constructed during the reign of Henry VIII and still standing three years after Shakespeare's death. In 1619, after a fire that virtually razed the building, James I commissioned Inigo Jones (1673–1652) to design the Whitehall Banqueting House that we see today. In the 17th century, it was in the realm of architecture that the British excelled, and its two most significant contributors were Inigo Jones and Christopher Wren.

INIGO JONES With his adaptation of Italian Renaissance designs and motifs in his designs for London buildings, Inigo Jones brought the revival of classicism to the medieval city. The block-like plan of the Banqueting House at Whitehall features many familiar characteristics (**Fig. 15.31**). The symmetrical alignment of windows, repetition of architectural elements (engaged columns, pilasters, arches, and pediments), references to the Doric and Corinthian architectural orders, and the balustrade pay homage in a creative way to buildings such as St. Peter's (see Fig. 15.4) and the villas designed by Palladio (see Fig. 13.22). Jones carried many of these elements into the interior of the Banqueting House, creating elegant and dignified formal spaces. His serene style provided a strong visual contrast to the elaborate *masque* productions held therein, as well as to three Flemish Baroque-style paintings by Peter Paul Rubens depicting the *Apotheosis of James I*, *The Union of the Crowns*, and *The Peaceful Reign of James I*.

▼ **15.30 Hall of Mirrors (Galerie des Glaces), begun 1676, Palace of Versailles. Versailles, France.**
Seventeen arches, each with 21 mirrors, reflect the arcaded windows that overlook the gardens as they descend toward and around a human-made lake.

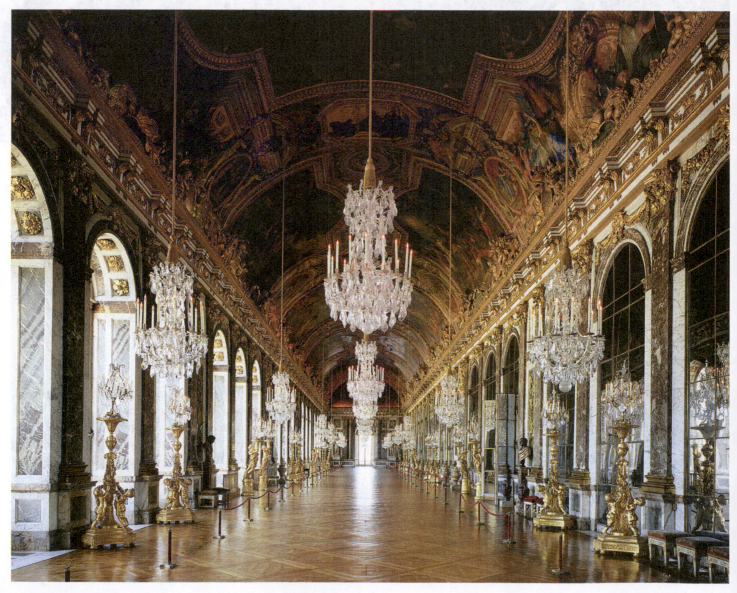

◀ **15.31** **Inigo Jones, Banqueting House at Whitehall, 1619–1622. London, United Kingdom.** The design repeats Classical elements such as windows separated by engaged columns and an overall balance of horizontal and vertical lines.

CONNECTIONS Peter Paul Rubens is ensconced in the history of art as the most important Flemish artist of the 17th century—rival to no one, heir to the legacy of the Italian masters of the Late Renaissance and Baroque in Italy, and originator and leading representative of the flamboyant Baroque style in the North. His were the most important patrons of the day, including King Philip IV of Spain, Queen Marie de' Medici of France, and Charles I of England. Rubens ran an enormous studio practice with many assistants in order to keep up with the demands of commissions and to keep projects in process during his long absences from Flanders. Rubens was more than a successful painter. He was also the confidant of kings, an international diplomat, and—in the courts of Spain and England—a knight.

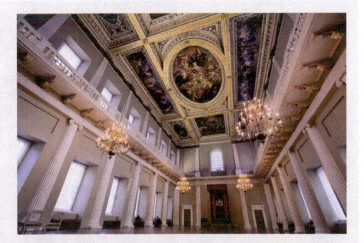

Among the works that were commissioned by Philip IV of Spain for his Alcazar palace were 18 hunting or battle scenes between men and animals and four paintings with antique subjects. And for England's Charles I, he lavishly decorated the ceiling in the Banqueting House of Whitehall Palace with nine paintings about his father's, King James I's, life that conveyed Charles's steadfast assertion of the Divine Right of Kings—the belief that no monarch is subject to earthly authority but derives the right to rule from God. It was that position that led to Charles's execution for treason under Oliver Cromwell in 1649 on a scaffold built outside the window in the room that holds, to this day, Rubens's only surviving *in situ* mural (the others are in museum collections worldwide).

A curious fact: The measurements for the ceiling space had been compulsory, but because Flanders and England used different systems, the paintings did not fit and required much on-site alteration of the canvases.

CHRISTOPHER WREN In 1666, the Great Fire of London destroyed the medieval city and threatened White Hall Palace of which the Banqueting Hall was a part. Christopher Wren, an architect who, at the age of 25, was a professor of astronomy, transitioned to a career in architecture and emerged as a figure who reshaped the character of the city, principally through his designs for churches—many of which had been gutted in the conflagration. His most famous is certainly Saint Paul's Cathedral (Fig. 15.32), the reconstruction of which was commissioned by King Charles II. It is a beloved symbol of the city of London to this day.

Influenced by Italian and French Baroque architecture, Wren reconciled the problematic relationship of the classical pedimented façade to the hemispherical dome that we first encountered in the Baroque expansion of Saint Peter's in Rome. He did this by placing tall bell towers on either side of the façade to soften the visual transition from the horizontal emphasis of the two-storied elevation to the vertical rise of the massive dome a nave length's away. Wren's design stands midway between the organic, flowing designs of the Italian Baroque and the strict classicism of the French Baroque, integrating both in a reserved, but not rigid, composition.

The dome of Saint Paul's is the world's second-highest, at 361 feet (Saint Peter's is higher). Inside the dome is the so-called Whispering Gallery; the acoustics enable visitors who whisper against its walls to be heard on the opposite side of the dome. The interior is richly embellished with marble inlays, frescoes, mosaics, and wrought iron. In addition to its stature as an architectural masterpiece, Saint Paul's holds a precious place in British memory. Winston Churchill took extraordinary measures to protect it from the Nazi bombing raids during World War II. The church survived amidst a virtually ruined city.

The American Colonies

During the 17th century, European powers continued to colonize the Western Hemisphere and compete for land, resources,

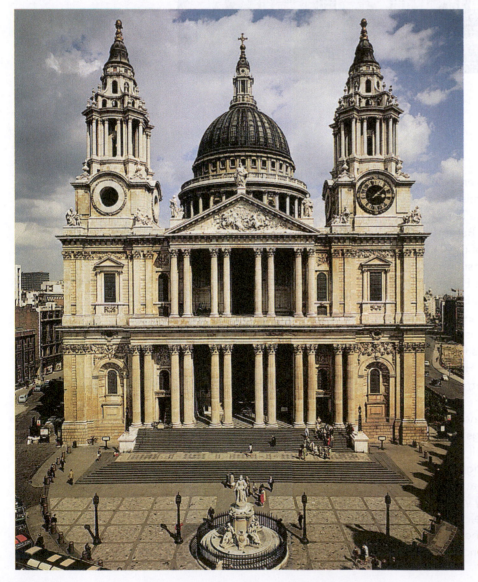

◀ **15.32** Sir Christopher Wren, Saint Paul's Cathedral, 1675–1710. London, United Kingdom. Wren reconciled the architectural relationship between the classical façade and the dome by placing tall bell towers on either side of the façade.

RELIGION

The Puritans

The Puritans who settled the Massachusetts Bay Colony were a particularly radical group of English religious dissidents and reformers whose mission it was to rid the Church of England from any vestiges of Roman Catholic ritual and dogma and to be able to practice freely their unbending, rigorous form of Protestantism. The groundwork for the discontent among the Puritans was first laid by Henry VIII's repudiation of the authority of the pope in Rome; it resulted in the desire to "purify" their religion by taking their instruction directly from the Bible and no other source—neither pope nor priest. Puritans in increasing numbers grew fiercely antagonistic toward the Church of England, and it was against this backdrop that mass immigrations of Puritan families to the Massachusetts Bay Colony occurred in the early decades of the 17th century after receiving a royal charter to do so in 1629. It must be remembered that the Puritan intention was to reform the Church of England from within and, in so doing, to purify the faith and institution of Protestantism back home, too.

The Puritans followed the teachings of John Calvin (see Chapter 14) that God is omniscient (all-knowing) and omnipotent (all powerful) and that the entire panoply of human existence is laid out before Him, and with His approval. Therefore, all is predestined, including the election (by God) of those who will ascend to heaven and those who will fall into the fiery pit of hell. Why, then, bother to be good, when one's own behavior will not determine one's fate? The Puritan answer was that by living a righteous life, one could develop a personal *conviction* of salvation and thus proceed on the assumption that one would, in fact, be rewarded rather than punished.

Puritanism was not the only strain of religious thought in the New World. Roger Williams (1603–1683) was ordained a minister of the Church of England but became a Puritan and joined the Massachusetts Bay Colony in 1631, two years after it was founded. However, he soon took exception to what he saw as the Puritans' intolerance as well as their confiscation of Native American territory. As a result of his dissident preaching, he was banished from Massachusetts and founded the colony of Rhode Island in 1636. Departing from the Puritan version of Protestantism, he became a Baptist and established the first Baptist church in the United States. He continued to argue for tolerance of other religions and the separation of church and state. Rhode Island Colony became a haven for early Jewish and Quaker settlers, and various religious minorities.

Puritanism, meanwhile, continued to roil the religious waters in Massachusetts Bay and spread throughout northern New England. Religious orthodoxy, and fear of outside influences, led to the infamous Salem, Massachusetts witch trials—and executions—of 1692–1693. Two classic works about the turbulent days of Puritanism remain very much with us: Nathaniel Hawthorne's *The Scarlet Letter* (1850) and Arthur Miller's *The Crucible* (1953). *The Scarlet Letter* (see Chapter 20) tells the story of Hester Prynne, a Puritan woman, and the consequences of bearing a child out of wedlock. *The Crucible* dramatizes the witch trials.

and influence. European citizens immigrated to the New World from England, the Netherlands, Germany, France, and Spain. Much of the early European settlement in what is now the United States occurred along the eastern seaboard in Virginia, New England, Pennsylvania, and New York. Immigrants from different countries settled different areas, each bringing their language, customs, religions, and cultural preferences.

The Massachusetts Bay Colony was settled by Puritans who emigrated from England. The severity of the Puritan lifestyle—the blandness of food, plainness of clothing, starkness of shelter, and dearth of entertainment—is reflected in paintings of the period, of which there are only a handful. They were all portraits, understandably, as the Puritans prohibited what they called graven images, that is, representations of God and saints that were used as objects of worship. These portraits occasionally reveal a familiarity with contemporary European art in the use of modeling to create a sense of three-dimensional form and painterly strokes here and there. But, for the most part, the styles of the Baroque era are nowhere to be seen; if there was a

European reference at all, it harked back to the rigid body poses and flattened drapery of the Elizabethan era.

THOMAS SMITH An exception is the work of Thomas Smith (died ca. 1691), a sea captain of some wealth who also painted portraits in and around Boston. His is the earliest self-portrait (see **Fig. 15.33** on p. 528), by an artist living in the American colonies and the first American painting for which we have the name of the artist. His financial position is confirmed by an account book in the archives of Harvard University (established by Puritans in 1636) and by his relatively upscale and showy attire. Smith's full modeling of the head using contrasts of light and shadow, flowing locks, and intricately painted lace *jabot* tell us that he was aware, at least, of Netherlandish Baroque art and imitated some of its flourishes.

But there is much more to this portrait than a blend of harsh, sometimes clumsily rendered realism and the more poetic, European approach to painting. Smith's self-portrait not only records his physical characteristics but is also a meditation

◄ **15.33** Thomas Smith, *Self-Portrait*, ca. 1680. Oil on canvas, 24⅝" × 23⅝" (62.8 × 60 cm). Worcester Art Museum, Worcester, Massachusetts. The battle scene outside the window may be the artist's recollection of a campaign off the north coast of Africa.

of music, one who shared Rembrandt's ability to communicate profound experience on the broadest level.

The qualities that make Baroque music popular today were responsible for its original success. Composers of the Baroque period were the first since Classical antiquity to write large quantities of music intended for the pleasure of listeners as well as the glory of God. The polyphonic music of the Middle Ages and the Renaissance, with its interweaving of many musical lines, had enabled composers like Machaut and Palestrina to praise the Lord on the highest level of intellectual achievement, but the result was a musical style far above the heads of most of their contemporary listeners. The Council of Trent, in accordance with Counter-Reformation principles, had even considered prohibiting polyphony in religious works in order to make church music more accessible to the average congregation, before finally deciding that this would be too extreme a measure. For once, the objectives of the Reformation and Counter-Reformation coincided, for Luther had already simplified the musical elements in Protestant services for the same reason (see Chapter 14).

The time was therefore ripe for a general move toward sacred music with a wider and more universal appeal. Since at the same time the demand for secular music was growing, it is not surprising that composers soon developed a style sufficiently attractive and flexible not only for the creation of masses and other liturgical works but also for instrumental and vocal music that could be played and listened to at home (Fig. 15.34).

on his life and, ultimately, inescapable death. The naval battle in the left foreground (a painting on a wall or view through a window?) draws our attention to his successful military accomplishments at sea, and in the left foreground—as if to counteract the element of vainglory—a skull sits atop a handwritten poem that rebukes him for this vanity. In art history, this is called a *memento mori*, literally a "reminder of death." Allegorical passages within paintings and also entire compositions reflect on the brevity of life and the reality that, when it comes to riches, "you can't take it with you."

BAROQUE MUSIC

Although the history of music is as long as that of the other arts, the earliest music with which most modern music lovers are on familiar ground is that of the Baroque period. It is safe to say that many thousands of listeners have tapped their feet to the rhythm of a Baroque concerto without knowing or caring anything about its historical context, and with good reason: Baroque music, with its strong emphasis on rhythmic vitality and attractive melody, is easy to respond to with pleasure. Furthermore, in the person of Johann Sebastian Bach, the Baroque period produced one of the greatest geniuses in the history

The Birth of Opera

Perhaps the major artistic innovation of the 17th century was a new form of musical entertainment that appeared at the beginning of the Baroque period: **opera**. This consisted of a play in which the text was sung rather than spoken. Throughout the 17th century, the taste for opera and operatic music swept Europe, attracting aristocratic and middle-class listeners alike.

▲ **15.34** Pieter de Hooch, *Portrait of a Family Playing Music*, 1683. Oil on canvas, 39" × 47" (98.7 × 116.7 cm). Cleveland Museum of Art, Cleveland, Ohio. This group portrait of a prosperous Dutch family seems to symbolize the harmonious nature of family, as the mother and father lead their children in a musical performance.

In the process, the public appetite for music with which it could identify grew even greater. Small wonder that 21st-century listeners have found pleasure and delight in music written to provide our Baroque predecessors with precisely these satisfactions.

Like much else of beauty, opera was born in Florence. Ironically enough, an art form that was to become so popular in so short a time was originally conceived of in lofty intellectual terms. Toward the end of the 16th century, a group of thinkers, poets, and musicians began to meet regularly at the house of a wealthy Florentine noble, Count Giovanni Bardi. This group, known as the Florentine *Camerata*, objected strongly to the way in which the polyphonic style in vocal music reduced the text to incomprehensible nonsense. They looked back nostalgically to the time of the Greeks, when almost every word of Greek tragedy was both sung and accompanied by instruments, yet remained perfectly understandable to the spectators. Greek music was lost forever, but at least the group could revive what they considered its essence.

The result was the introduction of a musical form known as **monody**, or **recitative**, which consisted of the free declamation of a single vocal line with a simple instrumental accompaniment for support. Thus, listeners could follow the text with ease. The addition of music also gave an emotional intensity

not present in simple spoken verse, thus satisfying the Baroque interest in heightened emotion.

Although in theory monody could be used for either sacred or secular works, its dramatic potential was obvious. In the winter of 1594–1595, the first play set to music, Jacopo Peri's *Dafne*, was performed in Florence. Its subject was drawn from Classical mythology and dealt with Apollo's pursuit of the mortal girl Daphne, who turned into a laurel tree to elude him. In the words of a spectator, "The pleasure and amazement of those present were beyond expression." *Dafne* is now lost, but another of Peri's works, *Euridice*, has survived as the earliest extant opera. It too was based on a Greek myth, that of Orpheus and Eurydice. The first performance took place in 1600, again in Florence, at the wedding of Henry IV of France to Marie de' Medici.

It is no coincidence that both of Peri's works, as well as many that followed, were written on Classical subjects, because the Camerata had taken its initial inspiration from Greek drama. The story of Orpheus and Eurydice, furthermore, had a special appeal for composers, because it told how the musician Orpheus was able to soften the heart of the King of the Underworld by his music and thereby win back his wife Eurydice from the dead. The theme was treated many times in the music of the following 400 years, yet no subsequent version is more moving or psychologically convincing than that of Claudio Monteverdi (1567–1643).

CLAUDIO MONTEVERDI Monteverdi's *L'Orfeo*, considered by many critics to be the first great opera, was first performed in 1607. Its composer brought to the new form not only a complete understanding of the possibilities of monody but also an impressive mastery of traditional polyphonic forms such as the madrigal. Equally important for the success of his work was Monteverdi's dramatic instinct and his ability to transform emotion into musical terms. The contrast between the pastoral gaiety of the first act of *L'Orfeo*, depicting the happy couple's love, and the scene in the second act in which Orpheus is brought the news of his wife's death is achieved with marvelous expressive power.

L'Orfeo was written for his noble employer, the Duke of Mantua, and intended for a limited aristocratic public. Monteverdi lived long enough to see the new dramatic form achieve widespread popularity at all levels of society throughout Europe. A taste for Italian opera spread to Germany and Austria and then to England, where, by the end of the century, Italian singers dominated the London stage.

The leading composer of opera at the court of Louis XIV was a Florentine who changed his name from Giovanni Battista Lulli to the French form: Jean-Baptiste Lully (1632–1687). His stately tragedies, which were performed throughout Europe, incorporated long sections of ballet, a custom continued by his most illustrious successor, Jean-Philippe Rameau (1683–1764).

Opera won its largest public in Italy. In Venice alone, where Monteverdi spent the last 30 years of his life, at least 16 theaters were built between 1637—when the first public opera house was opened—and the end of the century. As in the Elizabethan theater (see Fig. 14.24), the design of these opera houses separated the upper ranks of society, who sat in the boxes, from the ordinary citizens—the groundlings.

There is a notable similarity, too, between Elizabethan drama and opera in the way these forms of art responded to growing popularity. Just as the groundlings of Shakespeare's day demanded ever more sensational and melodramatic entertainment, so the increasingly demanding and vociferous opera public required new means of satisfaction. The two chief means by which these desires were met became a feature of most operas written during the following century. The first was the provision of lavish stage spectacles involving mechanical cloud machines that descended from above and disgorged singers and dancers, complex lighting effects that gave the illusion that the stage was being engulfed by fire, apparently magical transformations, and so on; it was Baroque extravagance at its most extreme. The second was a move away from the declamatory recitative of the earliest operas to self-contained musical pieces known as **arias**. In the case of opera and many other musical forms, we continue to use technical terms like *aria* in their Italian form—a demonstration of the crucial role played by Italy, and in particular Florence, in the history of music. The function of music as servant of the drama was beginning to change. Beauty of melody and the technical virtuosity of the singers became the glory of Baroque opera, although at the expense of dramatic truth.

In addition to his operas, Monteverdi wrote religious works, madrigals, and—as here—songs. "Quel Sguardo Sdegnosetto" was one of three *scherzi musicali* (musical jokes) composed in 1632 and shows a characteristically Baroque love of virtuosity and emotion. Unlike Morley's madrigal (Chapter 14), it is certainly not written for an amateur performer: the soloist is required to perform feats of brilliant singing (involving considerable breath control) while conveying the feeling behind a somewhat conventional anonymous Baroque poem.

🎵 **GO LISTEN!**
CLAUDIO MONTEVERDI
"Quel Sguardo Sdegnosetto"

The words deal with the joys and dangers of physical love (a new and typically Baroque subject: compare Bernini's *The Ecstasy of Saint Teresa*, Fig. 15.1). Note the change of mood in the central section of the song's three parts. Much of the effect of the song comes from the way in which Monteverdi constructs a solid bass line, above which the singer seems to weave her line at random (although, of course, everything is carefully calculated).

Thus, in miniature, Monteverdi constructs a subtle and varied picture of erotic delights. The middle verse contains the words "Bombard my heart with a shower of sparks, but let not your lips be slow to revive me when I die." The singer here is Emma Kirkby, whose purity of voice (musicians would describe it as "without vibrato") is regarded as highly appropriate for Baroque vocal music.

Baroque Instrumental and Vocal Music

The development of opera permitted the dramatic retelling of mythological or historical tales. Sacred texts as stories derived from the Bible were set to music in a form known as the **oratorio**, which had begun to appear toward the end of the 16th century. One of the Baroque masters of the oratorio was the Italian Giacomo Carissimi (1605–1674), whose works, based on well-known biblical episodes, include *The Judgment of Solomon* and *Job*. By the dramatic use of the chorus, simple textures, and driving rhythms, Carissimi created an effect of strength and power that 21st-century listeners have begun to rediscover.

HEINRICH SCHÜTZ The concept of the public performance of religious works, rather than secular operas, appealed especially to Protestant Germans. Heinrich Schütz (1585–1672) wrote a wide variety of oratorios and other sacred works. In his early *Psalms of David* (1619), Schütz combined the choral technique of Renaissance composers like Gabrieli with the vividness and drama of the madrigal. His setting of *The Seven Last Words of Christ* (1645–1646) uses soloists, chorus, and instruments to create a complex sequence of narrative sections (recitatives), vocal ensembles, and choruses. Among his last works are three settings of the Passion, the events of the last days of the life of Jesus, in the accounts given by Matthew, Luke, and John. Written in 1666, these works revert to the style of a century earlier, with none of the instrumental coloring generally typical of Baroque music, both sacred and secular.

Schütz is, in fact, one of the few great Baroque composers who, so far as is known, never wrote any purely instrumental music. The fact is all the more striking because the Baroque period was notable for the emergence of independent instrumental compositions unrelated to texts of any kind. Girolamo Frescobaldi (1583–1643), the greatest organ virtuoso of his day—he was organist at Saint Peter's in Rome—wrote a series of rhapsodic fantasies known as **toccatas** that combined extreme technical complexity with emotional and dramatic expression. His slightly older Dutch contemporary Jan Pieterszoon Sweelinck (1562–1621), an organist in Amsterdam, built sets of variations out of different settings of a chorale melody or hymn tune. The writing of **chorale variations**, as this type of piece became known, became popular throughout the Baroque period.

DIETRICH BUXTEHUDE The Danish Dietrich Buxtehude (1637–1707), who spent most of his career in Germany, combined the brilliance of the toccata form with the use of a chorale theme in his chorale fantasies. Starting with a simple hymn melody, he composed free-form rhapsodies that are almost improvisational in style. His suites for **harpsichord** (the keyboard instrument that was a primary forerunner of the modern piano) include movements in variation form, various dances, slow lyric pieces, and other forms; like other composers of his day, Buxtehude used the keyboard suite as a kind of compendium of musical forms.

DOMENICO SCARLATTI One of the greatest composers of the Late Baroque period was Domenico Scarlatti (1685–1757). The greatest virtuoso of his day on the harpsichord, Scarlatti wrote hundreds of **sonatas** (short instrumental pieces) for it and laid the foundation for modern keyboard techniques.

GEORG FRIDERIC HANDEL Scarlatti's contemporary Georg Frideric Handel (1685–1759) was born in Halle, Germany, christened with the name Georg Friedrich Händel, which he changed to George Frederick Handel when he settled in England and became a naturalized citizen. London was to prove the scene of his greatest successes, among them *Messiah*, first performed in Dublin in 1742. This oratorio is among the most familiar of all Baroque musical masterpieces, and its most famous section is the "Hallelujah Chorus."

From the time of its first performance, Handel's "Hallelujah Chorus," which ends the second part of his oratorio *Messiah*, has been recognized as one of the great masterpieces of Baroque splendor and fervor. With its hammering drums and triumphant trumpets soaring, it epitomizes the grandeur and religious conviction of the Baroque era.

GO LISTEN!
GEORG FRIDERIC HANDEL
"Hallelujah Chorus" from *Messiah*

It uses the typical Baroque device of light and shade to achieve its effect, with the music changing volume in order to dramatize the text. The chorus begins vigorously and fervently, repeating the word *hallelujah* with increasing emphasis and volume. Then the music suddenly drops to a lower level as the chorus sings, "For the Lord God omnipotent reigneth." The music becomes even quieter with the next section, beginning "The Kingdom of this world," as if the sound were about to fade away.

But Handel has a final punch up his sleeve. As the singers launch at top volume into the final section, "And He shall reign for ever and ever," the voices pile up into a massive and increasingly complex texture, urged on by trumpets and drums, until they reach their triumphant climax. Thus, the "Hallelujah Chorus" combines the emotionalism, spirituality, light and shade, and religious fervor that are all typical of Baroque art.

Handel also wrote operas, including a series of masterpieces in Italian for performance in England. Among the greatest glories in the operas are the arias, which are permeated by Handel's rich melodic sense; one of the best-known is "Ombra mai fu" from *Xerxes*, often called the "Largo." Among his best-known orchestral works are *Water Music* and *Music for the Royal Fireworks*, both originally designed for outdoor performance. Written for numerous instruments, they were later rearranged for regular concerts.

Johann Sebastian Bach

In the year that saw the births of both Scarlatti and Handel, Johann Sebastian Bach (1685–1750) was born in Eisenach, Germany, into a family that had already been producing musicians

for more than a century. With the exception of opera—which, as a devout Lutheran, he was not interested in—Bach mastered every musical form of the time, pouring forth some of the most intellectually rigorous and spiritually profound music ever created.

It is among the more remarkable achievements in the history of the arts that most of Bach's music was produced under conditions of grinding toil as organist and choir director in relatively provincial German towns. Even Leipzig—where Bach spent 27 years (from 1723 to his death) as **kantor** (music director) at the school attached to Saint Thomas's Church (*Thomaskirche* in German)—was far removed from the glittering centers of European culture where most artistic developments were taking place. As a result, Bach was little known as a composer during his lifetime and virtually forgotten after his death. Only in the 19th century did his body of work become known and published. He has since taken his place at the head of the Western musical tradition as the figure who raised the art of polyphony to its highest level.

If the sheer quantity of music Bach wrote is stupefying, so is the complexity of his musical thought. Among the forms he preferred was the fugue (derived from the Latin word for "flight"). In the course of a **fugue**, a single theme is passed from voice to voice or instrument to instrument (generally four in number), each imitating the principal theme in turn. The theme thus becomes combined with itself and, in the process, the composer creates a web of sound in which each musical part is equally important; this technique is called *counterpoint* (*contrapunctus* in Latin). Bach's ability to endow this highly intellectual technique with emotional power is little short of miraculous. The range of emotions Bach's fugues cover can best be appreciated by sampling his two books of 24 preludes and fugues each, known collectively as *The Well-Tempered Clavier*. Each of the 48 preludes and fugues creates its own mood while remaining logically organized according to contrapuntal technique.

Many of Bach's important works are permeated by a single concern: the expression of his deep religious faith. A significant number were written in his capacity as director of music at Saint Thomas's for performance in the church throughout the year. Organ music, masses, oratorios, motets—in all of these, he could use music to glorify God and to explore the deeper mysteries of Christianity. His **chorale preludes** consist of variations on chorales and use familiar and well-loved songs as the basis for a kind of musical improvisation. He wrote some 200 **cantatas** (short oratorios), made up of sections of declamatory recitative and lyrical arias, which contain an almost inexhaustible range of religious emotions, from joyful celebrations of life to profound meditations on death. Most overwhelming of all is his setting of the *Saint Matthew Passion*, the story of the trial and crucifixion of Jesus as recorded in the Gospel of Matthew. In this immense work, Bach asserted his Lutheranism by using the German rather than the Latin translation of the gospel and by incorporating Lutheran chorales. The use of self-contained arias is Italian, though, and the spirit of deep religious commitment and dramatic fervor can only be described as universal.

It would be a mistake to think of Bach as somehow unworldly and touched only by religious emotions. Certainly his personal life had its share of domestic happiness and tragedy. His parents died when he was 10, leaving him to be brought up by an older brother who treated him with less than complete kindness. At the age of 15, Bach jumped at the chance to leave home and become a choirboy in the little town of Lüneberg. He spent the next few years moving from place to place, perfecting his skills as organist, violinist, and composer.

In 1707, Bach married his second cousin, Maria Barbara, who bore him seven children, of whom three died in infancy. Bach was devoted to his family, and the loss of these children, followed by the death of his wife in 1720, made a deep impression on him. It may have been to provide a mother for his surviving sons that he remarried in 1721. His new wife, Anna Magdalena, proved a loving companion, bearing him 13 more children and helping him with the preparation and copying of his music. One of the shortest but most touching of Bach's works is the little song "Bist du bei mir," which has survived, copied out in her notebook. The words are "As long as you are with me, I could face my death and eternal rest with joy. How peaceful would my end be if your beautiful hands could close my faithful eyes." (Some scholars now believe that the song may have originally been written by G. H. Stölzel, a contemporary musician whom Bach much admired.)

The move to Leipzig in 1723 was dictated at least in part by the need to provide suitable schooling for his children, although it also offered the stability and security Bach seemed to have required. The subsequent years of continual work took their toll, however. Bach's sight had never been good, and the incessant copying of manuscripts produced a continual deterioration. In 1749, Bach was persuaded to undergo two disastrous operations, which left him blind. A few months later, his sight was suddenly restored but, within 10 days, he died of apoplexy (stroke).

Although most of Bach's works are on religious themes, the best known of all, the six Brandenburg Concertos, were written for the private entertainment of a minor prince, the Margrave of Brandenburg. Their form follows the Italian **concerto grosso**, an orchestral composition in three **movements** (sections): fast (**allegro**)—slow (**adagio** or **largo**)—fast (allegro).

THE BRANDENBURG CONCERTOS Four of Bach's six Brandenburg Concertos use a group of solo instruments, although the grouping differs from work to work. The whole set forms a kind of compendium of the possibilities of instrumental color, a true virtuoso achievement requiring equal virtuosity in performance. The musical mood is light, as befits works written primarily for entertainment, but Bach was incapable of writing music without depth, and the slow movements in particular are strikingly beautiful.

The second Brandenburg Concerto is written for a solo group of trumpet, recorder, oboe, and violin accompanied by a string orchestra. The first movement combines all of these to produce a brilliant rhythmic effect as the solo instruments now emerge from the orchestra, now rejoin it. The melodic line

avoids short themes. Instead, as in much Baroque music, the melodies are long, elaborate patterns that seem to spread and evolve, having much of the ornateness of Baroque visual art. The opening theme forms an unbroken line of sound, rising and falling and doubling back as it luxuriantly spreads itself out.

The slow second movement forms a tranquil and meditative interlude. The brilliant tone of the trumpet would be inappropriate here, and Bach therefore omits it, leaving the recorder, oboe, and violin to quietly intertwine in a delicate web of sound. After its enforced silence, the trumpet seems to burst out irrepressibly at the beginning of the third movement, claiming the right to set the mood of limitless energy that carries the work to its conclusion.

GO LISTEN!
JOHANN SEBASTIAN BACH

Third movement, Allegro assai, from Brandenburg Concerto No. 2 in F Major

Bach expects every one of his performers to be capable of extraordinary feats of virtuosity and movement. Listen to the opening trumpet solo, with its difficult trills: the player barely has time to breathe. And the oboist who picks up the tune has an even longer passage before the solo violin breaks in. With the entry of the flute, the texture becomes more complex but always remains crystal clear, as the four principal instruments play with fragments of the opening theme, breaking them up and putting them back together with the typical sense of Baroque unity in variety. The arrival of the other instruments provides a background for the continuous display of virtuosity as the trumpet seems to reach ever higher.

Other works of Bach illustrate a broader range of Baroque characteristics: religious fervor, illusionism, emotionalism. We hear this last feature in this work, where the music seems to express boundless joy. In two other respects, the work is typical of the Baroque period. It is written for a group of performers playing together—a technique that was to develop into the Classical orchestra—and, more importantly perhaps, the music's purpose is to give pleasure to performers and listeners alike: music as entertainment.

Antonio Vivaldi

The concerto grosso was pioneered by the Venetian composer Antonio Vivaldi (ca. 1676–1741), who delighted in strong contrasts between the orchestra, generally made up of string instruments, and a solo instrument—often a violin, but sometimes a flute, bassoon, or other wind instrument. Vivaldi's most often performed work is a set of four violin concertos known as "The Four Seasons," which illustrate in sound a set of four poems describing the characteristics of the annual cycle of the seasons. The one for spring, for example, describes the happy songs and dances with which the season is celebrated.

GO LISTEN!
ANTONIO VIVALDI

First movement from "Spring" (*La Primavera*), Concerto No. 1 in E major, "The Four Seasons"

Written according to typical Baroque practice, each movement of Vivaldi's concertos is based on a single, strongly rhythmic theme, heard right at the beginning of the section. The fast tempo of the first movement of the "Spring" concerto indicates in the work a delight at the return of the season of flowers. Two further Baroque devices help Vivaldi characterize the specific season: virtuosity (on the part of the solo violinist) and illusionism. Shortly after the opening, the violin imitates the trilling of the birds that have returned, and the music suddenly becomes quiet as all the instruments imitate the sound of the gentle spring breezes.

A sudden plunge announces the arrival of a spring storm, with upward leaps portraying lightning. The solo violin expresses the violence of the abrupt gusts of wind, while the lower strings seem to hint at not-so-distant thunder. Then the storm passes, the birdsong is heard again, and all ends with the joyful music of the opening.

In a matter of a few minutes, and with only a handful of instruments, Vivaldi has used Baroque techniques to illustrate human emotions evoked by natural events.

PHILOSOPHY AND SCIENCE IN THE SEVENTEENTH CENTURY

Throughout the 17th century, philosophy—like the visual arts—continued to extend and intensify ideas first developed in the Renaissance. With the spread of humanism, the 16th century had seen a growing spirit of philosophical and scientific inquiry. In the Baroque period, that fresh approach to the world and its phenomena was expressed in clear and consistent terms for the first time since the Greeks. It might be said, in fact, that if the Renaissance marked the birth of modern philosophy, the 17th century signaled its coming of age.

The chief difference between the intellectual attitudes of the Middle Ages and those inaugurated by the Renaissance was a turning away from the contemplation of the absolute and eternal to a study of the particular and the perceivable. Philosophy ceased to be the preserve of theologians and instead became an independent discipline, no longer prepared to accept a supernatural or divine explanation for the world and human existence.

The importance of objective truth, objectively demonstrated, continues to lie at the heart of all scientific method and most modern philosophy. Yet great thinkers before the Renaissance, such as Thomas Aquinas (1225–1274), had also asked questions in an attempt to understand the world and its workings. How did 17th-century scientists and philosophers differ from their predecessors in dealing with age-old problems? The basic difference lay in their approach. When, for example, Aquinas was concerned with the theory of motion, he discussed it in abstract, metaphysical terms. Armed with his copy of Aristotle, he claimed that "motion

CULTURE AND SOCIETY

Principal Scientific Discoveries of the Seventeenth Century

1609	Kepler announces his first two laws of planetary motion
1614	Napier invents logarithms
1632	Galileo publishes *Dialogue Concerning the Two Chief World Systems*
1643	Torricelli invents the barometer
1662	Boyle formulates his law of gas pressure
1675	The Royal Observatory is founded at Greenwich, England
1684	Leibniz publishes his first paper employing new notations of calculus
1687	Isaac Newton publishes his account of the principle of gravity
1724	Fahrenheit proposes his scale for measuring temperature

exists because things which are in a state of potentiality seek to actualize themselves." When Galileo wanted to study motion and learn how bodies move in time and space, he climbed to the top of the Leaning Tower of Pisa and dropped weights to watch them fall. It would be difficult to imagine a more dramatic rejection of abstract generalization in favor of objective demonstration.

Galileo Galilei

The life and work of Galileo Galilei (1564–1642) are typical both of the progress made by science in the 17th century and of the problems it encountered. Galileo changed the scientific world in two ways: first, as the stargazer who claimed that his observations through the telescope proved Copernicus right, for which statement he was tried and condemned by the Inquisition; and second, as the founder of modern physics. Although he is probably better known for his work in astronomy, from the scientific point of view his contribution to physics is more important.

Born in Pisa, Galileo learned from his father, Vincenzo—who had been one of the original members of the Florentine

Camerata—a lively prose style and a fondness for music. As a student at the University of Padua from 1581 to 1592, he began to study medicine, but he soon changed to mathematics. After a few months back in Pisa, he took a position at the University of Padua as professor of mathematics, remaining there from 1592 to 1600.

In Padua, Galileo designed and built his own telescopes (**Fig. 15.35**) and saw for the first time the craters of the moon, sunspots, the phases of Venus, and other phenomena that showed that the universe is in a constant state of change, as Copernicus had claimed. From the time of Aristotle, however, it had been widely believed that the heavens were unalterable, representing perfection of form and movement. Galileo's discoveries thus disproved what had been a basic philosophical principle for 2000 years and so outraged a professor of philosophy at Padua that he refused to shake his own prejudices by having a look through a telescope for himself.

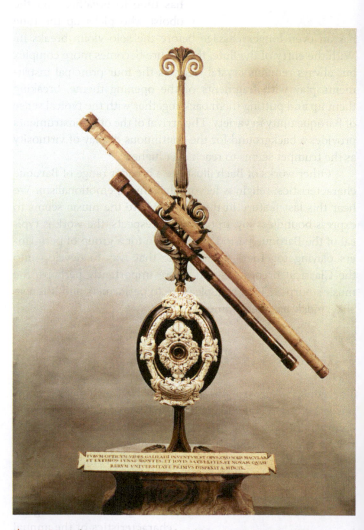

▲ **15.35** Telescope and lens of Galileo, 1609. Museo della Scienza, Florence, Italy. After his death near Florence in 1642, many of Galileo's instruments, including this telescope, were collected and preserved. The Museo della Scienza (Museum of Science) in Florence, Italy, where they can now be seen, was one of the earliest museums to be devoted to scientific rather than artistic works.

CULTURE AND SOCIETY

The Value of Scientific Truth

Nature, and Nature's laws lay hid in night.
God said: "Let Newton be!" and all was Light!

—Alexander Pope

Many factors contributed to the growth of science in the 17th century. Among them were the spread of education, the discovery of the Americas, explorations in Asia and Africa, and the development of urban life. Perhaps the most important of all was a growing skepticism toward traditional religious beliefs, induced by the violent wars of religion provoked by the Reformation and Counter-Reformation.

One of the leading figures in the scientific revolution, Francis Bacon (1561–1626), wrote that scientists should follow the example of Columbus and think all things possible until all things could be tested. This emphasis on the "empirical faculty"—learning based on experience—is a method of drawing general conclusions from particular observations. Medieval thinkers, relying on the examples of Aristotle and Ptolemy, had devised general theories and then looked for specific examples to confirm them. Scientific truth sought to reason in the opposite way: start from the specific and use it to establish a general theory, a process known as **induction**. Above all, the new scientists took nothing for granted and regarded no opinion as "settled and immovable."

The search for objective, scientific truth required the invention of new instruments. Galileo's telescope allowed him to study the sky and revolutionize astronomy. Other researchers used another form of optical instrument—the microscope—to analyze blood and describe bacteria. The invention of the thermometer and barometer made it possible to perform atmospheric experiments.

With the increasing circulation of knowledge, scientists could spread and test their ideas. An international scientific community began to develop, stimulated by the formation of academies and learned societies. The most influential were the Royal Society of London for Improving Natural Knowledge, founded in 1662, and the French Académie des Sciences, founded in 1666. By means of published accounts and private correspondence, scientists were able to see how their own discoveries related to other fields.

Although the study of natural science does not involve questions of theology or philosophy, the growing interest in finding rational explanations for natural phenomena led to a change in views of religion. Most early scientists continued to believe in God but abandoned the medieval view of the deity as incomprehensible creator and judge. Rather, they saw God as the builder of a world-machine, which he then put into motion. Humans could come to understand how the machine worked but only if they used their powers of reason to establish scientific truth.

The more triumphantly Galileo proclaimed his findings, the more he found himself involved in something beyond mere scientific controversy. His real opponent was the church, which had officially adopted the Ptolemaic view of the universe: that the Earth formed the center of the universe around which the sun, moon, and planets circled. This theory accorded well with the Bible, which seemed to suggest that the sun moves rather than the Earth; for the church, the Bible naturally took precedence over any reasoning or speculation independent of theology. Galileo, however, considered ecclesiastical officials incompetent to evaluate scientific matters and refused to give way. When he began to claim publicly that his discoveries had proved what Copernicus had theorized but could not validate, the church initiated a case against him on the grounds of heresy.

Galileo had meanwhile returned to his beloved Pisa, where he found himself in considerable danger from the Inquisition. In 1615, he left for Rome to defend his position in the presence of Pope Paul V. He failed and, as a result, was censured and prohibited from spreading the Copernican theory either by teaching or publication.

In 1632, Galileo returned to the attack when a former friend was elected pope. He submitted to Pope Urban VIII a *Dialogue Concerning the Two Chief World Systems*, having carefully chosen the dialogue form so that he could put ideas into the mouths of other characters and thereby claim that they were not his own. Once more, under pressure from the Jesuits, Galileo was summoned to Rome. In 1633, he was put on trial after spending several months in prison. His pleas of old age and poor health won no sympathy from the tribunal. He was made to recant and humiliate himself publicly and was sentenced to prison for the rest of his life. (It might well have appealed to Galileo's sense of bitter irony that 347 years later, in 1980, Pope John Paul II—a fellow countryman of the Polish Copernicus—ordered the case to be reopened so that belated justice might be done.)

Influential friends managed to secure Galileo a relatively comfortable house arrest in his villa just outside Florence, and he retired there to work on physics. His last and most important scientific work, *Dialogues Concerning Two New Sciences*, was published in 1638. In it he examined many long-standing problems, including that of motion, always basing his conclusions on practical experiment and observation. In the process, he established the outlines of many areas of modern physics.

In all his work, Galileo set forth a new way of approaching scientific problems. Instead of trying to understand the final cause or cosmic purpose of natural events and phenomena, he tried to explain their character and the manner in which they came about. He changed the question from why to what and how.

CONNECTIONS In the year 1610, Galileo aimed his telescope at the gas giant Jupiter and discovered the planet's four largest moons—Ganymede, Io, Europa, and Callisto. All are named after lovers or conquests of Jupiter, the Roman god of gods. A mathematician as well as an astronomer, Galileo calculated the moons' orbits around the planet. These four are now called the Galilean satellites in honor of the 17th-century astronomer, but Jupiter actually has at least 67 moons, most of which are quite small. Ganymede, however, is larger than Earth's moon and larger than the planet Mercury. Contemporary scientific observations have added to the lore bequeathed by Galileo and strongly suggest that although Ganymede has an icy crust, it harbors a saltwater ocean within that is some 60 miles thick, holding more water than is found on the entire surface of the Earth.

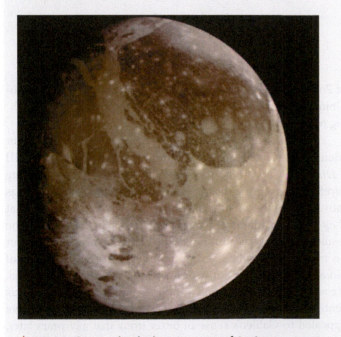

▲ **15.36 Ganymede, the largest moon of Jupiter.** Discovered by Galileo in 1610.

René Descartes

Scientific investigation could not solve every problem of human existence. While it could try to explain and interpret objective phenomena, there remained other, more subjective areas of experience involving ethical and spiritual questions. The Counter-Reformation on the one hand and the Protestant churches on the other claimed to have discovered the answers. The debates nevertheless continued, most notably in the writings of the French philosopher René Descartes (1596–1650), often called the Father of Modern Philosophy.

In many ways, Descartes's philosophical position was symptomatic of his age. He was educated at a Jesuit school but found traditional theological teaching unsatisfactory. Turning to science and mathematics, he began a lifelong search for reliable evidence in his quest to distinguish truth from falsehood. Attacking philosophical problems, his prime concern was to establish criteria for defining reality. His chief published works, the *Discourse on the Method* (1637) and the *Meditations* (1641), contain a step-by-step account of how he arrived at his conclusions:

READING 15.1 RENÉ DESCARTES

From *Discourse on the Method of Rightly Conducting the Reason and Seeking the Truth in the Sciences*, Part 4, Book 4

I attentively examined what I was, and as I observed that I could suppose that I had no body, and that there was no world nor any place in which I might be; but that I could not therefore suppose that I was not; and that, on the contrary, from the very circumstance that I thought to doubt of the truth of all things, it most clearly and certainly followed that I was; while, on the other hand, if I had only ceased to think, although all the other objects which I had ever imagined had been in reality existent, I would have had no reason to believe that I existed; I thence concluded that I was a substance whose whole essence or nature consists only in thinking, and which, that it may exist, has need of no place, nor is dependent on any material thing; so that "I," that is to say, the mind by which I am what I am, is wholly distinct from the body, and is even more easily known that the latter, and is such, that although the latter were not, it would still continue to be all that it is.

According to Descartes, the first essential in the search for truth was to make a fresh start by refusing to believe anything that could not be decisively proved to be true. This required that he doubt all of his previously held beliefs, including the evidence of his own senses. By stripping away all uncertainties, he reached a basis of indubitable certainty on which he could build: that he existed. The very act of doubting proved that he was a thinking being. As he put it in a famous phrase in his second Meditation, "Cogito, ergo sum" ("I think, therefore I am").

From this foundation, Descartes proceeded to reconstruct the world he had taken to pieces by considering the nature of material objects. He was guided by the principle that whatever is clearly and distinctly perceived must exist. He was aware at the same time that our perceptions of the exact nature of these objects are extremely likely to be incorrect and misleading. When, for example, we look at the sun, we see it as a very small disk, although the sun is really an immense globe. We must be careful, therefore, not to assume that our perceptions are bound to be accurate. All that they demonstrate is the simple existence of the object in question.

If the idea of the sun comes from the perception, however inaccurate, of something that actually exists, what of God? Is the idea of a divine being imagined or based on truth? Descartes concluded that the very fact that we who are imperfect and doubting can conceive of a perfect God proves that our conception is based on a reality. In other words, who could ever have imagined God unless God existed? At the center of the Cartesian philosophical system, therefore, lay a belief in a perfect being—not necessarily to be identified with the God of the Old and New Testaments—who had created a world permeated by perfect (that is, mathematical) principles.

At first, this may seem inconsistent with Descartes's position as the founder of modern rational thought. It may seem even stranger that, just at the time when scientific investigators like Galileo were explaining natural phenomena without recourse to divine intervention, Descartes succeeded in proving to his own satisfaction the undeniable existence of a divine being. Yet a more careful look at Descartes's method reveals that both he and Galileo shared the same fundamental confidence in the rational powers of human beings.

Thomas Hobbes

Although Galileo and Descartes represent the major trends in 17th-century thought, other important figures made their own individual contributions. Descartes's fellow countryman Blaise Pascal (1623–1662), for example, launched a strong attack on the Jesuits while providing his own somewhat eccentric defense of Christianity. A more mystical approach to religion was that of the Dutch philosopher Baruch Spinoza (1632–1677), whose concept of the ideal unity of nature later made a strong appeal to 19th-century Romantics.

The English philosopher Thomas Hobbes (1588–1679), however, had little in common with any of his contemporaries—as he was frequently at pains to make plain. For Hobbes, truth lay only in material things: "All that is real is material, and what is not material is not real." Hobbes was thus one of the first modern proponents of **materialism**, and like many of his materialist successors, he was interested in solving political rather than philosophical problems. Born in the year of the Spanish Armada, Hobbes lived through the turbulent English Civil War, a period marked by constant instability and political confusion. Perhaps in consequence, he developed an enthusiasm for the authority of the law, as represented by the king, that verged on totalitarianism.

Hobbes's political philosophy finds its fullest statement in his book *Leviathan*, first published in 1651. The theory of society that he describes there totally denies the existence in the universe of any divinely established morality. (Hobbes never denied the existence of God, not wishing to outrage public and ecclesiastical opinion unnecessarily, although he might as well have.) According to Hobbes, all laws are created by humans to protect themselves from one another—a necessary precaution, in view of human greed and violence. Organized society in consequence is arrived at when individuals give up their personal liberty in order to achieve security. As a result, the ideal state is that in which there is the greatest security, specifically one ruled by an absolute ruler.

From its first appearance, *Leviathan* created a scandal; it has been subjected to continual attack ever since. Hobbes managed to offend both of the chief groups of participants in the intellectual debates of the day: the theologians, by telling them that their doctrines were irrelevant and their terminology "insignificant sound," and the rationalists, by claiming that human beings, far from being capable of the highest intellectual achievements, are dangerous and aggressive creatures who need to be saved from themselves:

READING 15.2 THOMAS HOBBES

From *Leviathan*, part 1, chapter 13

Hereby it is manifest, that during the time men live without a common power to keep them all in awe, they are in that condition which is called war; and such a war is of every man, against every man. For "war" consisteth not in battle only or the act of fighting; but in a tract of time, wherein the will to contend by battle is sufficiently known....

Whatsoever therefore is consequent to a time of war, where every man is enemy to every man, the same is consequent to the time wherein men live without other security than what their own strength and their own invention shall furnish them withal. In such condition there is no place for industry, because the fruit thereof is uncertain, and consequently no culture of the earth; no navigation, nor use of the commodities that may be imported by sea; no commodious building; no instruments of moving and removing such things as require much force; no knowledge of the face of the earth; no account of time; no arts; no letters; no society; and, which is worst of all, continual fear and danger of violent death; and the life of man, solitary, poor, nasty, brutish, and short.

Hobbes's pessimism and the extreme nature of his position have won him few wholehearted supporters in the centuries since his death. Yet many modern readers, like others in the time since *Leviathan* first appeared, must reluctantly admit that there is at least a grain of truth in his picture of society, which can be attested to by personal experience and observation. At

the very least, his political philosophy is valuable as a diagnosis and a warning of some aspects of human potential that virtually all of his contemporaries, and many of his successors, preferred to ignore.

John Locke

The leading English thinker of the generation following Hobbes was John Locke (1632–1704), whose work helped pave the way for the European Enlightenment. The son of a country attorney, his education followed traditional Classical lines, but the young Locke was more interested in medicine and the new experimental sciences. In 1666, he became physician and secretary to the future Earl of Shaftesbury, who encouraged his interest in political philosophy.

In his first works, Locke explored the subjects of property and trade and the role of the monarch in a modern state. He then turned to more general questions: What is the nature of ideas? How do we get them? What are the limitations of human knowledge? His most influential work, *An Essay Concerning Human Understanding*, appeared in 1690. In it, he argued against a theory of innate (or *inborn*) ideas, proposing instead that our ideas derive from our perceptions. Thus, our notions and characters are based on our own individual sense impressions and on our reflections on them, not on inherited values:

READING 15.3 JOHN LOCKE

From *An Essay Concerning Human Understanding*, Book 1, "Of Innate Notions," chapter 2: No Innate Principles in the Mind

It is an established opinion amongst some men, that there are in the understanding certain innate principles; some primary notions,...characters, as it were, stamped upon the mind of man, which the soul receives in its very first being, and brings into the world with it. It would be sufficient to convince unprejudiced readers of the falseness of this supposition, if I should only show (as I hope I shall in the following parts of this discourse) how men, barely by the use of their natural faculties, may attain to all the knowledge they have, without the help of any innate impressions, and may arrive at certainty without any such original notions or principles. For I imagine, any one will easily grant that it would be impertinent to suppose the ideas of colours innate in a creature to whom God hath given sight, and a power to receive them by the eyes from external objects: and no less unreasonable would it be to attribute several truths to the impressions of nature and innate characters, when we may observe in ourselves faculties fit to attain as easy and certain knowledge of them as if they were originally imprinted on the mind.

For his successors in the 18th century, Locke seemed to have set human nature free from the control of divine authority. Humans were no longer perceived as the victims of innate original sin or the accidents of birth but, instead, derived their ideas and personalities from their experiences. Like many of the spokesmen of the Enlightenment, Voltaire acknowledged the importance of Locke's ideas; few modern students of education or theory of knowledge have escaped his influence.

LITERATURE IN THE SEVENTEENTH CENTURY

French Baroque Comedy and Tragedy

It is hardly surprising that the Baroque age, which put so high a premium on the expression of dramatic emotion, should have been an important period in the development of the theater. In France in particular, three of the greatest names in the history of drama were active simultaneously, all of them benefiting at one point or another from the patronage of Louis XIV.

Molière was the stage name of Jean-Baptiste Poquelin (1622–1673), who was the creator of a new theatrical form: French Baroque comedy. Having first made his reputation as an actor, he turned to the writing of drama as a means of deflating pretense and pomposity. In his best works, the deceptions or delusions of the principal characters are revealed for what they are with good humor and considerable understanding of human foibles, but dramatic truth is never sacrificed to mere comic effect. Unlike so many comic creations, Molière's characters remain believable. Jourdain, the good-natured social climber of *Le Bourgeois Gentilhomme*, and Harpagon, the absurd miser of *L'Avare*, are by no means mere symbols of their respective vices, but victims of those vices, albeit willing ones. Even the unpleasant Tartuffe in the play of the same name is a living character with his own brand of hypocrisy.

Tartuffe is something of a hedonist but presents himself to the world as a religious ascetic. He has managed to convince a wealthy Parisian, Orgon, that he is pious—so pious that Orgon will leave his fortune to Tartuffe. Tartuffe becomes Orgon's houseguest, but Orgon's family, who see through Tartuffe and wish to protect their own interests, attempt to expose him to Orgon, leading to a variety of humorous complications. In lines from act 3, we see the hypocrite referring to his hair-shirt (an instrument designed to mortify the flesh and used by some of the pious) and his scourge (an instrument with which he would flagellate himself, again to mortify the flesh). Then he approaches Orgon's maid Dorine and shows an interest in her—before he attempts to seduce Orgon's wife:

READING 15.4 MOLIÈRE

Tartuffe, act 3, scene 2, lines 1–16

TARTUFFE: *[Observing Dorine, and calling to his manservant
 offstage]* Hang up my hair-shirt, put my scourge in place,
 And pray, Laurent, for Heaven's perpetual grace.
 I'm going to the prison now, to share
 My last few coins with the poor wretches there.
DORINE: *[Aside]* Dear God, what affectation! What a fake!
TARTUFFE: You wished to see me?
DORINE: Yes…
TARTUFFE: *[Taking a handkerchief from his pocket]* For
 mercy's sake,
 Please take this handkerchief before you speak.
DORINE: What?
TARTUFFE: Cover that bosom, girl. The flesh is weak,
 And unclean thoughts are difficult to control.
 Such sights as that can undermine the soul.
DORINE: Your soul, it seems, has very poor defenses,
 And flesh makes quite an impact on your senses,
 It's strange that you're so easily excited;
 My own desires are not so soon ignited,
 And if I saw you naked as a beast,
 Not all your hide would tempt me in the least.

Classical motifs play a strong part in the works of the two greatest tragic dramatists of the age: Pierre Corneille (1606–1684) and Jean Racine (1639–1699). Corneille created, as a counterpart to Molière's comedy, French Baroque tragedy. Most of his plays take as their theme an event in Classical history or mythology, which is often used to express eternal truths about human behavior. The themes of patriotism, as in *Horace*, or martyrdom, as in *Polyeucte*, are certainly as relevant today as they were in 17th-century France or in ancient Greece or Rome. However, most people's response to Corneille's treatment of subjects such as these is probably conditioned by the degree to which they enjoy the cut and thrust of rhetorical debate.

Racine may well provide for many modern readers an easier entry into the world of French Baroque tragedy. Although for the most part he followed the dramatic form and framework established by Corneille, he used it to explore different areas of human experience. His recurrent theme is self-destruction: the inability to control one's own jealousy, passion, or ambition and the resulting inability, as tragic as it is inevitable, to survive its effects. Furthermore, in plays like *Phèdre*, he explored the state of mind of his principal characters, probing for the same kind of understanding of motivation that Monteverdi tried to achieve in music.

Cervantes and the Spanish Novel

By the middle of the 16th century, the writing of fiction in Spain had begun to take a characteristic form that was to influence future European fiction. The **picaresque** novel (in Spanish, *pícaro* means "rogue" or "knave") was a Spanish invention; books of this genre tell a story that revolves around a rogue or adventurer. The earliest example is *Lazarillo de Tormes*, which appeared anonymously in 1554. Its hero, Lazarillo, is brought up among beggars and thieves, and many of the episodes serve as an excuse to satirize priests and church officials—so much so, in fact, that the Inquisition ordered parts omitted in later printings. Unlike prose being written elsewhere at the time, the style is colloquial, even racy, and heavy with irony.

Although *Don Quixote*, by general agreement the greatest novel in the Spanish language, has picaresque elements, its style and subject are both far more subtle and complex. Miguel de Cervantes Saavedra (1547–1616), its author, set out to satirize medieval tales of chivalry and romance by inventing a character—Don Quixote—who is an amiable elderly gentleman looking for the chivalry of storybooks in real life. This apparently simple idea takes on almost infinite levels of meaning, as Don Quixote pursues his ideals, in general without much success, in a world with little time for romance or honor. In his adventures, which bring him into contact with all levels of Spanish society, he is accompanied by his squire Sancho Panza, whose shrewd practicality serves as a foil for his own unworldliness.

In part 2 of *Don Quixote*, Don Quixote and Sancho are searching for Don Quixote's ideal (and imaginary) mistress, Dulcinea. Sancho, who realizes the absurdity of the quest, pretends to recognize a passing peasant girl as the beloved Dulcinea. Don Quixote sees that the girl is plain, poorly dressed, and riding on a donkey, yet his own need to be convinced persuades him to greet her as his beautiful mistress:

READING 15.5 MIGUEL DE CERVANTES SAAVEDRA

From *Don Quixote*, part 2, chapter 10

By this time Don Quixote had fallen on his knees beside Sancho, and was staring, with his eyes starting out of his head and a puzzled look on his face, at the person whom Sancho called Queen and Lady. And as he could see nothing in her but a country girl, and not a very handsome one at that, she being round-faced and flat-nosed, he was bewildered and amazed, and did not dare to open his lips. The village girls were equally astonished at seeing these two men, so different in appearance, down on their knees and preventing their companion from going forward. But the girl they had stopped broke the silence by crying roughly and angrily: "Get out of the way, confound you, and let us pass. We're in a hurry."

To which Sancho replied: "O Princess and world-famous Lady of El Toboso! How is it that your magnanimous heart is not softened when you see the column and prop of knight errantry kneeling before your sublimated presence?"

On hearing this, one of the two others exclaimed: "Wait till I get my hands on you, you great ass! See how these petty

gentry come and make fun of us village girls, as if we couldn't give them as good as they bring! Get on your way, and let us get on ours. You had better!"

"Rise, Sancho," said Don Quixote at this; "for I see that Fortune, unsatisfied with the ill already done me, has closed all roads by which any comfort may come to this wretched soul I bear in my body. And you, O perfection of all desire! Pinnacle of human gentleness! Sole remedy of this afflicted heart, that adores you! Now that the malignant enchanter persecutes me, and has put clouds and cataracts into my eyes, and for them alone, and for no others, has changed and transformed the peerless beauty of your countenance into the semblance of a poor peasant girl, if he has not at the same time turned mine into the appearance of some spectre to make it abominable to your sight, do not refuse to look at me softly and amorously, perceiving in this submission and prostration, which I make before your deformed beauty, the humility with which my soul adores you."

"Tell that to my grandmother!" replied the girl. "Do you think I want to listen to that nonsense? Get out of the way and let us go on, and we'll thank you."

The structure of the novel is as leisurely and seemingly as rambling as the Don's wanderings. Yet the various episodes are linked by the constant confrontation between reality and illusion, the real world and that of the imagination. Thus, at one level, the book becomes a meditation on the relationship between art and life. By the end of his life, Don Quixote has learned painfully that his noble aspirations cannot be reconciled with the realities of the world, and he dies disillusioned. In the last part of the book, where the humor of the hero's mishaps does not conceal their pathos, Cervantes reaches that rare height of artistry where comedy and tragedy are indistinguishable.

English Literature

In England, the pinnacle of dramatic expression had been reached by the turn of the century in the works of Shakespeare. The literary form that proved most productive during the 17th century was that of lyric poetry, probably because of its ability to express personal emotions—although most scholars would agree that the single greatest English work of the age was John Milton's epic poem *Paradise Lost*. Yet another achievement of the era was not an original work at all but, rather, a translation.

THE KING JAMES BIBLE An important English-language literary achievement of the 17th century was not an original artistic creation but, rather, a new translation. It is difficult to know precisely how to categorize the Authorized Version of the Bible, commissioned by King James I and first published

in 1611, often called the only great work of literature ever produced by a committee. The 54 scholars and translators who worked on the task deliberately tried to create a biblical style that would transcend the tone of English as it was then generally used. Their success can be measured by the immense influence the King James Bible has had on speakers and writers of English ever since (see Chapter 14). It remained the Authorized Version for English-speaking people until the late 19th century, when it was revised in light of new developments in biblical studies.

JOHN DONNE Of all 17th-century literary figures writing in English, the group known as the Metaphysical poets, whose poetry sought to give intellectual expression to emotional experience, makes a particular appeal to modern readers. As is often pointed out, the label **metaphysical** is misleading for two reasons. In the first place, it suggests an organized group of poets consciously following a common style. While it is true that the earliest poet to write in the metaphysical style, John Donne (1572–1631), exerted a strong influence on a whole generation of younger poets, a unified group or school never existed. (Some scholars would, in fact, classify Donne's style as *Mannerist*.)

Second, *metaphysical* seems to imply that the principal subject of their poetry was philosophical speculation on the nature of reality. While it is certainly true that the Metaphysical poets were interested in ideas and that they used complex forms of expression and a rich vocabulary to express them, the chief subject of their poems was not philosophy, but themselves—particularly their own emotions.

Yet this concern with self-analysis should not suggest a limitation of vision. Some critics have ranked Donne's sonnets second only to Shakespeare's in their range and depth of expression. Donne's intellectual brilliance and his love of paradox and ambiguity make his poetry sometimes difficult to follow. Donne always avoided the conventional, both in word and thought, and the swift changes of mood within a single short poem from light banter to the utmost seriousness can confuse careless readers. Although it sometimes takes patience to unravel his full meaning, the effort is more than amply rewarded by contact with one of the most daring and honest of poets.

Donne's poems took on widely differing areas of human experience, ranging from some of the most passionate and frank discussions of sexual love ever penned to profound meditations on human mortality and the nature of the soul. Born a Catholic, he traveled widely as a young man and seems to have led a hectic and exciting life. He abandoned Catholicism, perhaps in part to improve his chances of success in Protestant England, and in 1601, on the threshold of a successful career in public life, he entered Parliament. The same year, however, he secretly married his patron's 16-year-old niece, Anne More. Her father had him dismissed and even imprisoned for a few days, and Donne's career never recovered from the disgrace.

Donne's "The Canonization" has its religious elements, but as we see in the first verse, it could also have been an argument against his wife's father:

READING 15.6 JOHN DONNE

"The Canonization," lines 1–9

For God's sake, hold your tongue, and let me
 love,
 Or chide my palsy, or my gout;
 My true gray hairs, or ruin'd fortune flout;
With wealth your state, your mind with art,
 improve,
 Take you a course, earn you a place,
 Observe his Honour, or his Grace;
Or the King's real or his stamp'd face
 Contemplate; what you will, approve,
 So you will let me love.

Although Donne's marriage proved a happy one, its early years were clouded by debt, ill health, and frustration. In 1615, at the urging of friends, he finally joined the Anglican Church and entered the ministry. As a preacher, he soon became known as among the greatest of his day. By 1621, Donne was appointed to one of the most prestigious positions in London: dean of Saint Paul's. During his last years, he became increasingly obsessed with death. After a serious illness in the spring of 1631, he preached his own funeral sermon and died within a few weeks.

Thus, the successful worldliness of the early years gave way to the growing somberness of his later career. We might expect a similar progression from light to darkness in his work, yet throughout his life the two forces of physical passion and religious intensity seem to have been equally dominant, with the result that in much of his poetry each is sometimes used to express the other.

RICHARD CRASHAW The poems of Donne's younger contemporary Richard Crashaw (1613–1649) blend extreme emotion and religious fervor in a way that is completely typical of much Baroque art. Yet Crashaw serves as a reminder of the danger of combining groups of artists under a single label, because although he shares many points in common with the other Metaphysical poets, his work as a whole strikes a unique note.

There can be little doubt that Crashaw's obsessive preoccupation with pain and suffering has more than a touch of masochism or that his religious fervor is extreme even by Baroque standards. Some of the intensity is doubtless a result of his violent rejection of his father's Puritanism and his own enthusiastic conversion to Catholicism. Stylistically, Crashaw owed much to the influence of the flamboyant Italian Baroque poet Giambattista Marino (1569–1625), whose virtuoso literary devices he imitated. Yet the eroticism that so often tinges Crashaw's spiritual fervor gives a highly individual air to his work:

READING 15.7 RICHARD CRASHAW

"On the Wounds of Our Crucified Lord," lines 1–8

O these wakeful wounds of thine!
 Are they mouths? or are they eyes?
Be they mouths, or be they eyn,
 Each bleeding part some one supplies.

Lo! a mouth, whose full bloom'd lips
 At too dear a rate are roses.
Lo! a blood-shot eye! that weeps
 And many a cruel tear discloses.

ANDREW MARVELL Marvell (1621–1678) was the son of a pastor and attended Cambridge. Through his studies and his travels, he learned Latin, Greek, Dutch, French, Spanish, and Italian—all of which served him well as an ambassador during his career. That career was largely political; he served in the Cromwell government and then in parliament for many years. His poetry, like that of other Metaphysical poets, contains some far-fetched similes, metaphors, and **hyperbole**—that is, poetic exaggeration. We find such exaggeration in his ever-popular "carpe diem"[2] poem "To His Coy Mistress," which is written in rhyming couplets of iambic tetrameter. His phrasing "if you please, refuse/Till the conversion of the Jews" refers to one Christian belief that Jews will convert to Christianity just before the end of time. Or consider the simile, "the youthful hue/Sits on thy skin like morning dew." Other phrasings of note include "thy marble vault" as your sepulcher or grave; if you persevere in protecting your honor, "then worms shall try/That long preserved virginity":

READING 15.8 ANDREW MARVELL

"To His Coy Mistress" (ca. early 1650s)

Had we but world enough, and time,
This coyness, lady, were no crime.
We would sit down, and think which way
To walk, and pass our long love's day.
Thou by the Indian Ganges' side
Shouldst rubies find: I by the tide
Of Humber would complain. I would
Love you ten years before the flood,
And you should, if you please, refuse
Till the conversion of the Jews;
My vegetable love should grow
Vaster than empires and more slow;
An hundred years should go to praise
Thine eyes, and on thy forehead gaze;
Two hundred to adore each breast;
But thirty thousand to the rest;

2. "Seize the day."

An age at least to every part,
And the last age should show your heart.
For, lady, you deserve this state,
Nor would I love at lower rate.
 But at my back I always hear
Time's wingèd chariot hurrying near,
And yonder all before us lie
Deserts of vast eternity.
Thy beauty shall no more be found,
Nor, in thy marble vault, shall sound
My echoing song; then worms shall try
That long-preserved virginity,
And your quaint honour turn to dust,
And into ashes all my lust:
The grave's a fine and private place,
But none, I think, do there embrace.
 Now therefore, while the youthful hue
Sits on thy skin like morning dew,
And while thy willing soul transpires
At every pore with instant fires,
Now let us sport us while we may,
And now, like amorous birds of prey,
Rather at once our time devour,
Than languish in his slow-chapt power.
Let us roll all our strength and all
Our sweetness up into one ball,
And tear our pleasures with rough strife,
Thorough the iron gates of life;
Thus, though we cannot make our sun
Stand still, yet we will make him run.

JOHN MILTON'S HEROIC VISION While the past 100 years have seen a growing appreciation for Donne and his followers, the reputation of John Milton has undergone some notable ups and downs. Revered in the centuries following his death, Milton's work came under fire in the early years of the 20th century from major poets such as T. S. Eliot and Ezra Pound, who claimed that his influence on his successors had been pernicious and had led much of subsequent English poetry astray. Now that the dust of these attacks has settled, Milton has resumed his place as one of the greatest of English poets. The power of his spiritual vision, coupled with his heroic attempt to wrestle with the great problems of human existence, seems in fact to speak directly to the uncertainties of our own time.

Milton's life was fraught with controversy. An outstanding student with astonishing facility in languages, he spent his early years traveling widely in Europe and composing relatively lightweight verse—lightweight, that is, when compared to what was to come. Among his most entertaining early works are the companion poems "L'Allegro" and "Il Penseroso," which compare the cheerful and the contemplative character to appropriate scenery. They were probably written in 1632, following his graduation from Cambridge.

By 1640, however, he had become involved in the tricky issues raised by the English Civil War and the related problems of church government. He launched into the fray with a series of radical pamphlets that advocated, among other things, divorce on the grounds of incompatibility. (It is presumably no coincidence that his own wife had left him six weeks after their marriage.) His growing support for Oliver Cromwell and the Puritan cause won him an influential position at home but considerable enmity in continental Europe, where he was seen as the defender of those who had ordered the execution of King Charles I in 1649. The strain of his secretarial and diplomatic duties during the following years destroyed his eyesight, but although completely blind, he continued to work with the help of assistants.

When Charles II was restored to power (in 1660), Milton lost his position and was fortunate not to lose his life or liberty. Retired to private life, he spent his remaining years in the composition of three massive works: *Paradise Lost* (1667), *Paradise Regained* (1671), and *Samson Agonistes* (1671).

By almost universal agreement, Milton's most important, if not most accessible, work is *Paradise Lost*, composed in the early 1660s and published in 1667. It was intended as an account of the fall of Adam and Eve, and its avowed purpose was to "justify the ways of God to man." The epic is in 12 books (originally 10, but Milton later revised the divisions), written in blank verse.

Milton's language and imagery present an almost inexhaustible combination of biblical and classical reference. From the very first lines of Book 1, where the poet calls on a Classical Muse to help him tell the tale of the Fall, the two great Western cultural traditions are inextricably linked. Like Bach, Milton represents the summation of these traditions. In his work, Renaissance and Reformation meet and blend to create the most complete statement in English of Christian humanism, the philosophical reconciliation of humanist principles with Christian doctrine. Milton owed his grounding in the classics to the Renaissance. In composing *Paradise Lost*, an epic poem that touches on the whole range of human experience, he was deliberately inviting comparison to Homer and Virgil. His language is also Classical in inspiration, with its long, grammatically complex sentences and preference for abstract terms. Yet his deeply felt Christianity and his emphasis on human guilt and repentance mark him as a product of the Reformation. Furthermore, although he may have tried to transcend the limitations of his own age, he was as much a child of his time as any of the other artists discussed in this chapter. The dramatic fervor of Bernini, the spiritual certainty of Bach, the psychological insight of Monteverdi, the humanity of Rembrandt—all have their place in Milton's work and mark him, too, as an essentially Baroque figure.

Paradise Lost is written in iambic pentameter (five feet, each with a soft syllable followed by an accented syllable), with occasional variations. It begins as shown in Reading 15.9—note that Milton reveals no false modesty about his ability to pen "things unattempted yet in prose or rhyme":

READING 15.9 JOHN MILTON

Paradise Lost, Book 1, lines 1–27

Of Man's first disobedience, and the fruit
Of that forbidden tree whose mortal taste

Brought death into the World, and all our woe,
With loss of Eden, till one greater Man
Restore us, and regain the blissful Seat,
Sing, Heavenly Muse, that, on the secret top
Of Oreb, or of Sinai, didst inspire
That Shepherd who first taught the chosen seed
In the beginning how the heavens and earth
Rose out of Chaos: or, if Sion hill
Delight thee more, and Siloa's brook that flowed
Fast by the oracle of God, I thence
Invoke thy aid to my adventurous song,
That with no middle flight intends to soar
Above the Aonian mount, while it pursues
Things unattempted yet in prose or rhyme.
And chiefly Thou, O Spirit, that dost prefer
Before all temples the upright heart and pure,
Instruct me, for Thou know'st; Thou from the first
Wast present, and, with mighty wings outspread,
Dove-like sat'st brooding on the vast Abyss,
And mad'st it pregnant: what in me is dark
Illumine, what is low raise and support;
That, to the highth of this great argument,
I may assert Eternal Providence,
And justify the ways of God to men.

A bit later Milton paints Satan (in Reading 5.10), who has been expelled from Paradise along with his entourage of fallen angels. They are immortal and therefore cannot die, but Satan bemoans their situation to Beelzebub, who to Satan was "next himself in power, and next in crime":

READING 15.10 JOHN MILTON

Paradise Lost, Book 1, lines 84–94

If thou beest he—but Oh how fallen! how changed
From him!—who, in the happy realms of light,
Clothed with transcendent brightness, didst outshine
Myriads, though bright—if he whom mutual league,
United thoughts and counsels, equal hope
And hazard in the glorious enterprise,
Joined with me once, now misery hath joined
In equal ruin; into what pit thou seest
From what height fallen: so much the stronger proved
He with his thunder: and till then who knew
The force of those dire arms?

There will be no "greater Man" who will ever restore the fallen angels to "regain the blissful seat." But for humans, there is hope.

American Literature

Across the Atlantic from England, the 17th century witnessed the early days of an American literature, which would grow more distinct from English literature as the years passed and Americans developed their own literary tradition. The term *American literature* refers to works produced in English in the British colonies and, later, the United States. At first, American literature was written by colonial people whose origins were in England, such as John Smith of Virginia. Works by William Penn of Pennsylvania and Thomas Ashe of the Carolinas touted the economic promise of America before there was a United States.

JOHN WINTHROP Winthrop (1588–1649) was the first governor of Massachusetts Bay and is generally considered to be the major figure in the founding of Puritanism in the colonies. In his sermon *A Model of Christian Charity*, dated 1630, Winthrop spoke of the Puritan desire to establish a theocracy, which had God as its head and whose laws were based on the Bible:

READING 15.11 JOHN WINTHROP

From *A Model of Christian Charity*

Now the only way to…provide for our posterity is to follow the Counsel of Micah, to do Justly, to love mercy, to walk humbly with our God, for this end, we must be knit together in this work as one man, we must entertain each other in brotherly Affection,… We must delight in each other, make others' Conditions our own, rejoice together, mourn together, labor, and suffer together, always having before our eyes our Commission and Community in the work, our Community as members of the same body, so shall we keep the unity of the spirit in the bond of peace; the Lord will be our God and delight to dwell among us as his own people and will command a blessing upon us in all our ways, so that we shall see much more of his wisdom, power, goodness and truth than formerly we have been acquainted with; we shall find that the God of Israel is among us, when ten of us shall be able to resist a thousand of our enemies, when he shall make us a praise and glory, that men shall say of succeeding plantations: the Lord make it like that of New England: for we must Consider that we shall be as a City upon a Hill,[3] the eyes of all people are upon us; so that if we shall deal falsely with our God in this work we have undertaken and so cause him to withdraw his present help from us, we shall be made a story and a byword through the world, we shall open the mouths of enemies to speak evil of the ways of God and all professors for God's sake; we shall shame the faces of many of God's worthy servants, and cause their prayers to be turned into Curses upon us till we be consumed out of the good land whither we are going:…

ANNE BRADSTREET Poetry was also written in Massachusetts. Anne Bradstreet (1612–1672) and her husband Simon, whom she had married at age 16, journeyed across the Atlantic from England in 1630. Simon became governor in 1679, after Anne's death.

Bradstreet, though a Calvinist, when still in England confessed, "as I grew up to be about 14 or 15, I found my heart

3. The phrase "City upon a Hill" originated in Jesus's Sermon on the Mount (Matthew 5:14) and is sometimes used as an alternate title to Winthrop's sermon.

more carnal, and sitting loose from God." She developed small-pox just before her marriage, which she—possibly tongue in cheek—attributed to divine retribution.

Bradstreet has been considered the first American poet and a key figure in the history of American literature. Much of her work recounts her struggles with New England colonial life and with her own illnesses. Even so, her first collection of poems, *The Tenth Muse Lately Sprung Up in America, By a Gentlewoman of Those Parts* (1650) is also the first book authored by a woman and published in America.

She begins her poem "The Prologue" with an apology for writing, which was common among writers, including male writers, of the day:

READING 15.12 ANNE BRADSTREET

"The Prologue," lines 1–6

To sing of wars, of captains, and of kings,
Of cities founded, commonwealths begun,
For my mean[4] pen are too superior things:
Or how they all, or each, their dates have run;
Let poets and historians set these forth,
My obscure lines shall not so dim their worth.

Following are lines from a lyric poem she wrote to her husband, when he was called away on business:

READING 15.13 ANNE BRADSTREET

"A Letter to Her Husband, Absent upon Public Employment," lines 1–8

My head, my heart, mine eyes, my life, nay, more,
My joy, my magazine[5] of earthly store,
If two be one, as surely thou and I.
How stayest thou there, whilst I at Ipswich[6] lie?
So many steps head from the heart to sever;
If but a neck, soon should we be together.
I, like the earth this season, mourn in black,
My sun[7] is gone so far in his zodiac...[8]

4. Humble.
5. Storehouse.
6. A town to the north of Boston.
7. Her husband.
8. Travels through the heavens.

GLOSSARY

Adagio (p. 532) Slow, as in a passage or piece of music.
Allegro (p. 532) Fast, as in a passage or piece of music.
Aria (p. 530) A solo song in an opera, oratorio, or cantata, which often gives the singer a chance to display technical skill.

Baldacchino (p. 501) An ornamental canopy for an altar, supported by four columns and often decorated with statuary.
Baroque (p. 496) A 17th-century European style characterized by ornamentation, curved lines, irregularity of form, dramatic lighting and color, and exaggerated gestures.
Cantata (p. 532) A short oratorio composed of sections of declamatory recitative and lyrical arias.
Chiaroscuro (p. 512) From the Italian for "light–dark"; an artistic technique in which subtle gradations of value create the illusion of rounded, three-dimensional forms in space; also called *modeling.*
Chorale prelude (p. 532) A variation on a chorale that uses familiar songs as the basis for improvisation.
Chorale variations (p. 531) Instrumental music consisting of a set of variations upon melodies taken from a familiar hymn or sacred song.
Concerto grosso (p. 532) An orchestral composition in which the musical material is passed from a small group of soloists to the full orchestra and back again.
Counter-Reformation (p. 496) The effort of the Catholic Church to counter the popularity of Protestantism by reaffirming basic values but also supporting a proliferation of highly ornamented Baroque churches.
Fugue (p. 532) A musical piece in which a single theme is passed from voice to voice or instrument to instrument (generally four in number), repeating the principal theme in different pitches.
Harpsichord (p. 531) A keyboard instrument; a forerunner of the modern piano.
Hyperbole (p.541) Poetic exaggeration.
Induction (p. 535) A kind of reasoning that constructs or evaluates propositions or ideas on the basis of observations of occurrences of the propositions; arriving at conclusions on the basis of examples.
Kantor (p. 532) Music director, as at a school.
Largo (p. 532) Slow, as in a passage or piece of music.
Materialism (p. 537) In philosophy, the view that everything that exists is either made of matter or—in the case of the mind, for example—depends on matter for its existence.
Metaphysical (p. 540) Pertaining to a group of British lyric poets who used unusual similes or metaphors.
Monody (p. 529) From the Greek *monoidia*, meaning an ode for one voice or one actor; in early opera, a single declamatory vocal line with accompaniment.
Movement (p. 532) A self-contained section of a larger musical work; the Classical symphony, for example, has four distinct movements.
Opera (p. 528) A dramatic performance in which the text is sung rather than spoken.
Oratorio (p. 531) A sacred drama performed without action, scenery, or costume, generally in a church or concert hall.
Picaresque (p. 539) Of a form of fiction having an engaging, roguish hero who is involved in a series of humorous or satirical experiences.
Recitative (p. 529) The free declaration of a vocal line, with only a simple instrumental accompaniment for support.
Sonata (p. 531) A kind of short piece of instrumental music.
Tenebrism (p. 507) A style of painting in which the artist goes rapidly from highlighting to deep shadow, using very little modeling.
Toccata (p. 531) A free-form rhapsody composed for an instrument with a keyboard, often combing extreme technical complexity and dramatic expression.

THE BIG PICTURE THE SEVENTEENTH CENTURY

Language and Literature

- King James I commissioned a new English translation of the Christian Bible.
- Three playwrights transformed French dramatic literature—the tragedians Pierre Corneille and Jean Racine and the comedic satirist Jean-Baptiste Poquelin (stage name: Molière).
- In Spain, Miguel de Cervantes Saavedra wrote *Don Quixote*, weaving keen perceptions of human nature with satire and comedy.
- John Donne, Richard Crashaw, and other English Metaphysical poets gave intellectual expression to emotional experience.
- In England, the blind poet John Milton composed his blank-verse epic poem *Paradise Lost* "to justify the ways of God to men."
- Anne Bradstreet, of the Massachusetts Bay Colony, was the first American poet and the first female American author of a published book.

Art, Architecture, and Music

- To counter the Protestant Reformation, the Roman Catholic Church constructed Baroque churches in Italy characterized by splendor, opulence, and theatricality. The portrayal of spiritual experiences in painting and sculpture was seen as a vehicle for promoting devotion and piety.
- Carlo Maderno was appointed chief architect of Saint Peter's by Pope Paul V. He enlarged the nave, fixing the Latin Cross plan of the basilica, and completed the façade.
- Gian Lorenzo Bernini, the foremost sculptor and architect of the Baroque era, succeeded Maderno at Saint Peter's. He designed the colonnaded piazza in front of the basilica and worked on interior projects for some 50 years.
- Bernini created his *David*, and other sculptures, for Cardinal Scipione Borghese, launching his lucrative and high-profile career.
- Pope Urban VIII, Bernini's unwavering supporter, patronized the arts on a grand scale.
- Caravaggio pioneered Tenebrism in painting—an exaggerated use of light and shade that heightens the drama of the narrative. He rejected standard, idealized versions of saints and biblical figures and turned to ordinary people for models in the search for naturalism and accessibility.
- Artemisia Gentileschi, stylistic heir to Caravaggio, was the most successful female artist in Italy. Many of her works focused on biblical heroines and offered a distinct woman's perspective on commonly painted themes.
- Diego Velázquez, the leading painter in the court of the Spanish king Philip IV, painted *Las Meninas*, an enigmatic portrait of the artist and the royal family.
- Peter Paul Rubens transformed Northern art with his dissemination of the Italian Baroque style. The greatest Flemish painter of his era, Rubens ran a large workshop to keep pace with his international commissions.
- Rembrandt van Rijn became the leading painter in the Dutch Republic. His unique handling of light and shadow are evident in portraits and biblical scenes; he also became a renowned printmaker and famously sold one of his etchings for the stunning price of 100 Dutch guilders.
- King Louis XIV of France built his immense palace at Versailles, with its glorious gardens and famed Hall of Mirrors.
- Opera, a new musical genre, combined performances of orchestral musicians and vocalists into a single, theatrical art form. The medium's complexity raised singers to new levels of virtuosity.
- Domenico Scarlatti, a harpsichord virtuoso, wrote hundreds of sonatas that laid the foundation for modern keyboard techniques.
- George Frederick Handel composed *Water Music* and *Messiah*, with its famed "Hallelujah Chorus."
- Johann Sebastian Bach, born in the late 17th century, composed fugues, chorale preludes, and cantatas.

Philosophy and Religion

- The Roman Catholic Church continued its Counter-Reformation against Protestantism by reaffirming basic Catholic doctrines such as transubstantiation, the papacy, and the rule of celibacy for the clergy.
- New religious orders—among them the Jesuits, Capuchins, and Discalced Carmelites—helped support the Counter-Reformation with their ministries and missionary work.
- Jesuits sought worship spaces to showcase the spectacle of Counter-Reformation art and ceremony.
- The French skeptic René Descartes, the Father of Modern Philosophy, sought scientific evidence to sort out truth from falsehood.
- In England, Thomas Hobbes, an early materialist, published *Leviathan*, a profoundly pessimistic work that speaks of the need to control human avarice and violence.
- The English philosopher and physician John Locke argued against the idea of inborn knowledge or understanding in his best-known work, *An Essay Concerning Human Understanding*.
- John Winthrop and his companions brought Calvinistic Puritanism to the Massachusetts Bay Colony in America.

Tlavavanaliztli.

Este espectaculo, de tlauauanaliz
tli, se hazia enla fiesta, de tlacaxi
peoaliztli: alli esta ala larga, escrip
to.

Injc muchivaia inmotenehoa
tlavavanaliztli injquac malli
moauchivaia ichimal imaqua
uh imac onoc aocmoiztzo in
imaquauh. auh intlavanque in
chimal in macquauhieticac
injc tlavavanaia iuhqujnquj
cali malli anoço tlacutli.

Acupan onoliztli

Esto esta dicho, en la fiesta, de
Eçalqualiztli.

Macujlilhujtl intulpan ne
tecoia injc neçavililoia tlaloc
iniquac vztoc tlaliloia vme
culnavati.

Çacapan nemanaliztli

Esta superstcion, o cerimonja, se
puso en la fiesta, de tlacaxipeoaliz
tli

Inçacapan nemanaliztli, ie
hoantin inqujxipevaia tlaca
inimevaio cequjntin conma
qujoia in choatl inmotene
vaia xixipeme, auh motze
tzeloaia in çacatl ipan qujn
valmanaia ipompa motze
vaia çacapan valnemana
lo.

Tlaçcaltiliztli.

Cultural Centers of the Americas

PREVIEW

At the same time that scribes were copying and illustrating holy books in Europe, on a continent an ocean away, artists and writers in what is today called Mesoamerica—the land of the Mixtec, Aztec, and Maya peoples—were producing their own manuscripts in their own system of writing. They recorded their histories, commercial activities, religious rituals, and calendar calculations; mapped their territory; and even charted the journeys of planets and stars across the nighttime sky. Some used logograms—written characters representing words or phrases—and some used pictographs and ideographs—forms of writing in which drawings represent things or ideas. Some manuscripts were written on paper, and others on sheets of deerskin coated with white lime plaster and then folded into pleats like an accordion—a **codex** rather than a bound book.

Codices (plural of *codex*) were built to last, but only a few managed to slip through the ruinous hands of the Spanish conquistadors and Christian missionaries who followed in their wake. Nearly all of them were destroyed by zealous priests, like Diego de Landa (1524–1579), who defended these actions: "Since they contained nothing but superstitions and falsehoods of the devil, we burned them all." He added, "which they took most grievously, and which gave them great pain."[1]

Contemplating the fate of these codices and, with their destruction, the loss to history of the fullness of Mesoamerican life, we cannot but value the work of one Franciscan missionary, Fray Bernardino de Sahagún (1499–1590). He arrived in Mesoamerica in 1529, eight years after the Spanish conquest, one of a wave of missionaries seeking to convert the indigenous peoples to Christianity. Sahagún came to believe that it would help his cause to understand their devotion to their "false gods" and thus set about interviewing them about their religion, culture, and values. His conclusion was noted in his prologue for what is now called the *Florentine Codex:* The Mesoamericans "are held to be barbarians and of very little worth; in truth, however, in matters of culture and refinement, they are a step ahead of other nations that presume to be quite politic."[2]

Sahagún's codex was a massive, 30-year-long undertaking. He questioned Nahua elders—indigenous Mexicans—who recorded their answers in pictographs. Their drawings were then converted into a written version of their language—Nahuatl—using the equivalent Latin script. Sahagún, who had picked up Nahuatl, then translated the responses into Spanish. His *Historia general de las cosas de nueva España* (*General history of the things of New Spain*) is encyclopedic, totaling 12 books with 2468 illustrations that combine Nahua traditional forms with features of European Renaissance art (**Fig. 16.1**). The codex was sent to Spain in 1579 and, nine years later, came into the possession of the Florentine Medici family—hence the *Florentine Codex*. It entered

◀ **16.1** Folio 126 from *The Florentine Codex*. Compiled by Fray Bernardino de Sahagún. Laurentian Library, Florence, Italy.

1. Diego de Landa, *Yucatan Before and After the Conquest,* trans. William Gates (Mineola, NY: Dover, 1978), p. 13.
2. Miguel Leon-Portilla, *Bernardino de Sahagún: First Anthropologist,* (trans. Mauricio J. Mixco (Norman, OK: University of Oklahoma Press, 2002), p. 136.

the collection of the Laurentian Library, on which Michelangelo had worked just 20 years earlier (see Fig. 13.30).

ORIGINS OF ANCIENT AMERICANS

Some 23,000 years ago, Stone Age nomads crossed a narrow strip of land that bridged two hemispheres—East and West.[3] Now submerged, that land bridge was the gateway to migration southward through the North and South American continents.

The progress of civilization among these peoples during the Neolithic period (8000 to 2000 BCE) followed a typical pattern. Agriculture took the place of hunting and gathering, and simple nomadic dwellings evolved into more permanent villages. Ceramic utensils and metal tools and weapons replaced earlier ones fashioned from bone or stone or wood. A more settled society brought with it more structure, self-awareness, and self-reflection. Social hierarchies were defined, religious beliefs were forged and institutionalized, and ritual became an inextricable part of authority as well as daily life. Villages grew into great planned cities, with advances in engineering, technology, and art accounting for their comfort, sophistication, and glorious presence.

The civilizations of what we call pre-Hispanic or pre-Columbian Mesoamerica and South America were highly advanced on virtually all levels—art, architecture, writing

3. Maanasa Raghavan et al., "Genomic Evidence for the Pleistocene and Recent Population History of Native Americans," *Science*, 349, no. 6250 (August 2015): 21.

systems, and mathematical knowledge—which, in tandem with an understanding of astronomy, produced the most accurate of any ancient calendar system. The continued evolution of these civilizations came to a screeching halt, starting with the invasion of the Spaniards in the early 16th century. The European conquest of ancient empires—the Maya, the Aztec, and the Inka—ended in their almost complete destruction and irretrievable loss to history. Thankfully, archaeologists and historians of pre-Hispanic Mesoamerica, South America, and North America have managed to reconstruct much of the history, lives, and monuments of these ancient Americans.

MESOAMERICA

The term **Mesoamerica** means "middle America" and defines the region consisting of present-day Mexico and parts of Central America, including Guatemala, Honduras, Belize, the northern part of Costa Rica, and the coastal region of El Salvador (**Map 16.1**). Except for mountain peaks, few of these areas ever witness the brutal winters of North and South America. The Mesoamerican climate ranges from tropical rain forests along coastal plains, to broad grasslands, to highlands and mountain valleys, with their perpetual springs, as in the Valley of Mexico.

The peoples of Mesoamerica showed great diversity in language, some of which remain in use, although the official first language in these nations is now Spanish. Aztec Nahuatl is still heard in the Mexican highlands as are Mayan dialects in southern Mexico and Guatemala. Only as recently as the 1950s did linguists make strides in deciphering Maya writing, yielding insight into the succession of Maya rulers.

Cultural Centers of the Americas

1200 BCE	900 CE	1492 CE
PRE-COLUMBIAN AMERICAS		POST-COLUMBIAN AMERICAS

Olmecs of the "mother cultures" of Mesoamerica sculpt colossal portraits of rulers 900–400 BCE	Maya build colossal pyramid-temple at Chichén Itzá 900–1500	Motecuhzoma II becomes emperor of Tenochtitlán in 1502
Large temple complexes erected in the Andes of South America 800–200 BCE	Mississippian culture builds 120 earth mounds 1000–1300	A German mapmaker attaches the name "America" to a map of New World in honor of Amerigo Vespucci 1507
Teotihuacán built 100 BCE–600 CE	Ancestral Puebloans wedge apartment complexes into southwestern hillsides ca. 850–1250	Hernán Cortés and Native American allies conquer Tenochtitlán 1521
Maya erect palaces, temple-pyramids, plazas, and ball courts in southern Mexico and Guatemala 300–900 CE	Mixteca-Puebla artists create illustrated codices	Francisco Pizarro conquers Inka Empire 1532
Nazca create geoglyphs ca. 500 BCE–500 CE	Aztecs found Tenochtitlán 1325	Fray Bernardino de Sahagún compiles the Florentine Codex
	Inka Empire begins 1200–1225	
	Inka construct 18,600 miles of roads in the Andes and build Machu Picchu 15th century	

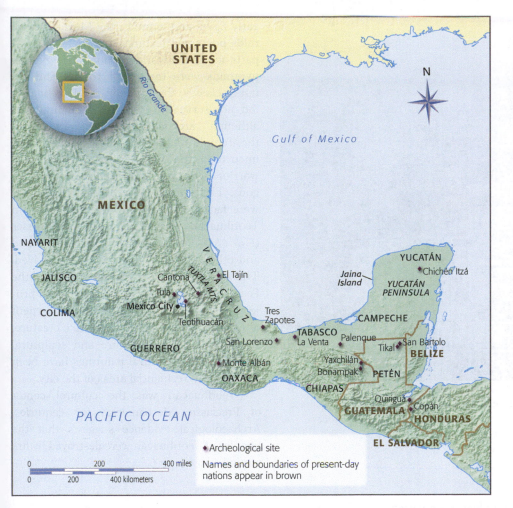

▲ MAP 16.1 Pre-Columbian Mesoamerica.

stone, and jadeite—were obtained. The overall shape of the heads conforms to the shape of the blocks from which they were carved, and all share similar characteristics: tight-fitting helmets, broad noses, full lips, and wide, flat cheeks. Whether these colossal heads represent gods or earthly rulers is unknown, but there can be no doubting of the power they project. The Olmec civilization declined around 400 BCE, but aspects of its religion, ritual, and culture lived on in the later Maya and Aztec civilizations.

The Olmec inhabited swampy, tropical lowlands within access of natural resources that could be exploited for sustenance, trade, and materials for the construction of buildings and monuments. This topography differs markedly from that of the Valley of Mexico, which was the setting for the major urban complex of Teotihuacán.

Teotihuacán

The remains of the holy city, Teotihuacán, "the place where the gods were created," lie about 30 miles northeast of Mexico City (**Fig. 16.3**). Development began at about 100 BCE, and at its peak, in about 600 CE, as many as 200,000 people lived and worked in Teotihuacán, making it one of the largest cities in the world. The city was designed on a grid plan bisected by

We speak of three Mesoamerican epochs: **Preclassic**, or formative, which defines the rise of Mesoamerican civilizations and rulers, and is usually bookended at about 2000 BCE and 300 CE. The **Classic period** extends from approximately 300 CE to 900 CE and is defined by the height of various cultures in the region, including the Maya. The **Postclassic** epoch begins in about 900 CE and ends, suddenly, with the Spanish conquest of 1521. The great Aztec civilization saw both its beginning and its termination during the Postclassic era.

Olmec

In what is now Mexico and Central America, the pre-Hispanic Olmec civilization—Mesoamerica's earliest—thrived from about 1500 to 400 BCE, spanning roughly the years between the Mycenaean era in the West through the Greek Golden Age. Some of the earliest—and certainly the most massive—works of art of the Americas were produced by the Olmec in what is now southern Mexico. More than a dozen gigantic heads (**Fig. 16.2**) up to 12 feet in height have been found at Olmec ceremonial centers, some 100 miles from the area where the materials for these sculptures—volcanic (basalt) rock,

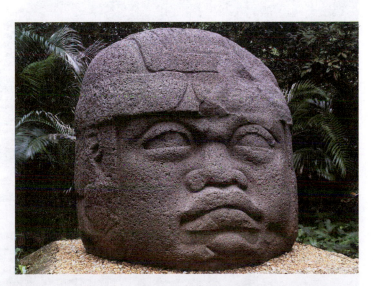

▲ 16.2 Colossal head, La Venta, Mexico, Olmec, c. 900–400 BCE. Basalt, 9' 4" high. Museo-Parque La Venta, Villahermosa, Mexico.

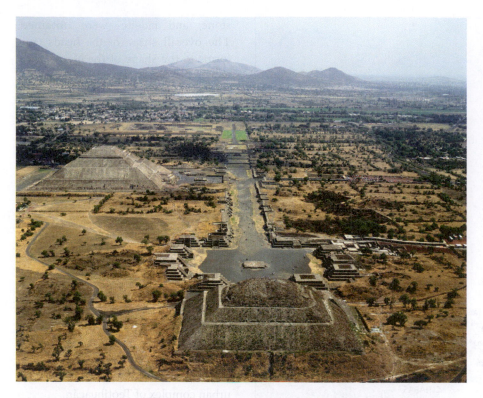

▲ **16.3** Aerial view of Teotihuacán (looking south), Mexico, c. 100 BCE–600 CE. The Pyramid of the Moon is shown in the foreground. The Pyramid of the Sun is on the left. The city has a grid-like pattern and is connected by the Avenue of the Dead, which is two miles long.

early Egyptian pyramids, the Mexican pyramids possessed features that their counterparts across the world did not. The Egyptian pyramids were tombs for royalty and the upper classes; the pyramids of Teotihuacán did not serve the same funereal function, although archaeological excavations of the Temple of the Feathered Serpent have uncovered the skeletons of children and warriors who were sacrificed to appease the gods. The sloping faces of Giza's pyramids were faced with smooth, dressed stone; in Teotihuacán, dramatically steep staircases (**Fig. 16.4A**) ascended to temples of wood and other materials that have not survived. The stepped terraces of the Temple of the Feathered Serpent are embellished with projecting stone heads of the feathered serpent alternating with another snake-like creature. In addition to architecture and sculptural reliefs, elaborate mural paintings have been excavated in residential areas of the city.

Teotihuacán was the cultural center of Preclassic Mesoamerica for centuries. Archaeological evidence suggests that the temples of Teotihuacán were destroyed by fire around 600 CE.

the broad Avenue of the Dead. The avenue features a variety of structures including colossal pyramids, smaller ceremonial platforms, and a shrine known as the Temple of the Feathered Serpent, dedicated to the deity Quetzalcoatl, which was flanked by two apartment compounds. While reminiscent of

Maya

Less than two centuries after Teotihuacán was razed, the Maya civilization in the Yucatán region of Mexico and the highlands of Guatemala reached its glorious peak. Dating back to 600 BCE, perhaps earlier, the Maya entered their Classic period in the centuries between 300 CE to 900 CE—at the same time that the Roman Empire had fallen and the European continent was in its middle ages. Construction flourished during the Classic period, as the Maya built many grand limestone structures featuring corbelled vaults, relief carvings of rulers and deities, and vividly colored murals commemorating events and illustrating rituals—including human sacrifice.

TIKAL Tikal, in present-day Guatemala, was one of the great Maya cities of the Classic era. At its height, its population was as large as 75,000. Unlike Teotihuacán, which had a regimented city plan, Tikal's consisted of

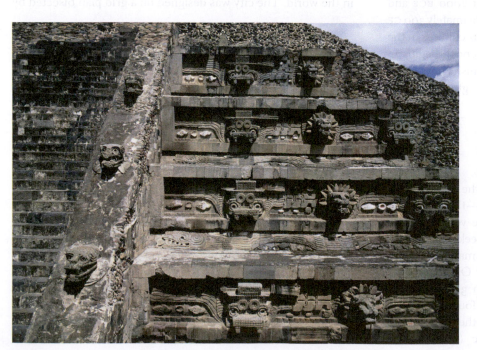

◄ **16.4A** Temple of the Feathered Serpent, the Ciudadela, Teotihuacán, Mexico, third century CE.

RELIGION

The Feathered Serpent

The ancient peoples of Mesoamerica had many deities, and the creator-god Quetzalcoatl, whose name in Nahuatl means "Feathered Serpent," was among the most important. He was worshipped as the creator and sustainer of humankind among the people of Teotihuacán and also by the later Maya and Aztecs. Credited with the discovery of maize (corn), a dietary staple in Mesoamerica, Quetzalcoatl was also the god of agriculture, but his "resume" grew significantly over time and in the traditions of various peoples in the region. He became the god of the evening and the morning stars—of death and resurrection; the god of village society and the protector of priests; the inventor of the calendar and the god of learning, of writing, and of books.

Creation myths of the Mesoamerican people have many permutations, but the notion that "in the beginning there was nothing" is fundamental to other creation narratives around the globe. According to the **Popol Vuh** (the bible or Council Book of the Maya people), in the dark—the night—the gods assembled and proclaimed "Let there be light." Afterward, the universe was created, importantly, out of sacrifice—a ceremonial practice that would be central to several Mesoamerican cultures. The gods gathered around fire and decided that, to create, one among them must be destroyed and transformed. One who was flawless in beauty though arrogant, balked in fear at self-sacrifice; another, dwarfish and unsightly, courageously jumped into the flames and was resurrected as the glorious sun. The beautiful god followed but was resurrected as the moon—a lesser light. Thus the universe was created, born of sacrifice and dualities—the sun, the moon; the beautiful and the horrible.

▲ **16.4B** Temple of the Feathered Serpent, detail.

The Popol Vuh also exclaims, "There shall be no glory until the human creature exists." The stage was set for Quetzalcoatl to create humans, and the necessity of sacrifice was instilled as the way to keep the sun god strong in his daily contest with the moon and the stars and therefore to assure the survival and prosperity of civilization.

an irregular grouping of buildings connected by causeways and a city center dominated by two large pyramidal temples that faced one another across a plaza. The Temple of the Giant Jaguar, which takes its name from relief carvings in the stone, was also a mausoleum for the ruler, Hasaw Chan K'awiil, who died in 732 CE (**Fig. 16.5**). He rests in a vaulted chamber beneath the base of the pyramid.

CHICHÉN ITZÁ Chichén Itzá is a complex of Maya structures and ruins on the Yucatán Peninsula, which extends into what is now called the Gulf of Mexico. Its architectural development came later than that, farther to the south,

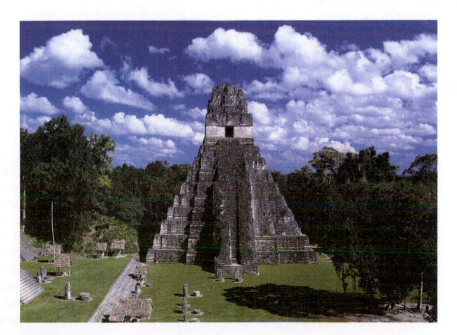

▶ **16.5** Temple I (Temple of the Giant Jaguar), Great Plaza, Tikal, Guatemala, Maya, ca. 732.

CULTURE AND SOCIETY

The Maya Ball Game

A Maya myth in the Popol Vuh, recorded in Spanish after the conquest, tells of a pair of twins who are compelled by the wicked lords of the Underworld to play a ball game. The brothers lose the game and their lives, sacrificed by the winners. Now the sons of one of the dead twins—twins themselves—journey to the Underworld to the scene of the contest and, in a turnabout, challenge those same wicked gods to a game. This time, the evil ones are slain and the sons are victorious. They return to the world above and resurrect their father from beneath the ball court, where he had been buried after he and his twin brother lost their contest to the evil gods of the Underworld. The victorious sons are transformed into the sun and the moon and their father, revived, becomes the god of life-sustaining maize. The Mesoamerican belief in the cycle of life, death, resurrection, and transformation is once again reflected in the details of the myth, as is the central principle of dualism in the occurrence of twins and the interconnectedness of the sun and the moon.

The mythological origins of the ball game suggest that it had symbolic and religious significance, that it was not just an entertaining spectator sport like the football, baseball, or soccer of our time. Questions about the game have still not been fully answered by historians: Why was it played? Who were the participants? What were the rules? Were the defeated always sacrificed, as the myth of the twins suggests? What we do know is this: The sport—which involved a court, protective gear, and a hard rubber ball—was played throughout Mesoamerica and may have dated back to the Olmecs (*Olmec* in Nahuatl means "rubber people"). The rectangular court was flanked by two facing stone structures with sloping walls that may have been used in play (think of the way that the walls of a racquetball court are used by the players); some ball courts have temples on the "short" ends of the rectangular space.

In addition to rubber balls that have been found in and around the archaeological remains of ball courts, clay figurines of athlete-participants in helmets and body-protecting-padding (**Fig. 16.6**), and mural paintings of players in action have also survived. The imagery carved on the walls of some ball courts depicts human sacrifice, bringing us full-circle to the myth of the ball court competition. It may be that participants—perhaps chosen from captives destined for sacrifice—were forced to compete, knowing full well that death awaited them.

▲ 16.6 Ball player from Jaina Island, Mexico, Maya, 700–900. Painted clay. 6 ¼" high. Museo Nacional de Antropologia, Mexico City, Mexico. The player wears protective gear and is apparently leaning in to the action.

and spanned the 9th through 12th centuries, from the Classic period into the Postclassic period. The pyramid in **Figure 16.7** was dubbed the Castillo ("castle") by the Spanish conquerors. According to the Maya Council Book (the Popol Vuh), Heaven and earth had 13 layers, with the earth at the bottom. The Underworld—*Xibalba* (meaning "place of fear")—however, had 9 layers, where the wicked gods of the dead tortured deceased humans endlessly. On the other hand, divine Maya rulers could descend through the Underworld to the bottom layer and then rise to Heaven. Connected with these beliefs is the design of the Castillo. It has nine levels.

Further, excavations found a smaller nine-level pyramid within. The Castillo is also connected with the solar year. The sides face the points of the compass. The north side has 92 steps and the other three sides have 91 steps apiece, totaling 365. Because of the design of the projecting parts of the pyramid and the height of the sun as it traverses the sky, during the summer and winter equinoxes, a shadow moves across the north face of the pyramid, as of a serpent god reacting to the sun above. That serpent god, of course, is Kukulcán, the Maya god that corresponds to the feathered-serpent god of Teotihuacán and Quetzalcoatl of the Aztecs.

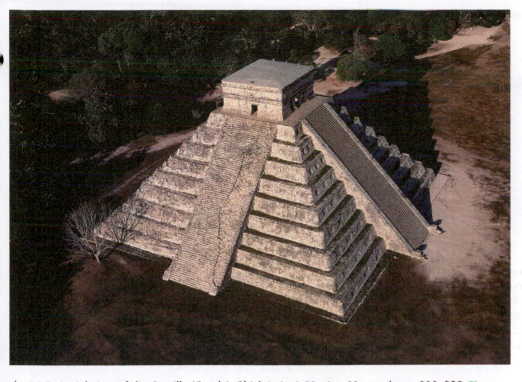

▲ **16.7** Aerial view of the Castillo (Castle), Chichén Itzá, Mexico, Maya culture, 800–900. Three hundred sixty-five steps lead to the summit (92 on the north side, 91 on each of the others). The pyramid was built so that during the summer and winter equinoxes, the sun would cast a shadow resembling a serpent along the staircase facing north.

and the rhythm of the steps provides unity. The quiet dignity and refinement of the composition contrast—disconcertingly—with the graphic depiction of human sacrifice.

MAYA LANGUAGES AND WRITING During their more than two-millennium history, Maya incorporated peoples who spoke dozens of languages, some of which can still be heard in Guatemala and southern Mexico where nearly seven million people of Maya descent live today. Guatemala recognized 21 Mayan languages in 1996, and Mexico recognizes another 8. Maya people committed a couple of these languages to writing and developed their writing system as many as three centuries before the birth of Christ.

Mayan writing incorporated about 800 unique signs or *glyphs* that represented words or syllables in the Mayan language. **Logograms** represented and resembled people, animals, and objects. **Syllabograms** were used to denote sounds. Maya symbols could represent anything they chose to record, including numbers, colors, and actions. Maya symbols are read in pairs, left and right, then going down to the next line.

THE BONAMPAK MURAL The copy of a damaged mural from Bonampak in southeastern Mexico portrays the offering of captives to a Maya lord for sacrifice to the gods (**Fig. 16.8**). Lord Chan Muwan stands in the center of the top of a multi-stepped platform (likely a pyramid), resplendent in a feather headdress and jaguar-pelt vest. He holds a ceremonial staff and looks downward at a prisoner who seems to be pleading for his life. Strewn on the stairs directly beneath him are men who have already been slain, while others cower in anticipation of their deaths. A strict social hierarchy is portrayed, with nobility on the upper tier, clad in splendor, and those of inferior status below. The eye is drawn upward to the center of the composition by the pyramidal shape formed by the scattered prisoners; the figures face the center of the composition, providing symmetry,

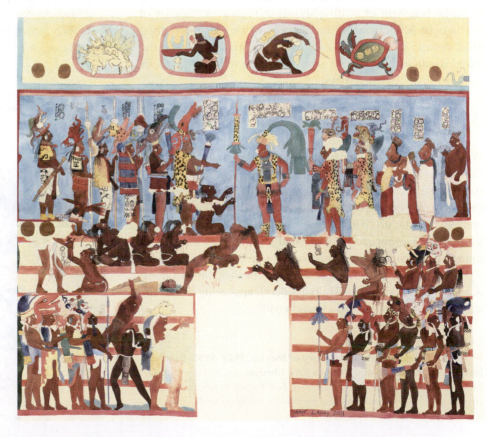

▶ **16.8** Presentation of captives to Lord Chan Muwan, Room 2 of Structure 1, Bonampak, Mexico, Maya culture, ca. 790. Mural, 17' × 15'; copy by Heather Hurst at one-half scale. Yale Peabody Museum of Natural History, New Haven, Connecticut.

◀ **16.9** Maya stela fragment with pictographic glyphs, ca. 300–800, Tabasco, Mexico. Stone, height 21 ¼". Metropolitan Museum of Art, New York, New York. The Michael C. Rockefeller Memorial Collection, Gift of Nelson A. Rockefeller, 1963. This fragment is part of the stela that forecast the end of the world in 2012.

Looking at **Figure 16.9**, one begins in the upper left, reads the first two symbols horizontally, then goes to the next line and repeats the process.

The Maya believed that writing was a gift from their god Itzamná, who was frequently depicted as a scribe on pottery. The Maya elite guarded this gift from the general population since they feared it could enable communication with the gods.

The fragment of writing shown in Figure 16.9 is part of Tortuguero Monument 6, the piece of writing that described great cosmic cycles of 52 years each and prophesied that the world would end in the year 2012. It became well known as our civilization approached that date.

Aztec

We are uncertain of the origins of the Aztecs, who are sometimes referred to as the Mexica/Aztec. They were a Nahuatl-speaking group who migrated into the Valley of Mexico from the north. According to myth, the Aztecs were guided by their god Huitzilopochtli ("Hummingbird of the South") in the search for their new home. A prophecy had foretold that they would found a great civilization where they saw an eagle perched upon a prickly-pear cactus and clutching a rattlesnake in its talons. A sacred narrative tells of Huitzilopochtli appearing before the standard-bearer of his flock, Quauhcoatl:

▶ **16.10** Diego Rivera, *The History of Mexico*, 1929–1935. Palacio Nacional (National Palace), Mexico City, Mexico. Detail of center panel showing an eagle and a snake on a prickly-pear cactus, as per the Aztec prophecy. The eagle, snake, and cactus are also found on the Mexican flag.

READING 16.1 FROM *THE FLORENTINE CODEX*

The Aztecs believe they have come upon the site where they will build their new city; Huitzilopochtli says to Quauhcoatl:

"But hear this:
There is something you still have not seen.
Go, go and look at the cactus,
and on it, standing on it, you shall see an eagle.
It is eating, it is warming itself in the sun,
and your hearts will rejoice,
for it is the heart of Copil[4] that you cast away where you halted
 in Tlalcocomoco.
There it fell, where you looked, at the edge of the spring,
among the rushes, among the reeds.
And from Copil's heart sprouted what is now called tenochtli.[5]
 There we shall be,
we shall keep guard,
we shall await, we shall meet the diverse peoples in battle.
With our bellies, with our heads,
with our arrows, with our shields,
we shall confront all who surround us
and we shall vanquish them all,
we shall make them captives,
and thus our city shall be established,
Mexico Tenochtitlán:
where the eagle screeches,
where he spreads his wings,
where the eagle feeds,
where the fish fly,
and where the serpent is torn apart.
Mexico Tenochtitlán!
And many things shall come to pass."

4. A wizard whose heart was torn out and interred in the earth.
5. Prickly-pear cacti.

It is said that the Aztecs happened upon such a sight in 1325 in swampland at the center of what is now Mexico City, and there they erected their great city Tenochtitlán on a large artificial island, with causeways connecting it to the surrounding regions. The eagle, snake, and cactus in the prophecy are depicted on the coat of arms of the nation of Mexico and also lie at the center of a Diego Rivera mural, *The History of Mexico* (**Fig. 16.10**).

Imagine the experience of the first Spaniards who came to Tenochtitlán, crossing a causeway, lured on by the splendor of the city in the lake, cradled in the Valley of Mexico by distant volcanoes and snow-capped mountains. The Spanish soldier Bernal Diaz del Castillo describes the arrival of his expeditionary force:

READING 16.2 BERNAL DIAZ DEL CASTILLO

From The Discovery and Conquest of Mexico

We proceeded along the Causeway which is here eight paces in width and runs so straight to the City of Mexico that it does not seem to me to turn either much or little, but, broad as it is, it was so crowded with people that there was hardly room for them all, some of them going to and others returning from Mexico, besides those who had come out to see us, so that we were hardly able to pass by the crowds of them that came; and the towers and [queues] were full of people as well as the canoes from all parts of the lake. It was not to be wondered at, for they had never before seen horses or men such as we are.

Gazing on such wonderful sights, we did not know what to say, or whether what appeared before us was real, for on one side, on the land, there were great cities, and in the lake ever so many more, and the lake itself was crowded with canoes, and in the Causeway were many bridges at intervals, and in front of us stood the great City of Mexico, . . .

Once established, the Aztec civilization would be famous for its advances in mathematics and engineering, along with monumental architecture, and would be infamous for its cruel subjugation of peoples from surrounding tribes. Prisoners of war fell victim to the ritual of human sacrifice intended to appease the sun god, who was believed to have sacrificed himself in the creation of humans.

THE SUN STONE Construction workers on a nearby church found the massive stone carved in relief shown in **Figure 16.11**, which is nearly 12 feet across and more than 3 feet thick, in the plaza in the heart of Mexico City, which was the sacred center of Tenochtitlán. It lay buried for nearly three centuries and was unearthed in 1790, when repairs to the cathedral in

the square were undertaken. Properly called the Cuauhxicalli Eagle Bowl, and also known as the Aztec Calendar Stone or Sun Stone, it shows an 18-month calendar of 20 days each, with 5 "unlucky" days tacked on to bring the total to 365. The distribution of months facilitated the prediction of weather and was of value to agriculture.

Most scholars believe that the figure in the center of the stone is the sun god, depicted within the time-space of the Aztec universe, which is shown as wheels within wheels. It is unknown whether the stone was a monument or a sacrificial altar. The god holds a human heart in each hand. His tongue is a blade used in sacrifice. (In Aztec belief, human blood was required to keep the sun shining.)

COATLICUE The compact, monumental stone effigy of Coatlicue, the Aztec "Mother of Gods," is no less fierce (see **Fig. 16.12** on p. 556). She is associated with the Earth and the cycle of birth, death, and rebirth. The effigy depicts the goddess as a symbol of creation and destruction (the Earth gives but also takes away). She wears a skirt of carved serpents, representing fertility, and a necklace of severed hands, hearts, and skulls. Scholars offer different interpretations of the uppermost part of the figure. Some read it as Coatilcue's head, composed of the heads of two facing snakes, whose eyes and fangs become her own. Others have said that the sculpture portrays a decapitated Coatlicue in which snakes coil out of her severed neck.

▼ **16.11 The Sun Stone, Tenochtitlán. Museo Nacional de Antropologia, Mexico City, Mexico.** The stone shows the Aztec universe as wheels within wheels and also displays the Aztec calendar.

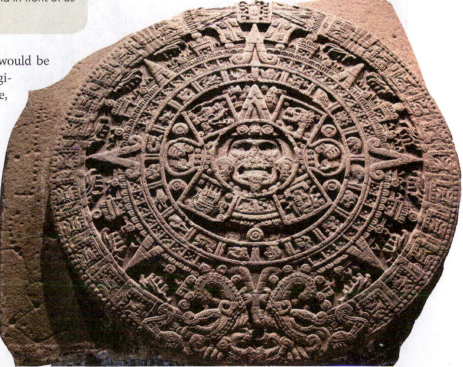

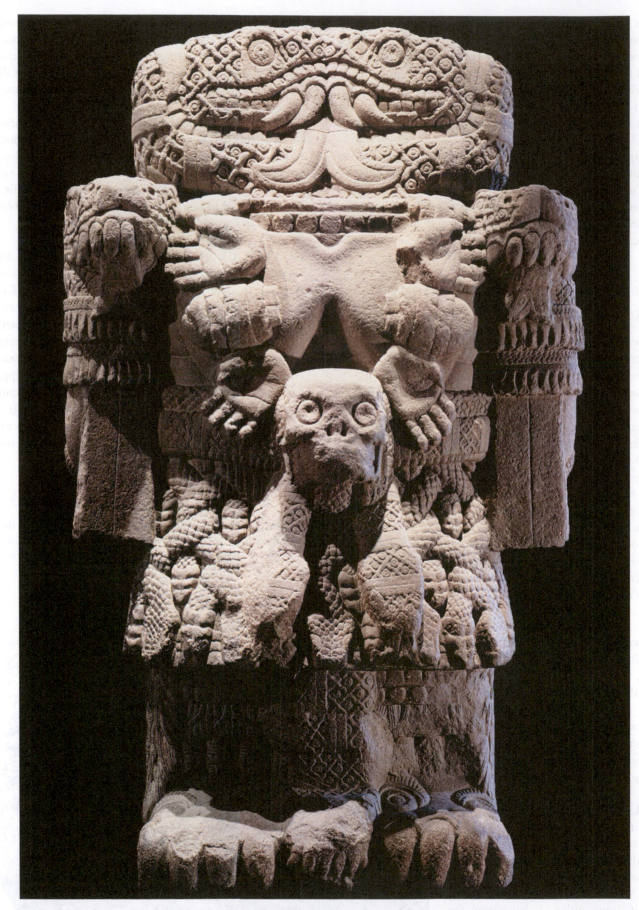

▲ **16.12 Coatlicue, from Tenochtitlán, Mexico City (Aztec, c. 1487–1520). Andesite, 11' 6" high. Museo Nacional de Antropología, Mexico City, Mexico.** With her necklace of human hands and hearts, the goddess is an emblem of the sacrificial ritual. She was discovered in 1790, the same year as the unearthing of the Sun Stone.

This interpretation more directly references one of two myths, in which one of Coatlicue's 400 children called upon her siblings to kill their mother. The ferocity of the imagery, incised and carved in relief, was not atypical of pre-Columbian imagery.

Given the violence of the Aztecs, it is not surprising that in the early part of the 16th century, the Spanish explorer-invaders found many Aztec neighbors more than eager to help them in their conquest of Tenochtitlán. The Aztecs also helped seal their own fate by initially treating the Spaniards, whom they believed were descended from Quetzalcóatl, with great hospitality. The Spaniards did not rush to disabuse their hosts of this notion and were thus able to creep into the hearts of the Aztecs within the Trojan horse of mistaken identity.

We have a sense of the conquest of the Aztecs from the Aztec point of view, because the *Florentine Codex* recorded the spoken memories of people who had witnessed it and their children. According to the codex, Cortés and his crew are spotted offshore in the Gulf of Mexico—their large ships looming as "mountains" in the water. Reports of their arrival reach Motecuhzoma, the Aztec ruler, who wonders if Cortés is the God Quetzalcoatl, returning, according to prophecy, to his kingdom. Let us see the messengers' first reports to Motecuhzoma and the king's response:

READING 16.3 FROM *THE FLORENTINE CODEX*

Excerpt from "The Broken Spears: The Aztec Account of the Conquest of Mexico"

"Our lord and king, it is true that strange people have come to the shores of the great sea. They were fishing from a small boat, some with rods and others with a net. They fished until late and then they went back to their two great towers and climbed up into them. There were about fifteen of these people, some with blue jackets, others with red, others with black or green, and still others with jackets of a soiled color, very ugly, like our *ichtilmatli*.[6] There were also a few without jackets. On their heads they wore red kerchiefs, or bonnets of a fine scarlet color, and some wore large round hats like small *comales*[7] which must have been sunshades. They have very fair skin, much lighter than ours. They all have long beards, and their hair comes only to their ears."

Motecuhzoma hears of the captain of the ships and is reported to be deep in thought following the report:

. . . It was as if [the king] thought the new arrival was our prince Quetzalcoatl. This is what he felt in his heart: *He has appeared! He has come back! He will come here, to the place of his throne and canopy, for that is what he promised when he departed!*

When Cortés arrives in Tenochtitlán, Motecuhzoma goes out to greet him:

[Motecuhzoma] presented many gifts to the Captain and his commanders, those who had come to make war. He showered gifts upon them and hung flowers around their necks; he gave them necklaces of flowers and bands of flowers to adorn their breasts; he set garlands of flowers upon their heads. Then he hung the gold necklaces around their necks and gave them presents of every sort as gifts of welcome. . . .

[Motecuhzoma] came forward, bowed his head low and addressed [Cortés]: "Our lord, you are weary. The journey has tired you, but now you have arrived on the earth. You have come to your city, Mexico. You have come here to sit on your throne, to sit under its canopy.

"The kings who have gone before, your representatives guarded it and preserved it for your coming. The kings Itzcoatl, Motecuhzoma the Elder, Axayacatl, Tizoc and Ahuitzol ruled for you in the City of Mexico. The people were protected by their swords and sheltered by their shields.

"Do the kings know the destiny of those they left behind, their posterity? If only they are watching! If only they can see what I see!

"No, it is not a dream. I am not walking in my sleep. I am not seeing you in my dreams. . . . I have seen you at last! I have met you face to face! [You] have come out of the clouds and mists to sit on your throne again.

"This was foretold by the kings who governed your city, and now it has taken place. You have come back to us; you have come down from the sky. Rest now, and take possession of your royal houses. Welcome to your land, my lords!"

Cortés's translator puts the king's words into Spanish. Then Cortés replies:

"Tell Motecuhzoma that we are his friends. There is nothing to fear. We have wanted to see him for a long time, and now we have seen his face and heard his words. Tell him that we love him well and that our hearts are contented."

Despite his encouraging words, Cortés takes Motecuhzoma prisoner as soon as they enter the Royal House. His troops fire a cannon ball, the shattering sound of which scatters the Aztecs, who have no experience with gunpowder. Cortés seizes many of Tenochtitlán's treasures. Once the people of the city see Cortés's true colors and realize that the Spaniards are men and not gods, they revolt. Cortés co-opts the subdued Motecuhzoma to speak to a crowd to sue for peace, but Motecuhzoma is pelted with stones and is killed. In a scenario to be repeated throughout the Americas, the European conqueror defeats a much larger number of natives with superior technology.

MUSIC AND DANCE Despite the severe demands of their religion and its rituals, more affluent Aztecs partook of leisure and pleasure. Aztec celebrations and festivals were

6. A cape made from coarse fiber.
7. A flat, roundish griddle made from sandstone or earthenware.

◀ **16.13** Ceramic flute (Aztec, 1300–1521). Mexico, Aztec culture. Fired clay and paint, 8.3 × 11 × 14 cm. Werner Forman Archive/ British Museum, London, United Kingdom. Location: 26. The flute has the shape of a macaw or parrot. It is played by blowing through an opening at the end of the bird's tail. Music, song, and dance played an important role in Aztec celebrations and festivals.

not considered complete without music, song, and dance. Professional singers, dancers, and actors performed at ceremonies and theatrical events, supported by noble households. Actors recited poetry to the rhythms of drums and the melodies of flutes. **Figure 16.13** shows a ceramic wind instrument in the unusual shape of a parrot, although most were less ornamental and made of clay or metal.

SONGS AND POEMS Many Nuahatl songs and poems are found in the *Cantares Mexicanos* (Mexican Songs), now housed in the collection at the National Library in Mexico City. Some are folk songs and poetic tales of unknown authorship; others whose names have been preserved were composed by Aztec nobility. One of the more interesting figures among the Aztecs in the context of Aztec poetry is Nezahualcoyotl (1402–1472). Described as both a ruthless warrior king and philosopher–poet, he oversaw a decades-long period of art, architecture, poetry, and philosophy, which has been likened to

a golden age in the Valley of Mexico.[8] The philosophical questions that Nezahualcoyotl asked in his poetry center on the meaning of life, whether there is an afterlife, and how humans should comport themselves in this life:

READING 16.4 NEZAHUALCOYOTL

"Song of the Flight"

Live peacefully,
Pass life calmly!
I am bent over,
I live with my head bowed
Beside the people.
For this I am weeping,
I am wretched!
I have remained alone
Beside the people on earth.
How has Your heart decided,
Giver of Life?
Dismiss your displeasure!
Extend your compassion,
I am at your side, You are God.
Perhaps you would bring death to me?

Is it true that we are happy,
That we live on the earth?

8. Miguel León-Portilla & Earl Shorris, *The Language of Kings* (New York: W. W. Norton and Company, 2001), p. 141.

RELIGION

Some Gods and Goddesses in the Aztec Pantheon

Centzon Huitznahua "Four hundred gods of the southern stars."

Coatlicue "She of the serpent skirt." Goddess of fertility, patron of life and death.

Coyolxauhqui "She of the golden bells." Goddess of the moon.

Huitzilopochtli "Hummingbird of the South." God of will and the sun; patron of war and fire; lord of the South.

Quetzalcoatl "The Feathered Serpent" or "Precious Twin." The benevolent god of life, wisdom, knowledge, fertility; patron of winds and light.

Mictlantecuhtli God of the Underworld.

Tlaloc "He Who Makes Things Sprout." God of rain, lightning and thunder, and earthquakes.

Tlaltecuhtli Earth God or Goddess.

Tlazolteotl Goddess of lust, fertility, and sexual misdeeds.

Xipe Totec "Our Lord the Flayed One." God of rejuvenation and spring.

Xochiquetzal "Flower Feather." The ever young and pretty goddess of flowers, love, pleasure, and beauty.

It is not certain that we live
And have come on earth to be happy.
We are all sorely lacking.
Is there anyone who does not suffer
Here, beside the people?

Would that my heart be not afflicted.
Do not reflect any more,
Truly, I scarcely
Pity myself here on earth.

Another of Nezahualcoyotl's poems offers a reflection on a familiar, often-quoted aphorism, "Art lasts long, life is brief." The poem begins with an invocation to Quetzalcoatl who, among other things, was the god of books and writing:

READING 16.5 NEZAHUALCOYOTL

"In Your Book of Paintings"

O Giver of Life,
Who paints with flowers,
Who bestows color with songs,
Who gives form to all those
Who dwell on earth;
In time you will destroy
The eagles, the tigers:
We live here only
In your book of paintings.

You will blot out,
With black ink,
All that was friendship,
Brotherhood, nobility.

You give form to all those
Who live on earth.
We live here only
In your book of paintings.

SOUTH AMERICA

Ancient Americans entered the North American continent via a land bridge from Siberia that no longer exists. As migrations southward continued, another thin strip of land—the Isthmus of Panama—would enable indigenous peoples to make their way from North to South America. Many built their civilizations in the highlands of the central Andes Mountains and along the Pacific coast in the regions of what are today Peru and Bolivia (see **Map 16.2**).

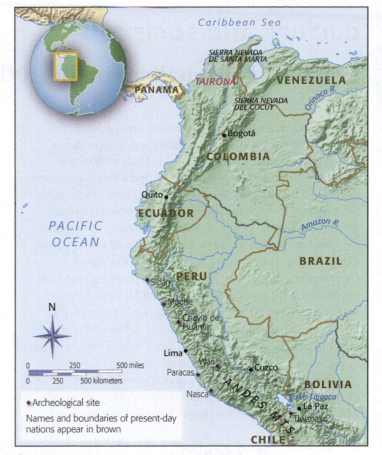

▲ **MAP 16.2** Inka sites in South America.

The Andean cultures—including the Nazca in the south and Moche in the north—actually date earlier than those of Mesoamerica, although we know less about them. The Nazca civilization had begun to decline by the end of the sixth century and had fallen completely by 750; the Moche had disappeared by 700. The Spanish conquest brought an end to the indigenous civilizations of Mesoamerica, but the culprit in the demise of the Nazca and the Moche may have been climate disaster. The Inka Empire, on the other hand, which had a much later and more far-reaching Andean civilization, was ultimately destroyed by European conquistadors.

Nazca

The Nazca and Moche cultures flourished simultaneously in two distinct areas of a narrow coastal desert—one of the driest on the planet. People of this area relied on the Pacific Ocean as a food source and on fresh water that flowed from the snow-capped Andes Mountains to irrigate crops. The eastern slopes of the same mountains look over (and feed) the Peruvian and Brazilian Amazon rain forests.

The most sensational remains of the Nazca civilization are earthworks (**geoglyphs**)—land "drawings" of stylized fish, birds, plants, as well as abstract shapes created on the flat,

CULTURE AND SOCIETY

Mexican Nationalism in the 20th Century

In Mexico, the shackles of Spanish rule were broken in the 19th century, and although the nation won independence, it entered a period of disarray that ended only with radical reforms, separation of church and state, and a new constitution established under the leadership of Benito Juarez. At the same time, Mexico lost nearly half of its territory (stretching from Texas to California) by the mid-19th century and, in the opening decade of the 20th, it would be on the threshold of a revolution. One of the seminal events of the period was the French Intervention in Mexico (1862) that forced Juarez into exile and established (very temporarily) the Second Mexican Empire, with Austrian Ferdinand Maximilian appointed as emperor by France's Napoleon III. Maximilian and his loyalist Mexican forces would fall in May of 1867, and, one month later, he would be executed by firing squad on Juarez's order.

In the first half of the 20th century, mural painters channeled the indigenous artistic traditions of pre-Hispanic Mexico in modern works with epic historical narratives and powerful social and political criticism. Diego Rivera (1886–1957) is one of them, along with José Clemente Orozco, David Alfaro Siqueiros, and many others.

After the Mexican Revolution, which started in 1910 and ended around 1920, the government established a public mural program to glorify the revolution, promote its ideals, and create pride in Mexico's **mestizo** heritage. Rivera, who had spent eight years in Paris and had studied Renaissance frescos in Italy, came back to his native Mexico and incorporated these influences into a new, national style that was heavy with elements drawn from ancient Mexico—and spiced with his desire to depict the workers' struggle. His fresco cycle for the main stairwell of the Palacio Nacional in Mexico City (1929–1951) is a sweeping historical narrative that played a large role in establishing what would become a national Mexican style with its large, simplified shapes and palette inspired by ancient, native murals. In the section of the murals depicting *The History of Mexico* (see **Fig. 16.14**)

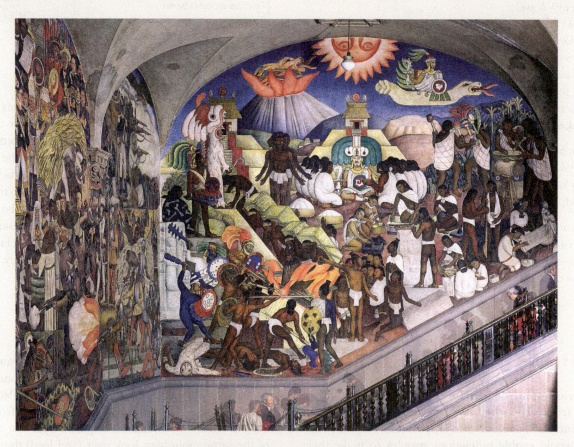

▲ **16.14** Diego Rivera, **Ancient Mexico (1929–1935).** Detail of *The History of Mexico,* **fresco in the stairwell of the Palacio Nacional (National Palace), Mexico City, Mexico.** At the center of the wall, we see Quetzalcoatl, shown with blond hair. To the left we see the central part of the mural, having the eagle, snake, and cactus (see Fig. 16.10).

illustrated here, Rivera represented the conflict between indigenous Mexicans and the Spanish conquerors. The blonde, blue-eyed figure sitting cross-legged in the center, wearing a bright green headdress, is Quetzalcoatl, god of the Toltecs, Maya, and Aztecs who was considered to be the creator of books, knowledge, and arts, as well as death and resurrection (note the artisans working at his feet to the right). Behind him are the pyramids of pre-Hispanic Mexico and, directly above, a child-like representation of the sun shines down—the upside-down positioning symbolizing the decline of the ancient cultures. Other figures include bearers of tribute, farmers planting corn, ceremonial dancers, and warriors. The compressed space, tight overlapping, and repetitive shapes create a vibrant pattern that keeps the eye dancing over the surface.

Although quite different in her approach, Rivera's contemporary (and, for some years, his wife), Frida Kahlo (1907–1954) created a body of work that was sometimes political, sometimes nationalistic, and always highly personal. Born to a Mexican mother and a German father, Kahlo's mixed heritage was a centerpiece of her iconography,

weighted, most often, in favor of her Mexican roots. In her extraordinary double portrait, *The Two Fridas* (**Figs. 16.15A** and **16.15B**), the artist shows herself in both a European-style lace dress and a traditional, indigenous Zapotec garment. The two Fridas, seated before a turbulent sky, are connected by blood—an artery that runs from one exposed heart to the other. Drops of red that trickle from the clamped end of the blood vessel form Rorschach-like stains that seem to transform into blossoms and cherries at the hem of her skirt. Her intent gaze and serious expression are an indication of her own physical suffering (she survived an accident that left her in unbearable pain for the rest of her life) and the travails of her people. Kahlo's marriage was also painful. Diego was an inveterate womanizer who even had an affair with Frida's younger sister. Frida once told a friend, "I have suffered two serious accidents in my life, one in which a streetcar ran over me. . . . The other accident was Diego."[9]

9. Frida Kahlo, quoted in Martha Zamora, *Frida Kahlo: The Brush of Anguish* (San Francisco: Chronicle Books, 1990), p. 37.

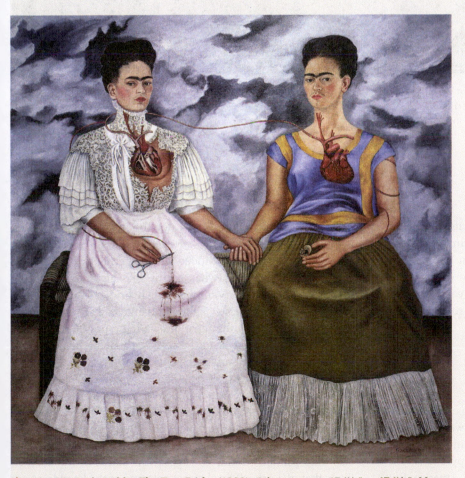

▲ **16.15A** Frida Kahlo, *The Two Fridas* (1939). Oil on canvas, 67 ¹¹⁄₁₆" × 67 ¹¹⁄₁₆". Museo de Arte Moderno, Mexico City, Mexico. The artist's dress speaks of her mestizo heritage, which is synthesized in the new Mexican nationalism of her day.

▲ **16.15B** Frida Kahlo, *The Two Fridas* (1939), detail.

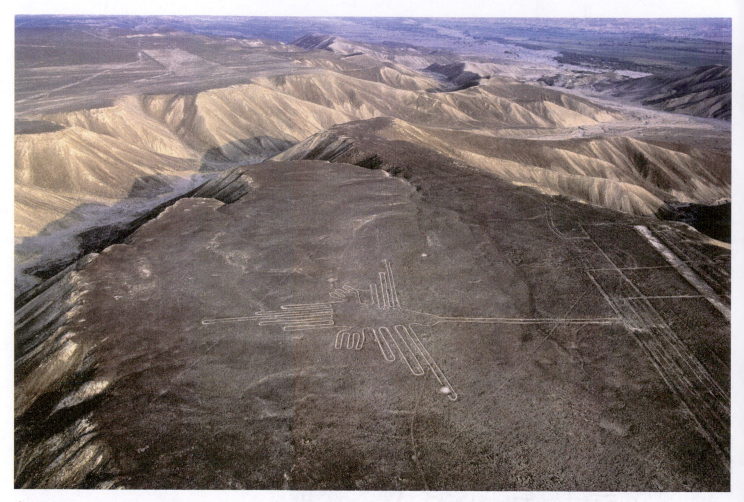

▲ **16.16 Nazca hummingbird geoglyph.** The lines that define the hummingbird and some 70 other animals, plants, and human figures were made by removing the red pebbles and revealing the white/gray ground beneath. There are also geometric symbols, such as trapezoids. Their purposes remain obscure although theories abound, even of signaling to aliens from outer space.

dry earth of the Nazca Plain in Peru (**Fig. 16.16**). The purpose of these drawings is unclear, but some speculate that these so-called "Nazca Lines" served as routes for pilgrims journeying to religious shrines. The lines are not laid down but are, one might say, revealed through the subtraction of material; dark, oxidized stones were scraped from the earth surface, exposing the lighter-colored calcite beneath that reads as white lines from an aerial perspective.

Moche

The Moche flourished at roughly the same time as the Nazca—between the first and eighth centuries CE. The power and status of the Moche is evident in the remains of an administrative and ceremonial center dominated by two enormous pyramids, one of which is the largest ancient structure in South America. But archaeologists and art historians also have been able to glean a great deal about their social hierarchy, system of religious belief, technology, and artistic sensibility from the abundant quantities

of decorated pottery found in burial sites as well as domestic compounds. Neither the Nazca nor the Moche had a written language.

Like the Nazca, the Moche were superbly skilled painter-potters who produced what seems like an endless variety of vessels with human, animal, and hybridized forms, often embellished with precisely painted organic and abstract shapes and patterns. Among the most interesting types of pottery are the so-called "portrait head" vessels that may be depictions of actual rulers or members of the elite class. The one illustrated here (**Fig. 16.17**) has a stirrup-shaped spout, seen on many Moche vessels, and realistic—individualized—facial features: a furrowed brow, puffiness below the eyes, deep lines extending from the nose toward a prominent chin, and a protruding lower lip. His intense, noble, and intelligent expression as well as his elaborate painted headdress suggest the status of the subject, likely that of a ruler. The abstract patterns of the headdress are characteristic of woven textiles, another important medium in Moche craft production. The juxtaposition of dark-and-light, or "positive-and-negative" in the patterning may represent

16.17 Portrait Vessel of a Ruler, 100 BCE/500 CE, Moche, north coast of Peru. Ceramic and pigment 14" × 9 ½". Other ceramic subjects include monkeys, deer, foxes, cats, sea lions, fish, and reptiles.

dualism, the principle (in religion or a life view, more generally) that reality is based on two basic, oppositional principles or forces (see nearby Culture and Society box).

Inka

The central motivation for European exploration in the 15th and 16th centuries was gold. Christopher Columbus was chasing after the gold that Marco Polo had reported in his travels ("The quantity of gold they have is endless . . .") when his own journey, intended to find Japan, landed him in the Caribbean on the island he would christen Hispaniola. Although the news of gold was greatly exaggerated in this part of the world, it certainly spurred Cortés to seek his own profitable expedition, pushing into the interior of Motecuhzoma's Aztec realm. Like Columbus, he was greeted with gifts of gold—in Cortés's case, copious amounts that he sent back to Spain. The gifts, as we know, were not enough to prevent his siege of Teotihuacán, destruction of its monuments, and imprisonment of their ruler. All of the precious, spectacularly crafted objects that had been brought back to Spain were melted down to fill the coffers of the royal courts of the country that was growing ever richer from the spoils of conquest.

Just a few years after Cortés's conquest of the Aztecs, Francisco Pizarro, who had been sailing along the coast of Colombia,

CULTURE AND SOCIETY

Dualism

Complementarity—the notion that two separate, opposite, but equivalent forces are interdependent and, together, explain phenomena in the natural world—is a fundamental part of the belief systems of many Andean societies, including the Moche culture of ancient Peru. They embraced symbolic *dualism*, and it is reflected in architectural design and in imagery woven into textiles, on painted pottery, in hammered ornaments of silver and gold, and sculpted ceramic vessels. Oppositions of many varieties convey this concept in Andean art: mirror images, inverted symmetries,

16.18 Bottle, Skeletal Couple with Child, third–seventh centuries. Ceramic, H: 6⅞"; W: 5⅝"; D: 6⅜". Moche, Peru. Metropolitan Museum of Art, New York, New York.

identical pairs, silver and gold; night and day, male and female, and life and death—often represented by animated skeleton figures who bridge both realms. In the Moche ceramic bottle (**Fig. 16.18**), male and female skeletons tenderly embrace and a small child skeleton seems to look on inquiringly. The figural group may signify human sacrifice as a necessary condition for the renewal of life.

In Chinese Daoist philosophy, this duality is symbolized by Yin and Yang (**Fig. 16.19**), interrelated, complementary forces that give rise to each other and contribute to Oneness.

16.19 Yin Yang symbol.

north of Peru, came upon settlements with significant stores of gold and silver. He carefully plotted a path to seizing control over the region for himself and then made his way to Inka Peru with an army of only 168 men and about 60 horses. Although he was unaware of it at the time, the Inkan civilization was in the midst of crisis. Smallpox, carried to Mesoamerica and South America by horses and cattle the conquistadors brought with them on earlier expeditions, had cut the population at least in half, in the view of some historians. Internal strife over authority had riven Inkan society; the Inkan ruler had just recently died, and his two sons had fought bloody battles for control of the empire.

On November 16, 1532, Pizarro lured the victorious son, Atahualpa—now the Inkan ruler—to a feast, ostensibly to honor his ascent to power. It was an ambush. Pizarro and his small army killed the unarmed Inkans (some say 5000 of them) and captured Atahualpa alive. Large quantities of gold and silver were offered for ransom—which Pizarro accepted—but Atahualpa continued to be held while Pizarro laid plans to conquer

his empire. The Inkan ruler outlived his usefulness and, after submitting to conversion to Christianity in return for clemency, nonetheless was executed by strangulation on August 29, 1533. The end of the Inkan Empire marked the beginning of the Spanish colonization of South America.

The nomadic roots of the Inka are similar to those of the Aztecs, and like them, the Inka created an extraordinary civilization. Established in the Andes Mountains in what is today southern Peru around 1000 CE, their empire eventually stretched from Ecuador to Chile. The native arts of the Inka include massive pyramid-shaped platforms for what were wooden temples; stone relief carvings, mostly in the form of architectural embellishment; ceramic wares; wall paintings; and decorative textiles.

MACHU PICCHU The grand ruins of Machu Picchu, an Inka imperial estate, are situated dramatically between two colossal mountain peaks (**Fig. 16.20**). Founded around 1450 CE by then-ruler Pachacuti, it was abandoned before the arrival of Pizarro, leaving the site unknown to the wider world until it was rediscovered in 1911 by the American explorer Hiram Bingham.

Machu Picchu is located about 50 miles north of Cuzco, the capital city of the Inka Empire, high up in the Andes. The architecture is shaped in concert with the landscape; natural terraces were broadened into plateau-platforms for building, and the dramatically descending slopes were terraced and buttressed with stone. Walls that remain indicate the precision of Inka masonry; archaeologists have also noted that windows and doorways were placed in such a way as to frame an optimal view of the surrounding mountains. The complementarity of grandeur of the natural landscape and human-made structures may be another symbol of duality.

The Inka produced a system of roads that many would say rivals that of ancient Rome. The Qhapaq Ñan—the Andean Road System—was constructed over centuries and linked Cuzco to communities in distant parts of the empire. The roads cover some 18,600 miles—from present-day Columbia to Chile via Peru, Ecuador, and Bolivia—and through diverse

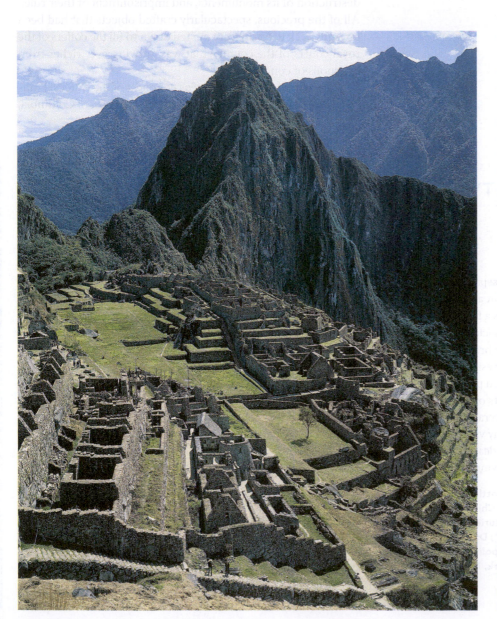

◀ **16.20 Machu Picchu, Peru, Inka, 15th century.** Machu Picchu was built at the time of the Renaissance in Europe and later abandoned. It is famous for its stone walls, which were assembled without use of mortar.

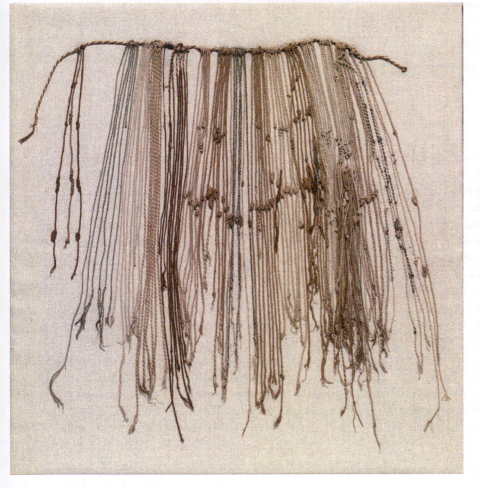

◀ **16.21** Inka *khipu*, 1425–1532. **Chulpaca, Ica, Peru.** Cotton, dye, 72 × 39 cm. National Museum of the American Indian, Washington, DC.

herds, and any other goods or stock; population censuses for taxation purposes; and debt and labor obligations—were recorded using an assemblage of strings and knots called **khipu** (or *quipu*; **Fig. 16.21**), about 600 of which survived the mass destruction of Inka artifacts by the Spanish. The people who kept records—*khipusamayu* ("keepers of the khipus")—had their own unique and secret systems of knots and color-coding that kept information confidential. They were essential to the management of the empire.

Historians have recently speculated that khipus also were a substitute for writing among the Inka, and that storytellers who kept myth and history alive by memorizing tales may have used the system to help them remember key facts and dates. If this speculation bears out—and if khipus are, among other things, a three-dimensional form of writing—it would put to rest the question, "Why did such an advanced civilization have no written language?" Khipus may be the answer.

terrains—snow-capped mountains, fertile valleys, rain forests, and deserts. The Andean Road System was granted UNESCO World Heritage Site status in 2014.

LANGUAGE, WRITING, AND RECORD KEEPING

The peoples of the South American continent who were conquered by the Inka and brought into the fold of the empire spoke as many as 20 different languages. By the time Pizarro arrived, however, these conquered peoples had learned the Inka language—Quechua (pronounced KESCH-wah)—and it was this tongue that the Spanish acquired in order to successfully convert the indigenous population to Christianity. If the Inka had a writing system, it is as yet unknown. But the Spanish adapted the Roman alphabet to Quechua, thus creating a written version of the language. What we know, then, of Inka literature and history has been filtered through Spanish translators.

It has been estimated that between 8 and 10 million people in the Andes region still speak Quechua, and there are a number of Quechua words that have entered the English language (for example, condor, jerky, puma, quinoa, cocaine, quinine, and llama); the Quechua words for father and mother are *tata* and *mama*.

The Inka counting system, based on units and multiples of 10, was used to record information and transfer it throughout the vast empire to and from Cuzco. All varieties of information—such as inventories of gold, grain, agricultural produce, land,

NORTH AMERICA

As the migrants from Asia made their way to the continents of the Americas—the last to be populated by humans—their first stop was North America, specifically, present-day Alaska. It was a fairly habitable place; even though glaciers covered most parts of North America, Alaska had relatively less snowfall and thus less accumulation of ice. Those who remained in Alaska, rather than returning to Asia back over the land bridge to Siberia, subsisted in small communities by hunting, mostly seals, and fishing. But continued migration was impossible until the glaciers began to melt, permitting people to move eastward and southward—some along the Pacific coast and others deeper inland—to what is now Canada and the United States. Descendants of these early migrants who continue to live in north Alaska and Siberia, Russia, are called Eskimos, and they are comprised of the Inuit and Yupik peoples. (But we should note that the term Eskimo, though widely used in Alaska, is considered derogatory by many because it was used by colonists to sometimes mean "eater of raw meat.") The Inuit inhabit some parts of northernmost Alaska, northern Canada, and also Siberia and Greenland.

CULTURE AND SOCIETY

The South Pacific

To the west of the South American continent, on islands dotting the vast expanse of the Pacific Ocean, island cultures took root as far back as 1500 BCE. Collectively, they are known as Oceania.

The West's consciousness of this vast region between continental landmasses only goes back as far as the early 1500s when European exploration got its real footing. Since the first third of the 19th century, the islands of Oceania—whose varied climatic conditions and terrains range from snow-capped mountains to rain forest to desert—have been grouped into distinct areas called Australia (which also includes the island of Tasmania), Melanesia, Micronesia, and Polynesia (which also includes New Zealand) (**Map 16.3**). The diversity of Oceania, however, is not simply seen in its habitats. The cultures of these islands spoke different languages, had different societal structures, and produced different art forms. Comparatively speaking, we know far less about Oceania than we do about Mesoamerica and South America. As in other cultures that did not develop systems of writing, the preservation of history and

transmission of information across generations was oral and therefore largely lost.

Although there was cross-cultural borrowing as a result of contact among peoples in Oceania, there is significant variety in artistic styles and practices—not only from geographic region to region, but also within any one place. Consider New Guinea, the world's second largest island, just north of the Australian continent. Two present-day countries share the territory of the island: the country of Papua New Guinea is on the eastern part of the island and encompasses offshore islands in the region called Melanesia; on the opposite end of the island, the provinces of Papua and West Papua are part of the country of Indonesia. More than 800 different languages are spoken on that single island.

The Asmat people of West Papua created wooden "spirit" poles (*bisj*, pronounced "bish") to honor their ancestors (**Fig. 16.22**). Each was made from the trunk of a single mangrove tree; the projections jutting from the top are actually inverted tree roots intricately carved in a pattern of looping

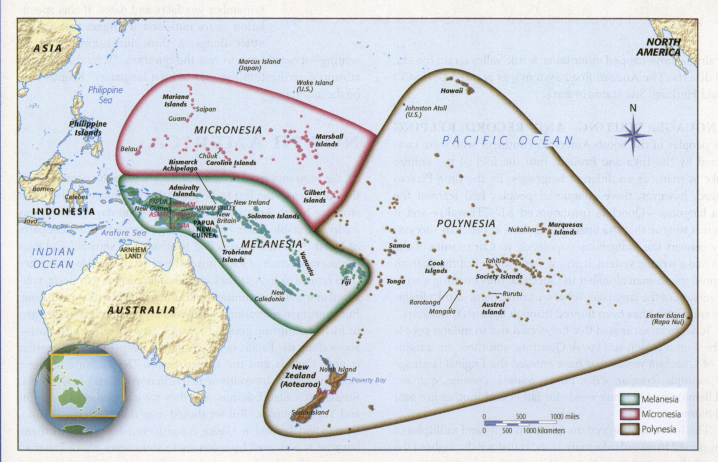

▲ **MAP 16.3** Oceania.

◀ **16.22 Bis pole, mid-20th century. New Guinea, Irian Jaya, Faretsj River, Omadesep village, Asmat people. Wood, paint, fiber, H. 216" (548.6 cm). The Metropolitan Museum of Art, New York, New York.**

lines. In some, painted human figures—each representing a specific individual—are stacked one upon the other, their cylindrical shapes not straying far from the shape of a tree (the overall form probably derives from the identification of humans with trees in Asmat culture). Other images refer to the now-defunct practice of headhunting to avenge death. The Asmat believed that death was not a natural process but rather could only be explained as the result of either direct killing or the casting of magic spells by an enemy. The poles were created for ceremonial one-time use and then "planted" in a field where they would be left to decompose naturally.

The swirling carved lines of the bisj resonate with the tattoo body adornment that is seen widely throughout the islands of the Pacific. The word *tattoo* is actually of Polynesian origin. Beyond beautification, tattoo was also used to signify identity and status, and various cultures displayed preferences for designs and their placement on the body. The curvilinear patterns seen in tattoo adornment can also be seen in a carved panel from a Maori men's meeting house (**Fig. 16.23**).

In the same year—1768—that the British occupied Boston, Massachusetts, to crack down on local radicals, Captain James Cook of the British Royal Navy made his first voyage to the Pacific Ocean, mapping the entire coastline of New Zealand and then sailing on to the

▶ **16.24 Moais (restored in 1960 by archaeologist William Mulloy) of Ahu Akivi, Easter Island, Chile. The island was given its name in 1722 by the explorer Jacob Roggeveen because he discovered it on Easter Sunday.**

◀ **16.23 Poupou (panel) depicting an ancestor from Maori men's village meeting house, early 19th century. Wood. Museum of New Zealand/Te Papa Tongarewa, Wellington, New Zealand.**

southeastern coast of Australia. On his next voyage (1772–1775), he landed on the Polynesian island closest to the South American continent, yet one of the most remote in the world—Rapa Nui. He was not the first European to arrive. Fifty years earlier, Dutch Captain Jacob Roggeveen had landed on the Easter Sunday of 1722; he named his discovery Easter Island.

Rapa Nui is the site of the most impressive stone sculpture in Polynesia (**Fig. 16.24**). The so-called *moai*, monoliths measuring up to 65 feet in height and nearly 1000 in number, were carved between the 5th and 17th centuries. The moai were set up vertically on stone platforms that served as markers for burial or sacred ceremony. Figure after figure has the same angular sweep of nose and chin, the severe pursed lips, and the overbearing brow. Archeologists have determined that these figures symbolize the power that chieftains were thought to derive from the gods and to retain in death through their own deification. Political power in Polynesia was believed to be a reflection of spiritual power.

The indigenous culture of Rapa Nui approached extinction in the second half of the 19th century as a result of diseases introduced by Europeans and the slave trade. In 1877, the population was at an all-time low, numbering 111. The island was annexed by Chile in 1888.

As the climate changed, forests and grasslands advanced across North America, encouraging settlement. From there, as time went on, these migrant peoples moved southward to Mesoamerica and South America. The geography and biodiversity of the United States and Canada are as varied as those we find in other parts of the Americas, as were the efforts of the indigenous peoples to adapt to these varied habitats.

Native Americans have continued to survive in literal Arctic temperatures. Many Native American cultures have dwelled in the arid Southwest, while still others have hunted and farmed in the Great Plains and in the woodlands east of the Mississippi.

The Northwest

Throughout the 1800s, we find a wealth of practical craft among Native Americans, much of it ceremonial, all of it richly varied. Their sculpture exhibits a simplicity of form and elegant refinement in their realistic and abstract designs. It can also be highly imaginative, as in the mask representing a moon goddess (**Fig. 16.25**). Such masks, worn by **shamans** in ritual ceremonies, were carved of ivory or wood and often had movable parts that added to the drama and realism of the object. Northwestern Native Americans had numerous gods and goddesses, including the ever-present sun god, a goddess of fertility, a gatherer of the dead who takes the deceased to the Underworld, and gods of polar bears and caribou.

▲ **16.25** Eskimo mask representing a moon goddess (before 1900). Phoebe A. Hearst Museum of Anthropology, The University of California at Berkeley, Berkeley, California.

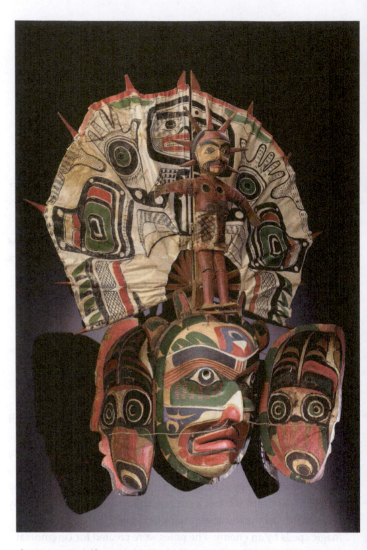

▲ **16.26** Transformation mask representing the sun, 1870–1910. Wood, paint, cotton cloth, metal hinges, iron nails, sinew, cotton cord/cordage, 46" × 52". Smithsonian, National Museum of the American Indian, Washington, DC.

Native peoples of the Northwest Coast such as the Kwakiutl of British Columbia have produced masks used by shamans in healing rituals, totem poles, and canoes and houses that are embellished with carving and painted ornamentation. The wood and muslin of a four-foot-high Kwakiutl headdress from British Columbia (**Fig. 16.26**) is vividly painted with abstracted human and animal forms. Like the Inuit moon goddess mask, it too has movable parts. When the string hanging from the inner mask is pulled, the two profiles to the sides are drawn together, forming another mask. The symbols represent the sun and other spirits. It is an extraordinary composition, balanced by the circular flow of fabric above the heads and by the bilateral symmetry in the placement of the shapes. As is often the case in ethnographic art, the embellishment of the work reflects traditional body decoration, such as painting, tattooing, or scarification.

The Alaskan Chilkat robe (**Fig. 16.27**), however, was created without a loom. Chilkat women traditionally achieved a very fine texture with a thread made from a core of a strand of cedar bark covered with the wool from a mountain goat. Clan

◄ **16.27** Blanket, Chilkat Tribe, American school, 19th century. Wool and cedar bark. Private collection. The design evokes formations of killer whales.

members used robes such as these on important occasions to show off the family crest. Here a strikingly stylized formation of killer whales is accompanied by a field of eyes, heads, and mysterious symbols.

The Southwest

The Ancestral Puebloans inhabited what we now call the Four Corners of the United States: parts of Utah, Arizona, New Mexico, and Colorado. They are known for their pottery and their architecture. Many Ancestral Puebloans dwelled in single-family houses, but they also constructed large apartment houses in sheltered mountain ledges. The strategic location of these complexes enabled them to "take the high ground" in case of threats from other tribes and also to maximize the warmth of the sun in winter and profit from the shelter of the overhang in the hottest months. The so-called Cliff Palace in Colorado's Mesa Verde National Park (**Fig. 16.28**) has some 200 rooms originally plastered with adobe. There are some 25 **kivas**— large circular rooms that served as community and ceremonial centers.

The native peoples of the Americas fashioned many craft objects in the early 20th century for decoration, practical use, and ceremonial use. Maria Montoya Martínez (1881–1980) of San Ildefonso Pueblo was a descendant of the Ancestral Puebloans, and she shared their gift for pottery. She was an innovator of the black-on-black pottery technique. The perfect contours of the

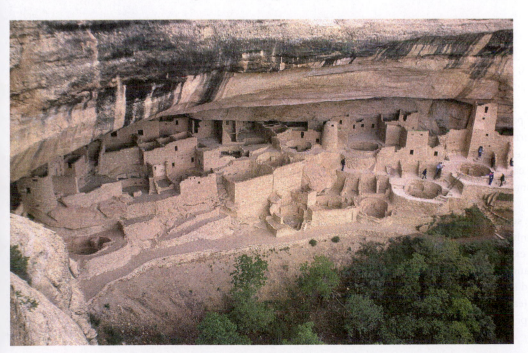

◄ **16.28** Cliff Palace, Mesa Verde National Park, Colorado, Ancestral Puebloan culture, ca. 1150–1300. The Ancestral Puebloans ingeniously wedged such communities into hillsides to absorb the heat of the low sun in winter yet be sheltered from the directly overhead sun of summer.

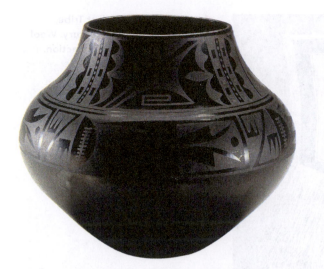

▲ **16.29** Maria Montoya Martínez, jar, San Ildefonso Pueblo, New Mexico, ca. 1939. Blackware, 11 ⅛" × 1' 1". National Museum of Women in the Arts, Washington, DC. Martínez is a descendant of the Ancestral Puebloans.

▲ **16.30** Serpent Mound, Ohio, Mississippian culture, ca. 1070. 1200' long, 5' high, 20' wide. The mound is so named because its winding resembles a snake. The functions of this and other Mississippian mounds remain open to debate.

coil-built vessel made by Maria and her husband Julian Martínez (**Fig. 16.29**) were created by smoothing the ridges of the stacked coils into flat, thin walls that belie the process. The surface effect of etched glass was achieved through a complex interplay of burnishing, glazing, and firing techniques.

The Great Plains

The Adena culture emerged more than 2000 years ago and spread throughout much of the eastern United States. The Adena interred important people in grand earthen mounds. Men were often buried with their pipes because smoking was an integral part of social and religious rituals, as well as a source of personal pleasure.

The Mississippian culture, after whom the state is named, emerged at about 800 CE, and its people also built great earth mounds, some 120 of them at Cahokia in present-day Illinois. Mississippians could settle down because their society was based on agriculture, mainly the farming of maize, as is so common in Mesoamerica. They traded with peoples as far north as the Great Lakes, as far west as the Rocky Mountains, and down to the Gulf of Mexico. Cahokia, a city of as many as 15,000–20,000 inhabitants with another 10,000 residing in the suburbs, was built around 1050–1200 CE. Farther east, in present-day Ohio, the Mississippians built the Serpent Mound (**Fig. 16.30**) around 1070 CE. Its meaning is unknown, but scholars have suggested that it might have something to do with agriculture or the transit of Halley's Comet across the stars in the night.

GLOSSARY

Classic period (p. 549) In Mesoamerica, the period between 300 CE and 900 CE, characterized by the height of various civilizations, especially the Maya.

Codex (p. 547) A bundle of manuscript pages that are stitched together in a manner resembling a modern book.

Geoglyph (p. 559) A large design produced on or in the ground, as by compiling stones or scraping into the earth.

Khipu (p. 565) Inka methods of recording information using fiber and knots.

Kiva (p. 569) A large circular room that serves as a ceremonial center in an Ancestral Puebloan community.

Logogram (p. 553) A sign or glyph that expresses meaning.

Mestizo (p. 560) A term used in Spain and conquered American nations to describe a person of combined European and Native American descent. In the Spanish *casta* (caste) system, mestizos received more favorable treatment than people who were fully Native American.

Mesoamerica (p. 548) Literally, "middle America," referring to present-day Mexico, Guatemala, Honduras, Belize, and parts of Costa Rica and El Salvador.

Popol Vuh (p. 551) The bible or Council Book of the Maya.

Postclassic period (p. 549) In Mesoamerica, the period between 900 CE and the Spanish conquest of 1521, characterized by the decline of some civilizations but the rise and fall of the Aztec civilization.

Preclassic period (p. 549) In Mezoamerica, the period between 2000 BCE and 300 CE, characterized by the rise of civilizations and rulers.

Shaman (p. 568) A person deemed capable of communicating with good and evil spirits. Shamans often enter trance states during a ritual and sometimes practice healing.

Syllabogram (p. 553) A sign or glyph that denotes sounds.

THE BIG PICTURE CULTURAL CENTERS OF THE AMERICAS

Language and Literature

- Aztec Nuahatl is spoken in central Mexico.
- Mayan dialects are spoken in southern Mexico and Guatemala.
- The Maya write using pictographic glyphs.
- The Mississippian civilization creates great earth mounds in the present-day eastern United States.
- The Ancestral Peubloans wedge communities into hillside cavities in the North American Southwest to take advantage of seasonal weather.
- The Aztec king Nezahualcoyotl writes philosophically oriented poetry.
- Music, song, dance, poetry, and theater are all parts of Aztec celebrations and festivals.
- The Inka use khipu ("talking knots") for record keeping and, possibly, storytelling.
- The *Florentine Codex*, containing sacred text and the Aztec account of the conquest of Mexico, is compiled during the 16th century.

Art, Architecture, and Music

- The Mesoamerican Olmec civilization produces gigantic heads for ceremonial centers at around 900–400 BCE.
- The Nazca of the Andes scrape huge geoglyphs in the earth between 500 BCE and 500 CE.
- The city of Teotihuacán is built and expanded northeast of present-day Mexico City at around 100 BCE–600 CE.
- The Temple of the Feathered Serpent is built in Teotihuacán in the third century CE.
- The Maya build the Temple of the Great Jaguar at Tikal, Guatemala, ca 732 CE.
- The Maya construct ball courts throughout their empire, compel captives to play, and sacrifice the losers.
- The Maya culture create a mural ca. 790 showing the presentation of captives to Lord Chan Muwan for sacrifice.
- The Maya build the Castillo at Chichén Itzá ca. 800–900.
- The Inka erect Machu Picchu high in the Andes during the 15th century.
- North American natives create ceremonial masks, pottery, and fiber arts during recent centuries.
- The art of the Mexican muralists of the 20th century is used to help forge a new Mexican national identity.
- Frida Kahlo's paintings reveal her interest in her mestizo heritage as well as her personal concerns.

Philosophy and Religion

- Eskimos and Inuit worship gods of the sun, moon, fertility, caribou, and polar bears.
- Mesoamericans produce an accurate calendar system.
- Mesoamerican cultures, including Teotihuacán, the Maya, and the Aztecs, share a pantheon of gods and a creation story involving the sacrifice of gods to create the sun, moon, and human beings.
- Aztecs fulfill the prophecy of founding their empire where they see an eagle with a snake in its claws upon a cactus in Tenochtitlán (present-day Mexico City) in 1325.
- Aztecs create a sophisticated calendar and conceptualize the universe as wheels within wheels, as shown in the Sun Stone.
- Following the conquest, Spaniards learn Native American languages to help convert Native Americans to Christianity.

South Asia, China, and Japan: From Medieval to Modern Times

PREVIEW

The phenomenon of *globalization* is perhaps nowhere more evident than in the Eastern nations of India, China, and Japan. Phone calls for tech support when our electronics go awry, or for customer service when our credit cards go missing, are often fielded by teams in places like Bangalore, India. Chinese workers assemble iPhones and iPads that are disseminated worldwide. For decades, our preferred electronics have born the label "Made in Japan." Globalization has become a familiar catchall term that describes global communication, economic integration, and the exchange of ideas and popular culture across nations in the 21st century. By this definition, however, globalization is also a thing of the past.

Turn back the clock to the centuries-old and centuries-long era of the Silk Road—a web of ancient trade routes that ran some 4000 miles through the Indian subcontinent and connected China to the Mediterranean Sea. Caravans of merchants on horses and Bactrian camels moved silk and other luxuries from East to West over perilous terrain—trading cotton, linen, pearls, ivory, spices, perfumes, and much more, for commodities such as copper, tin, wool, and wine. Ideas and customs, too, traveled along the Silk Road. Buddhism, for example, wended its way from India to China and had a profound impact on the history of Eastern religions; a relay-style messenger system was set up along the length of the route, employing the fastest horsemen to move documents and information efficiently over vast distances. But the sprawling network was also a conduit for the bubonic plague—history's first pandemic. The first reported case of the plague was in China in 224 BCE, at around the same time that the route was established by the Han dynasty; in the mid-1300s, roughly a century after the adventurer Marco Polo traveled from Venice to China and the court of the Mongol emperor Kublai Khan—and back again—one-half of the population of Europe succumbed to the disease.

The benefits, challenges, and fallout of globalization in our own time also bear reflection. Proponents believe that with cultural intermingling comes understanding and tolerance of difference, and that mass communication and the sharing of real-time information—made possible by social networking—provide knowledge and create empathy. Consumers have access to products from global markets, and the influx of capital into poor countries creates the conditions for development and democracy. Opponents, on the other hand, warn that globalization is a wolf in sheep's clothing, noting that laborers in poor countries are exploited and remain disadvantaged while the corporations for which they work—and their global investors—grow rich. Globalization has also been linked to the spread of communicable diseases such as HIV/AIDS. One thing seems certain: globalization is a force that shows no sign of stopping. People are connected like never before. The travelers along the Silk Road had to have been thinking the same thing.

Contemporary artist Subodh Gupta was born in 1964 in one of the poorest and most violent provinces in India and lives today in New Delhi, a city of economic extremes. Gupta taps into sacred

◄ **17.1** Subodh Gupta, *Silk Route* (detail), 2007. Stainless-steel kitchen utensils, 78¾" × 189" × 189" (200 × 480 × 480 cm). Installation photograph by Colin Davison at the BALTIC Centre for Contemporary Art, Gateshead, United Kingdom.

symbols and ancient cultural identity, but his frequent use of found objects connects his work—and message—to 21st-century issues and realities. *Silk Route* (Fig. 17.1) emphasizes India's key historic and contemporary role in globalization as an important economic conduit, at the same time illustrating the "current state of India's shifting society, migration, a sense of home and place and the effects and frictions caused by a rapidly globalizing society."[1] Gleaming, highly polished silvery bowls and utensils conjure the sight of shimmery silken fabrics that so mesmerized the West from the time of Julius Caesar through the era of the Silk Road. Yet piled on top of one another and crowded into the space of a single tabletop, the same glittering objects evoke the overcrowding of cities. They call attention to the societal disconnect between poverty-stricken inner-city life and some of the most critically acclaimed works of contemporary architecture (much of it designed by Western architects) springing up in cities across the globe, particularly in the East. The stacks of utensils move along mechanized tracks carved into the steel table, almost as luggage on an airport conveyer belt. Is world travel in our own era of globalization—and the objects we bring back home to remind us of the people and places we have seen—an echo of the past?

SOUTH ASIA

With the decline of Buddhism and the fall of the Gupta Empire, India separated into a series of kingdoms, many of which were ruled by **Rajputs**. For the most part, these local rulers were descendants of warriors from Central Asia who had converted to Hinduism and claimed membership in the warrior caste. (For a general view of South and Southeast Asia from medieval times until today,

1. From http://www.artesmundi.org/artists/subodh-gupta. Posted January 20, 2011.

see Map 17.1.) Their constant feuding prevented the formation of a thriving economy or stable government and left India vulnerable to conquest by an outside force—that of the Muslims.

The first major seat of Muslim power was at Delhi, where Turkish forces established a *sultanate* (a Muslim kingdom ruled by a sultan) in 1192. Although it fell to successive waves of invaders, the Sultanate of Delhi established Islam as a new force in the subcontinent; it was strongest in the northwest—the Indus Valley—a region that centuries later, after World War II, broke away from India to become the Islamic Republic of Pakistan.

The Mughal Empire

In 1526, Babur (1483–1530), an Afghan chieftain, led his troops into India and in a short time won control over most of northern India. His grandson Akbar (1542–1605) further extended Muslim rule to most of India and Afghanistan. Akbar's kingdom was called the **Mughal** (the Persian word for "Mongol") Empire and lasted until the British took control of India in the 18th century.

Unlike earlier raiders bent on plunder, both Akbar and his grandfather intended from the outset that the land they conquered should become a center for civilization. Akbar was famous not only for his courage and military prowess but also as a book collector and patron of the arts. Unlike Muslim rulers elsewhere, Akbar made no attempt to impose the Islamic faith on his subjects. He married a Hindu princess and allowed Hindu women at his court to practice their religion openly. In order to provide a common language for all his subjects, Akbar commissioned scholars to create a blend of Hindi (hitherto the most widely spoken language in India) with Arabic and Persian. The new language, called **Urdu**, is, together with Hindi and English, one of India's three official languages today, and spoken in Muslim areas.

South Asia, China, and Japan from Medieval to Modern Times

1400 CE	1700 CE	1900 CE	2010 CE

Age of Warring States in Japan r. 1467–1568	India falls under British rule in 1764	Boxer Rebellion in China 1900–1901
Mughal Empire in India r. 1500–1700	First Opium War in China 1839–1842	Japan defeats Russia in Russo–Japanese War in 1905
Muslim rule extends to most of India r. 1556–1605	Commodore Perry visits Japan in 1853	Republicans led by Sun Yat-sen defeat the Chinese monarchy in 1911
Hideyoshi reunites Japan in 1590	Japan begins modernization under the Meiji Emperor in 1868	Gandhi leads Indian independence campaign via satyagraha in 1917
Edo (Tokyo) becomes capital of Japan ca. 1603	National Congress Party is founded in India in 1885	Chiang Kai-shek retreats from mainland China in 1928
Qing dynasty in China r. 1644–1911		World War II 1937–1945
Chinese treaty with Peter the Great in 1689		Mao Zedong leads Communist Party into power in China in 1949
		End of British rule in India in 1950
		End of U.S. occupation of Japan in 1952

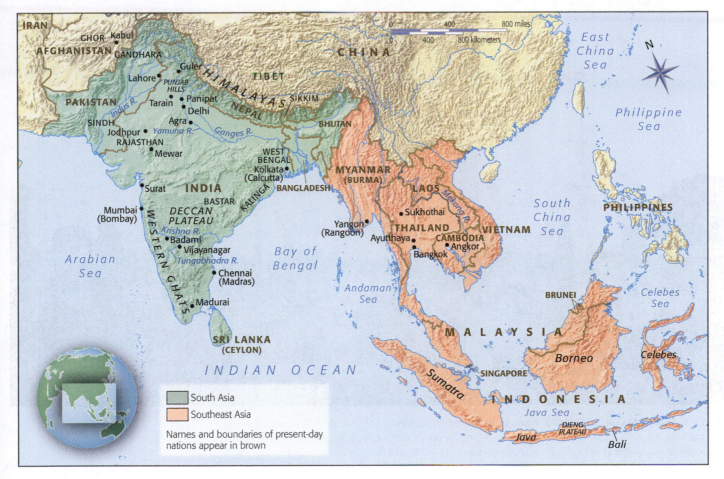

▲ **MAP 17.1** **Map of South Asia and Southeast Asia, around 1200–today.**

Under Akbar's successors, the Mughal Empire expanded further to include all but the extreme southern tip of the subcontinent. During the first half of the 17th century, patronage of the arts reached new heights, as Mughal architects and painters devised a new style that, like the Urdu language, combined aspects of the Hindu tradition with Persian and other Muslim elements.

MUGHAL ART The most visible remains of Mughal rule in India were left by Mughal architects. Mosques, palaces, walled cities, and forts all show traditional Indian techniques combined with new innovations from Arabic architecture. Among the most important of these innovations are the dome, pointed arch, and **minaret** (tower); this last feature formed a vital element in the construction of mosques, Islam's most important religious architectural form. The most famous of Mughal buildings—and one of the best-known anywhere in the world—is the Taj Mahal at Agra, built by order of Shah Jahan (1592–1666) during the years 1632–1649 (see **Fig. 17.2** on p. 576). The shah commissioned the Taj Mahal as a tomb and monument for his beloved wife Arjumand Banu Begum, the mother of 14 of his children, a woman as renowned for her charity as for her beauty. The dome, towers, and landscaping—in particular the use of water—are all typical Mughal features. Together with the elaborate decorations, or arabesques, they make the Taj Mahal seem an eternal symbol of the queen, "radiant in her youthful beauty, who still lingers on the riverbanks, at early morn, in the glowing midday sun, or in the silver moonlight."[2]

Virtually all Mughal painting is in the form of book illustrations or miniature paintings that were collected in portfolios. Unlike earlier Hindu and Buddhist art, Mughal painting is secular. It shows scenes of courtly life, including—for the first time in Indian art—realistic portraits and often depicts historical events (see **Fig. 17.3** on p. 577). As in the case of Mughal architecture, the overwhelming influence comes from Persian art of the period. A new art form in India also drew inspiration from Persian models, that of **calligraphy**, which was often combined with miniature paintings.

Literature and the production of fine books were highly esteemed by Mughal aristocrats. Babur, the founder of Mughal rule, wrote his autobiography, the *Baburnama*, in Chagatai, a now extinct Turkish language. It is still regarded as one of the finest examples of Turkish prose literature. Reading 17.1 on page 576, a journal entry from the year 911, describes events following the death of Babur's mother and other relatives. He had been planning a military campaign against Kandahar in Afghanistan, but it was then interrupted by an illness and a great earthquake. But as we see, nothing can prevent Babur from returning to his aggressive ways as soon as possible.

2. From http://www.columbia.edu/itc/mealac/pritchett/00artlinks/agra_havell/10tajmahal.html. Accessed March 2016.

▲ **17.2 The Taj Mahal, 1632–1649. Agra, India.** Built at the command of Shah Jahan as the tomb of his favorite wife, it eventually served as the shah's own tomb. Much of the building's visual effect comes from its proportions: the height of the central structure is equal to its width, and the dome and the central façade on which it sits are the same height.

READING 17.1 ZEHIR-ED-DIN MUHAMMED BABUR

From The Memoirs of Babur, "Events of the Year 911"

Our grief for the separations we had suffered was unbounded. After completing the period of mourning, food and victuals were dressed and doled out to the poor and needy. Having directed readings of the Koran, and prayers to be offered up for the souls of the departed, and eased the sorrows of our hearts by these demonstrations of love, I returned to my political enterprises which had been interrupted, and . . . led my army against Kandahar. We had marched as far as the meadow of Kush-Nadir . . . when I was seized with a fever. It came most unseasonably. Whatever efforts they made to keep me awake, my eyes constantly fell back into sleep. After four or five days, I got somewhat better.

At this period there was such an earthquake that many ramparts of fortresses, the summits of some hills, and many houses, both in the towns and villages, were violently shaken and leveled with the ground. Numbers of persons lost their lives by their houses and terraces falling on them. The whole houses of the village of Pamghan fell down, and seventy or eighty respectable householders were buried under the ruins. Between Pamghan and Bektut, a piece of ground, about a

stone's throw in breadth, separated itself, and descended for the length of a bow-shot; and springs burst out and formed a well in the place that it had occupied. . . . In some places the ground was elevated to the height of an elephant above its old level, and in other places as much depressed; and in many places it was so split that a person might have hid himself in the gaps. During the time of the earthquake, a great cloud of dust rose from the tops of the mountains. Nur-allah . . . happened to be playing before me on the mandolin, and had also another instrument with him; he instantly caught up both the instruments in his hands, but had so little command of himself, that they knocked against each other. . . . That same day there were thirty-three shocks; and for the space of a month, the earth shook two or three times every day and night.

. . .

My expedition against Kandahar had been delayed by my sickness and the earthquake; but as soon as I had regained my health, and restored the defenses of the fortress, I immediately resumed my former plan.

◀ **17.3** Basawan and Chatar Muni, *Akbar and the Elephant Hawai*, ca. 1590. Folio 22 from the *Akbarnama* (History of Akbar) by Abu'l Fazl. Opaque watercolor on paper, 13⅞" × 8¾" (32.5 × 22 cm). Victoria and Albert Museum, London, United Kingdom. The painting depicts an event that occurred when Akbar was 17. The elephant he was riding charged after another elephant and broke a bridge resting on boats. The emperor is shown successfully maintaining control over his beast—a symbol of his success in governing the state.

The End of Mughal Rule and the Arrival of the British

The religious tolerance of the early Mughal rulers eroded over time. The last significant Mughal emperor, Aurangzeb (1618–1707), destroyed Hindu temples and increased his Hindu subjects' taxes. For the first time, Hindus serving in the imperial bureaucracy had to convert to Islam. Another factor contributing to the collapse of Mughal power was the rise of a new religion, related to Hinduism but with no caste system: Sikhism. The Sikhs combined Hindu rituals with a highly activist approach, forming a military brotherhood that succeeded in setting up an independent state of their own, which lasted until 1849. In that same year, British forces won control over the rest of India.

Throughout the 18th century, the British and French had fought their battle for colonial supremacy on Indian soil. The British East India Trading Company began its operations as early as 1600, and the superiority of British naval forces assured them victory over other European rivals—first Portugal, then France. By 1764, although India was theoretically made up of separate kingdoms including a Sikh state and a much reduced Mughal Empire, in practice the government was in British hands, first under the East India Company and then, by 1849, directly under the British government. For the next century and a half, India was the "jewel in the crown" of the British Empire.

ARCHITECTURE AND ART The influence of Britain extended to architecture and art. Victoria Terminus (designed by the British architect Frederick W. Stevens during the Victorian Era of the late 19th century and renamed Chhatrapti Shivaji Terminus in 1996 to honor the founder of the Maratha

Babur's successor, Humayun (ruled 1530–1540 and again 1555–1556), was so devoted to books that when he rode into battle, he took with him part of his library, carried on camelback. Humayun also wrote poetry, using the Persian rather than the Turkish language. Mughal tolerance allowed Hindu writers to continue to write works in their own languages and on traditional themes. The poet Tulsidas (ca. 1532–1623), drawing on the Sanskrit epic the *Ramayana*, produced the *Ramcaritmanas* (*The Holy Lake of the Acts of Rama*), a work that combines monotheism with traditional Hindu polytheism and is still widely read.

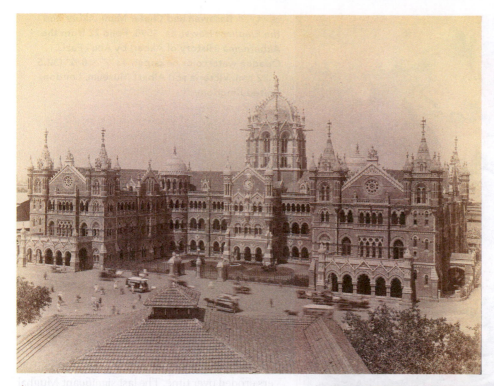

▲ **17.4** Frederick W. Stevens, Victoria Terminus (now Chhatrapati Shivaji Terminus), Mumbai (Bombay), India (1879–1887). Albumen silver print from glass negative, 7 3/16" × 9 5/16". Metropolitan Museum of Art, New York, New York.

Jaswant Singh, a local ruler of Jodhpur in Rajasthan (**Fig. 17.5**), painted in the late 1800s. The pose—that of a refined and relaxed Englishman amid the standard props of a conventional continental portrait—places the portrait unmistakably in India's Colonial period. And yet, the artist has taken great pains to distinguish his sitter from his Western counterparts—from his turbaned head and curly beard to his magnificent emerald bib necklace. The brushwork in this small portrait is fine and meticulous, as it is in traditional Indian miniature painting. The artist captures the detail of the Maharaja's face and clothing with exceptional realism, conveying a presence of power and grandeur.

Empire) (**Fig. 17.4**), exhibits a strong stylistic connection to 19th-century Italianate Gothic Revival architecture popular in Europe and the United States, but its motifs and details—as well as the sandstone construction—are unmistakably "local." The station is only one example of **hybridity**; that is, the hybridization—or fusion of styles east and west—evident in India during colonial rule. Subtly pointed arches frame the arcades and windows of the railway station, calling to mind architecture such as the Cathedral of Florence (see Fig 11.22), although the meandering floor plan bears close resemblance to Indian palace designs; medieval turrets are juxtaposed with domes and minaret shapes that are consistent with those found in subcontinent Hindu and Mughal architecture. The exterior of the Terminus is embellished with carvings of allegorical figures, gargoyles, animals and plants, portraits, and other human faces.

The blend of European and indigenous art forms also can be seen in a portrait of Maharaja

▶ **17.5** Maharaja Jaswant Singh of Marwar (ca. 1880). Opaque watercolor on paper, 1' 3½" × 11⅝". Brooklyn Museum, Brooklyn, New York.

COMPARE + CONTRAST

Mahatma Gandhi and Martin Luther King Jr.

The Indian Mahatma Gandhi (**Fig. 17.6**) and the American Martin Luther King Jr. (**Fig. 17.7**) both sought freedom for their people—the right to better their own lives. Both also preached nonviolence and civil disobedience as the means for achieving their goals.

However, the two leaders were very different in terms of their backgrounds and in terms of the forces that oppressed their people. Who were the oppressors of Indians in the mid-20th century? Who were the oppressors of African Americans? What did the oppressors have in common? How did they differ?

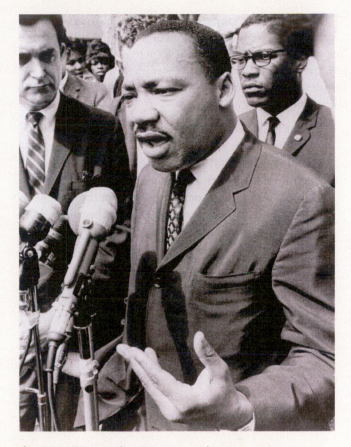

▲ **17.7** Martin Luther King Jr. speaking at a news conference in Selma, Alabama, 1965. Photograph. What is the significance of Selma, Alabama?

▼ **17.6** Mahatma Gandhi on the steps of 10 Downing Street in London, United Kingdom, 1931. Photograph. What is the significance of the address 10 Downing Street?

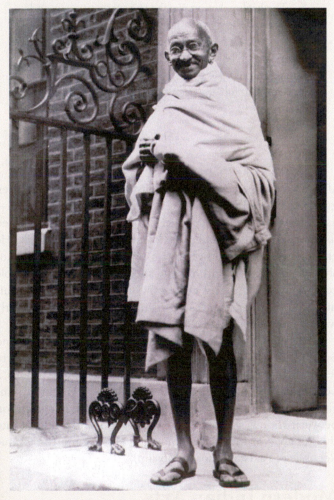

What were the personal and professional backgrounds of Gandhi and King? How did they each arrive at their methods of civil disobedience?

Were there other "liberators" in their lands at the time they preached and practiced? Did they espouse different methods of throwing off the oppressors? Who were they, and what were their arguments?

What were the political outcomes for the followers of Gandhi and King? What are their legacies?

VALUES

Satyagraha

The Sanskrit word *satya* means "truth." Mahatma Gandhi coined the term *satyagraha* to express his value upon "insistence on truth." He used the term to refer to nonviolent resistance to oppressive laws or governments, such as the British colonial rule of India. In his book *Non-Violent Resistance (Satyagraha)*, Gandhi wrote:

> For the past thirty years I have been preaching and practicing Satyagraha.... Satyagraha differs from passive resistance as the North Pole from the South. The latter has been conceived as a weapon of the weak and does not exclude the use of force or violence for the purpose of gaining one's end, whereas the former has been conceived as a weapon of the strongest and excludes the use of violence in any shape or form.
>
> …
>
> [Satyagraha's] root meaning is holding on to truth, hence truth-force. I have also called it Love-force or Soul-force. In the application of Satyagraha I discovered in the earliest stages that pursuit of truth did not admit of violence being inflicted on one's opponent but that he must be weaned from error by patience and sympathy.

For what appears to be truth to the one may appear to be error to the other. And patience means self-suffering. So the doctrine came to mean vindication of truth not by infliction of suffering on the opponent but on one's self.

But on the political field the struggle on behalf of the people mostly consists in opposing error in the shape of unjust laws. When you have failed to bring the error home to the lawgiver by way of petitions and the like, the only remedy open to you, if you do not wish to submit to error, is to compel him by physical force to yield to you or by suffering in your own person by inviting the penalty for the breach of the law. Hence Satyagraha largely appears to the public as civil disobedience or civil resistance. It is civil in the sense that it is not criminal.

The lawbreaker breaks the law surreptitiously and tries to avoid the penalty, not so the civil resister....But there come occasions, generally rare, when he considers certain laws to be so unjust as to render obedience to them a dishonor. He then openly and civilly breaks them and quietly suffers the penalty for their breach.

The Rise of Nationalism

Throughout the early years of the 20th century, many of those colonized by the chief European powers began to strive for self-rule. In India, the battle began a little earlier—in 1885—with the founding of India's National Congress Party. During World War I, three million Indian soldiers fought in British armies. This brought about further impetus, and a postwar campaign for India's independence was led by Mahatma Gandhi (1869–1948). First in South Africa, and then, after 1915, in India, Gandhi developed the principle of **satyagraha**, which gave rise to a form of resistance used in India and later in the United States: nonviolent civil disobedience.

Although Gandhi was born a Brahmin (the highest Hindu caste), he would come to oppose the caste system. He studied law in London and began his legal career in South Africa, where he found brutal discrimination against Indian workers who had been imported by British employers. To draw attention to these injustices, he devised his strategy of peaceful protest marches and nonviolent resistance to police actions.

Returning to India, he soon acquired supporters both among sophisticated nationalist leaders and among the Hindu rural masses, who respected his austere way of life. In 1919,

after hundreds of peaceful nationalist demonstrators had been gunned down by British-controlled forces at Amritsar, Gandhi—as leader of the Indian National Congress Party—campaigned for noncooperation and nonviolent civil disobedience. He encouraged the boycott of British products, urged the friendship of Hindus and Muslims, and spoke out against the terrible conditions of the lowest caste—the untouchables. During his numerous prison sentences between 1922 and 1942, he regularly went on hunger strikes.

Pressure for independence grew during the 1930s, and by the end of World War II, the British had no choice but to withdraw. Gandhi made efforts to unite Hindus and Muslims, a policy that led to his assassination in 1948 by a Hindu extremist. Britain had played its own part in encouraging tension between Hindus and Muslims, and the subcontinent split into the Republic of India (predominantly Hindu) and the Islamic Republic of Pakistan (mostly Muslim).

Modern Indian Arts

One of the effects of the struggle for self-rule was to create a generation of Indian authors who, writing in both their own languages and in English, sought to draw attention to their

country's plight. They include the novelist and short-story writer Munshi Premchand (1880–1936), who wrote in both Hindi and Urdu. In his works, he tried to describe to the outside world the grim life led by so many of India's poorest villagers:

READING 17.2 MUNSHI PREMCHAND

From "The Shroud"

I

Father and son were sitting silently at the door of their hut beside the embers of a fire. Inside, the son's young wife, Budhiya, was suffering the pangs of childbirth. Every now and then she gave such piercing cries that the hearts of both men seemed to stop beating. It was a winter night; all was silent and the whole village was plunged in darkness.

Gheesu said, "She may be dying. We've been out chasing around all day. You ought to go in now and see how she is."

Madhava answered peevishly, "If she has to die, then the sooner the better. What's there to see?"

"You're heartless. Such lack of consideration for the wife with whom you lived so pleasantly for a whole year!"

"I can't bear to watch her in pain and torment."

Theirs was a family of cobblers notorious throughout the village. Gheesu worked for a day, then rested for three days. His son, Madhava, tired so quickly that he needed an hour for a smoke after every half hour of work. Therefore they could find little work anywhere. If they had no more than a handful of grain in the house, they refused to stir themselves. After a couple of days' fasting, Gheesu would climb a tree and break off some branches for firewood. Madhava would take it to the bazaar and sell it. As long as they had any of the proceeds in their pockets, both of them lazed about. When it came to the fasting point once more, they again collected firewood or looked for work.

...

II

When Madhava entered the hut in the morning, his wife lay dead and cold. Flies swarmed over her face. Her eyes were fixed in a glassy stare. Her whole body was covered with dust. The child had died in the womb.

Rabindranath Tagore (1861–1941) won the Nobel Prize for Literature in 1913. He also painted and composed music, including India's first national anthem, and founded a school and a university. Tagore's writing and teaching stressed that national freedom was meaningless without personal freedom and that true authority comes only from basic humanity.

In Tagore's story "The Conclusion," young Apurba has returned from his B.A. examination in Calcutta to his village, where a marriage has been arranged for him. Yet his gaze falls upon a "madcap" girl, Mrinmayi. A struggle between custom and Apurba's heart ensues:

READING 17.3 RABINDRANATH TAGORE

From "The Conclusion"

Apurba knew much about this girl's reputation. The men of the village referred to her affectionately as Pagli—"Madcap"—but their wives were in a constant state of alarm at her wayward behavior. All her playmates were boys, and she had vast scorn for girls her own age. In the ranks of [easily led] children she was regarded as a scourge.

Being her father's favorite made her all the more unruly. Her mother never stopped grumbling about it to her friends. Yet because the father loved Mrinmayi, her tears would have hurt him deeply if he had been at home. That fact, and natural deference to her absent husband, kept the mother from imposing too strict a discipline.

Mrinmayi was dark complexioned with wavy hair that had straggled over her shoulders. Her expression was boyish. Her enormous black eyes held no shame or fear, and not the slightest coyness. She was tall, well built, healthy, strong—but of an age people found hard to estimate; otherwise they would have criticized her parents because she was still unmarried. If the boat of some distant [tax collector] arrived at the [pier], the villagers became impressively alert. As if at a signal, the women pulled their veils down to the tips of their noses, thus concealing their faces like curtains on a stage. But Mrinmayi would arrive holding a naked child to her chest, her unbound hair hanging free. She would stand like a young doe gazing inquisitively in a land where there was neither hunger nor danger. Eventually she would return to her boy playmates and give them elaborate descriptions of the new arrival's manners and mores.

VISUAL ARTS In the same year that political independence came to India, Maqbool Fida Husain (1915–2011) and others founded the Marxist-leaning Progressive Artists' Group. Rejecting colonial stylistic idioms that thrived during British rule, the Progressives embraced 20th-century European modernism, including primitivism, expressionism, cubism, and surrealism. In Husain's Ragamala Series (see **Fig. 17.8** on p. 582), references to these European styles are clear: fragmented form, integration of foreground and background, mood-evoking color, imagery that spreads from one edge of the canvas to the other. However, Husain's subject matter—drawn from traditional Indian painting—is distinct from that of his European counterparts. Ragamala painting, which combines references to art, poetry, and music (a raga is a musical mode) in a single illustration, date back to the 16th and 17th centuries. As in Husain's piece, moods are largely evoked in ragamala paintings through color. Blended blues and greens create a soothing atmosphere while bits of complementary yellow–orange add a dynamic counterpoint. The "beats and pulses" of color correspond to the sounds and movements suggested by the musicians, instruments, and dancing figures.

◀ **17.8 Maqbool Fida Husain, Ragamala Series (1960).** Oil on canvas, 35" × 74". Private collection.

Pakistan-born Shahzia Sikander was trained in the painstaking methods of Asian/Persian miniature painting and also studied at the Rhode Island School of Design; she now lives and works in the United States. In *Perilous Order* (**Fig. 17.9**), Sikander casts light on past and present challenges faced by

▲ **17.9 Shahzia Sikander, *Perilous Order* (1994–1997).** Vegetable color, dry pigment, watercolor, and tea on Wasli paper; 10½" × 8". Whitney Museum of American Art, New York, New York.

women and gays in the Islamic world, embedding her controversial commentary on hypocrisy regarding homosexuality in a diminutive work of traditional style. The centerpiece of the painting is a profile portrait of the 17th-century Mughal emperor Aurangzeb (in actuality, the likeness of one of her friends) who was reputed to be gay and yet punitively enforced Islamic restrictions against gay Muslims. We see "Aurangzeb" through the hovering, veil-like specter-spirit of a Hindu goddess and surrounded by Hindu nymphs. The rigidity of his profile and the tight frame surrounding it contrast considerably with the sensuality of the female figures, perhaps alluding to the contrast between more liberal Hindu sexuality and the oppressive strictures against it in the Muslim world.

The creator of many ready-made artworks, Subodh Gupta (b. 1964) was born in one of the poorest and most violent provinces in India and lives today in New Delhi. His work includes painting, sculpture, photography, installations, and video art. It taps into sacred symbols and ancient cultural identity but is connected to contemporary life realities through its found objects. A work like *Silk Route* (**Fig. 17.10**) is an example, composed of simple, mundane kitchen utensils. Just as India was once a key component of the Silk Route or Silk Road—a web of ancient trade routes that ran some 4000 miles through the Indian subcontinent and connected China to the Mediterranean Sea— so is it in today's era of globalization an important economic conduit.

The Indian director Satyajit Ray (1921–1992) was born into a prosperous Bengali family and studied art as a young man. His films aim to show the lives of ordinary people and use the details of their everyday existence to give a more general impression of the culture of which they form a part. His best-known work is probably the Apu Trilogy, three films that tell the story of a young Bengali boy growing to maturity: *Song of the Little Road* (*Pather Panchali*) of 1955, *The Unvanquished* (*Aparajito*) of 1956, and *The World of Apu* (*Opur Shôngshar*) of 1959. Taken together, the three movies (with specially composed background music played by Ravi Shankar) provide an

▲ **17.10** Subodh Gupta, *Silk Route*, 2007. Stainless-steel kitchen utensils, 78¾" × 189" × 189" (200 × 480 × 480 cm). Installation photograph by Colin Davison at the BALTIC Centre for Contemporary Art, Gateshead, United Kingdom. Gupta uses many found objects in his installations.

unforgettably moving impression of coming of age in both rural and urban India and point out the similarities between a culture that at first seems so remote and life in the West in the 21st century. A later Ray film, *The Home and the World (Ghare Baire)* (1984), sets a romantic love triangle against the background of the early years of the 20th century, with its scheming and treacherous British rulers.

CHINA

China retained a central government for most of its history. A series of dynasties brought the country and its arts forward in various ways.

The Ming Dynasty

In 1279, the urban society created in China under the Tang and Song dynasties fell under the control of Mongol invaders from Central Asia. It took almost a century for resentment of foreign occupation, coupled with a series of disastrous floods, to provoke a widespread peasants' revolt. One of the rebel leaders seized the Mongol capital, Beijing, and in 1368 declared himself the first emperor of the Ming dynasty (see **Map 17.2**).

For the period from 1368 to the Republican Revolution of 1911, two dynasties controlled Chinese political and cultural life: the Ming (1368–1644) and the Qing (1644–1911). As in India, European traders established operations in China—the British East India Company arrived in 1689. Portuguese Jesuit missionaries had been established in the preceding century, using Macao (leased by the emperor to Portugal) as their base. Unlike the Indian experience, however, where the European colonial powers fought out their wars on Indian soil, China remained virtually untouched by the West, and Macao remained the only port of entry for non-Chinese until the 19th century. Thus, the central government was able to maintain tight control over the arrival of both people and ideas. This encouraged the stability of the state bureaucracy and the social structure but did little to encourage trade or manufacturing. As a result, the rapid increase in population between 1600 and 1800—from around 150 million to some 300 million—led to widespread poverty

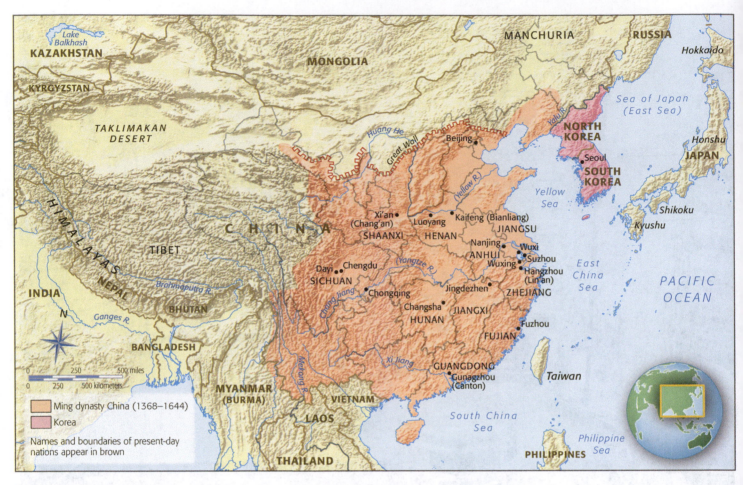

▲ **MAP 17.2 China during the Ming dynasty.**

and political unrest, conditions that Western colonial powers were quick to exploit during the 19th century, culminating in the Republican Revolution of 1911.

Under the Ming emperors, China enjoyed an extended period of political and economic stability and cultural enrichment. The basis for all aspects of life was Confucianism, which argues that social behavior must be derived from sympathy for one's fellows. Confucianism also stressed loyalty within the family, headed by the father, and in the state as a whole, headed by the emperor—the Son of Heaven—who ruled as the father of his country. Despite the emphasis on the traditional, writers and visual artists experimented and invented new artistic forms.

MING DYNASTY LITERATURE The most popular new literary genres were the novel and the short story. The latter, known as **huaben**, were often based on the oral tales of professional traveling storytellers, or at any rate aimed to give that impression. They included verses inserted into the prose narrative, recording of audience responses, and the use of the speech of the streets. Traditional Buddhist subjects were combined with scenes from everyday life. The earliest collections of huaben date to the 16th century, although many of these had probably circulated for more than a century.

One of the first novels to focus on daily life rather than extraordinary events is the anonymous *Jinpingmei* (*The Plum in the Golden Vase*), attributed to the late Ming dynasty. This story chronicles the lurid career of the licentious Ximen and his six wives. The society it describes is driven mainly by lust, greed, and vanity, although the author makes no attempt to moralize. The book owed its immediate and continuing popularity to its openly erotic episodes. Note that the extract in Reading 17.4 from *Jinpingmei* reads rather like a contemporary novel:

READING 17.4 ANONYMOUS

From *Jinpingmei*, chapter 28, "Beggar Ying Startles a Pair of Lovers in the Grotto"

Next morning Moon Lady was just sitting down to breakfast with the wife of her elder brother and the two nuns, when Hsi Men unexpectedly pushed the curtain aside and entered the room. Sister-in-law Wu quickly took the two nuns by the hand and retired with them to Sunflower's apartments.

"Was that Sister Pi?" Hsi Men inquired of Moon Lady, in a tone of surprise. "What is that accursed carrion, that female baldhead doing here?"

"You ought to control your tongue a little better," Moon Lady reproved him. "What has she done to you that you should speak of her so disgustingly? And how do you come to know her at all?"

"Don't I just know her! That's the old woman who fouls heaven and earth and turns her convent into a brothel. She once arranged for the youngest daughter of the Ministerial Councilor Chen to meet a young lover in the 'Cloister of Earthly Seclusion,' and took money for it. The affair became known afterwards and came up before me in court. I made the young couple husband and wife, but I had the old procuress's robe pulled off and gave her twenty strokes with the rod. Moreover, she had to revert to her lay status,[3] as being unworthy of holy orders. How is it she is wearing the nun's robe again today?"

"Oh, nonsense! She's a most orthodox person and lives a life of the greatest piety."

"Her piety consists in letting men through the convent gates at night!" he said, derisively.

Another novel to achieve a large readership, this one primarily intended for children, is *Monkey*, written by Wu Cheng'en (ca. 1501–1580). Describing the journey to India of a Buddhist priest, Tripitaka, it uses centuries-old tales and legends. Tripitaka is a historical figure who actually made a pilgrimage to India in the seventh century. By the 10th century, his travels had already inspired an entire cycle of fantastic tales, which by the beginning of the Ming dynasty were the subject of stage plays. Wu thus had a mass of material to draw on for his long fairy tale. The real hero of the story is not Tripitaka but his assistant, Monkey, whose magical powers and craftiness enable the two travelers to overcome all obstacles—both natural and supernatural—and complete their journey as we see in Reading 17.5:

READING 17.5 WU CHENG'EN

From *Monkey*, chapter 15

It was mid-winter, a fierce north wind was blowing and icicles hung everywhere. Their way took them up precipitous cliffs and across ridge after ridge of jagged mountain. Presently Tripitaka heard the roaring of a torrent and asked Monkey what this river might be. "I remember," said Monkey, "that there is a river near here called the Eagle Grief Stream." A moment later they came suddenly to the river side, and Tripitaka reined in his horse. They were looking down at the river, when suddenly there was a swirling sound and a dragon appeared in midstream. Churning the waters, it made straight for the shore, clambered up the bank and had almost reached them, when Monkey dragged Tripitaka down from the horse and turning his back to the river, hastily threw down the luggage and carried

the master up the bank. The dragon did not pursue them, but swallowed the horse, harness and all, and then plunged once more into the stream. Meanwhile Monkey had set down Tripitaka upon a high mound, and gone back to recover the horse and luggage. The luggage was there, but the horse had disappeared. He brought the luggage up to where Tripitaka was sitting.

"The dragon has made off," he said. "The only trouble is that the horse has taken fright and bolted."

"How are we to find it?" asked Tripitaka.

Monkey springs up into the sky, looks around, sees no horse, and concludes that the dragon has eaten it. Struggles ensue, in which Monkey beats the dragon in an attempt to recover the horse. The story combines fantasy, folklore, and history, together with strong elements of satire. The absurd bureaucratic behavior of the gods is clearly intended to poke fun at the complexity of the Chinese state bureaucracy. Tripitaka represents a kind of Chinese Everyman, blundering along through the various problems he has to face, whereas Monkey represents the ingenuity of human intelligence. One of Tripitaka's other fellow pilgrims, Pigsy, personifies human physical desires and brute strength. None of these layers of meaning are allowed to interfere with the narrative drive and the richness of the various adventures encountered by the pilgrims.

MING DYNASTY ART AND ARCHITECTURE The Ming dynasty is known for its landscape painting, its use of calligraphy on the surfaces of paintings, and its use of calligraphic types of strokes to create leaves and other natural shapes. But the period is also renowned for its ceramics and for its furniture and other objects—called *lacquerware*—made of lacquered wood.

The blue-and-white porcelain vase in **Figure 17.11** on page 586, from the Ming dynasty, speaks eloquently of the refinement of Chinese ceramics. The crafting of vases such as these was a hereditary art, passed on from father to son over many generations. Labor was also frequently divided so that one craftsman made the vase and others glazed and decorated it. The vase has a blue underglaze decoration—that is, a decoration molded or incised beneath rather than on top of the glaze. A transparent **glaze** increases the brilliance of the piece. In many instances, the incising or molding was so subtle that it amounted to "secret" decoration. Chinese connoisseurs had always prized and collected painted ceramic ware, and potters of the Ming dynasty produced vases of exceptional quality. Pieces of decorated porcelain began increasingly to circulate in the West, taken there by traders and missionaries. These transported pieces added a new word to the English language for high-quality pottery: **china**.

Lacquer is derived from the sap or resin of the sumac tree. Lacquerware has a hard and durable finish that can vary from high gloss to matte, according to the desires of the artisan. It can also be polished further, providing an even greater sheen. Lacquer

3. That is, her status prior to becoming a nun and joining the convent.

▼ **17.11** Vase in *meiping* shape with phoenix, late 16th or early 17th century (Ming dynasty). Porcelain painted with cobalt blue under transparent glaze (Jingdezhen ware), 25 ⅛" (63.8 cm) high, 13 ½" (34.3 cm) maximum diameter. Metropolitan Museum of Art, New York, New York. Transparent glazing enhances the brilliance of the vase.

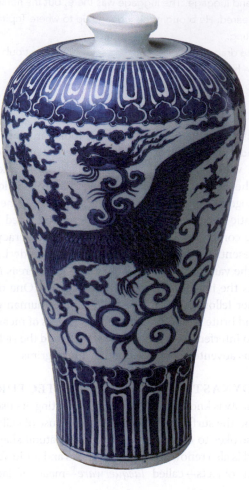

also prevents the wood beneath from rotting. The lacquerware table pictured here (**Fig. 17.12**) was produced during the Ming dynasty. It has intricate carvings as well as a lacquered finish. Because of the durability of the surface, it looks "good as new."

Li Kan's 14th-century ink painting *Bamboo* (**Fig. 17.13**), created during the period between the Song and Ming dynasties, possesses an almost unbearable beauty. The entire composition consists of minor variations in line and tone. On one level, it is a realistic representation of bamboo leaves, with texture gradient providing a powerful illusion of depth. On another level, it is a nonobjective symphony of calligraphic brushstrokes. The mass of white paper showing in the background is a symbolic statement of purity, not a realistic rendering of natural elements such as haze.

In much of Chinese art, there is a type of reverence for nature in which people are seen as integral parts of the order of nature, neither its rulers nor its victims. In moments of enlightenment, we understand how we create and are of this order, very much in the way Li Kan must have felt that his spirit had both created and been derived from these leaves of bamboo and the natural order that they represent.

Beijing, as the imperial capital, was originally laid out during the 13th century in a rectangular plan with a north–south axis, by order of the Mongol emperor Kublai Khan (ca. 1216–1294). We have a description of how it then looked from perhaps the most famous travel writer of all time, Marco Polo (ca. 1254–1324), who arrived in China in 1275 and spent time there as an envoy of Kublai Khan. When the Chinese succeeded in driving out the Mongols, they retained Beijing as the imperial capital; the city was reconstructed at the beginning of the 15th century, early in the Ming dynasty.

The chief buildings, including the emperor's residence—known as the Forbidden City—and the main government offices, or Imperial City, were constructed to the north of the city. The buildings faced south, with their backs to the direction that symbolized evil: the Mongol invasion. The Forbidden City stood to the extreme north of the complex so that the emperor, like the northerly polestar, could overlook his subjects (**Fig. 17.14**). A series of gateways and courtyards led from the main entrance, the southern Gate of Heavenly Peace (which now gives its name, Tiananmen, to the vast square in front of the buildings), to the heart of the palace, the Hall of Supreme Harmony, where the emperor held audiences and performed special rituals. Thus the entire complex represented traditional symbolic values.

The Qing Dynasty

The general attitude toward cultural development during the Ming dynasty can be summed up in a phrase frequently used

▼ **17.12** Lacquerware table with drawers, ca. 1426–1435 (Ming dynasty). Wood, lacquered red and carved 47" (119.38 cm) long. Victoria and Albert Museum, London, United Kingdom. Lacquerware, along with ceramics, was a luxury art much appreciated by nobility during the Ming and Qing dynasties. Lacquered objects can be inlaid with metals, semiprecious stones, and precious jewels.

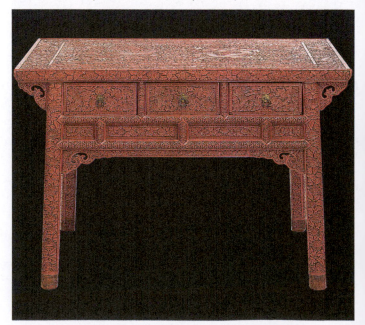

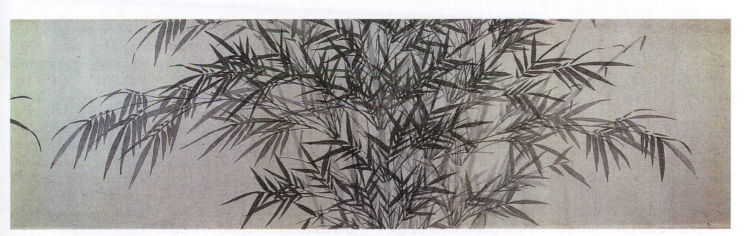

▲ **17.13** Li Kan, *Bamboo* (section), 1308 (Yuan dynasty). Hand scroll, ink on paper, 14¾" × 93½", (37.5 × 237.5 cm). The Nelson-Atkins Museum of Art, Purchase: William Rockhill Nelson Trust, 48–16, Kansas City, Missouri. There is no setting for the bamboo, just the stalks and leaves, apparently dashed out in loose calligraphic strokes.

▼ **17.14** **Hall of Supreme Harmony, the Forbidden City, Beijing, China. 98' × 5" (30 m) high.** The Forbidden City served as both the private residence for the emperor and the setting for his official appearances. The Hall of Supreme Harmony served as the throne room, set as it is on a high platform with marble staircases. The throne, inside, was set on another high dais.

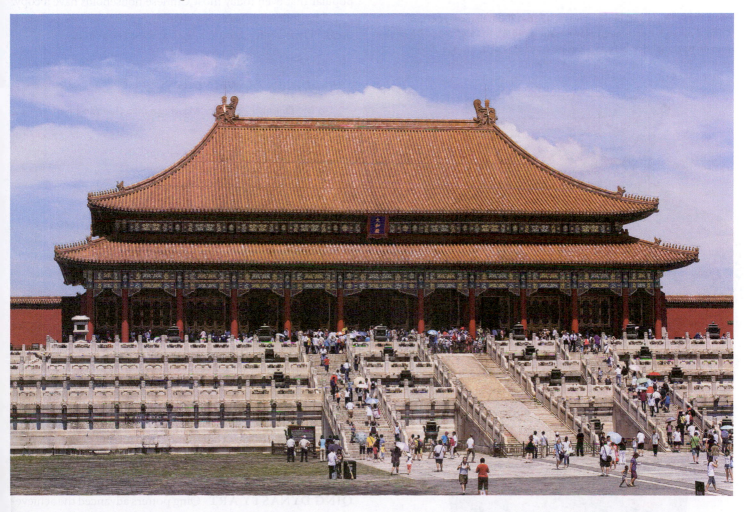

by Ming scholars: "change within tradition." The result was to produce a culture—and also a society—that was stable but subject to internal decay. The preeminence of gentleman-scholars, artists, and bureaucrats, rather than professionals, led to economic decline. By the early 17th century, as the bureaucracy became increasingly corrupt and the emperors began to lose

control, rebellions and banditry became rampant; in 1628, a popular uprising drove the last Ming emperor to hang himself. The resulting confusion attracted invaders from the south, who soon established a new dynasty—the Qing—the last royal house to rule China.

The new Qing rulers, who came from Manchuria, were foreigners in the eyes of most Chinese. Although they maintained their own army, they had to rely on the established bureaucracy for the day-to-day running of the empire. One of the early Qing emperors, Kangxi (1654–1722), set up a grand council to supervise the bureaucrats and succeeded in interweaving local and central administration. These measures strengthened the power of the emperor. Simultaneously, Kangxi began to make tentative contacts abroad. In 1689, he signed a treaty with Peter the Great of Russia, to set limits on the expanding Russian Empire, and encouraged the introduction—carefully controlled—of Western arts and education. The Jesuit missionary Matteo Ricci (1552–1610) had already studied Chinese in order to familiarize some of those at court with Western mathematics, geography, and astronomy. Kangxi employed other Jesuits as mapmakers and took Jesuit physicians with him on his travels. Some Westerners even received appointments at court. The Flemish missionary and astronomer Ferdinand Verbiest (1623–1688) became head of Beijing's astronomical bureau in 1669 and played a part in helping to determine the Chinese–Russian border. When, however, the pope sent an ambassador to ask if a permanent papal legation could be set up in Beijing (in part, probably, to keep an eye on the Jesuits), the emperor refused permission and required all resident Jesuits to sign a declaration stating that they understood and accepted the definition of Confucianism and ancestral rituals as formulated by Kangxi.

QING DYNASTY LITERATURE The most popular book of the Qing dynasty is actually a compilation of poetry from the Tang period (618–907), 1000 years earlier, which has been called the Golden Age of Chinese poetry. The compilation is simply titled *300 Tang Poems*, and it was collected in 1763 by Sun Zhu. Sun's choices for the anthology included works that were popular and built character. The anthology has been so popular that even today most Chinese households have a copy.

The following excerpts vividly portray sources of heartbreak. Their ability to cultivate character is obvious:

▼ **17.15** **Thousand Flowers vase**, 1736–1795 (Qianlong period, Qing dynasty). Porcelain, color enamels, 18 ⅞" × 14 ¼" (48 × 36 cm). Musée national des arts asiatiques Guimet, Paris, France. Qing potters advanced the techniques of earlier potters by applying more complex glazes to their works, allowing for more brilliant and varied colors.

READING 17.6 WEI YINGWU

"To My Daughter on Her Marriage into the Yang Family," lines 1–10

My heart has been heavy all day long
Because you have so far to go.
The marriage of a girl, away from her parents,
Is the launching of a little boat on a great river....
You were very young when your mother died,
Which made me the more tender of you.
Your elder sister has looked out for you,
And now you are both crying and cannot part.
This makes my grief the harder to bear;
Yet it is right that you should go.

READING 17.7 HE ZHIZHANG

"Coming Home"

I left home young. I return old;
Speaking as then, but with hair grown thin;
And my children, meeting me, do not know me.
They smile and say: "Stranger, where do you come from?"

QING DYNASTY ART Qing potters advanced the achievements of Ming dynasty potters by further developing porcelain ceramics with **underglazes** and **overglazes**. The Thousand Flowers vase (**Fig. 17.15**) is more colorful and complex in design than the earlier Ming dynasty vases. The flowers overlap each

other in an intricate, continuous pattern. Other vases of the era are partly covered with flowers or have other kinds of designs.

The Qing painter Shitao (1641–1707), who became a Buddhist monk at the age of 20, experimented with new approaches. In some cases, he boldly repeated lines with several strokes of ink, providing a massiveness to shapes. In other cases, he created areas of color to suggest fields of blossoms or distant mountains reaching into the sky. "Riverbank of Peach Blossoms" (**Fig. 17.16**) has an abstract quality to it. Strokes of black suggest tree trunks, and the blossoms merge in a sea—or a riverbank—of spring finery. The water is barely suggested. We see what appear to be sails in the river. The upper right part of the work consists of calligraphic writing, a tradition not found in Western art of the time, and we see the stamp of the artist prominently displayed in the lower right. The writing and the stamp are parts of the composition, helping to define open areas in the piece.

▼ **17.16** Shitao, "Riverbank of Peach Blossoms," ca. 1700. Leaf C from *Wilderness Colors*, an album of 12 paintings. Ink and color on paper, 10⅞" × 8½" (27.6 × 21.6 cm). The Metropolitan Museum of Art, New York, New York. The bank of blossoms and the distant mountains are both described by diagonals from lower left to upper right.

By 1800, Chinese independence was beginning to come under threat. Western traders establishing themselves in India and other parts of Asia recognized the potential for profit at home as demand rose for Chinese tea, fine vases, silks, and works of art. Trade, however, depended on exchange, and foreign merchants could find little in the way of Western products to interest the Chinese. Silver and gold would have been acceptable, but the British, who were the chief traders, had no intention of damaging their balance of trade by incurring trade deficits. British merchants, therefore, began importing large quantities of opium from India into China. The Chinese, well aware of the harmful effects of the drug, made little use of it. The Chinese government, therefore, attempted to prevent its importation; the emperor even addressed a personal appeal to Queen Victoria, which she ignored.

When (in 1839) the Chinese tried to block the introduction of opium, the result was outright war. The first Opium War, of 1839–1842—in which the British used their vastly superior naval power to blockade the entire coast—forced the Chinese to open up a string of ports along their coast, including Canton and Shanghai, thereby ending their isolation. Quite apart from their bitter resentment at the introduction of a drug that soon became widely used (importation rose from 6000 cases in 1820 to 100,000 in 1880), the Chinese also had to face the arrival of other Westerners—from France and the United States, among others. One of the results of all this turmoil was a series of internal rebellions, which the Chinese authorities could only put down by humiliatingly having to ask the invading foreigners for help. During the Taiping Rebellion (1850–1864), a Franco–British force occupied Beijing, drove out the emperor, and burned down the Summer Palace.

The Collapse of Chinese Imperial Rule

When the central government grew increasingly ineffectual, the foreign trading powers benefited from a weak central authority that depended on them for the little influence it possessed. With the suppression of the bloody Boxer Rebellion of 1900–1901, the Western powers took virtual control, constructing railways and opening up river traffic to all parts of the interior.

In 1911, republicans led by Sun Yat-sen (1866–1925) finally brought down the monarchy, but the collapse of centuries-old institutions created decades of chaos, complicated by two world wars. Two chief movements struggled for power in China. The Kuomintang, led by Chiang Kai-shek (1887–1975), offered authoritarian rule, which was supposed to evolve into a form of democracy. The other group, the Chinese Communist Party, aimed to follow

the example of Russia's Bolshevik movement and was led by Mao Zedong (1893–1976). The Communists rose to power in 1949. Just as Western art for many centuries was devoted to Christian themes, Chinese art under communism has had to advance—or at least be consistent with—the social and political environment. Virtually all of the art produced under Communist rule exalts the party (under Mao especially) and the virtues of hard work—most notably in the posters produced at the time of the Cultural Revolution (1966–1976). We see a smiling worker in **Figure 17.17**. It is of interest that the worker is a woman, somewhat feminine in appearance despite burly arms. The Communist Party teaches that the genders are equal, denying that there is such a thing as men's work or women's work. The woman smiles to reveal her pleasure at working to be one of the people of the People's Republic of China. Things have changed—somewhat.

Just a few years before this poster was created, Wu Hufan (1894–1968) painted one of his most famous scrolls—a homage to China's "glorious" 1964 entry into the world's nuclear "club," whose members, at the time, were limited to the United States,

▼ **17.17** "Women hold up half of heaven, and, cutting through mountains and rivers, change to a new attitude," 1970. **Propaganda poster, color lithograph, ca. 30" × 21" (76 × 53 cm). Private collection.** One of Mao's chief aims was to bring China's industrial strength to the level of Western powers, requiring the participation of women in the workforce.

▲ **17.18** Wu Hufan, *Celebrate the Success of Our Glorious Atomic Bomb Explosion!* (1965). Hanging scroll, ink, and color on absorbent paper; 53⅛" × 26⅜".

Russia, and the European powers of France and the United Kingdom. As with many Chinese painters, Hufan had concentrated his practice on traditional landscapes with images such as birds and flowers. In fact, critics had noted that for most of his life, Hufan's art had steered away from the social and political realities of his day in favor of eternal, beautiful, and mesmerizing scenes of nature. In this context, his 1965 scroll painting *Celebrate the Success of Our Glorious Atomic Bomb Explosion!* **(Fig. 17.18)** is all the more chilling. Just as his earlier works had

been untouched by the incessant warfare and social turmoil of the day, so does his ironic memorialization of China's entry into the "club" seem untouched by the reality of the meaning of the bomb. In this painting, Hufan exchanges the typical, delicate tracery of foliage for the instantly recognizable shape of the mushroom cloud of an atomic bomb explosion. Using the standard format and palette of traditional scroll painting, the artist creates a trope that perverts meaning even as it embraces the familiar. His gestural brushstrokes capture the column of death with no more emotion than they, in other works, conveyed the spirit of nature. The irony does not escape us: a landscape in the wake of an atom bomb is, and remains, dead.

China Today

The China of the 21st century is an economic powerhouse with a significant emerging military. Its influence is felt around the world. Although communist China is officially atheistic, many again think of Confucius in their daily lives, and there are those who practice Buddhism, Islam, and Christianity—although usually without overtly seeking converts. The China that abhorred capitalism in the mid 20th century now has a hybrid communist–capitalist system with more than a few billionaires. Contemporary Chinese art, produced in a variety of styles—and no longer necessarily progovernment—sells for millions. Chinese artists are represented by major galleries in London, New York, Paris, Rome, and, yes, Shanghai and Beijing. Some

Chinese artists protest too loudly against the Communist Party and wind up with certain restrictions and lost privileges, but many "commute" freely between the major cities in China and the rest of the world.

Welcome to the World Famous Brand (**Fig. 17.19**), by the Luo brothers, features their signature emphasis on the convergence of consumerism and globalism. It continues the theme of East meets West—or, in this case, West invades East—with Big Macs. Mimicking the garish packaging of Chinese merchandise, the Luo brothers' compositions are often overcrowded, intensely colored, and exuberant in mood. There is so much energy bound up in the imagery that it is almost impossible for the eyes to stop and focus. Emphasis through placement is an important device in this work, and to achieve it, once again, the Luo brothers use mimicry. The "enthroned" baby raising a McDonald's sandwich in the center of the piece becomes the focal point. It is emphasized by the red and yellow bands of lines that look like divine rays emanating from behind the baby, who in turn is bolstered on a floating rectangle by lesser, though no less jubilant, little ones. To the left and right are regimented stacks of burgers riding on chariots pulled by teams of lambs. Brightly colored peonies add to the outrageously festive atmosphere. This formula—enthroned central figure buoyed by devoted onlookers and flanked by symmetrical groups of regimented figures—is standard in religious altarpieces over centuries of art history. The Luo brothers appropriate this formula to sharpen their statement about what we "worship" in contemporary society.

▼ **17.19** The Luo Brothers, *Welcome the World Famous Brand*, 2000. Collage and lacquer on wood, 49⅝" × 96⅞" × 1¼" (126 × 246 × 3 cm). The Luo Brothers. Image courtesy of the artists. Compare the composition of this contemporary Chinese work to the paintings by Cimabue, Giotto, and others of the Madonna enthroned.

◄ **17.20** A view of
Shanghai's bustling Pudong
New Area. Three hundred
office towers are planned
for the Pudong New Area,
China's financial hub, which
constitutes most of the eastern
part of Shanghai. The twisting
Shanghai Tower, on the right, is
2073 feet tall. Unsurprisingly,
perhaps, a Disney theme park
is also under development in
Pudong.

Many Chinese cities have become boomtowns for contemporary architecture, although—at least for the time being—the principal architects involved in the designs for these cities are not Chinese, but European and American. Iraqi–British architect Zaha Hadid has called China "an incredibly empty canvas for innovation." American architect Anthony Fieldman has said that in China, "you're seeing things that no one in their right mind would build elsewhere."[4] Looking at a piece of Shanghai's conglomerate Pudong New Area skyline (**Fig. 17.20**), it is no wonder that Wang Lu of Beijing-based *World Architecture* magazine has said, "Architecture in China has become like a kung fu film, with all of these giants trying to vanquish each other."[5]

JAPAN

Following the period of feudal rule, as noted in Chapter 5, Japan was united and the capital was moved to Edo, known today as Tokyo. The nation achieved modernization through the Edo and Meiji periods. During the Meiji period, in fact, the Japanese modernized on a par with most of the West, defeating Russia in the Russo–Japanese War of 1904–1905 and seriously—one could say severely—challenging the Allies of the West during World War II. Today, of course, Japan is an unwavering ally of the United States.

The Edo Period

Artists during the Edo period, such as Hasegawa Tohaku (1539–1610), produced a wide variety of work, catering to the needs of an increasingly urban and sophisticated population. Hasegawa painted his masterful *Pine Forest* (**Fig. 17.21**) on a pair of six-panel screens. It is reminiscent of Li Kan's study of bamboo (see Fig. 17.13) in that the plant life stands alone. No rocks or figures occupy the foreground. No mountains press the skies in the background. Like *Bamboo*, it is monochromatic. The illusion of depth—and the illusion of dreamy mists—is evoked by subtle gradations in tone and texture. Overlapping and relative size also play their roles in the provision of perspective. Without foreground or background, there is no point of reference from which we can infer the scale of the trees. Their monumentality is implied by the power of the artist's brushstrokes. The groupings of trees to the left have a soft sculptural quality and the overall form of delicate ceramic wares. The groupings of trees within each screen balance one another, and the overall composition suggests the infinite directional strivings of nature to find form and express itself.

During the Edo period, the development of woodblock, a printmaking medium, made it possible to create multiple copies of works of art for a growing number of collectors. The best-known landscape artist to use woodblock was Katsushika Hokusai (1760–1849). His image of a monstrous wave crashing in the foreground while a diminutive but

▲ **17.21** Hasegawa Tohaku, *Pine Forest*, late 16th century. One of a pair of six-panel screens, ink on paper, 61⅜" × 136" (156.8 × 356 cm). Tokyo National Museum, Tokyo, Japan. The picture elicits a meditative mood, inviting the viewer to consider those things that are beyond our vision yet suggest infinite beauty.

enduring Mount Fuji appears at the center of the background is one of the best-known Japanese works of art (**Fig. 17.22**). The ominous claws of the whitecap seem certain to capsize the trading boats below and drown the sailors, who bend to gouge their oars into the rough waters to try to propel themselves past the wave. The vantage point from which we observe the unfolding drama is low in the water, such that we may feel vulnerable to the wave ourselves.

Japanese writers of the Edo period made major contributions in poetry, fiction, and dramatic writing. The greatest poet of the age was Matsuo Basho (1644–1694), who developed one of the most important Japanese verse forms, the **haiku** (originally called *hokku*). This consists of three lines of five, seven, and five syllables, respectively. Haiku typically juxtapose images, often drawn from nature, to see things freshly, to evoke or suggest a feeling or mood—of being within the scene. Basho spent most of his life either in retreat or on solitary journeys, writing poems that evoke entire landscapes by the telling selection of the crucial details. In this way, he aimed to provide a poetic equivalent of the flash of enlightenment that a meditating Buddhist hoped to achieve. Basho was a devout Buddhist, with a special interest in Zen Buddhism. (Zen, which avoided images, rituals, and sacred texts and stressed contemplation and meditation, had a great influence on Japanese culture.) See Reading 17.8 on page 594, which has perhaps the single most well known Haiku poem:

◄ **17.22** Katsushika Hokusai, *Under the Wave off Kanagawa* (also known as the "Great Wave"), ca. 1831 (Edo period). Polychrome woodblock print, 97¾" × 145¾" (25.5 × 37.1 cm). Musée national des arts asiatiques Guimet, Paris, France. This is one of a series of woodblocks called *Thirty-Six Views of Mount Fuji*; the mountain can be seen in the distance. Note the two boats, whose crews are trying desperately to negotiate the perilous seas.

READING 17.8 MATSUO BASHO

"An Old Pond"

Furu ike ya	Old pond
kawazu tobikomu	A frog jumps in
mizu no oto	The sound of water

These three lines have the standard haiku structure of five syllables, seven syllables, and five syllables, and they have been translated into English countless times. The first line creates the setting: *old pond*, with "old" possibly meaning ancient, settled, quiet, still, sleepy, serene, eternal, even overgrown with lilies, or all these and more. The second line expresses the action: *a frog jumps in*, with "jumps" sometimes translated as "leaps," making the action a bit more forceful and, perhaps, purposeful. The third line records the result of the action: *the sound of water*, which is sometimes translated as that phrase—that is, "the sound of water"—and sometimes into a single English word: "splash," "plop," "plunk," or even "kerplunk." Some translators have insisted that the English version also have five, seven, and five syllables; others have argued that you do not translate meaning with such verbal straitjackets.

The words and phrases in poems often have symbolic meanings. The pond, serene, might represent the pure mind of the meditating Buddhist who has cast out the worries of the world. Japanese poets have portrayed frogs as endearing, little creatures, and the frog, in this haiku, might represent the intrusion of reality or the sudden occurrence of an enlightening thought—"a flash of insight." The sound of water may be a disturbance in the eddies of the pond, as when a child tosses in a pebble and, in effect, says, "I am here and you will respond."

The poem could also be a simple record of an experience. But in the haiku, which is brief, little is simple.

Basho's contemporary Ihara Saikaku (1642–1693) also wrote poetry but was chiefly famous for his novels. Many of these follow the various adventures of their heroes and heroines rather in the manner of *The Tale of Genji*, to which they form a middle-class equivalent. *The Life of an Amorous Woman*, for example, is narrated by an old woman as she looks back over her life from the Buddhist retreat to which she has retired. Beginning as a high-class prostitute, she gradually declines to a mere streetwalker and eventually scrapes a living from the few occupations open to women. The overt eroticism is in strong contrast with Murasaki's delicacy and emerges in Saikaku's other writings, which include a collection of tales about male homosexual love. Similar themes of love among the bourgeois merchant classes inspire the plays of Chikamatsu Monzaemon (1653–1725). One of the most famous is *The Love Suicides at Amijima*, which describes the life and eventual death of a paper merchant, ruined by his hopeless love for a prostitute. The earlier **Noh** dramas had enacted traditional stories, passed down from generation to

generation. This new form of drama, based on real-life incidents, is called **Kabuki**; it grew increasingly popular despite government opposition.

At the end of the Edo period, Japan was thrust into contact with the Western powers. In 1853, the famous American naval expedition of Commodore Matthew Calbraith Perry arrived in Edo Bay and insisted, under threat of bombardment, that Americans be allowed to trade. The United Kingdom, Russia, and the Netherlands soon followed. The ensuing contest between conservatives and reformers was soon won by the latter, when a new emperor ascended to the throne in 1867.

Modern Japan: The Meiji

The reign of the new emperor Mutsuhito (from 1867 to 1912), known as the Meiji ("enlightened government"), introduced a radical program of reform, abolished feudalism, and quickly built a strong central government. A new army, modeled on the German system, was formed. A parliament, consisting of an upper and a lower house, served under the emperor. Banks, railways, and a merchant marine all permitted Japan to industrialize at a speed that far outstripped India or China, and by 1905, Japan could claim military victory over a European opponent[6] in the Russo–Japanese War.

During the early part of the century, Japanese artists portrayed contrasting aspects of the Japanese psyche: the warrior side, with its enduring samurai traditions, and the temperate side, meditative, at one with nature. The Japanese first warred against the Chinese in 1903 for control over Korea. The Russo–Japanese War (1904–1905) was waged over control of Korea and Manchuria. A woodblock triptych by Hirose Yoshikuni depicting combat along a 37-mile front during the Russo–Japanese War (**Fig. 17.23**) shows Japanese troops advancing inexorably, bayonets engaged. Russians are either dead or begging for mercy, their cannon no match for the fearless Japanese foot soldier. Delicate, transparent plumes of the palest wash rise from an unseen battlefield in the distance, while opaque, white smoke envelops the uniformed front-line warriors like a cloud of death.

The Taisho and Showa Periods

The Meiji period ended in 1912 and was followed by the short-lived, democratic Taisho period. That, too, ended, in 1926; the Showa period (1926–1989) followed, named for the Showa emperor Hirohito. Under Hirohito, Japan's economy dramatically expanded, but the nation also descended into totalitarianism, militarism, and racism, leading to their invasion of China in 1937. Japan was initially victorious over the underdeveloped

6. Russia, of course, spans the continents of Europe and Asia.

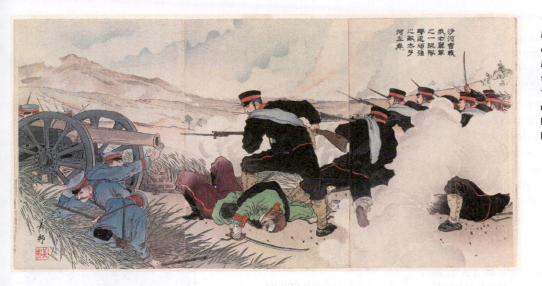

China but eventually lost World War II when the United States entered the war in 1941 following the Japanese attack on Pearl Harbor in Hawaii. The United States and its allies were victorious in 1945.

Contemporary Japanese Arts

At midcentury, Japan had lost the war, and industry and the economy were in a shambles. Yet within a couple of decades, the country managed an economic miracle. People were back to work, and the nation would go on to produce cars and trucks sold all over the world, along with electronics that would dominate the industry until competition arose from other Asian nations—South Korea and China.

Within this vibrant postwar setting, the Gutai Art Association—an experimental group founded in 1954, some two years after the Allied postwar occupation of Japan ended—explored new art forms that combined painting with performance and interactive installations. As did many contemporary performance artists elsewhere (although they were much more radical for the era than their Western counterparts), they used their bodies as a way to make permeable the boundaries between the artist and the spectator. A member of the association, Atsuko Tanaka (1932–2005), used unconventional—even intangible—materials in works such as Electric Dress (**Fig 17.24**), a wearable kimono-like sculpture composed of brightly painted, flickering bulbs and cathode tubes that envelop and etherealize the body with color and light.

Shiraga Kazuo Shiraga (1924–2008), who was trained in traditional Japanese style, emerged as one of the most celebrated artists of the country's avant-garde, joining the Gutai group in the early 1970s. As did American artist Jackson Pollock, he virtually abandoned the brush and the conventional artist–canvas relationship, spilling and dripping paint. But Shiraga radicalized the process by seamlessly weaving performance with painting,

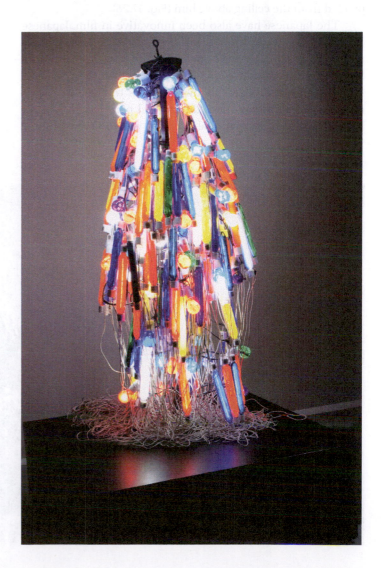

▶ **17.24** Atsuko Tanaka, Electric Dress (1956; reconstruction 1986). Enamel paint on lightbulbs, electric cords, and control console; 65" × 31½" × 31½". Takamatsu City Museum of Art, Takamatsu, Japan.

CONNECTIONS In describing his work in an interview, 20th-century American artist Jackson Pollock (1912–1956) said, "On the floor I am more at ease. I feel nearer, more a part of the painting, since this way I can walk around it, work from the four sides and literally be in the painting"* (**Fig. 17.25**). Pollock's comment may just as easily have described the work of Kazuo Shiraga, who used his body—specifically his hands and feet—to create the imagery in his paintings, as we see in **Figure 17.26.** Pollock's work has been referred to as action painting; Shiraga described his intent as exhibiting "traces of action carried out by speed".

* *Possibilities* 1, no. 1 (Winter 1947–1948): 79; as quoted in "Jackson Pollock: Is He the Greatest Living Painter in the United States?," *Life*, August 8, 1949, pp. 42–45.

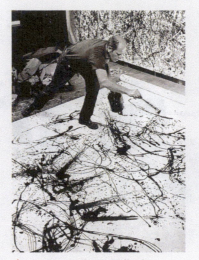

▲ **17.25 Jackson Pollock** dripping and splashing paint across his canvas.

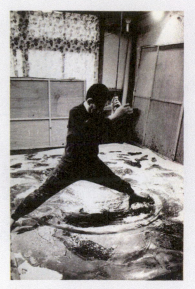

▲ **17.26 Kazuo Shiraga at work.**

using his feet to create "strokes" while hanging from a rope suspended from the ceiling above him (Fig. 17.26).

The Japanese have also been innovative in film. Japanese director Akira Kurosawa (1910–1998) made films that many movie critics consider to be among the greatest ever produced. Influenced by American movies, in particular those of John Ford, Kurosawa brought his own insights to bear on a wide range of human situations and historical periods. The first of his films to catch international attention was *Rashomon* (1950).

The film is based on two stories by the father of the Japanese short story, Ryunosuke Akutagawa (1892–1927). It is set in 12th-century Kyoto. In the opening scene, three characters—a commoner, a woodcutter, and a Shinto priest—seek shelter from a rainstorm under the ruins of the once magnificent Rashomon gatehouse. The priest and woodcutter talk about the killing of a samurai and the rape of his wife by a bandit in the nearby woods. The priest is devastated by the self-serving ways in which the survivors tell their versions of the crime at the police

◄ **17.27 Film still from** *Godzilla*, **1954.** Godzilla is awakened in the depths of the Pacific by hydrogen bomb tests. Is he the monster unleashed by humankind?

VALUES

Bushido: The Eight Virtues of the Samurai

Sixteenth-century Japan was wracked by civil war as warlords fought for control. Each warlord had an army drawn from the samurai caste. **Samurai** owed their loyalty to their warlords, but if their lord was killed or defeated, they were jobless. Unemployed samurai became wandering **ronin**, loners with the romantic aura of the gunfighter in an early Clint Eastwood Western.

We find seven such ronin in Akira Kurosawa's *Seven Samurai* (1954). They are swords for hire who defend a group of farmers against outlaws (**Fig. 17.28**). Many ronin became outlaws themselves in feudal Japan, but one of the seven samurai in the film, Kambei, personifies the **Bushido** code—the way of the warrior— in its purest form.

Bushido was not about stubbornly fighting to the death or committing suicide if one's lord was killed. Rather, the samurai were expected to evince the following traits.

Rectitude or justice: Making decisions on how to behave based on reason—striking the enemy when the time is right; dying when it is the proper thing to do.

Courage: Showing courage in the cause of righteousness.

Benevolence or mercy: Showing love, generosity, sympathy, and pity.

▲ **17.28 Film still from Akira Kurosawa's *Seven Samurai*, 1954.** Toshiro Mifune as the temperamental Kikuchiyo, who ultimately proves his worth defending villagers in the film.

Confucius lauded benevolence as the greatest virtue of the ruler.

Politeness: Showing courtesy and good manners, not for fear of offending but to express regard for the feelings of others.

Honesty and sincerity: Being thrifty, exercising abstinence.

Honor: Keeping a sense of personal dignity and worth; fearing disgrace but being able to overlook minor provocations.

Loyalty: Remaining loyal to those to whom one is indebted, as the seven samurai were expected to be to their lords and then to the farmers who employed them.

Character and self-control: Having a solid standard of what is right and wrong, and living up to it.

Rectitude, courage, and benevolence are shown by Kambei in the first scene of the film. A samurai's topknot is an emblem of Bushido, and losing it is considered a disgrace. However, Kambei maintains his sense of personal dignity, his loyalty, and his character when he shaves off his topknot to impersonate a priest so that he can rescue a kidnapped child.

court. Viewers see each story enacted on the screen, differentiated by tempo, editing, and camera shots. In one story, the bandit is honorable. In another, the wife is victimized. Each version blames a different individual for the outcome. Who is telling the truth? We cannot know. Indeed, the film suggests that there may not *be* one completely true story of events, such as wars. (It is said that the first casualty of war is truth.)

Rashomon was followed by *Seven Samurai* (1954), which re-creates the lives—and deaths—of Japanese feudal warriors and has been listed as one of the 10 greatest films of all time.

In the visual arts, one of the effects of globalization is hybridity, or the mixing of the traditions of different cultures

to create new blends and new connections. There is two-way hybridity with Kurosawa's films: *Seven Samurai* was remade as an American film, *The Magnificent Seven*. One critic writing of Kurosawa referred to the "Shakespearean cast of his genius"; two of his most dramatic films are based on works by Shakespeare: *Throne of Blood* (1957), based on *Macbeth*, and *Ran* (1985), Kurosawa's version of *King Lear*. The latter is a movie of immense power, profoundly pessimistic in tone.

Highly popular in the United States was Ishiro Honda and Terry O. Morse's *Godzilla: King of the Monsters!* (**Fig 17.27**). Godzilla began its life as a remake of Hollywood's *The Beast from 20,000 Fathoms* (1953) and was then recut to include the

American actor Raymond Burr. Despite this humble origin, it captured the interest of viewers around the world, spawning literally dozens of sequels and spin-offs, comic-book art, and tie-in products such as stuffed Godzillas and video games. *Godzilla* tells the story of a 400-foot prehistoric monster awakened from the depths of the Pacific by hydrogen-bomb tests. Provoked by depth charges, Godzilla uses his fiery breath to turn Tokyo to toast. Eventually, he is killed by another weapon of mass destruction, one that destroys the oxygen in the water around him.

By today's standards, *Godzilla*'s special effects are primitive, but the strength of this film lies in its portrayal of Japanese fears about weapons of mass destruction following World War II and in its personalization of the monster. Although humans must be saved from Godzilla, Godzilla is also a victim of the nuclear genie that humans have uncorked. The atomic devastation of Hiroshima and Nagasaki horrified the Japanese not only because of the immediate loss of life but also because of the disfigurement of survivors and lingering radiation sickness. Was *Godzilla* a not-so-subtle protest film?

Another example of the ways in which globalization has led to an intermingling of the world's cultural icons is found in the work of Takashi Murakami (b. 1962), a creator of **Pop art** who draws on consumer culture for his imagery. Murakami is also vigorously self-promotional, exhibiting his paintings and sculpture at major museums around the world while creating mass-market products ranging from T-shirts and key chains to mouse pads and Louis Vuitton handbags.

As a boy, Murakami fantasized about illustrating Japanese graphic novels called *manga*, which are also hybrids. Though illustrated manuscripts have as long and distinguished a history in Japanese art as they do in Western art, their modern form is heavily influenced by American comic books, which infiltrated Japanese culture soon after the end of World War II,

▼ **17.29** Takashi Murakami, *Tan Tan Bo*, 2001. Acrylic on canvas mounted on board, 141¾" × 212⅝" × 212⅝" (360 × 540 × 6.7 cm). Private collection.

when Japan was occupied by the United States and U.S. culture became popular. As a student, Murakami experimented with large-eyed cartoon figures in the popular **anime** style (a style of animation developed in Japan), but he was also trained in classical Japanese painting techniques. Consequently, his work often aims to reconcile "high art" and "low culture." *Tan Tan Bo* (**Fig. 17.29**) is filled with cartoonlike imagery rendered in simple, dark outlines filled in with bright colors. The overall shape may resemble a fierce Mickey Mouse, but the artist has dubbed his signature character Mr. DOB. Murakami has created a multimedia sensation of Mr. DOB in such objects as lithographs and inflatable balloons. Like some contemporary American Pop artists, he makes no distinction between art and merchandise.

The nations of South Asia, China, and Japan have been insulated and isolated from each other by mountain ranges and seas. They have connected with one another with trade, with religions that have crossed natural boundaries, and with styles in writing and the visual arts. They have also warred with one another from time to time, and each of them has warred with the West. Today, mass media and electronic forms of communication such as the Internet are intertwining the cultures of India, China, and Japan with those of the West ever more deeply. It is a two-way street. Cultural works in many, perhaps most, areas of the world are becoming increasingly hybrid. The American artist Robert Mothwerwell said, "Every intelligent painter carries the whole culture of modern painting in his head."[7] It is likely that no major writer or artist anywhere in the world now works without intimate knowledge of what is happening elsewhere on the globe.

7. Cited in Hilton Kramer, *The Triumph of Modernism: The Art World, 1987–2005* (Lanham, MD: Rowman & Littlefield, 2006), p. 85.

GLOSSARY

Anime (p. 599) A Japanese style of animation characterized by colorful graphics and adult themes.

Bushido (p. 597) The behavioral or moral code of the samurai; a Japanese counterpart to chivalry.

Calligraphy (p. 575) A stylized form of elegant handwriting.

China (p. 585) A translucent ceramic material; porcelain ware.

Glaze (p. 585) A coating of transparent or colored material applied to the surface of a ceramic piece before it is fired in a kiln.

Haiku (p. 593) Three-lined Japanese verse, with a syllable structure of 5-7-5, which usually juxtaposes images, often drawn from nature, to achieve deeper meaning.

Huaben (p. 584) Chinese short stories of the Ming dynasty.

Hybridity (p. 578) In the arts, the mixing of the traditions of different cultures to create new blends and new connections.

Kabuki (p. 594) A type of drama begun during the Edo period of Japan that was based on real-life events.

Lacquer (p. 585) A hard, durable finish for furniture and other objects that is created from the sap of the sumac tree.

Minaret (p. 575) A tall, slender tower attached to a mosque, from which a *muezzin* or crier summons people to prayer.

Mughal (p. 574) A Muslim dynasty in India, founded by the Afghan chieftain Babur in the 16th century.

Noh (p. 594) A type of Japanese drama in which actors wear wooden masks.

Overglaze (p. 588) The outer layer or **glaze** on a ceramic piece; a decoration applied over a glaze.

Pop art (p. 598) An art style originating in the 1960s that uses ("appropriates") commercial and popular images and themes as its subject matter.

Rajput (p. 574) A member of a Hindu people claiming descent from the warrior caste during the Indian Heroic Age.

Samurai (p. 597) Japanese professional warriors in medieval times.

Satyagraha (p. 580) Nonviolent civil disobedience.

Underglaze (p. 588) A decoration applied to the surface of a ceramic piece before it is glazed.

Urdu (p. 574) The literary language of Pakistan; similar to Hindi when spoken, but written in the Arabic alphabet and influenced by Persian.

THE BIG PICTURE SOUTH ASIA, CHINA,

SOUTH ASIA

Language and Literature

- Babur (1483–1530), the founder of the Mughal Empire, wrote his autobiography—the *Baburnama*—in Eastern Turkish.
- Humayun (1507–1556), Babur's son and successor, wrote poetry in Persian.
- The Mughal emperor Akbar (1542–1605), Babur's grandson, commissioned scholars to provide a common language for India; they created Urdu, which combines Hindi with Arabic and Persian.
- Calligraphy came into use during the Mughal Empire.
- The novelist and short-story writer Munshi Premchand (1880–1936) wrote in Hindi and Urdu to describe the lives of India's poorest villagers to the outside world.
- Rabindranath Tagore (1861–1941) won the Nobel Prize for Literature in 1913 for writing that stresses that true authority derives from basic humanity.

Art, Architecture, and Music

- Mughal architects and painters devised a style that combines Hindu tradition with Muslim elements in the early 17th century.
- The Taj Mahal, combining the dome, the pointed arch, and the minaret, was built at Agra between 1632 and 1649.
- Mughal painting consisted mainly of manuscript illuminations and miniatures, depicting courtly life, portraits, and historic events.
- Under British rule, Victoria Terminus (now Chhatrapati Shivaji Terminus) was erected in Mumbai (1879–1887).
- Rabindranath Tagore (1861–1941) painted and composed music, including India's first national anthem.
- The Progressive Artists group was founded in 1947, the year of India's independence.
- Indian director Satyajit Ray's (1921–1992) films, including the Apu Trilogy, portrayed the lives of ordinary people to provide a general impression of their culture.
- Subodh Gupta (b. 1964) created ready-made works of art.

Philosophy and Religion

- The monotheistic religion of Sikhism was founded in the 15th century in the Punjab region.
- Babur, an Afghan chieftain, brought the Muslim religion into northern India in 1526.
- The poet Tulsidas (ca. 1532–1623) produced the *Ramcaritmanas* (*The Holy Lake of the Acts of Rama*), which combined monotheism with traditional Hindu polytheism.
- The Mughal emperor Aurangzeb (1618–1707) destroyed Hindu temples and compelled Hindus serving in the imperial bureaucracy to convert to Islam.
- Gandhi founded the movement of nonviolent civil disobedience based on his concept of satyagraha, or "truth," in 1906.

AND JAPAN FROM MEDIEVAL TO MODERN TIMES

CHINA

Language and Literature

- During the Ming dynasty, the most popular new literary genres were the novel and short story.
- Professional traveling tellers of short stories inserted verses into prose narratives, included past audience reactions, and employed street language.
- The anonymous and openly erotic novel *Jinpingmei* (*The Plum in the Golden Vase*) appeared late in the Ming dynasty; it is noted as a landmark in the history of narrative prose.
- The 16th-century novel *Monkey*, by Wu Cheng'en, used old supernatural legends to tell the tale of a Buddhist priest's pilgrimage to India.
- Sun Zhu compiled 300 poems from the Tang period during the Qing dynasty.

Art, Architecture, and Music

- Chinese paintings of the Ming and Qing dynasties frequently included calligraphy.
- Ming potters produced vases of exceptional quality, including decorated porcelain, which became known as *china*.
- The imperial capital of Beijing, first constructed by the Mongols in the 13th century, was reconstructed during the Ming dynasty, including the emperor's residence, known as the Forbidden City.
- The Qing dynasty continued the development of fine pottery through developments in glazing.
- Lacquerware developed during the Ming and Qing dynasties.
- Qing painters experimented with new approaches, such as the bold repetition of strokes.
- Modern Chinese visual arts frequently comment on Communist rule and globalization.
- Shanghai's Pudong area has a multitude of skyscrapers of various types of designs, where the new Shanghai Tower is rising to 2073 feet.

Philosophy and Religion

- Confucianism served as the basis for all aspects of life under the Ming dynasty (1368–1644).

JAPAN

Language and Literature

- Edo writers made major contributions to poetry, fiction, and drama, as shown in the 17th-century haiku of Basho.
- Ihara Saikaku wrote popular novels in the 17th century.

Art, Architecture, and Music

- Woodblock, a printmaking method, was developed during the Edo period.
- The experimentalist Gutai Art Association was founded in 1954.
- The Japanese director Akira Kurosawa made *Rashomon* in 1950; *Seven Samurai* (the basis for the American *The Magnificent Seven*) in 1954; *Throne of Blood*, based on *Macbeth*, in 1957; and *Ran*, based on *King Lear*, in 1985.
- Ishiro Honda and Terry O. Morse produced *Godzilla: King of the Monsters!* in 1956.
- Takashi Murakami (b. 1962) became Japan's best-known Pop artist.

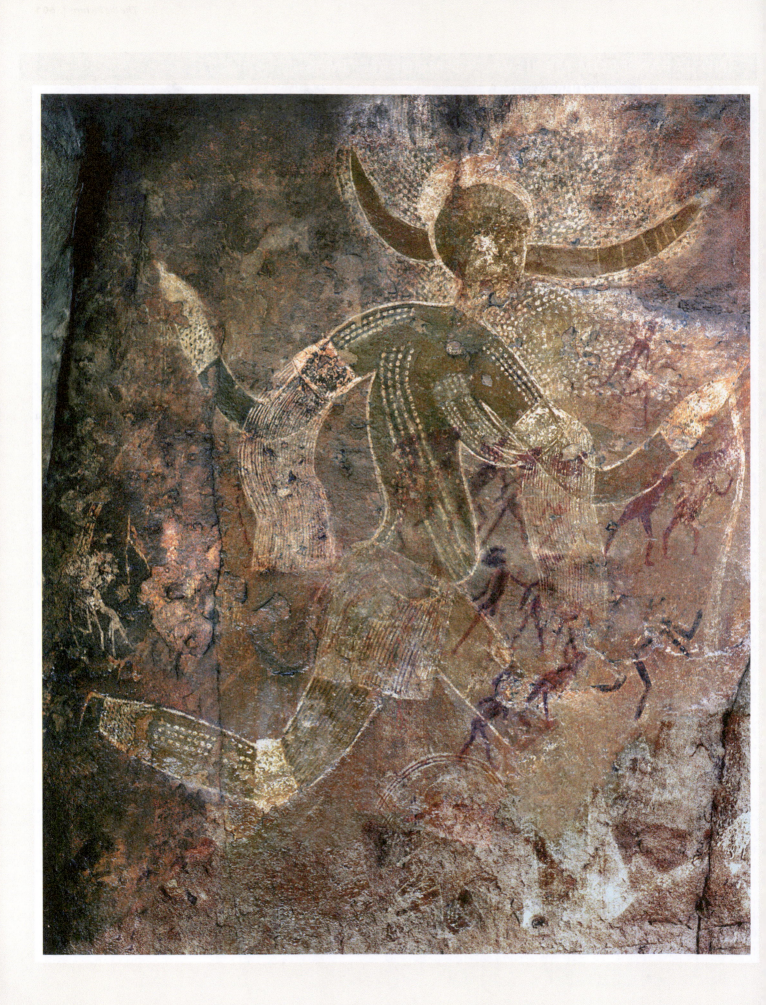

Africa

PREVIEW

Everything we are began in Africa. The first human species—hominids—trod the African plains and scaled African trees several million years ago. Our species emerged there some 150,000 to 200,000 years ago, and the earliest bones we know of have been unearthed in Africa. From that cradle, we began to spread to the four corners of the earth. We moved northeast into what is now the Arabian Peninsula, still farther north into Europe, eastward into Asia, down into Oceania and Australia, and across a natural land bridge—now submerged—from present-day Siberia to the Americas. Human migrations over thousands of miles go back more than 50 millennia.

As we adapted to our new environments over untold generations, skin color and other features changed. In Africa, our dark black skin helped block out the searing rays of the sun. In Europe, our skin paled to maximize our synthesis of vitamin D in lands where the sun was less intense. For thousands of years, those of us who stayed in Africa were relatively untouched by the ways and cultures of our migrant descendants—until they came back to the continent.

Greeks and Romans returned more than 2000 years ago, establishing settlements along the northern coast of Africa. Cleopatra, who reigned as the last Egyptian pharaoh, was of Macedonian Greek descent. Arabs returned from the Middle East in the seventh century CE, introducing Islam to northern parts of Africa. Western and northern Europeans returned to Africa about 1000 years later as colonial powers, bringing Christianity to many areas of the continent.

Africa is vast. Its land area is three times that of the continental United States and Alaska. Its climate and landforms are wildly diverse—from moderate Mediterranean conditions to humid rain forests, from grasslands to desert—and the cultures of African peoples that developed in these distinct zones were equally diverse. More than 2000 ethnic groups have been identified, and over 1000 languages are spoken in sub-Saharan Africa alone. Unlike in China or India, Africa's peoples never united under a single government; Western colonization, for the most part, determined the geographical and political boundaries of modern Africa. The cultural development of Africa is marked, then, by distinct indigenous traditions, sometimes blended with influences brought back from those humans who essentially made a round trip.

One of the oldest works discovered in Africa is a Neolithic rock painting of a woman in a horned headdress running, or, perhaps, dancing (Fig. 18.1). Her body is adorned with painted patterns, and she wears a skirt made of fiber from a palm tree that grew in what is now the Sahara Desert. The position of her arm and legs, seen in profile, and the sinuous lines of her fringed arm-cuffs contribute to an impressive representation of movement. Although the purpose of this painting is not known, given the elaborate costume and body art, it is likely connected with ritual.

◀ **18.1 Running woman, rock painting, Tassili n'Ajjer, Algeria (c. 6000–4000 BCE).**

SOCIETY AND RELIGION IN EARLY AFRICA

The continent of Africa has been described in terms of two broad regions: North Africa (the territories along the Mediterranean Sea that are considered part of the Arab world and are now Islamic) and sub-Saharan Africa (see **Map 18.1**). The latter region consists of the area—or countries—south of the broad expanse of the Sahara Desert; the religion in sub-Saharan Africa is now primarily Christian. Given the topography, cultural diversity and separation come as no surprise, although signs of a common cultural inheritance are strong. Africa's many languages are related to only four or five basic tongues, and traditional religion is tied into the beliefs and practices of linguistic cultural groups. Common to most are ancestor worship, deification of rulers, respect for nature (the environment and living creatures), and worship of nature deities. **Animism**, the belief that the world is governed by the workings of nature, underscores most traditional African religion, and ritual and ceremony often pertain to managing illness, warding off death, and controlling natural disasters.

In the absence of written texts, practices and beliefs were memorized and passed on by word of mouth to younger generations by their elders, who were revered. A tradition of ancestor worship emerged that placed emphasis on the family and, more broadly, on the village community. Within the community, certain extended families, or kinship groups, specialized in functions such as hunting, farming, and trade. Social structure and religious beliefs reinforced one another and allowed for the slow evolution of increasingly powerful kingdoms.

Writing begins in Africa with Ancient Egyptian hieroglyphics developed in the fourth millennium BCE. The history of language and writing varies across the continent, though, so in West Africa writing emerges about two thousand years ago in the use of Tifinagh scripts by Berber speakers, whereas Meroitic emerges in northeastern Africa around 300 BCE. Alongside the written record, archeology helps us understand the highly developed states that emerged in early Africa, and testifies to the range of cultural achievement.

THREE EARLY AFRICAN KINGDOMS: GHANA, BENIN, AND ZIMBABWE

The kingdoms of Ghana, Benin, and Zimbabwe flourished long before the Europeans entered Africa's interior. From the 16th century, with the beginning of the age of European colonization and the slave trade that accompanied it, Europeans began to settle in coastal regions, which served as bases for exploring and exploiting Africa's extraordinary natural resources. Muslim missionaries had carried their religion southward across the Sahara Desert centuries earlier. The arrival of the Europeans

Africa

	1300 CE	1800 CE	1900 CE
BCE / CE			

Modern humans emerge in Africa ca. 200,000–150,000 BCE	Beginnings of Ghana ca. 300 CE	Kingdom of Benin flourishes during the 14th–16th centuries	Prominence of Benin declines due to slave trade	Slave narratives based on interviews with former slaves are produced in the United States in the 1930s
Modern humans disperse from Africa to populate the earth ca. 60,000–50,000 BCE	Muslim missionaries bring Islam to Ghana in 8th century	Europeans settle in coastal regions in the 16th century	The European "Scramble for Africa" partitions Africa into regions ruled by European powers	Beginning of decolonization of Africa by European powers after 1945
North Africa is colonized by ancient Greeks, Phoenicians, and Romans (r. sixth century BCE –1st century CE)	Muslims begin to colonize North Africa	Slave trade by Europeans begins in the 16th century	Spirituals and quilting develop in the United States	Apartheid instituted in South Africa in 1948
	Arabs begin slave trade in Africa ca. 10th century			Apartheid ends in 1994
	Ghana becomes world's largest producer of gold			
	Ghana is defeated by Muslim Berbers ca. 1075			
	Huge stone buildings are erected in kingdom of Zimbabwe			

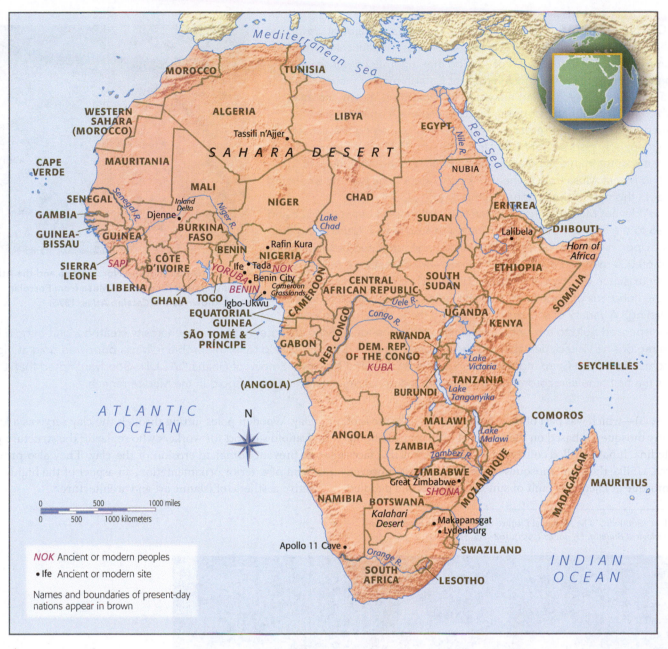

▲ **MAP 18.1** Africa.

brought Christianity, and, under the influence of both religions, traditional patterns of ritual and ancestor worship began to die out.

Ghana

One of the earliest states to develop was Ghana, in West Africa. Caravan routes crossing the Sahara linked the region to Mediterranean cities, first by horse and ox and then, after 300 CE, by camel. Shortly after, the city of Ghana on the upper Niger River began to export gold, animal hides, pepper, ivory, and slaves in exchange for salt, cloth, pottery, and other manufactured goods. Ghana grew increasingly wealthy; at the height of its success

(around 1000 CE), it was probably the world's largest gold producer. According to an Arab traveler who visited Ghana in 1065, the army numbered 200,000 men, of whom 40,000 were armed with bows and arrows. This formidable fighting force was defeated a decade later by a nomadic army of Muslim Berbers. The Berbers moved north after a few years to attack Morocco, but Ghana never fully recovered (in part because the gold mines were beginning to peter out), and by 1300, the great kingdom was only a memory.

Traders from North Africa in the eighth century CE brought Islam to Ghana, which, because of its wealth, became a vibrant center of Islamic culture. What emerged in terms of religious practice and art was a blend of both traditions. The plan of the Great Mosque at Djenné in present-day Mali

CONNECTIONS In 1375, Abraham Cresques, a Majorcan Jew, created what is known as the *Catalan Atlas*—a set of nautical charts commissioned by Prince John of Aragon that together comprise what some consider to be the most important Catalan map of the medieval era. In addition to recording the world as it was then known, the atlas (which has North at the bottom), features elaborate drawings and descriptive text. In the territory of northwest Africa, along the border of the map, is a "portrait" of Musa I (ca. 1280–ca. 1337), the King of Mali, with a scepter in one hand and a piece of gold in the other (**Fig. 18.2**). Called Mansa Musa (*mansa* means "king of kings"), he was the wealthiest ruler in this part of the continent in his day.

A devout Muslim, Musa I undertook a pilgrimage between 1325 and 1326 to the holy city of Mecca, planning to stop over in Cairo along the way. Upon his arrival—along with an entourage estimated between 8,000 and 60,000 men and 80–100 pack camels—Musa sent an emissary to the Mamluk sultan of Egypt along with 50,000 gold dinars (a small fraction of the hundreds of pounds of gold and gold dust with which he was traveling). A variety of sources documented the journey, during which

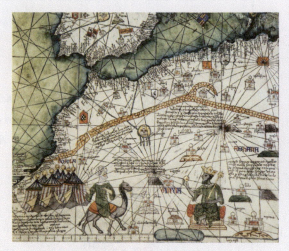

▲ **18.2** Detail showing North Africa and the Atlas mountains and King Mansa Musa from Portolan chart known as the *Catalan Atlas*, 1375.

he dispensed gold to the poor and to cities along the route. Scholars note that Musa's generosity created a glut of gold in the regions he visited, destabilizing their economies for a decade. To help to fix the problem, Musa borrowed gold at high interest rates from Cairo money-lenders. In his article, "The Medieval Empire of Ghana," A. J. H. Goodwin[1] noted that it was the first time in recorded history that one individual regulated the price of gold in the Mediterranean.

(**Fig. 18.3**)—which was part of the Ghana Empire—like those of all early mosques, is based on the model of Muhammad's home in Medina. It has a walled courtyard in front of a wall that faces Mecca. Unlike the stone mosques of the Middle East, however, the mosque at Djenné is built of sun-dried bricks and puddled clay. Wooden poles jutting through the clay serve as a kind of scaffold support for workers who replaster the structure yearly to prevent complete erosion of the clay. They also provide a form of exterior ornamentation, an aspect of the highly decorative aesthetic of Islamic art and architecture.

1. A. J. H. Goodwin, "The Medieval Empire of Ghana," *The South African Archaeological Bulletin,* 12, no. 47 (1957): 108–112.

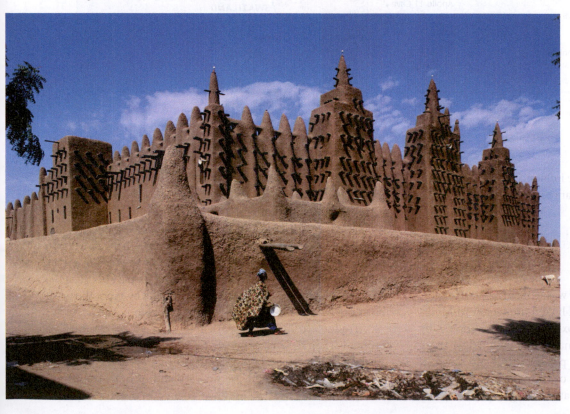

◄ **18.3** The Great Mosque, 14th century CE. Djenné, Mali. The mosque's design is based on that of Muhammad's home in Medina, but unlike many mosques, it is constructed of puddled clay, adobe brick, and wooden poles.

Benin

During the time of Ghana's slow decline, the kingdom of Benin was beginning to grow in what is now Nigeria (ancient Benin should not be confused with the modern African state of Benin). The period around 1000 CE saw the introduction of new food crops from East Asia and more sophisticated methods of metalworking, making larger communities possible. The kingdom of Benin flourished between the 14th and 16th centuries, trading widely in pepper and ivory. Its eventual decline was caused by the massive deportation of its male population in the 19th century by Arab and European slave traders. The kingdom was ruled by a hereditary male absolute monarch with the title of *oba*, who had at his disposal a powerful army and an effective central government.

BENINESE CULTURE The oba's central palace was adorned with a series of bronze plaques showing the life of the court and military exploits. Among the sculptures was a small portrait of a royal woman with tribal markings and a conical headdress, which offers insight into life at the Beninese court. She is the Queen Mother Idia, to whose mystical powers her son, the oba Esigie, attributed his success in warfare. In gratitude, he allowed her to have her own palace and sacred altars, and this head was made to decorate one of the altars (**Fig. 18.4**). At the same time, the beauty of line and the balance between decoration and naturalism give some idea of how much we have lost with the disappearance of so much African art.

Another bronze from Benin throws light on religious practices at court (**Fig. 18.5**). It comes on an *ikegobo*, or royal shrine, at which the oba would have offered up sacrifices either for favors received from the gods or in the hope of receiving future ones. The oba appears both on the side and on the lid, again dominating the accompanying attendants. On the lid, two meek leopards crouch humbly at his feet. Even the creatures of the wild acknowledge the supreme power of their master, while other animals range around the base.

Zimbabwe

The greatest ancient kingdom in South Africa was Zimbabwe. Bushmen's paintings and tools show that the earliest people to occupy the site settled there in the Stone Age. Around 1300, the

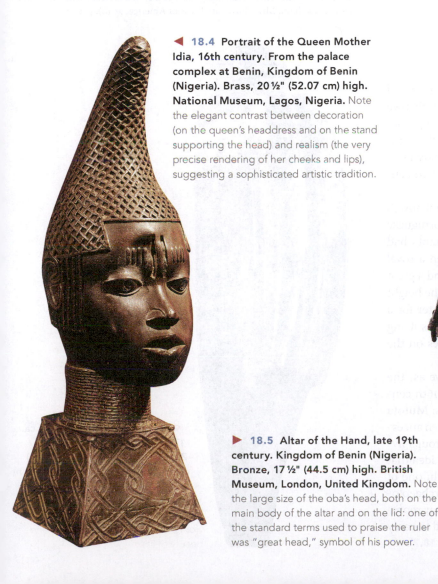

◄ **18.4 Portrait of the Queen Mother Idia, 16th century.** From the palace complex at Benin, Kingdom of Benin (Nigeria). Brass, 20½" (52.07 cm) high. National Museum, Lagos, Nigeria. Note the elegant contrast between decoration (on the queen's headdress and on the stand supporting the head) and realism (the very precise rendering of her cheeks and lips), suggesting a sophisticated artistic tradition.

► **18.5 Altar of the Hand, late 19th century.** Kingdom of Benin (Nigeria). Bronze, 17½" (44.5 cm) high. British Museum, London, United Kingdom. Note the large size of the oba's head, both on the main body of the altar and on the lid: one of the standard terms used to praise the ruler was "great head," symbol of his power.

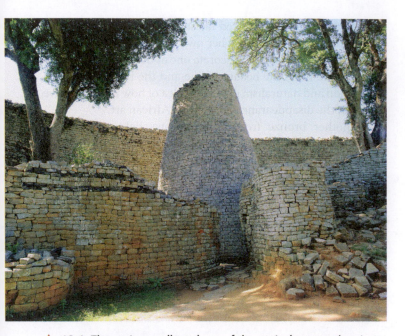

▲ **18.6 The ancient walls and one of the conical towers showing the inner passage of the Great Enclosure at Great Zimbabwe, 15th century. Zimbabwe.** Built of granite during the African Iron Age, the surrounding walls probably enclosed a royal residence with private living quarters and an open area for ceremonial assemblies. Some of the larger towers may have been used to store grain.

SLAVERY AND COLONIALISM

Africa has been beset by human-made disasters from within and without. Some wounds were self-inflicted: Africa, like other continents, saw its share of wars and the coercion of captives and their descendants into lives of servitude and **slavery**. Colonization by European powers may have brought with it some benefits, such as advanced technology and medicine, but these were outweighed by its destructive effect on African life and culture. But discussing the pros and cons of imperialism and **colonialism**, according to human-rights activist Arundhati Roy, "is a bit like debating the pros and cons of rape." It was physically brutal and psychologically humiliating.[2]

Slavery

One of the worst tragedies to befall Africans was the transatlantic slave trade. Slavery was common in ancient Africa, as in many other parts of the world—including ancient Greece

2. Cited in Samar Attar, *Debunking the Myths of Colonization: The Arabs and Europe* (Lanham, MD: University Press of America, 2010), p. 227.

rulers ordered the erection of huge stone buildings surrounded by massive walls; the complex is now known as Great Zimbabwe (**Fig. 18.6**). Finds in the ruins include beads and pottery from the Near East, Persia, and even China, suggesting that the complex served as the base for a trading empire that must have been active well before the arrival of the Europeans, some two centuries later.

Attempts to understand the function of Great Zimbabwe's constructions are largely based on accounts of Portuguese traders who visited the site after its original inhabitants had abandoned it. The main building seems to have been a royal residence, with other structures perhaps for nobles, and a great open ceremonial court. It has been calculated that at the height of its power, the complex may have served as the center for a population of some 18,000 people, with the ruling class living inside and the remainder in less permanent structures on the surrounding land.

Portuguese documents describe Great Zimbabwe as "the capital of the god-kings called Monomotapa." In the 16th century, Europeans used this name for two Shona rulers: Mutota and Matope. The original inhabitants may well have been ancestors of the Shona people, who are now among the groups living in modern Zimbabwe. Part of Shona beliefs is the idea that ancestral spirits take the form of birds, often eagles. In one of the enclosed structures, perhaps an ancestral shrine, archaeologists discovered a soapstone carving of an eagle that may represent one of these ancestral spirits, which were believed to carry messages between the human and divine worlds (**Fig. 18.7**).

◄ **18.7 Sculpture of a bird, ca. 1200–1400. Great Zimbabwe, Zimbabwe. Soapstone (steatite) carving. Private collection.** Thought to represent a mythical eagle that carries messages from human beings to the gods, the piece is remarkable for its elegant simplicity of form and beauty of line.

CONNECTIONS In 1789, the year that marked the beginning of the French Revolution, Gustavus Vassa published the first-ever slave autobiography as a free man living in England—*The Interesting Narrative of the Life of Olaudah Equiano, or Gustavus Vassa, the African.* According to his account, he was kidnapped along with his sister in what is now Nigeria at the age of about 11, was sold to slave traders, and then transported to Barbados. From there he was sent to the British colony of Virginia, where he was bought, in 1754, by Michael Pascal, a lieutenant in the Royal Navy; Pascal gave him the name Gustavus Vassa after King Gustav I of Sweden. Vassa (who used this given name his whole life) accompanied Pascal back to England, serving as his valet during the Seven Years' War (the main conflict was between 1756 and 1763) between opposing European coalitions led by Great Britain and France. After the war, Pascal arranged for him to attend school, although he later sold him to another English ship captain who, in turn, sold Vassa to Robert King, a Philadelphia Quaker merchant. It was from King that Equiano bought his freedom in 1767, having had some success in business. He returned to England, where he became an outspoken advocate for the abolition of slavery.

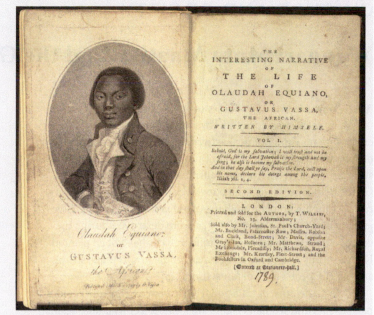

▲ **18.8** Olaudah Equiano, or Gustavus Vassa, the African. Portrait. Image taken from *The Interesting Narrative of the Life of Olaudah Equiano, or Gustavus Vassa, the African.* Originally published/produced in London, 1789.

and ancient Rome—but a distinction must be made between slavery practices such as existed in these ancient cultures and the slave trade that affected Africa from the 16th through the early 19th centuries. In some areas of Africa, slaves were more like **indentured servants**, who were not necessarily considered property, worked the fields, were paid wages, and could obtain land of their own. Some slaves were able to buy their freedom and advance socially. In Greece and Rome, the slave class mainly comprised enemy soldiers and vanquished citizens taken back home by the victorious generals as plunder. Slaves could be bought, sold, or traded, but they had certain rights and the potential for upward social mobility.

The slave trade in Africa was connected to European colonization. As new lands were explored, they were also exploited for their commodities through peaceful trade or outright seizure. This included human beings who were swept up in the system of the so-called triangular trade. The first leg began in Europe; factory goods including guns and ammunition were moved to Africa and then bartered or sold for slaves who had been captured by African rulers. The slaves were then shipped across the Atlantic Ocean (hence the term *transatlantic slave trade*) to the Caribbean islands and the Americas to work on sugar, tobacco, and cotton plantations. The commodities produced by the plantations were then shipped to Europe, sometimes on the very same vessels on which the slaves had arrived.

African slave trading became a business for foreigners, particularly Arabs (beginning in the 10th century CE) and Europeans (beginning with the Portuguese in the 15th century CE).

African groups including the Imbangala of present-day Angola and the Nyamwezi of what is now Tanzania were complicit in slave trading, waging war on other African peoples and states and exporting captives as slaves. In turn, Arabian and European slave traders supported the African rulers who were in league with them. The first enslaved Africans were brought to Portuguese and Spanish colonies in the Americas in the early 16th century, primarily by Portuguese traders. In the 17th century, the Dutch imported slaves to the southern American colonies, where most worked in agriculture and domestic servitude. Half of all enslaved Africans were traded during the 18th century, when the system operated at its peak and the countries involved included the United Kingdom, France, and Portugal. The British parliament outlawed the trading of enslaved people in 1807. In the United States, slavery was abolished after the Civil War with the ratification of the 13th Amendment to the U.S. Constitution in 1865. It is estimated that four million enslaved Africans lived and died in the Americas.

SLAVE NARRATIVES In the United States between 1936 and 1938, journalists and writers employed by the federal government's Works Progress Administration (WPA) conducted interviews with 2300 former slaves from the U.S. South. These slave narratives provide eyewitness testimony of life, work, relationships, and survival on plantations and small farms and in cities throughout the so-called slave states. Many of these interviews, with audio clips, are available on the U.S. Library of Congress's American Memory site (http://memory.loc.gov/ammem/collections/voices), including some songs.

CULTURE AND SOCIETY

Wangari Muta Maathai and the Green Belt Movement

Wangari Muta Maathai (1940–2011), nicknamed "Forest Queen," was born in Kenya and spent her adult life as an environmental and political activist. She championed the values of spirituality, tradition and continuity, community, family, agrarian life, and environmentalism. In 1977, she began the Green Belt Movement, which involves (and thereby empowers) rural women who plant millions of indigenous trees—fig, blue gum, acacia—to replace those that were destroyed during the colonial period. So far over 20 million trees have been planted. Kenya is thus one of the few African countries to make strides against the problem of deforestation.

Most societies in traditional Africa have been, and remain, patriarchal, and women's rights are limited. Yet Maathai, against overwhelming odds, earned a doctorate, became a university professor, and served as an academic department chair—the first Kenyan woman to do so. Her husband, a businessman and politician, was ridiculed for his highly educated and influential wife, a woman "beyond his control." Social pressure may have led him to divorce her, but it did not deter Maathai from her mission to connect women's issues with environmental concerns. In the past, Africa was oppressed by colonial powers; today, Maathai asserted, the oppressors are the African elite, who are "no better than the world which colonized us." The political elite hit back; the government restricted her travel, and she was beaten and teargassed by police. Nonetheless, her environmental work won national and international acclaim. Al Gore praised her accomplishments in his book *Earth in the Balance*, and in 2002 Maathai was elected to Kenya's parliament, serving as assistant minister for the environment and wildlife. In 2004, she was awarded the Nobel Peace Prize.

The following extract from her autobiography recounts the lush, rural circumstances of her birth and is suggestive of the development of her values.

Beginnings

I was born the third of six children, and the first girl after two sons, on April 1, 1940, in the small village of Ihithe in the central highlands of what was then British Kenya. My grandparents and parents were also born in this region near the provincial capital of Nyeri, in the foothills of the Aberdare Mountain Range. To the north, jutting into the sky, is Mount Kenya.

Two weeks into *mbura ys njahi*, the season of the long rains, my mother delivered me at home in a traditional mud-walled house with no electricity or running water. She was assisted by a local midwife as well as women family members and friends....

We lived in a land abundant with shrubs, creepers, ferns, and trees, like the *mitundu mikeu*, and *migumo*, some of which produced berries and nuts. Because rain fell regularly and reliably, clean drinking water was everywhere. There were large well-watered fields of maize, beans, wheat, and vegetables. Hunger was virtually unknown. The soil was rich, dark red-brown, and moist.

When a baby joined the community, a beautiful and practical ritual followed that introduced the infant to the land of the ancestors and conserved a world of plenty and good that came from that soil. Shortly after the child was born, a few of the women attending the birth would go to their farms and harvest a bunch of bananas, full, green, and whole. If any of the bananas had ripened and birds had eaten them, the women would have to find another full bunch. The fullness expressed wellness and wholeness, qualities the community valued. Along with the bananas, the women would bring to the new mother's house sweet potatoes from her and their gardens and blue-purple sugarcane...

According to the [**Gikuyu**] myth of origin, God created the primordial parents, Gikuyu and **Mumbi**, and from Mount Kenya showed them the land on which they were to settle: west from Mount Kenya to the Aberdares, on to Ngong Hills and Kilimambogo, then north to Garbatula. Together, Gikuyu and Mumbi had ten daughters—Wanjiru, Wambui, Wangari, Wanjiku, Wangui, Wangeci, Wanjeri, Nyambura, Wairimu, and Wamuyu—but they had no sons. The legend goes that, when the time came for the daughters to marry, Gikuyu prayed to God under a holy fig tree, *mugumo*, as was his tradition, to send him sons-in-law. God told him to instruct nine of his daughters—the tenth was too young to be married—to go into the forest and to each cut a stick as long as she was tall. When the daughters returned, Gikuyu took the sticks and with them built an altar under the *mugumo* tree, on which he sacrificed a lamb. As the fire was consuming the lamb's body, nine men appeared and walked out of the flames.

THE SPIRITUAL The spiritual, a primarily Christian song, was created during the period of enslavement. Slave owners forbade traditional African worship, in addition to speaking in African tongues. Thus, enslaved Africans were converted to Christianity and learned to speak the language of their masters. The spiritual has elements, however, that can be traced to African rhythms. In the United States, these traditions were combined with European ones—including Christian hymns—giving birth to a musical form that was unique to African Americans.

Spirituals had different components and purposes. These religious songs sometimes included *ring shouts*—probably derived from African ritual dance—during which participants moved in a circle, clapping and singing or praying spontaneously. The listening selection "Good Lord (Run Old Jeremiah)"

GO LISTEN!
SPIRITUAL

"Good Lord (Run Old Jeremiah)"

speaks of escaping the trials of a life of slavery. It was sung in connection with a West African dance pattern. Participants shuffled in single file, clapping the rhythm.

Many spirituals make reference to Biblical events relevant to slave experiences, such as the Israelites' exodus from Egypt and freedom from their oppressors. "Michael, Row the Boat Ashore" is one such spiritual. Other songs may have contained hidden meaning known only to those who sang them. "Swing Low, Sweet Chariot," for example, may contain veiled references to the Underground Railroad—a secret route to freedom between the South and the North. The listening selection "Go Down Moses" is a spiritual that refers to Exodus 7:16 in the Hebrew Bible, in which God instructs Moses to go before Pharaoh and tell him, "Let my people go." The song predates the U.S. Civil War but was popularized by the deep, resonant voice of Paul

GO LISTEN!
SPIRITUAL

"Go Down Moses"
Paul Robeson

Robeson in the 20th century. The William Faulkner novel, *Go Down, Moses* is named after the song.

The influence of spirituals can be heard in gospel music that originated in the United States in the early 20th century. Both music forms became familiar through recordings, and performances of both could be heard throughout the country and abroad. During the U.S. civil-rights movement in the late 1950s and early 1960s, demonstrators sang spirituals (such as "We Shall Overcome") that would

GO LISTEN!
SPIRITUAL

"We Shall Overcome"

become familiar and universal symbols of protest in the cause of freedom.

QUILTING The WPA slave narratives also revealed stories of African American women who created quilts from scraps of fabric left over from the sewing they did for the plantation households, some of which were sold to white people.

Quilting parties—often large gatherings—were opportunities for storytelling and recollection, for music making, socializing, and more. Harriet Beecher Stowe, the author of the antislavery novel *Uncle Tom's Cabin*, described a quilting bee in a later work:

> ### READING 18.1 HARRIET BEECHER STOWE
>
> *From The Minister's Wooing*
>
> The day was spent in friendly gossip as they rolled and talked and laughed…One might have learned in that instructive assembly how best to keep moths out of blankets; how to make fritters of Indian corn undistinguishable from oysters; how to bring up babies by hand; how to mend a cracked teapot; how to take grease from a brocade; how to reconcile absolute decrees with free will.

One of the finest and most completely preserved quilts, made by the freed slave Harriet Powers, features scenes from biblical stories in which she often juxtaposes cutouts of black and white figures (**Fig. 18.9**). These stories are stitched together with significant events that occurred in the artist's family and community.

▼ **18.9** Harriet Powers, *Bible Quilt*, 1885–1886. Pieced, appliquéd, and printed cotton embroidered with cotton, 75" × 89" (191 × 227 cm). National Museum of American History, Smithsonian Institution, Washington, DC.

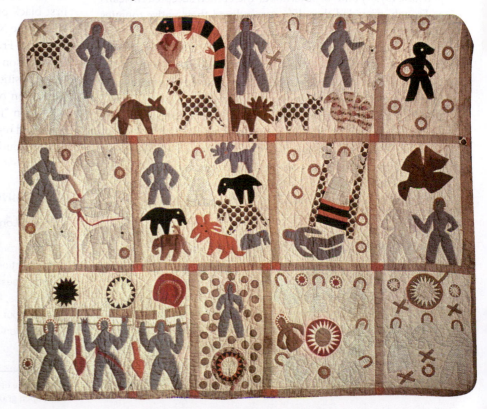

Colonialism

In ancient times, Greeks and Phoenicians established colonies in North Africa, principally along the coast, as they left their congested home cities and sought new trade relationships. Alexander the Great, the Greek king of the state of Macedon, established a major city on the Mediterranean Sea in Egypt called Alexandria, which changed hands among the Greeks, Romans, and Vandals until the Arabs conquered North Africa in the seventh century. From these colonies, Arabs began to penetrate sub-Saharan Africa.

The first modern European expeditions to Africa were launched by the Portuguese in the 15th century, followed by conquest and colonization. Over time, other European rulers, who vied among one another for power by accumulating and colonizing territories, saw Africa as fair game. Belgium took the Belgian Congo, now the Democratic Republic of the Congo. France took Algeria in North Africa and created colonial federations called French West Africa and French Equatorial Africa. The United Kingdom took Kenya, Rhodesia (now Zimbabwe), and eventually South Africa, among other territories, as imperial possessions. Power was one motivating factor in the explosion of European colonization in Africa, but there were others: the desire for exploration and the availability of raw materials for the taking; missionary zeal for the conversion of Africans from traditional religious beliefs to Christianity; a perceived obligation to "civilize" Africans; and lucrative markets for the sale or barter of European goods, most notoriously for African captives who would be enslaved and sent abroad.

European colonists were inconsistent in their policies regarding their African subjects. Ever committed to instilling patriotic loyalty and "brotherhood," the French accepted Africans as French, provided that they surrendered their native tongues and traditions and adopted French language and culture. The British embraced a policy of racial segregation that would lead to **apartheid** in South Africa, instituted in 1948. South Africa became a country of a few million transplanted Europeans and their descendants with disproportionate authority over Africans, who far exceeded them in number. Apartheid continued in some form until multiracial elections were held in 1994.

Alan Paton's 1948 novel *Cry, the Beloved Country* highlights the lives of ordinary South Africans under an oppressive system. The story follows a Zulu parson who searches for his son in the criminal underworld of the big city (Johannesburg):

READING 18.2 ALAN PATON

From *Cry, the Beloved Country*

He is silent, his head aches, he is afraid. There is this railway station to come, this great place with all its tunnels under the ground. The train stops, under a great roof, and there are thousands of people. Steps go down into the earth, and here is the tunnel under the ground. Black people, white people, some going, some coming. So many that the tunnel is full.

He goes carefully that he may not bump anybody, holding tightly on to his bag. He comes out into a great hall, and the stream goes up the steps, and here he is out in the street. The noise is immense. Cars and buses one behind the other, more than he has ever imagined. The stream goes over the street, but remembering Mpanza's son, he is afraid to follow. Lights change from green to red, and back again to green. He has heard that. When it is green, you may go. But when he starts across, a great bus swings along the path. There is some law of it that he does not understand, and he retreats again. He finds himself a place against the wall, he will look as though he is waiting for some purpose. His heart beats like that of a child, there is nothing to do or think to stop it. *Tixo*,[3] watch over me, he says to himself. *Tixo*, watch over me.

A poetic excerpt from chapter 12 addresses the debilitating effects of fear on the individual and on the apartheid South African society.

Cry, the beloved country, for the unborn child that is the inheritor of our fear. Let him not love the earth too deeply. Let him not laugh too gladly when the water runs through his fingers, nor stand too silent when the setting sun makes red the veld[4] with fire. Let him not be too moved when the birds of his land are singing, nor give too much of his heart to a mountain or a valley. For fear will rob him of all if he gives too much.

Nelson Mandela (born 1918) began writing his autobiography, *Long Walk to Freedom* (see Reading 18.3), while he was still in prison for "treason" for his efforts to end apartheid. Released in 1990 (after nearly 30 years), Mandela became the country's first black president in the election of 1994. A year earlier, he shared the Nobel Peace Prize with fellow countryman and state president Frederik Willem de Klerk, who had released Mandela from prison soon after he was elected. De Klerk lifted the ban on opposition political parties and ended apartheid with the institution of the democratic vote. The prize was awarded to both men "for their work for the peaceful termination of the apartheid regime, and for laying the foundations for a new democratic South Africa."

READING 18.3 NELSON MANDELA

From *Long Walk to Freedom*, chapter 1

Apart from life, a strong constitution, and an abiding connection to the Thembu royal house, the only thing my father bestowed upon me at birth was a name, Rolihlahla. In Xhosa, Rolihlahla literally means "pulling the branch of a tree," but its colloquial meaning more accurately would be "troublemaker." I do not believe that names are destiny or

3. The name of the Xosa god, a god of the Zulu.
4. An open grazing area; Dutch for "field."

> that my father somehow divined my future, but in later years, friends and relatives would ascribe to my birth name the many storms I have both caused and weathered. My more familiar English or Christian name was not given to me until my first day of school. But I am getting ahead of myself.

The decolonization of Africa began after World War II pursuant to the Atlantic Charter, which called for the autonomy of imperial territorial possessions. By 1980, Africa consisted of independent African nations. The former British colonies now have one-person-one-vote policies, in effect meaning majority rule.

AFRICAN LITERATURE

Although written African literature prior to the 20th century is scarce, there was a rich tradition of storytelling, often in verse. Much storytelling was passed down orally—in the same way as the Homeric epic poems, *The Iliad* and *The Odyssey*—and a little has been preserved, written down by later generations using either the Arabic or Roman alphabet. Somalia had a rich poetic tradition. Raage Ugaas (18th century), of the Somali Ogaden clan, was popular for his wisdom and piety, whereas another Somali oral poet, Qamaan Bulxan (probably mid-19th century), was well known for his philosophical and reflective verses, some of which have become proverbial expressions.

One area that did develop an earlier written tradition was the coastal region of East Africa, where Swahili (an African language strongly influenced by Arabic) was and remains spoken. Beginning in the 16th century, Muslim traders brought with them to the coastal trading centers didactic and religious verse that was paraphrased in Swahili, with the Swahili version written between the lines of the Arabic text. Over time, poets used this Swahili-Arabic script to compose their own works, either recording traditional songs or creating new ones. Saiyid Abdallah (ca. 1720–1810) was born on the island of Lamu, now part of Kenya. In his long poem *Self-Examination*, he uses the decline of the great Arab trading cities on the East African coast, increasingly overshadowed during Abdallah's time by the new European colonial centers, as a symbol of the inevitability of death.

Léopold Sédar Senghor and Negritude

As African writers began to use the Roman alphabet, they also adopted Western languages, normally the one spoken by their colonial occupiers. The modern state of Senegal, which once formed part of the 11th-century kingdom of Ghana, fell under French rule in 1895. As a young boy, Léopold Sédar Senghor (1906–2001) was sent to a Catholic mission school, where he learned French and Latin. In due course, he won a scholarship to study in Paris, where he became part of a group of talented black writers—some African, some West Indian, and some, including Langston Hughes, American. Angered by racism, particularly in the French colonies, Senghor found strength in his "blackness." Together with two other black writers living in Paris—Aimé Césaire (1913–2008) from Martinique and Léon-Gontran Damas (1912–1978) from French Guiana—Senghor created a literary and aesthetic movement called *Negritude*, articulated as "the sum total of the values of civilization of the black world." Césaire discussed the beginning of Negritude in an address in Geneva, Switzerland, in 1978:

> **READING 18.4 AIMÉ CÉSAIRE**
>
> From an address delivered in Geneva (1978)
>
> When it appeared, the literature of Negritude created a revolution: in the darkness of the great silence, a voice was rising up, with no interpreter, no alteration, and no complacency, a violent and staccato voice, and it said for the first time: "I, Negre."
> A voice of revolt
> A voice of resentment
> No doubt
> But also of fidelity, a voice of freedom, and first and foremost, a voice for retrieved identity.

Negritude as a philosophy reflected traditional African culture and values; as an aesthetic model in the visual arts, it emphasized African personality traits such as sensuality and emotional sensitivity. The literature of Negritude addresses themes of alienation (life as part of an uprooted minority subordinated by a more powerful group), revolt (against injustices of colonial rule), and rediscovery (what Nigerian Africanist Abiola Irele calls "an open and unashamed identification with the continent"). These themes are present in Senghor's foreword to an anthology of writings by the scholar, Leo Frobenius. Senghor refers to his experiences in early 20th-century Paris and how his European professors did not understand that Africans, as well as Europeans, understood what was meant by civilization and its values. Then Senghor expresses his views that while there may be universals in the arts, every "race" also has its own *Paiduma*, or ways of creating meaning:

> **READING 18.5 LÉOPOLD SÉDAR SENGHOR**
>
> From Foreword to *Leo Frobenius (1873–1938): An Anthology*. Wiesbaden, Germany: F. Steiner, 1973.
>
> Had our [African] ancestors left us…the values of civilization? The Father Director of my college…denied that they had left us those. But Louis Armstrong's trumpet had already sounded across the French capital like a judgment, Josephine Baker's

hips were vigorously shaking all its walls…Nevertheless, in our painstaking essays at the Lycée of Louis le Grand and the Sorbonne, where to the astonishment of our teachers we referred to "black values," we lacked not only "vision in depth," but also the basic philosophical explanation.…[Having] completed our studies, we were entering upon active militant life, with the concept and the idea of *Négritude* under our belts.…

For every race possesses its own *Paideuma*, that is its own peculiar capacity for and manner of being moved: of being "possessed." Nevertheless, the artist, whether dancer, sculptor or poet, is not content to relive the Other; he recreates it in order to better live it and make it live. He recreates it by rhythm and thus makes of it a higher, truer reality, one that is more real than the factual reality.

Senghor went on to a political career in Africa, using Negritude as a foundation for an African socialist model that was derived from Marxist communism but at the same time inspired by "black spiritualities." Whatever the lasting value of his aesthetic theories, his influence on 20th-century African history is undeniable. One of his fellow countrymen called him "the myth that is endlessly discussed."

Yet not all African writers viewed Negritude in positive terms. One Senegalese contemporary described it as "mystification" that ignored the class struggle, as elitist, and out of touch with the masses. Younger African critics have attacked the concept of Negritude as a compromise with Neo-Colonialism, a refusal to complete the decolonization of the African mind. The Nigerian writer Wole Soyinka (who in 1986 was the first African to receive the Nobel Prize for Literature) has dismissed Negritude, stating that "tigers do not contemplate their 'tigritude' but just act naturally by pouncing."

African Novelists

THOMAS MOFOLO Other important African writers used their own languages, rather than those of the colonizers. The first African novelist, Thomas Mofolo (ca. 1875–1948), was born in Lesotho, a landlocked kingdom in the middle of South Africa, upon which it has always depended economically. While he was teaching in South Africa and Lesotho, Mofolo's passion for storytelling led friends to encourage him to write. In 1906, he published *The Traveler of the East*, writing in the Sesotho language. The book is considered both the first novel by an African and the first written in an African language. In his early work, Mofolo sought to combine Christian elements with traditional tales and poems.

By the time he came to write his most important and successful novel, *Chaka* (1912), Mofolo used African religion as the overriding influence in his characters' lives. The book describes the career of Zulu King Chaka (ca. 1787–1828), an

actual historical figure who organized the hitherto weak Zulu warriors into a formidable fighting force. The real king was notorious for his cruelty and paranoia. In Mofolo's story, however, he begins as genuinely heroic and courageous. The tragic hero then declines into tyranny and eventual insanity when, in an African version of Faust's pact with the devil, he sells his soul into sorcery. The missionary press that had published Mofolo's earlier books refused to publish *Chaka*, and it did not appear in print until 1925. It became an instant best seller and has been widely translated:

READING 18.6 THOMAS MOFOLO

From Chaka, *chapter 18, "The Killing of the Cowards"*

After Noliwa's death Chaka underwent a frightful change both in his external appearance and also in his inner being, in his very heart; and so did his aims and his deeds. Firstly, the last spark of humanity still remaining in him was utterly and finally extinguished in the terrible darkness of his heart; his ability to distinguish between war and wanton killing or murder vanished without a trace, so that to him all these things were the same, and he regarded them in the same light. Secondly, his human nature died totally and irretrievably, and a beast-like nature took possession of him; because although he had been a cruel person even before this, he had remained a human being, his cruelty but a human weakness. But a man who had spilt the blood of someone like Noliwa [a young woman beloved by Chaka's mother], would understandably regard the blood of his subjects exactly as if it were no different from that of mere animals which we slaughter at will.

CHINUA ACHEBE Chinua Achebe (1930–2013) is one of the most widely read and acclaimed African novelists of the 20th century. He was born in Nigeria to a family that belonged to the Igbo people of eastern Nigeria. When Nigeria became independent in 1960, the country (an artificial creation of the British) became divided. In 1967, the Igbo seceded to form the Republic of Biafra, and Achebe, a passionate supporter of the Igbo, became minister of information in the new state. The Igbo revolt was crushed in 1970, and the central Nigerian government seized control of the breakaway country. Achebe, overwhelmed by the death of many of his closest friends and the defeat of his people, chose to remain in Nigeria under the terms of the general amnesty for the rebels, and the war became a constantly recurring subject in much of his writing.

The central theme of Achebe's work is the conflict between two worlds: Western technology and values and traditional African society. In most of his novels, the chief character is torn by these opposing forces and is often destroyed in the process. His first book, *Things Fall Apart* (1958), forewarns us by its title—a quotation from W. B. Yeats's poem "The Second Coming"—that its story is tragic; the beginning of that poem is ominous:

READING 18.7 W. B. YEATS

"The Second Coming," lines 1–6 (1919)

Turning and turning in the widening gyre[5]
The falcon cannot hear the falconer;
Things fall apart; the centre cannot hold;
Mere anarchy is loosed upon the world,
The blood-dimmed tide is loosed, and everywhere
The ceremony of innocence is drowned.

In Achebe's novel, the British intrude on a traditional Igbo society and undermine the values that have sustained it. Although the disaster is implicit from the beginning, Achebe's cool, laconic prose style somewhat distances the narrator from his tale.

Near the end of the novel, the clan of the black protagonist, Okonkwo, is holding a meeting to discuss how they can fend off the influences of the British. A messenger arrives to inform them that "the white man whose power you know too well has ordered this meeting to stop." Okokwo draws his machete "in a flash" and kills the messenger. His clan trembles with fear, and Okonkwo realizes that he will bring the wrath of the white man down on them. Learning of the killing, the district commissioner arrives at Okonkwo's compound with a band of soldiers to arrest him. Obierika, a village elder, says that Okonkwo is not there. The commissioner turns red in the face and demands that the men produce Okonkwo or they will be arrested themselves. Obierika says, somewhat mysteriously, "We can take you where he is, and perhaps your men will help us."

They find Okonkwo dangling dead from a tree. He has killed himself to avoid arrest or living in a world in which the traditional way of life has been destroyed—the "ceremony of innocence is drowned." Obierika asks whether the commissioner's men will take the body down and bury it. "Why can't you take him down yourselves?" the commissioner asks. Obierika explains that suicide is considered an abomination and that a man who kills himself must be buried by strangers, untouched by his clansmen. At the end of the novel, the commissioner refuses:

READING 18.8 CHINUA ACHEBE

From *Things Fall Apart*, chapter 25

"Take down the body," the Commissioner ordered his chief messenger, "and bring it and all these people to court."

"Yes, sah," the messenger said, saluting.

The Commissioner went away, taking three or four of the soldiers with him. In the many years in which he had toiled to bring civilization to different parts of Africa he had learned a number of things. One of them was that a District Commissioner must never attend to such undignified details as cutting a hanged man from the tree. Such attention would give the natives a poor opinion of him. In the book which he planned to write he would stress that point. As he walked back to the court he thought about that book. Every day brought him some new material. The story of this man who had killed a messenger and hanged himself would make interesting reading. One could almost write a whole chapter on him. Perhaps not a whole chapter but a reasonable paragraph, at any rate. There was so much else to include, and one must be firm in cutting out details. He had already chosen the title of the book, after much thought: *The Pacification of the Primitive Tribes of the Lower Niger.*

In Achebe's next novel, *No Longer at Ease* (1960), conflict becomes internalized. We meet a younger Obi Okonkwo. He has been sent by his community to England for his education, and on his return takes an uneasy position among the corrupt minor British bureaucrats governing local affairs. As the story unfolds, Achebe paints a bitter, if ironic, picture of the colonial ruling classes, the bewilderment of the Africans, and the disastrous effect of both forces on the innocent young man in the middle. Okonkwo's plight is made even more poignant by the impact on him of two powerful aspects of Western culture: Christianity and romantic love.

Achebe wrote his novels in English and, as in the case of Senghor, many of his fellow African writers have reproached him for writing in a colonial language. Achebe has always argued, however, that only Western languages can carry the message to those who most need to hear it. Furthermore, by using European languages, Africans can prove that their work can stand and be acknowledged alongside Western literature. Above all, throughout his long career, Achebe has always believed that the retelling of the African experience is crucial. In one of his novels, an elder says, "It is the story that saves our progeny from blundering like blind beggars into the spikes of the cactus fence. The story is our escort; without it, we are blind."[6]

TRADITIONAL AFRICAN ART IN THE MODERN PERIOD

In order to appreciate traditional African art, it is necessary to bear in mind its cultural context. Unlike most modern Western artists, African artists generally have not produced works as aesthetic objects to be viewed for pleasure but, rather, to fulfill a precise function in society and religion. Until the commercialization of recent times, the notion of a museum or gallery was alien to African art. Also, far from following Western ideas of

5. A rotating system of motion or currents.

6. Chinua Achebe, *Anthills of the Savannah* (New York: Anchor Books/Doubleday, 1988).

inspiration or progress, African art is firmly rooted in tradition. The identity of the individual creator is far less important than the authenticity of the object, and as a result, we know the names of very few African artists. Whether it exalts the secular power of rulers or the force of the spirit world—and often the two overlap—a sculpture or mask must evoke age-old memories and associations. At the same time, African artists are as open to the influences of changing times and the world around them as are Western or Asian artists.

The conflict between Achebe's Igbo tradition and the newly arrived Western forces, which leads to tragedy in his novels, is made visible in a pair of wooden figures produced by an Igbo artist to crown a dancer's headdress (**Fig. 18.10**). The male figure, which wears a European-style hat, is a slave trader, while the woman, bound to him with rope, is his captive.

The same conflict of influences can be seen in the customs of the Dogon people of the modern state of Mali. The coming of Islam to Africa produced a conflict between the strict Islamic ban on music, dancing, and the carving of realistic images, whether of humans or animals, and traditional African art, music, and dance. The Dogons reject the principles of Islam, and dance continues to play a central role in their

▲ **18.11** A ritual dance mask representing a monkey, Dogon culture, ca. 1975–1995. Mali.

▼ **18.10** Headdress, Igbo culture. Nigeria, 1900s. Wood carving. American Museum of Natural History, New York, New York. Worn by a dancer in a ritual, this headdress shows a slave trader, wearing a European hat, with his captive woman.

culture, marking religious events, honoring ancestors, welcoming the rainy season, and, most importantly, accompanying funerals. On all these occasions, masks play an important role in the ceremonies. As the Dogon philosopher Ogotemmêli has said, "Masked dancers are the world, and when they dance in a public place, they are dancing the process of the world and the world order."[7] At funerals, the dancers wear masks representing animals, as they usher the dead from village life back to the bush, thereby restoring that natural world order (**Fig. 18.11**).

Many traditional African works of art are used in customs that celebrate the transitions of life and rites of passage. When a young man of the Maasai undergoes circumcision, he and his

7. Marcel Griaule, *Conversations with Ogotemmêli: An Introduction to Dogon Religious Ideas* (London, England: Oxford University Press, 1965).

▲ **18.13** Ceremonial costume for the Egungun masquerade ritual, Yoruba culture, 1900s. Benin. Mixed media, 68" (172.7 cm) long. Indianapolis Museum of Art, Indianapolis, Indiana. Representing the collective spirit of ancestors, the Egungun costume uses velvet, cotton, and wool, decorated with a mixture of sequins, beads, metallic threads, and cowrie shells.

▲ **18.12 The bird headdress of a young Maasai warrior, 2006. Tanzania.** Note the designs painted on his face as well the multicolored headdress that marks his recent rite of passage.

friends construct a special bird headdress to mark the occasion (**Fig. 18.12**). They hunt down a variety of birds—kingfishers, orioles, lovebirds, and others—clean them out, and stuff them with a mixture of ashes and dried grass. The birds, which may be as many as 40 in number, are then attached to a large horseshoe-shaped crown, which the young man proudly wears at ceremonies and public occasions until the healing process is completed.

Other rituals require different forms of ceremonial dress. The Yoruba Egungun masquerade ceremony is performed in long elaborate costumes that cover the performer from head to foot (**Fig. 18.13**). They often involve a variety of fabrics, which are then decorated with sequins, beads, and other materials, using traditional patterns.

The beadwork evident in headdresses similar to the crown that is worn by the royal Yoruba ruler in **Figure 18.14** is created by a guild of artisans who pass their techniques down from

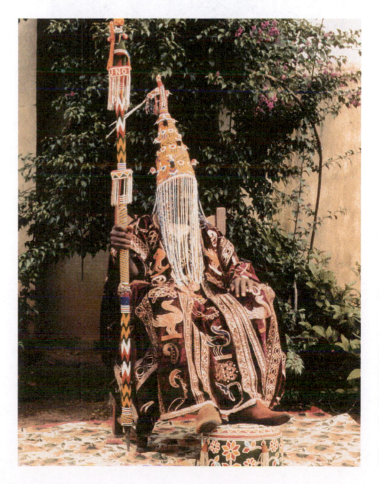

▶ **18.14 The Ruler of Orangun-Ila, Airowayoye I, with a beaded scepter, crown, veil, and footstool (1977). Nigeria.**

COMPARE + CONTRAST

Out of Africa: The Enduring Legacy of the Ceremonial Mask

asks of myriad designs and materials play an essential role in the rituals of the traditional peoples of sub-Saharan and West Africa. They typically have religious or spiritual meanings and are the focal piece of masquerades—ceremonial dances performed for events ranging from funerals and initiation rites to social gatherings and entertainment. Mask makers have special status in these societies, and their craft is usually passed down from father to son over the generations.

In the early 20th century, the mask became the quintessential object associated with traditional African culture and was widely collected by European artists, writers, and the intellectual elite (**Fig. 18.15**). Drawn to the simplicity, the directness of expression, the rustic carving, and the inherent power of the primitive forms—untouched and unmediated by the West—young modern artists such as Pablo Picasso and Henri Matisse incorporated aspects of African masks and other objects in their own paintings and sculpture. In his *Head of a Sleeping Woman* (**Fig. 18.16**),

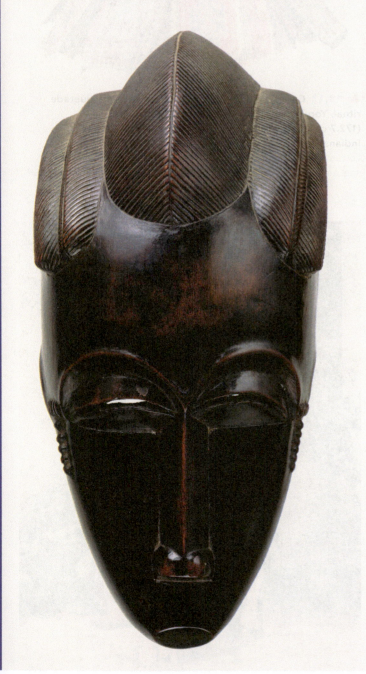

◀ **18.15 Portrait Mask (Gba gba), before 1913. Côte d'Ivoire. Wood, 10¼" × 4⅞" × 4⅛" (26 × 12.4 × 10.5 cm). Metropolitan Museum of Art, New York, New York.** This mask was used as part of a theatrical tradition that combines dance and dramatic skits. As a portrait mask, it is an idealized version of the face of a prominent member of the community, by whom it was commissioned. Only the best dancers were permitted to wear such masks.

▼ **18.16 Pablo Picasso, *Head of a Sleeping Woman (Study for Nude with Drapery)*, 1907. Oil on canvas, 24¼" × 18¾" (61.4 × 47.6). Museum of Modern Art, New York, New York.**

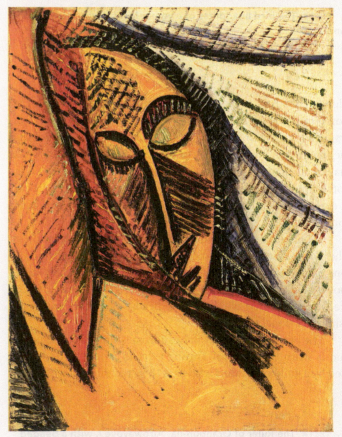

◀ **18.17** Faith Ringgold, *Mrs. Jones and Family*, 1973. Mixed media (embroidery and sewn fabric), 74" × 69" (187.96 × 175.26 cm). Artist's Collection.

▼ **18.18** Willie Cole, *Shine*, 2007. Shoes, steel wire, monofilament line, washers, and screws. 15¾" × 14" × 15" (40 × 35.6 × 38.1 cm). Metropolitan Museum of Art, New York, New York.

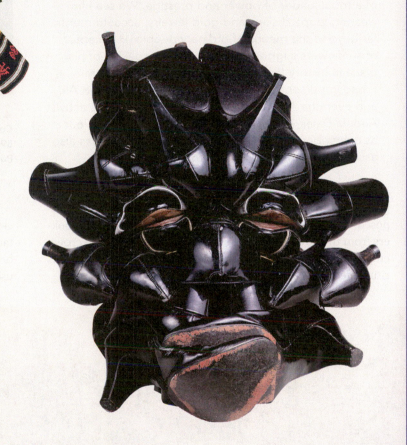

Picasso mimicked the geometric rhythms and simplified features of African objects. He would return to these forms—which he first saw in an exhibition in Paris—throughout his long career.

Contemporary African American artists Faith Ringgold and Willie Cole have also referenced masks in many of their works. Ringgold's *Mrs Jones and Family* (**Fig. 18.17**) is constructed of stitched fabric of kente-cloth patterns with embroidered details. The wedge-shaped noses and open mouths on the heads of the soft-sculpture dolls evoke common features of African masks. In combination, these elements connect the artist to both her African heritage and artistic traditions—like needlework and quilting—among enslaved African women.

Willie Cole has created masklike sculptures from women's high-heeled shoes that, while captivating in their cleverness, are stocked with multiple references that elicit conflicting emotions. His mask called *Shine* (**Fig. 18.18**) has positive and negative associations. The use of the word *shine* as a derogatory expression for African Americans originated in the early 20th century, perhaps in reference to shoe shining or polishing, which was a common way for urban black men and boys to earn money. At the same time, the word connotes radiance, and indeed, the positioning of the shoes with the heels aimed outward from the central core of the mask can read as rays emanating from a spiritual object. Cole has said, "I want the [masks] to be links between worlds,…art that looks like it is from another culture and another time, even though the materials in the work are strictly American."[8]

8. Willie Cole, *Shine*. The Metropolitan Museum of Art. http://www.metmuseum.org/art/collection/search/495572

CONNECTIONS Samuel Fosso (b. 1962), of the Central African Republic, began his career as a photographer by taking self-portraits that later morphed into impersonations with sociopolitical messages. For example, some of the most violent slave-runners were Africans themselves who plundered the villages of tribes to capture their victims. In the same way, a number of African chieftains sold their land and slaves to colonialists. In **Figure 18.19**, we see Fosso in the garb of such a chieftain (see Fig. 18.14), adopting the typical pose of a tribal leader of power and prestige. We see him wearing leopard skins and gold jewelry, accouterments far beyond the means of ordinary people. His scepter of sunflowers suggests the ruler's bold seeking of his place in history (and the tribe). In other self-portraits, Fosso impersonated Nelson Mandela, Muhammad Ali, and even the African American female civil rights activist Angela Davis, who achieved prominence in the 1960s as a member of the Communist Party USA and was also associated with the Black Panther Party.

▲ **18.19** Samuel Fosso, *The Chief: He Who Sold Africa to the Colonists,* from *Self-Portraits I–IV* (1997). C-print photograph, 39¾" × 39¾". Musee National d'Art Moderne, Centre Georges Pompidou, Paris, France.

generation to generation. In the ruler's costume, a veil composed of strands of beads covers the face, protecting onlookers from the power of the ruler's eyes. The height of the crown emphasizes the head as the center of power and often contains ritual medicines and potions to enhance that power.

Masks, headdresses, and costumes all serve as important elements in perhaps the most important of all artistic manifestations in Africa: the performance art of dance. Often religious or ceremonial, African dance is an integral part of cultural life, used to mark all important occasions.

◀ **18.20** El Anatsui, *Between Earth and Heaven,* 2006. Nigeria. Aluminum, copper wire, 86¾" × 128" (220.3 × 325.1 cm). Metropolitan Museum of Art, New York, New York. El Anatsui's wall hangings are reminiscent of Ghanaian works made of traditional kente cloth, even though El Anatsui assembles his wall hangings from caps of liquor bottles.

THE IMPACT OF WESTERN CULTURE ON CONTEMPORARY AFRICAN ART

Contemporary African artists often work with traditional techniques and art forms or combine them with Western references. These hybrid works correspond to the melding of cultures—for better or for worse—that occurred in Africa as a result of European and Arab colonization and continues to factor into African life today.

El Anatsui lives and works in Nigeria, but he was born in Ghana, where kente cloth—a silk and cotton textile made of colorful, interwoven strips—originated. This sacred cloth is most certainly the inspiration for his many wall hangings, but rather than weaving pieces of fabric, Anatsui recycles the aluminum wrappings of liquor-bottle caps and other packaging and assembles it all into a facsimile of cloth using copper wire (**Fig. 18.20**). The wall hangings are immense, evoking tapestries and mosaic murals as well. At the same time, they serve as a sociopolitical and economic commentary on globalization.

So, too, does **Figure 18.21**, a satirical riff on traditional African ceremonial masks from the "jerry can" series by Romuald Hazoumé. In this series of assemblages, Hazoumé is calling attention to the worldwide shortage of gasoline, the exploitation of Africa's resources, and the economic enslavement of Africans who are forced to ferry the fuel. Assemblages such

▲ **18.22** Wangechi Mutu, *Mask*, 2006. Mixed-media collage.

▲ **18.21** Romuald Hazoumé, *Bagdad City*, 1992. Brush, speakers, and plastic can. Geneva, Switzerland.

as these begin with what early 20th-century European artists called ready-mades—objects there for the taking which, with little to no manipulation, would take on a character that negated their original purpose. Like Anatsui, Hazoumé calls attention to the effects of global encounters on cultural traditions through the use of **ephemera**.

Many of the works of Kenyan artist Wangechi Mutu are also examples of **hybridity**. She juxtaposes contemporary print models and African objects in politically charged collages that feature women's bodies surrounded by rich, explosive colors, animal prints, botanical elements, and abstract patterns that evoke traditional textiles. In *Mask* (**Fig. 18.22**), the model becomes an exotic temptress who invokes the sexualized stereotype of the dominatrix and overturns the traditional male–female power relationship. Mutu shares Nobel laureate Wangari Muta Maathai's concerns about the place—and well-being—of women in patriarchal societies. Many of Mutu's works illustrate twisted female anatomy and conditions of deterioration that draw attention to what she describes as the sexualization and neglect of African women by oppressive men. Underneath the stereotype, women are suffering, and Mutu wants her viewers to challenge their assumptions about race, gender, and beauty.

AFRICAN MUSIC

Africa is a varied continent with different musical traditions. The music of North Africa is closely related to Islamic or Arabian music (see Chapter 8). There are a number of traditions in music in sub-Saharan Africa, but they are similar in rhythmic principles. Many of them use a cross-beat or **cross-rhythm**, in which the pattern of accents of a measure of music is contradicted by the pattern in a subsequent meter. Familiar modern examples with cross-beats include "Carol of the Bells" and Radiohead's "Myxomatosis." **Vocal harmony**, in which consonant notes are sung along with the main melody, is another characteristic of African music. (Vocal harmony is also used in European choral music and opera.) Vocal harmony is frequently used in contemporary music, by backup singers whose pitches must be in harmony with those of the lead singer.

Some instruments, such as the iron bell, are found throughout sub-Saharan Africa. Some peoples use a drum similar to those used in Arabia, and stringed instruments. One is a lute similar to a banjo. Another is a single-stringed instrument played with a bow. Xylophones of various kinds are used in some regions. Xylophones are percussion instruments (as are drums) made of wood bars that are struck by hammer-like sticks or mallets. Each bar sounds a different note when struck. The **kora** is a 21-stringed instrument, with 11 played by one hand and 10 by the other (**Fig. 18.23**). Instruments are usually accompanied by singing.

Music is used for initiations, coronations, weddings, funerals, hunting, working, other social functions, and just pleasure.

GLOSSARY

Animism (p. 604) A belief in spiritual beings; a belief that natural objects (such as plants, animals, or the sun) or natural events (such as wind, thunder, and rain) possess spiritual qualities or spiritual beings.

Apartheid (p. 612) In South Africa, the rigid former policy of segregation of the white and nonwhite populations.

Colonialism (p. 608) A political system in which one nation has control or governing influence over another nation; also known as *imperialism*.

Cross-rhythm (p. 622) A traditional African musical method in which the pattern of accents of a measure of music is contradicted by the pattern in a subsequent measure; also termed *cross-beat*.

Ephemera (p. 621) Items not of lasting significance that are meant to be discarded.

Gikuyu (p. 610) In Kikuyu beliefs, the male primordial parent; the father of the Kikuyu people.

Hybridity (p. 621) A cross between two separate races or cultures.

Indentured servant (p. 609) A person who is placed under a contract to work for another person for a period of time, often in exchange for travel expenses or an apprenticeship.

Kora (p. 622) A traditional African string instrument that is plucked; 11 strings are plucked by one hand, and 10 strings by the other hand.

Mumbi (p. 610) In Kikuyu beliefs, the female primordial parent; the mother of the Kikuyu people.

Slavery (p. 608) A social system or practice in which one person is the property of, and wholly subject to the will of, another person.

Vocal harmony (p. 622) A traditional musical method in which consonant notes are sung along with the main melody.

▲ **18.23** A kora, a stringed instrument that is plucked by both hands (1960). Gourd, goat skin, antelope-hide metal, wood. L: 45 9⁄16"; W: 20 11⁄16"; Diam. 10 7⁄8". Mandinka people, Senegambia, Senegal.

THE BIG PICTURE THE PEOPLES AND CULTURES OF AFRICA

Language and Literature

— Prior to the 20th century, most African storytelling was done by word of mouth.

— About 1500 CE, Islamic religious verse was translated into Swahili; the Swahili-Arabic script became a new poetic tradition.

— Saiyid Abdallah (Somalia, ca. 1720–1810) wrote *Self-Examination*, a long poem using the decline of great Arab trading cities on the East African coast as a symbol of the inevitability of death.

— Oral poet Raage Ugaas (Somalia) became popular for his wisdom and piety.

— In 1906, Thomas Mofolo (Lesotho, ca. 1875–1948) wrote *Traveler of the East* in his native Sesotho language, becoming the first African novelist. In 1912, Mofolo wrote *Chaka*, his most celebrated book, but the missionary-run press that published his previous works refused to publish it.

— In 1929, poet Léopold Sédar Senghor (Senegal, 1906–1989), writing in French, created a literary movement known as Negritude that celebrated the unique traditions of African art.

— Alan Paton wrote *Cry, the Beloved Country* in 1948.

— Chinua Achebe (Nigeria) published his first novel, *Things Fall Apart*, in English in 1958. He published *No Longer at Ease* in 1960.

— In 1986, Wole Soyinka (Nigeria) became the first African to receive a Nobel Prize for Literature.

Art, Architecture, and Music

— Neolithic rock paintings and objects such as arrowheads were found throughout North Africa.

— Between 1000–1300, Bantu-speaking ancestors of the Shona erected Great Zimbabwe, with huge stone buildings surrounded by massive walls.

— Ca. 1200–1400, the people of Great Zimbabwe created soapstone carvings.

— Ca. 1300–1500, Benin artists (in modern-day Nigeria) created sculptures honoring their rulers and ancestors; Yoruba culture created ceremonial costumes for masquerades honoring Egungun (collective spirit of ancestors).

— The Great Mosque at Djenné was first built in the 14th century but took its present form in the early 20th century.

— In the 1700s, the Dogon people (modern-day Mali) created masks for ceremony and dance.

— In the early 1900s, African artworks began to influence Western artists, such as Picasso.

— Contemporary African art continued to examine the conflict between traditional cultures and the West. Traditional art forms and rituals involving masks and headdresses continued to play a crucial role in African communities.

— Contemporary African and African American artists showed bidirectional influences.

Philosophy and Religion

— Native African religions were largely animistic.

— Arabs brought Islam to North Africa beginning in the seventh century.

— Europeans brought Christianity to West, Central, and Southern Africa beginning in about the 16th century.

— Ca. 1805, Qamaan Bulxan (Somalia) became well known for his philosophical and reflective verses, some of which have become proverbial expressions.

The Eighteenth Century

PREVIEW

Jacques-Louis David—by any art historical account—was a giant of 18th-century art. He was a pillar of the Neo-Classical style of painting in France. He was a recipient of the *Prix de Rome*—the coveted study-abroad scholarship for promising art students funded by the French monarchy. He had royal patrons. His paintings, inspired by themes from antiquity, were visual manifestations of the lofty ideals of the Enlightenment era: selflessness, courage, morality, and pure reason. Yet, as we look into his eyes in a self-portrait from 1794 (**Fig. 19.1**), we might wonder: who was David the man?

▶ **19.1** Jacques-Louis David, *Self-Portrait*, 1794. Oil on canvas, 31⅞" × 25¼" (81 × 64 cm). Musée du Louvre, Paris, France.

David was a Jacobin—a member of a fairly exclusive political club of mostly well-off men who supported individual and collective rights for the citizens of France—and a rabid supporter of the revolution against the monarchy. As a member of the Committee of Public Safety of the National Convention, the first postrevolution government assembly, David cast a vote for the death by guillotine of King Louis XVI. In the bloody years that followed, David participated in the Reign of Terror, spearheaded by his friend Maximilien de Robespierre. Tens of thousands of so-called enemies of the revolution were executed, more than 16,000 by guillotines erected throughout the country; David himself may have signed execution orders for more than 300 people. When Robespierre fell from power and was sentenced to death, David was arrested. He painted this portrait from his "prison cell" in the Luxembourg Palace—looking in a mirror but idealizing himself nonetheless.

On October 16, 1793, David had sketched Marie-Antoinette, the deposed queen of France, as she was led to her execution. David himself might have gone to the guillotine if not for the ironic intervention of his ex-wife, a supporter of the monarchy, who divorced him after he voted for Louis's execution. They remarried in 1796. David was the ultimate survivor, and for him, fate continued to twist and turn.

One of the nobles for whom David signed a death warrant was the husband of the woman who would become the wife of Napoléon Bonaparte—Joséphine. After Napoléon crowned himself emperor in 1804, David became *his* official court painter. Ten years later, after Napoléon had conquered much of Europe, his enemies led campaigns against him that would lead to his abdication of the throne and the restoration of the monarchy under Louis XVIII. The new king wanted the services of David, too. Even though the painter had been a revolutionary, a regicide, and a Bonapartist, Louis pardoned him and offered him the position of court painter. This time, David said no. He left France for Belgium, where he lived, worked, and taught until he was run over by a carriage and died from his injuries.

Like other artists, architects, writers, musicians, and philosophers of his day, Jacques-Louis David espoused the rejection of the ideologies of church and state that they believed fostered superstition and maintained the status quo of social inequity. He believed, as did his contemporaries at the forefront of the movement called the **Enlightenment**, that *reason* would unseat age-old, repressive traditions and lead to scientific knowledge and societal reforms.

A CENTURY OF REVOLUTIONS

The 18th century was one of pervasive resentment of, and dissatisfaction with, establishment rule and social conditions—particularly in urban centers with large populations. By the closing decades of the century, the desire for reform had grown into an irrepressible demand for change—if necessary, by violent means—leading to both the American and French Revolutions. The 18th century may have opened with Louis XIV still strutting down the Hall of Mirrors at the Palace of Versailles, but his death in 1715 marked the beginning of the end of absolute monarchy.

Although most of Europe continued to be ruled by hereditary monarchs, the former emphasis on splendor and privilege was leavened with a new concern for the welfare of the ordinary citizen. Rulers such as King Frederick the Great of Prussia (ruled 1740–1786) and Empress Catherine the Great of Russia (ruled 1762–1796) were no less determined than their predecessors to retain all power in their own hands, but they no longer thought of their kingdoms as private possessions to be manipulated for personal pleasure. Instead, they regarded them as trusts, which required them to show a sense of duty and responsibility. They built new roads, drained marshes, and reorganized legal and bureaucratic systems. In reflecting their greater concern for the welfare of their people, these new, more liberal monarchs, often known as "enlightened despots," undoubtedly braked the growing demands for change—for a while. Inevitably, however, by drawing attention to the injustices of the past, they stimulated an appetite for reform that they were in no position to satisfy. Furthermore, for all their claims—Frederick the Great, for example, described himself as "first servant of the state"—their regimes remained essentially autocratic. These enlightened despots, however, brought Enlightenment philosophers, scientists, writers, artists, and intellectuals into their royal circle and supported their endeavors.

In some countries in the second half of the 18th century, a conscious engagement with social issues cut across political hierarchies. Yet this concern was not universal; France remained under the control of aristocratic rulers until the French Revolution in 1789. The French kings and their courts insulated themselves from the widespread discontent of the citizenry in what amounted to a fantasy world of denial, pleasure, and escape from social unrest. This "fairy tale" lifestyle was satirized by composers, writers, and artists: for example, Wolfgang Amadeus Mozart's **opera** *The Marriage of Figaro* (premiered in 1786) is a spoof on the aristocracy, and William Hogarth's series of paintings *Marriage à la Mode* (1743–1745) satirized the marital ethics of the British upper class.

The Eighteenth Century

1700 CE	1774 CE	1783 CE	1814 CE
The rise of Russia and Prussia	Reign of Louis XVI and Marie-Antoinette	The French Revolution begins; the Declaration of the Rights of Man is promulgated	Napoléon rules France as consul
Excavation of Herculaneum begins	Americans declare independence from Britain	Wollstonecraft writes *A Vindication of the Rights of Women*	Napoléon crowns himself emperor
Death of Louis XIV	Adam Smith publishes *The Wealth of Nations*	Execution of Louis XVI and Marie-Antoinette	Napoléon rules France as emperor
Reign of Louis XV	The American Revolutionary War	The French Reign of Terror	
Reign of King Frederick the Great of Prussia		Execution of Robespierre	
Excavation of Pompeii begins			
Reign of Catherine the Great of Russia			

ROCOCO

CULTURE AND SOCIETY

European Rulers in the Eighteenth Century

Enlightened Despots

Frederick II of Prussia	1740–1786*
Catherine the Great of Russia	1762–1796
Gustav III of Sweden	1771–1792
Charles III of Spain	1759–1788
Joseph II of Austria	1780–1790

Rulers Bound by Parliamentary Government**

George I of the United Kingdom	1714–1727
George II of the United Kingdom	1727–1760
George III of the United Kingdom	1760–1820

Aristocratic Rulers

Louis XV of France	1715–1774
Louis XVI of France	1774–1792

* All dates are those of reigns.
** British political life was dominated not by the kings but by two powerful prime ministers, Robert Walpole and William Pitt, the Elder.

THE VISUAL ARTS IN THE EIGHTEENTH CENTURY

At the beginning of the century, two divergent styles of art competed for influence in France's Royal Academy of Painting and Sculpture, which was established during the reign of Louis XIV. The king had a taste for the Classical, and as we saw in Chapter 15, artists such as Nicolas Poussin gravitated toward Classical themes and subjects and focused on form in their compositions. Some of the leading artists in the French academy continued along the classical model, with Poussin as their inspiration. Others, by contrast, emphasized color, harking back to Peter Paul Rubens as a model. These conflicting approaches led to a categorization of artists as Poussinistes and Rubenists. The colorists—the Rubenists—were also characterized by vigorous, textural brushstrokes, whereas the Poussinistes created surfaces with a smooth, mirrorlike finish. In the early part of the 18th century, the colorists were on top; their style is called **Rococo**.

ROCOCO

Despite the changing social climate, most 18th-century artists still depended on aristocratic patronage; but tastes had changed, and so had the messages that monarchs wished to communicate through the works they commissioned. The desire to portray grandeur, glory, and, pomp—connected to absolute monarchy and captured so convincingly by the Baroque style—had faded. Enlightened despots liked beautiful things, but they had qualms about surrounding themselves with symbols of unchecked power.

The Rococo style developed to meet these less grandiose tastes and first reached maturity in France. The name *Rococo* is derived from the French *rocaille*, the elaborate encrustation of rocks and shells that often adorned grottoes of Baroque gardens. In its lightness and delicacy, Rococo art was conceived of as anti-Baroque, a contrast to the weighty grandeur and flamboyant, dramatic effects of 17th-century art. It might be said that, whereas Baroque artists preached to their audiences, Rococo artists engaged them in civilized and lighthearted conversation. Among the wealthy and highborn, the 18th century was an age of polite society, a time of letter writing, chamber music, dancing, and intimate liaisons. Having abandoned the formality of court life at Versailles, many nobles moved back to Paris and lived in elegant urban châteaus refurbished in the latest fashion.

The Rococo style was, for the most part, aimed at aristocratic audiences; its grace and charm shielded them psychologically from the burgeoning stresses of the real world. The elegant picnics, the graceful lovers, the triumphant Venuses represent an almost frighteningly unrealistic view of life, and one that met with disapproval from Enlightenment thinkers who sought to promote social change. Yet even the sternest moralist can hardly fail to respond to the enticing fantasy world of the best of Rococo art. The knowledge that the whole Rococo world was soon to be swept away imparts an unintentional poignancy to its art. The existence of all those fragile ladies and their refined suitors was to be cut short by the guillotine.

Rococo Painting

With its delicate embellishments such as scrolls, ribbons, and gold-gilt leaves—and, in painting, a pastel-hued palette—the overall impression of Rococo art is one of lightness and gaiety. The subject matter seems frivolous and often features romantic dalliances and the pursuit of pleasure.

JEAN-ANTOINE WATTEAU The first and probably most exemplary French Rococo painter, Jean-Antoine Watteau (1684–1721), seems to have felt instinctively the transitory and impermanent world he depicted. Watteau is best known for his paintings of *fêtes galantes* (elegant outdoor festivals attended by courtly figures dressed in the height of fashion). Yet the charming scenes are sometimes touched with a mood of nostalgia that can verge on melancholy. In *Return from Cythera* (see **Fig. 19.2** on p. 628), for instance, handsome young

▲ **19.2** Jean-Antoine Watteau, *Return from Cythera*, 1717. Oil on canvas, 51" × 76½" (130 × 194 cm). Musée du Louvre, Paris, France. One ancient Greek tradition claimed the isle of Cythera as the birthplace of Aphrodite (Venus), goddess of love. Thus the island became symbolic of ideal, tender love. Note that the mood of nostalgia and farewell is conveyed not only by the autumnal colors but also by the late-afternoon light that washes over the scene.

couples in silken fabrics return home from a visit to Cythera, the island sacred to Venus and to love. A few gaze wistfully over their shoulders at the idyllic setting they leave behind. Watteau's colorful palette and feathery brushstrokes, along with flourishes of thick paint that create the illusion of folds in lush, shimmery fabric, correspond in feeling to the sensuality of his subject.

JEAN-HONORÉ FRAGONARD Jean Honoré Fragonard (1732–1806), the last of the great French Rococo painters, lived long enough to see all demand for Rococo art disappear with the coming of the French Revolution. Fragonard often used landscape to accentuate an erotic or romantic mood. His painting *The Happy Accidents of the Swing* (**Fig. 19.3**) is a prime example of the aims and accomplishments of the Rococo artist. In the midst of a lush green park, whose opulent foliage was no doubt inspired by the Baroque, we are offered a glimpse of the

love games of the leisure class. A young, though not so innocent maiden, with petticoats billowing beneath her sumptuous pink dress, is being swung by an unsuspecting chaperone high over the head of her reclining gentleman friend, who seems delighted with the view. The subjects' diminutive forms and rosy cheeks make them doll-like, an image reinforced by the idyllic setting. This is 18th-century life at its finest—pampered by subtle hues, embraced by lush textures, and bathed by the softest of lights. Unfortunately, this is also life at its most clueless. As the ruling class continued to ignore the needs of the common people, the latter were preparing to rebel.

The end of Fragonard's career is a reminder of the ways in which artists are affected by social developments. When his aristocratic patrons died or fled France during the Revolution, Fragonard was reduced to poverty. It was perhaps because Fragonard supported the ideals of the Revolution, despite the fact

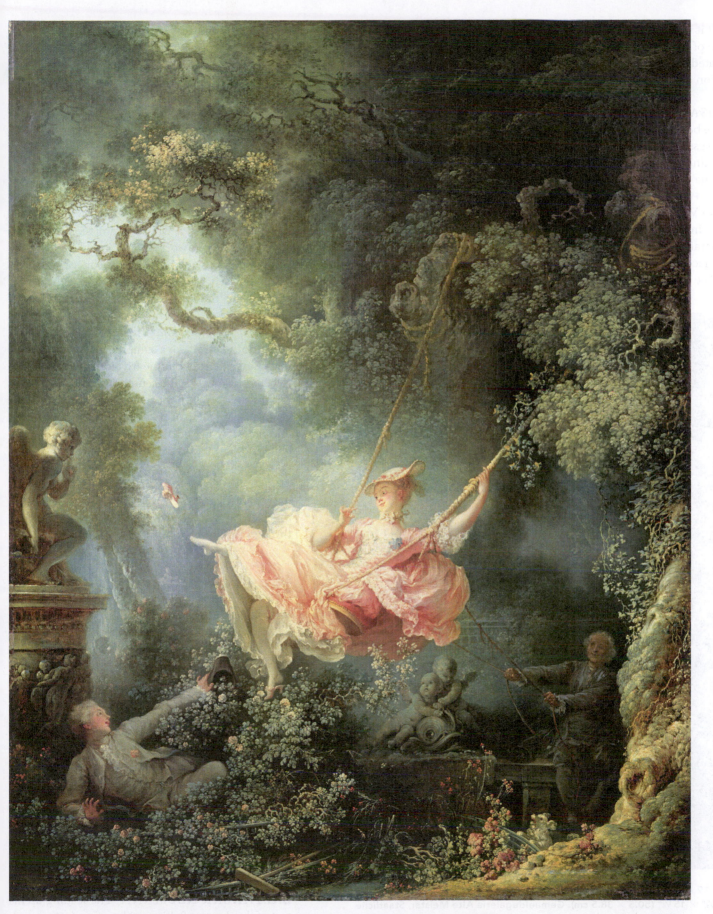

▲ **19.3** Jean-Honoré Fragonard, *The Happy Accidents of the Swing*, 1767. Oil on canvas, 31 7/8" × 25 3/8" (81.8 × 64.8 cm). The Wallace Collection, London, United Kingdom. The landscape is lush and all-encompassing, clearly symbolizing fecundity.

that it would eliminate his patronage, that Jacques-Louis David, one of the Revolution's chief artistic arbiters, found him a job related to art. Even so, the last representative of the Rococo tradition died in obscurity.

ROSALBA CARRIERA Fragonard's ill fortune could not have been further removed from Rosalba Carriera's (1675–1757) success. Born in Venice and trained as a lace maker and painter of miniature ivory portraits, Carriera first came to Paris in 1720. In the same year, she painted a portrait of Louis XV as a boy (**Fig. 19.4**). Louis, who became king at the age of five, was moved from Versailles to the Tuileries Palace in Paris until his coronation in 1722, at the age of twelve; Carriera painted this small portrait just two years before that date. The arresting detail of the face, contrasted with a freer handling of the materials in the jacket and lace cravat, illustrated her virtuosity in an unusual

medium—colored chalk. She was unparalleled in the technique, and her achievement was recognized by a grant of membership in the French Academy. Carriera traveled widely throughout Europe, where her portraits were in high demand and where she counted kings and aristocrats among her patrons. Hers was a talent to find the "sweet spot" between the portrait likeness and some degree of flattery that captured sitters as the best possible versions of themselves.

GIOVANNI BATTISTA TIEPOLO Carriera's Venetian contemporary Giovanni Battista Tiepolo (1696–1770) shared with her a remarkable sense of how to use color to create luminous effects. But unlike Carriera, whose commissions consisted of life-size portraits, Tiepolo worked on a grand scale. Many of Tiepolo's most ambitious and best-known works are decorations for the ceilings of churches and palaces, such as his fresco painting for the Ca' Rezzonico palazzo in Venice, painted in 1757–1758. The *Allegory of Merit Accompanied by Nobility and Virtue* (**Fig. 19.5**) seems quite a lofty subject for a sumptuous Rococo interior that speaks more about the frivolous lifestyles of the rich and famous in 18th-century Italy than any aspirations they might have for such ideals. The entire ceiling seems to open up to reveal a vast, blue, and luminous sky in which beautiful creatures dip and glide and hover around the throne of Merit, buoyed by billowy clouds. The palace was the residence of a wealthy family of Italian merchants who may have wanted to suggest to their guests (or convince themselves) that all this luxury was made possible through earnest accomplishment.

Rococo Architecture

Rococo architecture was principally concerned with delighting the eye rather than inspiring noble sentiments. One region of Europe in which the Rococo style exerted a powerful influence on religious architecture was southern Germany and Austria. Throughout the 17th century, a series of wars in that area had discouraged the construction of new churches or public buildings; with the return of relatively stable conditions in the German states, new building again became possible. By one of those fortunate chances in the history of the arts, the fantasy and complexity of the Rococo style provided a perfect complement to the new mood of exuberance. The result is a series of churches that is among the happiest of all Rococo achievements.

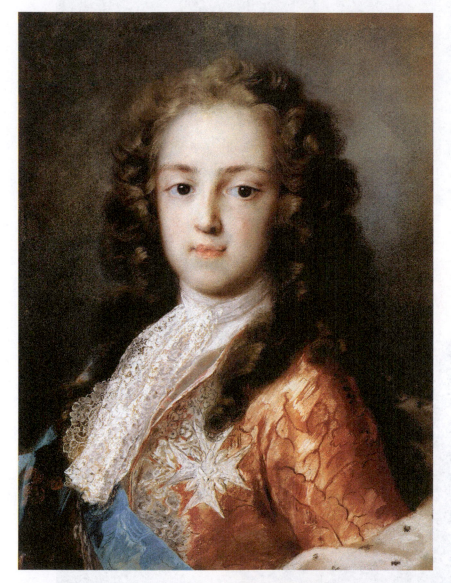

▲ **19.4** Rosalba Carriera, *Louis XV as a Boy*, 1720. Pastel on paper, 19⅞" × 15⅛" (50.5 × 38.5 cm). Gemaeldegalerie Alte Meister, Staatliche Kunstsammlungen, Dresden, Germany. The pale elegance of the subject is typical of most of Carriera's aristocratic sitters. The delicate colors of the pastels reproduce the tones of his skin.

BALTHASAR NEUMANN The leading architect of the day was Balthasar Neumann (1687–1753), who had begun his career as an engineer and artillery officer. Among the many palaces and churches

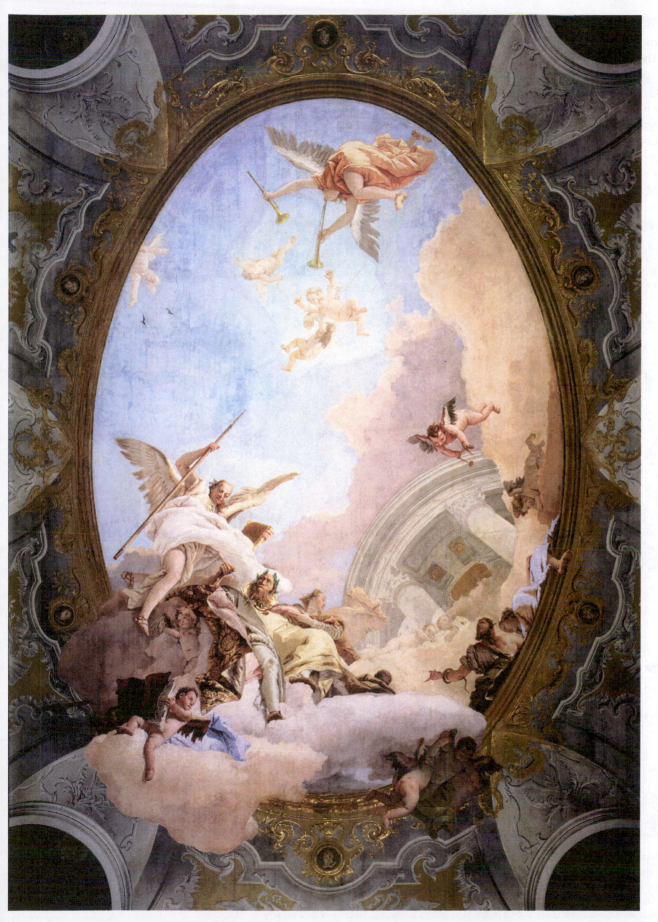

▲ **19.5** Giovanni Battista Tiepolo, *Allegory of Merit Accompanied by Nobility and Virtue*, 1757–1758. Fresco, 32' 10" × 20' 8" (10 × 6 m). Museo del Settecento Veneziano, Ca' Rezzonico, Venice, Italy.

he designed, none is more spectacular than the Vierzehnheiligen ("fourteen saints") near Bamberg, Germany. The relative simplicity of the exterior deliberately leaves the visitor unprepared for the spaciousness and elaborate decoration of the interior (**Fig. 19.6**), with its rows of windows and irregularly placed columns. The joint between the ceiling and walls is hidden by a fresco that, together with its border, spills downward in a series of gracious curves. It is not difficult to imagine what John Calvin would have said of such an interior, but if a church can be allowed to be a place of light and joy, Neumann's design succeeds admirably.

THE ENLIGHTENMENT

The Enlightenment, or the Age of Reason, originated in the second half of the 17th century when Louis XIV presided over his royal court at Versailles, although it really took hold as a cultural movement in the next century. The main figures associated with the Enlightenment in France were Voltaire, Denis Diderot, and Jean-Jacques Rousseau; John Locke in England; Francis Hutcheson, Adam Smith, and David Hume in Scotland; and, in America, Benjamin Franklin and Thomas Jefferson.

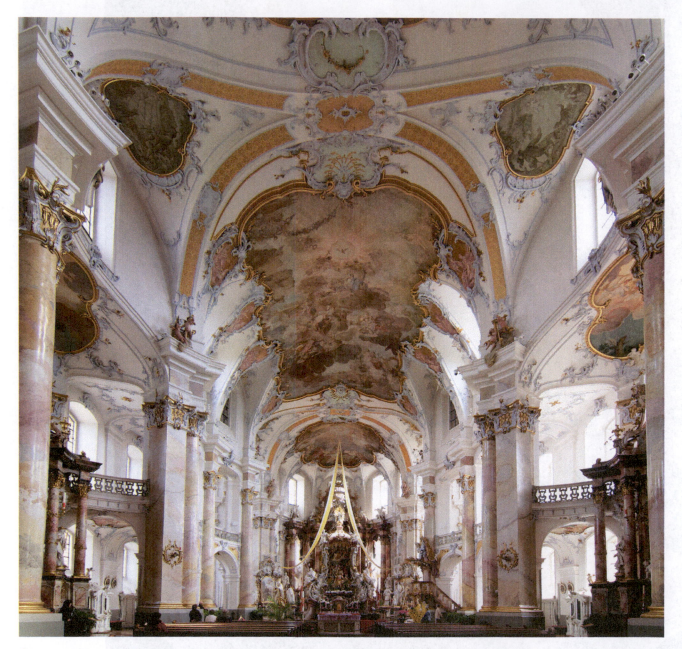

▲ **19.6** **Balthasar Neumann, Vierzehnheiligen pilgrim church, 1743–1772. Near Bamberg, Germany.** This interior view shows the high altar at the back of the nave (back left) and the oval altar in the middle of the church (center). The oval altar, the Gnadenaltar ("Mercy Altar"), is the work of Johann Michael Feuchtmayer and Johann Georg Übelherr and dates to 1763; its central location is characteristic of the pilgrimage churches of southern Germany and Austria, while its shape is echoed in the oval ceiling paintings. Neumann deliberately rejected the soaring straight lines of Gothic architecture and the symmetrical balance of the Renaissance style in favor of an intricate interweaving of surfaces, solid volumes, and empty spaces.

The Age of Enlightenment was an age of diverse intellectual developments beyond the humanities. Toward the end of the 17th century, Cesare Beccaria (1738–1794), an important Enlightenment figure in Italy, published *On Crimes and Punishments* (1764), the first application of rationalist principles to the study of criminal punishment; it led to reforms in the criminal-justice systems of many European countries. Beccaria argued that prison sentences should fit the crimes and should be used to deter crime and rehabilitate criminals rather than solely to exact retribution. He also spoke vehemently against the death penalty for reasons that echo in opponents' voices even today: no one (and no state) has the right to take the life of another, and the death penalty does not deter crime any more than other forms of punishment.

At the same time in Scotland, Adam Smith (1723–1790) adapted a central Enlightenment theme—individual liberty—for his new economic theory in *The Wealth of Nations*; it was published in 1776, the year that the American colonies declared independence from Britain. Smith promoted an economic approach called **laissez-faire**—"let it be." He believed that if market forces were allowed to operate without state intervention, an "invisible hand" would guide self-interest for the benefit of all. He further postulated that open competition would place a ceiling on prices and lead to the improvement of products. He is often called the Father of Capitalism.

Smith's theories were optimistic, and from one perspective, the whole 18th century was an age of optimism. It had trust in science and in the power of human reason, belief in a natural order, and an overriding faith in the theory of progress that the world was better than it had ever been and was bound to get better still.

Painting in France

During the late years of the 18th century, the forces of the Enlightenment and the decline of support for the maintenance of the monarchy and nobility led to a style—"natural" art—that was less frivolous, less saccharine, and much more unaffected. These stylistic changes were a reflection of Jean-Jacques Rousseau's association of moral values and human virtue with the innocence and unadulterated simplicity of peasant life.

ÉLISABETH VIGÉE-LEBRUN Carrying these views to an almost bizarre conclusion, Marie-Antoinette oversaw the construction of a mock peasant village on the grounds of Versailles where she could tend sheep in the simple clothes of a shepherdess, pretend to milk cows, and, with her attendants, engage in other activities associated with peasant life. In the end, this dalliance with the life of a commoner did not change the queen's image among her people; nor did the essentially propagandistic portrait that her court painter Élisabeth Vigée-Lebrun (1755–1842) created just two years before the French Revolution. *Marie Antoinette and*

Her Children (**Fig. 19.7**) was intended to counteract the queen's declining popularity by portraying her not as an entitled, indifferent spendthrift but as a loving mother who had had her share of heartbreak. The elegant dress and elaborate hat—both bright red—convey her regal stature, as does the setting adjacent to the famed Hall of Mirrors, which can be seen to the left. Her figure is imposing as the centerpiece of a grouping reminiscent of Madonna and Child compositions typical of the Italian Renaissance. Marie-Antoinette bounces a child on her lap; her eldest daughter leans on her shoulder affectionately. The queen's eyes look out of the canvas as if searching for sympathy as the dauphin—the boy who would be king—points to an empty cradle shrouded in black. Her fourth child, a girl named Marie Sophie Hélène Béatrice de France, died of tuberculosis when she was 11 months old. Neither this nor any other public-relations efforts to paint the royal family

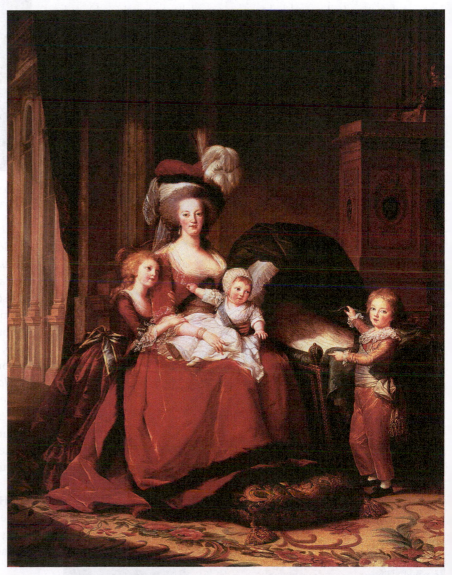

▲ **19.7** **Élisabeth Vigée-Lebrun, *Marie Antoinette and Her Children*, 1781. Oil on canvas, 106¾" × 76¾" (271 × 195 cm). Palace of Versailles, Versailles, France.** The queen's hat and skirts create a richness to which the common person could not reasonably aspire, but the triangular composition and the child on the lap are reminiscent of Renaissance images of the Madonna and Child.

as accessible and sympathetic persuaded the French populace, in spite of Vigée-Lebrun's best efforts and personal loyalty to the monarchy. When Louis XVI and Marie-Antoinette were imprisoned, the painter left France and traveled to Italy, Austria, and Russia, where she had ready patrons among royalty and nobility. Her career was as successful as any; she lived to be 87 and painted some 800 works. Her style epitomized the tendency toward naturalism that characterized late-18th-century painting.

Painting in the United Kingdom and America

THOMAS GAINSBOROUGH English art in the 18th century was also notable for its aristocratic portraits in what can best be described as a hybrid style, featuring both Rococo characteristics (color and light; vigorous, delicate brushwork) and more naturalistic elements (the sitters appear more thoughtful,

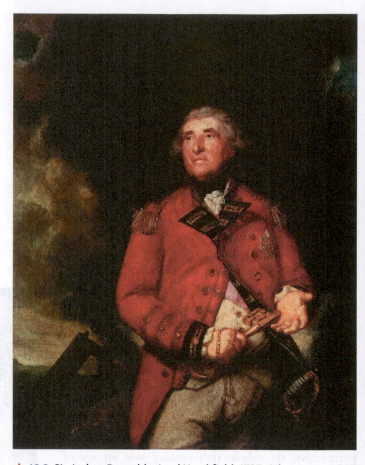

▲ **19.9** Sir Joshua Reynolds, *Lord Heathfield*, 1787. Oil on canvas, 56" × 44 ¾" (142 × 113.5 cm). National Gallery, London, United Kingdom.

confident, and less artificially perfect in appearance). Thomas Gainsborough (1727–1788) dominated English portraiture in his day, despite the fact that he was more interested in painting landscapes. One of the initiators of the so-called *Grand Manner* in portraiture, Gainsborough created an air of elegance and importance in his sitters by using several pictorial devices—a deep, lush landscape; a relatively large figure in relation to its surroundings; a simple pose and a dignified gaze. *Mary, Countess Howe* (**Fig. 19.8**) shows the subject dressed in a costume reminiscent of Watteau in its soft, feathery strokes, but her dignified pose and cool gaze suggest that she had thoughts other than romance in mind. Yet there is a visual poetry to the scene—the resplendent shimmer of the countess's refined dress set off by the rustic landscape elements and more somber tones of the sky.

JOSHUA REYNOLDS Sir Joshua Reynolds (1723–1792) painted numerous portraits of military figures (although not exclusively), using the Grand Manner to convey Classical values of heroism and patriotism (**Fig. 19.9**). He counted among his clientele

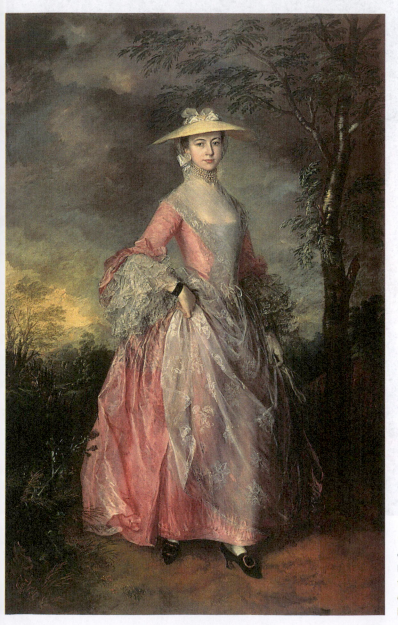

◄ **19.8** Thomas Gainsborough, *Mary, Countess Howe*, ca. 1765. Oil on canvas, 96" × 60" (244 × 152.4 cm). Kenwood House, London, United Kingdom. The wild background and threatening sky set off the subject, but their artificiality is shown by her shoes—hardly appropriate for a walk in the country. Gainsborough was famous for his ability to paint fabric: note the contrast between the heavy silk dress and the lacy sleeves.

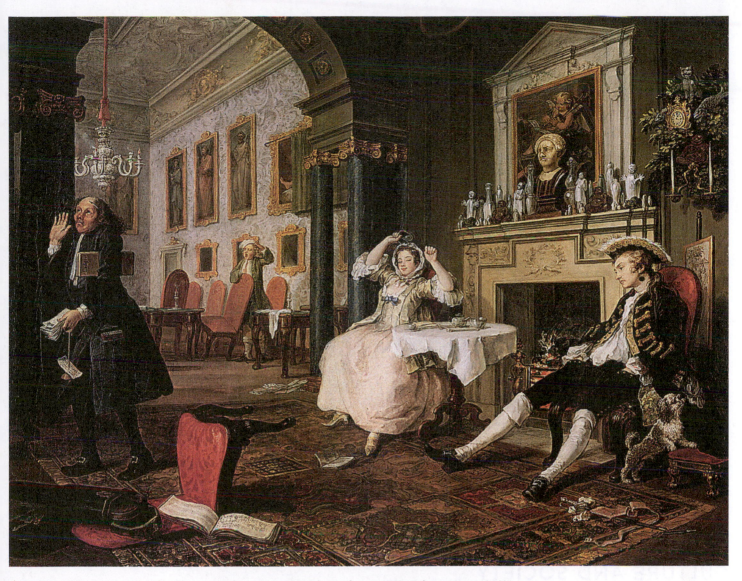

▲ **19.10** William Hogarth, *The Tête à Tête* from *Marriage à la Mode*, ca. 1745. Oil on canvas, 26¾" × 35" (68 × 89 cm). National Gallery, London, United Kingdom. Hogarth satirized the frequent marital indiscretions among the English.

military commanders who were associated with seminal histori-cal events in England; in his portraits, their stature was sometimes reinforced by their commanding presence in a landscape that contained references to their courageous deeds. He also painted portraits of the writer Samuel Johnson and of James Boswell, Johnson's biographer, who penned what some scholars believe to be the greatest biography ever written in the English language.

WILLIAM HOGARTH William Hogarth (1697–1764) stands dramatically apart from other English painters in that rather than portraying the lifestyle of the upper echelons of society, he focused with a rapier wit on the English middle class, satirizing their pretensions to the upper class. In his series of paintings called *Marriage à la Mode*, Hogarth illustrated the consequences of a loveless marriage between an impoverished earl and the daughter of a wealthy city merchant who wants to improve her social position. In one of the series, *The Tête*

à Tête (**Fig. 19.10**), matters have already begun to deteriorate. Even though it is morning, both the husband and wife appear to be exhausted from the events of the night before—events that they did not share. She spent the evening at home entertain-ing herself while he went out on the town. It is not clear what he was up to, but a small dog is sniffing a piece of lace that is sticking out of his pocket. The other adult in the room laments, holding a stack of bills in his hand. The environments in which Hogarth's characters are placed and the backdrop against which these comedic melodramas unfold cast an unforgiving light on the moral turpitude of the age. Hogarth is credited with creat-ing a genuinely English style of painting.

JOHN SINGLETON COPLEY America offered a new twist in portraiture, perhaps best represented by John Singleton Copley (1738–1815) of Massachusetts. Whereas Gainsborough combined naturalism with elements of French Rococo, Copley

▶ **19.11** John Singleton Copley, *Portrait of Paul Revere*, 1768. Oil on canvas, 35⅛" × 28 ½" (89.2 × 72.4 cm). Museum of Fine Arts, Boston, Massachusetts. Copley combined English naturalism with an American taste for realism and simplicity.

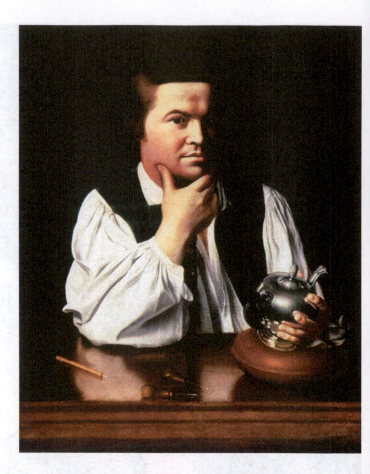

combined English naturalism with an American taste for realism and simplicity. His *Portrait of Paul Revere* (**Fig. 19.11**), which shows the silversmith-turned-revolutionary-hero, has a directness of expression and unpretentious gaze that undertakes an assertive visual dialogue with the viewer. Tools at hand, Revere ponders the teapot on which he is working and raises his head momentarily from the task to acknowledge the visitor, the patron, the observer. Gainsborough's painterly touch contrasts with Copley's exacting linear style. The lighting is dramatic rather than subtle, and the textures, softly blended in Gainsborough's portrait, are purposely distinct and different from one another (the soft folds of Revere's shirtsleeves against his sculptural arms; the warm wood surface of his worktable compared to the gleaming metal of his teapot). It is tempting to read Copley's approach as one that reflects American values and sensibilities. Like some other American-born artists of his generation, however, he moved to London, where he adapted his style to British tastes.

CULTURE AND SOCIETY

The Rediscovery of Classical Antiquity in the Eighteenth Century

1711	First excavations take place at Herculaneum
1734	Society of Dilettanti is formed in London to encourage exploration
1748	First excavations take place at Pompeii
1753	Robert Wood and James Dawkins publish *The Ruins of Palmyra*
1757	Wood and Dawkins publish *The Ruins of Baalbek*
1762	James Stuart and Nicholas Revett publish the first volume of *The Antiquities of Athens*
1764	Robert Adam publishes *The Ruins of the Palace of the Emperor Diocletian at Spalatro*; Johannes Winckelmann publishes *History of Ancient Art*
1769	Richard Chandler and William Pars publish the first volume of *The Antiquities of Ionia*
1772	The Hamilton collection of Greek vases is purchased by the British Museum
1785	Richard Colt Hoare explores Etruscan sites in Tuscany
1801	Lord Elgin receives Turkish permission to work on the Parthenon in Athens

NEO-CLASSICISM

For all its importance, the Rococo style was not the only one to influence 18th-century artists. The other principal artistic movement of the age was **Neo-Classicism**, which increased in popularity as the appeal of the Rococo declined.

There were good historical reasons for the rise of Neo-Classicism. The excavation of the buried cities of Herculaneum and Pompeii, beginning in 1711 and 1748, respectively, evoked immense interest in the art of Classical antiquity in general and of Rome in particular. The wall paintings from Pompeian villas of the first century CE were copied by countless visitors to the excavations, and reports of the finds were published throughout Europe. The German scholar Johannes Winckelmann (1717–1768), who is sometimes called the Father of Archaeology, played a major part in creating a new awareness of the importance of Classical art; in many of his writings, he encouraged his contemporaries not only to admire ancient masterpieces but also to imitate them.

Neo-Classical Painting and Sculpture

JACQUES-LOUIS DAVID The aims and ideals of the Roman Republic—freedom, opposition to tyranny, valor—held a special appeal for 18th-century republican politicians, and the evocation of Classical models became a characteristic of the art of the French Revolution. The painter who best represents the official revolutionary style is Jacques-Louis David (1748–1825). His *The Oath of the Horatii* (**Fig. 19.12**)

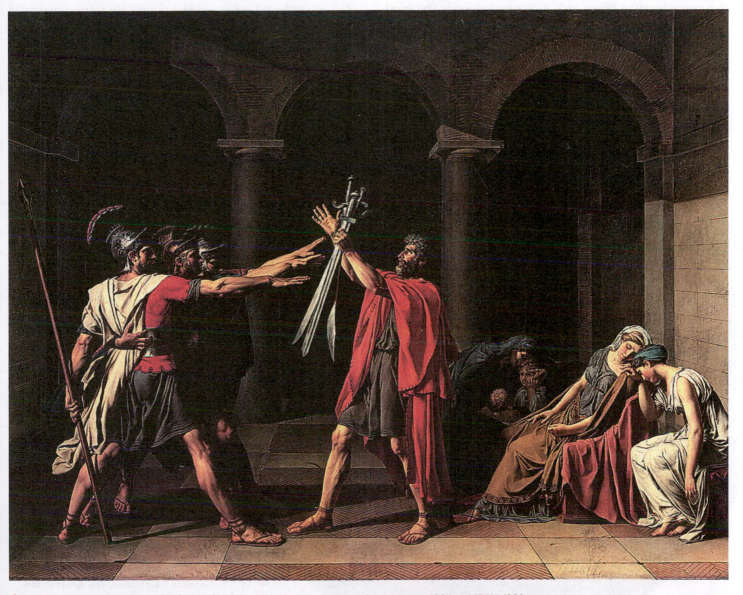

▲ **19.12** Jacques-Louis David, *The Oath of the Horatii*, 1784–1785. Oil on canvas, 130" × 167 ¼" (330 × 425 cm). **Musée du Louvre, Paris, France.** The story of the Horatii, three brothers who swore an oath to defend Rome even at the cost of their lives, is used here to extol patriotism. Painted only five years before the French Revolution, David's work established the official style of Revolutionary art.

draws not only on a story of ancient Roman civic virtue but also on a knowledge of ancient dress and armor derived from excavations of Pompeii and elsewhere. The simplicity of its message—the importance of united opposition to tyranny—is expressed by the austerity of its style and composition, a far cry from the lush, self-indulgent, indifferent world of Watteau and Fragonard.

David restored the Classical ideal of balance between emotion and restraint in the *Oath*; the atmosphere of the scene is highly charged, but the cool precision of David's brushwork and the harsh lines of the setting counteract it. The palette consists mostly of muted blues, grays, and browns, but these subtleties are punctuated with vibrant, strategically placed reds that heighten the tension in the painting. The figures occupy the extreme foreground, resembling a Classical relief sculpture in their placement. The three groupings are each arranged in a roughly triangular configuration, and each is visually related to a corresponding heavy arch in the background. The most dramatic moment in the action—the swearing of an oath on the swords clasped in the center—is brightly lit and silhouetted against darkness.

Knowing something of the historical circumstances under which *The Oath of the Horatii* was created, and understanding what is new about it in terms of style and composition, helps us appreciate its significance. But our full comprehension and appreciation of the work can occur only with our consideration and interpretation of the subject matter. The subject of David's *The Oath of the Horatii* is, on the face of things, fairly easy to read. In a bow to Classical themes, three brothers—the Horatii—swear their allegiance to Rome on swords held high by their father. They pledge to come back victorious from the fight or not at all. The sharp, unwavering gestures and stable stances convey strength, commitment, and bravery—male attributes associated with action. By contrast, the women have been pushed to the side in this painting; overwhelmed by emotion, they have collapsed. They have much to be upset about: one of the Horatii sisters is betrothed to one of the enemy—the Curatii—and one of the Horatii brothers is married to a Curatii sister. In David's world, not only are women incapable of action, but aggressive or assertive behavior would be viewed as unbecoming of ladies. The contrast between the women's postures and the men's represents, according to historian Linda Nochlin, "the clear-cut opposition between masculine strength and feminine weakness offered by the ideological discourse of the period." That ideological discourse was ingrained in Enlightenment principles, particularly the influential ideas of Rousseau, whose "social contract" enunciated specific gender roles.

David used the same lofty grandeur to depict Napoléon soon after his accession to power (see Fig. 20.5), although there is considerable, if unintentional, irony in the use of the Revolutionary style to represent the military dictator.

ANGELICA KAUFFMANN

Angelica Kauffman (1741–1807) was another leading Neo-Classical painter, an exact contemporary of David. Born in Switzerland and educated in the Neo-Classical circles in Rome, Kauffman was responsible for the dissemination of the style in England. She is known for her portraiture, history painting, and narrative works such as *The Artist in the Character of Design Listening to the Inspiration of Poetry* (**Fig. 19.13**).

◄ **19.13** Angelica Kauffmann, *The Artist in the Character of Design Listening to the Inspiration of Poetry*, 1782. Oil on canvas, 24" (61 cm) diameter. Kenwood House, London, United Kingdom. Kauffmann disseminated the Neo-Classical style in England.

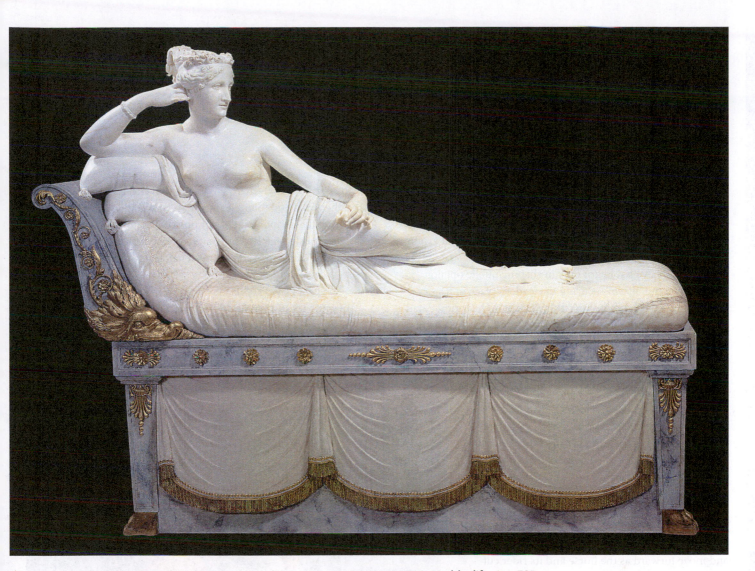

▲ **19.14** Antonio Canova, *Pauline Bonaparte Borghese as Venus Victorious*, 1808. Marble, life size, 78"
(198 cm) long. Galleria Borghese, Rome, Italy. Canova's blend of simplicity and grace was widely imitated by
European and American sculptors throughout the 19th century. The apple that Venus holds in her left hand is the
apple of discord, inscribed "to the fairest." According to legend, the goddesses Aphrodite (Venus), Hera, and
Athena each offered a tempting bribe to the Trojan Paris, who was to award the apple to one of them. Paris chose
Venus, who had promised him the most beautiful of women. The result was the Trojan War, which began when
Paris abducted his prize—Helen, the wife of a Greek king.

In this allegorical work, Kauffman paints her own features in the person of the Muse of Design, who is listening attentively with paper and pencil in hand to her companion, the Muse of Poetry. Poetry's idealized facial features, along with the severe architecture, Classically rendered drapery, and rich palette, place the work firmly in the Neo-Classical style.

ANTONIO CANOVA The principal Neo-Classical sculptors—the Italian Antonio Canova (1757–1822) and the Frenchman Jean-Antoine Houdon (1741–1829)—succeeded in using Classical models with real imagination and creativity. Canova's portrait *Pauline Bonaparte Borghese as Venus Victorious* (**Fig. 19.14**) depicts Napoléon's sister with an idealized Classical

beauty as she reclines on a couch modeled on one found at Pompeii. The cool worldly elegance of the figure, however, is Canova's own contribution.

Neo-Classical Architecture

The growing interest in Classical antiquity among travelers and scholars in the 18th century had a profound effect on architecture, reshaping—quite literally—the basic forms and design elements of Baroque buildings and offering an alternative that projected the rationalist underpinnings of the Enlightenment era.

(Re)framing History: The Assertion and Subversion of Power in Iconic Imagery

When the French painter Jacques-Louis David went to work for Napoléon Bonaparte, one of his foremost tasks would be PR, or more precisely, to create a public relations image for the famous general—one that would exude power, authority, heroism, and accomplishment. In so doing, David would have a role not only in shaping public opinion of Napoléon but also in securing the leader's place in history. That David would sometimes "fudge" accurate historical detail to reframe events in such a way as to aggrandize his subject or comply with his patron's legacy agenda, however, is well known. (David's painting of Napoléon's coronation, for example, includes a prominent portrait of his mother even though she refused to attend the ceremony [see Fig. 20.5]).

David's painting *Napoléon Crossing the Alps* (Fig. 19.15) was a feat of propaganda, glorifying and romanticizing the general's military prowess by utilizing a format—the equestrian portrait— that had deep historical roots in the ancient world (see Fig. 4.39, the equestrian portrait of Emperor Marcus Aurelius). Napoléon commands his troops, his magnificent steed, and even, one might say, the landscape around him, to rise up and move forward as the horse and its rider cut a vigorous, powerful diagonal swath across the canvas. The general's eyes meet ours, urging us to join the ascent to greatness; beneath the hooves of his rampant Arabian stallion, the names of his illustrious predecessors who also crossed the Alps are inscribed in stone: Hannibal and Charlemagne. As students of history, from David's awe-inspiring image of Napoléon, we would never know that the general did not, in fact, lead his troops through

the perilous St. Bernard Pass and up over the Alps himself but, rather, followed them the next day on a donkey. It is also worth noting that Napoléon did not pose for the painting; David used a previously sketched portrait of the general for his head and had one of his own sons climb a ladder (not mount a horse) to serve as a body-double.

From David's *Napoléon* and countless other paintings that ensconce historical figures, we would also never know that ordinary people played a role in the course of human events— women, workers, and people of color. It is to this point that Kehinde Wiley speaks in his witty and thought-provoking

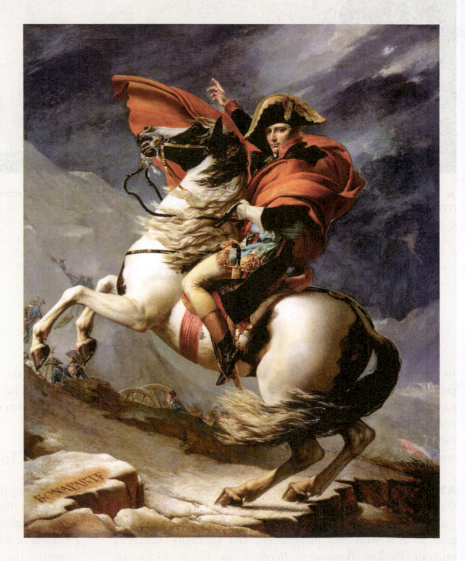

▶ **19.15 Jacques-Louis David,** *Napoleon Crossing the Alps*, **1800. Oil on canvas, 96" × 91" (244 × 231 cm). Chateau de Versailles, Versailles, France.** After he took his army across the Alps, Napoléon surprised and defeated an Austrian army. His calm, controlled guiding of a wildly rearing horse is symbolic of his own vision of himself as bringing order to postrevolutionary France.

revision of David's iconic portrait (**Fig. 19.16**). Many of the details of the original have been copied by Wiley to the letter: the rearing horse, swirling cloak, and the rider's pose and gesture. But the unmistakable figure of Napoléon has been replaced with an anonymous African American man, the general's dashing military trappings with contemporary camouflage fatigues, Magnum work boots, and a handkerchief sweatband—recognizable hip-hop culture attire.

Wiley also replaces the natural setting of David's painting with an opulent, red and gold patterned wallpaper, suggesting that the backdrop for his present-day "warrior" is no more decorative and contrived than the one that David conceived for his hero. The craggy rocks are reduced to stage props in Wiley's painting, reiterating the etched names of Hannibal, Charlemagne (Karolus Magnus Imp.), and Bonaparte, but also adding Williams. The addition of the ordinary name drives home the point that the role of ordinary "others" in shaping history has largely gone unnoticed. Wiley's specific use of the name "Williams" also calls attention to the historic roles of slaves—often assigned new "slave names"—in white society, imagined reversals of those roles and, with them, a subversion of power relationships.

▲ **19.16** Kehinde Wiley, *Napoleon Leading the Army Over the Alps*, 2005. Oil on canvas, 108" × 108" (274 × 274 cm). **Brooklyn Museum, Brooklyn, New York.** Wiley once asked, "How can we make art that matters?" His works would seem to suggest that part of the answer is to reaffirm the place of African Americans in our predominantly Eurocentric culture.

LE PANTHÉON The history, politics, and ideals of the 18th and early 19th centuries in France are reflected in the design and multiple renovations and reassignments of Le Panthéon in Paris (see **Fig. 19.17**). Originally commissioned by King Louis XV to replace a dilapidated medieval abbey, architect Jacques-Germain Soufflot's plan for the new Church of Sainte-Geneviève brought to French architecture a new direction. Having traveled to Rome where he studied Classical (and Neo-Classical) architecture firsthand, Soufflot's building displays references to St. Peter's Basilica and Bramante's Tempietto as well as to Saint Paul's Cathedral in London and Paris's own Église du Dôme (or Church of the Invalides) completed only 50 years earlier.

Le Panthéon has a Greek cross plan in which all of the "arms"—nave, transepts, and choir—are of equal dimensions and the focus of the exterior and interior is a central dome. The numerous Corinthian columns, inside and out, attest to the influence of Roman architecture on Soufflot, but the structural approach to the building was clearly Gothic; although the vaults are rounded (not pointed), the architect used hidden flying buttresses to support them and the dome. A pupil of Soufflot stated that his intention was "to unite . . . the purity and magnificence of Greek architecture with the lightness and daring of Gothic construction." But the structural system of the church enabled Soufflot to open the walls to windows, although you will not see this today. After the church was converted into a "Temple for Great Men"—and repository of their remains—during the height of the French Revolution in 1791, the lower windows were bricked over, resulting in the flat, unadorned planes of stone visible today. Both Voltaire and Rousseau, giants of the Enlightenment, are buried there. Le Panthéon changed back and forth between a church and mausoleum-monument until 1885, and the **pediment** sculpture over the columned **portico** changed four times to reflect the building's function and ideology.

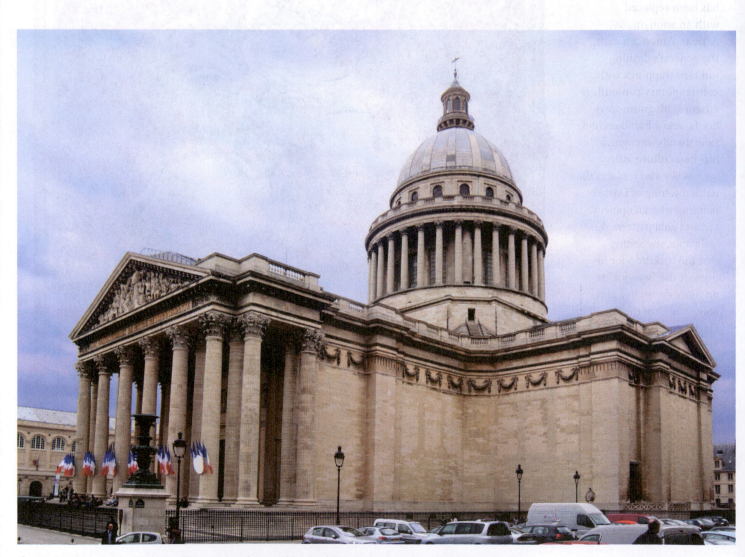

▲ **19.17** **Jacques-Germain Soufflot, Le Panthéon (Church of Sainte-Geneviève), 1755–1792. Paris, France.** Originally built as the Church of Sainte-Geneviève, the building was converted into a memorial to the illustrious dead at the time of the French Revolution. The architect studied in Rome; the columns and pediment were inspired by ancient Roman temples.

CONNECTIONS Milling about the inlaid marble floor beneath the stunning coffered dome of Rome's Pantheon, men and women, locals and tourists, all in 18th-century dress, gesture and observe, gather and discuss. Some are animated and congenial, others are reverential and introspective. *Interior of the Pantheon, Rome* is the work of Giovanni Paolo Panini (1691–1765), a painter and architect who lived and worked in Rome and profited from the popularity of the *Grand Tour* among European elites.

The Grand Tour began sometime in the late 16th century but hit its stride in the 1700s. Sometimes described as a an obligatory "cultural pilgrimage" for the abundantly wealthy leisure class as well as for the serious artist, the tour usually started in London, progressed to Paris, and culminated in Italy. The center of gravity was Rome, with its ancient history, classical architecture, and collections of (and market for) antiquities. It was not unusual for souvenirs of the Grand Tour to include objects small and large; the Metropolitan Museum of Art's third-century *Badminton Sarcophagus*, for example, was purchased in Rome by the third duke of Beaufort for his Gloucestershire estate back in England.

In the 18th century, encounters with Roman culture contributed to the formulation of Neo-Classical ideas and aspirations. Roman architecture and its Greek precedents, in particular, embodied history's greatest contributions to civilization: democracy, the rule of law, and duty to country and one's fellow citizens.

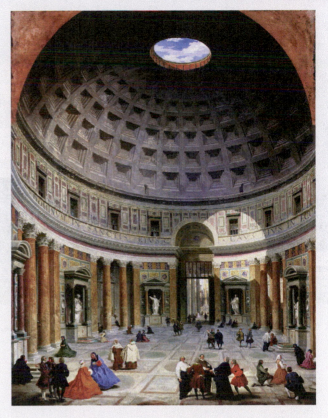

▲ **19.18** Giovanni Paolo Panini, *Interior of the Pantheon, Rome* (ca. 1734). Oil on canvas, 50⅜" × 45". National Gallery of Art, Washington, DC. Samuel H. Kress Collection.

THOMAS JEFFERSON The dignified, stately homogeneity of Washington, DC. is attributable to the aesthetic preferences of Thomas Jefferson, a Founding Father of the United States of America, principal author and signatory to the Declaration of Independence and Constitution, Secretary of State under George Washington, third president of the United States—and architect. Jefferson studied contemporary French Neo-Classical architecture while serving as minister to France and, in 1786, shared his vision for the capitol of the new nation in a letter to architect Pierre Charles L'Enfant, the man who would lay out the plan of the city:

> Whenever it is proposed to prepare plans for the Capitol, I should prefer the adoption of some one of the models of antiquity, which have had the approbation [esteem] of thousands of years.[1]

Jefferson embraced the same Classical model—this time via Palladio's interpretation (see Fig. 13.22)—for Monticello

(see **Fig. 19.19** on p. 644), his own home in Charlottesville, Virginia. Familiar architectural elements abound: a columned, pedimented portico; central dome; symmetry; balance; and the regular repetition of shapes. Jefferson's design, however, differs from Palladio's in the materials he used; brick and wood replace Neo-Classicism's typical pristine marble and cut stone.

CLASSICAL MUSIC

For the most part, music in the 18th century retained a serious purpose and was relatively untouched by the mood of the Rococo style. At the French court, however, there was a demand for elegant, lighthearted music to serve as entertainment. The leading composer in this **style galant** was François Couperin (1668–1733), whose many compositions for keyboard emphasized grace and delicacy at the expense of the rhythmic drive and intellectual rigor of the best of Baroque music. Elsewhere in Europe, listeners continued to prefer music that expressed emotion. At the court of Frederick the Great (himself an accomplished performer and composer), for example, a musical style known as *Empfindsamkeit* ("sensitiveness") developed.

1. Letter of Thomas Jefferson to the commission overseeing the plans for Washington, DC., January 26, 1786, quoted in Leland M. Roth, ed., *America Builds: Source Documents in American Architecure and Planning* (New York: Harper & Row, 1983), p. 29.

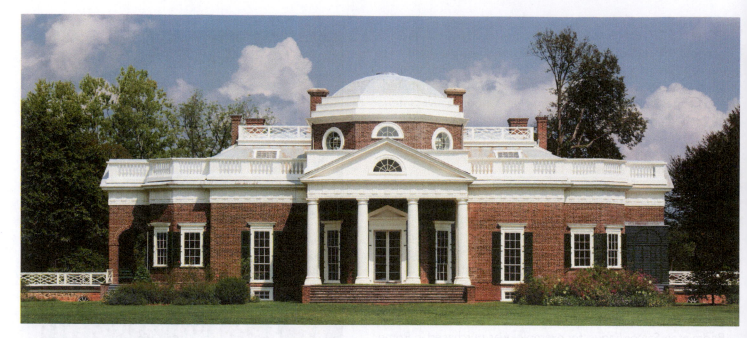

▲ **19.19** **Thomas Jefferson, Monticello, Charlottesville, Virginia, 1770–1806.** Jefferson sought to have government buildings designed in the Neo-Classical style.

The chief exponent of this expressive style was Carl Philipp Emanuel (C. P. E.) Bach (1714–1788), a son of Johann Sebastian Bach. His works have considerable emotional range and depth; their rich harmonies and contrasting moods opened up new musical possibilities. Like all his contemporaries, C. P. E. Bach was searching for a formal structure with which to organize the expression of emotion. A single piece or movement from a Baroque work first established a single mood and then explored it fully, whether it be joyful, meditative, or tragic. Now composers were developing a musical organization that would allow them to place different emotions side by side, contrast them, and thereby achieve expressive variety.

By the middle of the 18th century, a musical style developed that made possible this new range of expression. It is usually called **Classical**, although the term is also used in a more general sense, which can be confusing. It would be as well to begin by carefully distinguishing between these two usages.

In its general sense, the term *classical* is frequently used to distinguish so-called serious music from popular music, such that all music likely to be presented in a concert hall or opera house, no matter its age, is classical. One reason this distinction is confusing is that for many composers before our own time, there was essentially no difference between serious and popular music. They used the same musical styles and techniques for a formal composition to be listened to attentively by an audience of music lovers as for a religious work to be performed in church, or for dance music or background music for a party or festive occasion. Furthermore, used in this sense, *classical*

tells us nothing significant about the music itself or its period or form. It does not even describe its mood, because many pieces of classical or serious music were in fact deliberately written to provide light entertainment.

The more precise and technical meaning of *Classical* as it relates to music denotes a musical style that was in use from the second half of the 18th century and reached its fulfillment in the works of Franz Joseph Haydn (1732–1809) and Wolfgang Amadeus Mozart (1756–1791). It evolved in answer to new musical needs the Baroque style could not satisfy and lasted through the early years of the 19th century, when it in turn gave way to the Romantic style. The figure chiefly responsible for the change from Classical to Romantic music was Ludwig van Beethoven (1770–1827). Although his musical roots were firmly in the Classical style, he is more appropriately seen as a representative of the new Romantic age (see Chapter 20).

It is no coincidence that the Classical style in music developed at much the same time as painters, architects, and poets were turning to Greek and Roman models, because the aims of Classical music and Neo-Classical art and literature were similar. After the almost obsessive exuberance and display of the Baroque period, the characteristic qualities of ancient art—balance, clarity, intellectual weight—seemed especially appealing. Eighteenth-century composers, however, faced a problem that differed from that of artists and writers. Unlike literature or the visual arts, ancient music has disappeared almost without trace. As a result, the Classical style in music had to be newly invented to express ancient concepts of

balance and order. In addition, it had to combine these intellectual principles with the no-less-important ability to express a wide range of emotion. Haydn and Mozart were the two supreme masters of the Classical style because of their complete command of the possibilities of the new idiom within which they wrote.

The Classical Symphony

The most popular medium in the Classical period was instrumental music. In extended orchestral works—symphonies—divided into several self-contained sections called *movements*, composers were most completely able to express Classical principles.

THE ORCHESTRA One reason for this was the new standardization of instrumental combinations. In the Baroque period, composers such as Bach had felt free to combine instruments into unusual groups that varied from composition to composition. Each of Bach's Brandenburg

Concertos was written for a different set of solo instruments. By about 1750, however, most instrumental music was written for a standard orchestra (**Fig. 19.20**), the nucleus of which was formed by the string instruments: violins (generally divided into two groups known as first and second), violas, cellos, and double basses. To the strings were added wind instruments, almost always the oboe and bassoon and fairly frequently the flute; the clarinet began to be introduced gradually and, by about 1780, had become a regular member of the orchestra. The only brass instrument commonly included was the French horn. Trumpets, along with the timpani or kettledrums, were reserved for reinforcing volume or rhythm. Trombones were never used in classical symphonies until Beethoven did so.

Orchestras made up of these instruments were capable of rich and varied sound combinations ideally suited to the new Classical form of the symphony. In general, the Classical symphony has four movements (as opposed to the Baroque concerto's three): a first, relatively fast one, usually the most complex in form; then a slow, lyrical movement, often songlike; a third movement in the form of a **minuet** (a stately dance); and

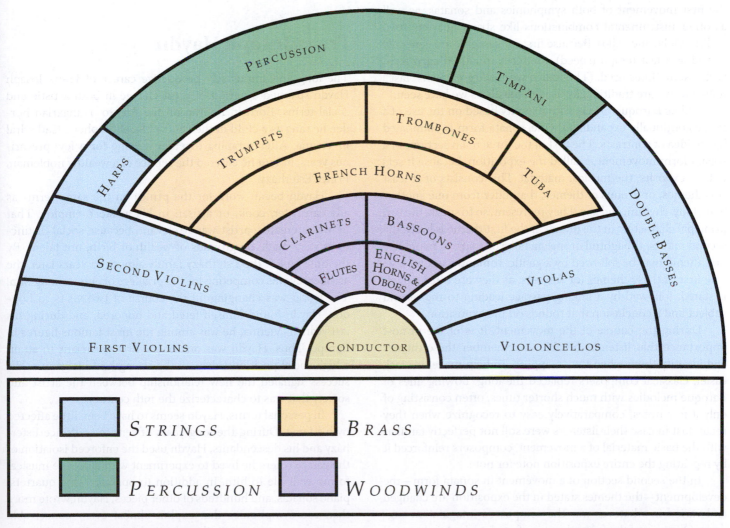

▲ **19.20** Layout of a modern symphony orchestra.

a final movement, which brings the entire work to a spirited and usually cheerful conclusion. As time went on, the length and complexity of the movements grew; many of Haydn's later symphonies last for nearly half an hour. In most cases, however, the most elaborate musical argument was always reserved for the first movement, presumably because during it the listeners were freshest and most able to concentrate.

SONATA FORM The structure almost invariably chosen for the first movement of a Classical symphony was called **sonata form**. Because sonata form was not only one of the chief features of Classical style but also a principle of musical organization that remained popular throughout the 19th century, it merits our attention in some detail. The term is actually rather confusing, because the word *sonata* is used to describe a work in several movements (like a symphony) but written for one or two instruments rather than for an orchestra. Thus, a piano sonata is a piece for solo piano, a violin sonata is a piece for violin and an accompanying instrument, almost always a piano, and so on. A symphony is, in fact, a sonata for orchestra.

The term *sonata form*, however, does not, as might be reasonably expected, describe the form of a sonata but, rather, a particular kind of organizing principle frequently found in the first movement of both symphonies and sonatas, as well as other instrumental combinations like string quartets (two violins, viola, and cello). Because first movements are generally played at a fast tempo (speed), the term sonata **allegro** form is also sometimes used. (The Italian word *allegro* means "fast"; Italian terms are traditionally used in music, as we have seen.)

Unlike Baroque music, with its unity based on the use of a single continually expanding theme, sonata form is dominated by the idea of contrasts. The first of the three main sections of a sonata form movement is called the exposition, because it sets out, or exposits, the musical material. This consists of at least two themes, or groups of themes, that differ from one another in melody, rhythm, and key. They represent, so to speak, the two principal characters in the drama. If the first theme is lively, the second may be thoughtful or melancholy; or a strong marchlike first theme may be followed by a gentle, romantic second one. The first of these themes (or subjects, as they are often called) is stated, followed by a linking passage leading to the second subject and a conclusion that rounds off the exposition.

During the course of the movement, it is of the utmost importance that listeners be able to remember these themes and identify them when they reappear. To help make this task easier, classical composers replaced the long, flowing lines of Baroque melodies with much shorter tunes, often consisting of only a few notes, comparatively easy to recognize when they recur. Just in case their listeners were still not perfectly familiar with the basic material of a movement, composers reinforced it by repeating the entire exposition note for note.

In the second section of a movement in sonata form—the development—the themes stated in the exposition are changed and varied in whatever way the composer's imagination suggests. One part of the first subject is often detached and treated on its own, passed up and down the orchestra, now loud, now

soft, as happens in the first movement of Mozart's Symphony No. 40. Sometimes different themes will be combined and played simultaneously. In almost all cases, the music passes through a wide variety of keys and moods. In the process, the composer sheds new light on what have by now become familiar ideas.

At the end of the development, the original themes return to their original form for the third section of the movement, the recapitulation (repeated theme). The first section is recapitulated with both first and second subjects now in the same key. In this way, the conflict implicit in the development section is resolved. A final coda (or tailpiece; *coda* is the Italian word for "tail") is sometimes added to bring the movement to a suitably firm conclusion.

Sonata form embodies many of the Classical principles of balance, order, and control. The recapitulation, which carefully balances the exposition, and the breaking down of the material in the development and its subsequent reassembling both emphasize the sense of structure behind a sonata-form movement. Both the first and last movements of Mozart's Symphony No. 40 demonstrate how the sonata form can be used to create music of extreme dramatic power.

Franz Joseph Haydn

The long and immensely productive career of Franz Joseph Haydn spanned a period of great change in both artistic and social terms. Born in Rohrau on the Austro–Hungarian border, he sang as a child in the choir of Saint Stephen's Cathedral in Vienna. After scraping together a living for a few precarious years, in 1761 he entered the service of a wealthy nobleman, Prince Esterházy.

Haydn began work for the prince on the same terms as any carpenter, cook, or artisan in his master's employ. That he was a creative artist was irrelevant, because social distinctions were made on grounds of wealth or birth, not talent. By the time he left the Esterházy family almost 30 years later, the aristocracy was competing for the privilege of entertaining him! The world was changing; in the course of two visits to London, Haydn found himself feted and honored, and during his last years in Vienna, he was among the most famous figures in Europe. Thus, Haydn was one of the first musicians to attain a high social position solely on the strength of his genius. His success signaled the new relationship between the artist and society that was to characterize the 19th century.

In personal terms, Haydn seems to have been little affected by his fame. During the long years of service to Prince Esterházy and his descendants, Haydn used the enforced isolation of the palace where he lived to experiment with all of the musical forms available to him. In addition to operas, string quartets, piano sonatas, and hundreds of other pieces, Haydn wrote more than 100 symphonies that exploit almost every conceivable variation on sonata and other classical forms, winning him the nickname Father of the Symphony. During his visits to London

(in 1791–1792 and 1794–1795), he wrote his last 12 symphonies, which are often known as the "London" Symphonies. Although less obviously experimental than his earlier works, they contain perhaps the finest of all his orchestral music; the slow movements in particular manage to express the greatest seriousness and profundity without tragedy or gloom.

Wolfgang Amadeus Mozart

In 1781, in his 50th year and at the height of his powers, Haydn met a young man about whom he was to say a little while later to the young man's father: "Before God and as an honest man, I tell you that your son is the greatest composer known to me either in person or by name." Many of us for whom the music of Wolfgang Amadeus Mozart represents a continual source of inspiration and joy, and a comforting reminder of the heights the human spirit can attain, would see no reason to revise Haydn's judgment.

Although Mozart's life, in contrast to Haydn's, was to prove to be one of growing disappointments and setbacks, his early years were comparatively happy. During his childhood, he showed extraordinary musical ability. By age six, he could already play the violin and piano and had begun to compose. His father Leopold—a professional musician in the service of the archbishop of Salzburg, where the family lived—took Wolfgang on a seemingly never-ending series of trips throughout Europe to exhibit his son's musical prowess. The effects of constant travel on the boy's health and temperament can be imagined, but during these trips, he was exposed to the most sophisticated and varied musical ideas of the day; the breadth of his own musical style must in part be the result of the wide range of influences he was able to assimilate, from the style galant of the Rococo to the Renaissance **polyphonies** he heard in Rome. From time to time, father and son would return to Salzburg, where by this time they both held appointments at the court of the archbishop.

In 1772, the old archbishop died. His successor, Hieronymus Colloredo, was far less willing to allow his two leading musicians to come and go as they pleased. Artistic independence of the kind Haydn was to achieve was still in the future, and the following 10 years were marked by continued quarreling between Mozart and his aristocratic employer. Finally, in 1781, when Mozart could take no more and asked the archbishop for his freedom, he was literally kicked out the palace door. Mozart spent the last years of his life (from 1781 to 1791) in Vienna, trying in vain to find a permanent position while writing some of the most sublime masterpieces in the history of music. When he died at age 35, he was buried in a pauper's grave.

The relationship between an artist's life and work is always fascinating. In Mozart's case, it raises particular problems. We might expect that continual frustration, poverty, and depression would have left its mark on his music, yet it is a grave mistake to look for autobiographical self-expression in the work of an artist who devoted his life to achieving perfection in his art. In general, Mozart's music reflects only the highest and noblest of human aspirations. Perhaps more than any other artist in any medium, Mozart combines ease and grace with profound learning in his art to come as near to ideal beauty as anything can. Nevertheless, his music remains profoundly human. We are reminded many times not of Mozart's own suffering but of the tragic nature of life itself.

A year before his death, Mozart wrote the last of his great series of concertos for solo piano and orchestra, the Piano Concerto No. 27 in B Flat, K. 595 (Mozart's works are generally listed according to the catalog first made by Köchel; hence the letter *K* that precedes the catalogue numbers). The wonderful slow movement of this work expresses, with a profundity no less moving for its utter simplicity, the resignation of one for whom the beauty of life is perpetually tinged with sadness.

MOZART'S LAST THREE SYMPHONIES In the summer of 1788, living in Vienna and with no regular work or source of income, Mozart wrote his last three symphonies, numbers 39, 40, and 41. He composed without a commission or even the possibility of hearing his own works; he may have died without ever hearing any of them performed.

The range of the three symphonies discourages us from making any easy connection between the composer's outward misery (some begging letters to friends from the same period have survived) and the spirit of his music. No. 39 is a serene and genial work. Some details—the major key, the writing for woodwind instruments, and some phrases in the first movement—suggest a Masonic connection in their sense of fellowship and kindness (Mozart himself was a Freemason and a firm believer in their ideas). The minuet forming the third movement is even festive in character, and the finale is positively cheerful.

Symphony No. 41, generally known as the "Jupiter" Symphony, is Mozart at his most Classical, combining elegance of ideas with a powerfully intellectual treatment. In the last movement, he builds excitement by combining themes into a massive but elegant texture of sound. Nothing could be more triumphant than the splendor and power of the overwhelming structure he builds, leaving us stunned by his brilliance and exhilarated by the music's drive. This is surely one of the high points of musical genius.

If we are to look for a darker side to the composer's state of mind, however, it can be found in Symphony No. 40, a work almost entirely written in a minor key. The first movement opens with an inexorable drive. Even a brief moment of relief is soon cut short, and the movement ends with the hopelessness of its beginning. The slow movement has a tentative melancholy that breaks into occasional outbursts of passion. The minuet, normally an occasion for relaxation, is stern and forceful, with only its wistful trio section to bring some relief.

The final movement, far from bringing us any light, is, from its very opening, the culmination of the tragedy. A short string passage leads upwards, only to be beaten down again no less

GO LISTEN!
WOLFGANG AMADEUS MOZART
Fourth movement from Symphony No. 40

than four times. Two powerful chords from the whole orchestra discourage the strings when they try to repeat their escape. From then on, the music hurtles to the end of the exposition, with only a brief, wan attempt to lighten the mood. The development section is brusque and in places violent, and when the opening returns, it does so with no resolution of the tension. While all of this emotion is subject to clear, Classical forms, the movement—and the symphony—storms to a close, offering no grounds for optimism or hope.

There is no real parallel in the Classical period for the almost unrelieved gloom of Mozart's Symphony No. 40. It would be easy to read it as the emotional expression of a desperate man. And yet, it is flanked by the serenity and fellowship of number 39 and the magisterial grandeur of number 41. All three were written between June 26 and August 10, 1788.

The need to earn a living, coupled with the inexhaustibility of his inspiration, drew from Mozart works in almost every conceivable category. Symphonies, concertos, masses, sonatas, and string quartets are only some of the forms he enriched. Many admirers of Mozart would choose his operas, however, if faced with a decision as to what to save if all else were to be lost. Furthermore, his operas provide the clearest picture of his historical position.

MOZART AND OPERA Mozart wrote many operas, including *The Magic Flute, Così fan tutte*, and the monumental *Don Giovanni*. His highly popular *Marriage of Figaro* is based on a play of the same name by the French dramatist Pierre-Augustin de Beaumarchais (1732–1799). Although a comedy, the play, which was first performed in 1784, contains serious overtones. The plot is too complicated to permit even a brief summary, but among the characters are a lecherous and deceitful, though charming, count; his deceived wife, the countess; her maid Susanna, who puts up a determined resistance against the count's advances; and Susanna's husband-to-be, Figaro, who finally manages to outwit and embarrass the would-be seducer, who is also his own employer. In other words, the heroes of the play are the servants and the villain is their master. Written as it was on the eve of the French Revolution, Beaumarchais's play was interpreted rightly as an attack on the morals of the ruling classes and a warning that the lower classes would fight back. Beaumarchais was firmly associated with the moves toward social and political change; he was an early supporter of the American Revolution and helped organize French support for the insurgent colonists.

Mozart's opera was first performed in 1786. It retains the spirit of protest in the original but adds a sense of humanity and subtlety perhaps only music can bring. No one suffered more than Mozart from the high-handedness of the aristocracy, yet when *The Marriage of Figaro* gives voice to the growing mood of revolution, it does so as a protest against the abuse of human rights rather than in a spirit of personal resentment. In the first act, Figaro's aria "Se vuol ballare" expresses the pent-up frustration of generations of men and women who had endured injustices and who could take no more. The musical form and expression is still restrained, indeed Classical, but Mozart pours into it the feelings of the age.

Mozart's ability to create characters who seem real, whose feelings we can identify with, reaches its height in the countess. Ignored and duped by her husband, the laughingstock of those around her, she expresses the conflicting emotions of a woman torn between resentment and deep attachment. Her third-act aria "Dove sono" begins with a recitative in which she vents her bitterness. Gradually, it melts into a slow and meditative section in which she asks herself what went wrong: "Where are those happy moments of sweetness and pleasure, where did they go, those vows of a deceiving tongue?" The poignant theme to which these words are set returns toward the end of the slow section to provide one of the most affecting moments in opera. Mozart's gift for expressing human behavior at its most noble is conveyed in the aria's final section, where the countess decides, despite everything, to try to win back her husband's love. Thus, in seven or eight minutes, we have been carried from despair to hope, and Mozart has combined his revelation of a human heart with music that by itself is of extraordinary beauty.

The opera as a whole is far richer than a discussion of these two arias can suggest. For instance, among the other characters is one of the composer's most memorable creations, the pageboy Cherubino, whose aria "Non so più" epitomizes the breathless, agonizing joy of adolescent love. An accomplishment of another kind is exemplified by the **ensembles** (groups of supporting singers and actors). Here Mozart combines clarity of musical and dramatic action while advancing the plot at a breakneck pace.

The Marriage of Figaro expresses at the same time the spirit of its age and the universality of human nature, a truly Classical achievement. Equally impressively, it illuminates the personal emotions of individual people and, through them, teaches us about our own reactions to life and its problems. As one distinguished writer has put it, in this work Mozart has added to the world's understanding of people—of human nature.

LITERATURE IN THE EIGHTEENTH CENTURY

While painters, poets, and musicians were reflecting the changing moods of the 18th century in their art, social and political philosophers were examining the problems of contemporary society more systematically. Individual thinkers frequently alternated between optimism and despair, because awareness of the greatness of which human beings were capable was always qualified by the perception of the sorry state of the world. The broad range of diagnoses and proposed solutions makes it difficult to generalize on the nature of 18th-century intellectual life, but two contrasting trends can be discerned. A few writers, notably Jonathan Swift, reacted to the problems of the age with deep pessimism, bitterly opposing the view that human nature is basically good.

Others, convinced that progress was possible, sought to devise new systems of intellectual, social, or political organization. Rational humanists like Diderot and political philosophers like Rousseau based their arguments on an optimistic view of human nature. However, Voltaire, the best known of all

18th-century thinkers, fitted into neither of these two categories—rather, he moved from one to the other. The answer he finally proposed to the problems of existence is as applicable to the world of today as it was to that of the 18th century, although perhaps no more welcome.

The renewed interest in Classical culture, visible in the portraits by Sir Joshua Reynolds and buildings like Le Panthéon, also made a strong impression on literature. French writers such as Jean Racine (1639–1699) had already based works on Classical models, and the fables of Jean de La Fontaine (1621–1695) drew freely on Aesop and other Greek and Roman sources. Elsewhere in Europe throughout the 18th century, poets continued to produce works on Classical themes, from the plays of Pietro Metastasio (1698–1782) in Italy to the lyric poetry of Friedrich von Schiller (1759–1805) in Germany.

The appeal of Neo-Classical literature was particularly strong in England, where major Greek and Roman works like Homer's *The Iliad* and *The Odyssey* or Virgil's *The Aeneid* had long been widely read and admired. In the 17th century, Milton's *Paradise Lost* had represented a deliberate attempt to create an equally monumental epic poem in English. Before the 18th century, however, several important works, including the tragedies of Aeschylus, had never been translated into English.

The upsurge of enthusiasm for Classical literature that characterized the 18th-century English literary scene had two chief effects: poets and scholars began to translate or retranslate the most important Classical authors; and creative writers began to produce original works in Classical forms, deal with Classical themes, and include Classical references. The general reading public was by now expected to understand and appreciate both the ancient masterpieces and modern works inspired by them.

The Augustans

The principal English writers formed a group calling themselves Augustans. The name reveals the degree to which these writers admired and modeled themselves on the Augustan poets of ancient Rome. In 27 CE, the victory of the first Roman emperor Augustus ended the chaos of civil war in Rome and brought peace and stability to the Roman world. The principal poets of Rome's Augustan Age, writers like Virgil and Horace, subsequently commemorated Augustus's achievement in works intended for a sophisticated public. In the same way in England, the restoration to power of King Charles II (in 1660) seemed to some of his contemporaries a return to order and civilization after the tumultuous English Civil War. The founders of the English Augustan movement, writers like John Dryden (1631–1700), explored not only the historical parallel, by glorifying English achievement under the monarchy, but also the literary one, by imitating the highly polished style of the Roman Augustan poets in works intended for an aristocratic audience. Dryden also translated the works of Virgil, Juvenal, and other Roman poets into English.

ALEXANDER POPE'S ROCOCO SATIRES Alexander Pope (1688–1744), the greatest English poet of the 18th century,

was one of the Augustans, yet the lightness and elegance of his wit reflect the Rococo spirit of the age. His genius lay precisely in his awareness that the dry bones of Classical learning needed to have life breathed into them. The spirit that would awaken art in his own time, as it had done for the ancient writers, was that of nature—not in the sense of the natural world but of that which is universal and unchanging in human experience. Pope's conception of the vastness and truth of human experience, given form and meaning by rules first devised in the ancient past, represents 18th-century thought at its most constructive.

Pope suffered throughout his life from ill health. When he was 12, an attack of spinal tuberculosis left him permanently crippled. Perhaps in compensation, he developed the passions for reading and the beauty of the world around him that shine through his work. A Catholic in a Protestant country, he was unable to establish a career in public life or obtain public patronage for his literary work. As a result, he was forced to support himself entirely by writing and translating. Pope's literary reputation was first made by the *Essay on Criticism*, but he won economic independence by producing highly successful translations of Homer's *The Iliad* (1713–1720) and *The Odyssey* (1725–1726) and an edition of the works of Shakespeare (1725). With the money he earned from these endeavors, he abandoned commercial publishing and confined himself, for the most part, to his house on the river Thames at Twickenham, where he spent the rest of his life writing, entertaining friends, and indulging his fondness for gardening.

Pope's range as a poet was considerable, but his greatest achievements were in the characteristically Rococo medium of satire. Like his fellow countryman Hogarth, Pope's awareness of the heights to which humans can rise was coupled with an acute sense of the frequency of their failure to do so. In the long poem *An Essay on Man* (1733–1734), for example, Pope combines Christian and humanist teachings in a characteristically 18th-century manner to express his philosophical position with regard to the preeminent place occupied by human beings in the divine scheme of life. Early in the poem, Pope strikes a chord that will resonate remarkably with contemporary astronomers seeking planets revolving around other stars:

READING 19.1 ALEXANDER POPE

An Essay on Man, lines 17–28

Say first, of God above or Man below,
What can we reason but from what we know?
Of Man what see we but his station here,
From which to reason, or to which refer?
Through worlds unnumbered though the God be known,
'Tis ours to trace him only in our own.
He, who through vast immensity can pierce,
See worlds on worlds compose one universe,
Observe how system into system runs,
What other planets circle other suns,
What varied being peoples ev'ry star,
May tell why Heav'n has made us as we are.

The poem is divided into four epistles (letters written in verse) to a friend, Henry Bolingbroke. The first of these discusses that part that evil plays in a world created by God. The conclusion of the epistle powerfully expresses the view that a belief that God has erred in permitting evil to invade the world is illusion, that humans cannot perceive the overall design of things:

READING 19.2 ALEXANDER POPE

An Essay on Man, lines 289–294

All nature is but art, unknown to thee;
All chance, direction, which thou canst not see;
All discord, harmony not understood;
All partial evil, universal good:
And, spite of pride, in erring reason's spite,
One truth is clear, "Whatever is, is right."

Pope is at his best when applying his principles to practical situations and uncovering human folly. Pope's reverence for order and reason made him the implacable foe of those who in his eyes were responsible for the declining political morality and artistic standards of the day. It is sometimes said that Pope's satire is tinged with personal hostility. In fact, a series of literary and social squabbles marked his life, suggesting that he was not always motivated by the highest ideals; nonetheless, in his poetry, he nearly always based his moral judgments on what he described as "the strong antipathy of good to bad," a standard he applied with courage and wit.

JONATHAN SWIFT'S SAVAGE INDIGNATION

Perhaps the darkest of all visions of human nature in the 18th century was that of Jonathan Swift (1667–1745). In a letter to Alexander Pope, he made it clear that, whatever his affection for individuals, he hated the human race as a whole. According to Swift, human beings were not to be defined automatically as rational animals, as so many 18th-century thinkers believed, but as animals capable of reason. It was precisely because so many of them failed to live up to their capabilities that Swift turned his "savage indignation" against them into bitter satire, never more so than when the misuse of reason served "to aggravate man's natural corruptions" and provide new ones.

Swift was in a position to observe at close quarters the political and social struggles of the times. Born in Dublin, for much of his life he played an active part in supporting Irish resistance to English rule. After studying at Trinity College, Dublin, he went to England and (in 1694) was ordained a priest in the Anglican Church. For the next few years, he moved back and forth between England and Ireland, taking a leading role in the political controversies of the day by publishing articles and pamphlets that, in general, were strongly conservative.

A fervent supporter of the monarchy and of the Anglican Church, Swift had good reason to hope that his advocacy of their cause would win him a position of high rank. In 1713, this hope was partially realized with his appointment as dean of Saint Patrick's Cathedral in Dublin. Any chances he had of receiving an English bishopric were destroyed in 1714 by the death of Queen Anne and the subsequent dismissal of Swift's political friends from power.

Swift spent the remainder of his life in Ireland, cut off from the mainstream of political and cultural life. Here he increasingly emerged as a publicist for the Irish cause. During his final years, his mind began to fail but not before he had composed the epitaph under which he lies buried in Saint Patrick's Cathedral: *Ubi saeva indignatio ulterius cor lacerare nequit* ("He has gone where savage indignation can tear his heart no more").

During his years in Ireland, Swift wrote his best-known work, *Gulliver's Travels*, which was first published in 1726. In a sense, *Gulliver's Travels* has been a victim of its own popularity, because its surprising success as a work for young readers has distracted attention from the author's real purpose: to satirize human behavior. (It says much for the 18th century's richness that it could produce two writers working in the same genre—the satirists Swift and Pope—with such differing results.) The first two of Gulliver's four voyages, to the miniature land of Lilliput (**Fig. 19.21**) and to Brobdingnag, the land of giants, are

▶ **19.21** Gulliver's Voyage to Lilliput, 1860s. Colored print from *Gulliver's Travels*, published by Nelson & Sons, United Kingdom. This color plate from *Gulliver's Travels* shows Gulliver ingratiating himself with the tiny populace of Lilliput by disabling an enemy fleet.

the best known. In these sections, the harshness of Swift's satire is to some extent masked by the charm and wit of the narrative. In the voyage to the land of the Houyhnhnms, however, Swift draws a bitter contrast between the Houyhnhnms, a race of horses whose behavior is governed by reason, and their slaves, the **Yahoos**, human in form but bestial in behavior. As expressed by the Yahoos, Swift's vision of the depths to which human beings can sink is profoundly pessimistic. His insistence on their deep moral and intellectual flaws is in strong contrast to the rational humanism of many of his contemporaries, who believed in the innate dignity and worth of human beings.

Yet even the Yahoos do not represent Swift's most bitter satire. It took his experience of the direct consequences of "man's inhumanity to man" to draw from his pen a short pamphlet, *A Modest Proposal for Preventing the Children of Poor People in Ireland from Being a Burden to Their Parents or Country, and for Making Them Beneficial to the Public*, the title of which is generally abbreviated to *A Modest Proposal*. First published in 1729, this brilliant and shocking work was inspired by the poverty and suffering of a large sector of Ireland's population. Even today, the nature of the supposedly benevolent author's "modest proposal" can take the reader's breath away, both by the calmness with which it is offered and by the devastatingly quiet logic with which its implications are explained. All the irony of which this master satirist was capable is here used to express anger and disgust at injustice and the apparent inevitability of human suffering. Although Swift was writing in response to a particular historical situation, the deep compassion for the poor and oppressed that inspired him transcends its time. Our own world has certainly not lost the need for it.

Swift's modest proposal for managing the problem of overpopulation and undernourishment turns out to be simple: the rich should eat the poor:

READING 19.3 JONATHAN SWIFT

From *A Modest Proposal for Preventing the Children of Poor People in Ireland from Being a Burden to Their Parents or Country, and for Making Them Beneficial to the Public*

It is a melancholy object to those who walk through this great town, or travel in the country, when they see the streets, the roads and cabin doors, crowded with beggars of the female sex, followed by three, four, or six children, all in rags and importuning every passenger for an alms. These mothers, instead of being able to work for their honest livelihood, are forced to employ all their time in strolling to beg sustenance for their helpless infants; who as they grow up either turn thieves for want of work, or leave their dear native country, to fight for the Pretender in Spain,[2] or sell themselves to the Barbadoes.[3]

I think it is agreed by all parties that this prodigious number of children in the arms, or on the backs, or at the heels of their mothers, and frequently of their fathers, is in the present deplorable state of the kingdom a very great additional grievance; and therefore whoever could find out a fair, cheap, and easy method of making these children sound useful members of the commonwealth, would deserve so well of the public as to have his statue set up for a preserver of the nation.

But my intention is very far from being confined to provide only for the children of professed beggars; it is of a much greater extent, and shall take in the whole number of infants at a certain age who are born of parents in effect as little able to support them as those who demand our charity in the streets.

. . .

There is likewise another great advantage in my scheme, that it will prevent those voluntary abortions, and that horrid practice of women murdering their bastard children, alas, too frequent among us! sacrificing the poor innocent babes I doubt more to avoid the expense than the shame, which would move tears and pity in the most savage and inhuman breast.

ROBERT BURNS The Scotsman Robert Burns (1759–1796) had a troubled life and died young, possibly from excessive drinking. Much of his work expresses Scottish nationalism, but his most beloved poem is likely "To a Mouse," which is addressed to an animal he turns up, accidentally, with his shovel. The poem contains a couple of the best-known lines in poetry, here translated as: "The best laid schemes of mice and men go oft awry." Burns concludes in expressing his envy of the mouse who cannot contemplate the disappointments of the past or the uncertainties of the future:

READING 19.4 ROBERT BURNS

"To a Mouse," lines 1–6 and 37–48

Wee, sleeket, cow'rin',[4] tim'rous beastie,
O, what a panic's in thy breastie!
Thou need na start awa sae hasty,
 Wi' bickering brattle![5]
I wad be laith[6] to rin an' chase thee,
 Wi' murd'ring pattle![7]

. . .

But Mousie, thou art no thy lane[8]
In proving foresight may be vain:
The best laid schemes o' mice an' men,
 Gang aft a-gley,[9]

2. The Pretender, who claimed the English throne, was James Stuart, son of James II of England, who was thrown off the throne during the Glorious Revolution.

3. Slaves sold to the Barbadoes, paralleled with the Irish, whom the English exploited for cheap labor.

4. Cowering.
5. Scurrying.
6. Loath; reluctant.
7. A small shovel.
8. Not alone.
9. Often go awry.

An' lea'e us nought but grief and pain,
 For promis'd joy.

Still, thou art blest, compar'd wi' me!
The present only toucheth thee:
But Och! I backward cast my e'e,
 On prospects drear!
An' forward, tho' I canna see,
 I guess an' fear.

MARY WOLLSTONECRAFT Mary Wollstonecraft (1759–1797) is a towering figure of the Enlightenment, although in her day, she was seen as more of a brilliant, erudite rabble-rouser. Not only did she criticize the concept of private property as a sort of oppression of the have-nots, she also was among the first to offer a sustained argument for women's rights and equality. (Incidentally, she was also the mother of Mary Wollstonecraft Shelley, who would write one of the most famed novels of all time: *Frankenstein.*) Wollstonecraft was the second of five siblings, born into a family with a drunken, brutal father and a submissive mother. More than once Wollstonecraft slept on the landing outside her parents' bedroom, futilely hoping to protect her mother. Even so, her mother favored a brother.

In spite of this background—or due to it—Wollstonecraft would obtain a Classical education and bear a biting pen, as in *A Vindication of the Rights of Women*:

READING 19.5 MARY WOLLSTONECRAFT

From *A Vindication of the Rights of Women*, Introduction

After considering the historic page, and viewing the living world with anxious solicitude, the most melancholy emotions of sorrowful indignation have depressed my spirits, and I have sighed when obliged to confess, that either nature has made a great difference between man and man, or that the civilization which has hitherto taken place in the world has been very partial. I have turned over various books written on the subject of education, and patiently observed the conduct of parents and the management of schools; but what has been the result?—a profound conviction that the neglected education of my fellow-creatures is the grand source of the misery I deplore; and that women, in particular, are rendered weak and wretched by a variety of concurring causes, originating from one hasty conclusion. The conduct and manners of women, in fact, evidently prove that their minds are not in a healthy state; for, like the flowers which are planted in too rich a soil, strength and usefulness are sacrificed to beauty; and the flaunting leaves, after having pleased a fastidious eye, fade, disregarded on the stalk, long before the season when they ought to have arrived at maturity. —One cause of this barren blooming I attribute to

a false system of education, gathered from the books written on this subject by men who, considering females rather as women than human creatures, have been more anxious to make them alluring mistresses than affectionate wives and rational mothers; and the understanding of the sex[10] has been so bubbled[11] by this specious homage, that the civilized women of the present century, with a few exceptions, are only anxious to inspire love, when they ought to cherish a nobler ambition, and by their abilities and virtues exact respect.

. . .

I wish to persuade women to endeavor to acquire strength, both of mind and body, and to convince them that the soft phrases, susceptibility of heart, delicacy of sentiment, and refinement of taste, are almost synonymous with epithets of weakness, and that those beings who are only the objects of pity and that kind of love, which has been termed its sister, will soon become objects of contempt.

Later, Wollstonecraft comments on the failure of education to teach people to think as individuals, with the consequence that they swallow the false ideas of the age:

READING 19.6 MARY WOLLSTONECRAFT

From *A Vindication of the Rights of Women*, chapter 2

Men and women [are] educated, in a great degree, by the opinions and manners of the society they live in. In every age there has been a stream of popular opinion that has carried all before it, and given a family character, as it were, to the century. It may then fairly be inferred, that, till society be differently constituted, much cannot be expected from education.

As she proceeds, Wollstonecraft challenges the misogynist view of the likes of John Milton, Alexander Pope, Jean-Jacques Rousseau, Cervantes, and a certain "Dr. Gregory"—that is, Dr. John Gregory, who had written a popular book on the education of women: *A Father's Legacy to His Daughters* (1774). Gregory, for example, urged his daughters to "dance with spirit" but never to allow themselves to be so transported by joy as to forget the "delicacy" of their gender. Gregory, writes Wollstonecraft, goes so far as to advise his daughters "to cultivate a fondness for dress, because a fondness for dress, he asserts, is natural to them." Wollstonecraft steadily demolishes the opposition and presents ideas for education that will defeat stereotypes and enhance the mental faculties of the individual.

10. That is, female.
11. Deceived by insubstantial nonsense.

Rational Humanism: The Encyclopedists

DENIS DIDEROT Belief in the essential goodness of human nature and the possibility of progress, as expressed by the humanists of the Renaissance, continued to find supporters throughout the 18th century. The enormous scientific and technical achievements of the two centuries since the time of Erasmus tended to confirm the opinions of those who took a positive view of human capabilities. It was in order to provide a rational basis for this positive humanism that the French thinker and writer Denis Diderot (1713–1784) conceived the preparation of a vast encyclopedia that would describe the state of contemporary science, technology, and thought and provide a system for the classification of knowledge.

Work on the *Encyclopédie*, as it is generally called, began in 1751; the last of its 17 volumes appeared in 1772. By its conclusion, what had begun as a compendium of information had become the statement of a philosophical position: that the extent of human powers and achievements conclusively demonstrates that humans are rational beings. The implication of this position is that any political or religious system seeking to control the minds of individuals is to be condemned. It is hardly surprising, therefore, that some years before the conclusion of the project, the *Encyclopédie* had been banned by decree of Louis XV; the last volumes were published clandestinely.

CHARLES-LOUIS MONTESQUIEU In religious terms, the *Encyclopédie* took a position of considerable skepticism, advocating freedom of conscience and belief. Politically, however, its position was less extreme and less consistent. One of the most distinguished philosophers to contribute political articles was Charles-Louis Montesquieu (1689–1755), whose own aristocratic origins may have helped mold his relatively conservative views. Both in the *Encyclopédie* and in his own writings, Montesquieu advocated the retention of a monarchy, with powers divided between the king and a series of "intermediate bodies" that included parliament, aristocratic organizations, the middle class, and even the church. By distributing power in this way, Montesquieu hoped to achieve a workable system of checks and balances, thereby eliminating the possibility of a central dictatorial government. His ideas proved particularly interesting to the authors of the Constitution of the United States.

JEAN-JACQUES ROUSSEAU A very different point of view was espoused by another contributor to the *Encyclopédie*, Jean Jacques Rousseau (1712–1778), whose own quarrelsome and neurotic character played a considerable part in influencing his political philosophy. Diderot had originally commissioned Rousseau to produce some articles on music, since the latter was an accomplished composer (his opera *Le Devin du village* is still performed occasionally). After violently quarreling with Diderot and others, however, Rousseau spent much of an unhappy and restless life writing philosophical treatises and novels that expressed his political convictions. Briefly stated, Rousseau believed that the natural goodness of the human race had been corrupted by the growth of civilization and that the freedom of the individual had been destroyed by the growth of society. For Rousseau, humans were good and society was bad.

Rousseau's praise of the simple virtues like unselfishness and kindness and his high regard for natural human feelings have identified his philosophy with a belief in the "noble savage," but this phrase is misleading. Far from advocating a return to primitive existence in some nonexistent Garden of Eden, Rousseau passionately strove to create a new social order. In *The Social Contract* (1762), he tried to describe the basis of his ideal state in terms of the general will of the people, which would delegate authority to individual organs of government, although neither most of his readers nor Rousseau himself seemed clear on how this general will should operate:

> ### READING 19.7 JEAN-JACQUES ROUSSEAU
>
> From *The Social Contract*, Book 1, section 4: Slavery
>
> Since no man has a natural authority over his fellow, and force creates no right, we must conclude that conventions form the basis of all legitimate authority among men.
>
> . . .
>
> It will be said that the despot assures his subjects civil tranquillity. Granted; but what do they gain, if the wars his ambition brings down upon them, his insatiable avidity, and the vexatious conduct of his ministers press harder on them than their own dissensions would have done? What do they gain, if the very tranquillity they enjoy is one of their miseries? Tranquillity is found also in dungeons; but is that enough to make them desirable places to live in? The Greeks imprisoned in the cave of the Cyclops lived there very tranquilly, while they were awaiting their turn to be devoured.
>
> To say that a man gives himself gratuitously, is to say what is absurd and inconceivable; such an act is null and illegitimate, from the mere fact that he who does it is out of his mind. To say the same of a whole people is to suppose a people of madmen; and madness creates no right.
>
> Even if each man could alienate himself, he could not alienate his children: they are born men and free; their liberty belongs to them, and no one but they has the right to dispose of it. Before they come to years of discretion, the father can, in their name, lay down conditions for their preservation and well-being, but he cannot give them irrevocably and without conditions: such a gift is contrary to the ends of nature, and exceeds the rights of paternity.
>
> . . .
>
> To renounce liberty is to renounce being a man, to surrender the rights of humanity and even its duties. . . . So, from whatever aspect we regard the question, the right of slavery is null and void, not only as being illegitimate, but also because it is absurd and meaningless. The words *slave* and *right* contradict each other, and are mutually exclusive. It will always be equally foolish for a man to say to a man or to a people: "I make with you a convention wholly at your expense and wholly to my advantage; I shall keep it as long as I like, and you will keep it as long as I like."

Although Rousseau's writings express a complex political philosophy, most of his readers were more interested in his emphasis on spontaneous feeling than in his political theories. His contempt for the superficial and the artificial, and his praise for simple and direct relationships between individuals, did a great deal to help demolish the principles of aristocracy and continue to inspire believers in human equality.

Voltaire's Philosophical Cynicism: *Candide*

It may seem extravagant to claim that the life and work of François-Marie Arouet (1694–1778), best known to us as Voltaire (one of his pen names), can summarize the events of a period as complex as the 18th century. That the claim can be not only advanced but also supported is some measure of the breadth of his genius. A writer of poems, plays, novels, and history; a student of science, philosophy, and politics; a man who spent time at the courts of Louis XV and Frederick the Great but also served a prison sentence; a defender of religious and political freedom who simultaneously supported enlightened despotism, Voltaire was above all a man engagé—one committed to the concerns of his age.

After being educated by the Jesuits, Voltaire began to publish writings in the satirical style he was to use throughout his life. His belief that the aristocratic society of the times was unjust must have received strong confirmation when his critical position earned him first a year in jail and then, in 1726, exile from France. Voltaire chose to go to England, where he found a system of government that seemed to him far more liberal and just than that of the French. He returned home in 1729 and published his views on the advantages of English political life in 1734, in his *Lettres philosophiques*. He averted the scandal and possibility of arrest that his work created by living the next 10 years in the countryside.

In 1744, Voltaire was finally tempted back to the French court, but he found little in its formal and artificial life to stimulate him. He discovered a more congenial atmosphere at the court of Frederick the Great at Potsdam, where he spent the years from 1750 to 1753. Frederick's warm welcome and considerable intellectual stature must have come as an agreeable change from the sterile ceremony of the French court, and the two men soon established a close friendship. It seems, however, that Potsdam was not big enough to contain two such powerful intellects and temperaments. After a couple of years, Voltaire quarreled with his patron and once again abandoned sophisticated life for that of the country.

In 1758, Voltaire finally settled in the village of Ferney, where he set up his own court. Here the greatest names in Europe—intellectuals, artists, politicians—made the pilgrimage to talk and, above all, listen to the sage of Ferney, while he published work after work, each of which was distributed throughout Europe. Only in 1778, the year of his death, did Voltaire return to Paris, where the excitement brought on by a hero's welcome proved too much for his failing strength.

It is difficult to summarize the philosophy of a man who touched on so many subjects. Nevertheless, one theme recurs continually in Voltaire's writings: the importance of freedom of thought. Voltaire's greatest hatred was reserved for intolerance and bigotry; in letter after letter, he ended with the phrase he made famous, "Écrasez l'infâme" ("Crush the infamous thing"). The infamous thing is superstition, which breeds fanaticism and persecution. Those Voltaire judged to be chiefly responsible for superstition were the Christians—Catholic and Protestant alike.

Voltaire vehemently attacked the traditional view of the Bible as the inspired word of God. He claimed that it contained a mass of anecdotes and contradictions totally irrelevant to the modern world and that the disputes arising from it, which had divided Christians for centuries, were absurd and pointless. Yet Voltaire was far from being an atheist. He was a firm believer in a God who had created the world but whose worship could not be tied directly to one religion or another: "The only book that needs to be read is the great book of nature." Only natural religion and morality would end prejudice and ignorance.

Voltaire's negative criticisms of human absurdity are more convincing than his positive views on a universal natural morality. It is difficult not to feel at times that even Voltaire had only the vaguest ideas of what natural morality really meant. In fact, in *Candide* (1759), his best-known work, he reaches a much less optimistic conclusion. *Candide* was written with the avowed purpose of ridiculing the optimism of the German philosopher Gottfried Wilhelm Leibniz (1646–1716), who believed that "everything is for the best in the best of all possible worlds." The premise of Leibniz's argument is that God is good, God is all-knowing (omniscient) and all-powerful (omnipotent); therefore, we live in the best of all possible worlds. What appears to be evil or unfortunate is actually for the best. Because both intellect and experience teach that this is far from the case, Voltaire chose to demonstrate the folly of unreasonable optimism, as well as the cruelty and stupidity of the human race, by subjecting his hero Candide to a barrage of disasters and suffering.

In chapter 5 of *Candide*, Candide and his tutor, Dr. Pangloss, are involved in an actual event, the earthquake that destroyed most of Lisbon in 1755. When called upon to help the injured, the learned doctor meditates instead on the causes and effects of the earthquake and duly comes to the conclusion that if Lisbon and its inhabitants were destroyed, it had to be so, and therefore was all for the best:

READING 19.8 VOLTAIRE

From *Candide*, chapter 5

[Candide, Pangloss, and a sailor] walked toward Lisbon; they had a little money by the help of which they hoped to be saved from

hunger after having escaped the storm… [They] had scarcely set foot in the town when they felt the earth tremble under their feet; the sea rose in foaming masses in the port and smashed the ships which rode at anchor. Whirlwinds of flame and ashes covered the streets and squares; the houses collapsed, the roofs were thrown upon the foundations, and the foundations were scattered; thirty thousand inhabitants of every age and both sexes were crushed under the ruins. Whistling and swearing, the sailor said: "There'll be something to pick up here."

"What can be the sufficient reason for this phenomenon?" said Pangloss.

"It is the last day!" cried Candide.

The sailor immediately ran among the debris, dared death to find money, found it, seized it, got drunk, and having slept off his wine, purchased the favors of the first woman of good will he met on the ruins of the houses and among the dead and dying. Pangloss, however, pulled him by the sleeve. "My friend," said he, "this is not well, you are disregarding universal reason, you choose the wrong time."

"Blood and 'ounds!"[12] he retorted, "I am a sailor and I was born in Batavia; four times have I stamped on the crucifix[13] during four voyages to Japan; you have found the right man for your universal reason!"

Candide … lay in the street covered with debris. He said to Pangloss: "Alas! Get me a little wine and oil; I am dying."

"This earthquake is not a new thing," replied Pangloss. "The town of Lima felt the same shocks in America last year; similar causes produce similar effects; there must certainly be a train of sulfur underground from Lima to Lisbon."

"Nothing is more probable," replied Candide; "but, for God's sake, a little oil and wine."

"What do you mean, probable?" replied the philosopher; "I maintain that it is proved."

. . .

Next day they found a little food as they wandered among the ruins and regained a little strength. Afterwards they worked like others to help the inhabitants who had escaped death. Some citizens they had assisted gave them as good a dinner as could be expected in such a disaster; . . . Pangloss consoled them by assuring them that things could not be otherwise. "For," said he, "all this is for the best; for, if there is a volcano at Lisbon, it cannot be anywhere else; for it is impossible that things should not be where they are; for all is well."

A little, dark man . . . politely took up the conversation, and said: "Apparently you do not believe in original sin; for, if everything is for the best, there was neither fall nor punishment."

"I most humbly beg your excellency's pardon," replied Pangloss still more politely, "for the fall of man and the curse necessarily entered into the best of all possible worlds."

12. "God's wounds"—a form of curse.
13. All foreigners were expelled from Japan after a conspiracy of Christians had been found out. Only the Dutch, who had revealed the plot to the emperor, were allowed to remain, on the condition that they gave up Christianity and stamped on the crucifix.

THE LATE EIGHTEENTH CENTURY: TIME OF REVOLUTION

Throughout the 18th century, Europe continued to prosper economically. The growth of trade and industry, particularly in Britain, France, and Holland, led to several significant changes in the lifestyles of increasing numbers of people. Technological improvements in coal mining and iron casting began to lay the foundations for the Industrial Revolution of the 19th century. The circulation of more books and newspapers increased general awareness of the issues of the day. As states began to accumulate more revenue, they increased both the size of their armies and the number of those in government employ. The Baroque period had seen the exploitation of imported goods and spices from Asia and gold from Latin America; the 18th century was marked by the development of trade with North America and the Caribbean.

Amid such vast changes, it was hardly possible that the systems of government should remain unaffected. Thinkers like Rousseau and Voltaire began to question the hitherto unquestioned right of the wealthy aristocracy to rule throughout Europe. In Britain, both at home and in the colonies, power was gradually transferred from the king to Parliament. Prussia, Austria, and Russia were ruled by so-called enlightened despots, as we have seen.

The French Revolution

In France, however—the center of much of the intellectual pressure for change—the despots were not even enlightened. Louis XV, who ruled from 1715 to 1774, showed little interest in the affairs of his subjects or the details of government. The remark often attributed to him, "Après moi le déluge" ("After me the flood"), suggests that he was fully aware of the consequences of his indifference. Subsequent events fully justified his prediction, yet throughout his long reign, he remained either unwilling or unable to follow the examples of his fellow European sovereigns and impose some order on government. By the time his grandson Louis XVI succeeded him in 1774, the damage was done. Furthermore, the new king's continued reliance on the traditional aristocratic class, into whose hands he put wealth and political power, offended both the rising middle class and the peasants.

When in 1788 the collapse of the French economy was accompanied by a disastrous harvest and consequent steep rise in the cost of food in the first phase of the revolution, riots broke out in Paris and in rural districts. In reaction to the ensuing violence, the Declaration of the Rights of Man and of the Citizen, which asserted the universal right to "liberty, property, security, and resistance to oppression," was passed on August 26, 1789. Its opening section clearly shows the influence of the American Declaration of Independence:

READING 19.9 FRENCH NATIONAL ASSEMBLY

From the Declaration of the Rights of Man and of the Citizen

The representatives of the French people, organized in National Assembly, considering that ignorance, forgetfulness, or contempt of the rights of man are the sole causes of public misfortunes and of the corruption of governments, have resolved to set forth in a solemn declaration the natural, inalienable, and sacred rights of man, in order that such declaration, continually before all members of the social body, may be a perpetual reminder of their rights and duties; in order that the acts of the legislative power and those of the executive power may constantly be compared to the aim of every political institution and may accordingly be more respected; in order that the demands of the citizens, founded henceforth upon simple and incontestable principles, may always be directed toward the maintenance of the Constitution and the welfare of all.

Accordingly, the National Assembly recognizes and proclaims, in the presence and under the auspices of the Supreme Being, the following rights of man and citizen.

- Men are born and remain free and equal in rights; social distinctions may be based only on general usefulness.
- The aim of every political association is the preservation of the natural and inalienable rights of man; these rights are liberty, property, security, and resistance to oppression.
- The source of all sovereignty resides essentially in the nation; no group, no individual may exercise authority not emanating expressly therefrom.
- Liberty consists of the power to do whatever is not injurious to others; thus the enjoyment of the natural rights of every man has for its limits only those that assure other members of society the enjoyment of those same rights; such limits may be determined only by law.
- The law has the right to forbid only actions which are injurious to society. Whatever is not forbidden by law may not be prevented, and no one may be constrained to do what it does not prescribe.
- Law is the expression of the general will; all citizens have the right to concur personally, or through their representatives, in its formation; it must be the same for all, whether it protects or punishes. All citizens, being equal before it, are equally admissible to all public offices, positions, and employments, according to their capacity, and without other distinction than that of virtues and talents.

Declarations alone hardly sufficed, however; after two and a half years of continual political bickering and unrest, the revolution entered its second phase. On September 20, 1792, the National Convention was assembled. One of its first tasks was to try Louis XVI, now deposed and imprisoned for treason. After unanimously finding him guilty, the convention was divided on whether to execute him. He was finally condemned to the guillotine by a vote of 361 to 360 and beheaded forthwith. The resulting Reign of Terror lasted until 1795. During it, utopian theories of a republic based on liberty, equality, and fraternity were ruthlessly put into practice. The revolutionary leaders cold-bloodedly eliminated all opponents, real or potential, and created massive upheaval throughout all levels of French society.

The principal political group in the convention, the Jacobins, was at first led by Maximilien de Robespierre (1758–1794). One of the most controversial figures of the revolution, Robespierre is viewed by some as a demagogue and bloodthirsty fanatic, by others as a fiery idealist and ardent democrat; his vigorous commitment to revolutionary change is disputed by no one. Following Rousseau's belief in the virtues of natural human feelings, Robespierre aimed to establish a "republic of virtue," made up democratically of honest citizens.

In order to implement these goals, revolutionary courts were established, which tried and generally sentenced to death those perceived as the enemies of the revolution. The impression that the Reign of Terror was aimed principally at the old aristocracy is incorrect. Only nobles suspected of political agitation were arrested, but the vast majority of the guillotine's victims—some 70 percent—were rebellious peasants and workers. Neither were revolutionary leaders immune. Georges-Jacques Danton (1759–1794), one of the earliest spokesmen of the revolution and one of Robespierre's principal political rivals, was executed in March 1794 along with some of his followers.

Throughout the rest of Europe, events in France were followed with horrified attention. Austria and Prussia were joined by England, Spain, and several smaller states in a war against the revolutionary government. After suffering initial defeat, the French enlarged and reorganized their army and succeeded in driving back the allied troops at the Battle of Fleurus in June 1794. Paradoxically, the military victory, far from reinforcing Robespierre's authority, provided his opponents the strength to eliminate him; he was declared an outlaw on July 27, 1794, and guillotined the next day.

By the spring of the following year, the country was in economic chaos and Paris was torn by street rioting. Many of those who had originally been in favor of revolutionary change, including businessmen and landowning peasants, realized that whatever the virtues of democracy, constitutional government was essential. In reply to these pressures, the convention produced a new constitution, which specified a body of five directors—the Directory—that held executive power. This first formally established French Republic lasted only until 1799, when political stability returned to France with the military dictatorship of Napoléon Bonaparte.

Revolution in America

Although the French Revolution was an obvious consequence of extreme historical pressures, many of its leaders were additionally inspired by the successful outcome of another revolution: that of the Americans against their British rulers. More specifically, the Americans had rebelled against not the British king but the British parliament. In 18th-century

CULTURE AND SOCIETY

Revolution

O wild West Wind, thou breath of Autumn's being,
Thou, from whose unseen presence the leaves dead
Are driven, like ghosts from an enchanter fleeing,
Yellow, and black, and pale, and hectic red,
Pestilence-stricken multitudes: O thou
Who chariotest to their dark wintry bed
The wingéd seeds, where they lie cold and low,
Each like a corpse within its grave, until
Thine azure sister of the spring shall blow
Her clarion o'er the dreaming earth, and fill
(Driving sweet buds like flocks to feed in air)
With living hues and odours plain and hill:
Wild Spirit, which art moving everywhere;
Destroyer and preserver; Hear, O hear!

—"Ode to the West Wind," stanza 1,
Percy Bysshe Shelley (1819)

Shelley's ode was written 19 years after the 18th century had passed, and on its surface, it is a pastoral description of changing seasons. Symbolically, many analysts find reference to the Age of Revolution which had just passed, ushering in new regimes in America and France, industry, and to the Enlightenment, in which intellectuals sought to lift reason and science above a sea of superstition. Perhaps the wind of freedom blows eastward from the Americas. Perhaps the leaves are peoples of different colors.

Indeed, the 18th century saw a series of vast upheavals in patterns of European life that had remained constant since the Late Middle Ages. The Renaissance and the subsequent Reformation and Counter-Reformation had laid the intellectual bases for the change. The 18th century was marked by their consequences. One revolution was in economic affairs. As a result of exploration and colonization, international trade and commerce increased, which enriched ever-growing numbers of middle-class citizens and their families. On the other hand, the endless wars of the 17th century left national governments deeply in debt. In England, the state introduced paper money for the first time in an attempt to restore financial stability. The transfer of wealth from the public sector to private hands encouraged

speculation. Spectacular financial collapses of private companies—the most notorious being that of the South Sea Company—produced panic and revolutionary changes in banking systems.

Another revolution, perhaps in the long run the most important of all, was the development of industry. The Industrial Revolution, which reached its climax in the mid-19th century, had its origins a century earlier. The invention of new machines, particularly in the textile industry, led to the establishment of factories, which in turn produced the growth of urban life. New mining techniques turned coal into big business. New technologies revolutionized modes of travel that had been virtually unchanged since Roman times.

At the same time, the complex structure of international diplomatic relations that had existed for centuries began to collapse. Although France remained the leading European power, its economy and internal stability were undermined by the refusal of its ruling class to admit change, and Britain became the richest country in the world. The dominant powers of Renaissance Europe and the Age of Exploration—Spain, Portugal, the city-states of Italy—were in decline, while important new players appeared on the scene: Prussia under the Hohenzollerns, the Russia of Peter the Great.

Impatience with the ways of the Old Regime, together with the desire for revolutionary political and social change, found expression in the writings of Enlightenment figures such as Voltaire. By the end of the 18th century, many people throughout Europe were increasingly frustrated with living in continual political and social deprivation. As a result, they took to the streets in direct physical action.

The American Revolution undermined the power of the monarchy in Britain and sped up the collapse of the Old Regime in France. The French Revolution petered out in the years of Napoleonic rule but marked a watershed in Western history and culture: ever since the late 18th century, governments have had to reckon with intellectual protest and direct political action by their citizens.

CONNECTIONS On December 14, 1799—just as the momentous 18th century drew to a close—George Washington died of a throat infection in his home in Mount Vernon. Ten years earlier, he had taken his oath of office as the first president of the United States. Washington served two terms (1789–1797), after which he returned to his life as a gentleman planter, albeit for less than three years.

Washington was a towering figure, literally (he was 6 feet 2 inches tall) and metaphorically—the "father" of a new nation who had been the Commander in Chief of the Continental Army and the force behind the Constitutional Convention that led to the ratification of the new Constitution of the United States. It is no surprise that likenesses of Washington became pervasive after his death and that a large percentage of them would be inferior works at best. A pamphlet published by the American Academy of Fine Arts in 1824 on the proper representation of the first president illustrates the fact that the trade in such portraits had gotten completely out of hand.

It was a wise decree of Alexander the Great that none should paint his portrait but Apelles, and none but Lysippus [see Fig. 3.21] sculpture his likeness; we feel the want of such a regulation in the case of our Washington, whose countenance and person, as a man, were subjects for the finest pencil and the most skillful chisel. But we are cursed as a nation with the common, miserable representations of our Great Hero, and with the shocking counterfeits of his likeness by every pitiful bungler that lifts a tool or a brush, working solely from imagination without any authority for their misrepresentations and deceptions, and bolstered up by every kind of imposture.

This evil has arisen to such a height that it is necessary for something to be done to rectify the public sentiment on this point, . . . For these reasons, we have drawn up a list of artists who painted and sculptured from life . . . that the public may know where to find the true standard of what were genuine likenesses of Washington at the respective periods of life at which they were done [namely, with his natural teeth intact, after he lost them, or after he acquired a new set], with a comparative view of those originals most worthy of confidence.

* Robert Charles Sands, *Atlantic Magazine* (October 1824): 433–435.

▲ **19.22** Gilbert Stuart, *George Washington* (1796). Oil on canvas, 121.3 × 94 cms.

England, the king was given little chance to be enlightened or otherwise, because supreme power was concentrated in the legislative assembly, which ruled both England and, by its appointees, British territories abroad. A series of economic measures enacted by Parliament succeeded in thoroughly rousing American resentment. The American Revolution followed the Declaration of Independence of July 4, 1776. Although the Declaration of Independence was certainly not intended as a work of literature, its author, generally assumed to be Thomas Jefferson, was as successful as any of the literary figures of the 18th century in expressing the more optimistic views of the age. The principles enshrined in the document assume that human beings are capable of achieving political and social freedom. Positive belief in equality and justice is expressed in universal terms like *man* and *nature*—universal for their day, that is—typical of 18th-century enlightened thought:

READING 19.10 PROBABLE PRINCIPAL AUTHOR: THOMAS JEFFERSON

From The Declaration of Independence (1776)

When in the Course of human events, it becomes necessary for one people to dissolve the political bonds which have connected them with another, and to assume among the powers of the earth, the separate and equal station to which the Laws of Nature and of Nature's God entitle them, a decent respect to the opinions of mankind requires that they should declare the causes which impel them to the separation.

We hold these truths to be self-evident, that all men are created equal, that they are endowed by their Creator with certain unalienable Rights, that among these are Life, Liberty and the pursuit of Happiness. That to secure these rights,

Governments are instituted among Men, deriving their just powers from the consent of the governed. That whenever any Form of Government becomes destructive of these ends, it is the Right of the People to alter or to abolish it, and to institute new Government, laying its foundation on such principles and organizing its powers in such form, as to them shall seem most likely to effect their Safety and Happiness. Prudence, indeed, will dictate that Governments long established should not be changed for light and transient causes; and accordingly all experience hath shown, that mankind are more disposed to suffer, while evils are sufferable, than to right themselves by abolishing the forms to which they are accustomed. But when a long train of abuses and usurpations, pursuing invariably the same Object, evinces a design to reduce them under absolute Despotism, it is their right, it is their duty, to throw off such Government, and to provide new Guards for their future security. Such has been the patient sufferance of these Colonies; and such is now the necessity which constrains them to alter their former Systems of Government. The history of the present King of Great Britain is a history of repeated injuries and usurpations, all having in direct object the establishment of an absolute Tyranny over these States.

The Constitution of the United States further underscores the beliefs in equality and freedom by delineating a balance of power between the various branches of government and between the government and the people. The Constitution has been a living document in the sense that it specifies ways in which it can be amended, lessening the need to "overthrow" it as times change. For example, the Constitution has been modified over the generations to grant freedom to slaves and full voting rights to people of all ethnic and racial backgrounds and to women.

The first ten amendments to the Constitution (see Reading 19.11) are known as the Bill of Rights, and they grant individuals freedoms that lie at the heart of the American experience, such as freedom of speech, freedom of religion, the right to bear arms, the right to "due process" of law when crimes are suspected, and the illegality of the use of "cruel and unusual punishments." They also, to some degree, reverse the weight of power between the people and the government by specifying that the states and the people bear all those powers not specifically given to the federal government. However, the states may not abridge the lawful powers of the federal government.

READING 19.11 THE BILL OF RIGHTS

The following text is a transcription of the first 10 amendments to the Constitution in their original form. These amendments were ratified December 15, 1791, and form what is known as the "Bill of Rights."

Amendment I: Congress shall make no law respecting an establishment of religion, or prohibiting the free exercise thereof; or abridging the freedom of speech, or of the press; or the right of the people peaceably to assemble, and to petition the Government for a redress of grievances.

Amendment II: A well regulated Militia, being necessary to the security of a free State, the right of the people to keep and bear Arms, shall not be infringed.

Amendment III: No Soldier shall, in time of peace be quartered in any house, without the consent of the Owner, nor in time of war, but in a manner to be prescribed by law.

Amendment IV: The right of the people to be secure in their persons, houses, papers, and effects, against unreasonable searches and seizures, shall not be violated, and no Warrants shall issue, but upon probable cause, supported by Oath or affirmation, and particularly describing the place to be searched, and the persons or things to be seized.

Amendment V: No person shall be held to answer for a capital, or otherwise infamous crime, unless on a presentment or indictment of a Grand Jury, except in cases arising in the land or naval forces, or in the Militia, when in actual service in time of War or public danger; nor shall any person be subject for the same offence to be twice put in jeopardy of life or limb; nor shall be compelled in any criminal case to be a witness against himself, nor be deprived of life, liberty, or property, without due process of law; nor shall private property be taken for public use, without just compensation.

Amendment VI: In all criminal prosecutions, the accused shall enjoy the right to a speedy and public trial, by an impartial jury of the State and district wherein the crime shall have been committed, which district shall have been previously ascertained by law, and to be informed of the nature and cause of the accusation; to be confronted with the witnesses against him; to have compulsory process for obtaining witnesses in his favor, and to have the Assistance of Counsel for his defence.

Amendment VII: In Suits at common law, where the value in controversy shall exceed twenty dollars, the right of trial by jury shall be preserved, and no fact tried by a jury, shall be otherwise re-examined in any Court of the United States, than according to the rules of the common law.

Amendment VIII: Excessive bail shall not be required, nor excessive fines imposed, nor cruel and unusual punishments inflicted.

Amendment IX: The enumeration in the Constitution, of certain rights, shall not be construed to deny or disparage others retained by the people.

Amendment X: The powers not delegated to the United States by the Constitution, nor prohibited by it to the States, are reserved to the States respectively, or to the people.

GLOSSARY

Allegro (p. 646) In music, a quick, lively tempo.

Classical (p. 644) A term for music written during the 17th and 18th centuries; more generally, referring to serious music as opposed to popular music.

Enlightenment (p. 626) A philosophical movement of the late 17th and 18th centuries that challenged tradition, stressed reason over blind faith or obedience, and encouraged scientific thought.

Ensemble (p. 648) A group of musicians, actors, or dancers who perform together.

Laissez-faire (p. 633) French for "let it be"; in economics, permitting the market to determine prices.

Minuet (p. 645) A slow, stately dance for groups of couples.

Neo-Classicism (p. 637) An 18th-century revival of Classical Greek and Roman art and architectural styles, generally characterized by simplicity and straight lines.

Opera (p. 626) A dramatic performance in which the text is sung rather than spoken.

Pediment (p. 642) In architecture, any triangular shape surrounded by *cornices*, especially one that surmounts the *entablature* of the *portico façade* of a Greek temple.

Polyphony (p. 642) A form of musical expression characterized by many voices.

Portico (p. 642) A roofed entryway, like a front porch, with columns or a colonnade.

Rococo (p. 627) An 18th-century style of painting and of interior design that featured lavish ornamentation. Rococo painting was characterized by light colors, wit, and playfulness. Rococo interiors had ornamental mirrors, small sculptures and reliefs, wall paintings, and elegant furnishings.

Sonata form (p. 646) A musical form having three sections: exposition (in which the main theme or themes are stated), development, and recapitulation (repetition) of the theme or themes.

Style galant (p. 643) A style of elegant, lighthearted music that was popular in France during the early part of the 18th century.

Yahoo (p. 651) In *Gulliver's Travels*, a crude, filthy, and savage creature, obsessed with finding "pretty stones" by digging in mud—Swift's satire of the materialistic and elite British.

THE BIG PICTURE THE EIGHTEENTH CENTURY

Language and Literature

- Pope wrote his "Essay on Criticism" in 1711, followed by successful translations of Homer's *The Iliad* (1713–1720) and *The Odyssey* (1725–1726).
- Swift wrote *Gulliver's Travels* in 1726 and *A Modest Proposal* in 1729.
- Diderot published 17 volumes of the *Encyclopédie* between 1751 and 1772, with contributions from Montesquieu and Rousseau.
- Voltaire wrote *Candide* in 1759.
- Rousseau wrote *The Social Contract* in 1762.
- Burns wrote "To a Mouse" in 1785.

Art, Architecture, and Music

- Watteau, Boucher, Fragonard, Carriera, Lebrun, Gainsborough, and Tiepolo painted in the Rococo style.
- Neumann designed buildings in the Rococo style.
- David painted in the Neo-Classical style, creating *The Oath of the Horatii* in 1784 and *Napoleon Crossing the Alps* in 1800.
- Canova sculpted *Pauline Bonaparte Borghese as Venus Victorious* in the Neo-Classical style in 1808.
- Soufflot's Le Panthéon in Paris and Jefferson's home in Monticello were constructed in the Neo-Classical style.
- Symphonies were written and the orchestra came to include most of the instruments used today, with separate sections for string instruments, brass, percussion instruments, and clarinets and flutes.
- Classical music reached a new height with the works of Haydn in the 1790s and Mozart in the 1760s through 1791.
- Mozart wrote 22 operas, including *The Marriage of Figaro* (1786), *Don Giovanni* (1787), *Così fan tutte* (1790), and *The Magic Flute* (1791).

Philosophy and Religion

- Pope wrote his *Essay on Man* in 1733–1734.
- Voltaire wrote *Lettres philosophiques* in 1734.
- Rousseau wrote *The Social Contract* in 1762.
- Adam Smith published *The Wealth of Nations* in 1776.
- Wollstonecraft wrote *A Vindication of the Rights of Women* in 1792.

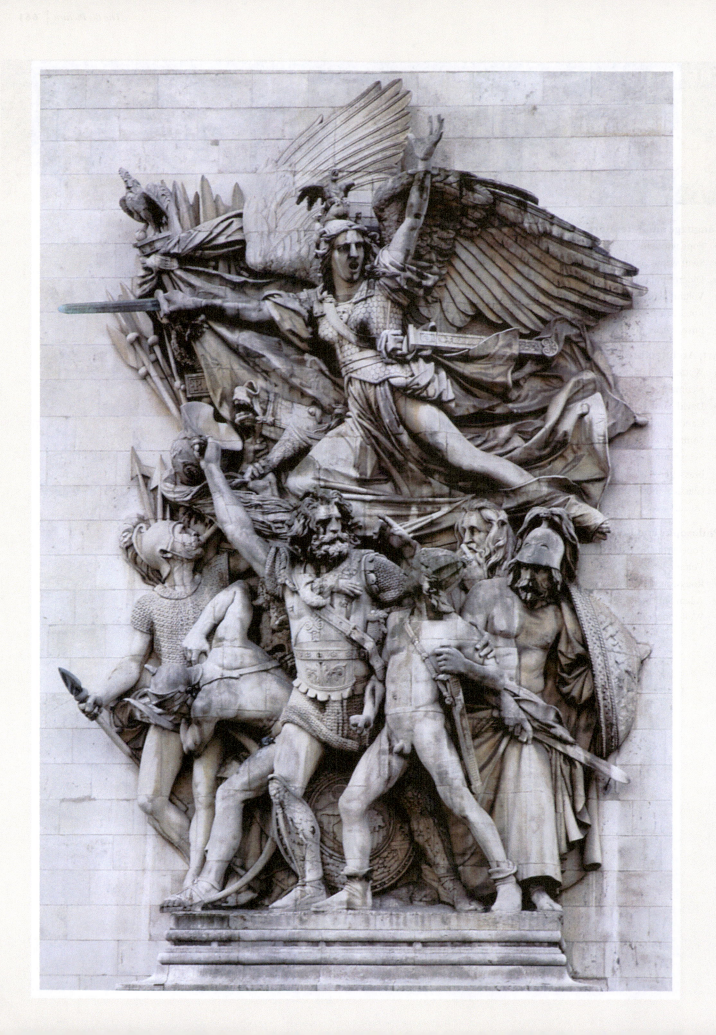

Europe and America: 1800–1870

PREVIEW

It was the best of times, it was the worst of times, it was the age of wisdom, it was the age of foolishness, it was the epoch of belief, it was the epoch of incredulity, it was the season of Light, it was the season of Darkness, it was the spring of hope, it was the winter of despair, we had everything before us, we had nothing before us, we were all going direct to heaven, we were all going direct the other way…

Thus begins Charles Dickens's novel *A Tale of Two Cities* set in the year 1775. It is the same year that the American colonists engaged with British troops in the Battle of Lexington and Concord after the "shot heard round the world" incited the armed struggle of the American Revolution against the United Kingdom, and just 14 short years before the storming of the Bastille prison sparked the beginning of the French Revolution against the ancient régime in 1789.

The intertwining human dramas of *A Tale of Two Cities*, which was published in 1859, unfold against the cities of Paris and London in the late 18th century. Almost 70 years after the event that inspired Dickens, it remained vivid in the minds of his readers, whose nostalgia for the glories of the not-so-recent past drove the novel's success. Dickens published its 45 chapters in a periodical called *All the Year Round* over the course of 30 weeks, enthralling readers who waited impatiently for the next installment. To what did this piece of historical fiction owe its popularity?

The Romantic poet William Wordsworth, who died in 1850, lived in England at the time of the French Revolution. He wrote, "Bliss was it in that dawn to be alive, / But to be young was very heaven!" In spite of the violence and bloodshed of the tumultuous era of revolutions, the memory of human resolve, the lust for freedom, and uncompromising heroism lingered. They also continued to inspire.

On one of the large pillars of the Napoleonic Arc de Triomphe (Arch of Triumph) in Paris, an inset relief over 40 feet high commemorates the heroism of volunteers who defended the French border along the Rhine River from foreign forces hostile to the revolution: men armed in Classically inspired costumes including greaves, helmets, and shields are roused by the battle cry of the personification of liberty (**Fig. 20.1**). She leads them to victory with an unsheathed sword, protecting them under her wings and cloak. The figural group, entitled *Departure of the Volunteers of 1792*, was created between 1833 and 1836, in the midst of the Romantic era; it is also known as *La Marseillaise*, after a war song written by Claude-Joseph Rouget de Lisle in 1792. "La Marseillaise" was adopted as the first anthem of the nation of France and is played and sung to this day.

◀ **20.1** François Rude, *Departure of the Volunteers of 1792 (La Marseillaise)*, 1833–1836. Limestone, 41' 8" (12.7 m) high. Arc de Triomphe, Paris, France.

GO LISTEN!
"LA MARSEILLAISE"

POLITICAL, INDUSTRIAL, AND TECHNOLOGICAL REVOLUTIONS

The tide of revolution that swept away much of the old political order in Europe and America in the last quarter of the 18th century had momentous consequences—political, social, and artistic. The French Revolution of 1789 and the almost decade-long American Revolutionary War (1775–1783) inspired waves of rebellion that led to the upheaval of political institutions throughout Europe. The year 1848 was a pivotal one, with revolutions in Italy, France, Germany, Denmark, the Habsburg Empire, parts of Poland, Belgium, the Danube States (Romania), and Ireland. Only a few European states escaped rebellions in this volatile year. Although in many instances the revolutions collapsed soon after, the balance of power and nature of society radically changed.

Similarly, the industrial development and scientific progress of the 19th century overthrew centuries-old ways and saw vast changes in the lives of millions of people. The railroad, using engines powered by steam, first appeared in 1825 between Stockton and Darlington in England. By 1850, there were 6000 miles of track in the United Kingdom, 3000 in Germany, 2000 in France, and the beginnings of a rail system in Austria, Italy, and Russia. The economic impact was overwhelming. The railroad industry provided jobs, offered opportunities for capital investment, and increased the demand for coal and iron.

Industry soon overtook agriculture as the source of national wealth. With the growth of mass production in factories, the cities connected by rail became vast urban centers, attracting migration from the countryside. The number of people living in cities rose dramatically. The population of Turin, in northern Italy, was 86,000 by 1800, 137,000 by 1850, and more than 200,000 by 1860. Half of the United Kingdom's inhabitants lived in cities by 1850, the first time in social history that so large a percentage of a population was concentrated in an urban center; one Londoner described his city in the 1820s as "a wilderness of human beings."

Crowds of provincials flocked to great cities like London, Paris, and Vienna for employment and better wages, but also to enjoy metropolitan life and culture. One visitor to Paris described it as "a glass beehive, a treat to the student of humanity." Cities were seductive: they had public gardens, dance halls, fireworks, concerts, and other attractions for the ever-expanding working class and the rising bourgeoisie. Cities also fed the social and material desires of the very rich, whose world of glittering balls and A-list parties were the subject of literature, art, and music. Giuseppe Verdi's opera, *La Traviata*, for example, was based on the life story of the Parisian courtesan Marie Duplessis, who died of tuberculosis. The opera's main protagonists—the courtesan Marguerite and her provincial lover Armand—embody the tension between the allure of city life (even with its perils of disease tied to overcrowded and unsanitary conditions) and the return to nature for physical and spiritual repair. The truth was that the life expectancy of a male living in mid-19th-century London was less than half that of one living in the country.

Tale of Two Cities: London and Paris

Vast social change in cities outstripped societies' abilities to keep pace; this was nowhere truer than in London. As people crowded into the densely packed city, housing burst at

Europe and America: 1800–1870

1789 CE	1815 CE	1848 CE	1870 CE
French Revolution	Napoléon escapes Elba and is defeated at the Battle of Waterloo	Revolutionary uprisings throughout Europe	
French Reign of Terror	Industrialization of England	Transatlantic cable is begun	
Napoléon rules France as consul	Faraday discovers the principle of the electric dynamo	Darwin publishes *On the Origin of Species*	
Napoléon's Russian campaign fails	Greek War of Independence from the Ottoman Empire	Unification of Italy	
Stephenson's first locomotive	Industrialization of France and Belgium	American Civil War	
Congress of Vienna	Reign of Queen Victoria in the United Kingdom (1837–1901)	Unification of Germany	
	Industrialization of Germany	United Kingdom grants Canada dominion status	
	Morse perfects the telegraph in 1844	First transcontinental railroad is completed in United States	

the seams. Many who arrived from farms in search of their fortunes drifted into marginal and disagreeable jobs (rag picking, collecting excrement), and public welfare programs sprang into being to address poverty. Some migrants turned to crime. In 1829, circumstances led Sir Robert Peel to establish the first British police force; its members became known as bobbies, after their founder.

A lack of an adequate sewage system and street cleaning led to cholera and typhoid fever, the result of water polluted with human and animal waste and the flies it attracted, as well as the spread of lice among humans. By the middle of the 19th century, London was at a breaking point; in 1858, the "Great Stink" emanating from the polluted Thames River forced the British Parliament to take legislative measures to stop the crisis. This is the London that features so prominently in stories by Charles Dickens like *Hard Times* and *Oliver Twist*—stories of a world that could not have seemed farther removed from the London of Westminster Abbey and the Houses of Parliament. By the end of the century, a sewer system was in place, public health had improved, and more and better housing had been constructed. By 1900, it was just about as safe and healthy to live in the city as it was in the countryside.

Another response to the ills of the industrialized city was the design and construction of public parks, which served both hygienic and humanitarian purposes. In his essay on 19th-century public parks, particularly in London, Frank Clark quotes the British social reformer Francis Place on the benefits of a bit of country in the city: public parks can "instill a hallowed calm, and a spirit of reverence into the mind and heart." Clark further cites the words of one of the bishop of London's priests: "they, who might otherwise have been absolutely pent up and stifled in the smoke and din of their enormous prison may take breath in our parks...to satisfy that inextinguishable love for nature and fresh air and the bright face of the sun."[1]

The arrival in London of the railways, including the underground railway system, and public transportation connected the inner city with the outer suburbs in a more efficient manner and thus offered the best of both worlds. It was possible for individuals to separate their living quarters from the workplace, and by the early 20th century, posters advertising the convenience and health benefits of suburban living papered London. The city reoriented itself around railway stations and terminals. Train travel was both mundane and exotic, carrying people from home to work and from the city to adventures beyond.

One of the grandest 19th-century urbanization projects in the West was the modernization of the city of Paris. The *Haussmann Plan*, named after Georges-Eugène Haussmann

▲ **20.2 Charles Garnier, Palais Garnier, 1860–1875. The Paris National Opera House, Paris, France.** The Beaux-Arts building is dramatically staged at the end of an opulent boulevard—the Avenue de l'Opéra—which connects it with the Musée du Louvre. The Palais Garnier—also known as the Opera Garnier—was not only a venue for music but also a place for fashionable Parisians who sought to see and be seen.

(1809–1891, known as Baron Haussmann) was commissioned by Louis-Napoléon (Napoléon III) following the 1848 Revolution, a series of rebellions that essentially pitted the working and lower middle classes against the privileged and wealthy. "Modernization" was begun in 1853, ostensibly for the benefit of the masses. Yet a primary motive was to replace the Parisian warren of streets and alleyways with straight, wide boulevards so that revolutionaries could not readily conceal themselves for attack and retreat. Paris today retains many of these smaller passageways that open into the boulevards and are dotted with shops and cafés. But Haussmann had many homes and neighborhoods *condemned*—that is, the city paid owners and took possession of them—and razed; he replaced them with apartments with pristine stone façades, wrought-iron balconies, and mansard roofs. Haussmann created a coding system that governed all aspects of the designs of buildings—including height—so as to create beauty through consistency. His boulevards, with their sweeping vistas, often culminated with something spectacular to look at, such as a splendid monument or building (**Fig. 20.2**). The effects were stunning, and Haussmann's aesthetic became synonymous with the city of Paris. He also built parks, new sewers, and water works.

The United States

The mid-19th century in the United States brought a grave challenge to the union with the secession of a block of 11 southern states that formed the Confederate States of America. From

1. Frank Clark, "Nineteenth-Century Public Parks from 1830," *Garden History* 1, no. 3 (Summer 1973): 31.

CULTURE AND SOCIETY

Charles Baudelaire: A View of the Modernization of Paris

For all of its renowned urban beauty, the mid-19th century modernization of Paris came with a price. Georges-Eugène Haussmann, the major architect of change, was seen as both creator and destroyer. In 1861, the French poet Charles Baudelaire, who felt alienated in his own city, wrote that Paris had been despoiled—just as the ancient Greeks had despoiled Troy.

From "The Swan," in *Flowers of Evil* ("Parisian Scenes," 1861):

Andromache,* I think of you! That stream,
and sometimes witness to your widowhood's
enormous majesty of mourning—that
mimic Simoïs salted by your tears,
suddenly inundates my memory
as I cross the new Place du Carrousel.†
Old Paris is gone (no human heart
changes half so fast as a city's face)
and only in my mind's eye can I see
the junk laid out to glitter in the booths
among the weeds and splintered capitals,
blocks of marble blackened by the mud;
there used to be a poultry market here,
and one cold morning—with the sky swept clean,
the ground, too, swept bay garbage men who raised
clouds of soot in the icy air—I saw
a swan that had broken out of its cage,

webbed feet clumsy on the cobblestones,
white feathers dragging in the uneven ruts,
and obstinately pecking at the drains,
drenching its enormous wings in the filth
as if in its own lovely lake, crying
"Where is the thunder, when will it rain?"
I see it still, inevitable myth,
like Daedalus dead-set against the sky†—
the sky quite blue and blank and unconcerned
that straining neck and that voracious beak,
as if the swan were castigating God!
Paris changes…But in sadness like mine
nothing stirs—new buildings, old
neighborhoods turn to allegory,
and memories weigh more than stone.
One image, near the Louvre, will not dissolve:
I think of that great swan in its torment,
silly, like all exiles, and sublime,
endlessly longing…

* Hector's widow in *The Iliad*.

† An area of Paris that was constructed to replace the bohemian artists' quarter where Baudelaire had lived.

‡ The mythical Greek inventor who escaped from imprisonment with his son Icarus on wax wings that melted in the sun.

1861 to 1865, the American Civil War was fought between the North (the Union forces consisting of 23 states) and the South (the Confederacy). It is estimated that as many as 620,000 lost their lives during the war, although more died from diseases and collateral damage than were killed in action. The right to own slaves was the reason for the secession of the southern states, which maintained that the system was necessary to support the agrarian economy—particularly the cotton industry. Abraham Lincoln—an antislavery president—was elected in 1860, prompting action on the part of the southern states. Secession, viewed as treason, became the *casus belli*, or justification for the war. The war concluded with a Union victory upon the surrender of the Confederacy on April 9, 1865. Consequently, slavery was outlawed throughout the nation. John Wilkes Booth, who sympathized with the Confederacy, assassinated Lincoln five days later. Because of the invention of photography, we have documentary photographs of the Civil War battlefields, as well as many images of Abraham Lincoln (**Fig. 20.3**).

THE INTELLECTUAL MILIEU

For many philosophers in the middle of the 18th century, *reason* was the guiding principle of human thought and existence. A banner for the Enlightenment era may well have quoted Immanuel Kant's definition of the philosophy in his 1784 essay "Answering the Question: What Is Enlightenment?" For Kant, it was the freedom to use one's own *intelligence*. Implicit in "one's own intelligence" was the rejection of the blind authority of established institutions (of the church and state), the pursuit of knowledge and scientific truths (as opposed to a belief in dogma and a life in the grip of superstition and fear), and the potential of the individual to achieve great things and to employ reason to effect the betterment of society. The ideals of the Enlightenment era shaped historical events in the late 18th century—including the revolutions in North America and France and the nature of their postmonarchy constitutions.

20.3 Mathew Brady, Abraham Lincoln, 1864. Albumen print 2¼" × 3¾" (5.7 × 9.5 cm) on carte de visite mount 2½" × 4" (6.4 × 10.2 cm). Library of Congress, Prints and Photographs Division, Washington, DC.

As the century came to a close, there was a dramatic shift in the intellectual and cultural discourse from reason to *feeling*. Kant questioned the validity of reason as the exclusive path to understanding the real, positing that feeling may offer an equally valuable guide to knowledge. The central role of feeling—and its expression—drew the focus on the uniqueness of the individual and the inner self and the human capacity for self-fulfillment.

Romanticism as a cultural movement was multifaceted. The emphasis on innate feeling led to an interest in the *primitive*—that is, in the simple life unmediated by the authority of established institutions and nature untouched, unspoiled by human presence. Romanticism also put a premium on *imagination* as a creative force—that intangible, powerful bit of consciousness that bridges the intellect and the emotions.

IMMANUEL KANT The ideas that proved most attractive to the Romantic imagination developed in Germany at the end of the 18th century. Their chief spokesman was Immanuel Kant (1724–1804), whose *Critique of Judgment* (1790) defined the pleasure we derive from art as "disinterested satisfaction." Kant conceived of art as uniting opposite principles. It unites the general with the particular, for example, and reason with the imagination. For Kant, the only analogy for the way in which art is at the same time useless and yet useful was to be found in the world of nature.

Kant also taught that the apparent characteristics of objects in the world are products of our minds. He noted that prior to Copernicus, people believed that the apparent motion of the sun around the earth was its actual motion. Copernicus showed that the sun's apparent motion was a product of our perception of the earth's motion. Kant further argued that the human mind imposes an order on the outside world, including concepts such as space and time. This order also requires our continuous consciousness. Whatever is "out there"—in the world beyond the person—must be filtered through the mind to become meaningful. So did Romantic artists and writers believe that experience was made meaningful by filtering it through their artistic minds.

GEORG WILHELM FRIEDRICH HEGEL Even more influential than Kant was Georg Wilhelm Friedrich Hegel (1770–1831), whose ideas continued to affect approaches to art criticism into the 20th century. Like Kant, Hegel stressed art's ability to reconcile and make sense of opposites—to provide a **synthesis** of the two opposing components of human existence, called **thesis** (an idea or pattern of behavior) and **antithesis** (the direct opposite). This process, he held, applied to the workings of the mind and also to the workings of world history, through the development and realization of what he called the World Spirit. Hegel's influence on his successors lay less in the details of his philosophical system than in his acceptance of divergences and his attempt to reconcile them. The search for a way to combine differences, to permit the widest variety of experience, still stimulates much contemporary thinking about the arts.

ARTHUR SCHOPENHAUER Both Kant and Hegel developed their ideas in the relatively optimistic intellectual climate of the late 18th and early 19th centuries, and their approach to art and to existence is basically positive. But in his major work, *The World as Will and Idea* (1819), Arthur Schopenhauer (1788–1860) expressed the belief that people are selfish and rarely rational, and that the sciences and the humanities both create the false impression that the world is a reasonable place. At the time of its appearance, Schopenhauer's work made little impression, largely because of the popularity of Kant's and Hegel's idealism. Schopenhauer did not help matters by launching a bitter personal attack on Hegel. But the failure of mid-century nationalist uprisings in many parts of Europe produced a growing mood of pessimism and gloom, against which background Schopenhauer's vision of a world condemned to be ravaged perpetually by strife and misery seemed more convincing. Thus, his philosophy, if it did not mold the Romantic movement, came to reflect its growing despondency.

KARL MARX Many of the developments in 19th-century thought had little direct impact on the arts. Perhaps the most influential of 19th-century philosophers, because of his effect on the 20th century to come, was Karl Marx (1818–1883), whose belief in the inherent evil of capitalism and in the historical inevitability of a proletarian revolution was powerfully expressed in his *Communist Manifesto* (1848).

Marx's belief that revolution was both unavoidable and necessary was based at least in part on his own observation of working conditions in industrial England, where his friend and fellow Communist Friedrich Engels (1820–1895) had inherited

a textile factory. Marx and Engels both believed that the factory workers, although creating wealth for the middle classes, derived no personal benefit. Living in overcrowded, unsanitary conditions, the workers were deprived of any effective political power and kept quiet only by the drug of religion, which offered them the false hope of rewards in a future life. The plight of the working classes seemed to Marx to transcend all national boundaries and create a universal proletariat who could only achieve freedom through revolution: "Workers of the world, unite!" Marx asserted. "You have nothing to lose but your chains!" The drive to political action was underpinned by Marx's economic philosophy, with its emphasis on the value of labor and, more generally, on the supreme importance of economic and social conditions as the true moving forces behind historical events. This so-called materialist concept of history was to have worldwide repercussions in the century that followed Marx's death. More recent writers, such as Bertolt Brecht

(1898–1956), have embraced Marxist principles, and Marxist critics have developed a school of aesthetic criticism that applies standards based on Marxist doctrines. During the 19th and early 20th centuries, however, Marx's influence was exclusively social and political.

Marx clearly delineated his views on the arts: Art can contribute to important social and political changes, and is thus a determining factor in history. Neither is artistic output limited to the upper or more prosperous social classes; according to the "principle of uneven development," a higher social order does not necessarily produce a correspondingly high artistic achievement. Capitalism is, in fact, hostile to artistic development because of its obsession with money and profit. As for styles, the only one appropriate for the class struggle and the new state is Realism, which would be understood by the widest audience. Vladimir Lenin, the Russian revolutionary who led the October Revolution of 1917—which overthrew the tsarist

READING 20.1 KARL MARX AND FRIEDRICH ENGELS

From *The Communist Manifesto* (1848)

Preface

A spectre is haunting Europe—the spectre of Communism. All the Powers of old Europe have entered into a holy alliance to exorcise this spectre; Pope [Vatican] and Csar [Russia], Metternich [Austria] and Guizot [France], French Radicals, and German police-spies.

Where is the party in opposition that has not been decried as communistic by its opponents in power? Where the Opposition that has not hurled back the branding reproach of Communism, against the more advanced opposition parties, as well as against its re-actionary adversaries?

Two things result from this fact.

I. Communism is already acknowledged by all European powers to be itself a Power.

II. It is high time that Communists should openly, in the face of the whole world, publish their views, their aims, their tendencies, and meet this nursery tale of the Spectre of Communism with a Manifesto of the party itself.

To this end, Communists of various nationalities have assembled in London, and sketched the following manifesto, to be published in the English, French, German, Italian, Flemish and Danish languages.

...

II Proletarians and Communists

In what relation do the Communists stand to the proletarians as a whole?

The Communists do not form a separate party opposed to other working-class parties.

They have no interests separate and apart from those of the proletariat as a whole.

They do not set up any sectarian principles of their own, by which to shape and mould the proletarian movement.

...

The immediate aim of the Communists is the same as that of all the other proletarian parties: formation of the proletariat into a class, overthrow of the bourgeois supremacy, conquest of political power by the proletariat.

The theoretical conclusions of the Communists...[express] actual relations springing from an existing class struggle, from a historical movement going on under our very eyes. . .

...

The distinguishing feature of Communism is not the abolition of property generally, but the abolition of bourgeois property. . .

...

IV Position of the Communists in Relation to the Various Existing Opposition Parties

In short, the Communists everywhere support every revolutionary movement against the existing social and political order of things.

In all these movements they bring to the front, as the leading question in each, the property question, no matter what its degree of development at the time.

Finally, they labour everywhere for the union and agreement of the democratic parties of all countries.

The Communists disdain to conceal their views and aims. They openly declare that their ends can be attained only by the forcible overthrow of all existing social conditions. Let the ruling classes tremble at a Communistic revolution. The proletarians have nothing to lose but their chains. They have a world to win.

Working men of all countries, unite!

regime—developed this doctrine further in the Soviet Union when he ordered that art should be a specific "reflection" of reality and used the Communist Party to enforce the official cultural policy.

The Communist Manifesto—Reading 20.1 reproduces the famous preface and part 4 with its ringing final exhortation—was written jointly by Marx and Engels to serve as a program for a secret workingmen's society, the Communist League, but subsequently became the core of all Communist doctrine. The translation that appears here was done by Samuel F. Moore under the supervision of Engels. *Bourgeois* defines the class of modern capitalists, owners of the means of social production and employers of wage labor. In a note to the 1888 English edition, Engels defined the proletariat as the "class of modern wage laborers who, having no means of production of their own, are reduced to selling their labor power in order to live."

CHARLES DARWIN

"My nose had spoken falsely."

—Charles Darwin

No single book affected 19th-century readers more powerfully than *On the Origin of Species by Means of Natural Selection* by Charles Robert Darwin (1809–1882), which appeared in 1859. As a student at Cambridge, in 1831 Darwin volunteered to serve as the scientist for an expeditionary voyage to the Galápagos Islands on the HMS *Beagle*. Darwin's adventure would lead to the development of his theory of evolution, but it might never have happened at all. The ship's captain, Robert Fitzroy, was concerned about having Darwin along on account of the shape of his nose. Fitzroy placed credence in *physiognomy*, a practice of assessing character by the facial features, and Darwin's nose worried him. He relented, however, and Darwin undertook the historic voyage that would change science.

Darwin studied geological formations, fossils, and the distribution of plant and animal types. On examining his material, he became convinced that species were not fixed categories, as had always been held, but were instead capable of variation. Drawing on the population theories of Thomas Malthus and the geological studies of Sir Charles Lyell, Darwin developed his theory of evolution as an attempt to explain the extinction of old species and the development of new species.

According to Darwin, animals and plants evolve by a process of **natural selection** (as opposed to artificial selection, which is used by farmers and animal breeders). Over time, some variations of each species survive while others die out. Those likely to survive are those best suited to prevailing environmental conditions—a process called survival of the fittest. Changes in the environment would lead to adjustments within the species. The first publication of this theory appeared in 1858, in the form of a short scientific paper; *On the Origin of Species* appeared a year later (see Reading 20.2):

READING 20.2 CHARLES DARWIN

From *On the Origin of Species*, chapter 14, "Recapitulation and Conclusion" (1859)

Under domestication we see much variability. This seems to be mainly due to the reproductive system being eminently susceptible to changes in the conditions of life; so that this system, when not rendered impotent, fails to reproduce offspring exactly like the parent-form. Variability is governed by many complex laws,—by correlation of growth, by use and disuse, and by the direct action of the physical conditions of life.

...

Man does not actually produce variability; he only unintentionally exposes organic beings to new conditions of life, and then nature acts on the organisation, and causes variability. But man can and does select the variations given to him by nature, and thus accumulate them in any desired manner. He thus adapts animals and plants for his own benefit or pleasure. He may do this methodically, or he may do it unconsciously by preserving the individuals most useful to him at the time, without any thought of altering the breed. It is certain that he can largely influence the character of a breed by selecting, in each successive generation, individual differences so slight as to be quite inappreciable by an uneducated eye.

...

There is no obvious reason why the principles which have acted so efficiently under domestication should not have acted under nature. In the preservation of favoured individuals and races, during the constantly-recurrent Struggle for Existence, we see the most powerful and ever-acting means of selection. The struggle for existence inevitably follows from the high geometrical ratio of increase which is common to all organic beings.... More individuals are born than can possibly survive. A grain in the balance will determine which individual shall live and which shall die, —which variety or species shall increase in number, and which shall decrease, or finally become extinct. As the individuals of the same species come in all respects into the closest competition with each other, the struggle will generally be most severe between them.... The slightest advantage in one being, at any age or during any season, over those with which it comes into competition, or better adaptation in however slight a degree to the surrounding physical conditions, will turn the balance.

With animals having separated sexes there will in most cases be a struggle between the males for possession of the females. The most vigorous individuals, or those which have most successfully struggled with their conditions of life, will generally leave most progeny. But success will often depend on having special weapons or means of defence, or on the charms of the males; and the slightest advantage will lead to victory.

▲ **20.4** Thomas Nast, cartoon from *Harper's Weekly*, August 19, 1871. Woodcut (colorized), 5" × 4" (12.7 × 10.2 cm). Private collection. Thomas Nast satirizes Charles Darwin's theory of evolution by showing a gorilla seeking the protection of Henry Bergh, the founder of the American Society for the Prevention of Cruelty to Animals while Darwin looks on. This is one of the less ugly cartoons that was used to denigrate Darwin.

In 1871, Darwin published *The Descent of Man*, which claimed that humans and apes descended from a common ancestor, even though the fossil record had not thus far provided evidence of the links. In the past few decades, however, anthropologists have been literally unearthing many of those links.

The impact of both books was spectacular. Their author quietly continued his research and tried to avoid the popular controversy surrounding his work. Church leaders thundered their denunciations of a theory that utterly contradicted the notion that humans, along with everything else, had been created by God in their current form in accordance with a divine plan. An example of the reaction against Darwin is shown in the Thomas Nast cartoon in **Figure 20.4**. On the other hand, scientists and freethinkers stoutly defended Darwin, often enlarging his claims. One hundred fifty years later, the debate continues in the United States, with some school districts demanding that creationism be taught alongside Darwinism or even that evolution not be taught at all.

Other Intellectual Developments

In other sciences, research brought a host of new discoveries. Experiments in magnetism and electricity advanced physics.

Using new chemical elements, the French chemist Louis Pasteur (1822–1895) explored the process of fermentation and invented pasteurization—a procedure that helped improve the safety of food. Equally beneficial was Pasteur's demonstration that disease is spread by living but invisible (to the naked eye, at least) germs, which can be combated by vaccination and the sterilization of medical equipment.

FROM NEO-CLASSICISM TO ROMANTICISM

American and French revolutionaries had used art as a means of expressing their spiritual rejection of the aristocratic societies against which they were rebelling, and both adopted Neo-Classicism to do it. Jacques-Louis David's portrayals of Greek and Roman virtue (see Fig. 19.12) and Thomas Jefferson's evocation of classical architecture as a symbol of the principles of the new Republic, represented the revolutionaries' view of their place in history. Neo-Classicism, however, barely survived into the beginning of the 19th century. Romanticism, which, at first, was a parallel movement, eventually replaced Neo-Classicism and came to dominate every aspect of art and culture in the 19th century.

NEO-CLASSICAL ART IN NINETEENTH CENTURY FRANCE

Napoléon Bonaparte crowned himself emperor in 1804 and enlisted Jacques-Louis David (1748–1825) as First Painter of the Empire, granting the artist (perhaps literally) a new lease on life. David was present at the coronation and afterward crafted—with the input of his patron—an enormous composition recording, in detail, the glory and politics of the event (**Fig. 20.5**). Napoléon chose the focal point of the painting: after crowning himself, rather than allowing the pope to crown him, he bestows the crown of empress on the head of his wife, Joséphine. The pope sits behind Napoléon, and Joséphine kneels and bows before her husband. In that exact moment, Napoléon's supreme authority and power are represented as unchallenged.

David's **Neo-Classical** style underscored this air of authority, bolstered by its association with the Classical past—especially the Roman Republic and Empire. The coronation took place in the Gothic cathedral of Notre-Dame in Paris, but the site was transformed to reflect Napoléon's taste for Neo-Classicism; architects were hired to create a stage set of sorts, featuring sweeping arches and thick piers inlaid with patterned stone. Napoléon knew well the potential power of images and used David to exploit it, even, as in *The Consecration of Emperor Napoleon I*, micromanaging the content to serve his own purpose. Napoléon insisted that David portray the pope

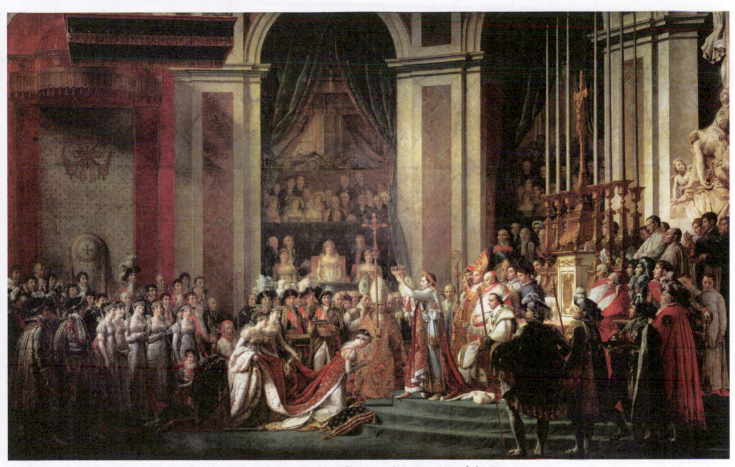

▲ **20.5** Jacques-Louis David, *The Consecration of Emperor Napoleon I and Coronation of the Empress Joséphine in the Cathedral of Notre-Dame de Paris, 2 December, 1804*, 1806–1807. Oil on canvas, 20′ 4½″ × 32′ 1¾″ (621 × 979 cm). **Musée du Louvre, Paris, France.** In the painting, Napoléon is about to crown his wife, Joséphine, as Empress. The painting also shows Napoléon's mother as present, although she was not.

with a gesture of blessing (not originally recorded in the artist's drawings of the event) and include the emperor's mother (in a seat of honor in the center middle ground of the painting), even though she refused to attend the event. Although the composition was intended to record the details of the coronation, some of those details rewrote history.

David remained a prominent figure in the French art world and a mentor of students in the Neo-Classical style. For all of his own strict adherence to Classical models and his belief that students should be learned in Classical studies, his respect for individual interests and talents and his flexibility as a master teacher are evident in the work of two of his most well-known students—Anne-Louis Girodet-Trioson (1767–1824) and Jean-Auguste-Dominique Ingres (1780–1867). While their styles were inspired by David and while they were committed to Classical form, their subjects pointed in a different direction—toward exoticism and emotion, eroticism and fantasy. We can consider both of these artists transitional figures between Neo-Classicism and Romanticism.

ANNE-LOUIS GIRODET-TRIOSON *The Entombment of Atala* (see **Fig. 20.6** on p. 672) depicts a Romantic narrative set in the American wilderness, acted out, as it were, by Classical figures. Drawn from a popular work by the French Romantic novelist François-Auguste-René de Chateaubriand (1768–1848), it is the tragic story of a young Native American man and woman—Chactas and Atala—who have fallen in love but are from different tribes. Atala has taken a vow of chastity and, rather than break it, commits suicide. A hooded priest helps Chactas lower her gently into her grave; his arms and torso are wrapped tightly around her legs, as he cannot bring himself to part with her.

David's Neo-Classical hand can be felt in Girodet-Trioson's painting by its idealism, linearity and sculptural forms, attention to detail, and frieze-like placement of the dramatic narrative in the foreground plane. But the painting also contains just about every conceivable element of Romanticism: an exotic location, eroticism, unfulfilled love, and the pain and emotion of the individual. Girodet-Trioson's setting, with its lush, tropical plants, is intended to evoke the New World—specifically the Louisiana wilderness. Atala's wan, feminine beauty, more delicate and sensual even in death, contrasts strongly with Chactas's rough, knotty musculature and the long, dark, curly hair that flows from his head, over her thighs, and into her lap.

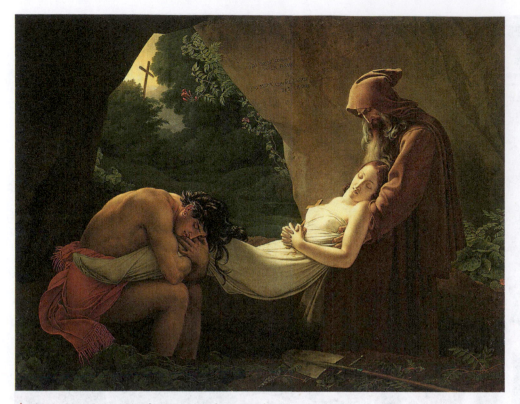

▲ **20.6** Anne-Louis Girodet-Trioson, *The Entombment of Atala*, 1808. Oil on canvas, 83" × 105" (207 × 267 cm). Musée du Louvre, Paris, France. The anti-Classical nature of the subject is emphasized by the Christian symbolism of the two crosses, one leaning on the cave wall behind Atala and the other rather improbably placed high in the jungle outside the cave.

Chactas mourns Atala deeply, movingly, but privately. Despite larger references to Christianity, primitivism, and social mores, it is the intimacy of Chactas's emotional suffering that moves the viewer.

JEAN-AUGUSTE-DOMINIQUE INGRES David's most prodigious student, Jean-August-Dominique Ingres created pristine compositions in an even purer style of Neo-Classicism that was inspired specifically by Greek art. Ingres's work is a combination of precise linearity and sculptural smoothness on the one hand, and delicacy and sensuality on the other. Like David's, Ingres's forms are flawless and his painted surfaces as smooth as glass. But as did Girodet-Trioson, Ingres tapped into the early-19th-century audience's appeal for the exotic in his themes. His *Grande Odalisque* (see Fig. 20.7 in the Compare + Contrast feature on pp. 674–675), although very much in the tradition of the art-historical reclining nude, presents a twist: a Turkish harem mistress has replaced the Venus figure.

In *La Grande Odalisque*, line has a prominent role, from the languid curve of the woman's spine to the staccato folds of the rumpled bed linens. Ingres tilts the Classically rendered body toward Mannerism in the attenuation of the torso and limbs, the fullness of the lower body, and the smallish turbaned head. The creamy flesh of the odalisque is set off by subtle hues and brilliantly rendered sheens and textures, all of which contribute to the lush, sensuous atmosphere. The odalisque turns

her head toward the viewer and fixes her gaze, yet her sultry, relaxed pose remains undisturbed; she is unfazed by our presence. In Romantic art, eroticism in the context of exoticism was a socially acceptable form of fantasy.

Ingres's version of Neo-Classicism was radical (even deviant) to many who still associated David with defining and perfecting the style. Although Ingres parted company with David, he would ultimately become the self-appointed defender of his legacy against a group of artists—including Théodore Géricault and Eugène Delacroix—whose style seemed barbarous in contrast to cultured Classicism. Ingres would wage a war against Romantic painting—against its brash color and bravado brushwork, its unchained emotion and extreme subjects.

ROMANTICISM

The poet and critic Charles Baudelaire wrote, "Romanticism is precisely situated neither in choice of subject nor in exact truth, but in a way of feeling." Romanticism is more easily described as a Western cultural phenomenon than a specific set of stylistic characteristics or tendency toward specific subjects and is thus more difficult to gather into a conceptual net. Romantic artists, writers, and musicians prioritized emotions over reason and imagination over realism, but their ways of expressing this point of view differed markedly. Romanticism's guiding principal led artists to explore and dissect their own personal hopes and fears rather than to seek universal truths. Emphasis on feeling rather than intellect resulted in the expression of subjective rather than objective visions. Romanticism's penchant for the fantastic and exotic provided a vehicle for probing more deeply into an individual's creative imagination.

At a time when many people felt submerged and depersonalized in overcrowded cities, the Romantic emphasis on the individual and on self-analysis found an appreciative audience. Many artists contrasted the growing problems of urban life with an idyllic (and highly imaginative) picture of rustic bliss. The growing mechanization of life in the great cities and the effect of inventions like the railway train on urban architecture stimulated a "back to nature" movement, as Romanticism provided an escape from the grim realities of urbanization and industrialization.

Whereas in the 18th century artists had turned to nature in search of order and reason, in the 19th, the turbulence and unpredictability of nature was stressed—a mirror of the artist's emotions. Painters turned increasingly to landscape, composers

CULTURE AND SOCIETY

Principal Characteristics of the Romantic Movement

Expression of Personal Feelings

Chopin, preludes
Goya, *The Family of Charles IV* (Fig. 20.12)
Goethe, *The Sorrows of Young Werther*

Self-Analysis

Berlioz, *Symphonie fantastique*
Keats, poetry
Whitman, *Leaves of Grass*

Love of the Fantastic and Exotic

Paganini, musical compositions and performances
Girodet-Trioson, *The Entombment of Atala* (Fig. 20.6)
Delacroix, *The Death of Sardanapalus* (Fig. 20.17)

Interest in Nature

Beethoven, "Pastoral" Symphony
Constable, *The Hay Wain* (Fig. 20.19)
Wordsworth, poetry
Emerson, "The American Scholar"

Nationalism and Political Commitment

Verdi, *Nabucco*
Smetana, *Má vlast* (*My Fatherland*)
Goya, *The Third of May, 1808* (Fig. 20.13)
Byron's support of the Greeks

Erotic Love and the Eternal Feminine

Goethe, *Faust, Part Two*
Wagner, *Tristan and Isolde*

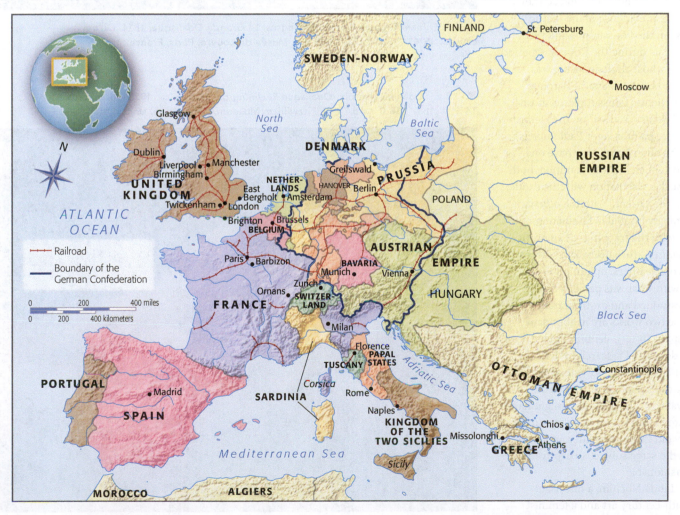

▲ **MAP 20.1** Europe around 1850.

COMPARE + CONTRAST

Women, Art, and Power: Ideology, Gender Discourse, and the Female Nude

We often use Compare + Contrast features to stimulate students' powers of visual recognition and discrimination, to test students' ability to characterize and categorize, and to encourage students to think critically about the content and context of literature and visual works of art.

You can write paragraphs on the stylistic differences alone between the odalisque paintings by Ingres (**Fig. 20.7**) and Delacroix (**Fig. 20.8**). They are archexamples of the contrast between a linear and a painterly approach to the same subject; they offer clear evidence of the "battle" between the Poussinistes and the Rubenists during the Romantic period (those whose draftsmanship was inspired by the Classical Baroque artist Nicolas Poussin versus those who "went to school" on the Flemish Baroque painter Peter Paul Rubens). On the other hand, they have one important element in common: both bespeak a fascination with the exotic, with "the Orient," with the *other*; a seemingly insatiable fascination not only with the trappings of an exotic *sensuality*—turbans, silken scarves, peacock feathers, opium pipes— but with what was perceived as an unrestrained and exotic *sexuality*. These two works are in abundant company in 19th-century France. Can you do a bit of research to discover what circumstances (historical, political, sociological, and so on) prevailed at this time and might have created a market for such paintings? Why did these very different artists find the same subject so captivating, so fashionable?

Linda Nochlin, a historian of 19th-century art and a feminist

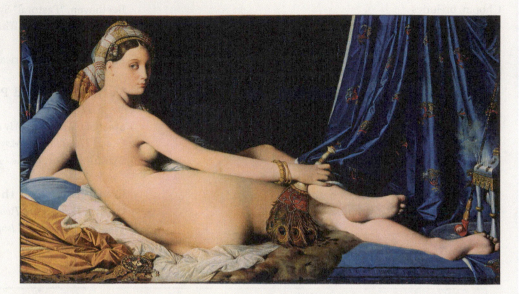

▲ **20.7** Jean-Auguste-Dominique Ingres, *La Grande Odalisque*, 1814. Oil on canvas, 35¼" × 63¾" (91 × 162 cm). Musée du Louvre, Paris, France.

▼ **20.8** Eugène Delacroix, *Odalisque Reclining on a Divan*, ca. 1825. Oil on canvas, 14⅞" × 18¾" (38.0 × 46.7 cm). Fitzwilliam Museum, Cambridge, United Kingdom.

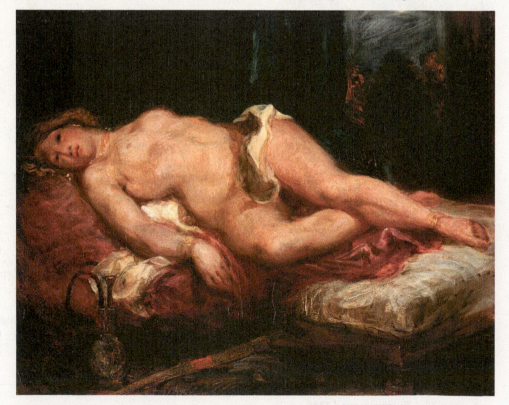

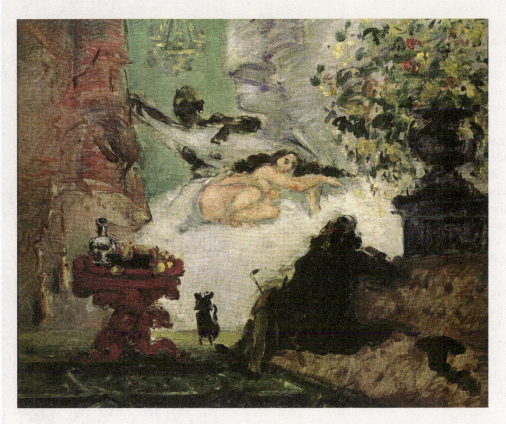

20.9 **Paul Cezanne, *A Modern Olympia*, 1873–1874. Oil on canvas, 18 ¼" × 21 ⅞" (46.0 × 55.5 cm). Musée d'Orsay, Paris, France.**

in art, literature, and film this way: Men are in the position of looking, and women are "passive, powerless objects of their controlling gaze."

Paul Cézanne's *A Modern Olympia* (**Fig. 20.9**) and Sylvia Sleigh's *Philip Golub Reclining* (**Fig. 20.10**) seem to address the issue of the male gaze straight on but in quite different ways. Cézanne was surely commenting on Édouard Manet's *Olympia* (see Fig. 21.7), which was painted just 10 years earlier and made quite a splash when exhibited. What are the similarities in content? What are the differences? Note, among other things, that Cézanne has placed himself in the picture—owning up, as it were, to the male gaze.

Sleigh attacks the issue by reversing the power relationship in painting. The artist is seen in the background, in a mirror reflection, painting the nude Philip Golub from the rear. Does the work raise questions such as "Is this also what women really want to paint?" or "Is this what women want to gaze upon?" Or do you think the main purpose of this painting is to call our attention to a tradition in the arts of perpetuating ideological gender attitudes?

scholar, has suggested that such paintings speak volumes about contemporary ideology and gender discourse:

> The ways in which representations of women in art are founded upon and serve to reproduce indisputably accepted assumptions held by society in general, artists in particular, and some artists more than others about men's power over, superiority to, difference from, and necessary control of women, assumptions which are manifested in the visual structures as well as the thematic choices of the pictures in question.

Among several that Nochlin lists are assumptions about women's weakness and passivity and sexual availability for men's needs.

The works in this feature speak to the tradition of the reclining nude in Western art. For whom—for whose "gaze"— do you think they were intended? The concept of the *male gaze* has been central to feminist theory for more than four decades. In a landmark article written in 1975, the filmmaker Laura Mulvey explained the roles of the viewer and the viewed

▶ 20.10 **Sylvia Sleigh, *Philip Golub Reclining*, 1971. Oil on canvas, 42" × 62" (106.7 × 157.5 cm). Private collection, Dallas, Texas. Sylvia Sleigh.**

evoked the rustling of leaves in a forest or the noise of a storm, and poets expressed their desire for union with the natural world.

Even as this mystical attachment to nature expressed a rejection of the Classical notion of a world centered on human activity, an increasing number of artists sought to portray what they viewed as national characteristics of their people. Abandoning the common artistic language of earlier periods and developing local styles that incorporated traditional folk elements enabled artists to stimulate (and in some cases to initiate) the growth of national consciousness and the demand for national independence (see **Map 20.1**). This was particularly effective in the Russian and Austrian empires (which incorporated many nationalities) as well as in America, which always had been on the fringe of the European cultural tradition. Thus, while some artists retreated into the private worlds of their own creation, others were at the forefront of the social and political movements of their age.

These attitudes, and the new imaginative and creative power they unleashed, had different but equally important effects on the relationship between the artist and society. Some artists increasingly became alienated from the public for whom they once had filled a precise role—providing pleasure or satisfying political and religious demands. Now their works reflected, and met, their own needs rather than those of their patrons.

Romantic Art in Spain and France

In the opening decades of the 19th century, artists began to abandon the idealized, remote, and pristine world of Neo-Classical art for graphic images intended to convey the artist's intense feelings and evoke them in the viewer.

FRANCISCO GOYA Ironically, the man considered by many to be the greatest painter among the Neo-Classicists and Romanticists associated himself with neither group. Francisco Goya y Lucientes (1746–1828) was born in Spain and, except for an academic excursion to Rome, spent most of his life there. He had an exalted reputation in his native country where he was awarded many important commissions, including religious frescoes and portraits of Spanish royalty, and served as a court painter to King Charles IV.

The Sleep of Reason Produces Monsters (**Fig. 20.11**), a print in his series titled *Los Caprichos (The Caprices)*, is generally viewed as a visual expression of Goya's conflicting personal views on the effect of the primacy of rationality and order on creativity and human emotion. The content can be interpreted in at least two diametrically opposed ways: when reason "sleeps," or is suppressed, ignorance (the bats) and folly (the owls) run rampant; or, it is only when reason "sleeps" that emotion, imagination, and the creative processes are set free.

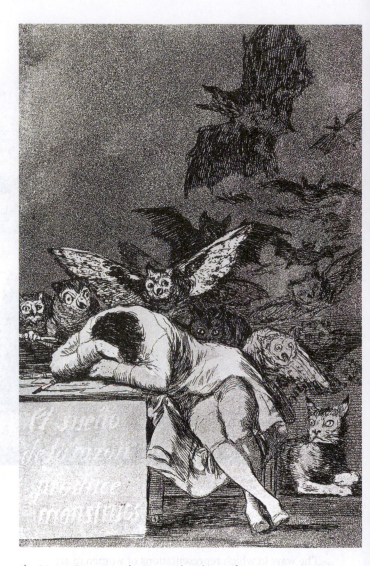

▲ **20.11** Francisco de Goya, *The Sleep of Reason Produces Monsters (El sueño de la razón produce monstruos)*, 1797–1798. Plate 43 from *Los Caprichos*. Etching and aquatint, 8½" × 6" (21.5 × 15.0 cm). Victoria and Albert Museum, London, United Kingdom. The etching suggests that the suppression of reason might release monsters from the mind—monsters that symbolize ignorance (bats) and folly (owls). The title of the piece is written on the desk below the sleeper.

The latter interpretation seems to be supported by a (perhaps deliberately vague) caption that Goya wrote to accompany the etching: "Imagination abandoned by reason produces impossible monsters; united with her (monsters united with imagination?), she is the mother of the arts and the source of their wonders." *The Sleep of Reason* illustrates the romantic proclivity for horrifying, nightmarish imagery that plays to the senses, fears, and emotions. Goya did a large number of such "fantasy" works at the same time that he created penetratingly realistic portraits, including many of the king and his family.

Goya became official painter to King Charles IV of Spain in 1799—a year or so after the *Caprichos* series was completed. The most famous of the formal court portraits, *The Family of Charles IV* (**Fig. 20.12**), was deliberately modeled on Velázquez's

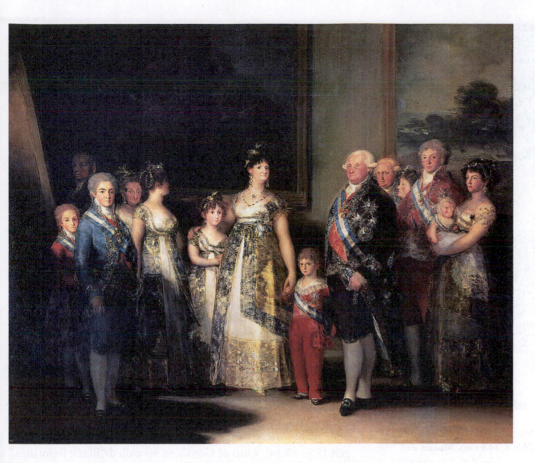

▲ **20.12** Francisco de Goya y Lucientes, *The Family of Charles IV*, 1800. Oil on canvas, 110" × 132" (280 × 336 cm). Museo del Prado, Madrid, Spain. In this portrayal of the Spanish royal family, the artist depicts himself working quietly at the far left. The French writer Alphonse Daudet said the painting showed "the grocer and his family who have just won top prize in the lottery."

Las Meninas (see Fig. 15.15) and yet, at the same time, it transformed and contemporized the earlier work. Goya shows us the royal family—king, queen, children, and grandchildren—gathered in the intimate setting of an unspecified room hung with large landscape paintings. As in Velasquez's painting, the artist stands off to the left side before a large canvas; although in Goya's portrait, he is absorbed into the shadows, a surreptitious observer rather than a point of focus. In *Las Meninas*, the presence of the king and queen is felt, and the cross section of characters who wait on the princess, Margarita, represents the hierarchy of the court. *The Family of Charles IV*, by contrast, is simply a painting showing a family posing for a portrait; there is no narrative here. If there is a subtext, it is the strength of familial ties and the Spanish view of the monarchy as "of them" and not "above them." They are dressed in finery, to be sure, but the only real trappings associating them with the throne are a few accessories—ribbons and medals.

The somewhat unflattering Realism of the individual portraits suggests that Goya did not idealize the royal family, and yet, the familial solidarity implied in this painting does not accurately portray the circumstances about to

unfold. Eight years after the portrait was completed, Ferdinand, shown in a blue suit to the far left, would force his parents, Queen Maria Luisa and King Carlos IV, to abdicate the throne, taking it for himself. In the meantime, French troops under Napoléon had entered Spain and the naïve Ferdinand thought them to be in support of the deposition of his father. Two months after Ferdinand took the throne, he and the former king and queen joined Napoléon in the south of France, effectively becoming prisoners. With threats leveled all around them, Ferdinand abdicated in favor of Carlos and Maria Luisa. They then turned the Spanish crown over to Napoléon, who pronounced his brother, Joseph Bonaparte, king of Spain (r. 1808–1813).

The Spanish citizenry had at first supported Ferdinand's takeover but, with the outcome such as it was, took up arms against the French upon Joseph I's appointment. On May 2, 1808, an uprising took place in Madrid, spearheaded by the city's poorest citizens. It was quashed by Napoléon's troops, assisted by Mamluk mercenaries and the Madrid police. The following day, the French carried out reprisal executions of Spanish rebels. Goya witnessed all of this turbulence.

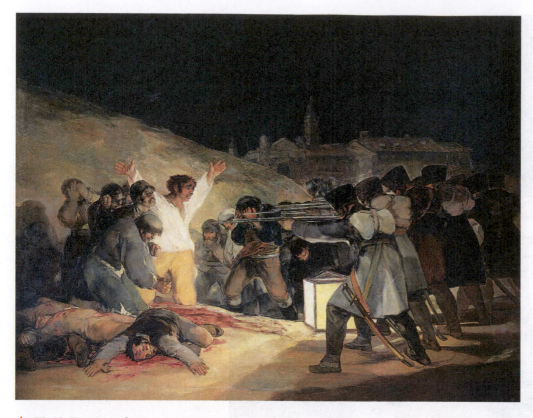

▲ **20.13** Francisco de Goya y Lucientes, *The Third of May, 1808,* 1814. Oil on canvas, 104¾" × 135¾" (266 × 345 cm). Museo del Prado, Madrid, Spain. The painting shows the execution of a group of citizens of Madrid, Madrileños, who had demonstrated against the French occupation by Napoléon's troops. The Spanish government commissioned the painting after the expulsion of the French army.

Two paintings by Goya—*The Second of May 1808* and *The Third of May 1808* (see **Fig. 20.13**) portray the bloody events surrounding what became known as the Dos de Mayo Uprising. Both paintings were commissioned by the restored monarch Ferdinand VII after the French were finally driven out of Spain. The first depicts fierce hand-to-hand combat as the

Spanish defend themselves against their mounted Mamluk attackers; the second, still and somber in tone, focuses attention not on the action and confusion of the clash in the city but on the point-blank-range summary execution of peasants in the countryside. Nothing is idealized. The horror and the terror of the victims, their faceless executioners, and the blood streaming in the dust all combine to create a cry of protest against unbearable human cruelty.

Goya must have had opinions about the disastrous consequences of Ferdinand's actions, but if so, he did not voice them in word or deed. He went on to serve as painter to Ferdinand VII, retiring in 1826. Still, a series of paintings seems to indicate that during this time, he held a fairly bleak and tortured view of society; in one, two solitary men, trapped up to their knees in mud within inches of one another, beat each other with cudgels (**Fig. 20.14**). One of Goya's 14 so-called "Black Paintings," it was applied directly to the plaster walls of his country house outside Madrid. As far as we know, they were never intended to be seen. The imagery is disturbing and evocative of his earlier suites of prints; it is also indecipherable. There is no scarcity of interpretation, but the truth is that we do not know for certain what Goya was thinking when he painted these works.

JEAN-LOUIS-ANDRÉ-THÉODORE GÉRICAULT The depiction of nature as unpredictable and uncontrollable—in the words of the French philosopher Denis Diderot, as stunning the soul and imprinting feelings of terror—was a favorite theme of the

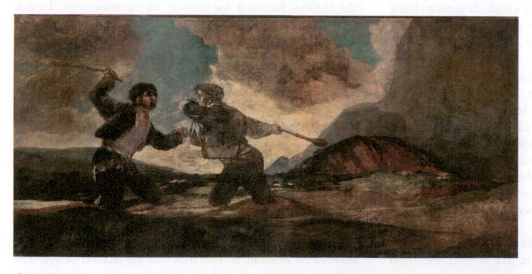

▲ **20.14** Francisco Goya y Lucientes, *Fight to the Death with Clubs,* 1820–1823. Painting from La Quinta del Sordo, Goya's house, now in the Museo del Prado, Madrid, Spain.

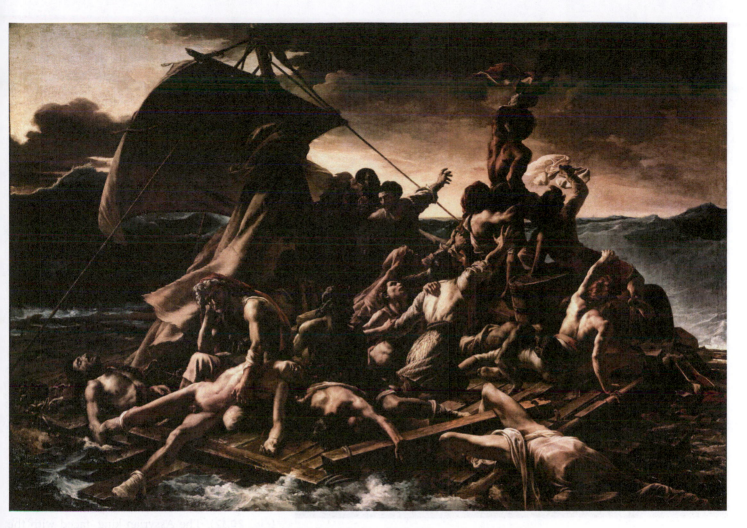

▲ **20.15** Jean-Louis-André-Théodore Géricault, *The Raft of the Medusa*, 1818. Oil on canvas, 16' 1 ¼" × 23'6" (491 × 716 cm). Musée du Louvre, Paris, France. Note the careful composition of this huge work, built around a line that leads from the bottom left corner to the top right, where a survivor desperately waves his shirt.

Romantic artist. Many French and British paintings of the period reveal a particular fascination with the destructive power of nature at sea, perhaps none as intensely as Théodore Géricault's *The Raft of the Medusa* (Fig. 20.15). Based on an actual event—a shipwreck off the coast of West Africa in 1816—during which a makeshift raft laden with Algerian immigrants was set adrift by the captain and crew of the crippled French ship *Medusa*, it is viewed as Géricault's most controversial and political work.

Like many of his liberal peers, Géricault (1791–1824) opposed the French monarchy and used the tragedy of the *Medusa* to call attention to the mismanagement and ineffectual politics of the French government, as well as the practice of slavery. The plight of the survivors and victims of the *Medusa* became a national scandal, and Géricault's authentic documentation, based on interviews with the rescued survivors and visits to the morgue, was intended as a direct indictment of the government. The powerful composition is full of realistic detail and explores the full gamut of human emotion under extreme hardship and duress. Much of the drama in the scene takes place along a diagonal grouping of figures, from the corpse in

the lower left that will soon slip into the ocean's roiling currents upward in a crescendo that culminates in the muscular torso of a man waving a shirt toward a rescue ship that is but a speck on the horizon. The fractured raft is tossed about mercilessly by the winds and waves; humans battle against nature and one another for sheer survival.

FERDINAND-EUGÈNE-VICTOR DELACROIX When Géricault died from falling off a horse, the cause of Romanticism was taken up by his young friend and admirer, Eugène-Victor Delacroix (1798–1863), whose name has become synonymous with Romantic painting. Although the subjects of many of his paintings involve violent emotions, Delacroix seems to have been aloof and reserved. He never married or, for that matter, formed any lasting relationship. His journal reveals him as a man constantly stimulated by ideas and experience, but he preferred to live his life through his art—a true Romantic. Among his few close friends was the composer Frédéric François Chopin; his portrait (see Fig. 20.25) seems to symbolize the introspective, creative vision of the romantic artist.

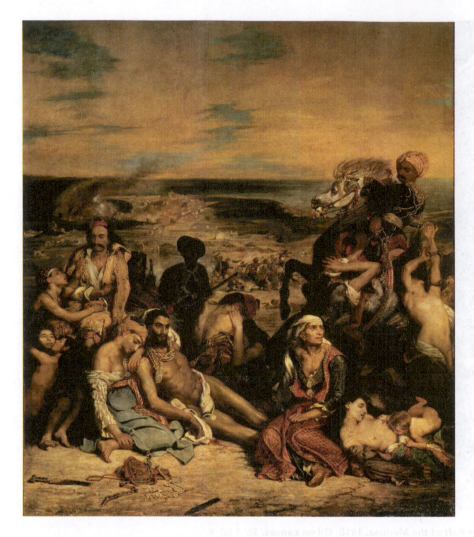

◄ **20.16** Ferdinand-Eugène-Victor Delacroix, *The Massacre at Chios*, 1824. Oil on canvas, 13' 7" × 11' 10" (419 × 354 cm). Musée du Louvre, Paris, France. Rather than depict a single scene, the painter chose to combine several episodes, contrasting the static misery of the figures on the left with a swirl of activity on the right.

Like his mentor Géricault, Delacroix supported the liberal movements of the day. His painting *The Massacre at Chios* (Fig. 20.16) depicts a particularly brutal event in the Greek War of Independence. In 1824, the year in which the poet Lord Byron died while supporting the Greek cause, the Turks massacred some 90 percent of the population of the Greek island of Chios. Delacroix's painting on the subject was intended to rouse popular indignation. It certainly roused the indignation of the traditional artists of the day, one of whom dubbed it "the massacre of painting," principally because of its revolutionary use of color. Whereas David and other Neo-Classical painters had drawn their forms and then filled them in with color, Delacroix used color to create form. The result is a much more fluid use of paint.

Byron figures again in another of Delacroix's best-known paintings, because it was on one of the poet's works that the artist based *The Death of Sardanapalus* (Fig. 20.17). The Assyrian king, faced with the destruction of his palace by the Medes, decided to prevent his enemies from enjoying his possessions after his death by ordering that his wives, horses, and dogs be killed and their bodies piled up, together with his treasures, at the foot of the funeral pyre he intended for himself. The opulent, violent theme is treated with appropriate drama; the savage brutality of the foreground contrasts with the lonely, brooding figure of the king reclining on his couch above. Over the entire scene, however, hovers an air of unreality, even of fantasy, as if Delacroix is trying to convey not so much the sufferings of the victims as the intensity of his own imagination.

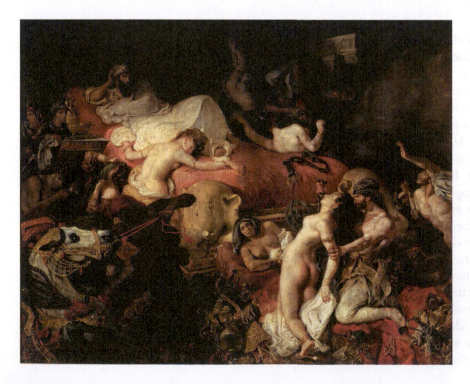

◄ **20.17** Ferdinand-Eugène-Victor Delacroix, *The Death of Sardanapalus*, 1826. Oil on canvas, 12' 1" × 16' 3" (368 × 495 cm). Musée du Louvre, Paris, France. This painting makes no attempt to achieve historical accuracy but instead concentrates on exploiting the violence and cruelty of the story. Delacroix called this work *Massacre No. 2*, a reference to his earlier painting *The Massacre at Chios* (Fig. 20.16). Although this suggests a certain detachment on the artist's part, there is no lack of energy or commitment in the free, almost violent, brushstrokes.

Romantic Art in the United Kingdom and Germany

Although Romantic art was mainly a 19th-century movement, it began toward the end of the 18th century.

WILLIAM BLAKE William Blake's (1757–1827) childhood imagination was filled with spiritual visions, yet he was far from a devotee of the Church of England. Rather, he interpreted the Bible for himself and came to believe in liberty for all people, including women. His artworks show his disgust with the practice of slavery and England's participation in the slave trade. His graphic *Black Slave on Gallows*, which he developed from a description of the punishment of resistant slaves in Surinam, speaks for itself (**Fig. 20.18**).

Blake spent his early years as an apprentice in engraving before entering the Royal Academy, where he clashed with the founders, who endorsed a Neo-Classical style. He left the academy and established himself as an illustrator and an engraver, and he framed his poetry with his own illustrations.

JOHN CONSTABLE The English painter John Constable (1776–1837) expressed a deep and warm love of nature. His paintings convey not only the physical beauties of the landscape but also a sense of the less tangible aspects of the natural world. In *The Hay Wain* (**Fig. 20.19**), for example, we not only see the peaceful rustic scene, with its squat, comforting house on the left, but we also can sense the light and quality of atmosphere, prompted by the billowing clouds that, responsible for the fertility of the countryside, seem about to release their moisture.

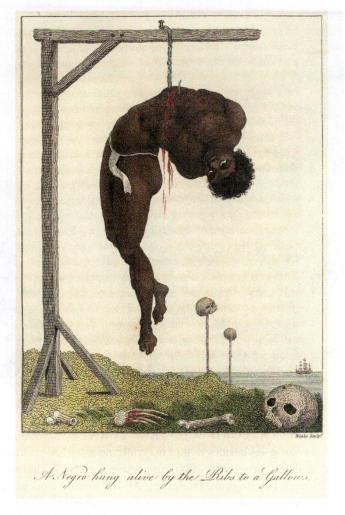

A Negro hung alive by the Ribs to a Gallows.

▲ **20.18** William Blake, *Black Slave on Gallows*, 1796. Copper engraving, original coloring, 7⅝" × 10" (19.5 × 25.4 cm). British Library, London, United Kingdom. Blake was outraged by the practice of slavery.

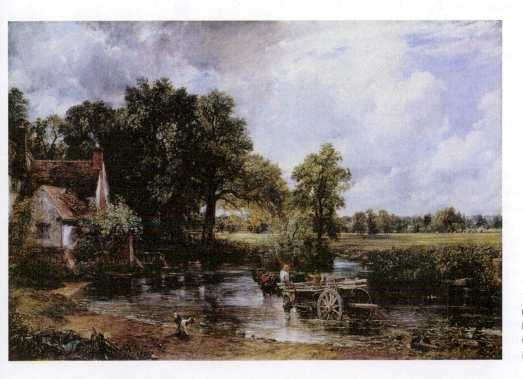

◀ **20.19** John Constable, *The Hay Wain*, 1821. Oil on canvas, 51" × 73" (128 × 185 cm). National Gallery, London, United Kingdom. Note Constable's bold use of color, which impressed Delacroix.

◄ **20.20** Joseph Mallord William Turner, *The Slave Ship*, 1840. Oil on canvas, 35¾" × 48¼" (90.8 × 122.6 cm). **Museum of Fine Arts, Boston, Massachusetts.** The title of this painting is an abbreviation of the longer *Slavers Throwing Overboard the Dead and Dying; Typhoon Coming On.* At the lower center, Turner includes the horrifying detail of the chains that still bind the slaves whose desperate hands show above the water.

JOSEPH MALLORD WILLIAM TURNER Constable's use of color pales besides that of his contemporary Joseph Mallord William Turner (1775–1851). In a sense, the precise subjects of Turner's paintings are irrelevant. All his mature works use light, color, and movement to represent a cosmic union of the elements in which earth, sky, fire, and water dissolve into one another and every trace of the material world disappears. His technique is seen at its most characteristic in *The Slave Ship* (Fig. 20.20).

Like Géricault's *The Raft of the Medusa* (see Fig. 20.15), Turner's *The Slave Ship* deals with a social disgrace of the time; in this case, the horrifyingly common habit of the captains of slave ships jettisoning their entire human cargo if an epidemic broke out. Turner only incidentally illustrates his specific subject—the detail of drowning figures in the lower right corner seems to have been added as an afterthought—and concentrates instead on conveying his vision of the grandeur and mystery of the universe.

CASPAR DAVID FRIEDRICH Romantic artists in both Germany and England were particularly attracted by the possibilities of landscape painting. *Wanderer Above a Sea of Mist* (Fig. 20.21) is German painter Caspar David Friedrich's (1774–1840) best-known painting. Inspired by ice-topped mountains in central Europe, it was completed in the studio, where its content was filtered through the mind of the artist.

The wanderer, having reached the pinnacle of a rocky promontory, finds himself agaze in wonderment at the vastness and splendor of nature. He has ascended to the summit, perhaps has lost his way, and finds distant peaks reaching farther yet into the sky. Claiming the center of the composition,

▲ **20.21** Caspar David Friedrich, *Wanderer Above a Sea of Mist*, 1817–1818. Oil on canvas, 37¾" × 29⅜" (94.8 × 74.8 cm). **Hamburger Kunsthalle, Hamburg, Germany.** The painting expresses the ideal of nature as sublime.

however, the wanderer is as prominent as the vista. If a divine spirit animates nature, it also circulates through the wanderer, connecting the two. Moreover, we the viewers join the wanderer, standing directly behind him, perhaps on another promontory but more likely impossibly suspended in midair. Because of our vantage point, we participate in his sublime experience.

ROMANTIC LITERATURE

Romantic literature developed throughout Europe and, as we shall see, it had its counterparts in the nascent United States.

JOHANN WOLFGANG VON GOETHE Johann Wolfgang von Goethe (1749–1832) spanned the transition from Neo-Classicism to Romanticism in literature. In the course of a long and productive life, he wrote in a bewildering variety of disciplines. One of the first writers to rebel against the principles of Neo-Classicism, Goethe used both poetry and prose to express the most turbulent emotions; yet he continued to produce work written according to Neo-Classical principles of clarity and balance until his final years, when he expressed in his writing a profound if abstruse symbolism.

Although the vein of Romanticism is only one of many that run through Goethe's work, it is an important one. As a young man he studied law, first at Leipzig and then at Strassburg, where by 1770 he was already writing lyric poetry of astonishing directness and spontaneity. By 1773, he was acknowledged as the leader of the literary movement known as **Sturm und Drang** ("Storm and Stress"). This German manifestation of Romanticism rebelled against the formal structure and order of Neo-Classicism, replacing it with an emphasis on originality, imagination, and emotion. Its chief subjects were nature, primitive emotions, and protest against established authority. Although the Sturm und Drang movement was originally confined to literature, its precepts were felt elsewhere. For instance, it was partly under the inspiration of this movement that Beethoven developed his fiery style.

The climax of this period in Goethe's life is represented by his novel *The Sorrows of Young Werther* (1774), which describes how an idealistic young man comes to feel increasingly disillusioned and frustrated by life, develops a hopeless passion for a happily married woman, and ends his agony by putting a bullet through his head. All of these events but the last were autobiographical. Instead of committing suicide, Goethe left town and turned his life experiences into the novel that won him international fame. Not surprisingly, it became a key work of the Romantic movement. Young men began to dress in the blue jacket and yellow trousers Werther is described as wearing, and some, disappointed in love, even committed suicide with copies of the book in their pockets—a dramatic if regrettable illustration of Goethe's ability to communicate his own emotions to others.

The years around the turn of the century found Goethe extending the range of his output. Along with such plays as the Classical drama *Iphigenia in Tauris*, which expressed his belief in purity and sincere humanity, were stormy works like *Egmont*, inspired by the idea that human life is controlled by demonic forces. The work for which Goethe is probably best known, *Faust*, was begun at about the turn of the century, although its composition took many years. Part One was published in 1808, and Part Two was only finished in 1832, shortly before Goethe's death.

The subject of Dr. Faustus and his pact with the devil had been treated before in literature, notably in the play by Christopher Marlowe. The theme was guaranteed to appeal to Romantic sensibilities, with its elements of the mysterious and fantastic. The play begins with Mephistopheles making a bet with God—as Satan challenges God in the Book of Job. In Job, the devil takes Job's livestock, kills his children, and gives him boils simply to test his love for God. In Goethe's *Faust*, Mephistopheles bets that he can lure Faust away from righteousness by offering him knowledge and worldly pleasures.

In Part One (1808), the pure and innocent Marguerite (also called by the diminutive of the name, Gretchen) becomes deranged and then is executed. Gretchen is the chief victim of Faust's lust for experience and power; he callously calls on Mephistopheles's help to seduce her and then—his lust satisfied—abandons her. She goes mad. She is accused of the murder of her child, which was fathered by Faust, condemned to death, and executed. Following the execution, voices from heaven intone that Gretchen has been saved ("Sie ist gerettet"), but this device only defuses some of the angst of the audience; it does nothing to ameliorate the "hero's" guilt. At a point in the play that presages this heartrending ending, Faust recognizes how his quest has led to misery—but even here, he focuses on his own suffering:

READING 20.3 JOHANN WOLFGANG VON GOETHE

From *Faust, Part One*, Night, lines 266–274 (1808)

I, God's own image, from this toil of clay
Already freed, with eager joy who hail'd
The mirror of eternal truth unveil'd,
Mid light effulgent and celestial day:—
I, more than cherub, whose unfetter'd soul
With penetrative glance aspir'd to flow
Through nature's veins, and, still creating, know
The life of gods, —how am I punished now!
One thunder-word hath hurl'd me from the goal!

In perhaps the most poetic passage of *Faust*, Gretchen, who has become enamored with Faust's intellect, asks him whether he believes in God. His response is Romantic in that he answers that the divine—howsoever one might name it—is found in the beauty of the everlasting stars that "climb on high," rather than falling to earth (nature), in gazing into the eyes of one's lover, in rapture and bliss (passion). For all this Faust has

no name—it is to experience, not to name: "Names are but sound and smoke":

READING 20.4 JOHANN WOLFGANG VON GOETHE

From *Faust, Part One*, Martha's Garden, lines 3089–3115 (1808)

Him who dare name?
And who proclaim,
Him I believe?
Who that can feel,
His heart can steel,
To say: I believe him not?
The All-embracer,
All-sustainer,
Holds and sustains he not
Thee, me, himself?
Lifts not the Heaven its dome above?
Doth not the firm-set earth beneath us lie?
And beaming tenderly with looks of love,
Climb not the everlasting stars on high?
Do we not gaze into each other's eyes?
Nature's impenetrable agencies,
Are they not thronging on thy heart and brain,
Viewless, or visible to mortal ken,
Around thee weaving their mysterious chain?
Fill thence thy heart, how large soe'er it be;
And in the feeling when thou utterly art blest,
Then call it, what thou wilt, —
Call it Bliss! Heart! Love! God!
I have no name for it!
'Tis feeling all;
Name is but sound and smoke
Enclouding heaven's glow.

Part Two of *Faust* is very different. Its theme, expressed symbolically through Faust's pact with the devil, is nothing less than the destiny of Western culture. Western civilization's unceasing activity and thirst for new experiences inevitably produces error and suffering; at the same time, it is the result of the divine spark within us and will, in the end, guarantee our salvation. In his choice of the agent of this salvation, Goethe established one of the other great themes of Romanticism: the Eternal Feminine. Faust is finally redeemed by the divine love of Gretchen, who leads him upward to salvation.

Romantic Poetry

William Wordsworth (1770–1850) and Samuel Taylor Coleridge (1772–1834) are usually credited with founding the Romantic movement in English poetry. They met in 1795 and developed a close friendship during which they published *Lyrical Ballads*, which included Coleridge's *Rime of the Ancient Mariner* and

is considered a key work in the Romantic movement. Wordsworth described his aims and ideals in his critical writings. He sought purposefully to create a new approach to poetry, one that preferred to portray intuition and emotion rather than reason, and to use rural or pastoral settings rather than urban ones. The Romantic movement, as we see in Wordsworth, also used a more colloquial language. Wordsworth emphasized the value of meter, a feature that differentiates between poetry and prose. Romantic poetry also aspires to feel spontaneous, to apparently gush forth in the passion of the moment, although Romantic poets, including Wordsworth, recognized that pure emotion must be shaped into poetry by the mind. For Wordsworth, the poet was a person with special gifts, "endowed with more lively sensibility, more enthusiasm and tenderness, who has a greater knowledge of human nature, and a more comprehensive soul" than other people. Wordsworth described his view of the Romantic in poetry in his preface to the 1798 edition of the *Lyrical Ballads*. Along with an explanation of his principles of composing poetry in the language of people in "rural occupations," you will note his caustic comment that the poet nevertheless needs to have colloquial language "purified indeed from what appear to be its real defects":

READING 20.5 WILLIAM WORDSWORTH

From Preface to *Lyrical Ballads* (1800)

The principal object, then, proposed in these Poems was to choose incidents and situations from common life, and to relate or describe them, throughout, as far as was possible in a selection of language really used by men, and, at the same time, to throw over them a certain colouring of imagination, whereby ordinary things should be presented to the mind in an unusual aspect; and, further, and above all, to make these incidents and situations interesting by tracing in them, truly though not ostentatiously, the primary laws of our nature: chiefly, as far as regards the manner in which we associate ideas in a state of excitement. Humble and rustic life was generally chosen, because, in that condition, the essential passions of the heart find a better soil in which they can attain their maturity, are less under restraint, and speak a plainer and more emphatic language; because in that condition of life our elementary feelings coexist in a state of greater simplicity, and, consequently, may be more accurately contemplated, and more forcibly communicated; because the manners of rural life germinate from those elementary feelings, and, from the necessary character of rural occupations, are more easily comprehended, and are more durable; and, lastly, because in that condition the passions of men are incorporated with the beautiful and permanent forms of nature. The language, too, of these men has been adopted (purified indeed from what appear to be its real defects, from all lasting and rational causes of dislike or disgust).

English Romantic poetry of the first half of the 19th century remains a peak in the history of English literature. It touches on several themes characteristic of the age. Wordsworth's deep

love of the country led him to explore the relationship between human beings and the world of nature; Percy Bysshe Shelley and George Gordon, also known as Lord Byron, probed the more passionate, even demonic aspects of existence; and John Keats expressed his own sensitive responses to the eternal problems of art, life, and death.

WILLIAM BLAKE There are several writers whom we might call "doubly gifted," that is, who are accomplished in both the realms of literature and the visual arts. Among the Romantic poets, Edgar Allan Poe and William Blake stand out as particularly noteworthy examples. Poe created pen and ink drawings, and Blake illustrated his collections of poetry, including his *Songs of Innocence and Experience.*

"The Lamb" is one of 19 poems from Blake's *Songs of Innocence* published in 1789; together with "The Tyger" from his 1794 collection, *Songs of Experience*, it is among the most widely read poems in the English language. Although "The Lamb" stands alone as a children's song, with its repetition and simple rhythm and rhyme scheme, as the poem progresses it becomes more complex in allusion and suggestion. Blake begins his first, pastoral verse with a question posed to a "little lamb"—one that cannot yield a reply. Rather, the question is used as a rhetorical device that is intended to lead the reader to reflect, in the second verse, on something larger and more significant. It is in this part of the poem that the lamb alludes to Jesus Christ, who is referred to in the Christian Bible as the "Lamb of God." Jesus enjoined his followers to be meek and mild, to "turn the other cheek" rather than to resist an evil person. The lamb symbolizes purity and innocence:

> **READING 20.6 WILLIAM BLAKE**
>
> "The Lamb," from *Songs of Innocence* (1789)
>
> Little Lamb who made thee
> Dost thou know who made thee
> Gave thee life & bid thee feed
> By the stream & o'er the mead;
> Gave thee clothing of delight,
> Softest clothing wooly bright;
> Gave thee such a tender voice,
> Making all the vales rejoice:
> Little Lamb who made thee
> Dost thou know who made thee
>
> Little Lamb I'll tell thee,
> Little Lamb I'll tell thee:
> He is called by thy name,
> For he calls himself a Lamb:
> He is meek & he is mild,
> He became a little child:
> I a child & thou a lamb,
> We are called by his name.
> Little Lamb God bless thee,
> Little Lamb God bless thee.

"The Tyger" can be seen as the antithesis of "The Lamb" just as experience is the antithesis of innocence. In "The Tyger," Blake again asks questions, but here they are sustained throughout the poem and, in the end, have no answers. The poem would seem to be Blake's commentary—or at least an outlet for his religious and philosophical questions—on the duality of God and the relationship between good and evil. Is it conceivable that the same God who created the meek and gentle lamb is also willing and capable of instilling violence in the tiger? Has this God also created good and evil in human beings? An illustrated poem, "The Tyger" (**Fig. 20.22** on p. 686 shows Blake's illustration for the poem) continues to mystify with its pulsating rhythms, brilliant imagery, and incongruity between the verbal and visual descriptions of the familiar jungle animal. Blake's drawing of a docile, wide-eyed, smiling cat set in a delicate, decorative frame is inconsistent with phrases such as "fearful symmetry," "dread head," "dread grasp," and twisted "sinews of the heart." One possible interpretation of this deliberate visual-verbal contrast is that "the immortal hand or eye" that "framed" the "fearful symmetry" of the tiger must (or perhaps cannot) be reconciled with our singular notion of a benevolent God:

> **READING 20.7 WILLIAM BLAKE**
>
> "The Tyger," from *Songs of Experience* (1794)
>
> Tyger Tyger, burning bright,
> In the forests of the night;
> What immortal hand or eye,
> Could frame thy fearful symmetry?
> In what distant deeps or skies,
> Burnt the fire of thine eyes?
> On what wings dare he aspire?
> What the hand, dare seize the fire?
> And what shoulder, & what art,
> Could twist the sinews of thy heart?
> And when thy heart began to beat,
> What dread hand? & what dread feet?
> What the hammer? what the chain,
> In what furnace was thy brain?
> What the anvil? what dread grasp,
> Dare its deadly terrors clasp!
> When the stars threw down their spears
> And water'd heaven with their tears:
> Did he smile his work to see?
> Did he who made the Lamb make thee?
> Tyger Tyger burning bright,
> In the forests of the night:
> What immortal hand or eye,
> Dare frame thy fearful symmetry?

WILLIAM WORDSWORTH Although Wordsworth's poetry is filled with beautiful visions of nature, his personal life had its share of tragedies. His parents died while he was still a

child. Even though he managed to graduate from St. John's College at Cambridge University, he and his four siblings had financial difficulties. Rejecting artificiality and stylization, Wordsworth aimed to make his poetry communicate directly in easily comprehensible terms. His principal theme was the relation between human beings and nature, which he explored by thinking back calmly on experiences that had earlier produced a violent emotional reaction: his famous "emotion recollected in tranquility."

The relation between humans and nature emerges in the following extract from "Lines Composed a Few Miles Above Tintern Abbey on Revisiting the Banks of the Wye During a Tour" (see Turner's painting of Tintern Abbey, Fig. 20.23 on p. 688). They describe the poet's reactions on his return to the place he had visited five years earlier. After painting the scene in lines 1–22, he recalls the joy its memory has brought to him in the intervening years. This in turn brings to mind the passage of time in his own life and the importance that the beauty of nature has always had for him:

READING 20.8 WILLIAM WORDSWORTH

"Lines Composed a Few Miles Above Tintern Abbey, on Revisiting the Banks of the Wye During a Tour. July 13, 1798." (1798), lines 1–22

Five years have passed: five summers, with the length
Of five long winters! and again I hear
These waters, rolling from their mountain-springs
With a soft inland murmur.—Once again
Do I behold these steep and lofty cliffs,
That on a wild secluded scene impress
Thoughts of more deep seclusion; and connect
The landscape with the quiet of the sky.
The day is come when I again repose
Here, under this dark sycamore, and view
These plots of cottage-ground, these orchard-tufts,
Which at this season, with their unripe fruits,
Are clad in one green hue, and lose themselves
'Mid groves and copses. Once again I see
These hedge-rows, hardly hedge-rows, little lines
Of sportive wood run wild: these pastoral farms,
Green to the very door; and wreaths of smoke
Sent up, in silence, from among the trees!
With some uncertain notice, as might seem
Of vagrant dwellers in the houseless woods,
Or of some Hermit's cave, where by his fire
The Hermit sits alone.

The following brief poem also expresses the poet's relationship with nature and contains the well-known line, "The Child is father of the Man":

READING 20.9 WILLIAM WORDSWORTH

"My Heart Leaps Up" (1802)

My heart leaps up when I behold
 A Rainbow in the sky:
So was it when my life began;
So is it now I am a Man;
So be it when I shall grow old,
 Or let me die!
The Child is father of the Man;
And I could wish my days to be
Bound each to each by natural piety.

SAMUEL TAYLOR COLERIDGE Coleridge was the youngest of the 14 children of a rural clergyman. He attended Jesus College at Cambridge, but he left without a degree. He joined the cavalry as a way of escaping the mundane life but found himself more suited to cleaning stables and writing love letters for his comrades than to riding.

He met Wordsworth in 1795, and the poets influenced one another's work. Although we may think of *Lyrical Ballads* as Wordsworth's because of Wordsworth's preface to the revised edition in 1800, Coleridge's works, including *The Rime of the Ancient Mariner*, account for about one-third of the volume's length.

In *The Rime of the Ancient Mariner*, an old sailor—the mariner—is apparently doomed to repeat his rime—his story—endlessly to those who will listen. In brief, his ship is penned in among floats of ice as lofty as its masts, until an albatross flies in and the ice melts, turning to fog. The mariner kills the albatross with his crossbow without cause, thus triggering events that bring about the death of his mates. The mariner wears the albatross around his neck in penance for his misdeed. The ship's course becomes aimless, and the mariner curses water snakes and other creatures of nature. Eventually, although the mariner is suffering from painful thirst, he is somehow transformed and recognizes beauty in the water snakes. The albatross drops off him, and seraphs—winged angels—bring the ship to port.

The following lines in part 1 describe the ill turn of weather, the ice, and the coming of the albatross:

READING 20.10 SAMUEL TAYLOR COLERIDGE

From *The Rime of the Ancient Mariner* (1797), part 1, lines 51–66

And now there came both mist and snow,
 And it grew wondrous cold:
And ice, mast-high, came floating by,
 As green as emerald.

And through the drifts the snowy clifts
 Did send a dismal sheen;
Nor shapes of men nor beasts we ken—
 The ice was all between.

The ice was here, the ice was there,
 The ice was all around:
It cracked and growled, and roared and howled,
 Like noises in a swound!

At length did cross an Albatross:
 Thorough the fog it came;
As it had been a Christian soul,
 We hailed it in God's name.

Although the albatross appears to save the crew from its fate in the ice, the mariner kills it. At first his mates are outraged because they think the bird had brought the winds that saved them from the ice, but then they cheer the mariner, thinking that the bird had brought the fog that surrounded them. In part 2, perhaps because of the crew's change of heart, the ship is once more dead in the water. The crew are without drinkable water, and the mariner notices "slimy" life atop the water. You may notice familiar phrases in these lines—"a painted ship upon a painted ocean," "Water, water, every where, / Nor any drop to drink."

▲ **20.23** Joseph Mallord William Turner, *Transept of Tintern Abbey*, 1794. Watercolor, 12⅝" × 9⅞
(32.2 × 25.1 cm). Victoria and Albert Museum, London, United Kingdom. The small watercolor speaks
nostalgically of a collective past we find, perhaps, in dreams. Human endeavors, no matter how beautiful, no
matter how majestic, are transient.

READING 20.11 SAMUEL TAYLOR COLERIDGE

The Rime of the Ancient Mariner (1797), part 2, lines 115–126

Day after day, day after day,
 We stuck, nor breath nor motion;
As idle as a painted ship
 Upon a painted ocean.

Water, water, everywhere,
 And all the boards did shrink;
Water, water, everywhere,
 Nor any drop to drink.

The very deep did rot: O Christ!
 That ever this should be!
Yea, slimy things did crawl with legs
 Upon the slimy sea.

Later, when all are dead but the mariner, he apparently saves himself from their fate by recognizing the beauty of these creatures. One of the messages of the poem would seem to be that one must appreciate all of God's creatures—nature—and safeguard their lives. The symbolic meaning of the albatross has been debated. The bird has been interpreted as an omen of good fortune and of ill. The phrase "wearing an albatross around one's neck" can be interpreted to mean bearing a burden or undergoing penance—or both. In any event, the tale would seem to illustrate the Romantic theme of humankind's powerlessness in the face of the majesty of nature.

GEORGE GORDON, LORD BYRON Wordsworth's emotion recollected in tranquility is in strong contrast to the poetry of Lord Byron (1788–1824), who filled both his life and work with the same moody, passionate frenzy of activity. Born with a lame foot, he nevertheless conditioned his body such that he became a championship swimmer. A woman whom he had spurned, Lady Caroline Lamb, wrote in her diary that he was "mad, bad, and dangerous to know." Their passionate affair began *after* this assessment of his character.

Much of Byron's time was spent wandering throughout Europe, where he became a living symbol of the unconventional, homeless, tormented Romantic hero who has come to be called Byronic. Much of his flamboyant behavior was no doubt calculated to produce the effect it did, but his personality must have been striking for no less a figure than Goethe to describe him as "a personality of such eminence as has never been before and is not likely to come again." Byron's sincere commitment to struggles for liberty—like the Greek war of independence against the Ottoman Empire—can be judged by the fact that he died while on military duty in Greece.

Byron's lyrical "She Walks in Beauty" is one of his most popular poems. The meter is iambic tetrameter (four feet, each with an unaccented and then an accented syllable). The rhyme scheme for each of the three verses is simple: ABABAB. The alliteration—repetition of consonant sounds—is something of a lesson in poetic methodology: "cloudless climes," "starry skies," or "gaudy day denies":

READING 20.12 GEORGE GORDON, LORD BYRON

"She Walks in Beauty" (1814)

She walks in beauty, like the night
 Of cloudless climes and starry skies;
And all that's best of dark and bright
 Meet in her aspect and her eyes:
Thus mellow'd to that tender light
 Which heaven to gaudy day denies.

One shade the more, one ray the less,
 Had half impair'd the nameless grace
Which waves in every raven tress,
 Or softly lightens o'er her face;
Where thoughts serenely sweet express
 How pure, how dear their dwelling-place.

And on that cheek, and o'er that brow,
 So soft, so calm, yet eloquent,
The smiles that win, the tints that glow,
 But tell of days in goodness spent,
A mind at peace with all below,
 A heart whose love is innocent!

Childe Harold's Pilgrimage is a more mature work, one that took Byron many years to write, as he continued to add and revise verses. The following verse speaks of the poet's struggle with death and his desire to achieve an imperishable fame—to become the "Byronic hero":

READING 20.13 GEORGE GORDON, LORD BYRON

Childe Harold's Pilgrimage (1812–1818), canto 4, stanza 137

But I have lived, and have not lived in vain:
My mind may lose its force, my blood its fire,
And my frame perish even in conquering pain;
But there is that within me which shall tire
Torture and Time, and breathe when I expire;
Something unearthly, which they deem not of,
Like the remember'd tone of a mute lyre,
Shall on their soften'd spirits sink, and move
In hearts all rocky now the late remorse of love.

Critics have referred to such verses in *Childe Harold's Pilgrimage* as set pieces, meaning that they stand by themselves, as do so many of the songs in a musical or arias in an opera. The following verse, in which Byron imagines himself at a gladiator contest, achieves a particular poignancy:

READING 20.14 GEORGE GORDON, LORD BYRON

Childe Harold's Pilgrimage (1812–1818), canto 4, stanza 140

> I see before me the Gladiator lie:
> He leans upon his hand—his manly brow
> Consents to death, but conquers agony,
> And his droop'd head sinks gradually low—
> And through his side the last drops, ebbing slow
> From the red gash, fall heavy, one by one,
> Like the first of a thunder-shower; and now
> The arena swims around him—he is gone,
> Ere[2] ceased the inhuman shout which hail'd the wretch
> who won.

PERCY BYSSHE SHELLEY Like Lord Byron, Percy Bysshe Shelley (1792–1822) spent many of his most creative years in Italy. He lived a life of continual turmoil. After being expelled from Oxford for publishing his atheistic views, he espoused the cause of anarchy and eloped with the daughter of one of its chief philosophical advocates—Mary Wollstonecraft Godwin. The consequent public scandal, coupled with ill health and critical hostility toward his work, gave him a sense of bitterness and pessimism that lasted until his death by drowning.

Shelley's brilliant mind and restless temperament produced poetry that united extremes of feeling, veering from the highest pitch of exultant joy to the deepest despondency. His belief in the possibility of human perfection is expressed in what many critics believe to be his greatest work, *Prometheus Unbound* (1820), in which the means of salvation is the love of human beings for one another. His most accessible works, however, are probably the short lyrics in which he seized a fleeting moment of human emotion and captured it by his poetic imagination.

The following sonnet is titled "Ozymandias," which is the Greek name for the mighty Egyptian pharaoh Ramses II. Shelley uses the image of his shattered statue to symbolize the impermanence of human achievement:

READING 20.15 PERCY BYSSHE SHELLEY

"Ozymandias" (1818)

> I met a traveller from an antique land
> Who said: Two vast and trunkless legs of stone
> Stand in the desert. Near them, on the sand,
> Half sunk, a shattered visage lies, whose frown,
> And wrinkled lip, and sneer of cold command,
> Tell that its sculptor well those passions read
> Which yet survive, stamped on these lifeless things,
> The hand that mocked them and the heart that fed:

> And on the pedestal these words appear:
> "My name is Ozymandias, king of kings:
> Look on my works, ye Mighty, and despair!"
> Nothing beside remains. Round the decay
> Of that colossal wreck, boundless and bare
> The lone and level sands stretch far away.

Following is the final stanza of *Adonais*, a lament for John Keats. Shelley learned in April of 1821 that Keats had died, and he published *Adonais* that July. The poem also alludes to Shelley's concerns about the possibility of his own passing. The metaphor that his "spirit's bark is driven / Far from the shore" places his imagination in the vastness of the sea that would eventually take him:

READING 20.16 PERCY BYSSHE SHELLEY

Adonais (1821), stanza 55, lines 487–495

> The breath whose might I have invoked in song
> Descends on me; my spirit's bark[3] is driven
> Far from the shore, far from the trembling throng
> Whose sails were never to the tempest given;
> The massy earth and spherèd skies are riven!
> I am borne darkly, fearfully, afar;
> Whilst burning through the inmost veil of Heaven,
> The soul of Adonais, like a star,
> Beacons from the abode where the Eternal are.

JOHN KEATS In John Keats (1795–1821), whose life was clouded by unhappy love and the tuberculosis that killed him so tragically young, we find a poet of rare poignancy and sensitivity. When we examine his works, we cannot help but be bewildered that he wrote nearly all of his major poems in one year—between the ages of 23 and 24. In his odes (lyric poems of strong feeling), in particular, he conveys both the glory and the tragedy of human existence and dwells almost longingly on the peace of death.

Keats wrote "Ode to a Nightingale" (see Reading 20.17) while living in Hampstead (London). His companion, Charles Brown, left an account of the circumstances of its composition:

> In the spring of 1819 a nightingale had built her nest near my house. Keats felt a tranquil and continual joy in her song; and one morning he took his chair from the breakfast table to the grass plot under a plum-tree where he sat for two or three hours. When he came into the house, I perceived he had some scraps of paper in his hand.[4]

2. Before.

3. A ship with three or more masts; often spelled *barque*.
4. Charles Armitage Brown. (1902, December). "Hampstead, 1819." *The McGill University Magazine*, Vol. 2, No. 1. P. 68. Montreal: A. T. Chapman.

READING 20.17 JOHN KEATS

"Ode to a Nightingale" (1819)

I

My heart aches, and a drowsy numbness pains
 My sense, as though of hemlock I had drunk,
Or emptied some dull opiate to the drains
 One minute past, and Lethe-wards[5] had sunk:
'Tis not through envy of thy happy lot,
 But being too happy in thine happiness,—
 That thou, light-winged Dryad[6] of the trees,
 In some melodious plot
 Of beechen green, and shadows numberless,
 Singest of summer in full-throated ease.

II

O, for a draught of vintage! that hath been
 Cool'd a long age in the deep-delved earth,
Tasting of Flora and the country green,
 Dance, and Provençal song, and sunburnt mirth!
O for a beaker full of the warm South,
 Full of the true, the blushful Hippocrene,
 With beaded bubbles winking at the brim,
 And purple-stained mouth;
 That I might drink, and leave the world unseen,
 And with thee fade away into the forest dim:

III

Fade far away, dissolve, and quite forget
 What thou among the leaves hast never known,
The weariness, the fever, and the fret
 Here, where men sit and hear each other groan;
Where palsy shakes a few, sad, last gray hairs,
 Where youth grows pale, and spectre-thin, and dies;
 Where but to think is to be full of sorrow
 And leaden-ey'd despairs,
 Where Beauty cannot keep her lustrous eyes,
 Or new Love pine at them beyond to-morrow.

IV

Away! away! for I will fly to thee,
 Not charioted by Bacchus and his pards,[7]
But on the viewless wings of Poesy,
 Though the dull brain perplexes and retards:
Already with thee! tender is the night,[8]
 And haply the Queen-Moon is on her throne,
 Cluster'd around by all her starry Fays;
 But here there is no light,
Save what from heaven is with the breezes blown
 Through verdurous glooms and winding mossy ways.

V

I cannot see what flowers are at my feet,
 Nor what soft incense hangs upon the boughs,
But, in embalmed darkness, guess each sweet
 Wherewith the seasonable month endows
The grass, the thicket, and the fruit-tree wild;
 White hawthorn, and the pastoral eglantine;
 Fast fading violets cover'd up in leaves;
 And mid-May's eldest child,
 The coming musk-rose, full of dewy wine,
 The murmurous haunt of flies on summer eves.

VI

Darkling I listen: and, for many a time
 I have been half in love with easeful Death,
Call'd him soft names in many a mused rhyme,
 To take into the air my quiet breath;
Now more than ever seems it rich to die,
 To cease upon the midnight with no pain,
 While thou art pouring forth thy soul abroad
 In such an ecstasy!
 Still wouldst thou sing, and I have ears in vain–
 To thy high requiem become a sod.

VII

Thou wast not born for death, immortal Bird!
 No hungry generations tread thee down;
The voice I hear this passing night was heard
 In ancient days by emperor and clown:
Perhaps the self-same song that found a path
 Through the sad heart of Ruth,[9] when, sick for home,
 She stood in tears amid the alien corn;
 The same that oft-times hath
 Charm'd magic casements, opening on the foam
 Of perilous seas, in faery lands forlorn.

VIII

Forlorn! the very word is like a bell
 To toll me back from thee to my sole self!
Adieu! the fancy cannot cheat so well
 As she is fam'd to do, deceiving elf.
Adieu! adieu! thy plaintive anthem fades
 Past the near meadows, over the still stream.
 Up the hill-side; and now 'tis buried deep
 In the next valley-glades:
 Was it a vision, or a waking dream?
 Fled is that music:—Do I wake or sleep?

5. Toward the river Lethe, in Greek mythology the river of forgetfulness.
6. A divinity presiding over trees and flowers.
7. Leopards.
8. *Tender Is the Night* would become the title of a 20th-century novel by F. Scott Fitzgerald.
9. From the Book of Ruth in the Hebrew Bible.

The song of the bird serves as inspiration for a meditation on the nature of human experience. It comes to represent an enduring beauty beyond human grasp. The sensuous images, the intensity of emotion, and the flowing rhythm join to produce a magical effect. Yet the poem begins in despondency as Keats, at age 24, broods on life's sorrows. As he muses, the immortal song consoles him, bringing comfort and release, and he accepts his tragic fate. He died less than two years later.

The Romantic Novel

During the 19th century, increases in literacy and a rise in the general level of education resulted in a European and American public that was eager for entertainment and instruction, and the success of such writers as Charles Dickens and Leo Tolstoy was largely the result of their ability to combine the two. The best of 19th-century novels were those rare phenomena: great works of art that achieved popularity in their own day. Many of these are still able to enthrall modern readers with their humanity and insight.

There was more to the 19th-century novel than we find in the movements of Romanticism and Realism, notably beginning with two British women who achieved recognition that has spanned two centuries and shows no signs of fading. We are speaking of Jane Austen and Mary Wollstonecraft Shelley.

JANE AUSTEN

It is a truth universally acknowledged, that a single man in possession of a good fortune must be in want of a wife.

—Jane Austen, *Pride and Prejudice*

So begins one of the most popular and beloved novels in the history of fiction. Of course, it is clearly *not* universally acknowledged that financially secure men are in want of a wife—although many characters in novels by Jane Austen (1775–1817), and even contemporary romance novels, would like to think they are. But therein lies much of the charm of Austen's witty works—*Northanger Abbey* (1798–1799), *Sense and Sensibility* (1811), *Pride and Prejudice* (1811–1812), *Mansfield Park* (1814), *Emma* (1814–1815), and *Persuasion* (1815–1816). Not only are these books widely read today, they have also been made into movies—several times. On a superficial level, they are about manners and dress. If this were all they were, they might fit the category of what George Eliot would later call "silly novels by lady novelists." But on a deeper level, they satirize the British evolution of mating strategies; they certainly do not necessarily adhere to paths that might be preferred by a moralist. Austen also shared an aversion, with Mary Wollstonecraft, to the view that women are driven about whimsically by their emotions. And in *Mansfield Park*, she expresses concern about the stereotyped education of women.

Although her fiction became popular, Austen herself led a rather secluded and brief life. She was one of eight children of an Anglican clergyman. Although most of the leading novelists of the 19th century wrote within a tradition of Romanticism or Realism, Austen fit only within a category of her own. In 1816, the year before her death from a fatal illness, she satirized the perfect novel expected of a British woman in her letter, "Plan of a Novel, According to Hints from Various Quarters":

READING 20.18 JANE AUSTEN

From "Plan of a Novel, According to Hints from Various Quarters" (1816)

Scene to be in the Country, Heroine the Daughter of a Clergyman, one who after having lived much in the World had retired from it and settled in a Curacy, with a very small fortune of his own.—He, the most excellent Man that can be imagined, perfect in Character, Temper, and Manners–without the smallest drawback or peculiarity to prevent his being the most delightful companion to his Daughter from one year's end to the other.—Heroine a faultless Character herself, —perfectly good, with much tenderness and sentiment, and not the least Wit—very highly accomplished, understanding modern Languages and (generally speaking) everything that the most accomplished young Women learn, but particularly excelling in Music—her favourite pursuit—and playing equally well on the PianoForte and Harp—and singing in the first stile. Her Person quite beautiful—dark eyes and plump cheeks. —Book to open with the description of Father and Daughter—who are to converse in long speeches, elegant Language—and a tone of high serious sentiment.

. . .

From this outset, the Story will proceed, and contain a striking variety of adventures.

MARY WOLLSTONECRAFT SHELLEY Percy Bysshe Shelley dedicated his poem *Laon and Cythna* to his young wife:

They say that thou wert lovely from thy birth, Of glorious parents, thou aspiring Child.

The "aspiring child" was Mary Wollstonecraft Godwin (1797–1851), the daughter of William Godwin, a liberal-leaning philosopher who argued in favor of **free love**, and Mary Wollstonecraft, the author of *A Vindication of the Rights of Women* (see Chapter 19). Percy Shelley was an adherent of the philosophy of Godwin, and at the age of 21, he met 16-year-old Mary at her father's house in London. The couple fell in love and ran off to France, Switzerland, and Germany. At the time, Mary Shelley probably had no idea that she would pen perhaps the most renowned **Gothic novel** of all time—a genre that shares Romantic roots with tales of horror. Gothic novels, like other Romantic novels, dwell on the relationship between humans and nature, but in the Gothic novel, it is nature gone wrong—in the case of Shelley's novel, *Frankenstein, or The Modern Prometheus* (1818),

there is a misuse of the natural; a scientist creates a monster in his attempt to rival the divine and conquer nature.

With another journey to the continent (of Europe), the year 1816 saw a grouping of genius in Geneva, Switzerland. The poet Byron and his friend John William Polidori were in attendance, along with Mary and Percy. They regaled each other with stories and fantasies, including a ghost-story competition that got their creative juices flowing against the blackness of the lake at night.

Mary Shelley tells of the ghost stories in the preface to *Frankenstein, or The Modern Prometheus*. Why "the modern Prometheus"? In Greek mythology, the Titan Prometheus stole fire from the god of gods, Zeus, and gave it to humankind. His punishment was being bound to a rock where an eagle every day ate his liver, which regrew and was eaten again. Dr. Victor Frankenstein, in the novel, steals the ability to create life from the gods, and he too gets his just deserts.

Frankenstein creates life and then, finding his creation grotesque, abandons him, leading to endless tragedies, including the monster's murder of Frankenstein's brother and his beloved Elizabeth. The pathway to the killings seems inevitable. The monster asks Frankenstein to create a bride for him so that the couple can depart humanity and live in peace as recluses, consoling one another. Frankenstein does not comply. In chapter 18 of the novel, he rationalizes that "I feared the vengeance of the disappointed fiend, yet I was unable to overcome my repugnance to the task which was enjoined me. I found that I could not compose a female without again devoting several months to profound study." We witness the consequences. In perhaps the novel's saddest episode, Frankenstein allows a young family friend, Justine, to be convicted by circumstantial evidence of the killing of his brother and to be hanged for it—all because he doubts that anyone would believe him if he were to come forth with the truth. Yet amid the horror, the Romantic spirit rises to the sublime, at one with the painting of Caspar David Friedrich (see Fig. 20.21), as in Dr. Frankenstein's descriptions of the lakes of Switzerland:

READING 20.19 MARY WOLLSTONECRAFT SHELLEY

From *Frankenstein, or The Modern Prometheus*, chapter 18

We travelled at the time of the vintage, and heard the song of the labourers, as we glided down the stream. Even I, depressed in mind, and my spirits continually agitated by gloomy feelings, even I was pleased. I lay at the bottom of the boat, and, as I gazed on the cloudless blue sky, I seemed to drink in a tranquillity to which I had long been a stranger. And if these were my sensations, who can describe those of Henry [Dr. Frankenstein's close friend, Henry Clerval]? He felt as if he had been transported to Fairy-land, and enjoyed a happiness seldom tasted by man. "I have seen," he said, "the most beautiful scenes of my own country; I have visited the lakes of Lucerne and Uri, where the snowy mountains descend almost perpendicularly to the water, casting black

and impenetrable shades, which would cause a gloomy and mournful appearance, were it not for the most verdant islands that relieve the eye by their gay appearance; I have seen this lake agitated by a tempest, when the wind tore up whirlwinds of water, and gave you an idea of what the waterspout must be on the great ocean, and the waves dash with fury the base of the mountain, where the priest and his mistress were overwhelmed by an avalanche, and where their dying voices are still said to be heard amid the pauses of the nightly wind; I have seen the mountains of La Valais, and the Pays de Vaud: but this country, Victor, pleases me more than all those wonders. The mountains of Switzerland are more majestic and strange; but there is a charm in the banks of this divine river, that I never before saw equalled. Look at that castle which overhangs yon precipice; and that also on the island, almost concealed amongst the foliage of those lovely trees; and now that group of laborers coming from among their vines; and that village half-hid in the recess of the mountain. Oh, surely, the spirit that inhabits and guards this place has a soul more in harmony with man, than those who pile the glacier, or retire to the inaccessible peaks of the mountains of our own country."

At the time she wrote *Frankenstein*, Shelley was familiar with Coleridge's poetry. When she was eight years old, Coleridge recited *The Rime of the Ancient Mariner* in her family's home. She mentions the poem in *Frankenstein*. Moreover, the final passages of the novel play out against threatening floes of ice in the polar sea—the floes that trapped the mariner and his crew until the albatross flew into their lives.

We noted that John William Polidori was in attendance at the ghostly soiree in Geneva where *Frankenstein* was born. There was another birth. Polidori published his own Gothic novel a year after Frankenstein came into being: *The Vampyre* (1819), which became another literary landmark and one of the progenitors of Bram Stoker's *Dracula*, which was published in 1897.

VICTOR HUGO In some cases, writers were able to combine the Romantic style with a social conscience, as in the case of the French novelist Victor Hugo (1802–1885), whose *Les Misérables* (1862) describes the plight of the miserable victims of society's injustices, as suggested in the following extract, in which a righteous bishop implores a congregation to help the needy:

READING 20.20 VICTOR HUGO

From *Les Misérables*, volume 1, book 1, chapter 4

"My very dear brethren, my good friends, there are thirteen hundred and twenty thousand peasants' dwellings in France which have but three openings; eighteen hundred and seventeen thousand hovels which have but two openings, the door and one window; and three hundred and forty-six

thousand cabins besides which have but one opening, the door. And this arises from a thing which is called the tax on doors and windows. Just put poor families, old women and little children, in those buildings, and behold the fevers and maladies which result! Alas! God gives air to men; the law sells it to them. I do not blame the law, but I bless God. In the department of the Isère, in the Var, in the two departments of the Alps, the Hautes, and the Basses, the peasants have not even wheelbarrows; they transport their manure on the backs of men; they have no candles, and they burn resinous sticks, and bits of rope dipped in pitch. That is the state of affairs throughout the whole of the hilly country of Dauphiné. They make bread for six months at one time; they bake it with dried cow-dung. In the winter they break this bread up with an axe, and they soak it for twenty-four hours, in order to render it eatable. My brethren, have pity! behold the suffering on all sides of you!"

The hero of the novel, Jean Valjean, is an ex-convict who is rehabilitated through the agency of human sympathy and pity. Hugo provides graphic descriptions of the squalor and suffering of the poor, but his high-flown rhetorical style is essentially Romantic. *Les Misérables*, of course, has given birth to numerous movies of the name and to one of the most popular musicals in the history of musical theater.

Most of the leading novelists of the mid-19th century wrote within a tradition of Realism that came gradually to replace Romanticism. Instead of describing an imaginary world of their own creation, they looked outward to find inspiration in the day-to-day events of real life. The increasing social problems produced by industrial and urban development produced not merely a lament for the spirit of the times but also a passionate desire for the power to change them as well.

ROMANTIC MUSIC

For many of the Romantics, music was the supreme art. Free from the intellectual concepts involved in language and the physical limits inherent in the visual arts, it was capable of the most wholehearted and intuitive expression of emotion.

Romantic Composers

Among the Romantic musicians, we find many familiar names: Ludwig van Beethoven, Hector Berlioz, Franz Schubert, Johannes Brahms, Anton Bruckner, Frédéric Chopin, Franz Liszt, and Niccolò Paganini.

LUDWIG VAN BEETHOVEN Ludwig van Beethoven (1770–1827), widely regarded as the pioneer of Romanticism in music, also manifested many characteristically Romantic attitudes—a love of nature, a passionate belief in the freedom of the individual, and a fiery temperament—so it is not surprising that he has come to be regarded as the prototype of the Romantic artist.

When Beethoven wrote proudly to one of his most loyal aristocratic supporters, "There will always be thousands of princes, but there is only one Beethoven," he spoke for a new generation of creators. When he used the last movement of his Symphony No. 9 to preach the doctrine of universal brotherhood, he inspired countless ordinary listeners by his fervor. Even today, familiarity with Beethoven's music has not dulled its ability to give dramatic expression to the noblest of human sentiments.

Although Beethoven's music served as the springboard for the Romantic movement in music, his own roots were deep in the Classical tradition. He pushed Classicism to the limits through use of the sonata allegro form. In spirit, furthermore, his work is representative of the Age of Enlightenment and the revolutionary mood of the turn of the century, as seen in the words and music of his opera *Fidelio*. A complex and many-sided genius, Beethoven transcended the achievements of the age in which he was born and set the musical tone for the 19th century.

Beethoven was born in Bonn, Germany, where he received his musical training from his father, an alcoholic. Beethoven's father saw the possibility of producing a musical prodigy in his son and forced him to practice hours at the keyboard, often locking him in his room and beating him on returning from drinking bouts. All possibilities of a happy family life were brought to an end in 1787 when Beethoven's mother died and his father descended into advanced alcoholism. Beethoven sought compensation in the home of the von Breuning family, where he acted as private tutor. It was there that he met other musicians and artists and developed a lifelong love of literature. He also struck up a friendship with a local minor aristocrat, Count von Waldstein, who remained his devoted admirer until the composer's death.

In 1792, Waldstein was one of the aristocrats who helped Beethoven go to Vienna to study with Haydn, who was then regarded as the greatest living composer; but, although Haydn agreed to give him lessons, the young Beethoven's impatience and suspicion, and Haydn's deficiencies as a teacher, did not make for a happy relationship. Nevertheless, many of the works Beethoven wrote during his first years in Vienna are essentially Classical in both form and spirit; only by the end of the century had he begun to extend the emotional range of his music.

One of the first pieces to express the characteristically Beethovenian spirit is his Piano Sonata No. 8 in C Minor, Op. 13, generally known as the "Pathétique." Beethoven's sonata is characteristic of Romantic music in its strong expression of personal feelings. Its three movements, of which we hear the last, tell a continuous story in which the hero (the composer) fights an increasingly desperate battle against what seems his certain destiny. Unlike the Classical, tragic resignation of Mozart's Symphony No. 40 (see Chapter 19), Beethoven's Romantic spirit drives him to fight.

GO LISTEN!
LUDWIG VAN BEETHOVEN
Piano Sonata No. 8 ("Pathétique") in C Minor, Op. 13

In the first movement, grim resistance gives way to forceful, turbulent struggle; after a second movement with a serene vision of beauty that offers hope of relief, Beethoven returns to the battle. The final movement appears to arrive at a synthesis between

the drama of the opening and the hushed beauty of the slow movement. The music opens in a fragile, reflective mood. The composer has not yet recovered from the solemn beauty of the slow movement, and we hear his changes of mood echoed in the music, as if he hesitates to prepare himself for further combat. His repeated instruction to the performer is *tranquillo* (peaceful). Yet the mood darkens, and the music is marked *agitato* (agitated). The strife-ridden mood of earlier sweeps away the sense of resignation. There are brief moments of respite, and just before the very end, the opening theme returns quietly and with simplicity. Yet the conclusion is both decisive and sudden. The piano hurtles down a violent scale, and a final brutal chord puts an end to the piece, with its alternating moods of faint hope and despair. Before the Romantics, no one had used music for such frank expression of the most fluctuating emotions, and Beethoven's use of abrupt changes of volume, his hesitations, and his sense of self-revelation are all typical of the new musical era.

It is important to understand precisely how Beethoven used music in a new and revolutionary way. Other composers had written music to express emotion long before Beethoven's time, from Bach's outpouring of religious fervor to Mozart's evocation of human joy and sorrow. What is different about Beethoven is that his emotion is autobiographical. His music tells us how he feels, what his succession of moods is, and what conclusion he reaches. It does other things at the same time, and at this early stage in his career, for the most part, it self-consciously follows Classical principles of construction, but the vivid communication of personal emotions is its prime concern. That Beethoven's range was not limited to anger and frustration is immediately demonstrated by the beautiful and consoling middle (slow) movement of the "Pathétique," with its lyrical main theme—but the final movement returns to passion.

Parallels for the turbulent style of the "Pathétique" can be found in other contemporary arts, especially literature, but although to some extent Beethoven was responding to the climate of the times, there can be no doubt that he was also expressing a personal reaction to the terrible tragedy that had begun to afflict him as early as 1796. In that year, the first symptoms of his deafness began to appear; by 1798, his hearing had grown very weak; and by 1802, he was virtually totally deaf.

CONNECTIONS

Whether you come from heaven or hell, what does it matter, O Beauty!

—Charles Baudelaire

Three of the most renowned contributors to the humanities in the 18th and 19th centuries—the painter Francisco Goya y Lucientes, the composer Ludwig von Beethoven, and the playwright Oscar Wilde—became deaf. Beethoven's symptoms of deafness became apparent between the ages of 26 and 30, but it was not until the age of 31 that he began to confide in others about his worsening hearing loss and his withdrawal into solitude. In a letter to Franz Gerhard Wegeler dated June 29, 1801, Beethoven wrote:

> …my ears continue to hum and buzz day and night. I must confess that I lead a miserable life. For almost two years I have ceased to attend any social functions, just because I find it impossible to say to people: I am deaf. If I had any other profession I might be able to cope with my infirmity; but in my profession it is a terrible handicap.*

By about 1814 or 1815, Beethoven was functionally deaf, his hearing having degenerated over the course of 20 years. Goya's deafness, by contrast, came about suddenly over the course of a couple of days during which he was gravely ill. He was 46 years old. Oscar Wilde died at the age of 46 of an ear infection and meningitis. He had a history of hearing loss as a result of persistent infections that worsened during his imprisonment for indecency. Ironically, he was the son of a famous

▲ **20.24 A scene from the film *Immortal Beloved* (1994) with Gary Oldman as Beethoven, here shown composing his *Moonlight Sonata* (Piano Sonata No. 14 in C-sharp minor "Quasi una fantasia," Op. 27, No. 2).** It was completed in the same year that Beethoven wrote to Wegeler of his deafness.

otolaryngologist-surgeon who established the original Eye and Ear Hospital in Dublin, Ireland.

After Wilde was released from prison, he never wrote again. Both Beethoven and Goya were able to rise above their circumstances and produce some of their better-known works after becoming deaf, although, for at least a period of time, each one had lapsed into isolation and despair. One might assume that deafness would be most disabling to a composer, but Beethoven, who had written of thoughts of suicide, completed his *Ninth Symphony* almost a decade after he became deaf. It is considered to be one of the masterworks of the Western musical canon.

* http://www.ringnebula.com/Beet/Letters/Anderson_vI_letter51.htm.

Nonetheless, although obviously affected by his condition, Beethoven's music was not exclusively concerned with his own fate. The same heroic attitude with which he faced his personal problems was also given universal expression, never more stupendously than in the Symphony No. 3 in E-flat, Op. 55, subtitled the "Eroica" (Heroic) Symphony. As early as 1799, the French ambassador to Vienna had suggested that Beethoven write a symphony in honor of Napoléon Bonaparte. At the time, Napoléon was widely regarded as a popular hero who had triumphed over his humble origins to rise to power as a champion of liberty and democracy. Beethoven's own democratic temperament made him one of Napoléon's many admirers. The symphony was duly begun, but in 1804—the year of its completion—Napoléon had himself crowned emperor. When Beethoven heard the news, he angrily crossed out Napoléon's name on the title page. The first printed edition, which appeared in 1806, bore only the dedication "to celebrate the memory of a great man."

The "Eroica" is not merely a portrait of Napoléon. Rather, inspired by what he saw as the heroic stature of the French leader, Beethoven created his own heroic world in sound, in a work of vast dimensions. The first movement alone lasts for almost as long as many a Classical symphony. Its complex structure requires considerable concentration by the listener. The form is basically the Classical sonata allegro form (see Chapter 19), but on a much grander scale and with a wealth of musical ideas. Yet the principal theme of the movement, which the cellos announce at the beginning after two hammering, impatient chords demand our attention, is of a rocklike sturdiness and simplicity.

Beethoven's genius emerges as he uses this and other similarly straightforward ideas to build his mighty structure. Throughout the first movement, his use of harmony and, in particular, discord adds to the emotional impact, especially in the middle of the development section, where slashing dissonances seem to tear apart the orchestra. His Classical grounding emerges in the recapitulation, where the infinite variety of the development section gives way to a restored sense of unity; the movement ends triumphantly with a long and thrilling coda. The formal structure is recognizably Classical, but the intensity of expression, depth of personal commitment, and heroic defiance are all totally Romantic.

The second movement of the "Eroica" is a worthy successor to the first. A funeral march on the same massive scale, it alternates a mood of epic tragedy—which has been compared, in terms of impact, with the works of the Greek playwright Aeschylus—with rays of consolation that at times achieve a transcendental exaltation. Although the many subtleties of construction deserve the closest attention, even a first hearing will reveal the grandeur of Beethoven's conception.

The third and fourth movements relax the tension. For the third, Beethoven replaces the stately minuet of the classical symphony with a **scherzo**—the word literally means "joke" and is used to describe a fast-moving, lighthearted piece of music. Beethoven's introduction of this kind of music, which in his hands often has something of the crude flavor of a peasant dance, is another illustration of his democratization of the symphony. The last movement is a brilliant and energetic series

of variations on a theme Beethoven had composed a few years earlier for a ballet he had written about Prometheus.

Many of the ideas and ideals that permeate the "Eroica" reappear throughout Beethoven's work. His love of liberty and hatred of oppression are expressed in his only opera, *Fidelio*, which describes how a woman rescues her husband, who has been unjustly imprisoned for his political views. A good performance of *Fidelio* is still one of the most uplifting and exalting experiences music has to offer.

The first notes of Beethoven's Fifth Symphony are probably the best known of any symphony. Nothing could be further from the Classical balance of Haydn and Mozart than Beethoven's Romantic drive and passion. The mood of pathos and agitation is present from the opening hammering motive that permeates the entire movement and eventually drives it to its fatal conclusion.

GO LISTEN!
LUDWIG VAN BEETHOVEN
Symphony No. 5 in C Minor

The careful listener will hear that Beethoven constructs his torrent of sound according to the principles of traditional sonata form (this performance does not repeat the opening section, the exposition). The first section ends with a pause, and the middle, development section concentrates almost exclusively on the opening motive, which is passed around the orchestra. We then hurtle into the recapitulation, which repeats the opening section with one important addition: a pathetic, almost weeping solo passage for the oboe. Then, as the recapitulation comes to its stormy end, Beethoven plunges into an extended coda (conclusion), which builds up to new heights of tension and violence before its abrupt conclusion.

Never before in the history of music had any composer maintained such emotional intensity and concentration throughout a symphonic movement. It is difficult for us today to realize the revolutionary impact of his music on Beethoven's contemporaries as an expression of personal feelings. When the French composer Hector Berlioz took his old teacher of composition to the first Paris performance of the Fifth Symphony, the old man was so bewildered that, on leaving, he could not put on his hat—because, Berlioz tells us, he could not find his head.

Beethoven's Symphony No. 6, Op. 68, called the "Pastoral," consists of a Romantic evocation of nature and the emotions it arouses, while his Symphony No. 9, Op. 125, is perhaps the most complete statement of human striving to conquer all obstacles and win through to universal peace and joy. In it Beethoven introduced a chorus and soloists to give voice to the "Ode to Joy" by his compatriot Johann Christoph Friedrich von Schiller (1759–1805). The symphony is one of the most influential works of the Romantic movement.

HECTOR BERLIOZ After Beethoven, music could not return to its former mood of Classical objectivity. Although Beethoven's music may remain unsurpassed for its universalization of individual emotion, his successors tried—and in large measure succeeded—to find new ways to express their own

feelings. Among the first to follow Beethoven was Hector Berlioz (1803–1869), the most distinguished French Romantic composer, who produced, among other typically Romantic works, *The Damnation of Faust* (a setting of Part One of Goethe's work) and the *Symphonie fantastique* ("Fantastic Symphony"), which describes the hallucinations of an opium-induced dream. In both of these, Berlioz used the full Romantic apparatus of dreams, witches, demons, and the grotesque to lay bare the artist's innermost feelings.

GO LISTEN!
HECTOR BERLIOZ
Symphonie fantastique, V, "Dream of a Witches' Sabbath"

In 1830 (three years after the death of Beethoven), Berlioz presented to an astonished Parisian public his *Symphonie fantastique*, subtitled "Episode in the Life of an Artist." Clearly this was self-confessed expression of personal feelings and self-analysis at its most Romantic.

Berlioz himself provides the background. A young musician of extraordinary sensibility, in the depths of despair because of hopeless love, has poisoned himself with opium. The drug is too feeble to kill him but plunges him into a heavy sleep accompanied by weird visions. His sensations, emotions, and memories become transformed into musical images and ideas. The beloved herself becomes a melody—what Berlioz calls the *idée fixe* (fixed idea)—that recurs throughout all five movements of the work. The writing for the orchestra introduces new sound colors and combinations in order to render the horror of the scene, in particular through Berlioz's highly unusual use of the woodwinds.

The last movement, from which we hear the opening section, depicts the funeral of the dreamer, who has seen his own execution in the preceding movement. The scene is that of a witches' Sabbath, and the music begins with a series of muffled groans and cries that convey a gradual assembly of cackling old witches. The theme that earlier represented the dreamer's beloved appears in a horribly distorted form played by the woodwinds, and at the climax of the tumult, the brass instruments hurl out the traditional Gregorian-chant theme of the **Dies Irae** (day of wrath), as in a Roman Catholic requiem mass for the dead. The brass blare combines with the witches' dance to form what the composer calls a "diabolical orgy."

It only remains for the historian to add that the beloved in question was the Irish actress Harriet Smithson, whom Berlioz married in 1833 and from whom he separated in 1842.

FRANZ SCHUBERT A highly intimate and poetic form of Romantic self-revelation is the music of Franz Schubert (1797–1828), who explored in the few years before his premature death the new possibilities opened up by Beethoven in a wide range of musical forms. In general, Schubert was happiest when working on a small scale, as evidenced by his more than 600 **lieder** (songs), which are an inexhaustible store of musical and emotional expression.

On the whole, the more rhetorical nature of the symphonic form appealed to Schubert less, although the wonderful Symphony No. 8 in B Minor, called the "Unfinished" because he completed only two movements, combines great poetic feeling with a sense of drama. His finest instrumental music was written for small groups of instruments. The two trios for piano, violin, and cello are rich in the delightful melodies that seemed to come to him so easily; the second, slow movement of the Trio in E-flat, Op. 100, touches profound depths of Romantic expression. Like the slow movement of Mozart's Piano Concerto No. 27 in B-flat (see Chapter 19), its extreme beauty is tinged with an unutterable sorrow.

JOHANNES BRAHMS Most 19th-century composers followed Beethoven in using the symphony as the vehicle for their most serious musical ideas. Robert Schumann (1810–1856) and his student, Johannes Brahms (1833–1897), regarded the symphonic form as the most lofty means of musical expression, and each as a result wrote only four symphonies. Brahms did not even dare to write a symphony until he was 44 and is said to have felt the presence of Beethoven's works "like the tramp of a giant" behind him. When it finally appeared, Brahms' Symphony No. 1 in C Minor, Op. 68, was inevitably compared to Beethoven's symphonies. Although Brahms's strong sense of form and conservative style won him the hostility of the arch-Romantics of the day, other critics hailed him as the true successor to Beethoven.

Both responses were, of course, extreme. Brahms's music certainly is Romantic, with its emphasis on warm melody and a passion no less present for being held in check—but far from echoing the stormy mood of many of the symphonies of his great predecessor, Brahms was really more at home in a relaxed vein. Although the Symphony No. 1 begins with a gesture of defiant grandeur akin to Beethoven's, the first movement ends by fading dreamily into a glowing tranquility. The lovely slow movement is followed not by a scherzo but by a quiet and graceful **intermezzo** (interlude), and only in the last movement are we returned to the mood of the opening.

ANTON BRUCKNER Closer to the more cosmic mood of the Beethoven symphonies are the nine symphonies of the Austrian Anton Bruckner (1824–1896). A deeply religious man imbued with a Romantic attachment to the beauties of nature, Bruckner combined his Catholicism and vision in music of epic grandeur. It has often been remarked that Bruckner's music requires time and patience on the listener's part. His pace is leisurely, and he creates huge structures in sound that demand our full concentration if we are to appreciate their architecture. There is no lack of incidental beauty, however, and the rewards are immense, especially in the slow movements of his last three symphonies. The **adagio** movement from the Symphony No. 8 in C Minor, for instance, moves from the desolate Romanticism of its opening theme to a mighty, blazing climax.

The Instrumental Virtuosos

Some composers were also known for their performance expertise. Beethoven's emphasis on the primacy of the artist inspired another series of Romantic composers to move in a different direction from that of the symphony. Beethoven had first made

his reputation as a brilliant pianist, and much of his music—both for piano and for other instruments—was of considerable technical difficulty. As composers began to demand greater and greater feats of virtuosity from their performers, performing artists came to attract more attention. Singers had already in the 18th century commanded high fees and attracted crowds of fanatical admirers, and they continued to do so. Now, however, they were joined by instrumental virtuosos, some of whom were also highly successful composers.

FRÉDÉRIC CHOPIN The life of Frédéric Chopin (1810–1849) seems almost too Romantic to be true (**Fig. 20.25**). Both in his piano performances and in the music he composed, he united the aristocratic fire of his native Poland with the elegance and sophistication of Paris, where he spent much of his life. His concerts created a sensation throughout Europe, while his piano works exploited (if they did not always create) new musical forms like the **nocturne**—a short piano piece in which an expressive, if often melancholy, melody floats over a murmuring accompaniment. Chopin is characteristically Romantic in his use of music to express his own personal emotions. The structure of works like the 24 **preludes** of Op. 28 is dictated not by formal considerations but by the feeling of the moment. Thus, the first three take us from excited agitation to brooding melancholy to bubbling high spirits in just over three minutes.

In private, Chopin's life was dominated by a much-talked-about liaison with the leading French woman author of the day,

George Sand (1804–1876). His early death from tuberculosis put the final Romantic touch to the life of a composer who has been described as the soul of the piano.

FRANZ LISZT Franz Liszt (1811–1886) shared Chopin's brilliance at the keyboard and joined it with his robust temperament. A natural Romantic, Liszt ran the gamut of Romantic themes and experiences. After beginning his career as a handsome, impetuous rebel, the idol of the salons of Paris, he conducted several well-publicized affairs and finally turned to the consolation of religion. His vast musical output includes some of the most difficult piano works (many of them inspired by the beauties of nature), two symphonies on the characteristically Romantic subjects of Faust and Dante (with special emphasis, in the latter case, on the *Inferno*), and a host of pieces that are infused with the folk tunes of his native Hungary.

NICCOLÒ PAGANINI The greatest violinist of the age was Niccolò Paganini (1782–1840). Like Chopin and Liszt, Paganini also composed, but his public performances secured his reputation. So apparently impossible were the technical feats he "casually" executed that rumor spread that, like the fictional Faust, he had sold his soul to the devil. This Romantic exaggeration was assiduously encouraged by Paganini, who cultivated a suitably ghoulish appearance to enhance his public image. Nothing more clearly illustrates the 19th century's obsession with music as emotional expression (in this case, diabolical) than the fact that Paganini's concerts earned him honors throughout Europe and a considerable fortune.

Music and Nationalism

Both Chopin and Liszt introduced the music of their native lands into their works, Chopin in his **mazurkas** and **polonaises** (traditional Polish dances) and Liszt in his *Hungarian Rhapsodies*. For the most part, however, they adapted their musical styles to the prevailing international fashions of the day.

Other composers placed greater emphasis on their native musical traditions. In Russia, a group of five composers—Mussorgsky, Balakirev, Borodin, Cui, and Rimsky-Korsakov (known collectively as the "Big Five")—purposefully set out to exploit their rich musical heritage. For example, Modest Mussorgsky's (1839–1881) opera *Boris Godunov* (1874) is based on an episode in Russian history. It makes full use of Russian folksongs and religious music in telling the story of Tsar Boris Godunov, who rises to power by killing the true heir to the throne. Although Boris is the opera's single most important character, the work is dominated by the chorus, which represents the Russian people. Mussorgsky powerfully depicts their changing emotions, from bewilderment to awe to fear to rage, and in so doing voices the feelings of his nation. The pulsating rhythms of Nikolai Rimsky-Korsakov's (1844–1908) symphonic suite *Scheherazade* (1888) retell the Arabic *One Thousand and*

▲ **20.25** Ferdinand-Eugène-Victor Delacroix, *Frédéric Chopin*, 1838. Oil on canvas, 18" × 15" (45 × 38 cm). Musée du Louvre, Paris, France. Delacroix's portrait of his friend captures Chopin's Romantic introspection. Delacroix was a great lover of music, although perhaps surprisingly the great Romantic painter preferred the Classical Mozart to Beethoven.

CULTURE AND SOCIETY

Nationalism

One of the consequences of the rise of the cities and growing political consciousness was the development of nationalism: the identification of individuals with a nation–state, with its culture and history. In the past, the units of which people felt a part were either smaller (a local region) or larger (a religious organization or a social class). In many cases, the nations with which people began to identify either were broken up into separate small states, as in the case of the future Germany and Italy, or formed part of a larger state: Hungary, Austria, and Serbia were all under the rule of the Austro–Hungarian Empire, with Austria dominating the rest.

In the period from 1848 to 1914, the struggle for national independence marked political and social life and left a strong impact on European culture. The arts became one of the chief ways in which nationalists sought to stimulate peoples' awareness of their national roots. One of the basic factors that distinguished the Hungarians or the Czechs from their Austrian rulers was their language, and patriotic leaders fought for the right to use their own language in schools, government, and legal proceedings. In Hungary, the result was the creation by Austria of the Dual Monarchy in 1867, which allowed Hungarian speakers to have their own systems of education and public life. A year later, the Habsburgs granted a similar independence to Hungarian minorities—Poles, Czechs, Slovaks, Romanians, and others.

In Germany and Italy, the reverse process operated. Although most Italians spoke one or another dialect of the same language, they had been ruled for centuries by a bewildering array of outside powers. In Sicily alone, Arabs, French, Spaniards, and English were only some of the occupiers who had succeeded one another. The architects of Italian unity used the existence of a common language, which went back to the poet Dante, to forge a sense of national identity.

The arts also played their part. Nationalist composers used folk tunes, sometimes real and sometimes invented, to underscore a sense of national consciousness. In the visual arts, painters illustrated historical events and sculptors portrayed patriotic leaders. While the newly formed nations aimed to create independent national cultures, the great powers reinforced their own identities. Russian composers turned away from Western models to underline their Slavic roots, while in the United Kingdom, the artists and writers of the Victorian Age depicted the glories (and, in some cases, the horrors) of their nation.

The consequences of the rise of national consciousness dominated the 20th century and are still with us today. The age of world war was inaugurated by competition between nation–states, and the last half of the 20th century saw the collapse and regrouping of many of the countries created in the first half. Among the casualties are the former Czechoslovakia and Yugoslavia. The struggle of minorities to win their own nationhood remains a cause of bloodshed, as with the Basques of northern Spain and the Corsican separatists. In both cases, language and the arts continue to serve as tools in the struggle.

One Nights with colorful orchestration, combining Russian music with a Russian fascination with the East.

Elsewhere in Eastern Europe, composers were finding similar inspiration in national themes and folk music. The Czech composer Bedřich Smetana (1824–1884), who aligned himself with his native Bohemia in the uprising against Austrian rule in 1848, composed a set of six pieces for orchestra under the collective title of *Má vlast* (*My Fatherland*). The best known, *Vltava* (*The Moldau*), depicts the course of the river Vltava as it flows from its source through the countryside to the capital city of Prague. His fellow countryman Antonín Dvořák (1841–1904) also drew on the rich tradition of folk music in works like his *Slavonic Dances*, colorful settings of Czech folk tunes.

Opera

Throughout the 19th century, opera achieved new heights of popularity in Europe, and "opera mania" spread to the United States, where opera houses opened in New York (1854) and Chicago (1865). Early in the century, the Italian opera-going public was interested in beautiful and brilliant singing rather than realism of plot or action.

BEL CANTO OPERA Composers such as Gaetano Donizetti (1797–1848) and Vincenzo Bellini (1801–1835) used their music to express sincere and deep emotions, even drama, but the emotional expression was achieved primarily by means of

bel canto (beautiful singing) and not by the unfolding of a convincing plot. The story lines of their operas apparently serve as "excuses" for the performance of their music; characters in bel canto operas are thus frequently given to fits of madness in order to give musical expression to deep emotion.

The revival and subsequent popularity of much early-19th-century opera is largely the result of the performances and recordings of Maria Callas (1923–1977), whose enormous talent showed how a superb interpreter could bring such works to life. Following her example, other singers turned to bel canto opera, with the result that performances of Bellini's *Norma* (1831) and of Donizetti's best-known opera, *Lucia di Lammermoor* (1835), have become a regular feature of modern operatic life, while lesser-known works are revived in increasing numbers.

Under the inspiration of the Italian Giuseppe Verdi and the German Richard Wagner, however, opera began to move in a different direction. Their subjects remained larger than life, but dramatic credibility became increasingly important. On both sides of the Atlantic, opera-house stages are still dominated by the works of these two 19th-century giants.

GIUSEPPE VERDI Giuseppe Verdi (1813–1901) showed a new concern for dramatic and psychological truth. Even in his early operas like *Nabucco* (1842) and *Luisa Miller* (1849), Verdi was able to give convincing expression to human relationships. At the same time, his music became associated with the growing nationalist movement in Italy. *Nabucco*, for example, deals ostensibly with the captivity of the Jews in Babylon and their oppression by Nebuchadnezzar, but the plight of the Jews became symbolic of the Italians' suffering under Austrian rule. The chorus the captives sing as they think of happier days, "Va, pensiero" ("Fly, thought, on golden wings, go settle on the slopes and hills where the soft breezes of our native land smell gentle and mild"), became a kind of theme song for the Italian nationalist movement, the Risorgimento, largely because of the inspiring yet nostalgic quality of Verdi's tune.

Verdi's musical and dramatic powers reached their first great climax in three major masterpieces—*Rigoletto* (1851), *Il trovatore* (1853), and *La traviata* (1853)—that remain among the most popular operas. They are very different in subject and atmosphere. *Il trovatore* is perhaps the most traditional in approach, with its gory and involved plot revolving around the troubadour Manrico and its abundance of superb melodies. In *Rigoletto*, Verdi achieved one of his most convincing character portrayals in the title character, a hunchbacked court jester who is forced to suppress his human feelings and play the fool to his vicious and lecherous master, the Duke of Mantua. With *La traviata*, based on Dumas's play *La dame aux camélias* (*The Lady of the Camellias*), Verdi broke new ground in the history of opera by dealing with contemporary life rather than a historical or mythological subject.

Act 1 of *La traviata* takes place at a party given by Violetta Valéry. She is used to being admired and flattered but, during the course of the party, a naïve young man from the provinces, Alfredo Germont, confesses that he feels a real and sincere love for her. Violetta is amused but moved, and when the guests have gone and she finds herself alone, she sings the aria "Ah, fors' è lui": perhaps this is the man who can offer her the joy of loving and being loved, a joy she has never known but for which she yearns. In typical Romantic fashion, she explores and analyzes her own feelings, repeating the phrase "croce e delizia" (torment and delight).

GO LISTEN!
GIUSEPPE VERDI

Violetta's aria "Ah, fors' è lui" from *La traviata*

Her conflicting emotions are expressed by a melody that at first is broken and unsure, but as her confidence grows, it breaks out into glowing, soaring phrases. Note that at the end, the unaccompanied vocal line serves to display not the excellent technique of the singer (although it certainly requires that) but the innermost personal feelings of the character—another Romantic characteristic. Equally Romantic is the way in which her fluctuating emotions reflect the illness that proves fatal at the end of the opera.

As the opera progresses, Violetta falls in love with Alfredo and decides to give up her sophisticated life in the capital for country bliss. Her reputation follows her, however, in the form of Alfredo's father. In a long and emotional encounter, he persuades her to abandon his son and put an end to the disgrace she is bringing on his family. Violetta, who is aware of her fatal illness, returns alone to the cruel glitter of her life in Paris. By the end of the opera, her money gone, she lies dying in poverty and solitude. At this tragic moment, Verdi gives her one of his most moving arias, "Addio del passato" ("Goodbye, bright dreams of the past"). Alfredo, learning of the sacrifice she has made for his sake, rushes to find her, only to arrive for a final farewell—Violetta dies in his arms.

Throughout the latter part of his career, Verdi's powers continued to develop and grow richer, until in 1887 he produced in *Otello*—a version of Shakespeare's tragedy—perhaps the supreme work in the entire Italian operatic tradition. From the first shattering chord that opens the first act to Otello's heartbreaking death at the end of the last, Verdi rose to the Shakespearean challenge with music of unsurpassed eloquence. In a work that is so consistently inspired, it seems redundant to pick out highlights, but the ecstatic love duet of act 1 between Otello and Desdemona deserves mention as one of the noblest and most moving of all depictions of Romantic passion.

RICHARD WAGNER The impact of Richard Wagner (1813–1883) on his times went far beyond the opera house. Not only did his works change the course of the history of music, but many of his ideas also had a profound effect on writers and painters. He became involved with the revolutionary uprisings of 1848 and spent several years in exile in Switzerland.

It is difficult to summarize the variety of Wagner's ideas, which ranged from art to politics to vegetarianism and are not noted for their tolerance. Behind many of his writings on opera and drama lay the concept that the most powerful form of artistic expression was one that united all the arts—music,

painting, poetry, movement—in a single work of art, the **Gesamtkunstwerk** (total artwork). To illustrate this theory, Wagner wrote both the words and music of what he called "music dramas" and even designed and built a special theater for their performance at Bayreuth, Germany, where they are still performed every year at the Bayreuth Festival.

Several characteristics link Wagner's mature works. He abolished the old separation between *recitatives* (in which the action was advanced) and arias, duets, or other individual musical numbers (which held up the action). Wagner's music flows continuously from the beginning to the end of each act with no pauses. He eliminated the vocal display and virtuosity that had been traditional in opera. Wagnerian roles are not easy to sing, but their difficulties are for dramatic reasons and not to display a singer's skill. He also placed new emphasis on the orchestra, which not only accompanies the singers but also provides a rich musical argument of its own. This orchestral innovation is enhanced by his device of the **leitmotiv** (leading motif), which gives each principal character, idea, and even object a theme of his, her, or its own. By recalling these themes and combining them or changing them, Wagner achieves complex dramatic and psychological effects.

Wagner generally drew his subjects from German mythology. By peopling his stage with heroes, gods, giants, magic swans, and the like, he aimed to create universal dramas with universal emotions. In his most monumental achievement, *The Ring of the Nibelung*, written between 1851 and 1874, he even represented the end of the world. The Ring cycle consists of four separate music dramas—*The Rhine Gold*, *The Valkyrie* (**Fig. 20.26**), *Siegfried*, and *Twilight of the Gods*—the plot of which defies summary. With rich music, Wagner depicted not only the actions and reactions of his characters but also the wonders of nature. In *Siegfried*, for example, we hear the rustling of the forest and the songs of wood birds, while throughout the Ring cycle and especially in the well-known "Rhine Journey" from *Twilight of the Gods*, the mighty river Rhine reverberates throughout the score. At the same time, *The Ring of the Nibelung* has several philosophical and political messages, many of which are derived from Schopenhauer. One of its main themes is that power corrupts; Wagner also adopted Goethe's idea of redemption by a woman in the final resolution of the drama.

The second opera of Wagner's Ring cycle, *The Valkyrie*, introduces us to the work's hero, Brünnhilde, who is one of the nine Valkyries, warrior daughters of Wotan, father of the gods. Their task is to roam the battlefields and carry the bodies of dead heroes to Valhalla (the home of the gods).

GO LISTEN!
RICHARD WAGNER
"The Ride of the Valkyries"
from act 3 of *The Valkyrie*

▲ **20.26** **Scene from *The Valkyrie*, the second work in Richard Wagner's *The Ring of the Nibelung*, June 24, 2007. Grand Théâtre de Provence, Aix-en-Provence, France.** Following the famous "Ride of the Valkyries," the warrior maidens surround their fellow Valkyrie Brünnhilde (played here by Eva Johannson), center stage. The woman dressed in white, lying prostrate, is Sieglinde, who is destined to give birth to Siegfried, the cycle's eventual hero.

At the beginning of the third act of *The Valkyrie*, Brünnhilde's sisters gather on a mountaintop, and Wagner's stormy music describes their ride through the clouds. Note how the composer sets the scene by his use of the orchestra. The woodwinds begin with a series of wild trills, the strings play scales that rush up and down, and then the heavy brass enter with the rhythmic motive of the Valkyries (a theme that returns many times during the rest of the Ring cycle). As each warrior maid arrives with her fallen hero, the music subsides, only to rise again to ever greater peaks of excitement as another rides in.

The version on the playlist is orchestral, prepared for performance in the concert hall rather than in the opera house, so no voices are heard. In the original, we hear the Valkyries calling to one another. The ending of the selection is also modified for concert performance; in the opera, the scene continues unbroken.

The wild and exotic nature of the music is typical of fully developed Romanticism, as is the extended development of the plot of *The Ring of the Nibelung*, with its emphasis on erotic love and the role of Wotan as eventual redeemer at the very end of the cycle, while the use of Norse and Germanic mythology (rather than biblical or Classical background) illustrates the Romantics' love of nationalism.

No brief discussion can begin to do justice to so stupendous a work as the Ring cycle. It is probably easier to understand Wagner by looking at a work on smaller scale, a single self-contained music drama—albeit one of some four hours'

duration. *Tristan and Isolde* was first performed in 1865, and its first notes opened a new musical era. Its subject is the overwhelming love of the English knight Tristan and the Irish princess Isolde: so great that the pair betray his dearest friend and lord and her husband, King Mark of Cornwall, and so overpowering that it can achieve its complete fulfillment only in death.

Wagner's typically Romantic preoccupation with love and death may seem morbid and far-fetched, but under the sway of his intoxicating music, it is difficult to resist. The sense of passion awakened but unfulfilled is expressed in the famous opening bars of the prelude. The music imparts no sense of settled harmony or clear direction. This lack of **tonality**, used here for dramatic purpose, was to have a considerable influence on modern music.

The core of *Tristan and Isolde* is the long love scene at the heart of the second act, where the music reaches heights of erotic ecstasy too potent for some listeners. Whereas Verdi's love duet in *Otello* presents two noble spirits responding to one another with deep feeling but with dignity, Wagner's characters are racked by passions they cannot begin to control. If ever music expressed what neither words nor images could depict, it is in the overwhelming physical emotion of this scene. The pulsating orchestra and surging voices of the lovers build up an almost unbearable tension that Wagner suddenly breaks with the arrival of King Mark. Once again, as in the prelude, fulfillment is denied both to the lovers and to us.

That fulfillment is reached only at the end of the work in Isolde's "Liebestod" (love death). Tristan has died, and over his body Isolde begins to sing a kind of incantation. She imagines she sees the spirit of her beloved, and in obscure, broken words describes the bliss of union in death before sinking lifeless upon him. Although the "Liebestod" does make its full effect when heard at the end of the entire work, even out of context the emotional power of the music as it rises to its climax can hardly fail to affect the sensitive listener.

REALISM

If Neo-Classical artists sought a visual counterpart to the primacy of reason based in Enlightenment philosophy, and the Romanticists emphasized feeling, imagination, and intuition, the driving force behind Realism was science. The emphasis in contemporary scientific thought on *empiricism*—the direct observation of natural phenomena and experience as the foundation of knowledge—found its equivalent among artists and writers subscribing to **Realism**.

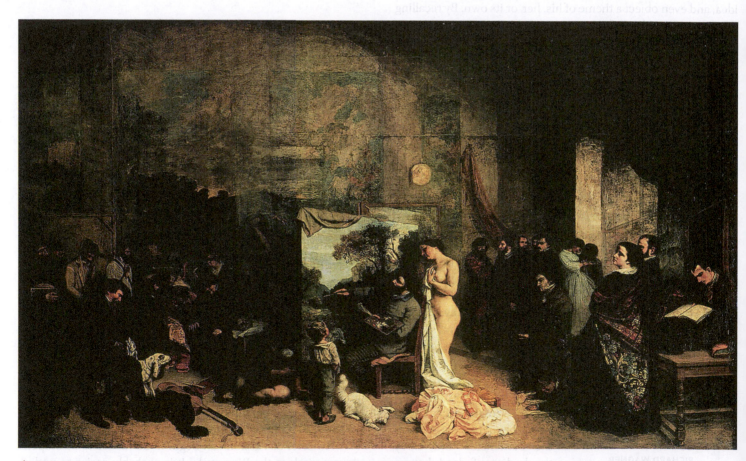

▲ **20.27** Gustave Courbet, *The Artist's Studio: A Real Allegory Summing Up Seven Years of My Artistic and Moral Life*, 1855. **Oil on canvas, 11' 9¾" × 19' 6" (360 × 596 cm). Musée d'Orsay, Paris, France.** Although most of the figures can be convincingly identified as symbols of real people, no one has ever satisfactorily explained the small boy admiring Courbet's work or the cat at his feet.

Realist Art

The major proponent of Realism in the visual arts, Gustave Courbet, stated, "Painting is an essentially concrete art and can only consist of the representation of real and existing things. It is a completely physical language, the words of which consist of all visible objects. An object which is abstract, not visible, non-existent is not within the realm of painting." Realists painted what they saw; anything else, they believed, did not represent the real world. Courbet also said, "I have never seen angels. Show me an angel and I will paint one." Realist writers approached their subjects from the same perspective: they too portrayed real-life situations without idealization or sentiment. For the Realists, human drama was human-scaled and therefore believable and knowable.

GUSTAVE COURBET Courbet's (1819–1877) Realism had a political tinge. He was a fervent champion of the working class whose ability to identify with ordinary people won him the label of Socialist. Yet Courbet did not fully accept this characterization of his artistic and philosophical positions and painted *The Artist's Studio: A Real Allegory Summing Up Seven Years of My Artistic and Moral Life* (**Fig. 20.27**), partly to respond to this misimpression. We find a self-portrait of the artist placed firmly in the center of the picture, engrossed in the creation of a landscape and inspired by a nude female model—a muse—who would appear to represent Realism or Truth. The various other figures symbolize the forces that made up Courbet's world. On the right side, we recognize his friends, other artists, and art lovers, including Baudelaire, a bearded art collector, and a philosopher (Proudhon). On the left side, we find what Courbet termed the "world of everyday life," including a merchant, a priest, a hunter, an unemployed worker, and a female beggar. There are also a guitar, dagger, and hat which, along with the male model, constitute a symbolic condemnation of traditional art. The painter stands in the middle as a mediator between these social types, affirming his view of the artist's cultural role in a scene painted on a grand scale. The work was intended to be shown at the 1855 Universal Exhibition, but Courbet got wind of the fact that it was going to be rejected. He therefore constructed, out of his own pocket, a "Pavilion of Realism" outside the official exhibition that would enable society at large to view his work.

HONORÉ DAUMIER The French Realists of the second half of the 19th century used everyday events to express their views. One of the first Realist artists was the printmaker and caricaturist Honoré Daumier (1808–1879), who followed the example of Goya in using his work to criticize the evils of society in general and government in particular. In *Le Ventre Legislatif* (*The Legislative Belly*) (**Fig. 20.28**), Daumier produced a powerful image of the greed and corruption of political opportunists that has, over time, lost nothing of its bitterness or, unfortunately, its relevance. The characters in the print, bloated and nodding off, are individually recognizable as members of the Chamber of Deputies. The government censored such subjects a year after the print was made, resulting in fines. Daumier's publisher managed to pay the fines by selling the prints.

▶ **20.28** Honoré Daumier, *Le Ventre Legislatif* (*The Legislative Belly*), 1834. Lithograph, 11" × 17" (28.1 × 43.2 cm). Bibliothèque Nationale, Paris, France. Although obviously caricatures, the politicians arranged in tiers were recognizable as individual members of the legislative assembly of the time.

Realist Literature

GUSTAVE FLAUBERT Increasingly, writers found that they could best do justice to the problems of existence by adopting a more naturalistic style and describing their characters' lives in realistic terms. One of the most subtle attacks on contemporary values is *Madame Bovary* (1856) by Gustave Flaubert (1821–1880). Flaubert's contempt for bourgeois society finds expression in his portrait of Emma Bovary, who tries to discover in her own provincial life the romantic love she reads about in novels. Her shoddy affairs and increasing debts lead to an inevitably dramatic conclusion. Flaubert is at his best when portraying the banality and futility of Emma's everyday existence:

READING 20.21 GUSTAVE FLAUBERT

From *Madame Bovary*, part 1, chapter 9

Every day at the same time the schoolmaster in a black skullcap opened the shutters of his house, and the rural policeman, wearing his sabre over his blouse, passed by. Night and morning the post-horses, three by three, crossed the street to water at the pond. From time to time the bell of a public house door rang, and when it was windy one could hear the little brass basins that served as signs for the hairdresser's shop creaking on their two rods. This shop had as decoration an old engraving of a fashion-plate stuck against a windowpane and the wax bust of a woman with yellow hair. He, too, the hairdresser, lamented his wasted calling, his hopeless future, and dreaming of some shop in a big town—Rouen, for example, overlooking the harbour, near the theatre—he walked up and down all day from the mairie to the church, sombre and waiting for customers. When Madame Bovary looked up, she always saw him there, like a sentinel on duty, with his skullcap over his ears and his vest of lasting.

HONORÉ DE BALZAC Honoré de Balzac (1779–1850) was the most versatile of all French novelists. He created a series of some 90 novels and stories, under the general title of *The Human Comedy*, in which many of the same characters appear more than once. Above all a Realist, Balzac depicted the social and political currents of his time while imposing on them a sense of artistic unity. His novels are immensely addictive. The reader who finds in one of them a reference to characters or events described in another novel hastens there to be led on to a third, and so on. Balzac thus succeeds in creating a fictional world that seems more real than historical reality.

His novel *Le Père Goriot* (*Father Goriot*) is set in Paris of 1819 and traces the intertwined lives of three people: the kindly and elderly Goriot, a criminal, and a law student. The book is noted for the use of characters from Balzac's other works and, as with Flaubert's *Madame Bovary*, for its attention to minute detail. The story is an adaptation of Shakespeare's *King Lear*,

in which the elderly Lear, like Father Goriot, is troubled by his children's selfishness. Goriot's daughters marry into the aristocracy but leave their father penniless. Lear said:

> How sharper than a serpent's tooth it is
> To have a thankless child.

In the passage below early in the novel, we find a character in the novel, Monsieur M. Poiret, ambling down the streets of Paris. Balzac comments on his appearance in detail and asks the reader to contemplate the indifference of the city of Paris—perhaps of the universe—which can squash individuality and drown its denizens in financial and psychological need:

READING 20.22 HONORÉ DE BALZAC

From *Le Père Goriot*, part 1

M. Poiret was a sort of automaton. He might be seen any day sailing like a gray shadow along the walks of the Jardin des Plantes, on his head a shabby cap, a cane with an old yellow ivory handle in the tips of his thin fingers; the outspread skirts of his threadbare overcoat failed to conceal his meagre figure; his breeches hung loosely on his shrunken limbs; the thin, blue-stockinged legs trembled like those of a drunken man; there was a notable breach of continuity between the dingy white waistcoat and crumpled shirt frills and the cravat twisted about a throat like a turkey gobbler's; altogether, his appearance set people wondering whether this outlandish ghost belonged to the audacious race of the sons of Japhet who flutter about on the Boulevard Italien. What devouring kind of toil could have so shriveled him? What devouring passions had darkened that bulbous countenance, which would have seemed outrageous as a caricature? What had he been? Well, perhaps he had been part of the machinery of justice, a clerk in the office to which the executioner sends in his accounts, —so much for providing black veils for parricides, so much for sawdust, so much for pulleys and cord for the knife. Or he might have been a receiver at the door of a public slaughter-house, or a sub-inspector of nuisances. Indeed, the man appeared to have been one of the beasts of burden in our great social mill; . . . a pivot in the obscure machinery that disposes of misery and things unclean; one of those men, in short, at sight of whom we are prompted to remark that, "After all, we cannot do without them."

Stately Paris ignores the existence of these faces bleached by moral or physical suffering; but, then, Paris is in truth an ocean that no line can plumb. You may survey its surface and describe it; but no matter how numerous and painstaking the toilers in this sea, there will always be lonely and unexplored regions in its depths, caverns unknown, flowers and pearls and monsters of the deep overlooked or forgotten by the divers of literature.

GEORGE SAND Among the leading literary figures of Balzac's Paris—and a personal friend of Balzac—was Aurore Dupin (1804–1876), better known by her pseudonym George

Sand. This redoubtable defender of women's rights and assailant of male privilege used her novels to wage war on many of the conventions of society. In her first novel, *Lélia* (1833), she attacked, among other targets, the church, marriage, the laws of property, and the double standard of morality, whereby women were condemned for doing what was condoned for men.

Translator Maria Espinosa commented on the questions troubling Lélia:

> How can I make sense of the universe? Is there a God, and if so, what is His nature? Why must I be a slave to the artificially defined role of a woman? What is the nature of sensuality, and is it compatible with spiritual love? Are love relationships between the sexes designed to be transitory? Lélia craves sexual variety in her fantasies—despite or because of her inability to achieve satisfaction through physical love. She asks how to deal with this. Should she live as a nun or as a courtesan? (She never considers the role of wife!) These are the queries of an intense, passionate, and singularly courageous woman.[10]

In the following extract from the Espinosa translation, one of Lélia's lovers writes to her of his passion for her and his idealization of her—idealization being one of the "symptoms" of romantic love. It is evident that Sand is writing a prose poem:

READING 20.23 GEORGE SAND

From *Lélia* (1833), II [Sténio to Lélia]

Yesterday when the sun set behind the glacier, drowned in vapors of a bluish rose, the warm winter evening glided through your hair, and the church bell threw its melancholy echoes into the valley. Lélia, I tell you that then you were truly the daughter of heaven. The soft light of the setting sun caressed you. Your eyes burned with a sacred fire as you looked up at the first timid stars. As for me, poet of woods and valleys, I listened to the mysterious murmur of the water, and I watched the slight undulations of the pines. I breathed the sweet perfume of wild violets which open beneath dried moss on the first warm, sunlit day. But you scarcely noticed all this—neither the flowers, the trees, the rushing stream, nor any object on earth aroused your attention. You belonged entirely to the sky. And when I showed you this enchanted spectacle at your feet, you raised your hand toward the heavens and cried, "Look at that!" Oh, Lélia, you long for your native land, don't you? Do you ask God why he has left you so long among us? And why He doesn't give you back your wings to return to Him?

In another passage, Lélia tells her sister, also a courtesan, of the experiences that led her to the point at which she cannot love a man:

READING 20.24 GEORGE SAND

From *Lélia* (1833), XXXIV

Oh, I remember the burning nights I passed pressed against a man's flanks in close embrace with him. During those nights I thoroughly studied the revolts of pride against the vanity of abnegation. I sensed one could simultaneously love a man to the point of submitting to him and love oneself to the point of hating him because he subjugates us.... What was cruelest for me...is that he failed to appreciate the extent of my sacrifices.... He pretended to believe me abused by a sentiment of hypocritical modesty. He affected to take for signs of rapture the moanings torn from me by suffering and impatience. He laughed harshly at my tears.... When he had broken me in ferocious embraces, he slept brusque and uncaring at my side, while I devoured my tears so as not to awaken him.... What caused me to love him a long time (long enough to weary my entire soul) was without doubt the feverish irritation produced in me by the absence of personal satisfaction.... I felt my bosom devoured by an inextinguishable fire, and his kisses shed no relief.... When he was drowsy, satisfied, and at rest, I would lie motionless beside him. I passed many hours watching him sleep.... I was violently tempted to awaken him, to hold him in my arms, and to ask for his caresses from which I hadn't yet known how to profit.

> ...

One day I felt so worn out with loving that I stopped suddenly. When I saw how easily this bond was broken, I was astonished at having believed in its eternal duration for so long.

Unconventional in her own life, Sand became the lover of Chopin, with whom she lived from 1838 to 1847. Her autobiographical novel *Lucrezia Floriani* (1846) chronicles as thinly disguised fiction the remarkable course of this relationship, albeit very much from its author's point of view.

The riches of mid-19th-century English literature include the profoundly intellectual and absorbing works of George Eliot—the pen name of Mary Ann Evans (1819–1880)—and *Wuthering Heights* (1847), the only novel by Emily Brontë (1818–1848) and one of the most dramatic and passionate pieces of fiction ever written. The book's brilliant evocation of atmosphere and violent emotion produces a shattering effect. Like the two already mentioned, many of the leading novelists of the time were women, and the variety of their works soon puts to flight any facile notions about the feminine approach to literature. Elizabeth Gaskell (1810–1865), for example, was one of the leading social critics of the day; her novels study the effects of industrialization on the poor.

LEO TOLSTOY The Russian Leo Tolstoy (1828–1910) produced, among other works, two huge novels of international stature: *War and Peace* (1863–1869) and *Anna Karenina*

10. George Sand, *Lélia*, trans. Maria Espinosa (Bloomington: Indiana University Press, 1978), p. xv.

(1873–1877). The first is mainly set against the background of Napoléon's invasion of Russia in 1812. Among the vast array of characters is the Rostov family, aristocratic but far from wealthy, who, together with their acquaintances, have their lives permanently altered by the great historical events through which they live. Tolstoy even emphasizes the way in which the course of the war affects his characters by combining figures he created for the novel with real historical personages, including Napoléon, and allowing them to meet.

At the heart of the novel is the young and impressionable Natasha Rostov, whose own confused love life seems to reflect the confusion of the times. Yet the novel's philosophy is profoundly optimistic, despite the tragedies of Natasha's own life and the horrors of war that surround her. Her final survival and triumph represent the glorification of the irrational forces of life, which she symbolizes as the "natural person," over sophisticated and rational civilization.

Toward the end of his life, Tolstoy gave up his successful career and happy family life to undertake a mystical search for the secret of universal love. Renouncing his property, he began to wear peasant dress and went to work in the fields, although at the time of his death he was still searching in vain for peace. Russia's other great novelist, Fyodor Dostoyevsky (1821–1881), although he died before Tolstoy, had far more in common with the late 19th century than with the Romantic movement, so he is discussed in Chapter 21.

CHARLES DICKENS The Englishman Charles Dickens (1812–1870) was immensely popular during his lifetime and has been widely read ever since. One of his best-known novels, *A Tale of Two Cities*, is set during the French Reign of Terror, in which thousands are sent to the guillotine; some observers, including Madame Defarge, knit while they observe the day's "entertainment." In the final chapter, Dickens describes the progress of the "death carts" through the Parisian streets:

> **READING 20.25 CHARLES DICKENS**
>
> From *A Tale of Two Cities*, Book 3, chapter 15 (1859)
>
> As the sombre wheels of the six carts go round, they seem to plough up a long crooked furrow among the populace in the streets. Ridges of faces are thrown to this side and to that, and the ploughs go steadily onward. So used are the regular inhabitants of the houses to the spectacle, that in many windows there are no people, and in some the occupation of the hands is not so much as suspended, while the eyes survey the faces in the tumbrils. Here and there, the inmate has visitors to see the sight; then he points his finger, with something of the complacency of a curator or authorised exponent, to this cart and to this, and seems to tell who sat here yesterday, and who there the day before.
>
> Of the riders in the tumbrils, some observe these things, and all things on their last roadside, with an impassive stare;

> others, with a lingering interest in the ways of life and men. Some, seated with drooping heads, are sunk in silent despair; again, there are some so heedful of their looks that they cast upon the multitude such glances as they have seen in theatres, and in pictures. Several close their eyes, and think, or try to get their straying thoughts together. Only one, and he a miserable creature, of a crazed aspect, is so shattered and made drunk by horror, that he sings, and tries to dance. Not one of the whole number appeals by look or gesture, to the pity of the people.

Dickens campaigned against social injustice and used his books to focus on individual institutions and their evil effects. In *Hard Times* (1854), he turned, like Gaskell, to the evils of industrialization and pointed out some of the harm that misguided attempts at education can do. Yet, better known today is *Oliver Twist* (1837–1839)—or at least the name "Oliver," because it, like *Les Misérables*, is the title of an extremely successful musical. The novel attacks the treatment of the poor in the workhouses and reveals Dickens's view of crime as the manifestation of a general failing in society. It is filled with unforgettable characters: Fagin, the conniving criminal who teaches orphaned children how to pick pockets for him but does not expose himself to danger; Nancy, the soft-hearted woman of the streets; Bill Sikes, the tough burglar who is Nancy's pimp, lover, and, ultimately, murderer; and, with typically Dickensian names, Mr. Bumble, the Artful Dodger, Mr. and Mrs. Sowerberry (undertaker and wife), and Mr. Grimwig. The novel was first serialized in a British literary magazine. It would not be an exaggeration to say that many readers became (psychologically) addicted to Dickens's works and could barely wait for the next installment. The beginning of *Oliver Twist* reveals Dickens at his ironic best:

> **READING 20.26 CHARLES DICKENS**
>
> From *Oliver Twist* (1837–1839), chapter 1
>
> Among other public buildings in a certain town, which for many reasons it will be prudent to refrain from mentioning, and to which I will assign no fictitious name, there is one anciently common to most towns, great or small; to wit, a workhouse: and in this workhouse was born: on a day and date which I need not trouble myself to repeat, inasmuch as it can be of no possible consequence to the reader, in this stage of the business at all events: the item of mortality whose name is prefixed to the head of this chapter [Oliver Twist].
>
> For a long time after it was ushered into this world of sorrow and trouble, by the parish surgeon, it remained a matter of considerable doubt whether the child would survive to bear any name at all, in which case it is somewhat more than probable that these memoirs would never have appeared; or,

if they had, that being comprised within a couple of pages, they would have possessed the inestimable merit of being the most concise and faithful specimen of biography, extant in the literature of any age or country.

Although I am not disposed to maintain that the being born in a workhouse, is in itself the most fortunate and enviable circumstance that can possibly befall a human being, I do mean to say that in this particular instance, it was the best thing for Oliver Twist that could by possibility have occurred. The fact is, that there was considerable difficulty in inducing Oliver to take upon himself the office of respiration—a troublesome practice, but one which custom has rendered necessary to our easy existence; and for some time he lay gasping on a little flock mattress, rather unequally poised between this world and the next: the balance being decidedly in favor of the latter. Now, if, during this brief period, Oliver had been surrounded by careful grandmothers, anxious aunts, experienced nurses, and doctors of profound wisdom, he would most inevitably and indubitably have been killed in no time.

THE ROMANTIC ERA IN AMERICA

The early history of the arts in colonial North America was intimately linked to developments in Europe. The United Kingdom, in particular, by virtue of its common tongue and political connections, exerted an influence on literature and painting that even the American Revolution did not end. U.S. writers sought publishers and readers there and modeled their style on that of English writers. U.S. painters went to London to study. The earliest U.S. composers confined their attention to settings of hymns and patriotic songs. A recognizably U.S. musical tradition of composition did not develop before the end of the 19th century, although European performers had much earlier found a vast and enthusiastic musical public in the course of their U.S. tours.

In the case of literature and the visual arts, the French Revolution provided a change of direction, for revolutionary ties inevitably resulted in the importation of Neo-Classicism into the United States. With the dawning of the Romantic era, however, U.S. artists began to develop for the first time

VALUES

Transcendentalism

Transcendentalism, a U.S. and European philosophical movement of the 1830s and 1840s, was largely a reaction against the rationalism of the 18th century and, in the United States, the austerity of New England Calvinism. Transcendentalists believed that organized religion and political parties corrupted humankind and that people rose to the height of their potential when they were self-reliant and listened to nature rather than books. They were in this sense religious: they believed that God was in us all, not a "person"—as defined by established religions—who demanded worship and would respond to human prayer.

Transcendental thought was partially rooted in the work of the German philosopher Immanuel Kant, who was himself skeptical of rationalism, as he explained in his *Critique of Pure Reason*. Kant appreciated the Latin motto of the Enlightenment, *Sapere aude* ("dare to know"); however, he challenged the idea that humans could perceive things as they are in reality. We only know reality as organized by limited human understanding. But society and its political and religious institutions corrupt the individual by coming between the individual and the perceived world. From this observation, Transcendentalists argue that people must be self-reliant, depending on their inner mental or spiritual essence. And people begin to reach their potential as individuals when they shed society and its institutions.

Ralph Waldo Emerson's essay "Nature" (1836) describes the Transcendental protest and also shows the way in which he and many of his fellow Transcendentalists opened themselves to that which is divine in nature and in themselves.

> Crossing a bare common, in snow puddles, at twilight, under a clouded sky, without having in my thoughts any occurrence of special good fortune, I have enjoyed a perfect exhilaration. I am glad to the brink of fear. In the woods too, a man casts off his years, as the snake his slough, and at what period soever of life, is always a child. In the woods, is perpetual youth. Within these plantations of God, a decorum and sanctity reign, a perennial festival is dressed, and the guest sees not how he should tire of them in a thousand years. In the woods, we return to reason and faith. There I feel that nothing can befall me in life, —no disgrace, no calamity, (leaving me my eyes,) which nature cannot repair. Standing on the bare ground, —my head bathed by the blithe air, and uplifted into infinite space, —all mean egotism vanishes. I become a transparent eye-ball; I am nothing; I see all; the currents of the Universal Being circulate through me; I am part or particle of God.

an authentic voice of their own. In many cases, they still owed much to European examples. The tradition of the expatriate North American artist who left home to study in Europe and remained there had been firmly established by the 18th century. Throughout the 19th century, writers like Washington Irving and painters like Thomas Eakins continued to bring back to the United States themes and styles they had acquired during their European travels. Something about the nature of Romanticism, however, with its emphasis on the individual, seemed to fire the U.S. imagination. The Romantic love of the remote and mysterious reached a peak in the macabre stories of Edgar Allan Poe. For the first time in the Romantic era, U.S. artists began to produce work that was both a genuine product of their native land and at the same time of international stature.

Literature

In a land where daily existence was lived so close to the wildness and beauty of nature, the Romantic attachment to the natural world was bound to make a special appeal. The Romantic concept of the transcendental unity of humans and nature was quickly taken up in the early 19th century by a group of U.S. writers who even called their style **Transcendentalism**. Borrowing ideas from Kant and from his English followers such as Coleridge and Wordsworth, they developed notions of an order of truth that transcends what we can perceive by our physical senses and that unites the entire world.

RALPH WALDO EMERSON One of the leading Transcendentalist representatives, Ralph Waldo Emerson (1803–1882), underlined the particular importance of the natural world for American writers in his essay "The American Scholar," first published in 1837. In calling for the development of a national literature, Emerson laid down as a necessary condition for its success that his compatriots should draw their inspiration from the wonders of their own country. A few years later he was to write: "America is a poem in our eyes; its ample geography dazzles the imagination, and it will not wait long for metres."

Emerson always tried to make his own work "smell of pines and resound with the hum of insects," and his ideas have exerted a profound effect on the development of American culture. His essay "Self-Reliance" (1841) could be considered something of a manifesto for the rugged individualist. Perhaps the best-known comments within the essay are: "Whoso would be a man must be a nonconformist" and "A foolish consistency is the hobgoblin of little minds." The first is self-explanatory. The second means to do what you believe is right and to speak your heart as you feel it, without worrying that it might contradict something you said yesterday. You will notice in the extracts that Emerson speaks against charity—alms for the poor. Is it simple selfishness, or do his comments emanate from the conviction that charity belittles the recipient and prevents him or her from becoming self-reliant? Even so, Emerson admits, "I sometimes succumb and give the dollar."

READING 20.27 RALPH WALDO EMERSON

From "Self-Reliance" (1841)

To believe your own thought, to believe that what is true for you in your private heart is true for all men, —that is genius.

...

Whoso would be a man must be a nonconformist. He who would gather immortal palms must not be hindered by the name of goodness, but must explore if it be goodness. Nothing is at last sacred but the integrity of your own mind.

...

[Do] not tell me, as a good man did to-day, of my obligation to put all poor men in good situations. Are they *my* poor? I tell thee, thou foolish philanthropist, that I grudge the dollar, the dime, the cent, I give to such men as do not belong to me and to whom I do not belong. There is a class of persons to whom by all spiritual affinity I am bought and sold; for them I will go to prison, if need be; but your miscellaneous popular charities; the education at college of fools; the building of meeting-houses to the vain end to which many now stand; alms to sots; and the thousandfold Relief Societies; —though I confess with shame I sometimes succumb and give the dollar, it is a wicked dollar which by and by I shall have the manhood to withhold.

...

A foolish consistency is the hobgoblin of little minds, adored by little statesmen and philosophers and divines. With consistency a great soul has simply nothing to do. He may as well concern himself with his shadow on the wall. Speak what you think now in hard words, and to-morrow speak what to-morrow thinks in hard words again, though it contradict every thing you said to-day.

...

Insist on yourself; never imitate....Where is the master who could have taught Shakespeare? Where is the master who could have instructed Franklin, or Washington, or Bacon, or Newton? Every great man is a unique....Shakespeare will never be made by the study of Shakespeare.

...

The civilized man has built a coach, but has lost the use of his feet. He is supported on crutches, but lacks so much support of muscle. He has a fine Geneva watch, but he fails of the skill to tell the hour by the sun. A Greenwich nautical almanac he has, and so being sure of the information when he wants it, the man in the street does not know a star in the sky.

...

Nothing can bring you peace but yourself. Nothing can bring you peace but the triumph of principles.

HENRY DAVID THOREAU

I went to the woods because I wished to live deliberately, to front only the essential facts of life, and see if I could not learn what it had to teach, and not, when I came to die, discover that I had not lived. I did not wish to live what was not life, living is so dear; nor did I wish to practise resignation, unless it was quite necessary. I wanted to live deep and suck out all the marrow of life, to live so sturdily and Spartan-like as to put to rout all that was not life, to cut a broad swath and shave close, to drive life into a corner, and reduce it to its lowest terms, and, if it proved to be mean, why then to get the whole and genuine meanness of it, and publish its meanness to the world; or if it were sublime, to know it by experience, and be able to give a true account of it in my next excursion.

—HENRY DAVID THOREAU, *WALDEN* (1854), CHAPTER 2

Thus, the best-known literary practitioner of Transcendentalist principles, Henry David Thoreau (1817–1862), explains why he left "civilization" to sojourn in solitude in the woods. In his masterpiece *Walden*, he uses his experiences and his observations on the shore of Walden Pond, in Massachusetts, to draw general conclusions about the nature of human beings and the nature of…nature. People still go on pilgrimages to Walden Pond, now in the suburbs of Boston, to try to commune with the spirit that drove Thoreau. *Walden* is truly a prose poem:

READING 20.28 HENRY DAVID THOREAU

From *Walden* (1854)

5. Solitude

This is a delicious evening, when the whole body is one sense, and imbibes delight through every pore. I go and come with a strange liberty in Nature, a part of herself. As I walk along the stony shore of the pond in my shirt-sleeves, though it is cool as well as cloudy and windy, and I see nothing special to attract me, all the elements are unusually congenial to me. The bullfrogs trump to usher in the night, and the note of the whip-poor-will is borne on the rippling wind from over the water. Sympathy with the fluttering alder and poplar leaves almost takes away my breath; yet, like the lake, my serenity is rippled but not ruffled. These small waves raised by the evening wind are as remote from storm as the smooth reflecting surface. Though it is now dark, the wind still blows and roars in the wood, the waves still dash, and some creatures lull the rest with their notes.

…

11. Higher Laws

As I came home through the woods with my string of fish, trailing my pole, it being now quite dark, I caught a glimpse of a woodchuck stealing across my path, and felt a strange thrill of savage delight, and was strongly tempted to seize and devour him raw; not that I was hungry then, except for that wildness which he represented. …I found in myself, and still find, an instinct toward a higher, or, as it is named, spiritual life, as do most men, and another toward a primitive rank and savage one, and I reverence them both. I love the wild not less than the good.

…

16. The Pond in Winter

After a still winter night I awoke with the impression that some question had been put to me, which I had been endeavoring in vain to answer in my sleep, as what—how—when—where? But there was dawning Nature, in whom all creatures live, looking in at my broad windows with serene and satisfied face, and no question on *her* lips. I awoke to an answered question, to Nature and daylight. The snow lying deep on the earth dotted with young pines, and the very slope of the hill on which my house is placed, seemed to say, Forward! Nature puts no question and answers none which we mortals ask.

…

18. Conclusion

However mean your life is, meet it and live it; do not shun it and call it hard names. It is not so bad as you are. It looks poorest when you are richest. The fault-finder will find faults even in paradise. …The setting sun is reflected from the windows of the almshouse as brightly as from the rich man's abode; the snow melts before its door as early in the spring. I do not see but a quiet mind may live as contentedly there, and have as cheering thoughts, as in a palace.

Thoreau's passionate support of the freedom of the individual led him to be active in the antislavery movement; by the end of his life, he had moved from belief in passive resistance to open advocacy of violence against slavery.

EDGAR ALLAN POE Edgar Allan Poe (1809–1849) occupies a unique place in the U.S. imagination, both for his tales of the macabre and for his poems with their pulsating rhythms. Every schoolchild in the United States is likely to have read him. Stories such as "The Tell-Tale Heart," "The Cask of Amontillado," and "The Pit and The Pendulum" all share the Gothic horror of something terrible that is going to happen and cannot be prevented. In "The Tell-Tale Heart" (1843), an unnamed narrator murders an old man, not for money or from the heat of passion, but because he cannot abide the victim's pale blue eye. He dismembers the body and conceals the parts beneath the floorboards. A neighbor reports the victim's shrieking to the police, who then drop by to investigate. The narrator imagines that he hears his victim's heart beating louder and louder, until he is certain that the police must hear it too, and he confesses.

Poe wrote an article, "The Philosophy of Composition" (1846), in which he expounds his theory of good writing: length must be controlled, there must be a unity of effect, and development of the narrative must be logical. He also asserts that the death of a beautiful woman is "unquestionably the most poetical topic in the world"; that is the subject of poems such as "Annabel Lee," "Ulalume," and "The Raven." "The Raven" is noted for its alliteration, assonance (repetition of vowel sounds), and rhyming within lines, not just at the ends of lines. The basic rhyme scheme is *trochaic octameter*; that is, eight feet, each with an accented syllable followed by an unaccented syllable. The stressed beginnings lend the lines their pounding rhythms. Following are the first two verses:

READING 20.29 EDGAR ALLAN POE

From "The Raven," lines 1–12

Once upon a midnight dreary, while I pondered, weak and
 weary,
Over many a quaint and curious volume of forgotten lore,
While I nodded, nearly napping, suddenly there came a
 tapping,
As of some one gently rapping, rapping at my chamber door.
"Tis some visitor," I muttered, "tapping at my chamber door—
 Only this, and nothing more."

Ah, distinctly I remember it was in the bleak December,
And each separate dying ember wrought its ghost upon the
 floor.
Eagerly I wished the morrow; —vainly I had sought to borrow
From my books surcease of sorrow—sorrow for the lost
 Lenore—
For the rare and radiant maiden whom the angels name
 Lenore—
 Nameless here for evermore.

The raven—an omen of misfortune—visits the narrator and quotes incessantly the word *nevermore*, which rhymes with *door* and *floor* and *Lenore* and *evermore*—and still more. The narrator implores the bird to bustle back into the bleakness beyond, but it takes up residence upon a "pallid bust of Pallas" (a pale statue of the Greek goddess of wisdom, Pallas Athena) and unfalteringly utters the one word in its vocabulary, nagging the narrator. The narrator does all the emotional work; the bird merely recites "nevermore" at intervals that accommodate the rhyme scheme.

Critic Harold Bloom condemns Poe's work: "Poe is a bad poet, a poor critic, and a dreadful prose stylist in his celebrated tales."[11] Yet he admits that "Poe is inescapable"—the most widely read U.S. writer—and he ironically includes two of Poe's poems in his anthology *The Best Poems of the English Language*: "Israfel" and "The City in the Sea."

11. Harold Bloom, *The Best Poems of the English Language* (New York: Harper Perennial, 2004), p. 517.

WALT WHITMAN Ideas of freedom, tolerance, and spiritual unity reached the height of poetic expression in the works of Walt Whitman (1819–1892), who many think of as the United States's first great poet. His first important collection of poems was published in 1855 under the title *Leaves of Grass*. From then until his death, he produced edition after edition, retaining the title but adding new poems and revising old ones. The central theme of most of his work was the importance of the individual, reminding us of the essentially Romantic character of Whitman's mission. By describing the details of his own feelings and reactions, he communicated a sense of the unity of the human condition. Much of the time the sheer vitality and flow of his language helps make his experiences our own, although many of his earlier readers were horrified at the implied and explicit sexual content of some of his poems. Above all, Whitman was a fiery defender of freedom and democracy. His vision of the human race united with itself and with the universe seems to continue to have significance for our own time.

Whitman's **free verse** was quite new in his day. He wrote at the time of the Romantic poets in the United Kingdom, yet he poured out his ideas—one after another, related but distinct—in a fashion that ignored the need for regular meter and, often, even sentence structure. Still you catch glimpses of rhythms, as when he refers to grass as "the flag of my disposition, out of hopeful green stuff woven." (He did *not* write "woven out of hopeful green stuff.") It gushes out, but certainly not at random. Whitman divided "Song of Myself," the main poem in his *Leaves of Grass*, into 52 numbered sections, some of which are reproduced here:

READING 20.30 WALT WHITMAN

From "Song of Myself," *Leaves of Grass* (1881–1882 edition)

1

I celebrate myself, and sing myself,
And what I assume you shall assume,
For every atom belonging to me as good belongs to you.

I loafe and invite my soul,
I lean and loafe at my ease observing a spear of summer
 grass.

My tongue, every atom of my blood, form'd from this soil,
 this air,
Born here of parents born here from parents the same, and
 their parents the same,
I, now thirty-seven years old in perfect health begin,
Hoping to cease not till death.

Creeds and schools in abeyance,
Retiring back a while sufficed at what they are, but never
 forgotten,
I harbor for good or bad, I permit to speak at every hazard,
Nature without check with original energy.

2

Houses and rooms are full of perfumes, the shelves are
 crowded with perfumes,
I breathe the fragrance myself and know it and like it,
The distillation would intoxicate me also, but I shall not let it.

The atmosphere is not a perfume, it has no taste of the
 distillation, it is odorless,
It is for my mouth forever, I am in love with it,
I will go to the bank by the wood and become undisguised and
 naked,
I am mad for it to be in contact with me.

…

6

A child said *What is the grass?* fetching it to me with full hands;
How could I answer the child? I do not know what it is any
 more than he.

I guess it must be the flag of my disposition, out of hopeful
 green stuff woven.

Or I guess it is the handkerchief of the Lord,
A scented gift and remembrancer designedly dropt,
Bearing the owner's name someway in the corners, that we may
 see and remark, and say *Whose?*

Or I guess the grass is itself a child, the produced babe of the
 vegetation.

Or I guess it is a uniform hieroglyphic,
And it means, Sprouting alike in broad zones and narrow zones,
Growing among black folks as among white,
Kanuck, Tuckahoe, Congressman, Cuff, I give them the same,
I receive them the same.

And now it seems to me the beautiful uncut hair of graves.

Tenderly will I use you curling grass,
It may be you transpire from the breasts of young men,
It may be if I had known them I would have loved them,
It may be you are from old people, or from offspring taken
 soon out of their mothers' laps,
And here you are the mothers' laps.

EMILY DICKINSON Emily Dickinson (1830–1886) was as private in her life and work as Whitman was public in his. She remained single, which was not all that uncommon, but she also secluded herself in her house in Amherst, Massachusetts, with few acquaintances. Her grave is to be seen in Amherst; carved into the stone is "Called Back."

Only seven of her poems appeared in print during her lifetime; the first complete edition was published in 1958. Yet today, few American poets are better known or better loved. Her work tries to create a balance between passion and the prompting of reason, while her interest in psychological experience appeals to modern readers. Many, too, are attracted by her desire for a secure religious faith, equaled only by her stubborn skepticism.

Followers of Dickinson feel an intimacy with her and usually refer to her by her first name. Of her body of 1800 works, the following two are considered to be among her greatest and address a recurrent theme: death. In reading Dickinson, you must picture the words—"a certain slant of light" breaking through glass in winter. And consider the **metaphor** and the **simile**: That slant of light *oppresses*—light as oppressing, the metaphor. And how does it oppress? Here is the simile: "like the Heft / of Cathedral Tunes." She uses short lines and rhyme. There is also **personification**: *He*—Death—"kindly stopped for me." The carriage held "Ourselves—/ And Immortality"; that is poetry:

READING 20.31 EMILY DICKINSON

Poems 258 (ca. 1861) and 712 (ca. 1863)

258

There's a certain Slant of light,
Winter Afternoons—
That oppresses, like the Heft
Of Cathedral Tunes—

Heavenly Hurt, it gives us—
We can find no scar,
But internal difference,
Where the Meanings, are—

None may teach it—Any—
'Tis the Seal Despair—
An imperial affliction
Sent us of the Air—

When it comes, the Landscape listens—
Shadows—hold their breath—
When it goes, 'tis like the Distance
On the look of Death—

712

Because I could not stop for Death—
He kindly stopped for me—
The Carriage held but just Ourselves—
And Immortality.

We slowly drove—He knew no haste
And I had put away
My labor and my leisure too,
For His Civility—

We passed the School, where Children strove
At Recess—in the Ring—
We passed the Fields of Gazing Grain—
We passed the Setting Sun—

Or rather—He passed Us—
The Dews drew quivering and chill—
For only Gossamer, my Gown—
My Tippet—only Tulle—

We paused before a House that seemed
A Swelling of the Ground—
The Roof was scarcely visible—
The Cornice—in the Ground—

Since then—'tis Centuries—and yet
Feels shorter than the Day
I first surmised the Horses' Heads
Were toward Eternity—

NATHANIEL HAWTHORNE Nathaniel Hawthorne (1804–1864) was born in Salem, Massachusetts, and was descended from John Hathorne, a judge who had presided over the Salem witch trials at the end of the 17th century. Upturning his Calvinist and Puritan heritage, Hawthorne and his future wife joined Brook Farm in 1841, a Transcendentalist utopian community. The couple left after a year, but the experience gave birth to the novel *The Blithedale Romance* (1852).

Hawthorne is best known as the author of *The Scarlet Letter* (1850), which tells the story of a young woman, Hester Prynne, who becomes pregnant through an adulterous affair with the Rev. Arthur Dimmesdale and bears a daughter, Pearl, who is something of a wild creature. Perhaps the sin of the mother is visited upon the child, along with the mother's punishment—ostracism and expulsion from society. Hester is compelled by her community to wear a red letter *A* upon her dress, a symbol that

READING 20.32 NATHANIEL HAWTHORNE

From *The Scarlet Letter* (1850), chapter 2

When the young woman—the mother of this child—stood fully revealed before the crowd, it seemed to be her first impulse to clasp the infant closely to her bosom; not so much by an impulse of motherly affection, as that she might thereby conceal a certain token, which was wrought or fastened into her dress. In a moment, however, wisely judging that one token of her shame would but poorly serve to hide another, she took the baby on her arm, and, with a burning blush, and yet a haughty smile, and a glance that would not be abashed, looked around at her townspeople and neighbours. On the breast of her gown, in fine red cloth, surrounded with an elaborate embroidery and fantastic flourishes of gold thread, appeared the letter A. It was so artistically done, and with so much fertility and gorgeous luxuriance of fancy, that it had all the effect of a last and fitting decoration to the apparel which she wore, and which was of a splendour in accordance with the taste of the age, but greatly beyond what was allowed by the sumptuary regulations of the colony.

The young woman was tall, with a figure of perfect elegance, on a large scale. She had dark and abundant hair, so glossy that it threw off the sunshine with a gleam, and a face which, besides being beautiful from regularity of feature and richness of complexion, had the impressiveness belonging to a marked brow and deep black eyes. She was ladylike, too, after the manner of the feminine gentility of those days; characterised by a certain state and dignity, rather than by the delicate, evanescent, and indescribable grace, which is now recognized as its indication. And never had Hester Prynne appeared more lady-like, in the antique interpretation of the term, than as she issued from the prison. Those who had before known her, and had expected to behold her dimmed and obscured by a disastrous cloud, were astonished, and even startled, to perceive how her beauty shone out, and

made a halo of the misfortune and ignominy in which she was enveloped. It may be true, that, to a sensitive observer, there was something exquisitely painful in it. Her attire, which, indeed, she had wrought for the occasion, in prison, and had modelled much after her own fancy, seemed to express the attitude of her spirit, the desperate recklessness of her mood, by its wild and picturesque peculiarity. But the point which drew all eyes, and, as it were, transfigured the wearer, —so that both men and women, who had been familiarly acquainted with Hester Prynne, were now impressed as if they beheld her for the first time—was that SCARLET LETTER, so fantastically embroidered and illuminated upon her bosom. It had the effect of a spell, taking her out of the ordinary relations with humanity, and inclosing her in a sphere by herself.

"She hath good skill at her needle, that's certain," remarked one of the female spectators; "but did ever a woman, before this brazen hussy, contrive such a way of showing it? Why, gossips, what is it but to laugh in the faces of our godly magistrates, and make a pride out of what they, worthy gentlemen, meant for a punishment?"

"It were well," muttered the most iron-visaged of the old dames, "if we stripped Madame Hester's rich gown off her dainty shoulders; and as for the red letter, which she hath stitched so curiously, I'll bestow a rag of mine own rheumatic flannel, to make a fitter one!"

"O, peace, neighbours, peace!" whispered their youngest companion. "Do not let her hear you! Not a stitch in that embroidered letter but she has felt it in her heart."

The grim beadle now made a gesture with his staff.

"Make way, good people, make way, in the King's name!" cried he. "Open a passage, and I promise ye, Mistress Prynne shall be set where man, woman, and child may have a fair sight of her brave apparel, from this time till an hour past meridian. A blessing on the righteous Colony of the Massachusetts, where iniquity is dragged out into the sunshine! Come along, Madame Hester, and show your scarlet letter in the market-place!"

broadcasts her adultery to the world. The novel plays out with themes of sin, pride, guilt, vengeance—and love and passion.

In the passage from chapter 2, seen in Reading 20.32, Hester steps literally into the daylight from prison, carrying her three-month-old infant. If the townspeople, especially women who dress and think austerely, expect to see penitence written across her face and upon her breast, they will be disappointed with Hester's demeanor. The child squints in the sun.

HERMAN MELVILLE Herman Melville (1819–1891), like Hawthorne, dealt with profound moral issues. His subjects and style are very different, however. *Moby-Dick* (1851), his masterpiece, is often hailed as the greatest of all U.S. works of fiction. It shares with Goethe's *Faust* the theme of the search for truth and self-discovery, which Melville works out by using the metaphor of the New England whaling industry. Both Melville and Hawthorne were at their greatest when using uniquely North American settings and characters to shed light on universal human experience.

The novel begins with the narrator offering a name: "Call me Ishmael." Ishmael, in the Hebrew Bible, is the son of Abraham and the servant Hagar, who is cast with his mother into the wilderness when Sarah becomes pregnant with Isaac. Ishmael in *Moby-Dick* is sent into the "wilderness" of the ocean aboard a whaling vessel captained by Ahab, the namesake of an evil idol worshipper in the Book of 1 Kings. The plot of *Moby-Dick* follows Ahab's obsession with killing the white whale, which had maimed him on an earlier voyage. White is normally a symbol of innocence and purity, yet this whale kills the crew and sinks the ship, apparently with purposeful intent. Looking at it from the whale's perspective, of course, the whalers had initially attacked the whale—an innocent creature. We see humans tackling the immense forces of nature at a time when there was somewhat more of an even match between hunter and hunted (today's whaling vessels are larger and made of steel, and the harpoons are deadlier).

As the story concludes (see Reading 20.33), Ahab thrusts his final harpoon at the whale, proclaiming "to the last I grapple with thee; from hell's heart I stab at thee; for hate's sake I spit my last breath at thee." As we see in the final moments of the novel, Ahab is caught up in a loop of rope from the harpoon, and the whale drags him down to his watery death. Only Ishmael survives. The story is about much more than how the thirst for revenge harms the vengeful. The whale has complex meanings, as does the "tyger" in William Blake's poem.

READING 20.33 HERMAN MELVILLE

From *Moby-Dick* (1851), chapter 135

From the ship's bows, nearly all the seamen now hung inactive; hammers, bits of plank, lances, and harpoons, mechanically retained in their hands, just as they had darted from their various employments; all their enchanted eyes intent upon the whale, which from side to side strangely vibrating his predestinating head, sent a broad band of overspreading semicircular foam before him as he rushed. Retribution, swift vengeance, eternal malice were in his whole aspect, and spite of all that mortal man could do, the solid white buttress of his forehead smote the ship's starboard bow, till men and timbers reeled. Some fell flat upon their faces. Like dislodged trucks, the heads of the harpooneers aloft shook on their bull-like necks. Through the breach, they heard the waters pour, as mountain torrents down a flume.

"The ship! The hearse!—the second hearse!" cried Ahab from the boat....

Diving beneath the settling ship, the whale ran quivering along its keel; but turning under water, swiftly shot to the surface again, far off the other bow, but within a few yards of Ahab's boat, where, for a time, he lay quiescent.

"I turn my body from the sun. What ho, Tashtego! Let me hear thy hammer. Oh! ye three unsurrendered spires of mine; thou uncracked keel; and only god-bullied hull; thou firm deck, and haughty helm, and Pole-pointed prow,—death-glorious ship! must ye then perish, and without me? Am I cut off from the last fond pride of meanest shipwrecked captains?[12] Oh, lonely death on lonely life! Oh, now I feel my topmost greatness lies in my topmost grief. Ho, ho! from all your furthest bounds, pour ye now in, ye bold billows of my whole foregone life, and top this one piled comber of my death! Towards thee I roll, thou all-destroying but unconquering whale; to the last I grapple with thee; from hell's heart I stab at thee; for hate's sake I spit my last breath at thee. Sink all coffins and all hearses to one common pool! and since neither can be mine, let me then tow to pieces, while still chasing thee, though tied to thee, thou damned whale! Thus, I give up the spear!"

The harpoon was darted; the stricken whale flew forward; with igniting velocity the line ran through the groove;—ran foul. Ahab stooped to clear it; he did clear it; but the flying turn caught him round the neck, and…he was shot out of the boat, ere the crew knew he was gone. Next instant, the heavy eye-splice in the rope's final end flew out of the stark-empty tub, knocked down an oarsman, and smiting the sea, disappeared in its depths.

For an instant, the tranced boat's crew stood still; then turned. "The ship? Great God, where is the ship?" Soon they through dim, bewildering mediums saw her sidelong fading phantom…only the uppermost masts out of water; while fixed by infatuation, or fidelity, or fate, to their once lofty perches, the pagan harpooneers still maintained their sinking lookouts on the sea. And now, concentric circles seized the lone boat itself, and all its crew, and each floating oar, and every lance-pole, and spinning, animate and inanimate, all round and round in one vortex, carried the smallest chip of the *Pequod* out of sight.

12. Ahab laments that he will not be able to go down with his ship, the *Pequod*.

Art and Architecture

During the 19th century, American artists turned, for the first time, from the tradition of portraiture to landscape and genre painting. From the 1830s to the 1860s, railways were laid all over the country, eventually linking the East and West. Rail travel overtook other forms of transportation; the movement of goods, for example, shifted from the waterways to railways. It became possible to observe the wonders and variety of the North American topography, no matter how far afield they might be. With the expansion of the rail system came the belief that the United States had a mandate to expand across the continent—that it was destiny. In U.S. history, this point of view is called *manifest destiny*; it is another aspect of nationalism.

THE HUDSON RIVER SCHOOL The earliest painters of landscapes that were intended to glorify nature are known collectively as the Hudson River school. The foundations of their style were laid by Thomas Cole (1801–1848), born in England, whose later paintings combine the effect of grandeur with an accurate rendering of detail based on close observation. His

View from Mount Holyoke, Northampton, Massachusetts, after a Thunderstorm—The Oxbow (**Fig. 20.29**) is a particularly representative work in its bird's-eye perspective, dramatic sky, and contrast between raw nature and human presence. The scene features an oxbow—a bend in the Connecticut River so called because of its resemblance to a U-shaped wooden yoke used for oxen. Half of the canvas space is devoted to the sky, whose storm clouds roll back to reveal bright white light. There is a contrast in mood, created both by the sky's shifting atmosphere and the juxtaposition of the still waters of the river, and the smooth lines of its banks, with the rough bark and snapped tree trunk of the dense hillside above it. The parallel lines of the river and the tree complement one another and reinforce their connection—almost as two aspects of a Janus-faced nature.

The painters of the Hudson River school were certainly influenced by U.S. Transcendentalist writers such as Thoreau, Whitman, and Emerson. In his "Thoughts on Art," Emerson reminds the artist who sets out to paint a nature scene that "landscape has a beauty for his eye because it expresses a thought which to him is good, and this because the same power which sees through his eyes is seen in that spectacle." Art was

▲ **20.29** Thomas Cole, *View from Mount Holyoke, Northampton, Massachusetts, after a Thunderstorm—The Oxbow*, 1836. Oil on canvas, 51½" × 76" (130.8 × 193.0 cm). Metropolitan Museum of Art, New York, New York. This painting shows a meticulous care for detail that is never allowed to detract from the broad sweep of the view. Note the shape of the river, its characteristic turns known as the Oxbow.

◀ **20.30** Asher B. Durand, *Kindred Spirits*, 1849. Oil on canvas, 44" × 36" (111.8 × 91.4 cm). Crystal Bridges Museum of American Art, Bentonville, Arkansas. Durand places himself in the pristine forest with fellow painter Thomas Cole. Who are the "kindred spirits"?

perceived as a way to connect the individual to the universal (to nature and the divine) and "an agent of moral and spiritual transformation."

The entirety of this philosophy is symbolized in Asher B. Durand's *Kindred Spirits* (**Fig. 20.30**), a self-portrait with his comrade in spirit, Thomas Cole. Perched on an outcropping of rock that juts over a deep gorge, the two artists contemplate the glories of nature. The title of the work has a double meaning: it refers to the mutual goals and respect between the two artists as well as to their relationship to nature and the presence of the divine believed to be revealed therein.

AMERICAN GENRE PAINTING Visual parallels to Walt Whitman's poetry can be found in the work of U.S. genre painters whose subjects featured narrative scenes and portraits of ordinary people at work and play. George Caleb Bingham (1811–1879) focused a great deal of his career on painting life on the American frontier, notably along the Mississippi and Missouri Rivers. *The Jolly Flatboatmen* (see **Fig. 20.31** on p. 716), painted in 1846, was already becoming a scene of the past. Flatboats were used to carry freight along rivers and canals but, as we saw, by mid-century other modes of transportation were being developed and deployed to meet the demands of what was becoming a highly industrialized society. Paddle-wheel steamboats would replace the flatboat, a human-powered vessel. Perhaps Bingham's painting was intended to reflect this transition: the boat seems devoid of cargo, and the men seem to be looking for ways to entertain each other and pass the time.

◀ **20.31** George Caleb Bingham, *The Jolly Flatboatmen*, 1846. Oil on canvas, 38⅛" × 48½" (96.8 × 123.2 cm). **Private collection.** Bingham is best known for his genre paintings of daily life on the Western frontier.

ARCHITECTURE Two works of architecture—the United States Capitol in Washington, DC, and Saint Patrick's Cathedral in New York City—offer case studies in the United States's assimilation of contemporary European philosophical thought and its embodiment in architecture. The groundbreaking ceremonies for these monuments took place 43 years apart (the Capitol in 1793 and Saint Patrick's in 1836), and the two buildings reflect changing contemporary European styles that span the Neo-Classicism of the Enlightenment era and the Gothic Revival of the Romantic era.

Thomas Jefferson, the third president of the United States, proposed a competition for a design for the Capitol in 1792, and he was inclined toward French models. He had lived in Paris for a number of years, having served as a diplomat and then the minister to France, and was a great admirer of Neo-Classicism. The design of the Capitol would undergo many revisions, and its signature dome was not constructed until the mid-19th century (**Fig. 20.32**), but its relationship to Enlightenment architecture always remained central to the design concept.

Saint Patrick's Cathedral (**Fig. 20.33**), by contrast, was created in the Gothic Revival style, one of the dominant strains of architectural design associated with Romanticism. The architect, James Renwick, was also inspired by European travel and exposure to historic monuments, and designed several important buildings in the style, including Grace Church in New York City (1843–1846) and the Smithsonian Institution Building (The Castle) (1847–1855). The Gothic Revival movement in architecture originated in the mid-19th century in England and can also

be seen in the design of Westminster Palace (the Houses of Parliament) in London. The Gothic Revival was used to reinforce a philosophical separation between rationalism (and liberal values) linked to the Neo-Classical style on the one hand and spiritualism (Christian values) that was evoked by medieval traditions in architecture on the other.

PHOTOGRAPHY

The origin of photography in the first half of the 19th century was the result of the intersection of technology, science, and art. The consequences of the invention of the camera and photographic processes were far ranging. It would bring Realism as an art form and art movement to its logical culmination. It would also alter forever our access to information and our awareness of the world around and beyond us. As such, photography was one of the most significant inventions in the modern era.

The word *photography* is derived from Greek roots meaning "to write with light," and the scientific aspects of photography concern the ways in which images of objects are captured on a **photosensitive** surface, such as film, by light that passes through a **lens**. Today, of course, digital cameras translate the visual images that pass through the lens into bits of digital information, which are recorded onto an electronic storage device such as a disk or flash memory card, not on film.

Although the ability to record images with a camera seemed to burst onto the scene in the mid-19th century, some of the

▲ **20.32 The United States Capitol. Washington, DC.** As of this writing, the U.S. Capitol Building has had 11 architects, beginning with Dr. William Thornton, who was appointed by President George Washington. The building is a study in bilateral symmetry: everything in the composition to either side of an actual or imaginary line is the same. The regularity and predictability of symmetry cannot help but conjure a sense of peace, calm, comfort, and order. Repetition and symmetry can imply rationality and decorum, tying the structure of the building to a certain symbolic ideal. There are also obvious references to the architecture of the Golden Age of Greece.

principles of photography can be traced back another 300 years, to the camera obscura, which was used by Renaissance artists to help them accurately portray depth, or perspective, on two-dimensional surfaces. The camera obscura could be a box or a room with a small hole that admitted light through one wall. The beam of light projected the outside scene upside down on a surface within the box. The artist then simply traced the scene to achieve proper perspective—to accurately imitate nature.

The next developments in photography concerned the search for photosensitive surfaces that could permanently affix images. These developments came by bits and pieces. In 1727, the German physicist Johann Heinrich Schulze discovered that silver salts had light-sensitive qualities, but he never tried to record natural images. In 1802, Thomas Wedgwood, son of the well-known English potter, reported his discovery that paper soaked in silver nitrate did take on projected images as a chemical reaction to light. However, the images were not permanent. But then in 1826, the Frenchman Joseph-Nicéphore Niépce invented **heliography**. *Bitumen*, or asphalt residue, was placed on a pewter plate to create a photosensitive surface. Niépce used a kind of camera obscura to expose the plate for several hours, and then he washed the plate in lavender oil. The pewter showed through where there had been little or no light, creating the image of the darker areas of the scene. The bitumen remained where the light had struck, leaving lighter values.

◄ **20.33 James Renwick, Saint Patrick's Cathedral, 1858–1878. New York, New York.** Saint Patrick's is a Gothic cathedral, with its pointed arches and walls of richly ornamented fenestration. However, it was built in the mid-1800s and is therefore an example of the Gothic Revival style.

The **daguerreotype** resulted from a partnership formed in 1829 between Niépce and another Frenchman, Louis-Jacques-Mandé Daguerre. The daguerreotype used a thin sheet of chemically treated silver-plated copper, placed it in a camera obscura, and exposed it to a narrow beam of light. After exposure, the plate was treated chemically once more. **Figure 20.34** shows the first successful daguerreotype, taken in 1837. In this work, called *Nature morte: Intérieur d'un cabinet de curiosités* (*Still Life: Cabinet of Curiosities*), Daguerre, a landscape painter, sensitively assembled deeply textured objects and sculptures. The contrasting light and dark values help create an illusion of depth. Remarkably clear images could be recorded. The first daguerreotypes required exposure to light from 5 to 40 minutes—quite some time for a human subject to sit still. But within a decade, the exposure time had been reduced to about 30 to 60 seconds, and the process had become so inexpensive that families could purchase two portraits for a quarter. Daguerreotype studios opened all across Europe and the United States, and families began to collect the rigid, stylized pictures that now seem to reflect days gone by.

The negative was invented in 1839 by British scientist William Henry Fox Talbot. Talbot found that sensitized paper, coated with emulsions, could be substituted for the copper plate of the daguerreotype. He would place an object, such as a sprig of a plant, on the paper and expose the arrangement to light. By the 1850s, photographic technology and the demands of a growing middle class came together to create a burgeoning business in portrait photography. Having a likeness of oneself was formerly reserved for the wealthy, who could afford to commission painters. Photography became the democratic equalizer. The rich, the famous, and average bourgeois citizens could now become memorable, could now make their presence known long after their flesh had rejoined the elements from which it was composed.

▲ **20.35** Nadar, *Sarah Bernhardt*, 1869. Photograph, 8¼" × 6⅜" (21.4 × 17.2 cm). Bibliothèque Nationale, Paris, France. The actress assumes a dreamlike pose.

Photographic studios spread like wildfire, and many photographers, such as Julia Margaret Cameron and Gaspard-Félix Tournachon—called "Nadar"—vied for famous clientele. Cameron's impressive portfolio included portraits of Charles Dickens; Alfred, Lord Tennyson; and Henry Wadsworth Longfellow. Nadar's 1859 portrait of the actress Sarah Bernhardt (**Fig. 20.35**) was printed from a glass plate, which could be used several times to create sharp copies. Early portrait photographers such as Nadar imitated both nature and the arts, using costumes and props that recalled Romantic paintings or sculpted busts caressed by flowing drapery. The photograph is soft and smoothly textured, with middle-range values predominating; Bernhardt is sensitively portrayed as pensive and intelligent. We saw another Nadar photograph of Bernhardt in Chapter 7 (Fig. 7.7).

Prior to the 19th century, there were few illustrations in newspapers and magazines. Those that did appear were usually engravings or drawings. Photography revolutionized the capacity of the news media to bring realistic representations of important events before the eyes of the public. Pioneers such as Mathew Brady and Alexander Gardner first used the camera to record major historical events such as the U.S. Civil War. The photographers and their crews trudged down the roads alongside the soldiers, horses drawing their equipment behind them in wagons referred to by the soldiers as "whatsits."

Equipment available to Brady and Gardner did not allow them to capture candid scenes, so there is no direct record of the bloody to-and-fro of the battle lines, no photographic record of

▲ **20.34** Louis-Jacques-Mandé Daguerre, *Nature morte: Intérieur d'un cabinet de curiosités* (*Still Life: Cabinet of Curiosities*), 1837. Daguerreotype, 6½" × 8" (16.5 × 20.3 cm). Société Française de Photographie, Paris, France. This is the first successful daguerreotype.

CONNECTIONS Early in 2014, Russian forces wrested control of the Crimean peninsula from Ukraine. The territory of Crimea was actually first annexed by Russia in 1783 under the reign of Catherine the Great, but it was assigned to Ukraine by Soviet leader Nikita Krushchev in 1954, when both Russia and Ukraine were republics of the Soviet Union. In a referendum following the Russian invasion of 2014, Ukrainian citizens of the region, primarily Russian-speaking, voted to join Russia. Crimea's self-defense units (Ukrainian citizens allied with Russia) participated in attacks against Ukrainian soldiers. Media images—photographs and video—brought Russian President Vladimir Putin's egregious actions to the attention of the world. But these 21st-century images were not the first to record the shifting fate of Crimean territory.

▲ **20.36** *The Crimean War*, 1853–1856. Photograph by Roger Fenton of a cannon shot falling short of its target in the siege of Sevastopol in 1855.

The Crimean War of 1854–1856 between Russia and the allied forces of France, England, the Ottoman Empire and Sardinia was the first war to ever be documented in photographs. Britain's Queen Victoria sent Roger Fenton (1819–1869) to provide photographic verification of camp activities, the aftermath of the battles, and in light of stories that appeared in the *London Times*, evidence of the mishandling of the war, military and otherwise. The Queen was not the only one who reacted to these reports. The Poet Laureate Alfred, Lord Tennyson, the literary voice of the nation, penned a poem, it is said, within minutes after reading a story about a particularly disastrous battle in the *Times*. "The Charge of the Light Brigade" at once honors the valor of the soldiers and casts a harsh light on the brutality of war.

each lunge and parry. Instead, they brought home photographs of officers and of life in the camps along the lines. Although battle scenes would not hold still for Gardner's cameras, the litter of death and devastation caused by the war and pictured in Gardner's *Home of a Rebel Sharpshooter, Gettysburg* (**Fig. 20.37**) most certainly did. Ever since, graphic images of distant conflicts have been brought into the homes of the citizenry, often influencing public support for a war in one direction or another.

◄ **20.37** Alexander Gardner, *Home of a Rebel Sharpshooter, Gettysburg*, July 1863. Glass, wet collodion, 7" × 9" (17.8 × 22.9 cm). Library of Congress Prints and Photographs Division, Washington, DC.

GLOSSARY

Adagio (p. 697) Slow, as in a passage or piece of music.

Antithesis (p. 667) An idea or pattern of behavior that is the direct opposite of another (the **thesis**).

Bel canto (p. 700) An Italian term for opera that is defined by "beautiful singing."

Daguerreotype (p. 718) A 19th-century form of photography in which a thin sheet of chemically treated, silver-plated copper is placed in a camera obscura and exposed to a narrow beam of light.

Dies Irae (p. 697) A medieval Latin hymn describing Judgment Day, used in some Roman Catholic requiems for the dead. (Latin for "day of wrath.")

Free love (p. 692) A social movement that originally sought to separate the state from matters such as sex, marriage, birth control, and adultery; more generally, sexual activity without legal sanction.

Free verse (p. 710) Poetry without rhyme or a consistent meter pattern.

Gesamtkunstwerk (p. 701) An artistic creation that combines several mediums, such as music, drama, dance, and spectacle, as in the operas of Wagner. (German for "total artwork.")

Gothic novel (p. 692) A kind of novel that shares Romantic roots with tales of horror, as in the novels *Frankenstein* and *Dracula*.

Heliography (p. 717) A 19th-century form of photography in which bitumen, or asphalt residue, is placed on a pewter plate to render the plate sensitive to light.

Intermezzo (p. 697) In music, an interlude.

Leitmotiv (p. 701) A leading motif; a recurring theme or idea in a literary, artistic, or musical work.

Lens (p. 716) A transparent object with two opposite surfaces, at least one of which is curved, used to magnify or focus rays of light.

Lieder (p. 697) German art songs. (The German word for "songs" [singular *lied*]).

Mazurka (p. 698) A traditional Polish dance similar to a polka.

Metaphor (p. 711) A figure of speech in which a word or phrase denoting one kind of object or idea is used in the place of another to suggest a similarity between them, as in "She was swimming in money."

Natural selection (p. 669) The means by which organisms with genetic characteristics and traits that make them better adjusted to their environment tend to survive, reach maturity, reproduce, and increase in number, such that they are more likely to transmit those adaptive traits to future generations.

Neo-Classicism (p. 670) An 18th-century revival of Classical Greek and Roman art and architectural styles, generally characterized by simplicity and straight lines.

Nocturne (p. 698) A short piano piece in which a melancholy melody floats over a murmuring accompaniment.

Personification (p. 711) The representation of a thing or idea in art or literature as a person, as in referring to a ship or car as "she."

Photosensitive (p. 716) Responsive to light.

Polonaise (p. 698) A traditional Polish dance that is marchlike and stately.

Prelude (p. 698) In music, a brief instrumental composition; a piece that precedes a more important movement.

Realism (p. 702) A movement in art directed toward the accurate representation of real, existing things.

Romanticism (p. 667) An intellectual and artistic movement that began in Europe in the late 18th century and emphasized rejection of Classical (and Neo-Classical) forms and attitudes, interest in nature, the individual's emotions and imagination, and revolt against social and political rules and traditions.

Scherzo (p. 696) A fast-moving, lighthearted piece of music (Italian for "joke").

Simile (p. 711) A figure of speech in which the words *like* or *as* are used to describe a person or thing by comparing it with something else, as in "He ran like the wind."

Sturm und Drang (p. 683) German for "storm and stress"; the German manifestation of Romanticism, which emphasized originality, imagination, and emotion.

Synthesis (p. 667) In Hegelian philosophy, the reconciliation of mutually exclusive propositions—the thesis and the antithesis; more generally, the combining of separate substances or ideas into a single unified object or concept.

Thesis (p. 667) A proposition that is stated for consideration.

Tonality (p. 702) The sum of melodic and harmonic relationships between the tones of a scale or a musical system.

Transcendentalism (p. 708) A 19th-century New England literary movement that sought the divine in nature. More generally, the view that there is an order of truth that goes beyond what we can perceive by means of the senses and that it unites the world.

THE BIG PICTURE EUROPE AND AMERICA: 1800–1870

Language and Literature

- William Blake wrote Romantic poetry from the late 1700s through the early 1800s, publishing *Songs of Experience*, with the poem "The Tyger," in 1794.
- Wordsworth wrote his "Preface to Lyrical Ballads," explaining some principles of Romantic poetry, in 1800; *Lyrical Ballads* also contained Coleridge's *Rime of the Ancient Mariner*.
- Goethe published the first part of *Faust* in 1808.
- English Romantic poets working in the early 19th century included Byron, Percy Bysshe Shelley, and Keats.
- English novelists in the early 19th century included Austen (*Pride and Prejudice*) and Mary Wollstonecraft Shelley (*Frankenstein*).
- Early- and mid-19th-century U.S. poets included Poe, Whitman, and Dickinson.
- Emerson wrote "Self-Reliance" in 1841; Thoreau published *Walden* in 1854.
- U.S. novelists included Hawthorne (*The Scarlet Letter*) and Melville (*Moby-Dick*).
- Realist writers included Flaubert (*Madame Bovary*), Balzac (*Le Père Goriot*), Sand (*Lélia*), Tolstoy (*War and Peace*), and Dickens (*A Tale of Two Cities*, *Hard Times*, *Oliver Twist*).
- Hugo published *Les Misérables* in 1862.

Art, Architecture, and Music

- William Blake worked as an illustrator from the late 1700s through the early 1800s and illustrated his own poetry.
- Ground was broken for the Neo-Classical U.S. Capitol in 1793.
- Beethoven composed his Romantic symphonies and other works in the late 1700s and early 1800s.
- Other Romantic composers working in the first half of the 19th century included Berlioz, Schubert, Brahms, Bruckner, and Chopin.
- Bel canto opera developed during the Romantic era.
- The operas of Verdi showed a new concern for dramatic and psychological truth.
- Goya etched *The Sleep of Reason Produces Monsters* in 1798–1798 and painted politically oriented works, including *The Third of May, 1808*, in the 1800s.
- David painted *The Consecration of Emperor Napoleon I and Coronation of the Empress Joséphine* in 1806–1807.
- Ingres painted *La Grande Odalisque* in 1814.
- Géricault painted *The Raft of the Medusa* in 1818.
- Delacroix painted the politically charged *Massacre at Chios* in 1824 and *The Death of Sardanapalus* in 1826.
- Daumier and Courbet produced art in the Realist style beginning in the 1830s.
- Turner painted *The Slave Ship* in 1840.
- U.S. painters of the Hudson River school included Cole (*The Oxbow*) and Durand (*Kindred Spirits*).
- Wagner composed *The Ring of the Nibelung* between 1851 and 1874.
- Haussmann began the modernization of Paris in 1853.
- Saint Patrick's Cathedral was constructed in New York between 1858 and 1878.

Philosophy and Religion

- Romanticism as a movement began in the 1790s.
- Hegel stressed the ability of art to reconcile and make sense of opposites.
- Schopenhauer published *The World as Will and Idea* in 1819.
- Transcendentalism developed in the United States in the early 19th century.
- Marx and Engels published *The Communist Manifesto* in 1848.

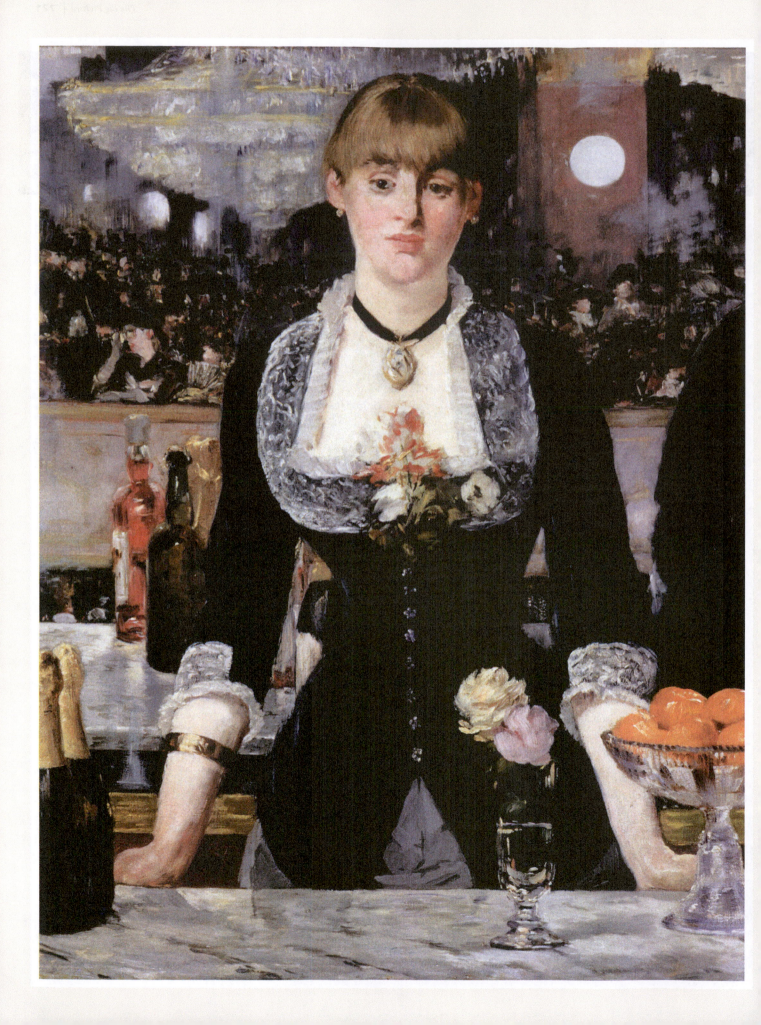

Toward the Modern Era: 1870–1914

PREVIEW

In 1863, the poet and art critic Charles Baudelaire published "The Painter of Modern Life," a groundbreaking treatise on art, beauty, fashion, and the role of the artist in modern times. That was the same year that the painter Édouard Manet presented his own groundbreaking work, *Le Déjeuner sur l'Herbe*, shocking the critics and public with an otherwise ordinary Parisian picnic scene in which one of the guests has removed all of her clothes. The coincidence was an important one—for art and for friendship. Baudelaire's essay presaged Manet's artistic message; the poet's definition of modernity—of being of one's time—found its visual counterpart in the work of the painter. The two men were close friends for over a decade.

In 1866, the writer Émile Zola published an article on Manet defending the painter against harsh criticism; a year later, he wrote again, in support of Manet's bold decision to create a private exhibition of his own outside the Exposition Universelle in Paris. In 1868, Manet painted a portrait of Zola in a gesture of gratitude. The two developed a lasting, loyal friendship.

Baudelaire, Manet, and Zola form a fascinating triangle, at the center of which is the concept of *modernity*. In "The Painter of Modern Life," Baudelaire defines modernity as "the transitory, the fugitive," and the role of the artist as that of an outsider, a flâneur, or a "passionate spectator." The artist, he says, is to be "a man of the crowd" who fades into the crowd, observing everything unnoticed and hastily sketching the mood and social conditions of his time. The "modern life" that the painter passively records, Baudelaire tells us, is one of desires (what he calls artificial desires) satiated by commodities, such as fashion, cosmetics, pleasure, and entertainment (including prostitution).

These desires drive Zola's *Au Bonheur des Dames*, a novel about material consumption and what art historian Ruth E. Iskin calls the "selling, seduction, and soliciting of the eye" at the center of a new phenomenon in 19th-century France—the department store. Desire and consumption, seduction and selling—according to Iskin—are also at the center of *A Bar at the Folies-Bergère* (**Figs. 21.1** and 21.5), Manet's painting of the legendary Parisian music hall. Her compelling argument derives from an examination of what she labels the historically specific discourses of mass consumption, the changing roles of women, and the development of the modern crowd or public. Zola's novel, first in serial form, and Manet's painting appeared in the same year—1882.

In Manet's painting, a man approaches a bar arrayed with consumables, displayed to titillate the eye as much as does the attractively attired barmaid or, as some have identified her, *marchande* (salesgirl). The large mirror behind her reflects the customer, a dandy bourgeois in a top hat, but also reflects a quickly sketched crowd of spectators—consumers of entertainment. The barmaid's gaze is blank, disinterested, as she seems to look past her customer in our direction. We too are spectators seduced by her spell and her wares.

◀ **21.1** Édouard Manet, *A Bar at the Folies-Bergère* (detail), 1882. Oil on canvas, 37¾" × 51" (96 × 130 cm). Courtauld Institute and Galleries, London, United Kingdom.

THE BIRTH OF THE MODERN ERA

The crux of modernity, in Baudelaire's view, was "impermanence," the constant shift and change to what was understood as the prevailing reality. By the last quarter of the 19th century, there was a widespread, if somewhat unfocused, feeling in Europe that life would not and could not continue as it had been. Social and political revolutions had replaced the old monarchies with relatively more equitable forms of government. Scientific and technological developments had affected millions of ordinary people, shifting the focus from the agrarian countryside to the industrialized city where employment opportunities were abundant and improvements in living conditions made the notion of urban life more attractive. The standard of living increased with economic prosperity and, overall, a new mood of optimism and hope was palpable in the great cities of Europe. In Paris, the period between the establishment of the Third Republic in 1871 and the First World War in 1914 is known as **La Belle Époque**—literally, the beautiful age. But this new "spirit of the age"—this zeitgeist of optimism—did not necessarily filter down to the masses for which change would carry with it damaging consequences.

Medical advances reduced the rate of infant mortality, cured hitherto fatal diseases, and prolonged life expectancy. But as a result, populations in most of Europe soared to record levels, creating shortages of food and housing. New forms of transport and industrial processes brought vast numbers of workers to the cities. New electronic forms of communication were making it possible for people to communicate instantaneously over vast distances. But looking at it from another perspective, the lives of many people were uprooted, and their daily existence became anonymous and impersonal.

While the growth of a world financial market, primarily dependent on the value of gold, gave new power to the forces of big business, the establishment of democratic systems of government brought awareness on the part of the urban working class that it had the right to share in the material benefits made possible by the Industrial Revolution. In the richest countries in Europe—France, England, and Germany—the poor compared their lot to that of the more affluent. Simultaneously, in the poorer European countries, including Ireland, Spain, Portugal, and almost all of Eastern Europe, people looked with envy—and resentment—upon their wealthier neighbors.

The disparity in wealth between classes and between nations led to the greatest period of European migration to the United States, where it was rumored—fancifully, to be sure—that the streets were paved with gold. In 1907, the peak year, more than 1.25 million European immigrants came to the United States, most of them from Southern and Eastern Europe. Between 1870 and 1914, millions upon millions of Europeans came to the United States (**Fig. 21.2**).

Political, Social, and Philosophical Developments

Distance lends perspective in human experience. The more intimately we are affected by events, the more difficult it is to evaluate them objectively. Looking back, we can see that the world

Toward the Modern Era: 1870–1914

1870 CE	1885 CE	1900 CE	1906 CE	1914 CE
Bismarck creates the German Empire in 1870	International League of Socialist Parties is founded	Marconi sends first transatlantic message via wireless telegraph in 1901	Social insurance and parliamentary reform are enacted in England	
Bismarck uses balance-of-power diplomacy to keep peace in Europe	Russia industrializes	Wright brothers make first powered flight in 1903	Ford introduces the Model T automobile	
Germans found the Social Democratic Party	French Dreyfus Affair reveals anti-Semitism and leads to separation of church and state	Pankhurst founds Women's Social and Political Union in 1903	Ford produces automobiles via the assembly line	
Bell invents the telephone in 1876	Roentgen discovers X-rays	Russo–Japanese War is fought in 1904	Revolution in China establishes republic	
Edison patents the light bulb in 1879	Marconi invents wireless telegraph in 1895	First revolution breaks out in Russia in 1905	Rutherford formulates "planetary model" of the atom	
Pasteur and Koch prove the germ theory of disease	Second Boer War leads to British control of all South Africa and tension with Germany	Einstein formulates theory of relativity in 1905	World War I begins in 1914	
Social insurance is initiated in Germany		First motion-picture theater opens in Pittsburgh in 1905		

in which we live—with its great hopes and fears—began to take its present political shape in 1870, with Otto von Bismarck's (1815–1898) creation of the German Empire—the incorporation of smaller German states into Prussia through a series of brief wars. As minister president of a unified Germany, he warred with Denmark, Austria, and France to assure his new nation's dominance over continental Europe. But he then worked to engineer a balance of power in Europe, which managed to keep the peace from the early 1870s through 1890, when he was dismissed from office.

Bismarck was a social and political conservative who abhorred the growth of the socialist movement in Europe, including the development of his country's Social Democratic Party. Therefore, it might strike you as quite strange that Bismarck also promoted the development of what we would now call the welfare state. He instituted old-age pensions (the forerunner of Social Security in the United States), government-sponsored medical care, unemployment insurance, and accident insurance. The socialists voted against all of these programs.

The British Empire reached its zenith in the 1880s (despite its loss of a few American colonies toward the end of the 18th century), with colonies stretching across the globe. It was said that "the sun never set on the British Empire." Other European nations, especially France, also had colonies, and Germany

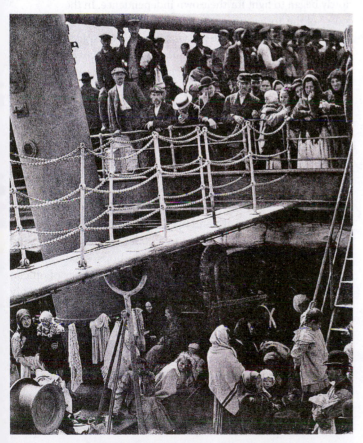

▲ **21.2** Alfred Stieglitz, *The Steerage*, 1907. Photogravure, 13" × 10" (33 × 25.4 cm). Library of Congress, Prints and Photographs Division, Washington, DC. The photographer wrote, "I stood spellbound for a while, looking and looking. Could I photograph what I felt, looking and looking and still looking?"

under Bismarck took some small steps in that direction as well, all of which heightened competition and tensions between Germany, the United Kingdom, and France. Despite hundreds of years of warfare, the United Kingdom and France signed a treaty designed, essentially, to protect themselves from this troublesome emerging Germany, and both sides gathered additional allies. The jockeying for position and power would eventually lead to World War I in 1914, although between the Franco-Prussian War of 1870–1871 and the start of World War I, Europe had remained mostly at peace. Despite this peace, however, most of the leading countries of Europe were constructing huge armies by introducing compulsory military service. Long before 1914, many people thus assumed that sooner or later war would break out—a belief that did not help to avert it.

At a time when so many political and social forces were pitted against one another, there seemed to be no certainty on which to fall back. Religion had lost its hold over intellectual circles by the 18th century, and by the end of the 19th century, strong religious faith and its manifestation in church attendance began to fall drastically at all levels of society. The newly developing fields of anthropology and psychology, far from replacing religion, provided fresh controversy with their radically different explanations of human life and behavior.

FRIEDRICH WILHELM NIETZSCHE In a state of such potential explosiveness, a collapse of the fabric of European civilization seemed likely. Events were moving so rapidly that few thinkers were able to detach themselves from their times and develop a philosophical basis for dealing with them. One of the few who did was Friedrich Wilhelm Nietzsche (1844–1900), whose ominous diagnosis of the state of Western civilization in *Thus Spoke Zarathustra* (1883–1892) and other works led him to propose drastic remedies.

For Nietzsche, Christianity was a slave religion, extolling feeble virtues such as compassion and self-sacrifice: the greatest curse of Western civilization. He viewed democracy as little better, calling it the rule of the mediocre masses. The only valid life force, according to Nietzsche, is the "will to power"—that energy that casts off all moral restraints in its pursuit of independence. Anything that contributes to power is good. Society can only improve if strong and bold individuals, who can survive the loss of illusions, by the free assertion of the will establish new values of nobility and goodness. Nietzsche called these superior individuals **Übermenschen** (literally "supermen"). Like Schopenhauer in the early 19th century (see Chapter 20), Nietzsche is valuable principally for the way in which he anticipated future ideas rather than for being the leader of a movement himself. Unfortunately, his concepts were later taken up and distorted by many would-be world rulers of the 20th century, most notoriously the leaders of Nazi Germany.

THE WOMAN'S MOVEMENT The rise of new political movements during the 19th century, of which socialism was perhaps the most prominent, drew upon a section of society new to political activism: women. Indeed, the first use of the term *feminism* dates to this period. Women campaigned for a

CULTURE AND SOCIETY

Imperialism

The transition from the world of the Late Middle Ages to the dawn of the modern era was largely the result of European expansion overseas and the economic developments that it brought. By the mid-19th century, the European search for new territories in which to engage in trade had solidified into a competitive drive to conquer and colonize them. Imperialism became one of the chief motivating forces in 19th-century politics and culture.

Imperialism arose in response to economic, political, and psychological goals. Economically, conquests of overseas territories and peoples provided sources of raw materials and abundant cheap labor. As the capitalist system grew, the colonies became centers for investment and thereby absorbed accumulating surplus capital—a point made by Lenin, one of the fiercest opponents of both capitalism and imperialism.

Politically, imperialism provided a means whereby the leading European powers could continue their rivalries outside Europe. At the beginning of the 19th century, the delegates at the Congress of Vienna in 1815 had created a political balance of power under which no European nation was able to dominate the others. By conquering more and richer territory in Africa and Asia, however, Western European colonizers could try to surpass one another.

No less important were the psychological factors inherent in nationalism. National pride became a powerful factor in determining political and military decisions. As European possessions abroad began to accumulate, the conquest of a well-located port or island could open up new territories, allow a nation to hold on to territories, or effectively block a rival nation. At the patriot's level, heroic achievement abroad, particularly military prowess, brought personal glory and offered avenues of advancement to the less advantaged.

At least some of the drive for imperialism also rested on the claim—expressed by many imperialists and surely believed by some—that colonizers were spreading civilization, in its European form at least. Missionaries accompanied most colonial expeditions, and colonial governments tried to outlaw those local customs that appalled their administrators: cannibalism, child marriage, nakedness. While in some cases, the physical conditions and education of the local populations improved, colonizers nevertheless resisted calls for self-government.

The eventual result was that the colonized peoples slowly began to fight for their own independence. In the course of the 20th century, struggles for independence reversed colonialism. In the process, European dominance gave way to a global culture that links the destinies of all parts of the world. Technological changes, weapons of mass destruction, and rapid progress in electronic communication have all helped build a global environment in which imperialism is now seen as arrogant and self-serving.

wide variety of causes—divorce reform, property ownership—but the issue that united most women across barriers of class or nationality was suffrage: the right to vote.

British women could vote in local elections from 1868, and they could vote for local governments in Finland and Sweden in the 1870s. In the 1890s, some U.S. states granted women the vote, but only single women who owned property. By the eve of World War I, with the exception of Finland, no Western country (including the United States) allowed women to vote in national elections.

In France, feminists began to organize protest groups, refusing to pay taxes and overturning voting urns. The best known British group was the Women's Social and Political Union, founded in 1903 by Emmeline Pankhurst. Pankhurst and her daughters believed that only direct, violent action would secure women the vote. Her organization campaigned against political candidates who were opposed to women's suffrage. When leading politicians, including British prime minister Herbert Asquith and his minister David Lloyd George, refused to back women's right to vote, her supporters smashed the windows of London's most exclusive shops, assaulted leading politicians, and chained themselves to the railings of official buildings. When sent to prison, they staged hunger strikes (only to be gruesomely force-fed). One of their activists, Emily Wilding Davison, threw herself in front of the king's horse on Derby day, 1913, and was trampled to death. Only after World War I, in 1918, did the suffragettes in Britain win the right to vote. U.S. women voted in national elections for the first time in 1920.

The Arts

Cut adrift from the security of religion or philosophy, the arts responded to the restless mood of the times by searching for new subjects and styles, which often challenged principles that had been accepted for centuries. In music, traditional concepts

of harmony and rhythm were first radically extended and then, by some composers at least, discarded. In literature, new areas of experience were explored, including the impact of the subconscious on human behavior, and traditional attitudes like the role of women were examined afresh. In the visual arts, movement followed movement in rapid succession. The formative years of the modern world were certainly not dull with respect to the arts.

THE VISUAL ARTS

Something of the feverish activity in the visual arts during this period can be gauged by the sheer number of movements and styles that followed one another in rapid succession: Impressionism, Postimpressionism, Fauvism, Expressionism, Cubism, and Futurism, culminating at about the beginning of World War I. But we begin with traditional Academic art.

Academic Art

Ironically, the style of painting that had the least impact on the development of modernism was Academic art, so called because its style and subject matter were derived from conventions established by the Académie Royale de Peinture et de Sculpture (the Royal Academy of Painting and Sculpture) in Paris, established in 1648. Artists educated in the academy painted traditional subjects (history, nudes, mythological subjects) rendered with precise drawing and highly polished surfaces. The academy maintained a firm grip on artistic production for more than two centuries and pretty much controlled the art scene by sponsoring annual juried exhibitions (salons) that featured only the work of artists whose style complied with academy standards. Many of these artists were followers rather than innovators, and because of the pedantic nature of their work, they often never rose above the level of mediocrity.

One of the more popular and accomplished Academic painters was William-Adolphe Bouguereau (1825–1905). Included among his oeuvre are religious and historical paintings in a grand Classical manner, although he is most famous for his meticulously painted nudes and mythological subjects. *Nymphs and Satyr* (**Fig. 21.3**) is nearly

photographic in its refined technique and attention to detail. Four sprightly and sensuous wood nymphs corral a hesitant satyr and tug him into the water. Their innocent playfulness would have appealed to the French man on the street, although the saccharine character of the subject matter and the extreme light-handedness with which the work was painted served only as a model against which the new wave of painters rebelled.

From Realism Toward Impressionism

The Realist painter Gustave Courbet (see Chapter 20) may have laid the groundwork for Impressionism, but he was not to be a part of the new wave. His old age brought conservatism, and with it disapproval of the younger generation's painting techniques. One of the targets of Courbet's derision was Édouard

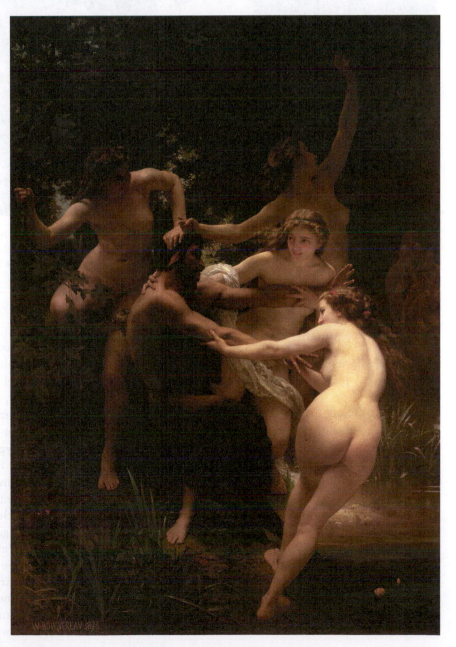

▶ **21.3** William–Adolphe Bouguereau, *Nymphs and Satyr*, 1873. Oil on canvas, 102⅜" × 70⅞" (260 × 179.8 cm). Sterling and Francine Clark Art Institute, Williamstown, Massachusetts. Bouguereau's work, though accomplished, epitomized the traditional standards that sparked rebellion among younger artists.

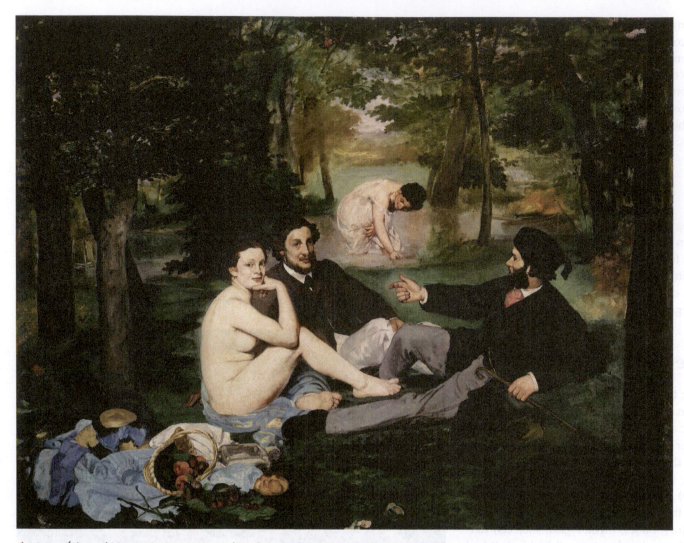

▲ **21.4** Édouard Manet, *Le Déjeuner sur l'Herbe* (Luncheon on the Grass), 1863. Oil on canvas, 93⅞" × 104" (208 × 264.5 cm). Musée d'Orsay, Paris, France. There are many mysteries about this painting: What are the women doing there? Why is one of them undressed? What, exactly, is the meaning of the expression on the face of the nude woman?

Manet (1832–1883). Yet according to some art historians, Manet is the artist who was most responsible for changing the course of the history of painting.

ÉDOUARD MANET Édouard Manet (1832–1883) was arguably the most influential painter to emerge in Paris between the movements of Realism and Impressionism, bridging the two styles and, with his subjects, soundly rejecting the conventions of the French Academy. Ten years before Bouguereau painted *Nymphs and Satyr*, Manet exhibited a work that would become legend in the history of modern art—*Le Déjeuner sur l'Herbe* (*Luncheon on the Grass*) (**Fig. 21.4**)—in what was called the Salon des Refusés (an alternative exhibition for artists who were rejected from the academy's official salon). To say that the painting raised a stir is an understatement; it met with disapproval from critics and the public alike. Why? It was the shock of the new.

The juxtaposition of nude women and clothed men was *not* new; the Venetian artists of the Renaissance had painted such

compositions before. Also, Manet lifted the poses and placement of his figural group from an engraving after a painting by Raphael. Beyond these deliberate, perhaps tongue-in-cheek references, everything else *was* new, radically new. A Venetian pastoral scene by Titian would have featured mythological women—for whom nudity was standard—juxtaposed with courtier-type men playing musical instruments or waxing philosophical. But in lieu of these personages, which had become the standard fare of the Academic artists, Manet offered ordinary—identifiable—mortals from the French middle class on a picnic in the park. Manet's brother Eugène extends a pointed finger in a gesture of conversation with a man identified by some historians as a sculptor friend of the artist; the seated nude who engages the viewer with her gaze is Victorine Meurent, a model who appears in several of Manet's paintings. Her eyes meet the viewer's and the viewer is transformed into voyeur, an unsettling relationship to be sure. Perhaps even more unsettling were the unanswered questions that likely ran through the minds of

the audience: Why has the woman removed her clothes? Why are the men uninterested in her nudity? Has she caught me staring?

Manet's painting technique was also unconventional, building on the innovations of Realist artists. In lieu of the smooth, highly polished technique that was the signature of the Academic style, Manet applied barely modeled pigment in thick, broad brushstrokes; he prioritized the physical presence of the materials and evidence of the painting process over illusionism. Manet also introduced a luminous quality in his canvases by reversing painting methods developed by Renaissance artists: rather than beginning with a dark underpainting and adding highlights in successive layers, Manet began with a white background to which he added darker tones. It is this luminosity that paved the way for the Impressionists. Modernism was on its way.

Déjeuner was not Manet's only subversive composition. In *Olympia* (see Fig. 21.7 in the nearby Compare + Contrast feature,) he also sardonically referenced Old Masters as the role models of the Academically trained artist. The painting he "revised" this time was Titian's *Venus of Urbino*, replacing the reclining nude in the Venetian work with another "goddess of love"—a prostitute (Olympia was a contemporary name for women who sold sexual favors in the red-light districts of Paris)—and the sleeping dog at her feet, which symbolized fidelity, with a black cat. Just as the seated nude in *Dejeuner*

ruffled the public's feathers, the prostitute in *Olympia* created her own outcry. She, too, stares directly out of the canvas, creating the uncomfortable impression that a transaction is being made between her and the viewer-as-client. Gone are the Old Master delicate glazes that create the illusion of supple, glowing flesh. Manet replaces them with a pasty white pigment that a critic described as "the tint of a cadaver in a morgue." The representation of a contemporary prostitute, the raw application of paint, and the juxtaposition of races (the maid who presents Olympia with flowers from a potential client is black) comprised a recipe for scandal. Yet a quarter of a century after *Olympia* was painted, only 17 years after his death, Manet's works were shown at the prestigious Louvre Museum.

We may respond to Manet's *A Bar at the Folies-Bergère* (Figs. 21.1 and **21.5**) on many different levels. Superficially, it is what has been called "a feast for the eye." There is a splendid array of alcoholic beverages, fruit, and flowers before us, along with a beautiful young woman. Might a male viewer identify with the reflection of the man in the mirror on the right? That man is engaging the barmaid in conversation; is he propositioning her? Might a female viewer identify with the barmaid—the object of the man's interest? We might note her disengaged expression. Although there is an overload of visual stimulation for the viewer, even a powerful suggestion of perfume, the barmaid has seen it all and is, perhaps, weary of it.

◀ **21.5 Édouard Manet,** *A Bar at the Folies-Bergère*, **1882. Oil on canvas, 37¾" × 51" (96 × 130 cm). Courtauld Institute and Galleries, London, United Kingdom.** The barmaid is inaccurately reflected in the mirror. Why do you think the artist chose to paint her this way? What "consumables" do you find in the painting?

COMPARE + CONTRAST

The Politics of Sexuality: The Female Body and the Male Gaze

"We never encounter the body unmediated by the meanings that cultures give to it." Right out of the starting gate, can you challenge yourself to support or contest this statement with reference to the four works in this feature? The words are Gayle Rubin's, and they can be found in her essay "Thinking Sex: Notes for a Radical Theory of the Politics of Sexuality."* Which of these works, in your view, are about "thinking sex"? Which address the "politics of sexuality"?

Titian's reclining nude (**Fig. 21.6**) was commissioned by the Duke of Urbino for his private quarters. There was a considerable market for erotic paintings in the 16th century. One point of view maintains that many of the "great nudes" of Western art were, in essence, created for the same purpose: as pinups. Yet there is also no doubt that this particular reclining nude has had an undisputed place in the canon of great art. This much, at least, has been reaffirmed by the reinterpretations and revisions the work has inspired into current times.

One of the first artists to use Titian's *Venus* as a point of departure for his own masterpiece was Édouard Manet. In his *Olympia* (**Fig. 21.7**), Manet intentionally mimicked the Renaissance composition as a way of challenging the notion that modern art lacked credibility when brought face-to-face with the Old Masters. In effect, Manet seemed to be saying, "You want a Venus? I'll give you a Venus." And just where do you find a Venus in 19th-century Paris? In the bordellos of the demimonde. What do these paintings have in common? Where do they depart? What details does Titian use to create an air of innocence and vulnerability? What details does

ruffled the public's feathers, the insistence in Olympia's cool [...] her own [...]

[...] of supple glowing flesh [...] shine present that is [...] in a grouping. The [...] the [...] separation of paint, and the [...]

▲ **21.6** Titian, *Venus of Urbino*, 1538. Oil on canvas, 47" × 65" (119 × 165 cm). Galleria degli Uffizi, Florence, Italy.

▼ **21.7** Édouard Manet, *Olympia*, 1863–1865. Oil on canvas, 51⅜" × 74¾" (130 × 190 cm). Musée d'Orsay, Paris, France.

▲ **21.8** Paul Gauguin, *Te Arii Vahine* (The Noble Woman), 1896. Oil on canvas, 38⅛" × 51¼" (97 × 130 cm). The National Pushkin Museum, Moscow, Russia.

▼ **21.9** Suzanne Valadon, *The Blue Room*, 1923. Oil on canvas, 35½" × 45⅝" (90 × 116 cm). Musée National d'Art Moderne, Centre Georges Pompidou, Paris, France.

Manet use to do just the opposite? For example, Titian placed a dog on the couch of his reclining nude in *Venus of Urbino*. Manet placed a black cat on the couch with Olympia. What are the meanings of these symbols?

Paul Gauguin, the 19th-century French painter who moved to Tahiti, was also inspired by the tradition of the Western reclining nude in the creation of *Te Arii Vahine* (The Noble Woman) (**Fig. 21.8**). The artist certainly knew Manet's revision of the work; in fact, he had a photograph of *Olympia* tacked on the wall of his hut. How does this Tahitian Venus fit into the mix? All three of these works have a sense of self-display. In which do the women solicit our gaze? Refuse it? How do the stylistic differences influence our interpretation of the women and our relationship to them? How is the flesh modeled in each work? What overall effects are provided by the different palettes? And: Are these paintings intended for the male gaze, the female gaze, or both?

Suzanne Valadon would probably have said that such images do *not* appeal equally to men and women. More to the point, Valadon would have argued that the painting of such subjects is not at all of interest to women artists. Perhaps this belief was the incentive behind her own revision of the reclining nude: *The Blue Room* (**Fig. 21.9**). With this work, she seems to be informing the world that when women relax, they really *don't* look like the Venuses of Titian, or Manet, or Gauguin. Instead, they get into their loose-fitting clothes, curl up with a good book, and sometimes treat themselves to a bit of tobacco.

*Gayle Rubin, "Thinking Sex: Notes for a Radical Theory of the Politics of Sexuality," in *Pleasure and Danger: Exploring Female Sexuality*, ed. Carole S. Vance (London: Pandora, 1992), pp. 267–293.

Impressionism

In the late 1800s, a group of artists were banding together against the French art establishment. Suffering from little recognition and much vicious criticism, many of them lived in abject poverty for lack of commissions. Yet they stand today as some of the most significant, and certainly among the most popular, artists in the history of art. They were called the **Impressionists**. The very name of their movement was coined by a hostile critic and intended to malign their work. The word *impressionism* suggests a lack of realism, and realistic representation was the standard of the day.

The Impressionist artists had common philosophies about painting, although their styles differed widely. They all reacted against the constraints of the Academic style and subject matter. They advocated painting out of doors and chose to render subjects found in nature. They studied the dramatic effects of atmosphere and light on people and objects and, through a varied palette, attempted to duplicate these effects on canvas.

Through intensive investigation, they arrived at awareness of certain visual phenomena. When bathed in sunlight, objects are optically reduced to facets of pure color. The actual color—or local color—of these objects is altered by different lighting effects. Solids tend to dissolve into color fields. Shadows are not black or gray, but a combination of colors.

Technical discoveries accompanied these revelations. The Impressionists duplicated the glimmering effect of light bouncing off the surface of an object by applying their pigments in short, choppy strokes. They juxtaposed complementary colors such as red and green to reproduce the optical vibrations perceived when one is looking at an object in full sunlight. Toward this end, they also juxtaposed primary colors such as red and yellow to produce, in the eye of the spectator, the secondary color orange. We shall discuss the work of the Impressionists Claude Monet, Pierre-Auguste Renoir, Berthe Morisot, and Edgar Degas.

CLAUDE MONET The most fervent practitioner of Impressionist techniques was the painter Claude Monet (1840–1926). His canvas *Impression, Sunrise* (**Fig. 21.10**)

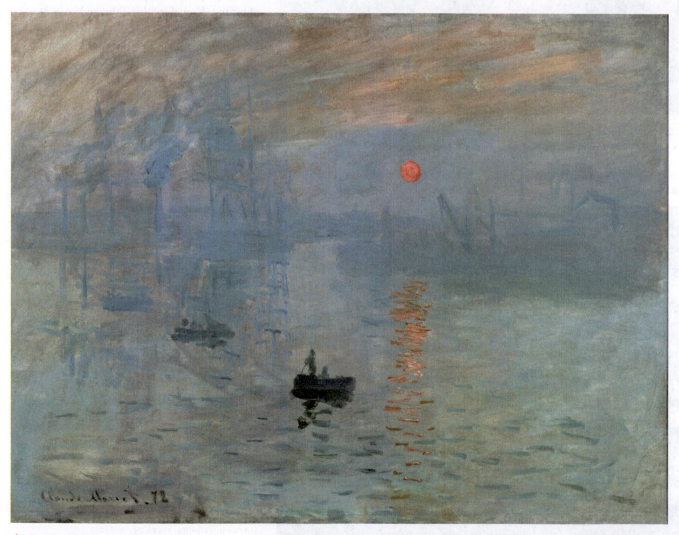

▲ **21.10** Claude Monet, *Impression, Sunrise*, 1872. Oil on canvas, 19" × 24 ¾" (48 × 63 cm). Musée Marmottan, Paris, France. This is the canvas that inspired the epithet *impressionist*. Impressionist artists appropriated the term and gave it a positive meaning.

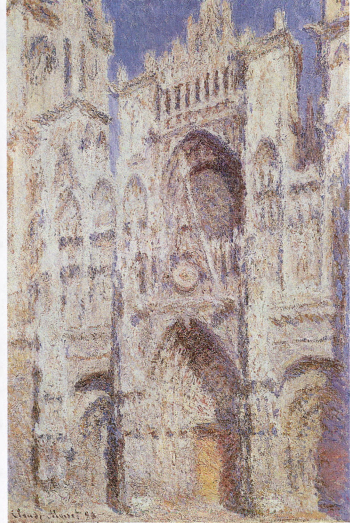

▲ **21.11** Claude Monet, *Rouen Cathedral*, The Portal (in Sun), 1894. Oil on canvas, 39¼" × 25⅞" (99.7 × 65.7 cm). Metropolitan Museum of Art, New York, New York. This painting is one of a series, each of which captures the cathedral in a different light.

patches of bright blue and splashes of yellow and red. With these delicate touches, Monet has recorded for us the feeling of a single moment in time. He offers us his impressions as eyewitness to a set of circumstances that will never be duplicated.

Throughout his long career, Monet retained a total fidelity to visual perception. His fellow painter Paul Cézanne (1839–1906) is said to have called him "only an eye, but my God what an eye!" Monet's preoccupation with the effects of light and color reached its most complete expression in his numerous paintings of water lilies in his garden. In version after version, he tried to capture in paint the effect of the shimmering, ever-changing appearance of water, leaves, and blossoms. The result, as in the *Nymphéas (Water lilies, water study, morning)* of 1914–1918 (**Fig. 21.12**), reproduces not so much the actual appearance of Monet's lily pond as an abstract symphony of glowing colors and reflecting lights. Paradoxically, the most complete devotion to naturalism was to pave the way for abstraction and for what we know as "modern art."

PIERRE-AUGUSTE RENOIR Most Impressionists counted among their subject matter landscape scenes or members of the middle class enjoying leisure-time activities. Of all the Impressionists, however, Pierre-Auguste Renoir (1841–1919) was perhaps the most significant figure painter. Like his peers, Renoir was interested primarily in the effect of light as it played across the surface of objects. He illustrated his preoccupation in one of the most wonderful paintings of the Impressionist period, *Le*

▼ **21.12** Claude Monet, *Nymphéas (Water lilies, water study, morning)*, ca. 1914–1918. Oil on canvas, 83¾" × 78¾" (200 × 212.5 cm). Musée de l'Orangerie, Paris, France. This is one of several large paintings that Monet produced in the garden of his house in Giverny.

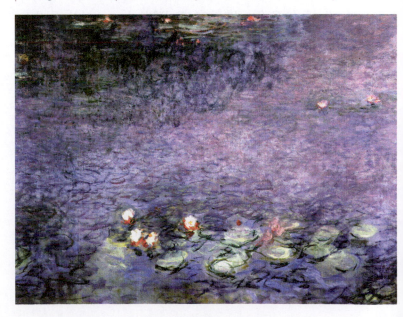

inspired the epithet *impressionist* when it was shown at the first Impressionist exhibition in 1874. Fishing vessels sail from the port of Le Havre toward the morning sun, which rises in a foggy sky to cast its copper beams on the choppy, pale-blue water. The warm blanket of the atmosphere envelops the figures, their significance having waned in the wake of nature's beauty.

The dissolution of surfaces and the separation of light into its spectral components remain central to Monet's art. They are dramatically evident in a series of canvases depicting Rouen Cathedral (**Fig. 21.11**) from a variety of angles, during different seasons and times of day. The harsh stone façade of the cathedral dissolves in a bath of sunlight, its finer details obscured by the bevy of brushstrokes crowding the surface. Dark shadows have been transformed into

▲ **21.13** Pierre-Auguste Renoir, *Le Moulin de la Galette*, 1876. Oil on canvas, 51 ½" × 69" (131 × 175 cm). Musée d'Orsay, Paris, France. Renoir, like other Impressionists, was fascinated by the play of light on various surfaces. Note the dappling of the sun on the straw hats.

Moulin de la Galette (**Fig. 21.13**). With characteristic feathery strokes, Renoir communicated all of the charm and gaiety of an afternoon dance. Men and women caress and converse in frocks that are dappled with sunlight filtering through the trees. All of the spirit of the event is as fresh as if it were yesterday. From the billowing skirts and ruffled dresses to the rakish derbies, top hats, and skimmers, Renoir painted all of the details that imprint such a scene on the mind forever.

BERTHE MORISOT As other Impressionists, Berthe Morisot (1841–1895) exhibited at the Salon—the prestigious official art exhibition of the French Académie des Beaux-Arts—early in her career, but she surrendered the safe path as an expression of her allegiance to the new. Morisot was a granddaughter of the 18th-century painter Jean-Honoré Fragonard (see Fig. 19.3) and the sister-in-law of Édouard Manet. Manet painted her quite often; in fact, Morisot is the seated figure in his painting *The Balcony*.

In Morisot's *Young Girl by the Window* (**Fig. 21.14**), surfaces dissolve into an array of loose brushstrokes, applied, it would seem, at a frantic pace. The vigor of these strokes contrasts markedly with the tranquility of the woman's face. The head is strongly modeled, and several structural lines, such as the back of the chair, the contour of her right arm, the blue parasol across her lap, and the vertical edge of drapery to the right, anchor the figure in space. Yet in this, as in most of Morisot's works, we are most impressed by her ingenious ability to suggest complete forms through a few well-placed strokes of pigment.

EDGAR DEGAS We can see the vastness of the aegis of Impressionism when we look at the work of Edgar Degas (1834–1917), whose approach to painting differed considerably from those of his peers. Degas, like Morisot, had exhibited at the Salon for many years before joining the movement. He was a superb draftsman who studied under Ingres. While in Italy,

▶ **21.14** Berthe Morisot, *Young Girl by the Window*, 1878. Oil on canvas, 30" × 24" (76.2 × 61 cm). Musée Fabre, Montpellier, France. Morisot uses a few strokes of pigment to suggest forms.

he copied the Renaissance masters. He was also intrigued by Japanese prints and the new art of photography.

The Impressionists, beginning with Manet, were strongly influenced by Japanese woodcuts, which were becoming readily available in Europe; Oriental motifs appeared widely in their canvases. They also adopted certain techniques of spatial organization found in Japanese prints, including the use of line to direct the viewer's eye to different sections of the work and to divide areas of the essentially flattened space. They found that the patterning and flat forms of Oriental woodcuts complemented similar concerns in their own painting. Throughout the Impressionist period, and even more so in the Postimpressionist period, the influence of Japanese artists remained strong.

Degas was strongly influenced by the developing art of photography, and the camera's exclusive visual field served as a model for the way in which he framed his own paintings. *The Rehearsal (Adagio)* (**Fig. 21.15**) contains elements both of photographs and of Japanese prints. Degas draws us into the composition with an unusual and vast off-center space that curves around from the viewer to the background of the canvas. The diagonals of the floorboards carry our eyes briskly from outside the canvas to the points at which the groups of dancers congregate. The imagery is placed at eye level so that we feel we are part of the scene. This feeling is enhanced by the fact that our "seats" at the rehearsal are less than adequate; a spiral staircase to the left blocks our view of the ballerinas. In characteristic camera fashion, the borders of the canvas slice off the forms and figures in a seemingly arbitrary manner. Although it appears as if Degas has failed to frame his subject correctly or has accidentally cut off the more important parts of the scene, he carefully planned the placement of his imagery. These techniques are what render his asymmetrical

▶ **21.15** Edgar Degas, *The Rehearsal (Adagio)*, 1877. Oil on canvas, 23" × 33" (58.4 × 83.8 cm). Burrell Collection, Glasgow, United Kingdom. The borders of the canvas slice through figures as if this were an imperfectly centered photograph.

◀ **21.16** Edgar Degas, *The Tub*, 1886. Pastel on card, 23⅝" × 32⅝" (60 × 83 cm). Musée d'Orsay, Paris, France. The simplicity of Degas's drawing gives an impression of action glimpsed momentarily, as if in passing by. As in *The Rehearsal*, Degas chooses to visualize the scene from an unusual angle. Here we view from above the crouching woman and still life of toilet articles on a shelf.

compositions so dynamic and, in the spirit of Impressionism, so immediate.

Degas won the reputation of being a misogynist because many of his representations of female nudes lack the idealizing qualities of Renoir's and other painters' works. In a series of pastels, he shows women caught unawares in simple, natural poses. *The Tub* (Fig. 21.16), with its unusual angle of vision, shows why these were sometimes called "keyhole visions." Far from posing, his subjects seem to be spied on while they are engrossed in the most intimate and natural activities.

A painting such as *The Boating Party* (Fig. 21.17), with its flat planes, broad areas of color, and bold lines and shapes, illustrates Cassatt's interest and skill in merging French Impressionism with elements of Japanese art. Like many of her contemporaries in Paris, she became aware of Japanese prints and art objects after trade was established between Japan and Europe in the mid-19th century. In their solidly constructed compositions and collapsed space, Cassatt's lithographs in particular stand out from the more ethereal images of other Impressionists.

JAMES ABBOTT MCNEILL WHISTLER In the same year that Monet painted his *Impression, Sunrise* and launched the movement of Impressionism, the U.S. artist James Abbott McNeill Whistler (1834–1903) painted one of the best-known compositions in the history of art. Who among us has not seen

American Expatriate Artists

Until the 20th century, art in the United States remained fairly provincial. Striving artists of the 18th and 19th centuries would go abroad for extended pilgrimages to study the Old Masters and mingle with the avant-garde. In some cases, they emigrated to Europe permanently. These artists, among them Mary Cassatt and James Abbott McNeill Whistler, are called the American Expatriates.

MARY CASSATT Mary Cassatt (1844–1926) was born in Pittsburgh but spent most of her life in France, where she was part of the inner circle of Impressionists. Cassatt's early career was influenced by Manet and Degas, photography, and Japanese art. She was a figure painter whose subjects centered on women and children.

▲ **21.17** Mary Cassatt, *The Boating Party*, 1893–1894. Oil on canvas, 14" × 18¼" (35.5 × 46.1 cm). National Gallery of Art, Washington, DC. Cassatt's friend Edgar Degas said, "I will not admit that a woman can draw so well."

▶ **21.18** James Abbott McNeill Whistler, *Arrangement in Grey and Black No. 1* (also called *Portrait of the Artist's Mother*), 1871. Oil on canvas, 56¾" × 64" (144.3 × 162.5 cm). Musée d'Orsay, Paris, France. This is the painting that has become known as "Whistler's Mother."

▼ **21.19** Thomas Eakins, *The Gross Clinic*, 1875. Oil on canvas, 96" × 78" (243.8 × 198.1 cm). Philadelphia Museum of Art, Philadelphia, Pennsylvania. With this painting, Eakins intended to make an international impression in 1876, at the Centennial Exhibition, which was scheduled to coincide with the "birthday" of the nation in 1776. However, the jury rejected the work as being too gruesome for placement in an art gallery. It wound up at the Jefferson Medical College in 1878 but was purchased by the Pennsylvania Academy of the Fine Arts and the Philadelphia Museum of Art in 2007, with the help of more than 3600 donors, and is now displayed at the museum.

"Whistler's Mother," whether on posters, on billboards, or in television commercials? *Arrangement in Grey and Black No. 1* (also called *Portrait of the Artist's Mother*) (**Fig. 21.18**) exhibits a combination of candid realism and abstraction that indicates two strong influences on Whistler's art: Courbet (see Chapter 20) and Japanese prints. Whistler's mother is silhouetted against a quiet backdrop in the right portion of the composition. The strong contours of her black dress are balanced by an Asian drape and a simple rectangular picture on the left. The subject is rendered with a harsh realism reminiscent of northern Renaissance portrait painting. However, the composition is seen first as a logical and pleasing arrangement of shapes in tones of black, gray, and white that work together in pure harmony.

American Artists in America

While Whistler and Cassatt were working in Europe, several U.S. artists of note remained at home working in the Realist tradition. This realism can be detected in figure painting and landscape painting, both of which were tinted with Romanticism.

THOMAS EAKINS The most important U.S. portrait painter of the 19th century was Thomas Eakins (1844–1916). Although his early artistic training took place in the United States, his study in Paris with painters who depicted historical events provided the major influence on his work. The penetrating realism of a work such as *The Gross Clinic* (**Fig. 21.19**) stems from Eakins's

endeavors to become fully acquainted with human anatomy by working from live models and dissecting corpses. Eakins's dedication to these practices met with disapproval from his colleagues and ultimately forced his resignation from a teaching post at the Pennsylvania Academy of the Fine Arts.

The Gross Clinic—no pun intended—depicts the surgeon Dr. Samuel Gross operating on a young boy at the Jefferson Medical College in Philadelphia. Eakins thrusts the brutal imagery to the foreground of the painting, spotlighting the surgical procedure and Dr. Gross's bloody scalpel, while casting the observing medical students in the background into darkness. The painting was deemed so shockingly realistic that it was rejected by the jury for an exhibition. Part of the impact of the work lies in the contrast between the matter-of-fact discourse of the surgeon and the torment of the boy's mother. She sits in the lower left corner of the painting, shielding her eyes with whitened knuckles. In brush technique, Eakins is close to the fluidity of Courbet, although his compositional arrangement and dramatic lighting are surely indebted to Rembrandt.

Eakins devoted his career to increasingly realistic portraits. Their haunting veracity often disappointed sitters who would have preferred more flattering renditions. The artist's passion for realism led him to use photography extensively as a point of departure for his paintings as well as an art form in itself. Eakins's style and ideas influenced U.S. artists of the early 20th century who also worked in a Realist vein.

Postimpressionism

The Impressionists were united in their rejection of many of the styles and subjects of the art that preceded them. These included Academic painting, the emotionalism of Romanticism, and even the depressing subject matter of some of the Realist artists. During the latter years of the 19th century, a group of artists who came to be called **Postimpressionists** were also united in their rebellion against that which came before them—in their case, Impressionism. The Postimpressionists were drawn together by their rebellion against what they considered an excessive concern for fleeting impressions and a disregard for traditional compositional elements.

Although they were united in their rejection of Impressionism, their individual styles differed considerably. Postimpressionists fell into two groups that in some ways paralleled the stylistic polarities of the Baroque period as well as the Neoclassical–Romantic period. On the one hand, the work of Georges Seurat and Paul Cézanne had at its core a more systematic approach to compositional structure, brushwork, and color. On the other hand, the lavishly brushed canvases of Vincent van Gogh and Paul Gauguin coordinated line and color with symbolism and emotion.

HENRI DE TOULOUSE-LAUTREC Henri de Toulouse-Lautrec (1864–1901), along with van Gogh, is one of the best-known 19th-century European artists—both for his art and for the troubled aspects of his personal life. Born into a noble French family, Toulouse-Lautrec broke his legs during adolescence, and they failed to develop correctly. This deformity resulted in alienation from his family. He turned to painting and took refuge in the demimonde of Paris, at one point taking up residence in a brothel. In this world of social outcasts, Toulouse-Lautrec, the dwarflike scion of a noble family, apparently felt at home.

He used his talents to portray life as it was in this cavalcade of cabarets, theaters, cafés, and bordellos—somewhat seamy, but also vibrant and entertaining, and populated by "real" people. He made numerous posters to advertise cabaret acts, and numerous paintings of his world of night and artificial light. In *At the Moulin Rouge* (**Fig. 21.20**), we find something of the Japanese-inspired oblique perspective in his poster work. The extension of the picture to include the balustrade on the bottom and the heavily powdered entertainer on the right is reminiscent of those "poorly cropped snapshots" of Degas, who had influenced Toulouse-Lautrec.

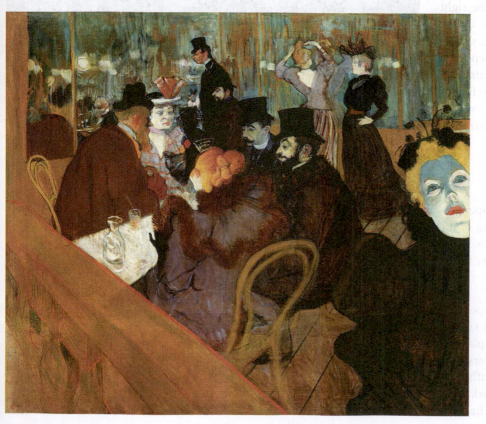

◄ **21.20** Henri de Toulouse-Lautrec, *At the Moulin Rouge*, 1892. Oil on canvas, 48½" × 55½" (123 × 141 cm). Art Institute of Chicago, Chicago, Illinois. Toulouse-Lautrec painted the nightlife—and the seamier side of life—in Belle Époque Paris.

The fabric of the entertainer's dress is constructed of fluid Impressionistic brushstrokes, as are the contents of the bottles, the lamps in the background, and the amorphous overall backdrop—lost suddenly in the unlit recesses of the Moulin Rouge. But the strong outlining, as in the entertainer's face, marks the work of a Postimpressionist.

The artist's palette is limited and muted, except for a few accents, as found in the hair of the woman in the center of the composition and the bright mouth of the entertainer. The entertainer's face is harshly sculpted by artificial light from beneath, rendering the shadows a grotesque but not ugly green. The green and red mouth clash, of course, as green and red are complementary colors, giving further intensity to the entertainer's masklike visage. But despite her powdered harshness, the entertainer remains human—certainly as human as her audience. Toulouse-Lautrec was accepting of all his creatures, just as he hoped that they would be accepting of him. The artist is portrayed within this work as well, his bearded profile facing left, toward the upper part of the composition, just left of center—a part of things, but not at the heart of things, certainly out of the glare of the spotlight. There, so to speak, the artist remained for many of his brief 37 years.

GEORGES SEURAT At first glance, the paintings by Georges Seurat (1859–1891)—such as *A Sunday Afternoon on the Island of La Grande Jatte* (**Fig. 21.21**)—have the feeling of Impressionism "tidied up." The small brushstrokes are there, as are the juxtapositions of complementary colors. The subject matter is entirely acceptable within the framework of Impressionism. However, the spontaneity of direct painting found in Impressionism is relinquished in favor of a more tightly controlled, "scientific" approach to painting.

Seurat's technique has also been called **pointillism**, after his application of pigment in small dabs, or points, of pure color. Upon close inspection, the painting appears to be a collection of dots of vibrant hues—complementary colors abutting one another, primary colors placed side by side. These hues intensify or blend to form yet another color in the eye of the viewer who beholds the canvas from a distance.

Seurat's meticulous color application was derived from the color theories and studies of color contrasts by the scientists Hermann von Helmholtz and Michel-Eugène Chevreul. He used these theories to restore a more intellectual approach to painting that countered nearly two decades of works focusing wholly on optical effects.

▼ **21.21** Georges Seurat, *A Sunday Afternoon on the Island of La Grande Jatte*, 1884–1886. Oil on canvas, 81¾" × 121¼" (207.5 × 308.1 cm). Art Institute of Chicago, Chicago, Illinois. Seurat constructed his forms from dots of color. When you move in for a closer look, every form dissolves.

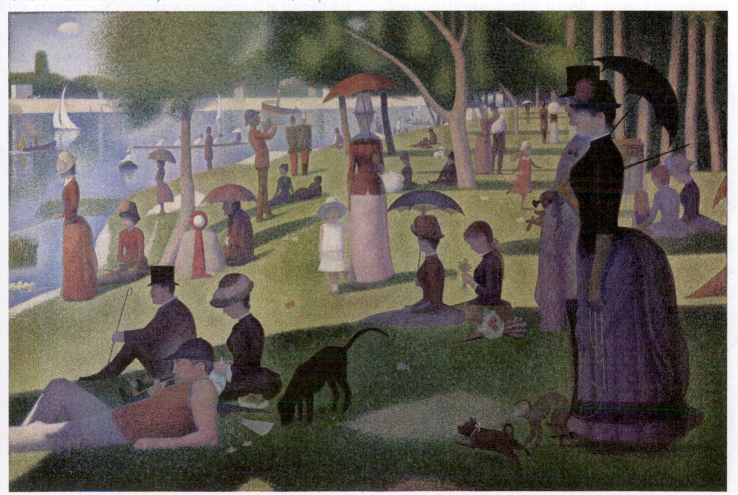

PAUL CÉZANNE

The same subject seen from a different angle gives a subject for study of the highest interest and so varied that I think I could be occupied for months without changing my place, simply bending a little more to the right or left.
—PAUL CÉZANNE

From the time of Manet, there was a movement away from a realistic representation of subjects toward one that was abstracted. Early methods of abstraction assumed different forms. Manet used a flatly painted form, Monet a disintegrating light, and Seurat a tightly painted and highly patterned composition. Paul Cézanne (1839–1906), a Postimpressionist who shared with Seurat an intellectual approach to painting, is credited with having led the revolution of abstraction in modern art from those first steps.

Cézanne's method for accomplishing this radical departure from tradition did not disregard the Old Masters. Although he allied himself originally with the Impressionists and accepted their palette and subject matter, he drew from Old Masters in the Louvre and desired somehow to reconcile their lessons with the thrust of Modernism, saying, "I want to make of Impressionism something solid and lasting like the art in the museums." Cézanne's innovations include a structural use of color and brushwork that appeals to the intellect, and a solidity of composition enhanced by a fluid application of pigment that delights the senses.

Cézanne's most significant stride toward Modernism, however, was a drastic collapsing of space, seen in works such as *Still Life with Basket of Apples* (**Fig. 21.22**). All of the imagery is forced to the picture plane. The tabletop is tilted toward us, and we simultaneously view the basket, plate, and wine bottle from front and top angles. Cézanne did not paint the still-life arrangement from one vantage point either. He moved around his subject, painting not only the objects but also the relationships among them. He focused on solids as well as on the void spaces between two objects. If you run your finger along the tabletop in the painting, you will see that it is not possible to trace a continuous line. This discontinuity follows from Cézanne's movement around his subject. Despite this spatial inconsistency, the overall feeling of the composition is one of completeness.

Cézanne's painting technique is also innovative. The sensuously rumpled fabric and lusciously round fruits are constructed of small patches of pigment crowded within dark outlines. The apples look as if they would roll off the table, were it not for the supportive folds of the tablecloth.

The miracle of Cézanne's paintings is that for all their concern with ideal order, they are still vibrantly alive. *Mont Sainte-Victoire* (**Fig. 21.23**) is one of several versions Cézanne painted of the same scene, visible from his studio window. Perhaps the contrast between the peaceful countryside and the grandeur of the mountain beyond partially explains the scene's appeal to him. He produced the transition from foreground to background and up to the sky by the wonderful manipulation of planes of pure color. It illustrates his claim that he tried to give the style of Impressionism a more solid appearance by giving his shapes a more continuous surface, an effect produced by broad brushstrokes. Yet the painting equally conveys the vivid colors of a Mediterranean landscape, with particular details refined away to leave behind the pure essence of all its beauty.

Cézanne can be seen as advancing the flatness of planar recession begun by David more than a century earlier. Cézanne asserted the flatness of the two-dimensional canvas by eliminating the distinction between foreground and background, and at times merging the two. This was perhaps his most significant contribution to future modern movements.

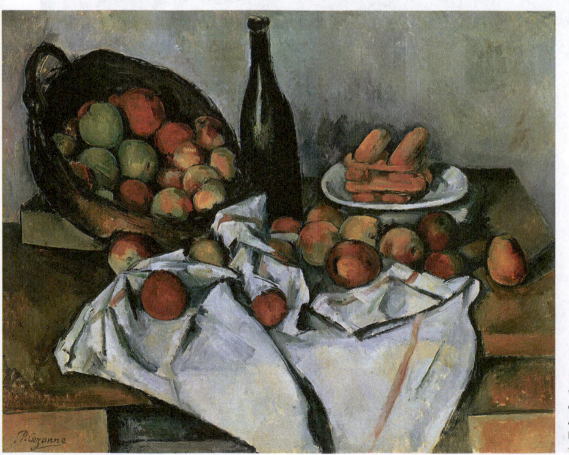

◄ **21.22** Paul Cézanne, *Still Life with Basket of Apples*, ca. 1893. Oil on canvas, 25½" × 31½" (65 × 80 cm). **Art Institute of Chicago, Chicago, Illinois.** A careful look will reveal that the tabletop does not align from left to right.

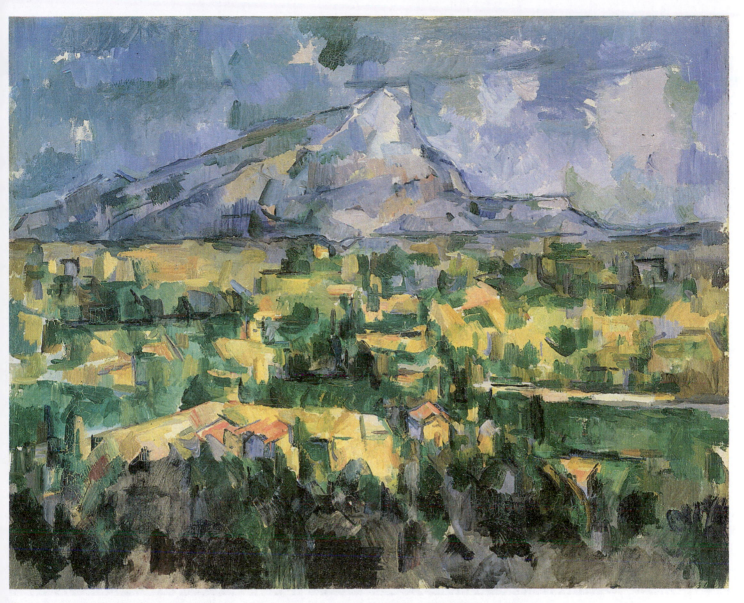

▲ **21.23** Paul Cézanne, *Mont Sainte-Victoire*, 1904–1906. Oil on canvas, 28¾" × 36¼" (73.0 × 91.9 cm). **Philadelphia Museum of Art, Philadelphia, Pennsylvania.** The reduction of the elements in the landscape to flat planes and the avoidance of the effect of perspective give the painting a sense of concentrated intensity.

VINCENT VAN GOGH

I paint as a means to make life bearable.... Really, we can only speak through our paintings.

—Vincent van Gogh, in a letter to
his brother Theo

One of the most tragic and best-known figures in the history of art is the Dutch Postimpressionist Vincent van Gogh (1853–1890). We associate him with bizarre and painful acts, such as the mutilation of his ear and his suicide. With these events, as well as his tortured, eccentric painting, he typifies the impression of the mad, artistic talent. Van Gogh also epitomizes the cliché of the artist who achieves recognition only after death: just one of his paintings was sold during his lifetime.

"Vincent," as he signed his paintings, decided to become an artist only 10 years before his death. His most beloved canvases were created during his last 29 months. He began his career painting in the dark manner of the Dutch Baroque, only to adopt the Impressionist palette and brushstroke after he settled in Paris with his brother Theo. Feeling that he was a constant burden on his brother, he left Paris for Arles, where he began to paint his most significant Postimpressionist works. Both his life and his compositions from this period were tortured, as he suffered from what may have been bouts of epilepsy and mental illness. He was eventually hospitalized in an asylum at Saint-Rémy, where he painted the famous *Starry Night* (**Fig. 21.24**).

In *Starry Night*, an ordinary painted record of a sleepy valley town is transformed into a cosmic display of swirling

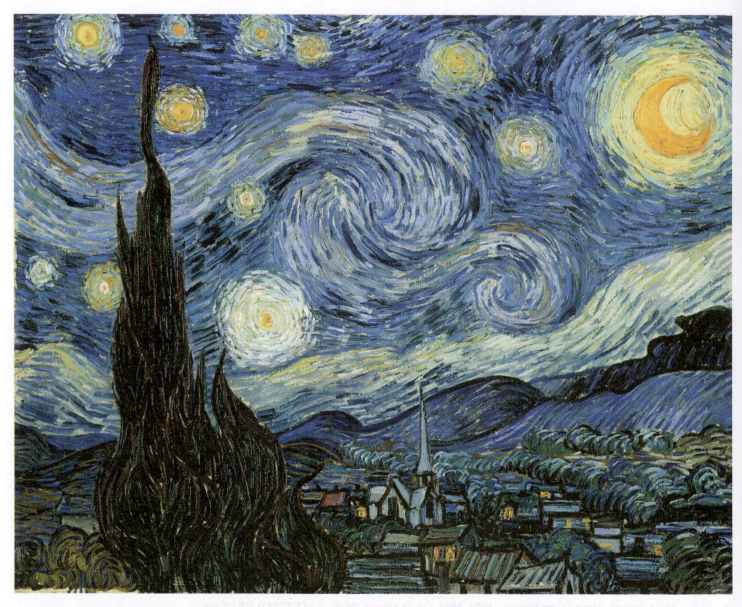

▲ **21.24** Vincent van Gogh, *Starry Night*, 1889. Oil on canvas, 29" × 36¼" (73.7 × 92.1 cm). **Museum of Modern Art, New York, New York.** Van Gogh rendered his *Starry Night* with a thick application of paint.

fireballs that assault the blackened sky and command the hills and cypresses to undulate to their sweeping rhythms. Van Gogh's palette is laden with vibrant yellows, blues, and greens. His brushstroke is at once restrained and dynamic. His characteristic long, thin strokes define the forms but also create the emotionalism in the work. He presents his subject not as we see it but as he would like us to experience it. His is a feverish application of paint, an ecstatic kind of drawing, reflecting at the same time his joys, hopes, anxieties, and despair.

The momentum of swirling, flickering forms in *Starry Night* is intoxicating, but much of van Gogh's vision of the world was profoundly pessimistic. *The Night Café* (**Fig. 21.25**) was described by the artist as "one of the ugliest I have done," but the ugliness was deliberate. Van Gogh's subject was "the terrible passions of humanity," expressed by the harsh contrasts between red, green, and yellow, which were intended to convey

the idea that "the café is a place where one can ruin oneself, go mad, or commit a crime."

PAUL GAUGUIN Paul Gauguin (1848–1903) shared with van Gogh the desire to express his emotions on canvas. But whereas the Dutchman's brushstroke was the primary means to that end, Gauguin relied on broad areas of intense color to transpose his innermost feelings to canvas.

Gauguin, a stockbroker by profession, began his artistic career as a weekend painter. At age 35, he devoted himself full-time to his art, leaving his wife and five children to do so. Gauguin identified early with the Impressionists, adopting their techniques and participating in their exhibitions. But Gauguin was a restless soul. Soon he decided to leave France for Panama and Martinique, which he viewed as primitive places where he could purge civilization from his art and life. The years until his

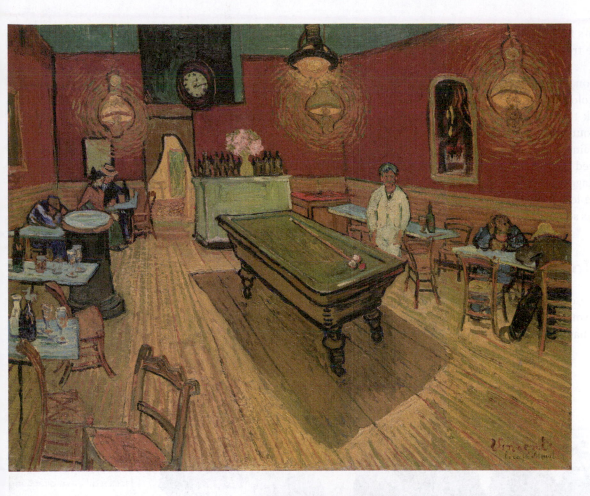

◄ **21.25** **Vincent van Gogh**, *The Night Café*, 1888. Oil on canvas, 28½" × 36¼" (72.39 × 92 cm). **Yale University Art Gallery, New Haven, Connecticut.** Compare the lack of perspective in Cézanne's *Mont Sainte-Victoire* (Fig. 21.23) to the highly exaggerated perspective used by van Gogh here to achieve a sense of violent intensity.

death were spent in France and the South Seas, where he finally died of syphilis five years after a failed attempt to take his own life.

Gauguin developed a theory of art called **Synthetism**, in which he advocated the use of broad areas of unnaturalistic color and "primitive" or symbolic subject matter. His *Vision After the Sermon (Jacob Wrestling with the Angel)* (**Fig. 21.26**), one of the first canvases to illustrate his theory, combines reality with symbolism. After hearing a sermon on the subject, a group of Breton women believed they had a vision of Jacob, ancestor of the Israelites, wrestling with an angel. In a daring composition that cancels pictorial depth by thrusting all elements to the front of the canvas, Gauguin presents all details of the event, actual and symbolic. An animal in the upper left portion of the canvas walks near a tree that interrupts a bright vermilion field with a slashing diagonal. The Bible tells that Jacob wrestled with an angel on the banks of the Jabbok River in Jordan. Caught, then, in a moment of religious fervor, the Breton women may

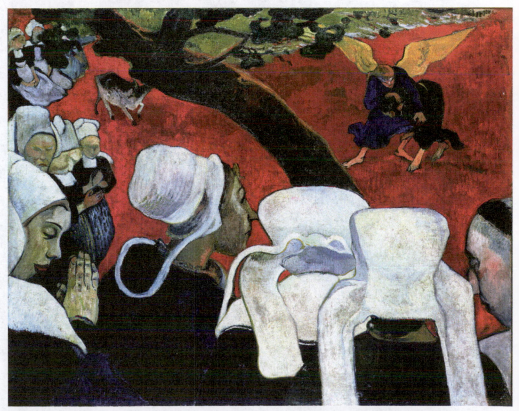

▲ **21.26** **Paul Gauguin**, *Vision After the Sermon (Jacob Wrestling with the Angel)*, 1888. Oil on canvas, 29⅜" × 36¼" (74.4 × 93.1 cm). **National Gallery of Scotland, Edinburgh, United Kingdom.** Gauguin painted broad areas of the canvas with unnatural color.

have imagined the animal's four legs to have been those of the wrestling couple, and the tree trunk might have been visually analogous to the river.

Gauguin's contribution to the development of modern art lay largely in his use of color. Writing on the subject, he said, "How does that tree look to you? Green? All right, then use green, the greenest on your palette. And that shadow, a little bluish? Don't be afraid. Paint it as blue as you can." He intensified the colors he observed in nature to the point where they became unnatural. He exaggerated his lines and patterns until they became abstract. He learned these lessons from the surroundings of which he was so fond. They were his legacy to art.

The Birth of Modern Sculpture

Some of the most notable characteristics of modern painting include a newfound realism of subject and technique; a more fluid, or impressionistic, handling of the medium; and a new treatment of space. Nineteenth-century sculpture, for the most part, continued stylistic traditions that artists saw as complementing the inherent permanence of the medium in which they worked. It would seem that working on a large scale with materials such as marble or bronze was not well suited to the spontaneous technique that captured fleeting impressions. One 19th-century artist, however, changed the course of the history of sculpture by applying to his work the very principles on which modern painting was based, including Realism, Symbolism, and Impressionism—Auguste Rodin.

AUGUSTE RODIN Auguste Rodin (1840–1917) devoted his life almost solely to the representation of the human figure. His figures were imbued with a realism so startlingly intense that he was accused of casting the sculptures from live models. (It is interesting to note that casting of live models is used today without criticism.)

Rodin's *The Burghers of Calais* (**Fig. 21.27**) represents a radical break with the past and a search for new forms of expression in three dimensions. The work commemorates a historical

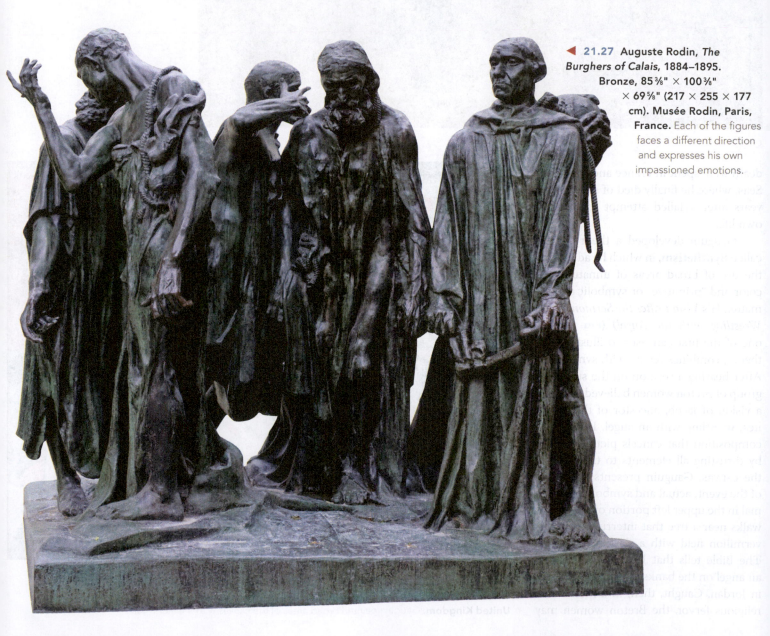

◀ **21.27 Auguste Rodin,** *The Burghers of Calais,* **1884–1895. Bronze, 85⅜" × 100⅜" × 69⅝" (217 × 255 × 177 cm). Musée Rodin, Paris, France.** Each of the figures faces a different direction and expresses his own impassioned emotions.

▶ **21.28** **Auguste Rodin, *The Kiss*, 1886. Marble, 74⅞"
(190 cm) high. Musée Rodin, Paris, France.** The sculpture is
based on the story of Paolo and Francesca, who were portrayed
in the second circle of Dante's *Inferno*.

event in which six prominent citizens of Calais offered
their lives to the conquering English so that their fellow
townspeople might be spared. They present themselves
in coarse robes with nooses around their necks. Their
psychological states range from quiet defiance to frantic
desperation. The reality of the scene is achieved in part
by the odd placement of the figures. They are not a sym-
metrical or cohesive group. Rather, they are a scattered
collection of individuals, who were meant to be seen at
street level. Capturing them as he did, at a particular
moment in time, Rodin ensured that spectators would
partake of the tragic emotion of the scene.

The original name of Rodin's marble sculpture
The Kiss (**Fig. 21.28**) was *Francesca da Rimini*, after
the 13th-century noblewoman depicted in the second
circle of hell in canto 5 of Dante's *Inferno*. She is half of
the tempest-tossed couple who fell in love after read-
ing of Lancelot and Guinevere. She married her lover—
her husband's younger brother, Paolo—by proxy, but
technically speaking, the couple committed adultery.
Rodin shows the man holding the book of Lancelot and
Guinevere. The lips of the lovers do not actually touch,
possibly suggesting that they were interrupted.

Rodin generally preferred modeling soft materials
to carving because it enabled him to achieve highly tex-
tured surfaces that captured the play of light, much as
in an Impressionist painting. As his career progressed,
Rodin's sculptures took on an abstract quality. Distinct
features were abandoned in favor of solids and voids
that, together with light, constructed the image of a
human being. Such works were outrageous in their own
day—audacious and quite new. Their abstracted fea-
tures set the stage for yet newer and more audacious art
forms that would rise with the dawn of the 20th century.

Fauvism

In some respects, **Fauvism** was a logical successor to the paint-
ing of van Gogh and Gauguin. Like these Postimpressionists, the
Fauvists also rejected the subdued palette and delicate brush-
work of Impressionism. They chose their color and brushwork
on the basis of their emotive qualities. Despite the aggressive-
ness of their method, however, their subject matter centered on
traditional nudes, still lifes, and landscapes.

What set the Fauves apart from their 19th-century prede-
cessors was their use of harsh, nondescriptive color, bold linear
patterning, and a distorted form of perspective. They saw color
as autonomous, a subject in and of itself, not merely an adjunct
to nature. Their vigorous brushwork and emphatic lines grew

out of their desire for a direct form of expression unencum-
bered by theory. Their skewed perspectives and distorted forms
were also inspired by the discovery of ethnographic works of art
from African, Polynesian, and other ancient cultures.

HENRI MATISSE

*My choice of colors does not rest on any scientific
theory; it is based on observation, on feeling, on the
very nature of each experience.*

—HENRI MATISSE

Henri Matisse (1869–1954) started law school at age 21, but
when an illness interrupted his studies, he began to paint. Soon

▲ **21.29** Henri Matisse, *Harmony in Red (The Red Room)*, 1908. Oil on canvas, 71" × 87" (180.5 × 221 cm). Hermitage, St. Petersburg, Russia. Photo: Archives H. Matisse. © 2016 Succession H. Matisse/Artists Rights Society (ARS), New York. Matisse, like other Fauvists, used color expressively and sensually.

thereafter, he decided to devote himself totally to art. Matisse's early paintings reveal a strong and traditional compositional structure, which he gleaned from his first mentor, Bouguereau, and from copying Old Masters in the Louvre. His loose brushwork is reminiscent of Impressionism, and his palette is inspired by the color theories of the Postimpressionists. In 1905, he consolidated these influences and painted several Fauvist canvases in which he used primary color as a structural element. These canvases were exhibited with those of other Fauvists at the Salon d'Automne of that year.

In his post-Fauvist works, Matisse used color in a variety of other ways: structurally, decoratively, sensually, and expressively. In his *Harmony in Red (The Red Room)* (**Fig. 21.29**), all of these qualities of color are present. A vibrant palette and

curvilinear shapes create the gay mood of the canvas. The lush red of the wallpaper and tablecloth absorb the viewer in their brilliance. The arabesques of the vines create an enticing surface pattern.

A curious contest between flatness and three dimensions in *Harmony in Red* characterizes much of Matisse's work. He crowds the table and wall with the same patterns. They seem to run together without distinction. This jumbling of patterns propels the background to the picture plane, asserting the flatness of the canvas. The two-dimensionality of the canvas is further underscored by the window in the upper left, which is rendered so flatly that it suggests a painting of a garden scene instead of an actual view of a distant landscape. Yet, for all of these attempts to collapse space, Matisse counteracts the effect

with a variety of perspective cues: the seat of the ladder-back chair recedes into space, as does the table; and the dishes are somewhat foreshortened, combining frontal and bird's-eye views.

Matisse used line expressively, moving it rhythmically across the canvas to complement the pulsing color. Although the structure of *Harmony in Red* remains assertive, Matisse's foremost concern was to create a pleasing pattern. Matisse insisted that painting ought to be joyous. His choice of palette, his lyrical use of line, and his brightly painted shapes are all means toward that end. He even said of his work that it ought to be devoid of depressing subject matter, that his art ought to be "a mental soother, something like a good armchair in which to rest."[1]

Although the colors and forms of Fauvism burst explosively on the modern art scene, the movement did not last very long. For one thing, the styles of the Fauvist artists were very different from one another, so the members never formed a cohesive group. After about five years, the Fauvist qualities began to disappear from their works as they pursued other styles. Their disappearance was, in part, prompted by a retrospective exhibition of Cézanne's paintings held in 1907, which revitalized an interest in this 19th-century artist's work. His principles of composition and constructive brush technique were at odds with the Fauvist manifesto.

While Fauvism was descending from its brief, colorful flourish in France, related art movements, termed *Expressionistic*, were ascending elsewhere.

Expressionism

Expressionism is a style of art that departs from optical realism (the mimicking of the outward appearances of things) with the intent of communicating the inner emotions, anxieties, obsessions, rage, and outrage of the artist. Expressionism may serve as a vehicle for personal emotional catharsis, enabling an artist to express and "work through" inner conflict, but it may also serve as an instrument of social change by creating empathy toward a subject or condition in the viewer. Stylistic characteristics of expressionist works of art include figural distortion, vigorous or aggressive brushwork, and unnatural, exaggerated color.

Expressionism in the first decade of the 20th century was influenced by earlier artists whose work exhibited these same characteristics—in particular, Vincent van Gogh and Paul Gauguin, Edvard Munch, and the French Fauves.

EDVARD MUNCH Munch (1863–1944), a Norwegian, had studied in Paris; his early work was Impressionistic, but during the 1890s he abandoned a light palette and lively subject matter in favor of a more somber style that reflected an anguished preoccupation with fear and death.

The Scream (**Fig. 21.30**) is one of Munch's best-known works, a portrayal of the pain and isolation that became his central themes. A figure in black walks across a bridge toward the viewer, cupping his ears as if to buffer the sound of his own screaming. Two figures in the background stroll in the opposite direction, seemingly unaware of or uninterested in the sounds of desperation piercing the atmosphere. Munch transformed what might have been a placid scene into one that reverberates in waves the high-pitched tones that emanate from the skeletal head. We are reminded of the swirling forms of van Gogh's *Starry Night*, but the intensity and horror pervading Munch's composition speak of his view of humanity as being consumed by an increasingly dehumanized society.

▼ **21.30** Edvard Munch, *The Scream*, 1893. Oil, tempera, and pastel on cardboard, 35¾" × 28⅞" (91 × 73.5 cm). National Gallery, Oslo, Norway. A skeletal figure crosses a bridge in anguish.

1. Quoted in Robert Goldwater and Marco Treves, eds., *Artists on Art* (New York: Pantheon Books, 1972), p. 413.

◀ 21.31 Ernst Ludwig Kirchner, *Street, Dresden*, 1908 (reworked 1919; dated on painting 1907). Oil on canvas, 59¼" × 78⅞" (150.5 × 200.4 cm). Museum of Modern Art, New York, New York. Many German Expressionist works feature themes of isolation and alienation. Agitated brushwork and unnatural color schemes suggest turbulence and uncertainty.

ERNST LUDWIG KIRCHNER This mood of isolation and anxiety is also seen in Ernst Ludwig Kirchner's *Street, Dresden* (**Fig. 21.31**). Kirchner was one of the founding members of a group of German expressionists who called themselves **Die Brücke**, or The Bridge. Founded in 1905 in Dresden at the same time that Fauvism was afoot in France, the concept of The Bridge was intended to symbolize the artists' desire to connect "all the revolutionary and fermenting elements" that rejected academic and other "fashionable" (socially or culturally acceptable) art forms. The inhabitants of Kirchner's crowded street do not interact but rather seem lost in their own thoughts as they rush to and fro. In spite of their common circumstances, they are each alone in carrying the weight of their emotional lives. Kirchner portrays, with these masked "automatons," an acute sense of alienation gripping society at the start of the new century.

VASSILY KANDINSKY Emotionally charged subject matter, often radically distorted, was the essence of Die Brücke art. Another German expressionist group, **Der Blaue Reiter** (The Blue Rider), depended less heavily on content to communicate feelings and evoke an emotional response from the viewer. Their work focused more on the contrasts and combinations of abstract forms and pure colors toward at times made no reference to visible reality. Such works can be described as nonobjective, or abstract.

Kandinsky (1866–1944) was a Russian artist who left a career in law to become an influential abstract painter and art theorist. During numerous visits to Paris early in his career, Kandinsky was immersed in the works of Gauguin and the Fauves and was inspired to adopt the Fauvist idiom. The French experience opened his eyes to color's powerful capacity to communicate the artist's inmost psychological and spiritual concerns. In his seminal essay "Concerning the Spiritual in Art," he examined this capability and discussed the psychological effects of color on the viewer. Kandinsky further analyzed the relationship between art and music in this study.

Early experiments with these theories can be seen in works such as *Improvisation 28* (**Fig. 21.32**), in which bold colors, lines, and shapes tear dramatically across the canvas in no preconceived fashion. The pictorial elements flow freely and independently throughout the painting, reflecting, Kandinsky believed, the free flow of unconscious thought. *Improvisation 28* and other works of this series underscore the importance of Kandinsky's early Fauvist contacts in their vibrant palette, broad brushstrokes, and dynamic movement, and they also stand as harbingers of a new art unencumbered by referential subject matter.

For Kandinsky, color, line, and shape were subjects in themselves. They were often rendered with a spontaneity born of the psychological process of free association. At this time, free association was also being explored by the founder of psychoanalysis, Sigmund Freud, as a method of mapping the geography of the unconscious mind.

◀ **21.32** Vasilly Kandinsky, *Improvisation 28 (second version)*, 1912. Oil on canvas, 3' 3⅞" × 5' 3⅞". Solomon R. Guggenheim Museum (gift of Solomon R. Guggenheim, 1937). The painting is nonobjective—freed from the shackles of representation.

KÄTHE KOLLWITZ Whereas many artists in Germany used Expressionist techniques to represent their own inner forces and preoccupations, isolation, loneliness, or themes of violence, expressionist Käthe Kollwitz (1867–1945) sought universal symbols for inhumanity, injustice, and humankind's self-destruction.

The Outbreak (Fig. 21.33) is one of a series of seven prints by Kollwitz representing the 16th-century Peasants' War. In this print, Black Anna, a woman who led the laborers in their struggle against their oppressors, incites an angry throng of peasants to action. Her back is toward us, her head down, as she raises her gnarled hands in inspiration. The peasants rush forward in a torrent, bodies and weapons lunging at Anna's command. Although the work records a specific historical incident, it stands as an inspiration to all those who strive for freedom against the odds. There are few more forceful images in the history of art.

Kollwitz, along with most German artists who embraced some form of modernism in their work, fell victim in the 1930s to Nazi policies that aimed to put an end to their form of artistic expression. Her work was confiscated and hung in a propagandistic exhibition of so-called "degenerate art." Many of her compositions were destroyed. Kirchner's work also suffered the same fate. After being labeled a degenerate artist, he committed suicide in 1938.

Cubism

The history of art is colored by the tensions of stylistic polarities within given eras, particularly the polarity of an intellectual versus an emotional approach to painting. Fauvism and German Expressionism found their roots in Romanticism and the emotional, expressionistic work of Gauguin and van Gogh. The second major art movement of the 20th century, **Cubism**, can trace its heritage to Neo-Classicism and the analytical and intellectual work of Cézanne.

Cubism is an offspring of Cézanne's geometrization of nature, his abandonment of scientific perspective, his rendering of multiple views, and his emphasis on the two-dimensional canvas surface. Picasso, the driving force behind the birth of

▼ **21.33** Käthe Kollwitz, *The Outbreak*, 1903. Plate no. 5 from *The Peasants' War*. Etching, dry point, aquatint, and softground, 20¼" × 23⅛" (51.3 × 58.7 cm). Library of Congress, Prints and Photographs Division, Washington, DC. Few works in the history of art are as impassioned.

Cubism and perhaps the most significant artist of the 20th century, combined the pictorial methods of Cézanne with formal elements from African, Oceanic, and Iberian sculpture.

PABLO PICASSO Pablo Ruiz y Picasso (1881–1973) was born in Spain, the son of an art teacher. As an adolescent, he enrolled in the Barcelona Academy of Art, where he quickly mastered the illusionistic techniques of the realistic Academic style. By age 19, Picasso was off to Paris, where he remained for more than 40 years—introducing, influencing, or reflecting the many styles of modern French art.

Picasso's first major artistic phase has been called his Blue Period. Spanning the years 1901 to 1904, this work is characterized by an overall blue tonality, a distortion of the human body through elongation reminiscent of El Greco and Toulouse-Lautrec, and melancholy subjects consisting of poor and downtrodden individuals engaged in menial tasks or isolated in their loneliness. *The Old Guitarist* (**Fig. 21.34**) is but

▲ **21.35** Pablo Picasso, *Gertrude Stein*, 1905–1906. Oil on canvas, 39⅜" × 32" (100 × 81.3 cm). Metropolitan Museum of Art, New York, New York. The face of the sitter is more like an African mask than an accurate portrait. Her attire is reduced to abstract forms.

▲ **21.34** Pablo Picasso, *The Old Guitarist*, 1903. Oil on canvas, 48⅜" × 32½" (122.9 × 82.6 cm). Art Institute of Chicago, Chicago, Illinois. The guitarist is a haunting image from the artist's Blue Period.

one of these haunting images. A contorted, white-haired man sits hunched over a guitar, consumed by the tones that emanate from what appears to be his only possession. The eyes are sunken in the skeletal head, and the bones and tendons of his hungry frame protrude. We are struck by the ordinariness of poverty, from the unfurnished room and barren window view (or is he on the curb outside?) to the uneventfulness of his activity and the insignificance of his plight. The essentially monochromatic blue palette creates an unrelenting, somber mood. Tones of blue eerily echo the ghostlike features of the guitarist.

Between his Blue Period and his innovation of Cubism with Georges Braque, Picasso painted a portrait of Gertrude Stein (**Fig. 21.35**). Stein was an expatriate American living in Paris, along with her brother Leo. She was an important writer and supporter of the new movements in the arts, helping nurture artists such as Matisse, Braque, and Picasso. In the portrait, Stein wears her preferred brown coat and skirt, which cloak her massive body. As described in *The Autobiography of Alice B. Toklas* (1933), the painting of the portrait was also a massive undertaking.

READING 21.1 GERTRUDE STEIN[2]

From *The Autobiography of Alice B. Toklas*

Picasso had never had anybody pose for him since he was sixteen years old, he was then twenty-four and Gertrude Stein had never thought of having her portrait painted, and they do not either of them know how it came about. Anyway it did and she posed for this portrait ninety times.

. . .

There was a large broken armchair where Gertrude Stein posed. There was a couch where everybody sat and slept. There was a little kitchen chair upon which Picasso sat to paint, there was a large easel and there were many canvases.

. . .

She took her pose, Picasso sat very tight in his chair and very close to his canvas and on a very small palette which was of a uniform brown grey colour, mixed some more brown grey and the painting began.

. . .

All of a sudden one day Picasso painted out the whole head. I can't see you any longer when I look, he said irritably. And so the picture was left like that.

The painting was begun in 1905 and not completed until 1906. Picasso reduced Stein's body to simple masses and made the face, which he had drawn earlier and discarded, masklike. At about that time, Picasso also became aware of the formal properties of ethnographic art from Africa, Oceania, and Iberia, which he viewed at the Musée de l'Homme in Paris. In 1907, he would paint women whose features were still more masklike and who would literally change the face of modern art.

During Picasso's Rose Period, which followed the Blue Period, works became lighter both in palette and in spirit. Subjects were drawn primarily from circus life and rendered in tones of pink. During this second period, which dates from 1905 to 1908, Picasso was inspired by two very different sources—the ethnographic works that had influenced his portrait of Stein and the Cézanne retrospective exhibition held at the Salon d'Automne in 1907. These two art forms, which at first glance might appear dissimilar, had in common a fragmentation, distortion, and abstraction of form that were adopted by Picasso in works such as *Les Demoiselles d'Avignon* (see **Fig. 21.36** on p. 752).

This startling, innovative work, still primarily pink in tone, depicts five women from Barcelona's red-light district. (Avignon was the name of a street in that city.) They line up for selection by a possible suitor who stands, as it were, in the position of the viewer of the painting. The faces of three of the women are primitive masks. The facial features of the other two have been radically simplified by combining frontal and profile views. The

thick-lidded eyes stare stage front, calling to mind some of the Mesopotamian votive sculptures we saw in Chapter 1.

The bodies of the women are fractured into geometric forms and set before a background of similarly splintered drapery. In treating the background and the foreground imagery in the same manner, Picasso collapses the space between the planes and asserts the two-dimensionality of the canvas surface in the manner of Cézanne. In some radical passages, such as the right leg of the leftmost figure, the limb takes on the qualities of drapery, masking the distinction between figure and ground. The extreme faceting of form, the use of multiple views, and the collapsing of space in *Les Demoiselles* together provided the springboard for **Analytic Cubism**, cofounded with the French painter Georges Braque in about 1910.

ANALYTIC CUBISM The term *Cubism*, like so many others, was coined by a hostile critic. In this case, the critic was responding to the predominance of geometrical forms in the works of Picasso and Braque. *Cubism* is a limited term in that it does not adequately describe the appearance of Cubist paintings, and it minimizes the intensity with which Cubist artists analyzed their subject matter. It ignores their most significant contribution—a new treatment of pictorial space that hinged upon the rendering of objects from multiple and radically different views.

The Cubist treatment of space differed significantly from that in use since the Renaissance. Instead of presenting an object from a single view, assumed to have been the complete view, the Cubists—as did Cézanne—realized that our visual comprehension of objects consists of many views that we perceive almost at once. They tried to render this visual "information gathering" in their compositions. In their dissection and reconstruction of imagery, they reassessed the notion that painting should reproduce the appearance of reality. Now the very reality of appearances was being questioned. To Cubists, the most basic reality involved consolidating optical vignettes instead of reproducing fixed images with photographic accuracy.

The theory of Analytic Cubism reached the peak of its expression in works such as Picasso's *Aficionado* (or *The Bullfight*) (**Fig. 21.37**). Numerous planes intersect and congregate at the center of the canvas to form a barely perceptible triangular human figure, which is alternately constructed from and dissolved into the background. There are only a few concrete signs of its substance: a mustache, perfectly formed lips, the triangular points of a starched collar, and, beneath, a U-shaped shirtfront, the circular opening of a stringed instrument. The multifaceted, abstracted form appears to shift position before our eyes, simulating the time lapse that would occur in the visual assimilation of multiple views. The structural lines—sometimes called the *Cubist grid*—that define and fragment the figure are thick and dark. They contrast with the delicately modeled short, choppy brushstrokes of the remainder of the composition. The monochromatic palette, chosen so as not to interfere with the exploration of form, consists of browns, tans, and ochres.

2. Stein is said to have penned a new genre of literature—writing another person's autobiography.

▲ **21.36** Pablo Picasso, *Les Demoiselles d'Avignon*, 1907. Oil on canvas, 96" × 92" (243.9 × 233.7 cm). **Museum of Modern Art, New York, New York.** Women from the demimonde of Avignon stand before a viewer, waiting for selection.

CONNECTIONS At the same time that socio-political changes prior to the First World War created an atmosphere of uncertainty, the French mathematician and theoretical physicist Jules Henri Poincaré (1854–1912) set the basis for chaos theory in his discovery of chaotic behavior in a complex system. His mathematical concept was this: small, seemingly insignificant events can create random results and affect the long-term behavior of a system.

Poincaré published his widely read book, *Science and Hypothesis*, in 1902. Among those who were influenced by the text were Albert Einstein (1879–1955) and Pablo Picasso (1881–1973). Einstein had met Poincaré in 1911 and, although Picasso never did, he was familiar with Poincaré's advice on how to view the fourth dimension from conversations about *Science and Hypothesis* among the avant-guard circle of intellectuals of which he was a part. Einstein's *Special Theory of Relativity* and Picasso's Cubist works took Poincaré's concepts further, although the debt they owe to the French mathematician is clear.

Einstein's first publication on relativity appeared in 1905, just two years before Picasso painted *Les Demoiselles d'Avignon* (see Fig. 21.36), but his General Theory of Relativity, what has been called "the highest achievement of humanity," came in 1915. Einstein concluded that the passage of time is variable, that time has "shape," and that time is bound up with space in *spacetime* (in a single, interwoven continuum). The core of Einstein's theory, however, was the relationship between space and time and the notion that space and time are not absolute but, rather, are relative to the observer and the thing that is being observed. The underlying theory of Cubism, as suggested by Figure 21.37, can be described the same way.

Poincaré once wrote: "It is only through science and art that civilization is of value."

▲ **21.37** Pablo Picasso, *The Aficionado* (or *The Bullfight*), 1912. Oil on canvas, 134.8 × 81.5 cm. Kunstmuseum, Basel, Switzerland.

GEORGES BRAQUE During the analytic phase of Cubism, which spanned the years from 1909 to 1912, the works of Picasso and Braque were very similar. The early work of Georges Braque (1882–1963) graduated from Impressionism to Fauvism to more structural compositions based on Cézanne. He met Picasso in 1907, and from then until about 1914, the artists worked together toward the same artistic goals.

Although the paintings of Picasso and Braque were almost identical at this time, Braque was the first to begin inserting words and numbers and using **trompe l'oeil** effects in portions of his Analytic Cubist compositions. These realistic elements contrasted sharply with the abstraction of the major figures and reintroduced the nagging question, "What is reality and what is illusion in painting?"

SYNTHETIC CUBISM Picasso and Braque did not stop with the inclusion of precisely printed words and numbers in their works. In the phase of their work known as **Synthetic Cubism**, they began to add characters cut from newspapers and magazines, other pieces of paper, and found objects such as labels from wine bottles, calling cards, theater tickets—even swatches of wallpaper and bits of rope. These items were pasted directly onto the canvas in a technique Picasso and Braque called *papier collé*—what we know as **collage**.

Some Synthetic Cubist compositions, such as Braque's still life of the "Le Quotidien," called "La Pipe" (Fig. 21.38), are constructed entirely of found elements. In this work, newspaper clippings and opaque pieces of paper function as the shifting planes that hover around the aperitif label and define the bottle and glass. These planes are held together

▲ **21.38** Georges Braque, *Still life with Violin and Pipe* (formerly called "Le Quotidien"). 1913–1914. Oil on canvas, 75 × 106 cm. Musee National d'Art Moderne, Centre Georges Pompidou, Paris, France.

by a sparse linear structure much in the manner of Analytic Cubist works. In contrast to Analytic Cubism, however, the emphasis is on the form of the object and on constructing instead of disintegrating that form. Color reentered the compositions, and much emphasis was placed on texture, design, and movement.

Futurism

Some years after the advent of Cubism, a new movement sprang up in Italy under the leadership of poet Filippo Marinetti (1876–1944). **Futurism** was introduced angrily by Marinetti in a 1909 manifesto that called for an art of "violence, energy, and boldness" free from the "tyranny of…harmony and good taste."[3] In theory, Futurist painting and sculpture were to glorify contemporary life, "unceasingly and violently transformed by victorious science." In practice, many of the works owed much to Cubism.

UMBERTO BOCCIONI

Everything moves, everything runs, everything turns swiftly. The figure in front of us never is still, but ceaselessly appears and disappears. Owing to the persistence of images on the retina, objects in motion are multiplied, distorted, following one another like waves through space. Thus a galloping horse has not four legs; it has twenty.

—UMBERTO BOCCIONI

An oft-repeated word in the Futurist credo is **dynamism**, defined as the theory that force or energy is the basic principle of all phenomena. Irregular, agitated lines communicate the energy of movement. The Futurist obsession with illustrating images in perpetual motion found a perfect outlet in sculpture. In works such as *Unique Forms of Continuity in Space* (**Fig. 21.39**), Boccioni, whose forte was sculpture, sought to convey the elusive surging energy that blurs an image in motion, leaving but an echo of its passage. Although it retains an overall figural silhouette, the sculpture is devoid of any representational details. The flame-like curving surfaces of the striding figure do not exist to define movement; instead, they are a consequence of it.

GIACOMO BALLA The Futurists also suggested that their subjects were less important than the portrayal of the "dynamic sensation" of the subjects. This declaration manifests itself fully in Giacomo Balla's (1871–1958) pure Futurist painting *Street Light*

(**Fig. 21.40**). The light of the lamp pierces the darkness in reverberating circles; V-shaped brushstrokes simultaneously fan outward from the source and point toward it, creating a sense of constant movement. The palette consists of complementary colors that forbid the eye to rest. All is movement; all is sensation.

Cubist and Futurist works of art, regardless of how abstract they might appear, contain vestiges of representation, whether they be unobtrusive details like an eyelid or mustache, or an object's recognizable contours. Yet with Cubism, the seeds of abstraction were planted. It was just a matter of time until they would find fruition in artists who, like Kandinsky, would seek pure form unencumbered by referential subject matter.

◄ **21.39** Umberto Boccioni, *Unique Forms of Continuity in Space*, 1913 (cast 1931). Bronze, 43⅞" × 34⅞" × 15¾" (111.2 × 88.5 × 40 cm). Museum of Modern Art, New York, New York. Boccioni wrote, "The figure in front of us never is still, but ceaselessly appears and disappears."

3. F. T. Marinetti, "The Foundation and Manifesto of Futurism," in *Theories of Modern Art*, ed. Herschel B. Chipp (Berkeley: University of California Press, 1968), pp. 284–288.

▶ 21.40 Giacomo Balla, *Street Light*, 1909. Oil on canvas, 68¾" × 45¼" (174.7 × 114.7 cm). Museum of Modern Art, New York, New York. The artist portrays the staid street lamp with a dynamic quality.

ARCHITECTURE

Nineteenth-century industrialization introduced cast iron, one of several structural materials that would change the face of architecture. It was the first material to allow the erection of tall buildings with relatively slender walls; iron beams and bolted trusses were capable of spanning vast interior spaces, freeing them from the forests of columns and thick walls that were required to support stone structures. In the second half of the 19th century, architecture took new turns and literally reached new heights.

PAXTON'S CRYSTAL PALACE

The 1851 Great Exhibition in London's Hyde Park featured the spectacular Crystal Palace, an iron building designed by Sir Joseph Paxton that was constructed from prefabricated parts that were cast at a factory and assembled locally on a 17-acre site. New railways facilitated transportation of the parts, and it was a simple matter to bolt them together at the exhibition. It was also relatively simple to dismantle the structure and reconstruct it on another site. The iron skeleton, with its myriad arches and trusses, was an integral part of the design. The huge plate-glass paneled walls bore no weight. Paxton asserted that "nature" had been his "engineer," explaining that he merely copied the system for longitudinal and transverse supports that can be found in a leaf.

The Crystal Palace was moved to another location (and much enlarged and altered) after the exhibition and, until

CONNECTIONS The second half of the 19th century witnessed frenetic competition among European nations for the distinction of most modern, most innovative, most progressive, and most influential in the ever-globalizing world. The phenomenon of World's Fairs provided the opportunity for countries to brand themselves by displaying their accomplishments in science, technology, industry, commerce, and the arts, and by showcasing their colonial possessions to assert their positions on the world stage; "villages" were constructed and "inhabited" by natives brought in to demonstrate their ways of life, leaving visitors with what they believed was firsthand knowledge of far-flung, exotic cultures.

The fever for World's Fairs began in London with the Great Exhibition of 1851, also known as the Crystal Palace exhibition. Between the London exhibition and the Paris Exposition Universelle of 1900, there would be some 15 World's Fairs throughout Europe; the United States held its own in Philadelphia in 1876, the centennial of the Declaration of Independence. The numbers of exhibits rose from 17,000 at the Crystal Palace exhibition to 83,000 in the 1900 Paris Exposition, and the crowds burgeoned from 6 million to 51 million.

Perhaps the best-known remnant of this era of World's Fairs is the Eiffel Tower (see Fig. 21.42), constructed for the 1889 Exposition held in Paris. At 984 feet high and made of iron, it was the tallest structure in the world (until the Empire State Building in New York City took the title at 1250 feet in 1937) and effectively symbolized France's position as a leading industrial nation. That fair drew 30 million visitors and included almost 62,000 exhibitors.

destroyed by fire in 1936, served as a museum and concert hall. Winston Churchill, the Prime Minister of England during World War II, was among those who watched the blaze and was quoted as saying, "This is the end of an age."

One of the precedents for the Crystal Palace, the Palm House in London's Kew Botanic Gardens (**Fig. 21.41**) was built between 1844 and 1848 by the architect Decimus Burton. It was the first large-scale structure to be completely supported by wrought iron. Now a UNESCO World Heritage Site, the Palm House offers the opportunity to see a structure similar to Paxton's even more imposing Crystal Palace.

EIFFEL TOWER The uncontested and beloved symbol of Paris, the Eiffel Tower was constructed by Gustave Eiffel (1832–1923) for that city's 1889 world's fair. As with the Crystal Palace, the iron trusses of the 984-foot-tall tower were prefabricated and assembled on site in 17 months by only 150 workers (**Fig. 21.42**). Mainly openwork, the tower's minimal function (embedded within are some restaurants and minor structures) can be explained by its original purpose: it was built as the gateway to the international exposition. It was not intended to be a permanent fixture in Paris, but the populace responded to it so positively that it has remained in place; it is visited by close to 7 million tourists each year. Cast iron structures were the foundation of steel-cage construction and the skyscraper.

WAINWRIGHT BUILDING The Wainwright Building (see **Fig. 21.43A** on p. 758)—erected in St. Louis, Missouri, in 1890–1891—is an early example of steel-cage construction. With steel-cage construction, the weight of the building is borne by its structural core and not its walls, allowing

▲ **21.41** Decimus Burton, **Palm House, Kew Botanic Gardens, London, England, 1844–1848.**

◀ **21.42** **Gustave Eiffel, Eiffel Tower, 1889. Paris, France. Iron, 1050' (320 m) high.** To prevent rusting, the tower is repainted every seven years with 50 to 60 tons of paint.

▲ **21.43A** Louis Sullivan, Wainwright Building, 1890–1891. St. Louis, Missouri. The building may not be impressively tall by today's standards, but its steel-cage construction set the pattern for modern skyscrapers.

▲ **21.43B** Steel-cage construction.

and engineering and reflected the function of the building. The idea of organic shapes in architecture would almost seem oxymoronic given the degree to which technology and mathematics are embedded in the engineering of structures, but the work of the Catalan Spanish architect Antoni Gaudí (1852–1926) gives lie to that premise. His Casa Milà apartment house in Barcelona, Spain (**Fig. 21.44A**), subverts the geometric, steel-cage construction that forms the skeleton of the typical multistory apartment-style residence. The building façade of undulating carved stone has few straight lines or flat surfaces, the rooftop is wavelike, the wrought-iron balcony railings mimic vegetation (**Fig. 21.44B**), and the forest of chimneys resemble, in shape, the peaks of soft-serve

for an expansive use of glass—called a *curtain wall*—on the building's elevations (**Fig. 21.43B**). Architect Louis Sullivan (1856–1924), one of the fathers of modern American architecture, emphasized the verticality of the Wainwright Building by running pilasters between the windows through the upper stories. Many of today's skyscrapers run pilasters up their entire façades. Sullivan also emphasized the horizontal features of the Wainwright Building. Ornamented horizontal bands separate most of the windows, and a severe decorated cornice crowns the structure. Sullivan's motto was "form follows function," and the rigid horizontal and vertical processions of the elements of the façade suggest the regularity of the rectangular spaces within. Sullivan's early "skyscraper"—in function, in structure, and in simplified form—was a precursor of the 20th-century behemoths to follow.

CASA MILÀ The form of architecture that emerged during the Industrial Revolution showcased current technology

▲ **21.44A** Antoni Gaudí, Casa Milà Apartment House, 1905–1907. Barcelona, Spain. A visitor will be hard-pressed to find a straight line in Gaudí's building.

▲ **21.44B** Close up of the exterior of the Casa Milà, showing detail of the wrought-iron railings.

▲ **21.44C** Ceiling light in the Casa Milà, with swirling ceiling above.

ice-cream cones. Even "minor" interior details, such as ceiling lights, have a unique organic quality (**Fig. 21.44C**). The playful organic shapes infuse the building with warmth, spontaneity, and implied movement, and evoke an illusion of living and breathing stone.

The Casa Milà is one example of an international Modernism that spread throughout parts of Europe and found a unique form of expression in Barcelona. This thread of Modernism was a reaction to what was perceived as the negative impact of industrialization and featured designs and materials that harked back to nature.

MUSIC

The latter 19th and early 20th centuries saw new beloved composers of opera whose works remain as compelling as they have ever been. Impressionism had forced both artists and the public to think afresh about painting and seeing; by the early years of the 20th century, musicians and music lovers were also to have many of their preconceptions challenged. Not only were traditional forms like the symphony either discarded or handled in a radically new way, but even the basic ingredients of musical expression—melody, harmony, and rhythm—were subject

CONNECTIONS In October of 2015, architect Jordi Fauli announced that the structure of the Roman Catholic La Sagrada Familia basilica in Barcelona, Spain, was on track to be completed in the year 2026. The foundation stone of the building was laid, however, over 100 years ago, in 1882.

The construction of cathedrals during the Middle Ages went on for decades, if not centuries. In most cases, people working on them never would have expected to live long enough to see them finished. Notre Dame in Paris took about 100 years to complete, and Cologne Cathedral took over 600 years from start to finish. Construction on La Sagrada Familia has been ongoing for 133 years.

Of Antonio Gaudí's life obsession, only the façade of the basilica had been completed when the architect died in 1926 after being struck by a trolley. La Sagrada Familia is a reflection

▲ **21.45** La Sagrada Familia, Barcelona, Spain, under construction since 1882. Part A: Exterior; Part B: Interior, showing ceiling of the nave.

of Gaudí's Catalan aesthetic and his devout Catholic belief. The design elements—exterior and interior (**Figs. 21.45A** and **21.45B**)—combine to create an organic whole, a "oneness," to which all of the parts are subservient. When complete, it will have 18 towers dedicated to, among other religious figures, the Virgin Mary and the four evangelists (Matthew, Mark, Luke, and John); the tallest—the Tower of Jesus Christ—will make the basilica the tallest in Europe.

to startling new developments. Few periods in the history of music have been, if fact, more packed with change than that between 1870 and 1914, which saw a fresh approach to symphonic form, the rise of a musical version of Impressionism, and the revolutionary innovations of the two giants of modern music: Schönberg and Stravinsky.

Opera

Two of the most beloved opera composers of all time lived and composed during the era from 1870 to 1914. One was French and the other Italian.

GEORGES BIZET One of these is the French composer Georges Bizet (1838–1875), whose best-known work, *Carmen*, was completed in 1874 and apparently failed, leading Bizet to despair prior to his death in the following year. Yet *Carmen* has blossomed into one of opera's major success stories, with some fans ensuring that they see it once a year. The story is simple: A soldier in Seville, Don José, is seduced by a gypsy, Carmen, who works in a tobacco factory. She leads him into a life of crime, which for her is carefree but for him, deeply conflicted. But Carmen tires of him and takes up a relationship with a toreador. Don José cannot accept that he has been but a temporary plaything, and he kills Carmen. Morality in the opera is interesting: Carmen is a criminal, yet she is always honest with Don José; in one of her arias she sings about the fact that she may love a man today, but what of tomorrow? At the end, she refuses to disavow her feelings for the toreador although she knows Don José will kill her for it. The opera is known for its "set pieces," including what we refer to as "The Toreador Song" and Carmen's "Habanera." The opera is in French, and the aria begins *"L'amour est un oiseau rebelle que nul ne peut apprivoiser,"* which translates as "Love is a rebellious bird that nobody can tame."

GO LISTEN!
GEORGES BIZET
Carmen, Act One, "Habanera"

The habanera was a Cuban dance genre with African roots. It originated early in the 19th century, and its rhythms are also used in dances such as the *conga* and the *tango*. It became exported across the world and was highly popular in France and Spain toward the latter part of the century, when Bizet composed *Carmen*. Carmen moves seductively as she sings the aria "Habanera" which, of course, bears the name of the dance.

GIACOMO PUCCINI The Italian composer Giacomo Puccini (1858–1924) also emerged toward the turn of the century. His shimmering musical passages are part traditional Italian opera and part Impressionism, influenced by contemporaries such as Igor Stravinsky. Puccini also swept audiences on exotic journeys, for example, to Japan in *Madame Butterfly* (1904) and to the American West in *La Fanciulla del West* (1910). His most popular operas are *La Bohème* (1896), whose tragic plot revolving around impoverished artists set the stage for the rock

musical *Rent*; *Madame Butterfly*, whose impossible love affair with an American is retold in the musical *Miss Saigon*; and *Tosca* (1900), which may have no precise present-day parallels but whose story, set in Rome in 1800, rushes poignantly to its dramatic conclusion—the deaths of an opera singer, Tosca, and her lover, the artist Mario Cavaradossi, at the hands of a corrupt police chief, Scarpia. *Tosca's* most compelling arias include Scarpia's "Va, Tosca," followed immediately by the Te Deum at the end of act 1—Scarpia's declaration that he will possess the opera's heroine, Tosca, is ironically followed by his singing a religious piece, in which he declares "Everlasting Father, all the earth worships thee"; Tosca's plaintive "Vissi d'arte" in act 2 ("I lived for art, I lived for love"); and Cavaradossi's all-too-brief "E lucevan le stele" ("And shone the stars") just prior to his execution in act 3.

Light Opera

Although opera was well attended during this era, light opera was more accessible to the masses. Dialogue and soliloquies were interspersed with songs of melodies that theatergoers could hum and sing on the way home.

GILBERT AND SULLIVAN Perhaps the most successful stagers of light opera were the librettist William S. Gilbert (1836–1911) and the composer Arthur Sullivan (1842–1900), known collectively as simply Gilbert and Sullivan. Sullivan had tried his hand at "heavier" opera and other musical pieces, but they never achieved renown. The duo's light operas, on the other hand, remain attended today, with the most popular—*The Mikado*, first staged in 1885 (Fig. 21.46)—turning up in the repertoire of opera companies throughout the English-speaking world at various intervals. Their other popular works include *H.M.S. Pinafore* (that is, Her Majesty's Ship *Pinafore*, staged in 1878), with an admiral who is appointed because of his social rank but suffers from seasickness.

The mikado is the ruler of Japan, and the opera—as does Puccini's *Madame Butterfly*—suggests the European fascination of its time with all things Oriental. Maidens parade in tiny steps, fluttering their fans. Men, similarly, open and slap fans closed as punctuation marks. Their dress mimics that found in Japanese prints of the period. Having said all this, the lyrics are fundamentally a satire of British society. The officious Pooh-Bah might represent any pompous and puffed-up minor government official—one of excellent "pedigree" who is nevertheless susceptible to bribes ("insults"). Ko-Ko, the Lord High Executioner who would never be able to bring himself to execute a fly, is a neurotic mess who aspires to a position in society. He sings "I've got them on my list"—a laundry list of society's worst offenders, especially among the upper crust. Current-day American stagers of the opera are likely to insert their own laundry lists of obnoxious politicians and reality TV icons.

In the lyrics in Reading 21.2 from *H.M.S. Pinafore's* "Ruler of the Queen's Navy," the admiral, Sir Joseph, describes his rise to wealth and power. Without any self-insight, Sir Joseph

◀ **21.46 Cover of the score for** *Airs from The Mikado*, **by Gilbert and Sullivan, arranged by P. Bucalossi, 1885. Sheet music ca. 10" × 13" (25.4 × 33.0 cm). Royal Academy of Music, London, United Kingdom.** *The Mikado* suggested Europe's fascination with all things Oriental. Although the setting was exotic, the opera satirized British society.

GO LISTEN!
GILBERT & SULLIVAN

H.M.S. Pinafore
"When I Was a Lad"

actually mocks the absurdity of the British bureaucracy's delegation of power to people of established lineage, name, or nobility. Ability is all but irrelevant. In Parliament, for example, he simply voted the party line, never thinking for himself. (Might we have such politicians in the U.S. Congress today?) Since this is a rollicking comedy, the chorus repeats each verse with dancing and posturing. The queen is Queen Victoria, who reigned from 1837 to 1901—a span of time that was most or all of many Britons' lifetimes.

"When I Was a Lad" is a *patter song*. Patter songs range in tempo from moderately rapid to extremely rapid. They are found mainly in light opera and *opera buffa* (comic opera). Many patter songs accelerate in pace as they proceed, and some performers repeat the lyrics ever faster—so fast that the audience may wonder how it is possible. Patter songs often have tongue-twisting lyrics, as in Gilbert and Sullivan's *Pirates of Penzance*, which has the song "I Am the Very Model of a Modern Major General." Since "When I Was a Lad" is accompanied by a dancing chorus, the dancing accelerates with the music:

READING 21.2 W. S. GILBERT

From *H.M.S. Pinafore*, "When I Was a Lad"

When I was a lad I served a term
As office boy to an Attorney's firm.
I cleaned the windows and I swept the floor,
And I polished up the handle of the big front door.
 I polished up that handle so carefully
 That now I am the Ruler of the Queen's Navee!
 …

Of legal knowledge I acquired such a grip
That they took me into the partnership.
And that junior partnership, I ween,
Was the only ship that I ever had seen.
 But that kind of ship so suited me,
 That now I am the Ruler of the Queen's Navee!

I grew so rich that I was sent
By a pocket borough into Parliament.
I always voted at my party's call,
And I never thought of thinking for myself at all.
 I thought so little, they rewarded me
 By making me the Ruler of the Queen's Navee!
 Now landsmen all, whoever you may be,

If you want to rise to the top of the tree,
If your soul isn't fettered to an office stool,
Be careful to be guided by this golden rule—
 Stick close to your desks and never go to sea,
 And you all may be rulers of the Queen's Navee!

Orchestral Music

Although many extended orchestral works written in the last years of the 19th century and the early years of the 20th century were called symphonies by their composers, they would hardly have been recognizable as such to Haydn or Beethoven. The custom of varying the traditional number and content of symphonic movements had already begun during the Romantic period; Berlioz wrote his *Symphonie fantastique* as early as 1830 (see Chapter 20). Nonetheless, by the turn of the century, so-called symphonies were being written that had little in common with one another, much less the Classical symphonic tradition.

The driving force behind many of these works was the urge to communicate something beyond purely musical values. From the time of the ancient Greeks, many composers attempted to write instrumental music that told a story or described some event, including Vivaldi in his "Four Seasons" and Beethoven in his curious work known as the "Battle" Symphony. By the mid-19th century, however, composers had begun to devise elaborate *programs* (plots), which their music would then describe. Music of this kind is generally known as **program music**; its first great exponent was Franz Liszt (see Chapter 20), who wrote works with titles such as *Hamlet*,

Orpheus, and *The Battle of the Huns*, for which he invented the generic description *symphonic poem*.

The principle behind program music is no better or worse than many another. The success of any individual piece depends naturally on the degree to which narrative and musical interest can be combined. There are, to be sure, some cases in which a composer has been carried away by eagerness for realism. Ottorino Respighi (1879–1936), for example, incorporated the sound of a nightingale by including a record player and a recording of live birdsong in *Pines of Rome* (1924).

RICHARD STRAUSS No one was more successful at writing convincing program symphonies and symphonic poems— **tone poems**, as he called them—than the German composer Richard Strauss (1864–1949). One of his first successful tone poems, *Don Juan* (begun in 1886), deals with the familiar story of the compulsive Spanish lover from a characteristically late-19th-century point of view. Instead of the unrepentant Don Giovanni of Mozart or Byron's amused (and amusing) Don Juan, Strauss presents a man striving to overcome the bonds of human nature, only to be driven by failure and despair to suicide. The music, gorgeously orchestrated for a vast array of instruments, moves in bursts of passion, from the surging splendor of its opening to a bleak and shuddering conclusion.

Strauss was not limited to grand and tragic subjects. *Till Eulenspiegel's Merry Pranks* tells the story of a notorious practical joker and swindler and is one of the most successful examples of humor in music. Even when Till goes too far in his pranks and ends up on the gallows (vividly depicted by Strauss's orchestration), the music returns to a cheerful conclusion.

One of Strauss's most remarkable works, and one that clearly demonstrates the new attitude toward symphonic form, is *An Alpine Symphony*, written between 1911 and 1915. In one huge movement lasting some 50 minutes, it describes a mountain-climbing expedition, detailing the adventures on the way (with waterfalls, cowbells, and glaciers all in the music) and, at its climax, the arrival on the summit. The final section depicts the descent, during which a violent storm breaks out, and the music finally sinks to rest in the peace with which it opened. All this may sound more like a movie sound track than a serious piece of music, but skeptical listeners should try *An Alpine Symphony* for themselves.

Not surprisingly, a composer capable of such exuberant imagination was also fully at home in the opera house. Several of Strauss's operas are among the greatest of all 20th-century contributions to the repertoire. In some, he was clearly influenced by the prevailingly gloomy and morbid mood of German Expressionist art. His first big success, for example, was a setting of the Irish writer Oscar Wilde's play *Salome*, based on a biblical story, which was first performed to a horrified audience in 1905. After one performance (in 1907) at the Metropolitan Opera House in New York, it was banned in the United States for almost 30 years. The final scene provides a frightening yet curiously moving depiction of erotic depravity, as Salome kisses the lips of the severed head of John the Baptist.

Works such as *Don Juan* and *An Alpine Symphony* deal with stories we know or describe events with which we are familiar. In other cases, Strauss took as his subject his own life, and a few of his pieces—including the *Domestic Symphony* and the somewhat immodestly titled *Ein Heldenleben* (A Hero's Life)—are frankly autobiographical. In this he was following a custom that had become increasingly popular in the late 19th century—the composition of music concerned with the detailed revelation of its composer's inner emotional life.

PIOTR ILYCH TCHAIKOVSKY The late-Romantic composer Piotr Ilych Tchaikovsky (1840–1893) is best known for composing the ballets *Swan Lake* in 1875–1876 (**Fig. 21.47**) and *The Nutcracker* in 1892. *The Nutcracker* is surely the most beloved and familiar of Tchaikovsky's ballets. Performances around the world are a perpetual part of the Christmas tradition, and the melodies accompanying the ballet numbers ring familiar to many an ear. *The Nutcracker Suite*, Op. 71a is a group of eight numbers chosen by Tchaikovsky for an orchestral performance before the ballet's premier in 1892. Among the eight are the well-known "Waltz of the Flowers" and a series of numbers for the "Danses Caracterisques," in which the composer appropriated what he deemed to be the "characteristic" musical styles of diverse cultures. The "Arabian Dance" is based on a lullaby from Georgia that, in Tchaikovsky's time, was under control of the Russian tsar.

GO LISTEN!
TCHAIKOVSKY

"Waltz of the Flowers"
"Arabian Dance"

Tchaikovsky was one of the first musicians to make his personal emotions the basis for a symphony. His Symphony No. 6 in B Minor, Op. 74, known as the "Pathétique," was written in the year of his death. An early draft outline of its "story" was found among his papers, describing its "impulsive passion, confidence, eagerness for activity," followed by love and disappointments, and finally collapse and death. It is now believed that the Russian composer did not die of cholera, as formerly thought, but by suicide. The reasons are still not clear, but they perhaps related to a potentially scandalous love affair. In the light of this information, the "Pathétique" takes on new poignancy. Its last movement sinks mournfully into silence after a series of climaxes that seem to protest bitterly, if vainly, against the injustices of life.

GUSTAV MAHLER The revelation of a composer's life and emotions through his music reached its most complete expression in the works of Gustav Mahler (1860–1911). Until around 1960, the centenary of his birth in Bohemia, Mahler's music was almost unknown, and those who did know it generally derided him as unoriginal and overambitious. Now that he has become one of the most frequently performed and recorded of composers, we can begin to appreciate his true worth and learn the danger of hasty judgments.

The world of Mahler's symphonies is filled with his own anxieties, triumphs, hopes, and fears, but it also illuminates our own problem-ridden age. It may well be that Mahler speaks so convincingly and so movingly to a growing number of

▼ **21.47** Yelizaveta Chaprasova, Svetlana Ivanova, Yelena Chmil, and Valeria Martynyuk as the Little Swans in a scene from the ballet *Swan Lake* by Piotr Tchaikovsky, choreographed by Marius Petipa and Lev Ivanov and adapted by Konstantin Sergeyev. St. Petersburg, Russia.

ordinary music lovers because his music touches on areas of human experience that were unexplored before his time and are increasingly significant to ours. In purely musical terms, however, Mahler can now be seen as a profoundly original genius. Like Rodin, Mahler stands as both the last major figure of the 19th century in his field and a pioneer in the modern world. Mahler's innovations won him the scorn of earlier listeners: his deliberate use of popular, banal tunes, for example, and the abrupt changes of mood in his music were derided. A symphony, he once said, should be like the world: it should contain everything. His own 9 completed symphonies (he left a 10th unfinished) and *Das Lied von der Erde* (The Song of the Earth), a symphony for two singers and orchestra, certainly contain just about every human emotion.

As early as the Symphony No. 1 in D, we can hear the highly individual characteristics of Mahler's music. The third movement of the symphony is a funeral march, but its wry, ironic tone is totally unlike any other in the history of music. The movement opens with the mournful sound of a solo double bass playing the old round "Frère Jacques," which is then taken up by the rest of the orchestra. There are sudden bursts of trite nostalgia and violent aggression until the mood gradually changes to one of genuine tenderness. After a gentle middle section, the movement returns to the bizarre and unsettling spirit of the opening.

By the end of his life, Mahler was writing far less optimistic music than his Symphony No. 1, which—despite its third-movement funeral march—concludes with a long finale ending in a blaze of triumphant glory. Mahler's last completed works—*The Song of the Earth* and Symphony No. 9—composed under the shadow of fatal heart disease and impending death, express all of the beauty of the world together with the sorrow and ultimate resignation of one who has to leave it. The final movement of the Symphony No. 9, in particular, is a uniquely eloquent statement of courage in the face of human dissolution. Opening with a long, slow theme of great passion and nobility, the movement gradually fades away as the music dissolves into fragments and finally sinks into silence. Like all of Mahler's music, and like the paintings of van Gogh or Munch, the Symphony No. 9 does not turn its back on the ugliness and tragedy of life; but Mahler, unlike many of his contemporaries, was able to see beyond these realities and express something of the painful joy of human existence. Perhaps this is why his music has become so revered today.

CLAUDE DEBUSSY At about the same time painters in France were developing the style we call Impressionist, the young French composer Claude Debussy (1862–1918) began to break new musical ground. Abandoning the concept of the development of themes in a systematic musical argument, which lies behind Classical sonata form and Romantic symphonic structure, he aimed for a constantly changing flow of sound. Instead of dealing with human emotions, Debussy's music evoked the atmosphere of nature: the wind and the rain and the sea. The emphasis on shifting tone colors led inevitably to comparisons to Impressionist painting. Like Monet or Renoir, he avoided grand, dramatic subjects in favor of ephemeral, intangible sensations and replaced Romantic opulence with refinement.

These comparisons should nevertheless not be exaggerated. Debussy and the Impressionists shared a strong reaction against tradition in general and the Romantic tradition in particular, in response to which they created a radically new approach to their respective arts; but Impressionism permanently changed the history of painting, while the only really successful Impressionist composer was Debussy. Later musicians borrowed some of Debussy's musical devices, including his highly fluid harmony and frequent dissonances, but Debussy never really founded a school. The chief developments in 20th-century music after Debussy took a different direction, and they were summed up rather unsympathetically by the French poet Jean Cocteau (1889–1963): "After music with the silk brush, music with the axe." These developments represent a more determined break with tradition than the refined style of Debussy. With the passing of time, Debussy's musical style appears increasingly to represent the last gasp of Romanticism rather than the dawn of a new era.

Whatever his historical position, Debussy was without doubt one of the great creative musical figures of his time. He is at his best and most Impressionist in orchestral works like *La Mer* (The Sea), composed in 1903–1905, which Debussy called symphonic sketches. This marine counterpart of Strauss's *An Alpine Symphony* is in three movements, the titles of which ("From Dawn to Noon on the Sea," "Play of the Waves," and "Dialogue of the Wind and the Sea") describe the general atmosphere that concerned Debussy rather than literal sounds. There are no birdcalls or thunderclaps in the music; instead, the continual ebb and flow of the music suggest the mood of a seascape. The second movement, for example, depicts the sparkling sunlight on the waves by means of delicate, flashing violin scales punctuated by bright flecks of sound color from the wind instruments. It is scarcely possible to resist a comparison with the shimmering colors of Monet's *Nymphéas*, (see Fig. 21.12).

Elsewhere, Debussy's music is less explicitly descriptive. His piano music, among his finest compositions, shows an incredible sensitivity to the range of sound effects that instrument can achieve. Many of his pieces have descriptive titles—"Footsteps in the Snow," "The Girl with the Flaxen Hair," and so on—but these were often added after their composition as the obligatory touch of musical Impressionism. Sometimes they were even suggested by Debussy's friends as their own personal reactions to his music. His "Claire de Lune" (Moonlight) is a case in point. The tranquil calm of the music might well convey to some listeners the beauty of a moonlit night, but equally, the piece can be enjoyed as a musical experience in its own right.

GO LISTEN!
CLAUDE DEBUSSY
"Claire de Lune"
(Moonlight)

"Claire de Lune" is one of Debussy's earliest piano works, written in 1890, at a time when he was closer to Impressionist art than he was to become as his style developed. Thus, the

peaceful descending scale that begins the piece might very well be intended to depict a calm, glowing night. Throughout the piece, interest is centered on the right hand and the higher, "celestial" notes of the piano. The music intensifies, although remaining within the limits of its placid opening.

Debussy's interest in French keyboard music of the Rococo period may be responsible for the slightly "antique" air of the piece. Like most of his music, it creates its own form, following neither Classical nor Romantic principles of organization and remaining the expression of a mood rather than a personal outpouring of feeling. Whether that mood is related to a peaceful scene under moonlight or is more generalized is up to the individual listener to decide. It is interesting to speculate on what our reactions to the piece would be if we did not know its title.

JOSEPH-MAURICE RAVEL The only composer to make wholehearted use of Debussy's Impressionistic style was his fellow countryman Joseph-Maurice Ravel (1875–1937), who, however, added a highly individual quality of his own. Ravel was far more concerned with Classical form and balance than Debussy. His musical god was Mozart, and something of the limpidity of Mozart's music can be heard in many of his pieces, although certainly not in the all-too-familiar *Boléro*. His lovely Piano Concerto in G alternates a Mozartian delicacy and grace with an exuberance born of Ravel's encounters with jazz. Even in his most overtly Impressionistic moments, like the scene in his ballet *Daphnis and Chloé* that describes dawn rising, he retains an elegance and verve that differ distinctly from the veiled and muted tones of Debussy.

The Search for a New Musical Language

In 1908, the Austrian composer Arnold Schönberg (1874–1951) wrote his Three Piano Pieces, Op. 11, in which he was "conscious of having broken all restrictions" of past musical traditions. After the first performance, one critic described the pieces as "pointless ugliness" and "perversion." In 1913, the first performance of *The Rite of Spring*, a ballet by the Russian-born composer Igor Fyodorovich Stravinsky (1882–1971), was given in Paris, where he was then living. It was greeted with hissing, stamping, and yelling, and Stravinsky was accused of the "destruction of music as an art." Stravinsky and Schönberg are today justly hailed as the founders of modern music, but we can agree with their opponents in at least one respect: their revolutionary innovations permanently changed the course of musical development.

It is a measure of their achievement that today listeners find *The Rite of Spring* exciting, even explosive, but perfectly approachable. If Stravinsky's ballet score has lost its power to shock and horrify, it is principally because we have become accustomed to music written in its shadow. *The Rite of Spring*

has created its own musical tradition, one without which present-day music at all levels of popularity would be unthinkable. Schönberg's effect has been less widespread, and subtler; nonetheless, no serious composer writing since his time has been able to ignore his music. It is significant that Stravinsky, who originally seemed to be taking music down a radically different "path to destruction," eventually adopted principles of composition based on Schönberg's methods.

As is true of all apparently revolutionary breaks with the past, Stravinsky and Schönberg were really only pushing to extreme conclusions developments that had been under way for some time. Traditional harmony had been collapsing since the time of Wagner, and Schönberg only dealt it a deathblow by his innovations. Wagner's *Tristan and Isolde* had opened with a series of chords that were not firmly rooted in any key and had no particular sense of direction (see Chapter 20), a device Wagner used to express the poetic concept of restless yearning. Other composers followed him in rejecting the concept of a fixed harmonic center from which the music might stray so long as it returned there, replacing it with a much more fluid use of harmony. (Debussy, in his attempts to go beyond the bounds of conventional harmony, often combined chords and constructed themes to avoid the sense of a tonal center; the result can be heard in the wandering, unsettled quality of much of his music.)

ARNOLD SCHÖNBERG Arnold Schönberg believed that the time had come to abandon a harmonic (or tonal) system that had served music well for more than 300 years but had simply become worn out. He therefore began to write **atonal** music, which deliberately avoided traditional chords and harmonies. Thus, Schönberg's atonality was a natural consequence of earlier musical developments. At the same time, it was fully in accordance with the spirit of the times. The sense of a growing rejection of traditional values, culminating in a decisive and violent break with the past, can be felt not only in the arts but also in the political and social life of Europe; Schönberg's drastic abandonment of centuries of musical tradition prefigured by only a few years the far more drastic abandonment of centuries of tradition brought about by World War I.

There is another sense in which Schönberg's innovations correspond to contemporary developments. One of the principal effects of atonality is a mood of instability—even disturbance—that lends itself to the same kind of morbid themes that attracted Expressionist painters. In fact, many of Schönberg's early atonal works deal with such themes. (Schönberg was also a painter of some ability and generally worked in an Expressionist style.)

One of Schönberg's most extraordinary pieces is *Pierrot Lunaire* (finished in 1912), a setting of 21 poems for a woman's voice and small instrumental group. The poems describe the bizarre experiences of their hero, Pierrot, who is an Expressionist version of the eternal clown, and their mood is grotesque and at times demonic. The 8th poem, for example, describes a crowd of gigantic black moths flying down to block out the sunlight, while in the 11th, titled "Red Mass," Pierrot holds his

GO LISTEN!
ARNOLD SCHÖNBERG

"Mondestrunken" from *Pierrot Lunaire*

own heart in his bloodstained fingers to use as a "horrible red sacrificial wafer." Schönberg's music clothes these verses in appropriately fantastic and macabre music. The effect is enhanced by the fact that the singer is instructed to speak the words at specific pitches. This device of **Sprechstimme** ("speaking voice") is mainly associated with Schönberg in *Pierrot Lunaire*. Sprechstimme is a hybrid of speaking and singing in which the pitch of speech is raised or lowered according to musical notation. Sprechstimme is difficult to execute, but when it is done properly by a skilled performer, it imparts a wistfully dreamlike quality to the music. In the mid-20th century, Sprechstimme was used in English by Sam Levene, the original Nathan Detroit in *Guys and Dolls*, and by Rex Harrison, who played Henry Higgins in *My Fair Lady*. Neither Levene nor Harrison could be accused of having had a singing voice, but their more-than-adequate Sprechstimme brought something unique to their songs.

In this first number of Schönberg's *Pierrot Lunaire*, "Mondestrunken" (literally "Moondrunk"), the poet, his eyes drunk with wine and moonlight, seeks inspiration in the beauty of the night. The piece begins with brief piano scales before the voice enters, accompanied by the flute and later, the violin and cello. Indeed, the flute dominates the setting, soaring and trilling, as if to express the ecstasy of the moment. The piece reaches a brief climax, with the flute in its highest register, and then fades away.

This first number sets the tone for the whole cycle. Schönberg uses a group of eight solo instruments to accompany his "reciter," varying the combination from piece to piece. The moon as a topic returns in several of the later pieces, most notably number seven, "The Sick Moon."

Of all the selections discussed so far, none is likely to seem more perplexing to first-time listeners or further from most people's musical experience. It may help to know that in an earlier work, his String Quartet No. 2, Schönberg included a setting of a poem by the German Symbolist poet Stefan George, which included the line "I feel the breath of another planet." Schönberg was indeed seeking to break with the long history of musical development and open up new worlds.

The freedom atonality permitted the composer became something of a liability, and by the 1920s, Schönberg replaced it with a system of composition as rigid as any earlier method in the history of music. His famous **twelve-tone technique** uses the 12 notes of the chromatic scale (on the piano, all of the black and white notes in a single octave) carefully arranged in a row or series, the latter term having given rise to the name *serialism* to describe the technique. The basic row, together with variant forms, then serves as the basis for a movement or even an entire work, with the order of the notes remaining always the same.

Just as with program music, the only fair way to judge the twelve-tone technique is by its results. Not all works written using it are masterpieces, but we can hardly expect them to be. It is not a system that appeals to all composers or brings out the best in them, but few systems ever have universal application. Some of Schönberg's own twelve-tone works, including his unfinished opera *Moses and Aaron* and the Violin Concerto of 1934, demonstrate that serial music can be both beautiful and moving. The 21st century will decide whether the system has permanent and enduring value.

IGOR STRAVINSKY Like *Pierrot Lunaire*, Igor Stravinsky's *The Rite of Spring* deals with a violent theme. It is subtitled "Pictures from Pagan Russia" and describes a springtime ritual culminating in the sacrifice of a chosen human victim. Whereas Schönberg jettisoned traditional harmony, Stravinsky used a new approach to rhythm as the basis of his piece. Constantly changing, immensely complex, and frequently violent, his rhythmic patterns convey a sense of barbaric frenzy that is enhanced by the weight of sound obtained from the use of a vast orchestra. There are some peaceful moments, notably the nostalgic opening section, but in general the impression is of intense exhilaration.

GO LISTEN!
IGOR STRAVINSKY

"Dance of the Adolescents" from *The Rite of Spring*

The Rite of Spring opens quietly, with no hint of the violence to come. The first outbreak occurs in this dance, with the strings hammering out a repeated dissonant chord, while wind instruments can be heard in the background, playing fragments of themes. Stravinsky creates a sense of excitement by repeating the same rhythm obsessively, while violently stressing some of the notes. When the heavy brass instruments enter, they bring an ominous tone, but soon we return to the hammering string chords. The mood grows quieter for a while, but as Stravinsky increases the tension, the dance moves to a frenzied climax, with rhythm and melodic fragments reaching a fever pitch before plunging into the next dance.

It is difficult to imagine a more complete break with the Romantic movement. Subject and style, the violence of contrasts, the sheer brute power of the music, all took Stravinsky's contemporaries by storm, and many accounts have survived of the scandalous scenes of protest that broke out at the ballet's first performance. In a way, *The Rite of Spring* marks both a beginning and an end: Stravinsky never returned to the work's style. Yet, as an illustration of the collapse of traditional values on the eve of World War I (the ballet was first performed in 1913), Stravinsky's musical revolution, like Picasso's in the visual arts, was indeed prophetic of the troubled 20th century.

The Rite of Spring was the last of three ballets (the others were *The Firebird* and *Petrouchka*) that Stravinsky based on Russian folk subjects. In the years following World War I, he wrote music in a wide variety of styles, absorbing influences as varied as Bach, Tchaikovsky, and jazz. Yet a characteristically Stravinskian flavor pervades all of his best works, with the result that his music is almost always instantly recognizable. Short, expressive melodies and unceasing rhythmic vitality, both evident in *The Rite of Spring*, recur in works like the Symphony in Three Movements from 1945. Even when, in the 1950s, he finally adopted the technique of serialism, he retained his own unique

musical personality. Stravinsky is a peculiarly 20th-century cultural phenomenon, an artist uprooted from his homeland, cut off (by choice) from his cultural heritage, and exposed to a barrage of influences and counterinfluences. That he never lost his sense of personal identity or his belief in the enduring value of art made him a 20th-century hero.

LITERATURE

At the end of the 19th century, many writers were still as concerned with exploring the nature of their own individual existences as they had been when the century began. In fact, the first years of the 20th century saw an increasing interest in the effect of the subconscious on human behavior, a result largely of the work of the Austrian psychoanalyst Sigmund Freud (1856–1939), whose work is discussed in Chapter 22. In many ways, his interest in the part played by individual frustrations, repressions, and neuroses (particularly sexual) in creating personality was prefigured in the writing of two of the greatest novelists of the late 19th century: Fyodor Dostoyevsky (1821–1881) and Marcel Proust (1871–1922).

FYODOR DOSTOYEVSKY Self-knowledge played a major part in Dostoyevsky's work, and his concern for psychological truth led him into a profound study of his characters' subconscious motives. His empathy for human suffering derived in part from his identification with Russian Orthodox Christianity, with its emphasis on suffering as a means to salvation. Although well aware of social injustices, he was more concerned with their effect on the individual soul than on society as a whole. His books present a vivid picture of the Russia of his day, with characters at all levels of society brought brilliantly to life. Nevertheless, he was able to combine realism of perception with a deep psychological understanding of the workings of the human heart. Few artists have presented so convincing a picture of individuals struggling between good and evil.

The temptation to evil forms a principal theme of one of his most powerful works, *Crime and Punishment* (1866). In it, Dostoyevsky tells the story of a poor student, Raskolnikov, whose growing feeling of alienation from his fellow human beings leads to a belief that he is superior to society and above conventional morality. To prove this to himself, Raskolnikov decides to commit an act of defiance: the murder of a defenseless old woman, not for gain but as a demonstration of his own power.

He murders the old woman and also her younger sister, who catches him in the act. Crime is followed immediately, however, by punishment, not of the law but of his own conscience. Guilt and remorse cut him off even further from human contact until finally, in utter despair and on the verge of madness, he goes to the police and confesses to the murders. Here and in his other works, Dostoyevsky underlines the terrible dangers of intellectual arrogance. The world he portrays is essentially cruel, one in which simplicity and self-awareness are the only weapons against human evil, and suffering is a necessary price for victory.

MARCEL PROUST One of the most influential of all modern writers was the French novelist Marcel Proust. Proust's youth was spent in the fashionable world of Parisian high society, where he entertained lavishly and mixed with the leading figures of the day while writing elegant, if superficial, poems and stories. The death of his father in 1903 and of his mother in 1905 brought about a complete change. He retired to his house in Paris and rarely left his soundproofed bedroom, where he wrote the vast work for which he is famous, *Remembrance of Things Past*. The first volume appeared in 1913; the seventh and last volume was not published until 1927, five years after his death.

It is difficult to do justice to this amazing work. The lengthy story is told in the first person by a narrator who, though never named, obviously has much in common with Proust. The story's entire concern is to recall the narrator's past life—from earliest childhood to middle age—by bringing to mind the people, places, things, and events that have affected him. In the course of the narrator's journey back into his past, he realizes that all of it lies hidden inside him and that the tiniest circumstance—a scent, a taste, the appearance of someone's hair—can trigger a whole chain of memory associations.

The following extract contains the well-known episode involving a sensory memory: biting into the madeleine—a small cake—triggers a host of memories:

READING 21.3 MARCEL PROUST

From Remembrance of Things Past, Vol. I: Swann's Way

Many years had elapsed during which nothing of Combray,[4] save what was comprised in the theatre and the drama of my going to bed there, had any existence for me, when one day in winter, on my return home, my mother, seeing that I was cold, offered me some tea, a thing I did not ordinarily take. I declined at first, and then, for no particular reason, changed my mind. She sent for one of those squat, plump little cakes called "petites madeleines," which look as though they had been moulded in the fluted valve of a scallop shell. And soon, mechanically, dispirited after a dreary day with the prospect of a depressing morrow, I raised to my lips a spoonful of the tea in which I had soaked a morsel of the cake. No sooner had the warm liquid mixed with the crumbs touched my palate than a shudder ran through me and I stopped, intent upon the extraordinary thing that was happening to me. An exquisite pleasure had invaded my senses, something isolated, detached, with no suggestion of its origin. And at once the vicissitudes of life had become indifferent to me, its disasters innocuous, its brevity illusory—this new sensation having had on me the effect which love has of filling me with a precious essence; or rather this essence was not in me it *was* me.

4. The narrator's family.

By the end of the final volume, the narrator has decided to preserve the recollection of his past life by making it permanent in the form of a book—the book the reader has just finished. Proust's awareness of the importance of the subconscious and his illustration of the way in which it can be unlocked have had a great appeal to modern writers, as has his **stream of consciousness** style, which appears to reproduce the narrator's thought processes as they actually occur rather than as edited by a writer for logical connections and development. Furthermore, as we follow Proust's (or the narrator's) careful and painstaking resurrection of his past, it is important to remember that his purpose is far more than a mere intellectual exercise. By recalling the past, we bring it back to life in a literal sense. Memory is our most powerful weapon against death.

ANTON CHEKHOV If Dostoyevsky used violence to depict his worldview, his contemporary and fellow Russian, Anton Pavlovich Chekhov (1860–1904), used irony and satire to show the passivity and emptiness of his characters. In plays and short stories, Chekhov paints a provincial world whose residents dream of escape, filled with a frustrated longing for action. The three sisters who are the chief characters in the play of that name never manage to achieve their ambition to go "to Moscow, to Moscow!" In stories such as "The Lady with the Dog," Chekhov uses apparent triviality to express profound understanding, whereas in "The Bet," he ironically challenges most of our basic values.

MARK TWAIN Perhaps the most beloved U.S. writer toward the close of the 19th century and into the early part of the 20th century was Mark Twain (1835–1910), the pen name of Samuel Langhorne Clemens. Twain was once a Mississippi River steamboat captain, and sailors would plumb the depths of the river by dropping in a weighted rope and calling out the numbers. "Mark twain" meant two fathoms deep, or 12 feet—safe sailing for the steamboat. Much of Twain's sailing as a writer and humorist was indeed safe. He told tall tales of the inner parts of the United States, capturing the rhythms and the sounds of local speech. The passage in Reading 21.4 is from a book called *Roughing It*, and it will give you the flavor. It is supposedly the story of Grandfather's old ram, but it is not easy for the narrator to get around to it.

Twain may be best known for his novels *The Adventures of Tom Sawyer* (1876) and *Adventures of Huckleberry Finn* (1885), with "Huck Finn" often referred to as "the great American novel." Most critics agree that Twain was the greatest humorist of the era, but as time went on, his writings took a darker tone. Twain was very concerned about the hardships—including wanton murder—often inflicted upon natives in the era of imperialism and colonization. Colonization was supposed

READING 21.4 MARK TWAIN

From *Roughing It*, "The Story of Grandfather's Old Ram," chapter 53

Every now and then, in these days, the boys used to tell me I ought to get one Jim Blaine to tell me the stirring story of his grandfather's old ram—but they always added that I must not mention the matter unless Jim was drunk at the time—just comfortably and sociably drunk. . . . His face was round, red, and very serious; his throat was bare and his hair tumbled; in general appearance and costume he was a stalwart miner of the period. On the pine table stood a candle, and its dim light revealed "the boys" sitting here and there on bunks, candle-boxes, powder-kegs, etc. They said:

"Sh-! Don't speak—he's going to commence."

I found a seat at once, and Blaine said:

"I don't reckon them times will ever come again. There never was a more bullier old ram than what he was. Grandfather fetched him from Illinois—got him of a man by the name of Yates—Bill Yates—maybe you might have heard of him; his father was a deacon—Baptist—and he was a rustler, too; a man had to get up ruther early to get the start of old Thankful Yates; it was him that put the Greens up to jining teams with my grandfather when he moved west. Seth Green was prob'ly the pick of the flock; he married a Wilkerson—Sarah Wilkerson— good cretur, she was—one of the likeliest heifers that was ever raised in old Stoddard, everybody said that knowed her.

She could heft a bar'l of flour as easy as I can flirt a flapjack. And spin? Don't mention it! Independent? Humph! When Sile Hawkins come a browsing around her, she let him know that for all his tin he couldn't trot in harness alongside of *her*. You see, Sile Hawkins was—no, it warn't Sile Hawkins, after all—it was a galoot by the name of Filkins—I disremember his first name; but he *was* a stump—come into pra'r meeting drunk, one night, hooraying for Nixon, becuz he thought it was a primary; and old deacon Ferguson up and scooted him through the window and he lit on old Miss Jefferson's head, poor old filly. She was a good soul—had a glass eye and used to lend it to old Miss Wagner, that hadn't any, to receive company in; it warn't big enough, and when Miss Wagner warn't noticing, it would get twisted around in the socket, and look up, maybe, or out to one side, and every which way, while t' other one was looking as straight ahead as a spy-glass. Grown people didn't mind it, but it most always made the children cry, it was so sort of scary. She tried packing it in raw cotton, but it wouldn't work, somehow—the cotton would get loose and stick out and look so kind of awful that the children couldn't stand it no way. She was always dropping it out, and turning up her old dead-light on the company empty, and making them oncomfortable, becuz *she* never could tell when it hopped out, being blind on that side, you see. So somebody would have to hunch her and say, 'Your game eye has fetched loose, Miss Wagner dear'— and then all of them would have to sit and wait till she jammed it in again—wrong side before, as a general thing. . . ."

to bring "the light" to "people sitting in darkness," but it often brought deprivation, destruction, and disease. Twain was also horrified at what people did to one another in the name of their religion; whatever his personal beliefs about god might have been, he developed a mistrust of "organized religion" and what he viewed as nonsensical beliefs.

He worked on and off over the last 20 years of his life on a short novel called *The Mysterious Stranger*. The stranger is Satan, but actually the nephew of the fallen archangel of the same name. He visits a bunch of youngsters in Austria in 1590 and points out their errors in logic. As the novel is drawing to a close, Satan offers them the diatribe in Reading 21.5:

READING 21.5 MARK TWAIN

From *The Mysterious Stranger*

Strange, indeed, that you should not have suspected that your universe and its contents were only dreams, visions, fiction! Strange, because they are so frankly and hysterically insane— like all dreams: a God who could make good children as easily as bad, yet preferred to make bad ones; who could have made every one of them happy, yet never made a single happy one; who made them prize their bitter life, yet stingily cut it short; who gave his angels eternal happiness unearned, yet required his other children to earn it; who gave his angels painless lives, yet cursed his other children with biting miseries and maladies of mind and body; who mouths justice and invented hell—mouths mercy and invented hell—mouths Golden Rules, and forgiveness multiplied by seventy times seven, and invented hell; who mouths morals to other people and has none himself; who frowns upon crimes, yet commits them all; who created man without invitation, then tries to shuffle the responsibility for man's acts upon man, instead of honorably placing it where it belongs, upon himself; and finally, with altogether divine obtuseness, invites this poor, abused slave to worship him!

ÉMILE ZOLA The French writer Émile Zola (1840–1902) lived as an impoverished clerk in his early 20s but was determined to earn his living by writing only (**Fig. 21.48**). He had the rare capacity to bring symbols of modernity to life: the factory, the mine, and, as we see in this chapter, that new monster of merchandising we know as the department store. His work is emotional, ranging from the poignantly descriptive to the humorous. His first significant novel, *Thérèse Raquin*, appeared in 1867. He wrote a cycle of 20 novels intended to scientifically explore the effects of nature (genetics) and nurture (environmental experiences) on one family. He then wrote another cycle of novels that attack the Roman Catholic Church. His famous open letter of 1898, "J'accuse" (I Accuse) attacked the French government for being anti-Semitic because of its sentencing of army officer Alfred Dreyfus to a life sentence for espionage. Zola argued that the government had trumped up the charges

against Dreyfus and convicted him on flimsy evidence. Zola was then found guilty of libeling the government and was given a prison sentence, causing him to flee to England. He returned to Paris a year later.

He published the novel *Au Bonheur des Dames* (*The Ladies' Delight*) in 1883. The title of the novel is also the name of the dazzling department store in Belle Époque Paris. The owner of the store, Octave Mouret, was one of the entrepreneurs who helped rip up the old Paris and shepherd in the new. "He belonged to his age," writes Zola. "Honestly you had to have something wrong in your make-up, some weakness in your head and limbs, to shrink from action at a time when so much was being done, when the whole century was thrusting forward into the future."[5]

5. Émile Zola, *Au Bonheur des Dames* (*The Ladies' Delight*), trans. Robin Buss (London: Penguin Books, 2001), p. 66. © Robin Buss.

▲ **21.48 Edouard Manet, *Émile Zola*, 1868. Oil on canvas, 57⅝"** **× 44⅞" (146.5 × 114 cm). Musée d'Orsay, Paris, France.** The pictures in the upper right include a sketch of *Olympia*, which Zola fiercely defended as Manet's best work, a Japanese print of a wrestler, and an engraving of Velazquez's *Bacchus*, suggesting Zola's appreciation of Spanish art. The Japanese screen on the left further attests to Zola's and Manet's shared interest in Japanese art.

In a theme that resonates today, Mouret (in effect, speaking for Zola) pontificates on how modern merchandising relies on the exploitation of women's appetites. The department store was set up just so—just so that women would be drawn to it like insects to a source of light and then open their purses:

READING 21.6 ÉMILE ZOLA

From *Au Bonheur des Dames (The Ladies' Delight)*

Here…emerged the exploitation of women. Everything led to this point: the capital which was constantly being renewed, the system of concentrating the merchandise, the low prices to attract the customers, the fixed prices to reassure them. Woman was what the shops were fighting over when they competed, it was woman whom they ensnared with the constant trap of their bargains, after stunning her with their displays. They had aroused new desires in her flesh, they were a huge temptation to which she must fatally succumb, first of all giving in to the purchases of a good housewife, then seduced by vanity and finally consumed. By increasing their sales tenfold and democratizing luxury they became a dreadful agent of expense, causing ravages in households and operating through the madness of fashion, which was constantly more expensive. And if in store woman was queen, adulated in herself, humoured in her weaknesses, surrounded by every little attention, she reigned as a queen in love, whose subjects were swindling her so that she paid for each of her whims with a drop of her own blood…[Mouret] raised a temple to her, had a legion of servants to perfume her with incense and devised the ritual of a new religion. He thought only of her and sought constantly to invent more powerful means of seduction; and, when her back was turned, when he had emptied her pockets and unhinged her nerves, he was filled with the secret contempt of a man whose mistress has just been stupid enough to give herself to him.

OSCAR WILDE Oscar Fingal O'Flahertie Wills Wilde was born in Dublin in 1854 and died in Paris in 1900. He is best known as a playwright, having penned the comedies *The Importance of Being Earnest* (1895) and *An Ideal Husband* (also 1895), among several others. He wrote one novel, *The Picture of Dorian Gray* (1891). He was a clever satirist of British society and truly a master of the one-liner. In *Earnest*, for example, Jack Worthing tells Lady Augusta Bracknell that he has lost both of his parents (that is, they have died). Her rejoinder is: "To lose one parent, Mr. Worthing, may be regarded as a misfortune. To lose both looks like carelessness." Wilde's first produced play was *Lady Windermere's Fan* (1892), which has the line "I can resist anything except temptation."

In his preface to *Dorian Gray*, Wilde shares some thoughts about art and criticism:

READING 21.7 OSCAR WILDE

From Preface to *The Picture of Dorian Gray*

The artist is the creator of beautiful things.
> To reveal art and conceal the artist is art's aim.
The critic is he who can translate into another manner or a new material his impression of beautiful things.
> The highest, as the lowest, form of criticism is a mode of autobiography.
Those who find ugly meanings in beautiful things are corrupt without being charming. This is a fault.
> Those who find beautiful meanings in beautiful things are the cultivated. For these there is hope.
They are the elect to whom beautiful things mean only Beauty.
> There is no such thing as a moral or an immoral book.
> Books are well written, or badly written. That is all.

MONA CAIRD Mona Caird (1854–1932) was a feminist author who wrote of women's lives and position in Victorian society. A typical plot is found in her novel *The Daughters of Danaus* (1894), in which a young woman's aspirations to pursue a career in music inevitably come into conflict with her responsibilities to her family. Her 1888 essay "Marriage" launched a series of hot debates about the role and destiny of women. Like many feminists before her and since, Caird equates a marriage that is not entered into freely with prostitution:

READING 21.8 MONA CAIRD

From "Marriage," *Westminster Review*

We come then to the conclusion that the present form of marriage—exactly in proportion to its conformity with orthodox ideas—is a vexatious failure. If certain people have made it a success by ignoring those orthodox ideas, such instances afford no argument in favour of the institution as it stands. We are also led to conclude that modern "Respectability" draws its life-blood from the degradation of womanhood in marriage and in prostitution. But what is to be done to remedy these manifold evils? How is marriage to be rescued from a mercenary society, torn from the arms of "Respectability" and established on a footing which will make it no longer an insult to human dignity?

…

The ideal marriage, then, despite all dangers and difficulties, should be free. So long as love and trust and friendship remain, no bonds are necessary to bind two people together; life apart will be empty and colourless; but whenever these cease the tie becomes false and iniquitous, and no one ought to have power to enforce it.

…

> The economical independence of woman is the first condition of free marriage. She ought not to be tempted to marry, or to remain married, for the sake of bread and butter.

A. E. HOUSMAN The Englishman Alfred Edward Housman (1859–1936) became a student of the Latin classics and led an academic life, teaching Classical literature at University College in London and then at Cambridge. During his career, he wrote some poetry that has become quite familiar, including "When I was one-and-twenty" from his collection *A Shropshire Lad* (1896). In the poem, the narrator fails to heed good advice, either because he was too young to understand the wisdom of the sage or else because he was too young and feverishly in love to listen:

READING 21.9 A. E. HOUSMAN

"When I was one-and-twenty"

When I was one-and-twenty
 I heard a wise man say,
"Give crowns and pounds and guineas
 But not your heart away;
Give pearls away and rubies
 But keep your fancy free."
But I was one-and-twenty,
 No use to talk to me.

When I was one-and-twenty
 I heard him say again,
"The heart out of the bosom
 Was never given in vain;
'Tis paid with sighs a plenty
 And sold for endless rue."
And I am two-and-twenty,
 And oh, 'tis true, 'tis true.

RUDYARD KIPLING Rudyard Kipling (1865–1936) was born to Britons in India—at the time, the most important colony of the United Kingdom. He was schooled for a few years in the United Kingdom, but he was unhappy there and returned to India. He spent part of his life married to a U.S. woman in Vermont but then moved to England. Britons were fascinated by his reporting on India, and he also wrote many stories, books, and poems. Generations of children have enjoyed his two-volume *Jungle Book* (1894, 1895). He also wrote the celebrated novel *Kim* (1901) and was awarded the Nobel Prize for Literature in 1907. His poems include "The Ballad of East and West," in which an Afghan horse thief and an Englishman develop mutual respect, and "If."

READING 21.10 RUDYARD KIPLING

"The Ballad of East and West," lines 1–4

Oh, East is East, and West is West, and never the twain shall
 meet,
Till Earth and Sky stand presently at God's great Judgment
 Seat;
But there is neither East nor West, Border, nor Breed, nor
 Birth,[6]
When two strong men stand face to face, tho' they come from
 the ends of the earth!

In the poem "If," we hear a father giving his son advice about how to live the decent life:

READING 21.11 RUDYARD KIPLING

"If," lines 1–8, 31–32

If you can keep your head when all about you
 Are losing theirs and blaming it on you;
If you can trust yourself when all men doubt you,
 But make allowance for their doubting too;
If you can wait and not be tired by waiting,
 Or being lied about, don't deal in lies,
Or being hated don't give way to hating,
 And yet don't look too good, nor talk too wise:

 . . .

If you can fill the unforgiving minute
 With sixty seconds' worth of distance run,
Yours is the Earth and everything that's in it,
 And—which is more—you'll be a Man, my son!

Changing Roles of Women

Not all writers in the late 19th and early 20th centuries devoted themselves to the kind of psychological investigation found in the works of Dostoyevsky and Proust. The larger question of the nature of society continued to attract the attention of more socially conscious writers, who explored the widening range of problems created by industrial life as well as a whole new series of social issues.

One of the most significant aspects of the development of the modern world has been the changing role of women in family life and in society at large. The issue of women's right to vote was bitterly fought in the early years of the 20th century, and not until 1918 in the United Kingdom and 1920 in the United States were women permitted to participate in the electoral

6. Family name or social standing.

process on a wide scale. On a more personal basis, the growing availability and frequency of divorce began to cause many women (and men) to rethink the nature of the marriage tie. The pace of women's emancipation from the stock role assigned to them over centuries was extremely slow, and the process is far from complete. A beginning had to be made somewhere, however, and it is only fitting that a period characterized by cultural and political change should also be marked by social change in this most fundamental of areas.

In the same way that Dickens had led the drive against industrial oppression and exploitation in the mid-19th century, writers of the late 19th and early 20th centuries not only reflected feminist concerns but actively promoted them as well. They tackled a range of problems so vast that we can do no more than look at just one area, marriage, through the eyes of two writers of the late 19th century. One of them, Henrik Ibsen (1828–1906), was the most famous playwright of his day and a figure of international renown. The other, Kate Chopin (1851–1904), was ignored in her own lifetime even in her native United States.

HENRIK IBSEN Ibsen was born in Norway, although he spent much of his time in Italy. Most of his mature plays deal with the conventions of society and their consequences, generally tragic. Although many are technically set in Norway, their significance was intended to be universal. The problems Ibsen explored were frequently ones regarded as taboo, including sexually transmitted infections, incest, and insanity. The realistic format of the plays brought issues like these home to his audience with shocking force. At first derided, Ibsen eventually became a key figure in the development of drama, particularly in the English-speaking world, where his work was championed by George Bernard Shaw (1856–1950), who inherited Ibsen's mantle as a progressive social critic.

In one of his first important plays, *A Doll's House* (1879), Ibsen deals with the issue of women's rights. The principal characters, Torvald Helmer and his wife Nora, have been married for eight years, apparently happily enough. Early in their marriage, however, before Helmer became a prosperous lawyer, Nora secretly borrowed some money from Krogstad, a friend, to pay for her husband's medical treatment; she told Torvald that the money came from her father, because he was too proud to borrow. As the play opens, Krogstad—to whom Nora is still in debt—threatens to blackmail her if she does not persuade Helmer to find him a job. When she refuses to do so, Krogstad duly writes a letter to Helmer revealing the truth. Helmer recoils in horror at his wife's deception. The matter of the money is eventually settled by other means and Helmer eventually forgives Nora, but not before the experience has given her a new and unforgettable insight into her relationship with her husband. In the final scene, she walks out the door, slams it, and leaves him forever.

Nora decides to abandon her husband on two grounds. In the first place, she realizes how small a part she plays in her husband's real life. As she says, "Ever since the first day we met, we have never exchanged so much as one serious word about serious things." The superficiality of their relationship horrifies her. In the second place, Helmer's inability to rise to the challenge presented by the discovery of his wife's deception and prove his love for her by claiming that it was he who had borrowed and failed to repay the debt diminishes him in Nora's eyes. Ibsen tries to express what he sees as an essential difference between men and women when, in reply to Helmer's statement that "one doesn't sacrifice one's honor for love's sake," Nora replies, "Millions of women have done so." Nora's decision not to be her husband's childish plaything—to leave the doll's house in which she is the doll—was so contrary to accepted social behavior that one noted critic remarked, "That slammed door reverberated across the roof of the world."

The final scene of act 3 reveals Nora's controlled fury at the role society has assigned her:

READING 21.12 HENRIK IBSEN

A Doll's House, act 3, final scene, lines 1–38

[The action takes place late at night, in the Helmers' living room. Nora, instead of going to bed, has suddenly reappeared in everyday clothes.]

HELMER…What's all this? I thought you were going to bed. You've changed your dress?
NORA Yes, Torvald; I've changed my dress.
HELMER But what for? At this hour?
NORA I shan't sleep tonight.
HELMER But, Nora dear–
NORA [looking at her watch] It's not so very late—Sit down, Torvald; we have a lot to talk about.

[She sits at one side of the table.]
HELMER Nora–what does this mean? Why that stern expression?
NORA Sit down. It'll take some time. I have a lot to say to you.

[Helmer sits at the other side of the table.]
HELMER You frighten me, Nora. I don't understand you.
NORA No, that's just it. You don't understand me; and I have never understood you either—until tonight. No, don't interrupt me. Just listen to what I have to say. This is to be a final settlement, Torvald.
HELMER How do you mean?
NORA [after a short silence] Doesn't anything special strike you as we sit here like this?
HELMER I don't think so—why?
NORA It doesn't occur to you, does it, that though we've been married for eight years, this is the first time that we two— man and wife—have sat down for a serious talk?
HELMER What do you mean by serious?

NORA During eight whole years, no—more than that—ever since the first day we met—we have never exchanged so much as one serious word about serious things.

HELMER Why should I perpetually burden you with all my cares and problems? How could you possibly help me to solve them?

NORA I'm not talking about cares and problems. I'm simply saying we've never once sat down seriously and tried to get to the bottom of anything.

HELMER But, Nora, darling—why should you be concerned with serious thoughts?

How, indeed, could Nora participate in solving Helmer's problems, and why, indeed, should she be concerned with serious thoughts? After all, she is just a woman. Helmer's befuddlement reflects traditional society's clueless degradation of women; marital satisfaction will require new attitudes on the part of men.

KATE CHOPIN In comparison to the towering figure of Ibsen, the U.S. writer Kate Chopin found few readers in her own lifetime; even today she is not widely known. Only recently have critics begun to do justice to the fine construction and rich psychological insight of her novel *The Awakening*, denounced as immoral—even banned—when it was first published in 1899. Its principal theme is the oppressed role women are forced to play in family life. Edna, its heroine, like Nora in *A Doll's House*, resents the meaninglessness of her relationship with her husband and the tedium of her daily existence. Her only escape is to yield to her sexual drives and find freedom not in slamming the door behind her but in throwing herself into a passionate if unloving affair.

In her short stories, Chopin deals with the same kind of problem, but with greater delicacy and often with a wry humor. Frequently on the smallest of scales, these stories examine the prison that marriage seems so often to represent. In the course of a couple of pages, Chopin exposes an all-too-common area of human experience and, like Ibsen, touches a chord that rings as true now as it did at the turn of the century.

In "The Story of an Hour" (1894), Mrs. Mallard learns that her husband has been killed in an accident. She cries at once, "with sudden, wild abandonment," but then goes to her room alone:

READING 21.13 KATE CHOPIN

From "The Story of an Hour" (Originally titled "The Dream of an Hour")

There was something coming to her and she was waiting for it, fearfully. What was it? She did not know; it was too subtle and elusive to name. But she felt it, creeping out of the sky, reaching toward her through the sounds, the scents, the color that filled the air.

Now her bosom rose and fell tumultuously. She was beginning to recognize this thing that was approaching to possess her, and she was striving to beat it back with her will—as powerless as her two white slender hands would have been.

When she abandoned herself a little whispered word escaped her slightly parted lips. She said it over and over under her breath: "free, free, free!" The vacant stare and the look of terror that had followed it went from her eyes. They stayed keen and bright. Her pulses beat fast, and the coursing blood warmed and relaxed every inch of her body.

She did not stop to ask if it were or were not a monstrous joy that held her. A clear and exalted perception enabled her to dismiss the suggestion as trivial.

She knew that she would weep again when she saw the kind, tender hands folded in death; the face that had never looked save with love upon her, fixed and gray and dead. But she saw beyond that bitter moment a long procession of years to come that would belong to her absolutely. And she opened and spread her arms out to them in welcome.

TOWARD A WORLD AT WAR

As we will see in Chapter 22, the pessimists of the era of 1870–1914 turned out to be correct in their perceptions of what the future would hold. But not even they grasped the scale of the deluge of metal and gunpowder to come. Those who survived to look back upon the era would generally do so with nostalgia: in their bloodshot eyes, the Belle Époque would appear to be more beautiful than it ever was in reality. And as we think back on it today, the world of the *Bar at the Folies-Bergère* seems to recede farther and farther—as if all the glitter were more a thing of the imagination than of the past.

GLOSSARY

Analytic Cubism (p. 751) The early phase of Cubism (1909–1912), during which objects were dissected or analyzed in a visual information-gathering process and then reconstructed on the canvas.

Atonal (p. 765) Referring to music that does not conform to the tonal character of European Classical music.

Belle époque (p. 724) French for "beautiful era"; a term applied to a period in French history characterized by peace and flourishing of the arts, usually dated as beginning in 1890 and ending with World War I in 1914.

Collage (p. 753) An assemblage of two-dimensional objects to create an image; a work of art in which materials such as paper, cloth, and wood are pasted to a two-dimensional surface, such as a wooden panel or canvas.

Cubism (p. 749) A 20th-century style of painting developed by Picasso and Braque that emphasizes the two-dimensionality of the canvas, characterized by multiple views of an object and the reduction of form to cube-like essentials.

Der Blaue Reiter (p. 748) German for The Blue Rider; a 20th-century German Expressionist movement that focused on the contrasts between, and combinations of, abstract form and pure color.

Die Brücke (p. 748) German for The Bridge; a short-lived German Expressionist movement characterized by boldly colored landscapes and cityscapes and by violent portraits.

Dynamism (p. 754) The Futurist view that force or energy is the basic principle that underlies all events, including everything we see. Objects are depicted as if in constant motion, appearing and disappearing before our eyes.

Expressionism (p. 747) A modern school of art in which an emotional impact is achieved through agitated brushwork; intense coloration; and violent, hallucinatory imagery.

Fauvism (p. 745) From the French for "wild beast"; an early-20th-century style of art characterized by the juxtaposition of areas of bright colors that are often unrelated to the objects they represent and by distorted linear perspective.

Futurism (p. 754) An early-20th-century style of art that portrayed modern machines and the dynamic character of modern life and science.

Impressionism (p. 732) A late-19th-century artistic style characterized by the attempt to capture the fleeting effects of light through painting in short strokes of pure color.

Pointillism (p. 739) A systematic method of applying minute dots of discrete pigments to the canvas; the dots are intended to be "mixed" by the eye when viewed.

Postimpressionism (p. 738) A late-19th-century artistic style that relied on the gains made by Impressionists in terms of the use of color and spontaneous brushwork but employed these elements as expressive devices. The Postimpressionists rejected the essentially decorative aspects of Impressionist subject matter.

Program music (p. 762) Music that describes elaborate programs or plots.

Sprechstimme (p. 766) Arnold Schönberg's term for "speaking voice," that is, speaking words at specific pitches.

Stream of consciousness (p. 768) A literary technique that is characterized by an uncensored flow of thoughts and images, which may not always appear to have a coherent structure.

Synthetic Cubism (p. 753) The second phase of Cubism, which emphasized the form of the object and constructing rather than disintegrating that form.

Synthetism (p. 743) Paul Gauguin's theory of art, which advocated the use of broad areas of unnatural color and "primitive" or symbolic subject matter.

Tone poem (p. 762) Richard Strauss's term for a program symphony (see program music).

Trompe l'oeil (p. 753) Literally, French for "fool the eye." In works of art, trompe l'oeil can raise the question as to what is real and what is illusory.

Twelve-tone technique (p. 766) A musical method that uses the 12 notes of the chromatic scale—on the piano, all of the black and white notes in a single octave—carefully arranged in a row or series; also called *serialism*.

Übermensch (p. 725) Nietzsche's term for a person who exercises the will to power (plural *Übermenschen*).

THE BIG PICTURE TOWARD THE MODERN ERA: 1870–1914

Language and Literature

- Dostoyevsky published *Crime and Punishment* in 1866.
- Ibsen staged *A Doll's House* in 1879.
- Zola published *Au Bonheur des Dames* (*The Ladies' Delight*) in 1883.
- Twain published *Adventures of Huckleberry Finn* in 1885.
- Caird published *The Daughters of Danaus* in 1894.
- Chopin published "The Story of an Hour" in 1894.
- Kipling published his two-volume *Jungle Book* in 1894 and 1895.
- Wilde staged *The Importance of Being Earnest* in 1895.
- Housman published *A Shropshire Lad* in 1896.
- Proust published the first volume of *Remembrance of Things Past* in 1913.

Art, Architecture, and Music

- Bouguereau painted Academic works in the 1870s.
- Manet's paintings of the 1860s through the 1880s bridged Realism and Impressionism.
- Monet painted *Impression, Sunrise* in 1872.
- Bizet's opera *Carmen* was first performed in 1875.
- Tchaikovsky composed his ballets *Swan Lake* in 1875–1876 and *The Nutcracker* in 1892.
- Renoir painted *Le Moulin de la Galette* in 1876.
- Morisot painted *Young Girl by the Window* in 1878.
- Degas painted ballet dancers and nudes in the 1870s and 1880s.
- American Expatriates Cassatt and Whistler painted in Paris toward the turn of the century.
- Gilbert and Sullivan staged *H.M.S. Pinafore* in 1878 and *The Mikado* in 1885.
- Postimpressionsts Toulouse-Lautrec, Seurat, Cézanne, and van Gogh painted in Europe toward the turn of the century; Cézanne painted groundbreaking still lifes and landscapes; van Gogh created emotional works with feverish brushstrokes.
- Eiffel constructed the Eiffel Tower in Paris in 1889.
- Sullivan erected the Wainwright Building in St. Louis in 1890–1891.
- Munch painted *The Scream* in 1893, an early Expressionist work evoking anguish and dehumanization.
- Puccini composed the operas *La Bohème* in 1896, *Tosca* in 1900, and *Madame Butterfly* in 1904.
- Rodin created modern sculpture with works such as *The Burghers of Calais* (1884–1895) and *The Kiss* (1886).
- Matisse espoused Fauvism in the early 1900s by using color emotionally and sensually.
- Debussy composed *La Mer* in 1903–1905.
- Gaudí built the Casa Milà in Barcelona in 1905–1907.
- Nolde (Die Brücke), Kandinsky (Der Blaue Reiter), and Kollwitz developed German Expressionism.
- Picasso and Braque developed Analytic Cubism and then Synthetic Cubism early in the 20th century; Picasso painted his seminal *Les Demoiselles d'Avignon* in 1907.
- Mahler composed his Symphony No. 9 in 1910–1911.
- The futurists Boccioni and Balla sculpted and painted mainly between 1909 and 1914.
- Strauss composed *An Alpine Symphony* between 1911 and 1915.
- Ravel premiered *Daphnis and Chloé* in 1912.
- Schönberg composed *Pierrot Lunaire* in 1912.
- Stravinsky premiered *The Rite of Spring* in 1913.

Philosophy and Religion

- Nietzsche espoused the "will to power" as opposed to compassion and self-sacrifice in the 1880s.
- Anthropology and psychology brought new points of view into the debates over human origins and human nature.
- Zola wrote "J'accuse," assailing the French government for widespread anti-Semitism and leading, eventually, to separation of church and state.

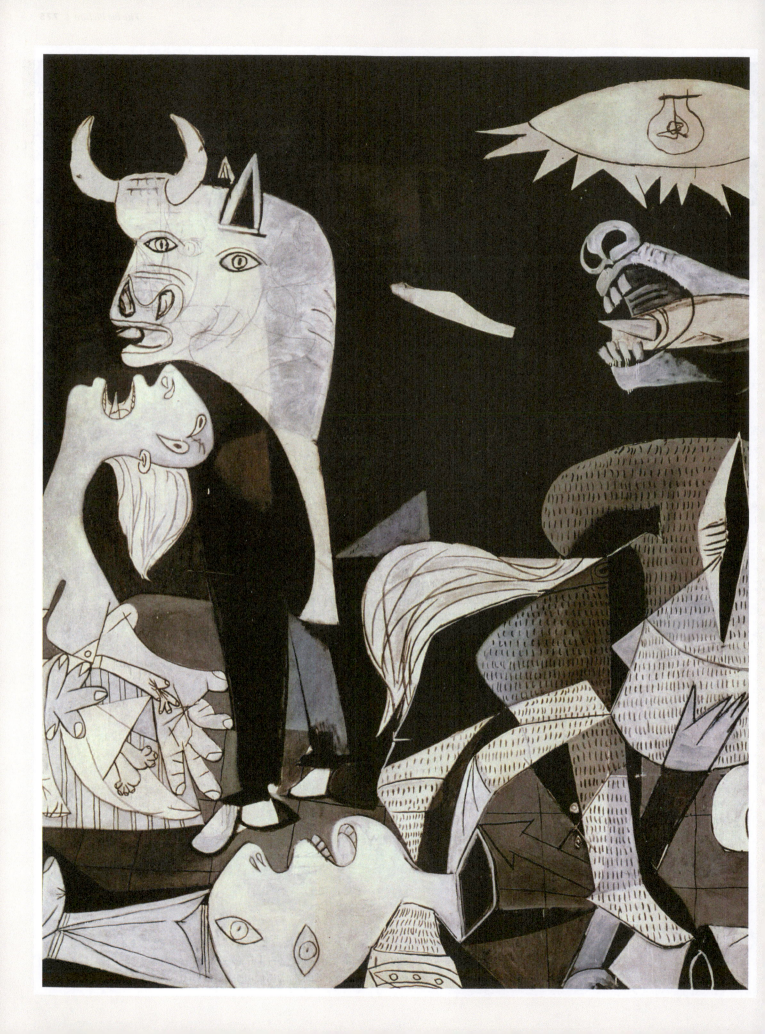

The World at War: 1914–1945

PREVIEW

On April 26, 1937, volunteer aviators from German Nazi and Italian fascist air forces took to their bombers and flew toward Spain. Their destination was Guernica, a small town in the infamously independent Basque region that had sided against the country's right-wing Nationalist forces in their attempt to overthrow Spain's more left-leaning, duly elected Republican government in the Spanish Civil War. Both the fascists under Benito Mussolini and the Nazis under Adolf Hitler supported the Nationalist general, Francisco Franco, in his efforts to wrest control of the country by a military coup. What ensued was known as Operation Rügen (*Rügen* is German for "rebuke" or "harsh reprimand"), one of the earliest campaigns of *terror bombing* (bombs and missiles deployed from fighter or bomber aircraft) and *strafing* (attacks from low-flying planes with weapons like machine guns). The goal was complete destruction of villages and the massacre of civilians as a strategic tactic to demoralize the enemy. Operation Rügen began in the late afternoon on Guernica's market day and continued in waves until the town was taken three days later with little to no resistance reported. Some estimates put the number of dead at roughly 1700, with some 900 more wounded. The campaign was a test run for what would be similar actions by the Luftwaffe, the deadly air-warfare division of the German army, during World War II.

One month after the bombing of Guernica, the International Exposition of Art and Technology in Modern Life opened in Paris, a celebration of modern invention and ingenuity in the service of humanity. But a painting by Pablo Picasso, who had been commissioned by the Spanish Republican government to create a work for that country's pavilion, would become a potent symbol of the dark side of these technological advances: their potential for human destruction. Picasso's *Guernica* (Figs. 22.1 and 22.2), a vast canvas exhibited at this World's Fair that commemorates the brutal attack, comes down to us as one of the harshest vilifications of modern warfare and one of the most deeply moving antiwar messages put forth by an artist. Picasso's familiar Cubist idiom, in which multiple perspectives yield fractured forms, is used to disturbing effect—one that eerily reflects an eyewitness report of the carnage by a British journalist, Noel Monks:

> We were still a good ten miles away when I saw the reflection of Guernica's flames in the sky.... I was the first correspondent to reach Guernica, and was immediately pressed into service by some Basque soldiers collecting charred bodies that the flames had passed over. Some of the soldiers were sobbing like children.... Houses were collapsing into the inferno.[1]

◀ **22.1** Pablo Picasso, *Guernica* (detail), 1937. Oil on canvas, 137⅜" × 305½" (349 × 776 cm). Museo Nacional Centro de Arte Reina Sofia, Madrid, Spain.

1. Monks, Noel, *Eyewitness* (1955); Thomas, Hugh, *The Spanish Civil War* (1977). As appears in "The Bombing of Guernica, 1937," EyeWitness to History, www.eyewitnesstohistory.com (2005).

As a political statement, *Guernica* had—and still has—great power. After the close of the Paris Exposition, the painting traveled to several Scandinavian countries before coming back to France. When Franco came to power, Picasso sent *Guernica* to the United States to raise funds for Spanish refugees; in 1939, he placed it on loan in the Museum of Modern Art in New York. Although the painting traveled to various museums for special exhibition, the Museum of Modern Art was to remain its home base, at Picasso's request, until such time as Spain reverted to a democratic government. In 1974, Tony Shafrazi, a contemporary artist and art dealer, defaced *Guernica* with the words "Kill Lies All" spray-painted across the canvas (it was quickly cleaned with no lasting damage). Shafrazi used one of art history's most famous protest paintings as a billboard for his own protest against the much publicized My Lai village massacre by American soldiers during the Vietnam War. Franco died in 1975, two years after Picasso's death; free elections were held in Spain in 1977, and a year later a democratic constitution was adopted. On September 9, 1981, *Guernica* finally moved to Spain.

In 2003, just before the Iraq War, when Secretary of State Colin Powell was to meet the press standing before a tapestry reproduction of *Guernica* that hangs outside the United Nations Security Council chamber, United Nations officials hid the work behind a blue curtain—so potent a symbol of the atrocities and injustices of war is *Guernica*, even in recent times.

"A WAR TO END ALL WARS"

The armed conflict that raged throughout Europe from 1914 to 1918—World War I or The Great War—put to rest forever the notion that war was a heroic rite of passage conferring nobility and glory. The use of technology—especially artillery, poison gas, tanks, and airplanes—made slaughter possible on a scale previously only imagined by storytellers. Trench warfare took its toll. Soldiers dug deep, miles-long crevices in the earth, where they lived and prepared to assault or defend against enemy soldiers dug into trenches across from them. Intermittently, they rose up from their trenches and ran toward the

The World at War

1914 CE	1920 CE	1929 CE	1939 CE	1941 CE	1945 CE
World War I begins in 1914	Women receive the right to vote in the United States in 1920	The U.S. stock market crashes in 1929	Hitler invades Poland in 1939	The United States defeats Japanese fleet at Midway in 1942	
Panama Canal opens	Fascists rise to power in Italy	The Great Depression begins	Einstein alerts Roosevelt of the need to develop an atom bomb in 1939	The Soviet Union defeats Germany at Stalingrad and Kursk in 1943	
Germans use poison gas and sink the *Lusitania*	Lindbergh makes the first solo flight from the United States to Europe in 1927	The analog computer is invented at the Massachusetts Institute of Technology in 1930	The Netherlands, Belgium, and France are all taken by German blitzkrieg in 1940	The Allies land in Normandy on June 6, 1944	
The October Revolution brings communism to Russia in 1917	Television images are transmitted from Washington, DC, to New York City in 1927	Franklin Delano Roosevelt is first elected president in 1932	Hitler invades Russia in 1941	Germany surrenders in 1945	
United States enters World War I in 1917	Fleming discovers penicillin in 1928	Roosevelt declares, "We have nothing to fear but fear itself"	Japan bombs Pearl Harbor, bringing the United States into the war on Dec. 7, 1941	The United States drops atom bombs on Hiroshima and Nagasaki in 1945	
The war ends in 1918	First sound movie is produced in 1928	Prohibition ends in 1933		World War II ends	
Women receive the right to vote in Britain in 1918		Nazis rise to power in Germany in 1933			
Prohibition begins in the United States in 1919		The Spanish Civil War (1936–1939)			
		Golden Gate Bridge opens in 1937			
		Japan invades China in 1937			

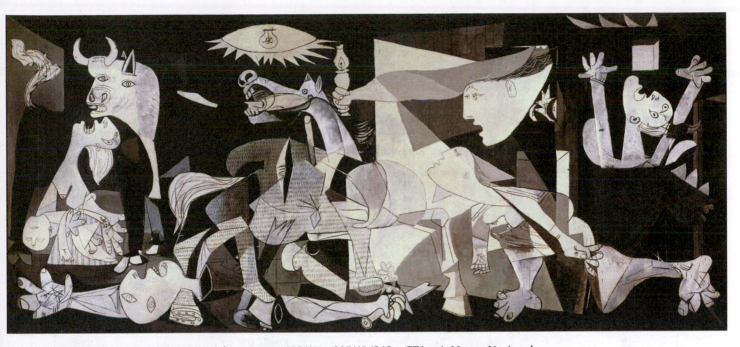

▲ **22.2** **Pablo Picasso,** *Guernica,* **1937. Oil on canvas, 137⅜" × 305½" (349 × 776 cm). Museo Nacional Centro de Arte Reina Sofia, Madrid, Spain.** By Picasso's specification, this monumental painting remained on extended loan in New York until after the death of the fascist dictator General Francisco Franco, after which it was moved to the artist's native Spain.

enemy's trenches, to be largely mowed down by artillery and machine-gun fire. The other side would attack, and the slaughter would be repeated. By the end of the war, the Germans had lost 3.5 million men and the Allies had lost 5 million men (see **Map 22.1**).

The immediate cause of the war was the assassination of Archduke Franz Ferdinand of Austria, heir to the Austro–Hungarian throne. But the war was actually a logical, if horrific, outcome of the tensions in Europe that had been brewing throughout the modern era and solidified via Otto von Bismarck's unification of Germany and the competition for territories and influence that followed. Britain was concerned about Germany's rising economic power, and there was a naval arms race between the two countries. France rebuilt its armed forces rapidly following the humiliation of the Franco–Prussian War of 1870–1871, and anger toward Germany simmered. By the early years of the 20th century, the efforts of Bismarck (who was relieved of his position in 1890) to maintain a balance of power were slipping away. Russia was also rearming after its defeat in the Russo–Japanese War of 1904–1905. Britain, France, Italy, and Russia formed alliances to balance the strength of Germany and Austria–Hungary. In 1908, the Austro–Hungarian Empire annexed Bosnia and Herzegovina. There was a crisis in the Balkans in 1912 and 1913 as landlocked Serbia tested its growing military might by invading Albania, desirous of an Albanian seaport. The Russians—Slavs—supported Slavic Serbia, increasing tensions with nearby Austria–Hungary and its ally, Germany. The assassination might have been the spark, but years of competition and local warfare were the powder keg.

The United States officially entered the war on the side of Britain, France, Italy, and Russia in 1917, although President Woodrow Wilson initially had sought to keep the country neutral. The United States, of course, was home to immigrants who had come from all of the now-warring nations, and support for participating in the war had been mixed. But in May of 1915, after a German U-boat (an "under-sea" boat or submarine) sank a British passenger liner, RMS *Lusitania,* that had set sail from New York City bound for Liverpool with Americans (and a payload of munitions) onboard, popular opinion shifted dramatically. Two years later, Wilson asked the U.S. Congress for a declaration for "a war to end all wars" against Germany and its allies to "make the world safe for democracy." The United States tipped the balance, and Germany, defeated, surrendered in 1918.

The Aftermath of the Great War

The sociopolitical consequences of the Great War were monumental. The geopolitical face of Europe was considerably altered. Europe demanded unreasonably high reparations from Germany—so high that while the United States was experiencing the Roaring Twenties, Germany remained in economic despair for more than a decade, with such inflation that it was said, with some exaggeration, that one would have to bring a wheelbarrow full of marks (the German currency) to purchase a loaf of bread. Germany's miseries led to a decade of decadence,

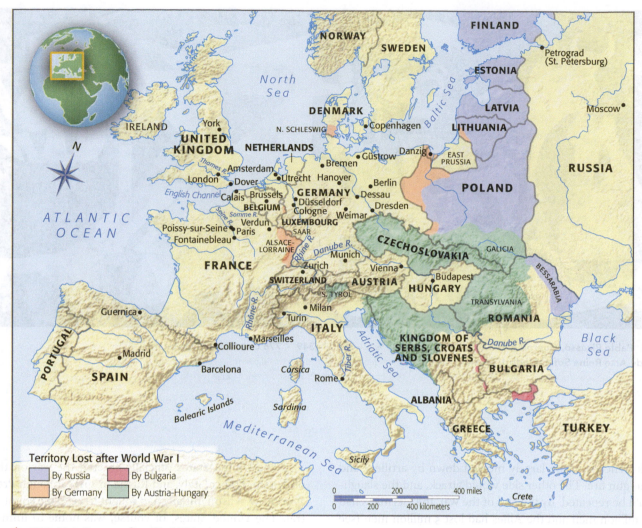

▲ **MAP 22.1** Europe after World War I.

CULTURE AND SOCIETY

Disillusionment

The period between the two world wars has often been characterized as a time of disillusionment. The horrendous slaughter of World War I, the brief spasm of economic prosperity followed by the worldwide depression, the lack of trust in governments, and the questioning of traditional culture created a search for ways to fill the moral vacancy of the times. Responses ranged from a new hedonism reflected in the excesses of the Jazz Age to a renewed search for some kind of a center for culture in the works of the modernist writers.

The most dangerous reaction to this disillusioned spirit was the rise of the total state. From Lenin's Russia, Hitler's Germany, and Mussolini's Italy arose a totalitarianism that saw the state as the total center of power that would guide everything from

economics and social policy to the arena of culture, arts, and propaganda. The distinction between public and private life was erased by the total state.

One lesson that can be learned from the rise of modern totalitarianism is the vigor with which the total state repressed all cultural alternatives to its own vision of reality. The suppression of free speech, independent media, toleration for the arts, and space for independent social groups, churches, or civic organizations was total in the Soviet Union, Germany, and Italy. The vigorous antifascist novelist Ignazio Silone once wrote that what the state feared more than anything else was one person scrawling "NO" on a wall in the public square.

with Berlin known as a capital for drinking and womanizing, as suggested in the musical *Cabaret*.

The punitive reparations inflicted by the Allies on Germany and the stricken state of that country's postwar economy provided the seedbed from which Hitler's **National Socialism** (Nazism)—a form of **fascism**—sprang. Postwar turmoil also led to Benito Mussolini's ascendancy in Italy. In 1917, the October Revolution led by Vladimir I. Lenin in Russia toppled the tsarist regime and produced a Bolshevik (communist) government in Russia. Several months later, on March 3, 1918, the peace Treaty of Brest-Litovsk between the Bolsheviks and the Central Powers (Germany and its allies), ended Russia's participation in the war. The price for the peace treaty would have been high in terms of treasure and the transfer of land, but it was overturned when Germany surrendered to the Allies in November of 1918. The ultimate shape of the Soviet Union, which had its roots in the October Revolution, was a direct result of the events of the First World War.

Culturally, World War I sounded the death knell for the world of settled values. The battle carnage and the senseless destruction—in no small part the result of callous and incompetent military leadership—made a mockery of patriotic slogans, appeals to class, and the metaphysical unity of nations. One result of this disillusionment was bitter cynicism about anything connected with military "glory."

The Arts in the Midst and Wake of War

The experience of war had searing effects on those who lived through it—in art, in literature, and in film.

MAX BECKMANN As World War I drew to a close, German Expressionist painters took different stylistic paths. Some, like Max Beckmann (1884–1950), reacted to the horrors and senselessness of wartime suffering with an art that commented bitterly on the bureaucracy and military with ghastly visions of human torture. They called themselves the **Neue Sachlichkeit** (New Objectivity). In *The Dream* (**Fig. 22.3**), dread occupies every nook and cranny—from the amputated and bandaged hands of the man in red stripes to the blinded street musician and maimed harlequin. Are these marionettes from some dark comedy or human puppets locked in a world of manipulation and hopelessness? Born in Leipzig, Germany, Beckmann idealistically enlisted in the army because he believed (as did the Italian Futurists) that the chaos of war would plant the seeds of a superior society. Serving as a medic, he had not anticipated the massive destruction or the loss of life and limb—especially since Germany appeared to be invulnerable since its unification. Beckmann's painting after the war took a direction that reflected what he saw as humankind's descent into cruelty and madness.

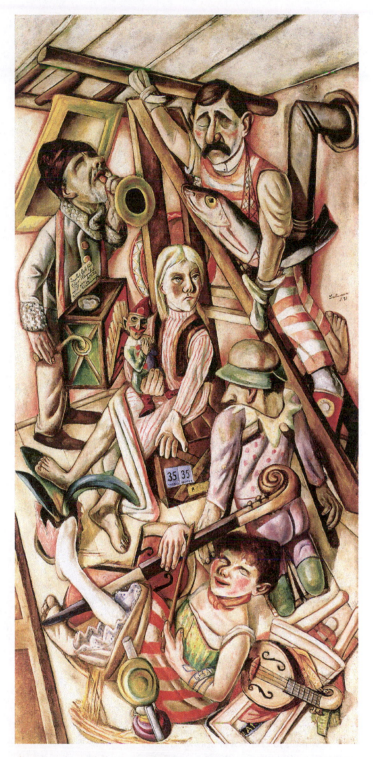

▲ **22.3** Max Beckmann, *The Dream*, 1921. Oil on canvas, 73⅛" × 35" The Saint Louis Art Museum, Saint Louis, Missouri.

RUPERT BROOKE A whole school of poets vented their disgust with this first modern war; many of them who entered service did not survive. The English poet Rupert Brooke (1887–1915) was known for his sonnets and also for his work as a travel journalist. During the war, he was aboard a vessel of the British Mediterranean Expeditionary Force when he developed blood poisoning and died. His poem "The Soldier" is remembered for its patriotism, its sense of peace, and its opening lines:

READING 22.1 RUPERT BROOKE

"The Soldier"

If I should die, think only this of me:
 That there's some corner of a foreign field
That is for ever England. There shall be
 In that rich earth a richer dust concealed;
A dust whom England bore, shaped, made aware,
 Gave, once, her flowers to love, her ways to roam,
A body of England's, breathing English air,
 Washed by the rivers, blest by suns of home.

And think, this heart, all evil shed away,
 A pulse in the eternal mind, no less
 Gives somewhere back the thoughts by England given;
Her sights and sounds; dreams happy as her day;
 And laughter, learnt of friends; and gentleness,
 In hearts at peace, under an English heaven.

ISAAC ROSENBERG Isaac Rosenberg (1890–1918) worked as an engraver in London and aspired to be an artist, but he began to write poetry and soon was encouraged to continue by the literati around him. He enlisted in the army in 1915 and was killed in action in 1918, the final year of the war. His literary reputation grew after his death because of his poetic innovations. In "Dead Man's Dump," the verse beginning "Maniac Earth!" captures the despair of humanity, metal, poison gas ("chemic smoke"), and earth intertwined in madness:

READING 22.2 ISAAC ROSENBERG

"Dead Man's Dump," lines 1–13, 39–54, 63–71

The plunging limbers[2] over the shattered track
Racketed with their rusty freight,
Stuck out like many crowns of thorns,
And the rusty stakes like sceptres old
To stay the flood of brutish men
Upon our brothers dear.

The wheels lurched over sprawled dead
But pained them not, though their bones crunched,
Their shut mouths made no moan.
They lie there huddled, friend and foeman,
Man born of man, and born of woman,
And shells go crying over them
From night till night and now.

 ...

The air is loud with death,
The dark air spurts with fire,

The explosions ceaseless are.
Timelessly now, some minutes past,
Those dead strode time with vigorous life,
Till the shrapnel called "An end!"
But not to all. In bleeding pangs
Some borne on stretchers dreamed of home,
Dear things, war-blotted from their hearts.

Maniac Earth! howling and flying, your bowel
Seared by the jagged fire, the iron love,
The impetuous storm of savage love.
Dark Earth! dark Heavens! swinging in chemic smoke,
What dead are born when you kiss each soundless soul
With lightning and thunder from your mined heart,
Which man's self dug, and his blind fingers loosed?

 ...

Here is one not long dead;
His dark hearing caught our far wheels,
And the choked soul stretched weak hands
To reach the living word the far wheels said,
The blood-dazed intelligence beating for light,
Crying through the suspense of the far torturing wheels
Swift for the end to break
Or the wheels to break,
Cried as the tide of the world broke over his sight.

LITERARY MODERNISM IN EUROPE

The poems by Brooke and Rosenberg are both graphic and metaphorical in their depiction of the contemporary world. Both died at the age of 28, and thus we are left with only a few verses and regrets about their promise. Might their artistic maturation have contributed to the development of Modernism in literature?

Modernism goes beyond the simple depiction of contemporary life and events to contemplate, instead, the premise of art itself. The core of Modernist principles—whether in literature or in art—is the concern about the aesthetics and form of a work rather than its content per se.

WILLIAM BUTLER YEATS At the end of World War I, the Irish poet William Butler Yeats (1865–1939), profoundly moved by unrest in his own country (particularly the Easter Rising of 1916) and the growing militarism in Europe, wrote one of the most extraordinarily beautiful and prophetic poems of modern times, "The Second Coming." The title of the poem is deeply ironic because it refers not to the glorious promised return of the Christian Messiah but to an event the poet only hints at in an ominous manner. We already noted these lines in Chapter 18, because the Nigerian writer Chinua Achebe took

2. Carts.

the first phrase, "things fall apart," as the title of a novel that protests British colonialism. But the following lines from the poem also seem to sum up the catastrophe of the Great War and to look into the future. It seems to be as strikingly relevant for the era of the great wars, and perhaps for our own times, as it was for Yeats.

> Things fall apart; the centre cannot hold;
> Mere anarchy is loosed upon the world,
> The blood-dimmed tide is loosed, and everywhere
> The ceremony of innocence is drowned;
> The best lack all conviction, while the worst
> Are full of passionate intensity.

The themes are all there. Some kind of center—political, philosophical, social, artistic, even scientific—seems to be in perpetual jeopardy. There is a sense of anarchy as nations fail to act in a responsible manner and groups within nations move viciously within and across borders, with or without government sanction. "Innocence is drowned"; disillusionment reigns. Blind trust in governments, religious institutions, even educational systems has evaporated because history has revealed us as the creators of "the blood-dimmed tide." Those who mean well are plagued by hesitation and indecision ("lack all conviction"), and those who would destroy ("the worst") harbor passion. The only surprise is that these words were penned nearly a century ago. Most of the literature of 1914 to 1945 touches on these themes in one way or another.

VIRGINIA WOOLF Virginia Woolf (1882–1941) is one of the most important writers in the period of literary Modernism. Novels like *Mrs. Dalloway* (1925), *To the Lighthouse* (1927), and *The Waves* (1931) have been justly praised for their keen sense of narrative, sophisticated awareness of time shifts, and profound feeling for the textures of modern life.

Woolf's reputation would be secure if she had been known only for her novels, but she was also an accomplished critic, a founder (with her husband Leonard Woolf) of the esteemed Hogarth Press, and a member of an intellectual circle in London known as the Bloomsbury Group. That informal circle of friends was at the cutting edge of some of the most important cultural activities of the period. Lytton Strachey, the biographer, was a member, as was John Maynard Keynes, the influential economist. The group also included the art critics Roger Fry and Clive Bell, who championed the new art coming from France, and had close contacts with mathematician–philosopher Bertrand Russell and poet T. S. Eliot.

Two small books, written by Woolf as polemical pieces, are of special contemporary interest. *A Room of One's Own* (1929) and *Three Guineas* (1938) were passionate but keenly argued polemics against the discrimination against women in public intellectual life. Woolf argued that English letters had failed to provide the world with a tradition of great women writers not because women lacked talent but because social structures never provided them with a room of their own—that is, the social and economic aid to be free to write and think or the encouragement to find outlets for their work. Woolf, a brilliant and intellectually restless woman, passionately resented the kind of society that had barred her from full access to English university life and entry to the professions. Her books were early salvos in the battle for women's rights. Woolf is rightly seen as one of the keenest thinkers of the modern feminist movement, whose authority was enhanced by the position she held as a world-class writer and critic.

In the extract from *A Room of One's Own* in Reading 22.3, Woolf imagines what life might have been like for Shakespeare's sister—a sister Woolf named Judith. She is responding to the remark of a bishop that no woman could have written as well as Shakespeare. Woolf ironically agrees with the bishop. The bishop, however, is attributing the distance between the talents of men and women to natural or inborn differences. Woolf argues that there is no evidence for such inborn differences but that there is ample evidence for cultural or societal forces that create such differences:

READING 22.3 VIRGINIA WOOLF

From *A Room of One's Own*

I could not help thinking, as I looked at the works of Shakespeare on the shelf, that…it would have been impossible, completely and entirely, for any woman to have written the plays of Shakespeare in the age of Shakespeare. Let me imagine, since facts are so hard to come by, what would have happened had Shakespeare had a wonderfully gifted sister, called Judith, let us say. Shakespeare himself went, very probably—his mother was an heiress—to the grammar school, where he may have learnt Latin—Ovid, Virgil and Horace—and the elements of grammar and logic….He had, it seemed, a taste for the theatre; he began by holding horses at the stage door. Very soon he got work in the theatre, became a successful actor, and lived at the hub of the universe, meeting everybody, knowing everybody, practising his art on the boards, exercising his wits in the streets,…Meanwhile his extraordinarily gifted sister, let us suppose, remained at home. She was as adventurous, as imaginative, as agog to see the world as he was. But she was not sent to school….She picked up a book now and then, one of her brother's perhaps, and read a few pages. But then her parents came in and told her to mend the stockings or mind the stew and not moon about with books and papers….Perhaps she scribbled some pages up in an apple loft on the sly but was careful to hide them or set fire to them. Soon, however, before she was out of her teens, she was to be betrothed to the son of a neighbouring woolstapler.[3] She cried out that marriage was hateful to her, and for that she was severely beaten by her father….How could she disobey him?

3. Wool merchant.

How could she break his heart? The force of her own gift alone drove her to it. She made up a small parcel of her belongings, let herself down by a rope one summer's night and took the road to London....She had the quickest fancy, a gift like her brother's, for the tune of words. Like him, she had a taste for the theatre. She stood at the stage door; she wanted to act, she said. Men laughed in her face....She could get no training in her craft. Could she even seek her dinner in a tavern or roam the streets at midnight? Yet her genius was for fiction and lusted to feed abundantly upon the lives of men and women and the study of their ways. At last...Nick Greene the actor manager took pity on her; she found herself with child by that gentleman and so...killed herself one winter's night and lies buried at some cross-roads where the omnibuses now stop outside the Elephant and Castle.

GERTRUDE STEIN Many would agree that if there is one single literary figure who best personifies Modernism, it is Gertrude Stein. She once said that "Einstein was the creative philosophic mind of the century and I have been the creative literary mind of the century." If Modernism is defined as a self-conscious break with traditional styles of prose and poetry, an experimental approach to literary form, and an expression of new, postwar sensibilities, then Stein's work is synonymous with it.

Stein was born in the United States but moved to Paris in 1903, where she remained for the rest of her life. Her celebrated home at 27 rue de Fleurus became a gathering place for the most celebrated writers and artists of the day—including Matisse and Picasso, whose portrait of Stein we saw in Chapter 21 (see Fig. 21.35). As a writer, she is known for her radical linguistic experimentation that was, in part, influenced by her college mentor, William James, with whom she studied psychology at Radcliffe, the "Harvard Annex" for women. Sandra M. Gilbert and Susan Gubar, in their *Norton Anthology of Literature by Women* (New York and London: 1985), state:

> Early in her career...Stein began working in "the continuous present": derived from William James, her notion of time as a series of discrete moments, rather than a linear progression, allowed her to move toward a language drained of conventional meaning and charged, through repetition (for example, her "Rose is a rose is a rose is a rose"), with the insistent, recurrent obsessions of her characters' consciousnesses.[4]

Stein's poem, "If I Told Him: A Completed Portrait of Picasso," written two decades after he painted her famous portrait, features her characteristic, slightly varied repetitions and disordering of words and phrases; she challenges us to consider the relationship between the meanings of words and their form—that is, where and how they are used in the poem. As in a Cubist painting, a "completed portrait" is not necessarily a full image in the conventional sense. Rather, it is a record, so to speak, of observation and perception from a multiplicity of angles. The poem is best heard in its entirety—read by Stein herself—to experience the "continuous presence" of its nonlinear style. What follows are several lines that, essentially, have been chosen arbitrarily:

> Exact resemblance. To exact resemblance the exact resemblance as exact as a resemblance, exactly as resembling, exactly resembling, exactly in resemblance exactly a resemblance, exactly and resemblance. For this is so.
>
> Because. Now actively repeat at all, now actively repeat at all, now actively repeat at all.
>
> Have hold and hear, actively repeat at all.[5]

The Lost Generation

In *A Moveable Feast*, Ernest Hemingway's memoir about his early years as a struggling journalist and writer in Paris, he recalls a conversation with Gertrude Stein that would coin the phrase the "Lost Generation" to describe the group of local and expatriate writers who frequented her salon at 27 rue de Fleurus. The prompt was a story Stein told Hemingway about a young garage mechanic servicing her car who drew criticism about his abilities from his older employer. Frustrated by the boy's performance, the owner shouted, "You are all a '*génération perdue*'" (perdue is French for "lost"). Stein added, "That is what you are. That's what you all are...all of you young people who served in the war. You are a lost generation."

Among the "Lost Generation" writers—those who came of age during World War I—were Ernest Hemingway, T. S. Eliot, James Joyce, and Aldous Huxley.

ERNEST HEMINGWAY Ernest Hemingway (1899–1961), a native of Illinois, was quite young to serve in World War I, but serve he did. Much of his fiction is set in that war and other wars of the period, such as the Spanish Civil War, a military revolt against the Republican Spanish government. The rebels, called Nationalists, were aided by Nazi Germany and fascist Italy. The Republicans, on the other hand, were supported by the communist Soviet Union and International Brigades made up of European and U.S. volunteers. Hemingway's experiences in reporting that war provided the backdrop for perhaps his greatest novel, *For Whom the Bell Tolls* (1940). His first important novel, *The Sun Also Rises* (1926), chronicles expatriates who are physically and psychologically damaged by World War I and who wander through Europe, particularly Spain. The characters

4. Sandra M. Gilbert and Susan Gubar, *The Norton Anthology of Literature by Women: The Tradition in English* (New York and London: W. W. Norton, 1985), p. 1306.

5. http://www.english.upenn.edu/~jenglish/Courses/Spring02/104/steinpicasso.html

in *The Sun Also Rises* are lost. Their lives go around in circles as they have some sexual liaisons, get into some minor trouble, and are rescued. In that novel, Hemingway sets up the bullfighter as a hero, because the bullfighter faces death with honor, with grace under pressure.

Hemingway did not settle in one place for long. He lived in Europe but also in Cuba and Key West, Florida. One of the great stories about Hemingway—which may or may not be accurate, but is in keeping with his persona as a formidable hunter, boxer, soldier, and raconteur—is that he personally entered and "liberated" Paris, by seizing the bars at the Ritz and Crillon Hotels, before the Free French army and the U.S. army formally liberated the city from the German occupation.

Reading 22.4 is from one of Hemingway's short stories, "In Another Country," published in 1927. It, too, is about World War I, during which a very young Hemingway served as an ambulance driver and was wounded by shrapnel. He fell in love with his Red Cross nurse, an event that inspired his novel *A Farewell to Arms* (1929).

The story provides a fine example of Hemingway's writing style, which one critic suggested might lead to a grade of F in a high school because of its use of small words and its repetition. But the language is purposeful. It builds and builds. Writers are generally taught to try to avoid using the same word twice in the same sentence or even the same paragraph. But notice Hemingway's repeated use of words such as *fall* (the season), *cold*, and *wind*. Moreover, if you read the first paragraph aloud, you will discover that several lines have a poetic meter. The story is about injured soldiers in a hospital. They will recover, supposedly, and the rehabilitation machines will help them—supposedly. What, the reader may ask, is the other country? Is it Italy, the hospital, or something else? The soldiers in the story, clearly, have lost their way as well as their limbs:

READING 22.4 ERNEST HEMINGWAY

From "In Another Country"

In the fall the war was always there, but we did not go to it any more. It was cold in the fall in Milan and the dark came very early. Then the electric lights came on, and it was pleasant along the streets looking in the windows. There was much game hanging outside the shops, and the snow powdered in the fur of the foxes and the wind blew their tails. The deer hung stiff and heavy and empty, and small birds blew in the wind and the wind turned their feathers. It was a cold fall and the wind came down from the mountains.

We were all at the hospital every afternoon, and there were different ways of walking across the town through the dusk to the hospital. Two of the ways were alongside canals, but they were long. Always, though, you crossed a bridge across a canal to enter the hospital. There was a choice of three bridges. On one of them a woman sold roasted chestnuts. It was warm, standing in front of her charcoal fire, and the chestnuts were warm afterward in your pocket. The hospital was very old and very beautiful, and you entered through a gate and walked across a courtyard and out a gate on the other side. There were usually funerals starting from the courtyard. Beyond the old hospital were the new brick pavilions, and there we met every afternoon and were all very polite and interested in what was the matter, and sat in the machines that were to make so much difference.

T. S. ELIOT The year 1922 was a turning point for literary Modernism. In that year, T. S. Eliot (1888–1965), a U.S. expatriate living in England, published his poem *The Waste Land* and James Joyce, an expatriate Irish writer living on the Continent, published his novel *Ulysses*. In their respective works, Eliot and Joyce reflect some of the primary characteristics of what is called the *modernist temper* in literature. There is a fragmentation of line and image, an abandonment of traditional forms, an overwhelming sense of alienation and human homelessness (both authors were self-imposed exiles), an ambivalence about traditional culture, an intense desire to find some anchor in a past that seems to be escaping, a blurring of the distinction between reality "out there" and the world of subjective experience, and, finally, a straining and pushing of language to provide new meanings for a world the writers see as exhausted.

Both Eliot and Joyce reflect the conviction that, in Yeats's phrase, "the centre cannot hold." For Joyce, only art would give people a new worldview that would provide meaning. Eliot felt that if culture was to survive, people had to recover a sense of cultural continuity through a linkage of the artistic and religious tradition of the past. That perceived need for past cultural links helps explain why Eliot's poems are filled with allusions to works of art and literature as well as fragments from Christian rituals.

The gradual shift from cultural despair in *The Waste Land* can be traced in Eliot's later poems, beginning with "The Hollow Men" (1925) and "Ash Wednesday" (1930) and culminating in *Four Quartets*, which were completed in the early 1940s. The *Four Quartets* were Eliot's mature affirmation of his Christian faith as a bulwark against the ravages of Modernist culture. To read *The Waste Land* and the *Four Quartets* in tandem is to see one way in which a sensitive mind moved from chaos to stability in the period between the wars.

Eliot's "The Love Song of J. Alfred Prufrock," written in 1920, has one of the more interesting similes in English literature:

> …the evening is spread out against the sky
> like a patient etherized upon a table; …

JAMES JOYCE Before World War I, Joyce (1882–1941) had already published his collection of short stories under the title *Dubliners* (1914) and his *Portrait of the Artist as a Young Man* (1916). The former is a series of linked short stories in which people come to some spiritual insight (which Joyce called an

epiphany), while the latter is a thinly disguised autobiographical memoir of Joyce's youth before he left for the Continent in self-imposed exile after his graduation from college. With the 1922 publication of *Ulysses*, Joyce was recognized as a powerful innovator in literature. In 1939, two years before his death, Joyce published the dauntingly difficult *Finnegans Wake*. Joyce once said that *Ulysses* was a book of the day (the action takes place in one day) while *Finnegans Wake* was a haunting dream book of the night.

Joyce's blend of myth and personal story, his many-layered puns and linguistic allusions, his fascination with stream of consciousness, his sense of the artist alienated from his roots, and his credo of the artist as maker of the world have all made him one of the watershed influences on literature in the 20th century.

Ulysses's final episode (or chapter) chronicles the thoughts of the concert singer Molly Bloom, the spouse of Leopold Bloom, an advertising agent. The episode begins and ends with the word *yes*, which is also repeated throughout. Reading 22.5 shows the end of the novel but begins with one of the yesses. Joyce had elsewhere written that *yes* is "the female word"—assuming, traditionally, that the male is the sexual aggressor and the female is the gatekeeper. The episode title "Penelope" refers to Ulysses's wife, Molly Bloom's counterpart (Leopold Bloom is the ironic distorted mirror image of the heroic Ulysses). *Ulysses* is intended to portray the characters' **stream of consciousness**, as if they were lying on the couch of the psychoanalyst and uttering, uncensored, every thought that came into mind:

READING 22.5 JAMES JOYCE

From *Ulysses*, episode 18, "Penelope"

yes 16 years ago my God after that long kiss I near lost my breath yes he said was a flower of the mountain yes so we are flowers all a womans body yes that was one true thing he said in his life and the sun shines for you today yes that was why I liked him because I saw he understood or felt what a woman is and I knew I could always get round him and I gave him all the pleasure I could leading him on till he asked me to say yes and I wouldnt answer first only looked out over the sea and the sky I was thinking of so many things he didnt know of Mulvey and Mr Stanhope and Hester and father and old captain Groves and the sailors playing all birds fly and I say stoop and washing up dishes they called it on the pier and the sentry in front of the governors house with the thing round his white helmet poor devil half roasted and the Spanish girls laughing in their shawls and their tall combs and the auctions in the morning the Greeks and the jews and the Arabs and the devil knows who else from all the ends of Europe and Duke street and the fowl market all clucking outside Larby Sharans and the poor donkeys slipping half asleep and the vague fellows in the cloaks asleep in the shade on the steps and the big wheels of the carts of the bulls and the old castle thousands of years old yes and those handsome Moors all in white and turbans

like kings asking you to sit down in their little bit of a shop and Ronda with the old windows of the posadas glancing eyes a lattice hid for her lover to kiss the iron and the wineshops half open at night and the castanets and the night we missed the boat at Algeciras the watchman going about serene with his lamp and O that awful deepdown torrent O and the sea the sea crimson sometimes like fire and the glorious sunsets and the figtrees in the Alameda gardens yes and all the queer little streets and pink and blue and yellow houses and the rosegardens and the jessamine and geraniums and cactuses and Gibraltar as a girl where I was a Flower of the mountain yes when I put the rose in my hair like the Andalusian girls used or shall I wear a red yes and how he kissed me under the Moorish wall and I thought well as well him as another and then I asked him with my eyes to ask again yes and then he asked me would I yes to say yes my mountain flower and first I put my arms around him yes and drew him down to me so he could feel my breasts all perfume yes and his heart was going like mad and yes I said yes I will Yes.

FRANZ KAFKA Perhaps the quintessential Modernist in literature is the Czech writer Franz Kafka (1883–1924). A German-speaking Jew born and raised in Prague, Kafka was by heritage alienated from both the majority language of his city and its predominant religion. An obscure clerk for a major insurance company, he published virtually nothing during his lifetime. He ordered that his works be destroyed after his death, but a friend did not accede to his wish. What we have from Kafka's pen is so unique that it has contributed the adjective *Kafkaesque* to our language. A Kafkaesque experience is one in which a person feels trapped by forces that seem simultaneously ridiculous, threatening, and incomprehensible.

This is precisely the tone of Kafka's fiction. In *The Trial* (1925), Josef K. (note the near anonymity of the name) is arrested for a crime that is never named, by a court authority that is not part of the usual system of justice. At the end of the novel, the hero (if he can be called that) is executed in a vacant lot by two seedy functionaries of the court. In *The Castle* (1926), a land surveyor known merely as K., hired by the lord of a castle overlooking a remote village, attempts in vain to approach the castle, to communicate with its lord and learn of his duties. In time, he comes to the point where he would be satisfied just to know if there actually was a lord who hired him.

No critic has successfully uncovered the meaning of these novels—if in fact they should be called novels. Kafka's work might better be called extended parables that suggest, but do not explicate, a terrible sense of human guilt, a feeling of loss, and an air of oppression and muted violence.

The parable in Reading 22.6 from *The Trial*, told to Josef K. in a cathedral, is meant to be an enigma and a puzzle. As a parable, it mirrors the confusion of the hero, who is pursued by the court for crimes he cannot identify, a guilt he recognizes, but whose source he cannot name:

READING 22.6 FRANZ KAFKA

From *The Trial*, chapter 9, "In the Cathedral, Before the Law"

Before the Law stands a doorkeeper. To this doorkeeper there comes a man from the country who begs for admittance to the Law. But the doorkeeper says that he cannot admit the man at the moment. The man, on reflection, asks if he will be allowed, then, to enter later. 'It is possible,' answers the doorkeeper, 'but not at this moment.' Since the door leading into the Law stands open as usual and the doorkeeper steps to one side, the man bends down to peer through the entrance. When the doorkeeper sees that, he laughs and says: 'If you are so strongly tempted, try to get in without my permission. But note that I am powerful. And I am only the lowest doorkeeper. From hall to hall, keepers stand at every door, one more powerful than the other. And the sight of the third man is already more than even I can stand.' These are difficulties which the man from the country has not expected to meet, the Law, he thinks, should be accessible to every man and at all times, but when he looks more closely at the doorkeeper in his furred robe, with his huge pointed nose and long thin Tartar beard, he decides that he had better wait until he gets permission to enter. The doorkeeper gives him a stool and lets him sit down at the side of the door. There he sits waiting for days and years. He makes many attempts to be allowed in and wearies the doorkeeper with his importunity. The doorkeeper often engages him in brief conversation, asking him about his home and about other matters, but the questions are put quite impersonally, as great men put questions, and always conclude with the statement that the man cannot be allowed to enter yet. The man, who has equipped himself with many things for his journey, parts with all he has, however valuable, in the hope of bribing the doorkeeper. The doorkeeper accepts it all, saying, however, as he takes each gift: 'I take this only to keep you from feeling that you have left something undone.' During all these long years the man watches the doorkeeper almost incessantly. He forgets about the other doorkeepers, and this one seems to him the only barrier between himself and the Law. In the first years he curses his evil fate aloud; later, as he grows old, he only mutters to himself. He grows childish, and since in his prolonged study of the doorkeeper he has learned to know even the fleas in his fur collar, he begs the very fleas to help him and to persuade the doorkeeper to change his mind. Finally his eyes grow dim and he does not know whether the world is really darkening around him or whether his eyes are only deceiving him. But in the darkness he can now perceive a radiance that streams inextinguishably from the door of the Law. Now his life is drawing to a close. Before he dies, all that he has experienced during the whole time of his sojourn condenses in his mind into one question, which he has never yet put to the doorkeeper. He beckons the doorkeeper, since he can no longer raise his stiffening body. The doorkeeper has to bend far down to hear him, for the difference in size between them has increased very much to the man's disadvantage. 'What do you want to know now?' asks the doorkeeper, 'you are insatiable.' 'Everyone strives to attain the Law,' answers the man, 'how does it come about, then, that in all these years no one has come seeking admittance but me?' The doorkeeper perceives that the man is nearing his end and his hearing is failing, so he bellows in his ear: 'No one but you could gain admittance through this door, since this door was intended for you. I am now going to shut it.'

ALDOUS HUXLEY The English novelist Aldous Leonard Huxley (1894–1963) saw the unrestrained growth of technology as an inevitable tool of totalitarian control over individuals and society. His 1932 novel *Brave New World* is set in the far distant future: 600 A.F.—the abbreviation for "after Ford," referring to Henry Ford, who has been deified as the founder of industrial society. In this society, babies are born and raised in state hatcheries according to the needs of the state. They are produced in five classes (from Alpha to Epsilon) so that the exact numbers of needed intellectuals (Alphas) and menials (Epsilons) are produced. The goal of society is expressed in three words: Community/Identity/Stability. All sensory experience is supplied either by machines or by a pleasure drug called *soma*. Individuality, family relationships, creativity, and a host of other "unmanageable" human qualities have been eradicated from society by either coercion or programming.

Toward the end of the novel, there is a climactic conversation between John Savage (known as "the Savage"), a boy from the wilds of New Mexico raised outside the control of society, and Mustapha Mond, one of the controllers of the "brave new world" of the future. Patiently, Mond explains to the young man the reasons why certain repressions are inevitable and necessary in the society of the future. Savage asks why workers in Mond's society waste their time on entertainments such as "feelies"—why they are not permitted to see something of quality, such as Shakespeare's *Othello*. Mond informs him that people in his world would not understand *Othello*:

READING 22.7 ALDOUS HUXLEY

From *Brave New World*, chapter 16

"Because our world is not the same as Othello's world. You can't make flivvers without steel—and you can't make tragedies without social instability. The world's stable now. People are happy; they get what they want, and they never want what they can't get. They're well off; they're safe; they're never ill; they're not afraid of death; they're blissfully ignorant of passion and old age; they're plagued with no mothers or fathers; they've got no wives, or children, or lovers to feel strongly about; they're so conditioned that they practically can't help behaving as they ought to behave. And if anything should go wrong,

there's *soma*. Which you go and chuck out of the window in the name of liberty, Mr. Savage. *Liberty!*" He laughed. "Expecting Deltas to know what liberty is! And now expecting them to understand *Othello*! My good boy!"

The Savage was silent for a little. "All the same," he insisted obstinately, "*Othello's* good, *Othello's* better than those feelies."

"Of course it is," the Controller agreed. "But that's the price we have to pay for stability. You've got to choose between happiness and what people used to call high art. We've sacrificed the high art. We have the feelies and the scent organ instead."

"But they don't mean anything."

"They mean themselves; they mean a lot of agreeable sensations to the audience."

The reader understands Huxley's warning that the great humanistic achievements—literature, art, religion—are threatening forces to any totalitarian society and as such are logical targets for a scientifically constructed society. His explanations now have a prescient and somber reality to us in the light of what we know about the real totalitarian societies of our own time.

Post-War Literature in the U.S.

SINCLAIR LEWIS U.S. novelist Sinclair Lewis (1885–1951) was not one of the Lost Generation, but his early writing, too, was affected by the war and postwar values. His novel *Babbitt* (1922) satirized what he saw as the dangers of America's growing contentment and intellectual apathy. Lewis's philistine hero, George Babbitt, became synonymous with mindless materialism, the love of gadgets and comfort, and passive, indiscriminate receptiveness to the opinions of others. The novel was a scathing indictment of the middle-class definition of fulfillment.

In the following passage, we learn what counts as "art" for Babbitt as well as how he forms critical opinions about culture:

READING 22.8 SINCLAIR LEWIS

From *Babbitt*, chapter 6

Babbitt looked up irritably from the comic strips in the *Evening Advocate*. They composed his favorite literature and art, these illustrated chronicles in which Mr. Mutt hit Mr. Jeff with a rotten egg, and Mother corrected Father's vulgarisms by means of a rolling-pin. With the solemn face of a devotee, breathing heavily through his open mouth, he plodded nightly through every picture, and during the rite he detested interruptions. Furthermore, he felt that on the subject of Shakespeare he wasn't really an authority. Neither the *Advocate-Times*, the *Evening*

Advocate, nor the *Bulletin of the Zenith Chamber of Commerce* had ever had an editorial on the matter, and until one of them had spoken he found it hard to form an original opinion.

Later we learn about Babbitt's views on religion, reward and punishment, and the concern over what we today call "optics"—what we, and our behavior, look like to other people. In the context of this excerpt, it is interesting to reflect on words in the Gospel of Matthew: "Beware of practicing your piety before men in order to be seen by them; for then you will have no reward from your Father who is in heaven":

READING 22.9 SINCLAIR LEWIS

From *Babbitt*, chapter 16

Actually, the content of his theology was that there was a supreme being who had tried to make us perfect, but presumably had failed; that if one was a Good Man he would go to a place called Heaven (Babbitt unconsciously pictured it as rather like an excellent hotel with a private garden), but if one was a Bad Man, that is, if he murdered or committed burglary or used cocaine or had mistresses or sold non-existent real estate, he would be punished. Babbitt was uncertain, however, about what he called "this business of Hell." He explained to Ted, "Of course I'm pretty liberal; I don't exactly believe in a fire-and-brimstone Hell. Stands to reason, though, that a fellow can't get away with all sorts of Vice and not get nicked for it, see how I mean?"

Upon this theology he rarely pondered. The kernel of his practical religion was that it was respectable, and beneficial to one's business, to be seen going to services; that the church kept the Worst Elements from being still worse; and that the pastor's sermons, however dull they might seem at the time of taking, yet had a voodooistic power which "did a fellow good—kept him in touch with Higher Things."

The Harlem Renaissance

Between the two World Wars, a cultural movement took root in a section of Manhattan known as Harlem, where a concentration of African American writers, artists, intellectuals, and musicians produced a conspicuous body of work that was a reflection of and response to issues concerning members of the black community. The movement became known as the **Harlem Renaissance**.

Writers and philosophers including Zora Neale Hurston, James Weldon Johnson, and Alain LeRoy Locke (known as the "Dean of the Harlem Renaissance") probed the meanings of African American identity and culture; Countee Cullen, Helene Johnson, Claude McKay, and Langston Hughes wrote poetry that spoke to the African American experience in postwar

America; Hale Woodruff, Sargent Johnson, Augusta Savage, Aaron Douglas (see Fig. 22.7), and Romare Bearden (see Fig. 23.34) aimed a spotlight on the history, beliefs, hopes, and discontents of African Americans, the harsh reality of their lives, and the resistance to despair that was evident in the explosion of cultural pride that marked the Harlem Renaissance.

Without a doubt, music—and specifically jazz—was the most far-reaching and influential artistic development of the Harlem Renaissance. Harlem's Cotton Club featured the talents of those who would become the jazz greats of the century: Duke Ellington, Louis Armstrong, Billie Holiday, Bessie Smith, and Jelly Roll Morton, to name a few. The art and music of the period is discussed later in this chapter.

LANGSTON HUGHES Harlem Renaissance poetry and fiction features abiding themes of African American experiences: ancestral roots in Africa; the quest for dignity in a culture of racism; the debate over the degree to which African American values should be interwoven with—as opposed to distinct from—the majority culture; and the role of religion in African American life. Behind most of these questions was one posed at the beginning of the century by W.E.B. DuBois (1868–1963): what self-identity can African Americans affirm when they are balancing their African heritage, their place in white America, and their ability to endure racism? Those issues burn at the heart of the Harlem Renaissance, as suggested in a poem by one of its best-known figures—the poet, novelist, playwright, and social activist, James Mercer Langston Hughes (1902–1967). "I, Too, Sing America" is an answer, so to speak, to Walt Whitman's late 19th-century poem, "I Hear America Singing":

READING 22.10 LANGSTON HUGHES

"I, Too"

I, too, sing America.

I am the darker brother.
They send me to eat in the kitchen
When company comes,
But I laugh,
And eat well,
And grow strong.

Tomorrow,
I'll be at the table
When company comes.
Nobody'll dare
Say to me,
"Eat in the kitchen,"
Then.

Besides,
They'll see how beautiful I am
And be ashamed—

I, too, am America.

CONNECTIONS Langton Hughes's "I, Too" is, in effect, a response to Walt Whitman's 19th-century poem:*

> I hear America singing, the varied carols I hear,
> Those of mechanics, each one singing his as it
> should be blithe and strong,
> The carpenter singing his as he measures his plank
> or beam,
> The mason singing his as he makes ready for work,
> or leaves off work,
> The boatman singing what belongs to him in his boat,
> the deckhand singing on the steamboat deck,
> The shoemaker singing as he sits on his bench, the
> hatter singing as he stands,
> The wood-cutter's song, the ploughboy's on his
> way in the morning, or at noon intermission or at
> sundown,
> The delicious singing of the mother, or of the young
> wife at work, or of the girl sewing or washing,
> Each singing what belongs to him or her and to
> none else,
> The day what belongs to the day—at night the
> party of young fellows, robust, friendly,
> Singing with open mouths their strong melodious
> songs.

* http://www.poetryfoundation.org/poem/175779.

Hughes also invented "jazz poetry," a literary art form that took root among Harlem writers. Like Gertrude Stein's poetry and prose, it utilized unconventional rhythm, repetition, and reinvention (or improvisation). In 1920s Harlem, both jazz and poetry developed along similar lines and the artistic genres influenced each other. Hughes said, "... jazz to me is one of the inherent expressions of Negro life in America; the eternal tom-tom beating in the Negro soul—the tom-tom of revolt against weariness in a white world, a world of subway trains, and work, work, work; the tom-tom of joy and laughter, and paint swallowed in a smile."[6] The style of his 1925 poem, "The Weary Blues," written in 1925, illustrates his affinity for jazz:

> Droning a drowsy syncopated tune,
> Rocking back and forth to a mellow croon,
> I heard a Negro play.
> Down on Lenox Avenue the other night
> By the pale dull pallor of an old gas light
> He did a lazy sway . . .
> He did a lazy sway . . .
> To the tune o' those Weary Blues.

6. Langston Hughes, "The Negro Artist and the Racial Mountain," *The Nation*, 1926.

THE VISUAL ARTS: 1914 TO 1945

The visual arts moved in many directions in the three decades during and between the two World Wars. The New Objectivity, as we have seen, parted ways with the abstract and idealistic tendencies of its parent German Expressionism to fix a harsh light on the grim realities—and absurdities—of contemporary life in a postwar world. During the war, in neutral Zurich, a nihilistic, anti-art movement called **Dada** arose, challenging the validity of culture and institutions in a world that seemed to have gone mad. Exploring the inner world of the unconscious became the basis of the art of the **Surrealists**. Sigmund Freud's emphasis on nonrational elements in human behavior struck a chord with those who had been horrified by the carnage of war.

Early 20th-century experiments with abstraction progressed toward more simplified and purer forms, leading, in countries like Holland and Russia, to completely **nonobjective** works—that is, images that have no reference to visible reality. Inspired by Modernism in general and these revolutionary artistic ideas in Russia in particular, the Bauhaus art school in Germany was founded on the near-Utopian principle of the "total work of art" in which all forms of art, design, and architecture would be brought together.

This period between the wars would also witness the intersection of art, nationalism, cultural identity, and social consciousness. European Modernism hit U.S. artists and audiences by storm with the New York Armory Show in 1913. Dada anti-art ideology found adherents in New York City, and surrealist techniques were appropriated by some American artists. But the strongest force in American art between the two World Wars was **social realism**. In the American Midwest, a stolid realism reflected regional values and, in New York City's Harlem, African American artists sought to fuse their common identity and cultural experiences with their idiosyncratic styles.

Dada

In 1916, during World War I, an international movement arose that declared itself against art—Dada. Responding to the absurdity of war and the insanity of a world that gave rise to it, the Dadaists declared that art—a reflection of this sorry state of affairs—was stupid and must be destroyed. Yet, in order to communicate their outrage, the Dadaists created works of art! This inherent contradiction spelled the eventual demise of their movement. Despite centers in Paris, Berlin, Cologne, Zürich, and New York City, Dada ended with a whimper in 1922.

The name *Dada* was supposedly chosen at random from a dictionary. It is an apt epithet. The nonsense term describes nonsense art—art that is meaningless, absurd, unpredictable. Although it is questionable whether this catchy label was in truth derived at random, the element of chance was important to the Dada art form. Dada poetry, for example, consisted of nonsense verses of random word combinations. Some works of art, such as the Dada collages, were constructed of materials found by chance and mounted randomly. Yet, however meaningless or unpredictable the poets and artists intended their products to be, in reality they were not. In an era influenced by the doctrine of psychoanalysis, the choice of even nonsensical words spoke something at least of the poet. Works of art supposedly constructed in random fashion also frequently betrayed the mark of some design.

MARCEL DUCHAMP In an effort to advertise their nihilistic views, the Dadaists assaulted the public with irreverence. Not only did they attempt to negate art, but they also advocated antisocial and amoral behavior. Marcel Duchamp offered for exhibition a urinal, turned on its back and titled *Fountain*. Later he summed up the Dada sensibility in works such as *L.H.O.O.Q. (Mona Lisa)* (see Fig. 22.10), in which he impudently defaced a color print of Leonardo da Vinci's masterpiece with a mustache and goatee.

Fortified by growing interest in psychoanalysis, Dada, with some modification, would provide the basis for a movement called Surrealism that began in the early 1920s.

Abstraction Comes to America

The **Fauves** and German **Expressionists** had an impact on art in the United States as well as Europe. Although the years before World War I in the United States were marked by an adherence to realism and subjects from everyday rural and urban life, a strong interest in European Modernism was brewing.

291 GALLERY The U.S. photographer Alfred Stieglitz propounded and supported the development of abstract art in the United States by exhibiting modern European works, along with those of U.S. artists who were influenced by the Parisian avant-garde—Picasso, Matisse, and others—in his 291 gallery (at 291 Fifth Avenue in New York). Georgia O'Keeffe was among the artists supported by Stieglitz.

GEORGIA O'KEEFFE

I said to myself—I'll paint what I see—what the flower is to me but I'll paint it big and they will be surprised into taking the time to look at it—I will make even busy New Yorkers take time to see what I see of flowers.

—GEORGIA O'KEEFFE

Throughout her long career, Georgia O'Keeffe (1887–1986) painted many subjects, from flowers to city buildings to the skulls of animals baked white by the sun of the desert Southwest. In each case, she captured the essence of her subjects by simplifying their forms. In 1924, the year O'Keeffe married Stieglitz, she began to paint enlarged flower pictures such as *White Iris* (**Fig. 22.4**). In these paintings, she magnified and abstracted the details of her botanical subjects, so that often a

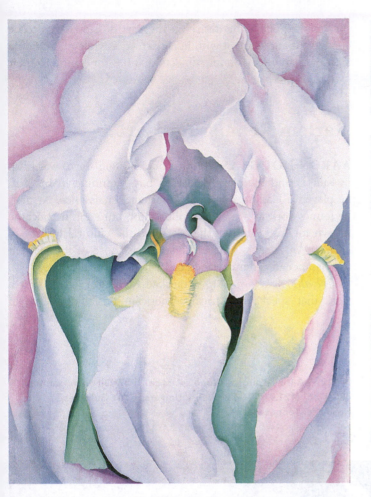

▲ **22.4** Georgia O'Keeffe, *White Iris*, 1924. Oil on canvas, 40" × 30" (101.6 × 76.2 cm). Virginia Museum of Fine Arts, Richmond, Virginia. O'Keeffe helped clear the path for women to join the ranks of the art world by drawing the attention of New York artists as early as 1916. Many of her paintings of flowers appear to be suggestive of female genitalia, but the artist denied any such implications.

large canvas was filled with but a fragment of the intersection of petals. These flowers have a yearning, reaching, organic quality, and her botany seems to function as a metaphor for zoology. That is, her plants are animistic; they seem to grow because of will, not merely because of the blind interactions of the unfolding of the genetic code with water, sun, and minerals.

And, although O'Keeffe denied any attempt to portray sexual imagery in these flowers (those who saw it, she said, were speaking about themselves and not her), the edges of the petals, in their folds and convolutions, are frequently reminiscent of parts of the female body. The sense of will and reaching renders these petals active rather than passive in their implied sexuality, so they seem symbolically to express a feminist polemic. This characteristic may be one of the reasons that O'Keeffe was "invited" to Judy Chicago's *Dinner Party* (see Fig. 23.31).

THE ARMORY SHOW Between 1908 and 1917, Stieglitz brought to 291—and thus to New York City—European Modernists, the likes of Toulouse-Lautrec, Cézanne, Matisse, Braque,

and Brancusi. In 1913, the sensational Armory Show—the International Exhibition of Modern Art held at the 69th Regiment Armory in New York City—assembled works by leading U.S. artists and an impressive array of Europeans, including Goya, Delacroix, Manet and the Impressionists, van Gogh, Gauguin, Picasso, and Kandinsky. Many more U.S. than European works were exhibited, but the latter dominated the show—raising the artistic consciousness of the Americans while raising some eyebrows. The most scandalous of the Parisian works, Marcel Duchamp's *Nude Descending a Staircase (No. 2)* (**Fig. 22.5**), which

▼ **22.5** Marcel Duchamp, *Nude Descending a Staircase (No. 2)*, 1912. Oil on canvas, 57⅞" × 35⅛" (147 × 89.2 cm). Philadelphia Museum of Art, Philadelphia, Pennsylvania. The painting in effect creates multiple exposures of a machine-tooled figure walking down a flight of stairs. The overlapping of shapes and the repetition of linear patterns blur the contours of the figure. Even though the *New York Times* art critic Julian Street labeled the painting "an explosion in a shingle factory," it symbolized the dynamism of the modern machine era.

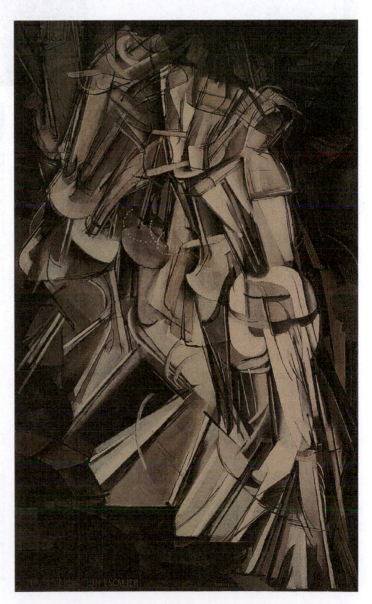

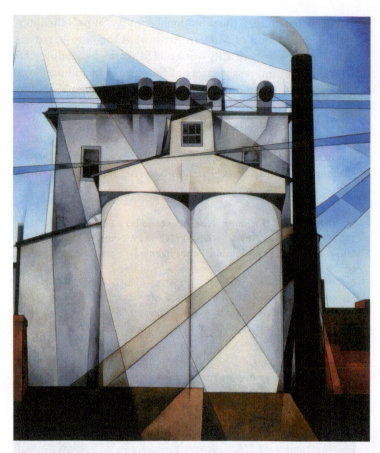

▲ **22.6** Charles Demuth, *My Egypt*, 1927. Oil on composition board, 35¾" × 30" (90.8 × 76.2 cm). Whitney Museum of American Art, New York, New York. The painting is of a grain elevator reduced to its essential forms. It is one of many industrial images the artist painted of his hometown, Lancaster, Pennsylvania.

reflects the styles of Cubism and Futurism, was dismissed as a "pile of kindling wood." But the message to U.S. artists was clear: Europe was the center of the art world—for now.

CHARLES DEMUTH In the years following the Armory Show, U.S. artists explored abstraction to new heights, finding ways to maintain a solid sense of subject matter in combination with geometric fragmentation and simplification. Charles Demuth (1883–1935) was one of a group of artists called Cubo-Realists, or Precisionists, who overlaid stylistic elements from **Cubism** and **Futurism** on authentic American imagery. *My Egypt* (**Fig. 22.6**) is a precise rendition of a grain elevator in Demuth's hometown of Lancaster, Pennsylvania. Diagonal lines—contradictory rays of light and shadow—sweep across the solid surfaces and lessen the intensity of the stone-like appearance of the masses. The shapes in *My Egypt* are reminiscent of limestone monoliths that form the gateways to ancient temple complexes such as that at Karnak in Egypt. The viewer cannot help being drawn to Demuth's title, which acknowledges the association of the architectural forms and, at the same time, asserts a sense of American pride and history in the possessive adjective *my*.

It seems to reflect the desire on the part of U.S. artists to be conversant and current with European style while maintaining a bit of chauvinism about subjects that have meaning to their own time and place.

Harlem Renaissance Art

AARON DOUGLAS Aaron Douglas (1899–1979) was born in Kansas and died in Tennessee, but beginning in his 20s, he played a leading role in the Harlem Renaissance. At first, he found work as a magazine illustrator, but soon he became known for his paintings that depicted the cultural history of African Americans. One of his aims, as those of the Harlem Renaissance in general, was to cultivate black pride.

Noah's Ark (**Fig. 22.7**) translates a biblical story into a work that speaks to African American sensibilities. One of

▼ **22.7** Aaron Douglas, *Noah's Ark*, ca. 1927. Oil on masonite, 48" × 36" (121.9 × 91.4 cm). Fisk University Art Galleries, Nashville, Tennessee. Forms are partially abstracted but recognizable. The painting, as with many of the artist's others, has hard edges, flat forms, and repeated geometric shapes.

▲ **22.8** Jacob Lawrence, *The Life of Harriet Tubman, No. 4*, 1939–1940. Casein tempera on gessoed hardboard, 12" × 17⅞" (30.5 × 45.4 cm). Hampton University Museum, Hampton, Virginia. The diagonal lines contribute to the sense of movement. Lawrence termed his style "Dynamic Cubism," although he asserted that the visual elements of Harlem provided his main inspiration.

seven paintings based on James Weldon Johnson's book *God's Trombones: Seven Negro Sermons in Verse* (1927), it expresses Douglas's powerful vision of the great flood. Animals enter the ark in pairs as lightning flashes about them, and the sky turns a hazy gray-purple with the impending storm. African men, rendered in rough-hewn profile, ready the ark and direct the action in a dynamically choreographed composition that takes possession of, and personalizes the biblical event for, Douglas's race and culture.

JACOB LAWRENCE Born in New Jersey, Jacob Lawrence (1917–2000) moved to Harlem with his family as a teenager. He, like Aaron Douglas, would bring features reminiscent of African masks into his paintings. His best-known works address themes such as slavery, African American migration northward from the South, Harlem lifestyles, and World War II.

Lawrence used assertive sticklike diagonals to give the slave children in his painting *The Life of Harriet Tubman, No. 4* (**Fig. 22.8**) a powerful sense of movement and directionality. While the horizon line provides a somewhat stable world, the brightly clad children perform acrobatic leaps, their branch-like limbs akin to the wood above. The enduring world implied by the horizon is shattered by the agitated back-and-forth of the brushed lines that define ground and sky. Such turmoil presumably awaits the children once they mature and realize their lot in life.

Surrealism and the Freudian Unconscious

In 1899, on the threshold of the century, the Viennese physician Sigmund Freud (1856–1939) published *The Interpretation of Dreams*, one of the most influential works of modern times. According to Freud's **psychoanalytic theory**, deep in the unconscious mind—which he called the *id*—were chaotic emotional forces of life and love (a life instinct called *Eros*) and death and violence (a death instinct called *Thanatos*). These unconscious forces, often at war with each other, are kept in check by the *ego*, which is the more conscious self, and the *superego*, which is the formally received training of parental control and social reinforcements. Human life is shaped largely by the struggle between the id, ego, and superego to prevent the submerged drives of the *unconscious* from emerging. One way to penetrate the murky realm of the human unconscious, according to Freud, is via dreams. In the life of sleep and dreams, the ego and superego are less likely to be able to keep primitive impulses repressed. "The dream," Freud wrote, "is the royal road to the unconscious." To put it simply, Freud turned the modern mind inward to explore those hidden depths of the human personality where he believed the most primitive and dynamic forces of life dwell:

READING 22.11 SIGMUND FREUD

From *The Interpretation of Dreams*, VI. The Dream Work (continued). E. Representation in Dreams by Symbols: Some Further Typical Dreams

Dreams employ...symbolism to give a disguised representation to their latent thoughts....The Emperor and the Empress (King and Queen) in most cases really represent the dreamer's parents; the dreamer himself or herself is the prince or princess....All elongated objects, sticks, tree-trunks, umbrellas (on account of the opening, which might be likened to an erection), all sharp and elongated weapons, knives, daggers, and pikes, represent the male member....Small boxes, chests, cupboards, and ovens correspond to the female organ; also cavities, ships, and all kinds of vessels. A room in a dream generally represents a woman; the description of its various entrances and exits is scarcely calculated to make us doubt this interpretation. The interest as to whether the room is "open" or "locked" will be readily understood in this connection....The dream of walking through a suite of rooms signifies a brothel or a harem....Steep inclines,

ladders, and stairs, and going up or down them, are symbolic representations of the sexual act. Smooth walls over which one climbs, facades of houses, across which one lets oneself down—often with a sense of great anxiety—correspond to erect human bodies, and probably repeat in our dreams childish memories of climbing up parents or nurses. "Smooth" walls are men; in anxiety dreams one often holds firmly to "projections" on houses. Tables, whether bare or covered, and boards, are women, perhaps by virtue of contrast, since they have no protruding contours.... Of articles of dress, a woman's hat may very often be interpreted with certainty as the male genitals. In the dreams of men one often finds the necktie as a symbol for the penis; this is not only because neckties hang down in front of the body, and are characteristic of men, but also because one can select them at pleasure, a freedom which nature prohibits as regards the original of the symbol.... It is quite unmistakable that all weapons and tools are used as symbols for the male organ: e.g., ploughshare, hammer, gun, revolver, dagger, sword, etc.... To play with or to beat a little child is often the dream's representation of masturbation. The dream-work represents castration by baldness, hair-cutting, the loss of teeth, and beheading. As an insurance against castration, the dream uses one of the common symbols of the penis in double or multiple form; and the appearance in a dream of a lizard—an animal whose tail, if pulled off, is regenerated by a new growth—has the same meaning. Most of those animals which are utilized as genital symbols in mythology and folklore play this part also in dreams: the fish, the snail, the cat, the mouse (on account of the hairiness of the genitals), but above all the snake, which is the most important symbol of the male member. Small animals and vermin are substitutes for little children, e.g., undesired sisters or brothers. To be infected with vermin is often the equivalent for pregnancy.—As a very recent symbol of the male organ I may mention the airship, whose employment is justified by its relation to flying, and also, occasionally, by its form.

Freud's ideas were readily accessible to large numbers of European intellectuals in the years following the war. Literary and artistic proponents of Surrealism, established under the leadership of the French poet and critic, André Breton, were particularly interested in using Freud's theories about the dream world of the unconscious as well as his therapy technique of *free association* as a basis for a new aesthetics. Free association allowed for spontaneous, unrestrained associations of ideas and feelings that might be repressed in individuals who experienced trauma. Freud's free association was analogous in many respects to William James's *stream of consciousness*, introduced in his 1890 publication, *The Principles of Psychology*. Stream of consciousness was an important element in the writing styles of Marcel Proust (see Chapter 21) and Virginia Woolf (see Reading 22.3).

The literary version of free association had already been seen among the Dadaists, whose *automatic writing* exercises were intended to purge the mind of purposeful thought and to release a series of free associations that revealed the unconscious. Words were not meant to denote their literal meanings but to symbolize the often seething contents of the inner psyche.

After the war, some Dadaists broke with the movement and joined the Surrealists, artists and writers who had gathered around the Parisian journal, *Littérature*, edited by Breton. In 1924, Breton published his first *Surrealist Manifesto*, which paid explicit homage to Freud's ideas on the subjective world of the dream and the unconscious:

> Surrealism, noun, masc., pure psychic automatism by which it is intended to express either verbally or in writing, the true function of thought. Thought dictated in the absence of all control exerted by reason, and outside all aesthetic or moral preoccupations.
>
> Encycl. Philos. Surrealism is based on the belief in the superior reality of certain forms of association heretofore neglected, in the omnipotence of the dream, and in the disinterested play of thought. It leads to the permanent destruction of all other psychic mechanisms and to its substitution for them in the solution of the principal problems of life.[7]

From the beginning, Surrealist artists expounded two very different methods of working. **Illusionistic Surrealism**, exemplified by artists such as Salvador Dalí and Yves Tanguy, rendered the irrational content, absurd juxtapositions, and metamorphoses of the dream state in a highly illusionistic manner. The other, called **Automatist Surrealism**, was used to divulge mysteries of the unconscious through methods analogous to the automatic writing on the literary side of Dada and Surrealism. The Automatist style is typified by Joan Miró and André Masson.

Some of the first artists associated with Surrealism, like the American Man Ray, also experimented with both still photography and moving pictures. The motion picture camera could produce effects that corresponded closely with Surrealist intentions: images could be distorted and could dissolve, blend, and disappear. Dalí, for example, collaborated with his compatriot film director Luis Bunuel to produce two famous Surrealist films: *Un Chien Andalou* (1929) and *L'Age d'Or* (1930).

SALVADOR DALÍ One of the few household names in the history of art belongs to a leading Surrealist figure, the Spaniard Salvador Dalí (1904–1989). His reputation for leading an unusual—one could say surreal—life would seem to precede his art. Even those not familiar with his canvases likely have a picture of the mustached Dalí in their minds.

7. Robert Goldwater and Marco Treves, eds., *Artists on Art* (London: John Murray Publishers Ltd., 1974), p. 426.

CONNECTIONS In the year 1938, the founder of Surrealism—André Breton—traveled to Mexico to visit with the Soviet communist leader, Leon Trotsky. Trotsky had come to the country seeking political asylum from his rival Joseph Stalin, and, for two years, had lived in the home of the famed Mexican muralist, Diego Rivera, and his artist-wife, Frida Kahlo. It was on this visit that Breton saw Kahlo's work and attempted to bring her into the fold of the Surrealist movement in Paris—an association she ultimately rejected. Although much of her work may be described as a hybrid of fantasy and reality, Kahlo steadfastly maintained, "I never paint dreams. I paint my own reality."

Frida Kahlo's *The Two Fridas* (1939) (Fig. 16.15A)

Dalí began his painting career, however, in a somewhat more conservative manner, adopting, in turn, Impressionist, pointillist, and Futurist styles. Following these forays into contemporary painting, he sought academic training at the Royal Academy of Fine Arts in Madrid. This experience steeped him in a tradition of illusionistic realism that he never abandoned.

In what may be Dalí's most famous canvas, *The Persistence of Memory* (**Fig. 22.9**), the drama of the dreamlike imagery is enhanced by his trompe l'oeil technique. Here, in a barren landscape of incongruous forms, time, as almost all else, has expired. A watch is left crawling with insects like scavengers over carrion; three other watches hang limp and useless over a rectangular block, a dead tree, and a lifeless, amorphous creature that bears a curious resemblance to Dalí. The artist conveys the world of the dream, juxtaposing unrelated objects in an extraordinary situation. But a haunting sense of reality threatens the line between perception and imagination. Dalí's is, in the true definition of the term, a surreality—or reality above and beyond reality.

JOAN MIRÓ

My way is to seize an image that moment it has formed in my mind, to trap it as a bird and to pin it at once to canvas. Afterward I start to tame it, to master it. I bring it under control and I develop it.

—JOAN MIRÓ

Not all of the Surrealists were interested in rendering their enigmatic personal dreams. Some found this highly introspective subject matter meaningless to the observer and sought a more universal form of expression. The Automatist Surrealists believed that the unconscious held such universal imagery, and they attempted to reach it through spontaneous, or automatic, drawing. Artists of this group, such as Joan Miró (1893–1983), sought to eliminate all thought from their minds and then trace their brushes across the surface of the canvas. The organic shapes derived from intersecting skeins of line were believed to be unadulterated by conscious thought and thus drawn from the unconscious. Once the basic designs had been outlined, a conscious period of work could follow in which the artist intentionally applied his or her craft to render them in their final form. But because no conscious control was to be exerted in determining the early course of the designs, the Automatist method was seen as spontaneous, as employing chance and accident. Needless to say, the works are abstract, although some shapes are amoebic.

Miró was born near Barcelona and spent his early years in local schools of art learning how to paint like the French Modernists. He practiced several styles, ranging from Romanticism to Realism to Impressionism, but Cézanne and van Gogh seem

► **22.9** Salvador Dalí, *The Persistence of Memory*, 1931. Oil on canvas, 9½" × 13" (24.1 × 33 cm). Museum of Modern Art, New York, New York.
In this work, which the artist called a "dream photograph," Dalí uses precise representation of Surrealistic objects. The melted watches and the swarming ants are suggestive of decay. The fleshy shape in the center, with a watch draped over its side, suggests the profile of the artist's own face.

COMPARE + CONTRAST

Mona Lisa: From Portrait to Pop Icon

I f you were asked to close your eyes and picture the top five works of art in all of history, surely one of the first couple that would come up on your memory screen would be none other than Leonardo's *Mona Lisa* (**Fig. 22.10**). The portrait has captivated poets and lyricists, museumgoers, and artists for centuries. Simply put, that face has been everywhere. Why and how did it attain this icon status? The *Mona Lisa* is almost definitely an actual portrait, although the identity of the sitter has not been verified. Giorgio Vasari, the painter and art historian of the Renaissance, claimed that the woman in the painting is Lisa di Antonio Maria Gherardini—the wife of a wealthy Florentine banker—hence the title *Mona Lisa*.

In its own day, though, it was quite an innovative composition. Among other things, Leonardo rejected the

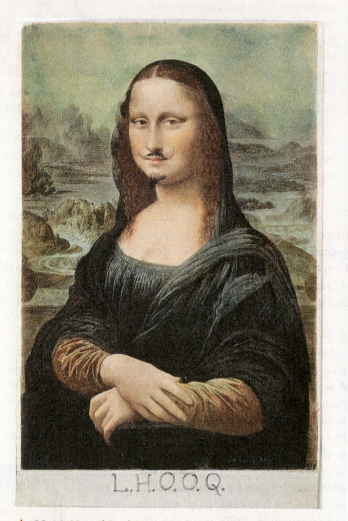

▲ **22.11** Marcel Duchamp, *L.H.O.O.Q. (Mona Lisa)*, 1919. Rectified ready-made; pencil on colored postcard reproduction of Leonardo da Vinci's *Mona Lisa*, 7¾" × 4⅞" (19.7 × 12.4 cm). Private collection.

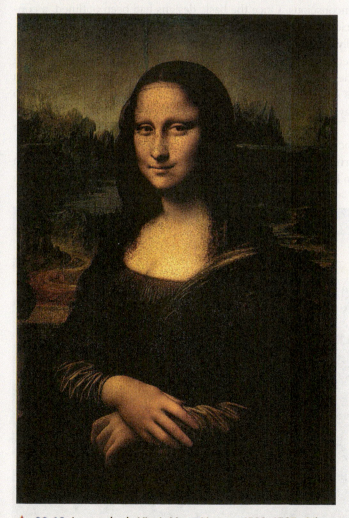

▲ **22.10** Leonardo da Vinci, *Mona Lisa*, ca. 1503–1505. Oil on wood panel, 30¼" × 21" (77 × 53 cm). Musée du Louvre, Paris, France.

traditional profile portrait bust in favor of a three-quarter-turned, half-length figure. The inclusion of the hands in a natural position, for the most part uncharacteristic of earlier portraiture, was essential for Leonardo as a method of exploring and revealing the personality of the sitter: "A good painter has two chief objects to paint, man and the intention of his soul; the former is easy, the latter hard, because he has to represent it by the attitudes and movements of the limbs."*

* Edward McCurdy, *Leonardo da Vinci's Note-books: Arranged and Rendered into English with Introductions* (New York: Charles Scribner's Sons, 1908), p. 12.

A new look at portrait painting, to be sure. But there is still the matter of that enigmatic smile. And those eyes, which many have vouched follow the viewer's movements across a room. The *Mona Lisa* is a beautiful painting, but does that account for why a visitor in search of the masterpiece in Paris's Louvre Museum need only look for the one painting that cannot be viewed because of the crowd surrounding it?

The selection of images in this feature represents but a sampling of work that attempts to come to terms with Mona Lisa: The Icon. One of the most infamous revisions of Leonardo's painting is by the Dada artist Marcel Duchamp (1887–1968), who in 1919 modified a reproduction of the original work, graffiti style, by penciling in a mustache and goatee (**Fig. 22.11**). Beneath the image is Duchamp's irreverent explanation of that enigmatic smile: if you read the letters "L.H.O.O.Q." aloud with their French pronunciation (ell osh oh oo coo) using a slurred, legato style, the sound your ears will hear is "elle a chaud au cul." (Rough PG-13-rated translation: "She has a hot behind.") The manifesto of the Dada movement contended that the museums of the world are filled with "dead art" that should be "destroyed." Dadaists also challenged the premises of originality and validity in works of art. How, would you say, did Duchamp question those premises in *L.H.O.O.Q.*?

By using a reproduction of the Mona Lisa, an example of what he called a *ready-made*, Duchamp took what had become, on one level, a hackneyed image and transposed it into a work of art—simply because he chose it, modified it, and presented it as such. Is the artist's say-so enough to define

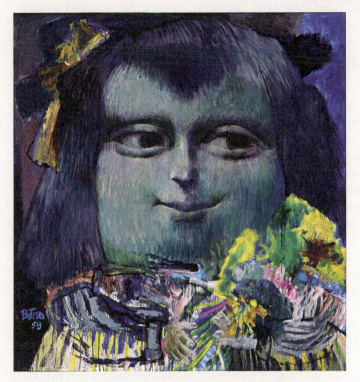

▲ **22.13** Fernando Botero, *Mona Lisa, Age Twelve*, 1959. Oil and tempera on canvas, 6' 11⅛" × 6' 5" (211 × 195.5 cm). Museum of Modern Art, New York, New York.

an object as a work of art? What are the variables that you would list in your definition of a work of art? With works like *L.H.O.O.Q.*, Duchamp pressed the issue of whether one can—or even should—define art.

Duchamp's controversial work is also a commentary on the commodification—what the dictionary calls the inappropriate treatment of something as if it can be acquired or marketed like all other commodities, that is, articles of trade or commerce—of art. Jean-Michel Basquiat's (1960–1988) appropriation of Leonardo's famed portrait as a replacement for the head of George Washington on a U.S. one-dollar bill (**Fig. 22.12**) adds to the critical conversation about art and the forces that drive the art market.

The *Mona Lisa*. That smile. Those eyes. That eternal beauty. One might say that they would be recognized anywhere. It is just these idiosyncratically charming features that Fernando Botero (b. 1932) captures in his imagined portrait *Mona Lisa, Age Twelve* (**Fig. 22.13**). Far from the idealized, dignified, serene countenance of Leonardo's mature lady, the painting nonetheless bears telltale signs of the signature beauty and allure that the little girl will eventually grow to possess. The disproportions that characterize Botero's style have a special irony here, in that Leonardo was a keen student of the perfect proportions of the human body. Botero reminds us that the celebrities we iconize—and against whom perfection is measured—were, at one time, ordinary people.

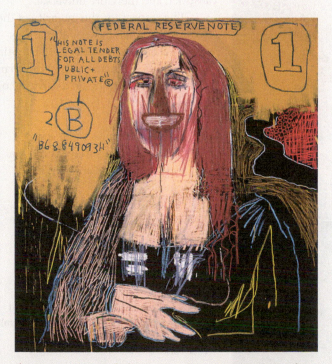

▲ **22.12** Jean-Michel Basquiat, *Mona Lisa*, 1983. Acrylic and pencil on canvas, 66¾" × 60¾" (169.5 × 154.5 cm). Private collection.

to have influenced him most. In 1919, Miró moved to Paris, where he was receptive to the work of Matisse and Picasso. A use of native symbols and an inclination toward fantasy further shaped Miró's unique style.

Miró's need for spontaneity in communicating his subjects was compatible with Automatist Surrealism, although the whimsical nature of most of his subjects often appears at odds with that of other members of the movement. In *Painting* (**Fig. 22.14**), meandering lines join or intersect to form the contours of clusters of organic figures. Some of these shapes are left void to display a nondescript background of subtly colored squares. Others are filled in with sharply contrasting black, white, or bright-red pigment. In this work, Miró applied Automatist Surrealism in an aesthetically pleasing, decorative manner.

By 1930, Surrealism had developed into an international movement, despite the divorce of many of the first members from the group. New adherents exhibiting radically different styles kept the movement alive.

De Stijl

All painting is composed of line and color. Line and color are the essence of painting. Hence they must be freed from their bondage to the imitation of nature and allowed to exist for themselves.

—PIET MONDRIAN

The second decade of the 20th century witnessed the rise of many dynamic schools of art in Russia and Western Europe. **De Stijl** was dedicated to pure abstraction, or nonobjective art. Nonobjective art differs from the abstraction of Cubism or Futurism in that it does not use nature as a point of departure and it makes no reference to visible reality. Compositions by artists associated with De Stijl consist primarily of some combination of geometric shapes, mostly primary colors, and emphatic black lines. In nonobjective art, the earlier experiments in abstracting images by Cézanne and then by the Cubists reached their logical conclusion. Kandinsky (see Fig. 21.32) is recognized as the first painter of pure abstraction, although several artists were creating nonobjective works at about the same time.

PIET MONDRIAN Although he began his career as a painter of Impressionist landscapes, Dutch painter Piet Mondrian (1872–1944) ultimately was drawn to the geometry of Cubism—an avant-garde style he saw in person in Paris in 1910. His study of Cubist theory opened the door to an even more radical art form that was simple, pure, precise, and unapologetically nonobjective. Back in Holland during and after the war years, Mondrian concentrated on the elements and principles of art, drastically reducing both his vocabulary of forms and his palette, as in *Composition II, with Red, Blue, Black, and Yellow* (**Fig. 22.15**). These limitations, Mondrian believed, produced a more comprehensible art form—one that was not referential and therefore limited in terms of accessibility, but one that was simple, abstract, and therefore universal.

The respect for the integrity of the two-dimensional surface—its flatness—was a salient characteristic of De Stijl paintings, as summarized by Mondrian in an excerpt from his extensive theoretical writings:

> Painting occupies a plane surface. The plane surface is integral with the physical and psychological being of the painting. Hence the plane surface must be respected, must be allowed to

◄ **22.14** Joan Miró, *Painting*, 1933. Oil on canvas, 68½" × 77¼" (174 × 196.2 cm). **Museum of Modern Art, New York, New York.** Clusters of organic figures, representing nothing in the real world, float in space. The overall impression of many such works is intentionally childlike—what the artist referred to as an "assassination" of traditional painting.

▲ 22.15 Piet Mondrian, *Composition II, with Red, Blue, Black and Yellow*, 1929. Oil on canvas, 45 × 45 cm. National Museum, Belgrade, Serbia. De Stijl works such as this are nonobjective, meaning that they are not derived from objects, figures, or scenes in the real world. The artist believed that more spiritual paintings would originate in the mind rather than in real life.

declare itself, must not be falsified by imitations of volume. Painting must be as flat as the surface it is painted on.[8]

This approach may be viewed, in one sense, as the culmination of experiments with shallow, compressed pictorial space and the integration of figure and ground. In De Stijl compositions, canvas and painting, figure and ground, are one.

Abstract Sculpture

CONSTANTIN BRANCUSI The universal accessibility of art sought by Mondrian through extreme simplification can also be seen in the sculpture of Constantin Brancusi (1876–1957). Born in Romania, Brancusi studied at the National School of Fine Arts in Bucharest and, in 1904, traveled to Paris to continue his training at the prestigious École Nationale Supérieur des Beaux-Arts. His work at that time was heavily indebted to Rodin (see Fig. 21.27), but as early as 1909 he began to explore a radically new direction, reducing the human head—a favorite theme he would draw upon for years—to an egg-shaped form with only spare cues to facial features. In this and in other abstractions such as *Bird in Space* (Fig. 22.16), he reached for

8. André Breton, *Manifeste du Surréalisme* (Paris: Éditions du Sagittaire, 1924).

the essence of the subject by offering the simplest contour that, along with a descriptive title, would fire recognition in the spectator. *Bird in Space* evolved from more representational versions into a refined symbol of the cleanness and solitude of flight.

Figurative Art in the United States

Although most of the groundbreaking artists in the United States and Europe were creating abstract art, some artists chose to continue to work with **figurative art**. The term *figurative* does not refer just to human or animal figures but to any art that contains strong references to people and objects in the real world. Two such artists working in the Depression era and during World War II were Grant Wood and Edward Hopper.

GRANT WOOD Grant Wood (1891–1942) was a proponent of a style known as Midwestern Regionalism. He trained in Europe during the 1920s, but rather than returning home with the latest developments in European abstract art, he was drawn to the realism of 16th-century German and Flemish artists.

The weatherworn faces and postcard-perfect surroundings in Grant Wood's *American Gothic* (see Fig. 22.17 on p. 800) suggest the duality of rural life in the modern United States—hardship and serenity. The painstakingly realistic portrait is also one of our more commercialized works of art; images derived from it have adorned boxes of breakfast cereal, greeting cards, and numerous other products. Note the repetition of the pitchfork pattern in the man's shirtfront, the upper-story window of the house, and the plant on the porch. He is very much tied to his environment. Were it not for the incongruously spry curl falling from the woman's otherwise tucked-tight hairdo, we might view this composition—as well as the sitters therein—as solid, stolid, and monotonous.

EDWARD HOPPER Edward Hopper (1882–1967) was also a realist painter who depicted commonplace subjects, but unlike Wood, he often

▶ 22.16 Constantin Brancusi, *Bird in Space*, 1924. Polished bronze, 56½" (143.8 cm) high, including base, 17¾" (45 cm) circumference. Philadelphia Museum of Art, Philadelphia, Pennsylvania. This particular sculpture is one of a series begun in 1923. It represents the movement of the bird in flight; the wings and feathers are not shown, the body is lengthened, and the head is severely abstracted.

▲ **22.17** Grant Wood, *American Gothic*, 1930. Oil on beaverboard, 30¾" × 25¾" (78 × 65.3 cm). Art Institute of Chicago, Chicago, Illinois. The couple in the painting clearly lead an austere, rural life. The artist's style is representative of the U.S. movement called Midwestern Regionalism.

made them into metaphors for rootlessness and loneliness. He was fascinated by bleak New England architectural vistas that were either bereft of people or emptied of people by the artist. Yet he often used strong light playing off these buildings.

The architecture, hairstyles, and fashion—even the price of cigars (only five cents)—all set Hopper's *Nighthawks* (**Fig. 22.18**) in an unmistakably American city during the late 1930s or 1940s. The subject is commonplace and uneventful, though somewhat eerie. There is a tension between the desolate spaces of the vacant street and the corner diner. Familiar objects become distant. The warm patch of artificial light seems precious, even precarious, as if night and all its troubled symbols are threatening to break

in on disordered lives. Hopper uses a specific sociocultural context to communicate an unsettling, introspective mood of aloneness, of being outside the mainstream of experience.

Architecture in Europe and the United States

In 1919, the year after Germany accepted the Weimar constitution at the conclusion of World War I, Walter Gropius organized the **Bauhaus**, a school founded on the desire to integrate craft, art, industrial design, and architecture.

WALTER GROPIUS Walter Gropius's (1883–1969) basic principles, in full reaction against Romanticism, emphasized simplicity, rationality, and functionality. The Bauhaus was one of the most important artistic influences in the period between the wars—a period that almost exactly coincides with the physical life of the school (**Fig. 22.19**). Its faculty offered courses in art, graphics, typography, and domestic and industrial design. Paradoxically enough, the school did not teach architecture as such until 1927. Its faculty designed everything from factories and apartment complexes to furniture, typefaces, and household items. Gropius's successor, Ludwig Mies van der Rohe, oversaw the school when it moved from Weimar to Dessau.

▼ **22.18** Edward Hopper, *Nighthawks*, 1942. Oil on canvas. 33⅛" × 60" (84.1 × 152.4 cm). The Art Institute of Chicago, Chicago, Illinois. The painting is one of those in which Hopper takes an ordinary scene or event and imbues it with a sense of desolation. The men in the painting, other than the counter worker, can be read as somewhat sinister. The corner setting places the people—again, other than the counter worker—against the black glass of the farther window. The diner setting and the apparel of the people have a distinctly American quality.

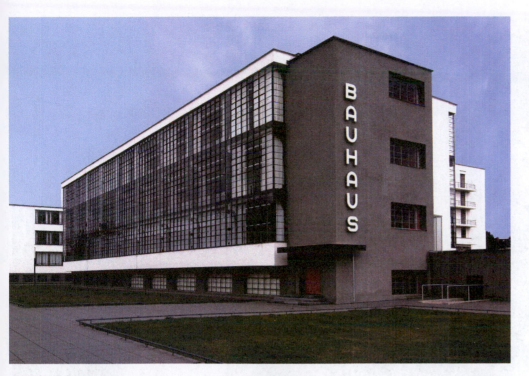

intersecting in strata that lie parallel to the natural rock formations. Wright's **naturalistic style** integrates the building with its site. In the Kaufmann House, reinforced concrete and stone walls complement the sturdy rock of the Pennsylvania countryside.

For Wright, unlike the Bauhaus architects, modern materials did not warrant austerity; geometry did not preclude organic integration with the site. A small waterfall seems mysteriously to originate beneath the broad white planes of a deck. The irregularity of the structural components—concrete, cut stone, natural stone, and machine-planed surfaces—complements the irregularity of the wooded site.

▲ **22.19 Walter Gropius, technical wing, Bauhaus School, 1925–1927. Dessau, Germany.** The school consisted of three arms radiating from a central hub. Each arm was bent into an L shape, and each served a distinct purpose: studios and dormitories, workshops, and classrooms.

The interim director, the Swiss Hannes Meyer, was a militant Communist whose political views brought unwelcome attention to the Bauhaus from the Nazi authorities in the early 1930s. Meyer fled to the Soviet Union when the school was closed in 1933. The Bauhaus was judged "decadent" and a front for communist activities.

Walter Gropius found refuge in the United States, settling at Harvard University's School of Design. Mies moved to Chicago. Both architects had an enormous influence on the subsequent history of American architecture, where both, in their own ways, laid the foundations for what is now known as modernist architecture. Other members of the Bauhaus school, like Marcel Breuer, were instrumental in the field of design as well as architecture.

The Bauhaus "style" is almost a synonym for "modern" architecture and design—a movement so powerful, especially in the United States, that it was a major voice in American building, with its characteristic unity of glass, steel framing, and clean lines. Its influence persisted well into the last quarter of the 20th century and lingers today.

FRANK LLOYD WRIGHT During the early years of the 20th century, Frank Lloyd Wright (1867–1959), as always, went his own way. His Kaufmann House (see **Fig. 2.20** on p. 802), which has also become known as Fallingwater, shows cantilevered decks of reinforced concrete rushing outward into the surrounding landscape from the building's central core,

PHOTOGRAPHY AND FILM

Continued technical advances in cameras and film, including the still much-admired 35mm Leica, invented in Germany in the early 20th century, contributed to the advance of photography in the period following World War I. Accompanying these was an intense and growing interest in photography as a new instrument for artistic expression. Man Ray (1890–1976), an American artist living in Paris, experimented with darkroom manipulations to produce what he called *rayograms*. Laszlo Moholy-Nagy (1895–1946) taught a wide range of techniques while he was an instructor at the influential Bauhaus school of design in Germany. When the Bauhaus was shut down by the Nazis in 1933, Maholy-Nagy came to the United States where he continued to be a great influence. A group of American photographers loosely connected with what was called the "f/64 Group" included pioneers who are now recognized as giants in the medium: Alfred Stieglitz (1864–1984), Imogen Cunningham (1883–1975), Edward Weston (1886–1958), and Ansel Adams (1902–1984).

The first motion pictures are attributed to the French Lumière Brothers in 1895 and the American Panopticon and Vitascope developed in New York the year after. By the beginning of World War I, a vast movie industry was already turning out short silent films for eager audiences. Sound technology was added to films in 1927, but by that time, longer and more lavish productions were already being produced.

Photography

In the United States, the most powerful pictures produced for social purposes were those photographs made to show the

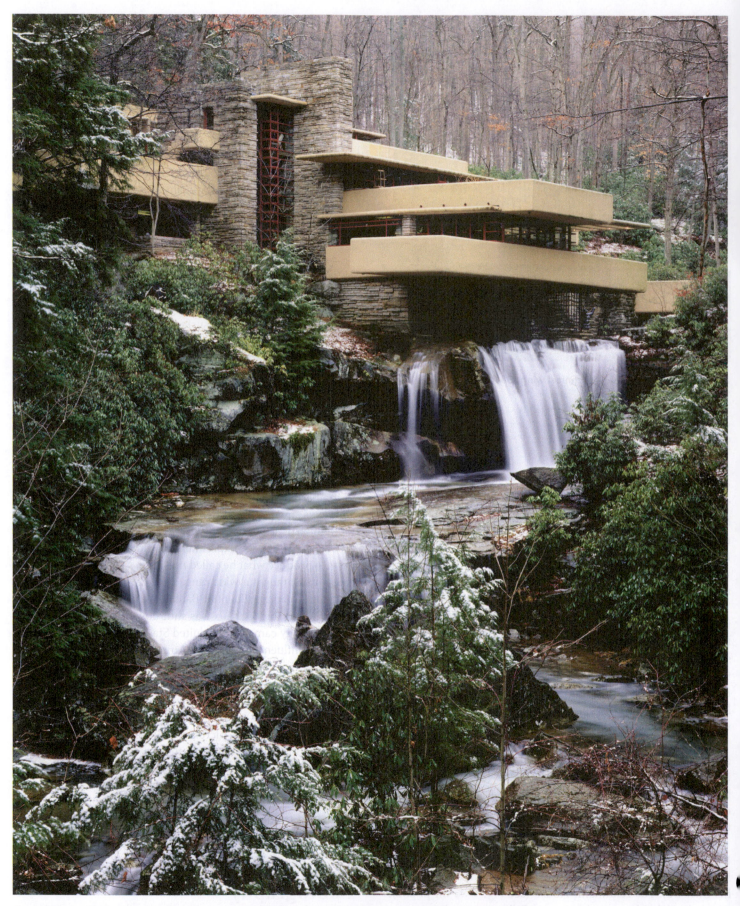

▲ **22.20 Frank Lloyd Wright, Kaufmann House ("Fallingwater"), 1936. Bear Run, Pennsylvania.** Edward Kaufmann, a first lieutenant in World War I and the owner of the upscale Kaufmann's department store in Pittsburgh, commissioned the house. Wright's naturalistic style fully integrated the building with its picturesque site.

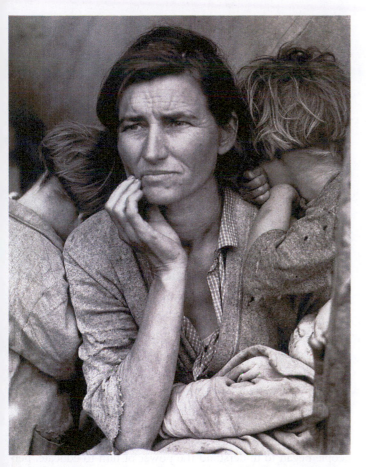

▲ **22.21** Dorothea Lange, *Migrant Mother, Nipomo, California,* 1936. Gelatin silver print, 12½" × 9⅞" (31.6 × 25.1 cm). Library of Congress, Prints and Photographs Division, FSA/OWI Collection, Washington, DC. Photographers such as Lange and Evans memorialized the hardships suffered by ordinary Americans during the Great Depression. They both worked for the Farm Security Administration. After 1935, Lange focused on the exploitation of sharecroppers.

outer edges of her eyes tell the story of a woman who has aged beyond her years. Lange crops her photograph close to her subjects; they fill the print from edge to edge, forcing us to confront them rather than allowing us to seek comfort in a corner of the print not consigned to such an overt display of human misery. The migrant mother and her children, who turn away from the camera and heighten the futility of their plight, are constrained as much by the camera's viewfinder as by their circumstances.

During the 1940s, as the world again went to war, photographers such as Margaret-Bourke White (1904–1971) carried their handheld cameras into combat and captured tragic images of the butchery in Europe and the Pacific. Bourke-White had begun her career in 1929 as a staff photographer for *Fortune*, a new magazine published by Henry Luce. When Luce founded *Life* in 1936, Bourke-White became one of its first staff photographers. Like Dorothea Lange, she recorded the poverty of the Great Depression, but in the 1940s, she traveled abroad to become one of the first female war photojournalists. As World War II was coming to an end in Europe, Bourke-White arrived at the Nazi concentration camp of Buchenwald in time for its liberation by General George S. Patton. Her photograph, *The Living Dead of Buchenwald, April 1945* (**Fig. 22.22**), published in *Life* in 1945, became one of the seared images of the Holocaust—the Nazi effort to annihilate the Jewish people. The indifferent countenance of each survivor expresses, paradoxically, all that has been witnessed and endured. In her book,

▼ **22.22** Margaret Bourke-White, *The Living Dead at Buchenwald, April 1945.* **Photograph.** The photograph was taken for *Life* magazine when Bourke-White and her colleagues accompanied General George Patton's Third Army in the spring of 1945. The few survivors of genocide stare out disbelievingly at their Allied liberators.

terrible economic deprivations of the Great Depression. In the mid-1930s, the Farm Security Administration of the United States Department of Agriculture commissioned photographers to record the life of the country's rural poor. The resulting portfolios of these pictures taken by such photographers as Dorothea Lange, Arthur Rothstein, and Walker Evans still stir the conscience. Lange and Evans portrayed the lifestyles of migrant farmworkers and sharecroppers. Lange's *Migrant Mother* (**Fig. 22.21**) is a heartrending record of a 32-year-old woman who is out of work but cannot move on because the tires have been sold from the family car to purchase food for her seven children. The etching in her forehead is an eloquent expression of a mother's thoughts; the lines at the

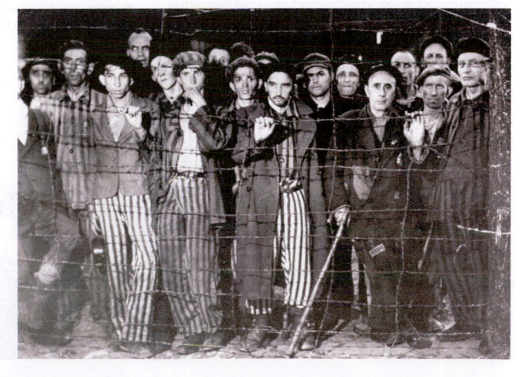

Dear Fatherland, Rest Quietly, Bourke-White put into words her own reactions to the assignment:

> I kept telling myself that I would believe the indescribably horrible sight in the courtyard before me only when I had a chance to look at my own photographs. Using the camera was almost a relief; it interposed a slight barrier between myself and the white horror in front of me…it made me ashamed to be a member of the human race.[9]

Film

Following the war, commercial movie houses sprang up in France and the United States, and motion pictures were distributed widely for public viewing. These were silent films accompanied by live orchestral music and stage shows. The next big step in moviemaking occurred in 1927 with the first feature-length musical film with synchronized dialogue, *The Jazz Singer*, the story of a young Jewish singer who elects not to follow in the footsteps of his cantor father but, instead, to pursue the life of an entertainer. From then on, the recording of sound on film would shape the future of cinema.

The art of film, like photography, took off in many directions and fell into different genres: art films, propaganda, satire, and social commentary are but a few.

EXPRESSIONISM, SURREALISM, AND FILM Robert Wiene's 1920 film *The Cabinet of Dr. Caligari* (**Fig. 22.23**) featured sets that were designed by three Expressionist painters who employed stylistic devices such as angular, distorted planes and skewed perspectives. The hallucinatory backdrop disconnects the protagonist—a carnival hypnotist who causes a sleepwalker to murder people who displease him—from the realm of reality. The line between truth and fantasy is further obscured when, as the film ends, the hypnotist becomes a mental patient telling an imaginary tale.

In 1929, Salvador Dalí collaborated with Spanish–Mexican filmmaker Luis Buñuel on *Un Chien Andalou* (**Fig. 22.24**), a silent, surrealist short film in which free association plays a starring role. In the shocking opening scene, the slicing of a human eyeball seems to graphically assert that in order to really "see," "normal" vision must be destroyed. The audience is then propelled through a series of disconnected, dreamlike sequences that are intended to evoke instinctive reactions of attraction and repulsion.

PROPAGANDA Propaganda is the presentation of a point of view with the intention to persuade and convince. We usually think of it in political terms.

▲ **22.23** Robert Wiene, still from *The Cabinet of Dr. Caligari*, **1919.** The psychological (and perceptual) mind game central to the film makes overt reference to psychoanalysis.

Throughout history, propagandists have used books, art, and music to spread their ideas, but the rise of film in the early part of the 20th century added immeasurably to propagandists' weapons. During the period between the wars, at a time when totalitarian governments rose dependent on a cooperative population, people began to understand the power of film to educate, persuade, and shape public opinion. Film most successfully blended propaganda with attempts at an artistic vision.

Sergei Eisenstein (1898–1948), a Soviet filmmaker, remains one of the most influential artists in the history of the cinema. A dedicated supporter of the Russian Revolution, Eisenstein appreciated Lenin's observation that the cinema would become

▼ **22.24** Luis Buñuel and Salvador Dalí, still from *Un Chien Andalou (An Andalusian Dog)*, **1929.** The creators of this film stated that nothing in the film symbolized anything, but alternatively they allowed that the symbols could be investigated by means of psychoanalysis.

9. Margaret Bourke-White, *Dear Fatherland, Rest Quietly* (New York: Simon and Shuster, 1946), p. 73.

the foremost cultural weapon in winning over the proletariat to the Revolution. From his early film *Strike* (1925) to his last work *Ivan the Terrible, Part I* (1944) and *Part II* (1946), Eisenstein was conscious of the needs of the working class and what he saw as the inevitable triumph of communism—themes dear to the official line of Stalin's Soviet Union. His *Alexander Nevsky* (1938) had an impressive musical score by Sergei Prokofiev, and the two men collaborated to integrate musical and visual concepts. The vast *Ivan the Terrible* was indebted to a study of El Greco's paintings, in which Eisenstein was inspired by the cinematic possibilities in that artist's striking canvases.

Eisenstein's most influential film, *Battleship Potemkin* (1925), is the story of the 1905 naval mutiny on the battleship *Potemkin* and the subsequent riot in Odessa that was crushed by the tsarist police. The Communists saw that incident as a foreshadowing of the October Revolution of 1917, which brought the **Bolsheviks** to power.

The scene in *Battleship Potemkin* of the crowd cheering the mutineers on a broad flight of stairs in Odessa and the subsequent charge of the police is a classic sequence in film history. In that sequence, Eisenstein uses the device of **montage** (the sharp juxtaposition of shots by film cutting and editing) with such power that the scene became a benchmark for subsequent filmmakers.

His close-ups were meant to convey a whole scene quickly: A shot of a wounded woman cuts to a close-up of a clenched hand that slowly opens, telling the story of death in a moment. An erratically moving baby carriage is a macabre metaphor for the entire crowd in panic and flight. Shattered eyeglasses and blood pouring from an eye (**Fig. 22.25**) symbolize tsarist oppression of the populace.

For sheer explicit propaganda, one must turn to two documentary films made in Nazi Germany in the 1930s by the popular film actor and director Leni Riefenstahl (1902–2003). Her first great film was a documentary of the 1934 Nazi Congress in Nuremberg, called *Triumph of the Will* (1935). Designed to glorify the Nazi Party and to impress the rest of the world, the film made ample use of the great masses of party stalwarts who gathered for their rally. That documentary allowed the young filmmaker to show the party congress as a highly stylized and ritualistic celebration of the Nazi virtues of discipline, order, congregated might, and the racial "superiority" of the Teutonic elite of the party members.

Riefenstahl's other great film, and arguably her masterwork, was a long documentary made at the Berlin Olympics of 1936 and issued in 1938 under the title *Olympia*. Riefenstahl used five camera technicians and 38 assistants, as well as footage shot by news-agency photographers, to make her film. The completed documentary, divided into two parts, pays tribute to the Olympic spirit of ancient Greece, develops a long section on the carrying of the Olympic torch to Berlin, records the homage to Hitler and the Nazi Party, and shows most of the major athletic competitions.

As a film, *Olympia* is matchless in its imaginative use of the camera to catch the beauty of sport (**Fig. 22.26**). The vexing

▲ **22.25 Sergei Eisenstein, still from *Battleship Potemkin*, 1925.** A classic shot in the history of film, this single close-up from the Odessa steps sequence represents the horror of the entire scene.

▲ **22.26 Leni Riefenstahl, still from *Olympia*, 1938.** This shot from the diving sequence shows the unique camera angles Riefenstahl used. Such angles became a model for documentary filmmakers.

question is to what degree the film is political beyond the obvious homage paid to the German Third Reich, which sponsored the Olympics in 1936. Many critics note its elitist attitude to justify their contention that it is propaganda, albeit of a high and subtle quality. Athletes are depicted as superior beings who act beyond the range of ordinary mortals. They give all and seem almost demigods. The film praises the heroic, the conquest, the struggle. It praises the ritualized discipline of the crowds and lovingly seeks out examples of the adoring Berlin masses surrounding the party leaders.

The flip side of propaganda is satire. Within several years after Riefenstahl glorified German National Socialism in her *Triumph of the Will* and *Olympia*, British–American filmmaker and actor Charlie Chaplin satirized the authoritarianism of Adolf Hitler and Benito Mussolini in his film *The Great Dictator*.

SOCIAL COMMENTARY One of the most powerful Hollywood feature-length films of the period between the wars was *The Grapes of Wrath* (**Fig. 22.27**). Based on the 1939 novel of the same title by John Steinbeck, it follows one family's struggle for survival during the Great Depression in the United States, when banks failed and the Midwest—the nation's "breadbasket"—turned into the Dust Bowl. As in a Dorothea Lange photograph, the camera lens zooms in to capture the hopelessness and despair of the era.

MOVIE NEWSREELS Television news with film footage did not appear until 1948, but movie newsreels debuted in 1911. Structured like a daily newspaper and distributed to movie theaters where these roughly 10-minute-long films were shown along with the main feature, newsreels focused on politics and current events, natural and human-made disasters, pop culture, sports, and, in the 1940s, updates on the progress of the Allies at war.

MUSIC IN THE JAZZ AGE

Born out of the unique experiences of Americans of African heritage, jazz is a distinctively American contribution to Western culture. The matrix out of which jazz was born is an imperfectly documented history of a process that combined intonations, rhythmic patterns (especially repetition), and melodic lines that came from the African ancestors of African Americans and the tradition of the black spiritual, Christian hymns sung both in the slave culture of the South and in the free churches of blacks after the Civil War. In addition, jazz drew on the ineffable music of the blues, developed in the Deep South, with its characteristic and instantly recognizable **blue note** (a melody note bent a half step down). The blues existed mainly as an oral tradition in the rural Deep South in the 19th century, with one singer passing down songs to another, but it became a popular, public entertainment in city life from the 1920s onward. Musicians like W. C. Handy (the "Grandfather of the Blues") and singers like Mamie Smith, Ethel Waters, Ma Rainey, and Bessie Smith were immensely popular in the 1920s. And finally, jazz adapted certain European songs, especially French quadrilles and polkas, into a slightly different style of music that became known as *ragtime*.

Ragtime

Although **ragtime** music has undergone many revivals and is, in fact, still composed and performed today, it reached its height in popularity during the approximately 20-year period stretching from the last decade of the 19th century to the second decade of the 20th. Its single most important feature is rhythmic syncopation: the accentuation of melodic notes not coinciding with the tune's beat. (Indeed, many believe that the designation "ragtime" derives from the long-standing African American tradition of playing music in syncopated or "ragged" time.) In the typical rag, a solo pianist's left hand defines the regular beats of the piece by playing a steady bass line in an upbeat march meter, while the right hand plays the melody with opposing beats, creating the rhythmic push and pull that gives the genre its distinctive feel.

Scott Joplin (1868–1917), the unrivaled "King of Ragtime," scored his biggest success with the "Maple Leaf Rag," composed in 1897 and published as sheet music in 1899. The publication sold over 1 million copies, making it by many accounts the first platinum hit of all time. Its irresistible appeal still can be felt today in the jaunting, forward-driving rhythms, the effective

▲ **22.27** John Ford, still from *The Grapes of Wrath*, 1940. The severe drought of the Dust Bowl—an ecological and agricultural disaster in the prairielands of the U.S. and Canada—left farmers destitute. Forced to migrate to survive, many sought opportunities elsewhere that turned out to be fruitless.

CULTURE AND SOCIETY

The Works Progress Administration

Franklin Delano Roosevelt's New Deal, a series of legislative and relief programs designed in response to the effects of the Great Depression, included the Works Progress Administration (WPA), a government-funded work program that employed millions of people to carry out public projects. The idea was to help people through hard times until the economy gained some footing. In November 1938—the peak of WPA employment—3,334,594 people were working on government projects.

The WPA had numerous divisions. The Division of Engineering and Construction, for example, designed and supervised the building of dams, highways, bridges, and airports as well as community centers, playgrounds, and public swimming pools. Projects ranged from the Griffith Observatory in Los Angeles and LaGuardia Airport in New York to the Dock Street Theatre in Charleston, South Carolina, and Camp David, the U.S. presidential retreat in Maryland.

Arguably the most exceptional of the WPA programs was "Federal Project Number One," designed to provide support for artists, writers, actors, and musicians and, at the same time, to improve the quality of American life through the exposure to culture. In a letter dated January 4, 1938, President Roosevelt wrote, "I, too, have a dream—to show people in the out of the way places, some of whom are not only in small villages but in corners of New York City—something they cannot get from between the covers of books—some real paintings and prints and etchings and some real music."* Federal Project Number One

* Franklin Roosevelt to Hendrik Willem Van Loon, January 4, 1938. Art of the New Deal. Franklin D. Roosevelt Presidential Library and Museum. http://www.fdrlibrary.marist.edu/museum/artdetail.html.

included the Federal Art Project, Federal Music Project, Federal Writers Project, and the Federal Theatre Project. At their peaks, the art project employed 3500 artists, the music project over 16,000 musicians, the theatre project an estimated 12,700 performers, and the writers project some 6,686 writers.

Among those employed in the service of culture under the various programs of the WPA were many who otherwise might never have pursued careers in the arts. A cross section of these participants include many who are discussed in this chapter and the next: photographer Dorothea Lange; painters Jacob Lawrence, Jackson Pollock, and most of the Abstract Expressionists; and writers including Zora Neal Hurston, Langston Hughes, Ralph Ellison, and Gwendolyn Brooks.

▲ **22.28 Michigan artist Alfred Castagne sketching Works Progress Administration (WPA) construction workers, May 19, 1939. Franklin D. Roosevelt Library and Museum, Hyde Park, New York.**

contrast between the piano's high and low registers, and the remarkable variety: it packs four distinct sections, each repeated at least once, into less than three and a half minutes of music.

GO LISTEN!
SCOTT JOPLIN
"Maple Leaf Rag"

The history of the recording of the music selection is itself of some interest. Shortly before his death in 1916, Joplin recorded his ragtime hits onto a piano roll—a perforated roll of paper that, when inserted into a mechanized apparatus, makes it

possible for a piano essentially to play itself. Thus we are able to hear Joplin's performance of his own song, in much higher fidelity than would have been possible using the standard audio recording technology of his day.

The Emergence of Jazz

Jazz rose to prominence early in the 20th century in cities throughout the U.S. South and Midwest. Without question,

however, the epicenter of the jazz boom was New Orleans, Louisiana. The rich and varied musical culture of the city—including African American, French, Cuban, and other Caribbean idioms—made it the ideal locale to spark a new, progressive musical genre, one that has now become so revered as to be referred to as "America's Classical Music." The musicians, who were African Americans, performed without written music and were self-taught. They formed bands and played in the streets and in the cabarets of the city. By the end of World War I, many of these musicians had migrated north to Chicago, which, in the early 1920s, was the center of jazz music. From there, jazz spread to St. Louis, Kansas City, Harlem in New York City, and other urban centers on both coasts.

GO LISTEN!
JOE "KING" OLIVER
"West End Blues," Louis Armstrong and His Hot Five

So profound was the influence of the blues on the emergence of the earliest jazz idioms that it is entirely appropriate that the first true jazz compilation carries the word *blues* in its title. In "West End Blues," blues elements are featured prominently throughout the song. The piece begins with an expressive and virtuosic trumpet introduction, performed by Louis Armstrong—not only the most prominent exponent of New Orleans jazz, but also among the most important and revered U.S. musicians of the 20th century. Armstrong's Hot Five then launch into the **12-bar blues** form that will persist throughout the rest of the song. In a 12-bar blues, a fixed series of chords, 12 bars (or measures) in length, is restated continuously throughout the piece. What maintains the musical interest in such a seemingly repetitive form is the ongoing variation that occurs above the chords; it is as if with each pass through the series, the ensemble offers a new perspective on a familiar story.

Armstrong's recording of "West End Blues"—a piece composed originally by Joe "King" Oliver with lyrics by Clarence Williams—features five passes through the 12-bar form. The first (beginning at 0:15) is something of a communal effort, with Armstrong's solo trumpet accompanied by lively, responsorial interplay between the clarinet and trombone, while the rhythm section provides the beat steadily underneath. The second time through (0:49–1:23), Armstrong's trumpet gives way to a soulful, bluesy trombone solo, featuring repeated bends and slides in pitch, often exploring the spaces *between* the pitches that Western ears are used to, and in the process passing through countless blue notes. The third statement of the form (1:23–1:57) shifts to a *call-and-response texture*—another hallmark of blues practice—between Armstrong and his clarinetist. Here, the clarinet takes the lead, performing short phrases, and Armstrong, **scatting** (singing improvised syllables with no literal meaning), first imitates and then embellishes them, before the two voices perform the last phrase together in parallel harmony. The piano takes over with a lively solo for the fourth statement of the form (1:57–2:30) before the full band returns for the final pass (2:31), with trumpeter Armstrong taking the lead once again, beginning impressively by holding a single pitch fully 16 beats. Finally, the piano initiates a flashy solo passage that leads to the song's concluding strains, which the full

band plays in rich harmony. We hear Ella Fitzgerald scatting in the nearby music selection, "Blue Skies."

GO LISTEN!
ELLA FITZGERALD
"Blue Skies"

Jazz as Swing

By the 1930s, the influence of jazz in the United States had moved into the cultural consciousness of the country at large. Jazz was now commonly referred to as *swing*, and swing bands toured the country. By far the most popular jazz ensemble during the 1930s and 1940s, the swing band or big band typically consisted of between 12 and 25 musicians: sections of trumpets, trombones, and saxophones and clarinets (each section featuring approximately three to five musicians), as well as a rhythm section made up of drums, bass, piano, and guitar. In contrast to the improvised nature of New Orleans jazz, swing-era jazz pieces were arranged in advance by the band leader and read from sheet music or "charts" by the band members in performance. The genre is characterized by intricate, lush arrangements with a danceable "swing" feel.

The song "Take the 'A' Train" unquestionably holds a place among the most popular, influential, and enduring of all big-band-era jazz standards. Its title and lyrics refer to the "A" subway line running through New York City's Brooklyn, Harlem, and Manhattan. Edward Kennedy "Duke" Ellington (1899–1974), a giant in the history of jazz, gained fame at the glamorous Cotton Club in Harlem in the 1920s. This recording showcases his skills as an arranger and bandleader, creating a lively, creative, and varied instrumental showpiece. The piece was to become the signature number for Duke Ellington and his big band, and has been performed and recorded by countless jazz luminaries.

GO LISTEN!
BILLY STRAYHORN
"Take the 'A' Train," Duke Ellington Orchestra

After an introduction by piano (performed by Ellington) and drums, the piece lays out its AABA form: A (0:06–0:17), A (0:17–0:28), B (0:28–0:39), A (0:40–0:50). After this initial iteration of the melody and chord progression (the "head," in jazz parlance), the rhythm section repeats the AABA progression while a muted trumpet performs an improvisatory solo (0:50–1:35). After the trumpet solo, the AABA pattern is unexpectedly interrupted by a lively call-and-response sequence (the brass call and the winds respond) that executes a **modulation** (a shift to a new key). After this brief interlude, the AABA form repeats, now in the new key (beginning at 1:41). Here, the winds and solo trumpet alternate and interweave phrases before a brilliant, staggered, "stop-time" passage (2:12–2:14) leads to a coda that repeats the A melody in subdued fashion as the piece draws to a close.

Today Ellington is known not only for his virtuoso orchestral skills but, with such popular works as "Mood Indigo," is considered the most important composer in big-band jazz. But he was also a true original in his attempt to extend the musical idiom of jazz into a larger arena. After World War II, Ellington produced many works for symphonic settings. His symphonic

suite *Black, Brown, and Beige* had its first hearing at Carnegie Hall in 1943. This work was followed by others—whose titles alone indicate the ambition of his musical interests: *Shakespearean Suite* (1957), *Nutcracker Suite* (1960), *Peer Gynt Suite* (1962), and his ballet *The River* (1970), which he wrote for the dance company of Alvin Ailey, a notable African American choreographer.

Benny Goodman, known as "the king of swing," was a brilliant impresario. He set the musical world on its heels in 1938 by staging a swing and jazz concert in New York's Carnegie Hall—the inner sanctum of classical music. He also was one of the few band leaders to incorporate African American musicians into a predominantly European American band. As a musician, his greatest talent was performance on the clarinet. As we

GO LISTEN!
BENNY GOODMAN
"Sing, Sing, Sing"

see in the nearby music selection, "Sing, Sing, Sing," Goodman's clarinet solos set a standard for speed, pattern, and flawless execution that other reed players tried to copy.

Trombonist and band leader Glenn Miller created a distinctive, almost instantly recognizable sound. His smooth, danceable jazz captured the romance of the swing era. His original song "Moonlight Serenade" (1939) and his arrangements of "Tuxedo Junction" (1939) and the music selection "In the Mood" (1940) contributed to the popularity

GO LISTEN!
GLENN MILLER
"In the Mood"

of his band. His death in a plane crash in 1944, after enlisting in the Air Force and leading an Air Force orchestra, made Miller a legend.

The Influence of Jazz

Jazz as a musical and cultural phenomenon was not limited to the United States in the period after World War I. It had a tremendous following in Paris in the 1920s, where one of the genuine celebrities was the African American singer and dancer Josephine Baker (**Fig. 22.29**). Furthermore, just as Pablo Picasso had assimilated African sculptural styles in his painting, so serious musicians on the Continent began to understand the possibilities of this African American music for their own explorations in modern music. As early as 1913, Igor Stravinsky (1882–1971) utilized the syncopated rhythms of jazz in his path-breaking ballet *The Rite of Spring*. His *L'Histoire du soldat* (1918) incorporates a ragtime piece that he composed based only on sheet music he had seen of such music. Other avant-garde composers

in Europe also came under the influence of jazz. Paul Hindemith's (1895–1963) piano suite "1922" shows the clear influence of jazz. Kurt Weill's (1900–1950) *Dreigroschenoper* (*Threepenny Opera*; 1928), with a libretto by Bertolt Brecht, shows a deep acquaintance with jazz, demonstrated notably in the song "Mack the Knife."

GO LISTEN!
LOTTE LENYA
"Mack the Knife"

Most music can be placed on one side or the other of the classical/popular divide. Mozart's Symphony No. 40 in G Minor (K. 550) is an unequivocally classical symphony; Usher's "Love in This Club" falls comfortably into the popular genre. But a number of artists have made efforts to straddle or cross over this border—British pop star Sting's *Songs from the Labyrinth* is a collection of Renaissance composer John Dowland's material; and classical cello virtuoso Yo-Yo Ma collaborates with renowned fiddler Mark O'Connor, bluegrass artist Alison Krauss, and singer/songwriter James Taylor on *Appalachian Journey*.

Many of the extremely talented musicians of the popular swing era were able to cross musical boundaries. Goodman recorded Mozart's Clarinet Quintet with the Budapest String Quartet in 1939. In the same year, the African American

▼ **22.29 Josephine Baker, Paris, ca. 1925.** Josephine Baker, shown here lying on a tiger rug in a silk evening gown and diamond earrings, was born in St. Louis, Missouri. She first danced for the public on the streets of St. Louis and in the Booker T. Washington Theater, an African American vaudeville house there. Her first job in Paris was at the Folies-Bergère, where, nicknamed Black Venus, she became a tremendously popular jazz entertainer. Just before the onset of World War II, she renounced her U.S. citizenship to become a citizen of France; during the war, she worked for the French Resistance.

jazz pianist Fats Waller wrote his London Suite, an impressionistic tribute to that city. Such crossovers were the exception rather than the rule, but they underscore the rich musical breadth of the jazz movement.

Among the most fascinating crossover musicians in history is George Gershwin (1898–1937), who strove to bring African American idioms into contemporary American classical music. Gershwin's fascination with African American music predated his American opera *Porgy and Bess* (1935); many of his compositions had drawn on ragtime, blues, and jazz (the latter most famously in his *Rhapsody in Blue* of 1924). Nevertheless, *Porgy and Bess* represents Gershwin's magnum opus and one of the most ambitious attempts ever to integrate traditional African American cultural and musical characteristics with those of classical music. The opera incorporates jazz rhythms and "shouting" spirituals of the Carolina coastal black churches into a libretto written by the Southern novelist DuBose Heyward and Gershwin's brother, Ira. Some of its most famous songs, such as "Summertime" and "It Ain't Necessarily So," have become standards.

GO LISTEN!
GEORGE AND IRA GERSHWIN
"Summertime," *Porgy and Bess*

Porgy and Bess features an all-black cast of characters and is set in the fictional Catfish Row, an African American neighborhood in South Carolina in the 1920s. In the first scene, Clara, a fisherman's wife, sings the opera's most popular song, "Summertime," to her baby as a lullaby. The tension between the supremely optimistic text of the libretto ("the livin' is easy...the fish are jumping...your daddy's rich and your momma's good looking") and the anxious chromaticism of the minor key foreshadows the profound tension that is to persist throughout this tragic story of poverty, murder, drugs, and betrayal. The longevity of the song, and especially the diverse nature of subsequent renditions, is perhaps a testament to Gershwin's success in integrating popular and traditional African American idioms into the operatic medium. Indeed, most listeners are likely to be more familiar with the variety of jazz recordings of the piece—from Louis Armstrong and Ella Fitzgerald to Billie Holliday to John Coltrane—than with the full-throttle operatic version performed by Camilla Williams in the music selection.

Porgy and Bess was not an immediate success in New York, but later revivals in the 1940s and after World War II established its reputation. In 1952, it had a full week's run at the La Scala opera house in Milan; in 1976, the Houston Opera mounted a full production, with earlier deletions restored, that then moved to the Metropolitan Opera in New York. It now ranks as a classic.

Ultimately, as Gershwin's opera perhaps foreshadowed, jazz itself would move away from popular music for dancing and toward classical music for the listener. In the post–World War II era, John Birks "Dizzy" Gillespie (1917–1993) and Charlie "Bird" Parker (1920–1955) would lead the way in the transformation of swing to bebop and modern jazz, and John Coltrane (1926–1967) and Miles Davis (1926–1991) would later experiment with *new wave* or cool jazz that further extended the definition and range of jazz.

BALLET

In the period between the world wars, one form of culture where the genius of the various arts most easily fused was the ballet. The most creative experiments took place in Paris, and the driving force was Serge Diaghilev (1872–1929). A Russian-born impresario, Diaghilev founded a dance company called the Ballets Russes, which opened its first artistic season in 1909. Diaghilev brought from Russia two of the most famous dancers of the first half of the century: Vaslav Nijinsky (1890–1950) and Anna Pavlova (1881–1931).

Ballet, like opera, is an art form that lends itself to artistic integration. To enjoy ballet, one must see the disciplined dancers in an appropriate setting replete with theatrical sets and costumes, hear the musical score that at once interprets and guides the movements of the dancers, and follow the narrative or "book" of the action. Seeking out and nurturing the efforts of the most creative artists of his era, Diaghilev had a particular genius for recruiting artists to produce works for his ballet.

CONNECTIONS Ballet, like opera, is an art form that lends itself to artistic collaboration. Seeking out and nurturing the work of his period's most creative artists, Russian-born ballet impresario Serge Diaghilev (1872–1929) had a particular knack for recruiting them to collaborate on his avant-garde pieces. Over the years, his company—the Ballets Russes—danced to music he commissioned from Igor Stravinsky, Maurice Ravel, Sergei Prokofiev, Claude Debussy, and Erik Satie set to stories by writers and poets like Jean Cocteau, and on sets (and in costumes) designed by such artists as Pablo Picasso, Georges Rouault, Naum Gabo, and Giorgio de Chirico.

Diaghilev's one-act ballet, *Parade*, debuted in Paris in 1917—right in the middle of World War I. The story of the interaction of street performers and men going off to war was written by the poet Jean Cocteau (1891–1963), and the composer Erik Satie (1866–1925) provided a score replete with street noise, whistles, horns, and assorted sounds of the din of the urban environment. Picasso designed the curtain, sets, and costumes.

▲ **22.30** Costumes made after Pablo Picasso's sketches for the ballet *Parade*, displayed at the exposition to mark the 100th anniversary of Sergei Diaghilev's Russian Seasons in Paris, Tretyakov Gallery, Moscow, Russia.

PARADE Diaghilev produced a one-act dance called *Parade*, which debuted in Paris in 1917. This short piece (revived in 1981 at the Metropolitan Opera with sets by the English painter David Hockney) is an excellent example of the level of artistic collaboration Diaghilev could obtain. The story of the interaction of street performers and men going off to war was by the poet Jean Cocteau (1891–1963), and the avant-garde composer Erik Satie (1866–1925) contributed the score. Pablo Picasso designed the curtain drop, the sets, and the costumes. *Parade* had much to say about musicians, players, and street performers, so the production was ready-made for Picasso's well-known interest in these kinds of people.

The collaborative effort of these important figures was a fertile source of artistic inspiration for Picasso, who had a great love for such work and returned to it on several occasions. He designed the sets for the ballets *Pulcinella* (1920), with music by Igor Stravinsky; *Mercury*, with music by Erik Satie; and *Antigone*, based on Jean Cocteau's French translation of Sophocles's Greek tragedy.

WORLD WAR II

It was as if the world had not learned the lessons of the Great War, which would come to be renamed World War I. Japan invaded China in 1937; in the West, an effort to roll back Hitler's invasion of Poland began in 1939. Britain and France, allied with Poland, declared war on Germany within two days. In 1940, the Netherlands, Belgium, and France were taken by a German blitzkrieg—literally, "lightning war"—which involved an overwhelming attack by artillery, tanks, and air power. Hitler was considering invading Britain across the English Channel, and he might very well have succeeded. Germany bombed Britain, especially London, mercilessly in order to soften up the country, but in the Battle of Britain, the outnumbered Royal Air Force held out—successfully stemming the German onslaught.

Also in 1941, Hitler made what was probably his biggest mistake of the war—invading the Soviet Union. A rabid anti-Semite, he also began slaughtering Jews wherever he found them, eventually killing one of every three Jews on the planet. The mass slaughter of Jews is called the Holocaust. The word *holocaust*, with a lowercase *h*, means a conflagration—a killing by flames, as in a city or forest aflame. With a capital *H*, it refers specifically to the genocide of the Jews.

At first, the movement into the Soviet Union by Hitler and his allies—Romanians, Hungarians, and Italians—was swift. Hitler reached Leningrad (now Saint Petersburg) in the north and Stalingrad (now Volgograd) in the east. But he never reached Moscow, the capital, nor the vital oil fields in the Crimea. He also became bogged down in Stalingrad, which the Soviets held with fierce though costly resistance. As time went on, the Soviets were able to secretly amass an army that ultimately surrounded and defeated the attackers of Stalingrad,

turning the war in the east in 1943. The Russians then won the largest tank battle in history at Kursk. More Soviets than Germans died in every engagement, but the Soviets seemed to be without number, and their armaments, reinforced with supplies from the United States, became more sophisticated and also seemed limitless.

A couple of "details" will provide a sense of the German–Soviet horror. Some 90,000 Germans and their allied forces were taken prisoner at Stalingrad. They were marched to prisoner-of-war camps. Of this number, about 5000 survived to eventually return home. Stalingrad was left a ruin, with more than a million dead. The Germans had dubbed Stalingrad "das Kessel"—"the kettle."

The United States declared war on Hitler's East Asian ally, Japan, after the Japanese attacked Hawaii's Pearl Harbor on December 7, 1941, sinking an important part of the U.S. Pacific Fleet. President Franklin Delano Roosevelt called December 7th "a day that will live in infamy." Although at first the West Coast of the United States appeared to be vulnerable to a Japanese invasion, U.S. productive power (see **Fig. 22.31** on p. 812) and military strategy decisively defeated the Japanese navy at Midway in 1942, not ending the war but terminating the possibility of a Japanese invasion or victory. But in the same year, Hitler sped up the murder of Jews in death camps, most notably Auschwitz in captured Poland, where some 17,000 people were gassed and cremated *every day*.

There had been fighting in North Africa, and the Allies, mainly the United States and Great Britain, defeated the Germans there in artillery duels and tank battles. They then invaded Germany's ally, Italy, in 1943. Italy surrendered and, after removing its fascist dictator, Mussolini, from power, turned about-face and declared war on Germany. On D-Day, the sixth of June, 1944, the Allies landed on the beaches of Normandy, a French region on the English Channel, which had been in the hands of the Germans. The Germans were now attempting to defend multiple fronts—with the Soviets approaching from the east and the Americans, British, and other allies driving in from the west and coming up through Italy and southern France. The Germans could not succeed. Meanwhile, in the Pacific, Americans were taking Japanese-occupied island after island, at immense cost, moving ever closer to Japan proper.

Events in 1945 were fast and furious. Auschwitz was liberated, although very few prisoners there remained alive. The Soviets reached Berlin. Hitler and many of his inner circle committed suicide, and a German field marshal surrendered, for Germany, on May 7. The president of the United States, then Harry S. Truman, concluded that an invasion of Japan would be too costly and instead dropped atom bombs on Hiroshima and Nagasaki. More Japanese lives were actually lost in an earlier firebombing of Tokyo, but the message was clear. The Japanese surrendered on August 14 (see **Fig. 22.32** on p. 813).

The casualties were unprecedented in warfare. It is estimated that some 20–25 million Soviets died and some 6–9 million Germans. Other deaths included 10–20 million Chinese,

◀ 22.31 J. Howard Miller, "We Can Do It" (also called "Rosie the Riveter"), 1942. Color lithograph, 93" × 120" (236.2 × 304.8 cm). National Museum of American History, Smithsonian Institution, Washington, DC. With millions of men in uniform during World War II, industries retooled for the manufacture of war materials and turned to women to fill jobs on production lines. Posters like "We Can Do It" were part of an appeal to women to join the war effort. They also suggested to traditionalists that there was no place for division between gender roles in a country at war.

2–3 million Japanese, 1–3 million Indians, and hundreds of thousands of British, French, and Americans. Add these and other losses to the 6 million Jewish civilians—men, women, and children—slaughtered for no reason except they were Jewish. It adds up to 60–80 million people, combined military and civilian.

The United States occupied Japan. Germany was split into four areas of occupation—by the United States, Britain, France, and the Soviet Union, which took what would be called East Germany. The capital of Berlin, although within the Soviet sphere of occupation, was similarly split four ways. The Soviets also maintained a tight fist on nations they had captured in Eastern Europe, from Poland in the north to Albania in the south. The war over, hostility between the capitalist and socialist West and the communist Soviet Union soon resumed. But that is a story for another chapter.

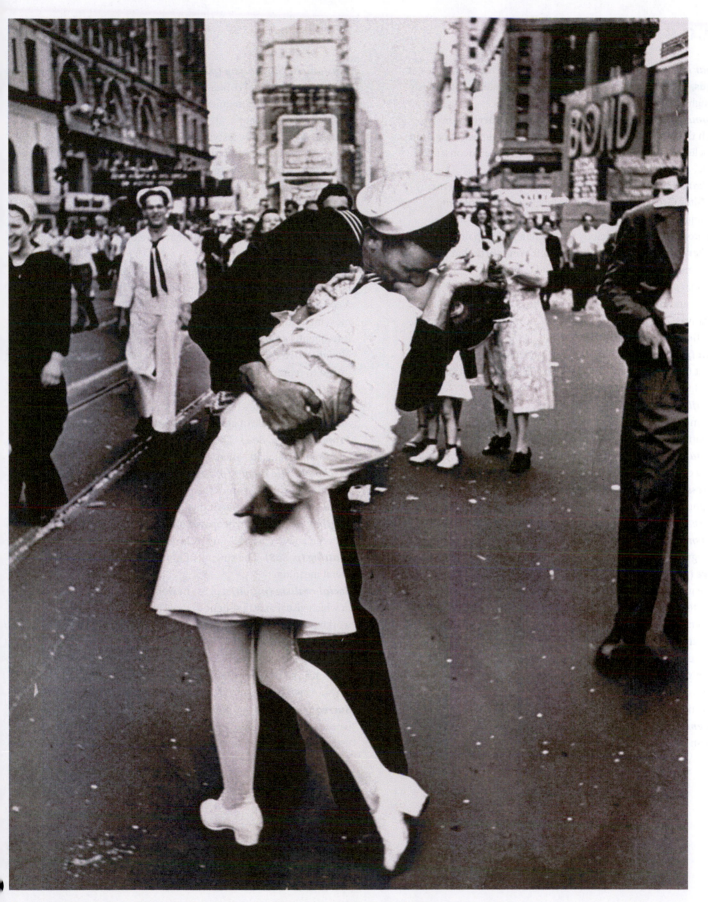

▲ **22.32 Alfred Eisenstaedt, *The Kiss*, August 14, 1945. Photograph.** A sailor kisses a nurse in Times Square, New York City, on Victory over Japan Day. The iconic photo was published along with others in a 12-page section in *Life* magazine called "Victory." Eisenstaedt happened to catch a spontaneous event. The nurse, apparently surprised, clutches her skirt and purse.

GLOSSARY

12-bar blues (p. 808) A form of blues in which a fixed series of chords, 12 bars (or measures) in length, is restated continuously throughout the piece.

Automatist Surrealism (p. 794) A form of **Surrealism** in which the artist or writer freely associates to the task at hand in the belief that the work is being produced by the unconscious mind.

Bauhaus (p. 800) A school of design established in Germany by Walter Gropius based on functionalism and employing techniques and materials used in manufacturing.

Blue note (p. 806) A melody note bent a half step down.

Bolshevik (p. 805) A member of a left-wing party that adopted the Communist concepts of Marx and Lenin.

Cubism (p. 792) A 20th-century style of painting developed by Picasso and Braque that emphasizes the two-dimensionality of the canvas, characterized by multiple views of an object and the reduction of form to cube-like essentials.

Dada (p. 790) A post–World War I movement that sought to use art to destroy art, thereby underscoring the paradoxes and absurdities of modern life.

De Stijl (p. 798) An early-20th-century art movement that emphasized the use of basic forms, particularly cubes, horizontals, and verticals; also called *Neo-Plasticism*.

Epiphany (p. 786) A sudden realization of the meaning or nature of something.

Expressionism (p. 790) A modern school of art in which an emotional impact is achieved through agitated brushwork, intense coloration, and violent, hallucinatory imagery.

Fascism (p. 781) A radical authoritarian national political ideology.

Fauve (p. 790) An early-20th-century style of art characterized by the juxtaposition of areas of bright colors that are often unrelated to the objects they represent and by distorted linear perspective.

Figurative art (p. 799) Art that represents forms in the real world, especially human and animal forms.

Futurism (p. 792) An early-20th-century style of art that portrayed modern machines and the dynamic character of modern life and science.

Harlem Renaissance (p. 788) A renewal and flourishing of African American literary, artistic, and musical culture following World War I in the Harlem section of New York City.

Illusionistic Surrealism (p. 794) A form of **Surrealism** that renders the irrational content, absurd juxtapositions, and changing forms of dreams in a manner that blurs the distinctions between the real and the imaginary.

Jazz (p. 807) A musical style born of a mix of African and European musical traditions at the beginning of the 20th century.

Modulation (p. 808) In music, the shift to a new key.

Montage (p. 805) The sharp juxtaposition of scenes by film cutting and editing.

National Socialism (p. 781) A right-wing, **fascist**, anti-Semitic, and anti-Communist movement that developed in Germany; also known as *Nazism*.

Naturalistic style (p. 801) Frank Lloyd Wright's architectural style, in which a building's form is integrated with its site.

Neue Sachlichkeit (p. 781) A cynical, socially critical art movement that arose in Germany in the aftermath of World War I. It frequently employed a harsh realism to protest war.

Nonobjective (p. 790) Referring to art that does not represent or intend to represent any natural or actual object, figure, or scene.

Prohibition (p. 778) The period in the United States from 1920 to 1933, during which the 18th Amendment prohibited the manufacture or sale of alcoholic beverages.

Propaganda (p. 804) The presentation of a point of view with the intention to persuade and convince.

Psychoanalytic theory (p. 793) Sigmund Freud's theory of personality, which assumes the presence of unconscious conflict and the mental structures of the id, ego, and superego.

Ragtime (p. 806) A syncopated (off-beat) musical style popular between about 1899 and 1917. A forerunner of jazz.

Scatting (p. 808) The singing of improvised syllables that have no literal meaning.

Social realism (p. 790) An art movement largely of the 1930s in which visual artists sought to draw attention to the plight of working class and poor people, often tinged with satire and social protest.

Stream of consciousness (p. 786) A literary technique that is characterized by an uncensored flow of thoughts and images, which may not always appear to have a coherent structure.

Surrealism (p. 790) A 20th-century style of art and literature whose content and imagery is believed to stem from unconscious, irrational sources and therefore takes on fantastic forms, although often rendered with extraordinary realism.

THE BIG PICTURE THE WORLD AT WAR

Language and Literature

- Poets of the Lost Generation wrote poetry during World War I.
- Joyce wrote novels such as *Ulysses* (1922) in which he used stream of consciousness.
- Lewis wrote the novel *Babbitt* (1922), which is an indictment of the intellectual vacancy of the middle class and its pressure to conform.
- Hughes's writings (e.g., "I, Too," 1925) reflected the movement known as the Harlem Renaissance.
- Kafka wrote stories and novels in which people are trapped by dangerous, incomprehensible forces (e.g., *The Trial*, 1925).
- Hemingway published short stories (e.g., "In Another Country," 1927) and novels about World War I and the Spanish Civil War.
- Woolf wrote *A Room of One's Own* (1929), in which she protests the relegation of women to second-class status.
- Huxley published the novel *Brave New World* (1931), in which the effort to create stability results in a mechanistic society that uses selective breeding of humans so that they will be content with menial labor.

Art, Architecture, and Music

- The functionalist Bauhaus movement was innovated by Gropius in Germany in 1919.
- Ragtime and jazz developed from African and European musical styles, with Joplin considered the "King of Ragtime."
- O'Keeffe and Demuth were among those who created abstract art in the early-20th-century United States.
- Armstrong popularized New Orleans jazz after World War I.
- Ballet blossomed between the wars, particularly in France and Russia.
- Mondrian worked in the De Stijl movement.
- Duchamp worked in the Dada style, in which art is used to destroy art.
- Gershwin's *Porgy and Bess* was first staged in 1935.
- Wright designed buildings in the naturalistic style, including "Fallingwater" in 1936.
- Photographers such as Lange and Evans recorded the desperation of ordinary citizens during the Great Depression.
- Freud's psychoanalytic theory was used as an inspiration for Surrealism.
- Dalí and Miró created artworks in the Surrealist style.
- Douglas and Lawrence's paintings represented the flourishing of the Harlem Renaissance.
- Propaganda films were made by Eisenstein in the Soviet Union and Riefenstahl in Germany.
- Picasso painted *Guernica* in 1937 as a protest against the bombing of civilians in the Spanish Civil War.
- Wood and Hopper created figurative artworks in the United States.

Philosophy and Religion

- Disillusionment reigned following World War I.
- Communism came to power in Russia in 1917.
- Fascism came to power in Germany, Italy, and Spain in the 1930s and was defeated in Germany and Italy in 1945.

The Contemporary Contour

PREVIEW

In the summer of 1950, a radio broadcaster named William Wright interviewed the artist Jackson Pollock, who by that time had become somewhat of a household name. Just one year earlier, *Life*—a weekly magazine with 50 pages of pictures and the news condensed to accompanying captions—featured a four-page spread on Pollock that carried the headline, "Is he the greatest living painter in the United States?" He was certainly the most famous.

When Pollock died in a car crash in the summer of 1956, *Life* magazine dubbed him "Jack the Dripper." His signature style—drips, spatters, and looping skeins of enamel paint flung from sticks and brushes onto a canvas spread on the studio floor—was called "action painting," the by-product of a dynamic, choreographed process in which Pollock's body, his gestures, were fully invested. He defied the traditional relationship of the artist to the easel, departed from conventional materials, and prioritized the notion that "technique is just a means of arriving at a statement."

More recently, the *New York Times Magazine* and the *Huffington Post* Internet newspaper both ran stories on Martin Klimas, a German artist who has been called a "3-D Jackson Pollock." Posing the question, "What does sound look like?" Klimas combines paint, music, photography, and technology to produce transfixing images whose unique character is determined not by the artist's hand but by relationships among these elements that occur outside of his direct control (**Fig. 23.1**). His work is influenced by the studies of wave phenomena and of the effect of vibrations on liquids and powders undertaken by the Swiss scientist Hans Jenny. These effects, Jenny concluded, are not unregulated chaos but, rather, a dynamic but ordered pattern.

Klimas begins a project by placing paint directly on a scrim on top of a sound speaker, after which he turns up the volume on a specifically chosen piece of music (anything from the jazz trumpet of Miles Davis to the 1960s rock tunes of the Velvet Underground and the electronic music of Kraftwerk). The vibrations created by the music blasting though the speaker create explosive patterns of shape and color that are captured by Klimas with his Hasselblad camera at a shutter speed of 1/7000th of a second. One of his projects, which resulted in 212 printed images, used an average of six ounces of paint per shot and a total of 18.5 gallons of paint. The number of blown speakers: two.

It is hard to imagine Klimas's work outside of Pollock's legacy (see Fig. 23.4). With his radical experimentation with materials and processes, Pollock cast a wide net of possibilities that would, in its own way, make Klimas's work possible. Pollock's painting defined, and was of, his age, just as it would be inconceivable to separate Klimas from the digital age in which he lives. In his interview with Pollock, Wright asked this question: "Mr. Pollock, there's been a good deal of controversy and a great many comments have been made regarding your method of painting. Is there something you'd like to tell us about that?" Pollock answered: "My opinion is that new

◀ **23.1** Martin Klimas, *Untitled* (Miles Davis, "Pharaoh's Dance," from "Bitches Brew"), 2011. Lambda print facemounted on acrylic, 20" × 18⅛" (52 × 46 cm).

needs need new techniques. And the modern artists have found new ways and new means of making their statements. It seems to me that the modern painter cannot express this age, the airplane, the atom bomb, the radio, in the old forms of the Renaissance or of any other past culture. Each age finds its own technique."[1]

TOWARD A GLOBAL CULTURE

From the perspective of the 21st century, the events that happened just after 1945 seem to recede into distant history. It is difficult to remember what has happened to U.S. culture in the three generations since the end of World War II. Events that occurred in the past more than four decades ago are still perhaps

1. Jackson Pollock, interview by William Wright in "Pollock: A Catalogue Raisonné", ed. Francis V. O'Connor and Eugene Victor Thaw (New Haven: Yale University Press, 1978).

too close to know whether they have permanently changed us as a people. Was the moon landing of 1969 really a watershed event in our consciousness as humans? Has the "American Century" so proudly forecast by commentators at the end of World War II drawn to a close? Has the revolution in communications—the age of information—changed the way we learn? Are microtechnology, new forms of communication, and the computer going to usher in a new, wonderful era or an anti-utopia?

The decades following World War II were rightly called the Atomic Age. Developed largely by refugee scientists during that war, atomic weaponry placed an ominous shadow over international tensions and conflicts. It is not merely a question of bigger nuclear bombs or deadlier weapons, although they are surely that. Nuclear weapons can have long-term and little-understood consequences for both nature and the individuals who might survive the first blast. Today, with a precariously balanced peace between the dominant powers, the major fear of nuclear weapons is their possible use by rogue nations or terrorist groups.

First, because modern warfare was so far beyond the power of the postwar human intellect to imagine, artists turned to satire as a way of expressing their fear and hatred of it. Novels like

The Contemporary Contour

1945 CE	1950 CE	1960 CE	1970 CE	1990 CE
United States drops atomic bombs on Hiroshima and Nagasaki in 1945	Korean War begins in 1950	East Germany erects the Berlin Wall in 1961	U.S. Supreme Court decision in *Miller v. California* effectively ends censorship in 1973	East and West Germany reunite in 1990
World War II ends in Europe and Japan in 1945	United States explodes first hydrogen bomb in 1952	Soviet Union launches first human into space in 1961	United States withdraws from Vietnam in 1975	Soviet Union is dissolved in 1991
United Nations General Assembly meets for first time in 1946	Korean War ends with a truce in 1953	An American orbits the earth in space in 1962	Microsoft is established in 1975	Google is incorporated in 1998
The transistor is invented in 1947	School segregation is outlawed by the U.S. Supreme Court in 1954	A TV signal crosses the Atlantic via a satellite in 1962	Apple Computer is established in 1976	Terrorists attack World Trade Center and Pentagon in 2001
Israel becomes an independent state in 1948	U.S. civil-rights movement begins in the South	U.S. president John F. Kennedy is assassinated in 1963	1981 Space shuttle first flies	United States invades Afghanistan in 2001
Mao Zedong becomes leader of Communist China in 1949	Sputnik, the first artificial satellite, is launched by the Soviet Union in 1957	United States builds up troops in Vietnam in 1964	Communist governments of Eastern Europe fall beginning in 1989	United States invades Iraq in 2003
		National Organization for Women is founded in 1966		Facebook is launched in 2004
		Martin Luther King Jr. and Robert Kennedy are assassinated in 1968		
		A U.S. astronaut takes the first walk on the moon in 1969		

Joseph Heller's *Catch-22* (1961) and Thomas Pynchon's *Gravity's Rainbow* (1973) sketched out war in terms of absurdity, irrationality, and the blackest of humor, while Stanley Kubrick's brilliant movie *Dr. Strangelove* (1964) mounted a scathing attack on those who speak coolly about "megadeaths" and "mutual assured destruction" (MAD in military jargon). Any attempt at mere realism, these artists seemed to say, pales into triviality.

Second, at the end of World War II, the United States emerged both as a leading economic power in the world and as the leader of the "free world" in its struggle against Communism. This preeminence explains both the high standard of living in the country and the resentment of those who did not share it. However, economic supremacy does not permit a nation to live free from outside forces. The energy crises, the need for raw materials, the quest for labor, and the search for new markets today bind many nations together in a delicate economic and social network of political relationships. The United States depends on other countries; the shifting patterns of economic relationships among North America, Europe, the developing world, China, Japan, and the oil producers of the Middle East are all reminders of how fragile that network really is. That is why we can speak of a global economy. With the collapse of Communism in Eastern Europe, new patterns of culture slowly began to emerge, as the vigor of the Pacific Rim nations attest. We do not know exactly how the new world order will operate. What we do know is that our lives are not insulated: our stereos are assembled in Malaysia, our vegetables may come from Mexico, our blue jeans are sewn in Bangladesh, and our sneakers are manufactured in Romania.

The phenomenon of globalization has created a world in which cultures are no longer distant from one another and people and places are no longer separate. Television, smartphones, and the Internet create an immediacy of communication as never before. War around the globe finds its way onto the screens of our devices around the clock. "Distant" hurricanes, cyclones, and earthquakes are witnessed everywhere at the same time and often in real time. South Korea's electronics monopolize Americans' holiday gift-giving. China's air pollution flows into California.

The interconnectedness of globalization heightens our awareness that this is a shared planet and that, collectively, we are witnessing changing patterns in global weather. There has been a gradual rise in planetary temperatures leading to the melting of glaciers and polar ice caps, along with resultant rises in sea level. Nearly all scientists agree that it appears that the burning of fossil fuels is a major contributor to global warming, burdening the atmosphere with greenhouse gasses such as carbon dioxide that trap solar energy. Some disagree and deny, although the supporting evidence for their positions is wanting. One thing is clear: replacing the burning of fossil fuels with nonpolluting resources such as solar power and wind power will cause disruptions in current world economies. There is thus conflict between those who desire to maintain energy-sector jobs connected with fossil fuels and those who see the fate of the planet in the balance. The issue is playing out before our eyes.

The Demand for Rights

The material satisfactions of Western life spawned other kinds of dissatisfaction. While we may be the best-fed, best-housed, and best-clothed citizens in history, the hunger for individual and social meaning remains a constant in our lives. For instance, many sociopolitical movements in this country are signs of that human restlessness that will not be satisfied by bread alone. These movements are not peculiar to North America, as democratic movements in other parts of the world so readily attest.

The incredible achievements of modern society have exacted their price. Sigmund Freud shrewdly pointed out in *Civilization and Its Discontents* (1929) that the price of advanced culture is a certain repression of the individual, together with pressure for that individual to conform to the larger will of the community. North Americans have always been sensitive to the constraints of the state, because their history began as a revolt against statist domination.

The Western world tends to view repression in terms more social than political. The complexity of the technological management of modern life has led many to complain that we are becoming mere numbers or ciphers under the indifferent control of data banks and computers. Such warnings began as early as George Orwell's political novel *1984* (1946), written right after World War II; progressed through David Riesman's sociological tract of the 1950s, *The Lonely Crowd*; to the futurist predictions of Alvin Toffler's *Future Shock* in the 1970s. Now, in the 21st century, many more such analyses are appearing.

The 1960s

Dramatic changes occurred in American attitudes and behavior during the "Swinging Sixties." Society was on the threshold of major social upheaval in science, politics, fashion, music, art, cinema, and sexual behavior. Many of the so-called Woodstock generation, disheartened by commercialism and the Vietnam War, followed the advice of Harvard University professor Timothy Leary to "tune in, turn on, and drop out." That is, many of them tuned in (to rock music), turned on (to drugs), and dropped out (of mainstream society). The heat was on between the hippies and the hard hats. Long hair became the mane of men. Bell-bottomed jeans flared. Films became sexually explicit. Hard-rock music bellowed the message of rebellion and revolution.

The 1960s were also the heart of the sexual revolution. Social movements such as the sexual revolution often gain momentum from a timely interplay of scientific, social, political, and economic forces. The war (in Vietnam), the bomb (fear of a nuclear holocaust), the pill (the introduction of the birth-control pill), and the mass media (especially television) were four such forces. The pill lessened the risk of unwanted pregnancy,

permitting young people to engage in recreational or casual sex, rather than procreative sex. Pop psychology movements, such as the Human Potential Movement of the 1960s and 1970s (the "Me Decade"), spread the message that people should get in touch with and express their genuine feelings, including their sexual feelings. "Do your own thing" became one catchphrase; "if it feels right, go with it" became another.

Film scenes of lovemaking became so commonplace that the movie rating system was introduced to alert parents. And censors lost the battle to keep everything that had been banned in the arts—the visual arts, the performing arts, literature, and music—under wraps.

THE INTELLECTUAL BACKGROUND

The philosophy that most persistently gripped the intellectual imagination of the Western world in the period immediately after World War II was **existentialism**. Existentialism is more an attitude than a single philosophical system. Its direct ancestry can be traced to the 19th-century Danish theologian and religious thinker Søren Aabye Kierkegaard (1813–1855), who set

out its main emphases. Kierkegaard strongly reacted against the great abstract philosophical systems developed by such philosophers as Georg Wilhelm Hegel (1770–1831) in favor of an intense study of the individual person in his or her actual existing situation in the world. Kierkegaard emphasized the single individual ("the crowd is untruth") who exists in a specific set of circumstances at a particular time in history with a specific consciousness. Philosophers like Hegel, Kierkegaard once noted ironically, answer every question about the universe except "Who am I?," "What am I doing here?," and "Where am I going?"

This radically subjective self-examination was carried on throughout the 20th century by philosophers like Friedrich Nietzsche and novelists like Fyodor Dostoyevsky, who are regarded as forerunners of modern existentialist philosophy. In the 20th century, writers like Franz Kafka, the German poet Rainer Maria Rilke, the Spanish critic Miguel de Unamuno, and, above all, the German philosopher Martin Heidegger gave sharper focus to the existentialist creed.

JEAN-PAUL SARTRE The postwar writer who best articulated existentialism both as a philosophy and a lifestyle, however, was the French writer and philosopher Jean-Paul Sartre (1905–1980). Sartre believed it the task of the modern thinker to take seriously the implications of atheism. If there is no God, Sartre insisted, then there is no blueprint for what a person should be and no ultimate significance to the universe. People are thrown into life, and their very aloneness forces them to make decisions about who they are and what they shall become. "People are condemned to be free," Sartre wrote. Existentialism was an attempt to help people understand their place in an absurd world, their obligation to face up to their freedom, and the kinds of ethics available to them in a world bereft of absolutes.

Sartre began his mature career just as Germany was beginning its hostilities in the late 1930s. After being a prisoner of war in Germany, Sartre lived in occupied France, where he was active in the French Resistance, especially as a writer for the newspaper *Combat*. Sartre and the feminist writer Simone de Beauvoir (1908–1986) were the major voices demanding integrity in the face of the absurdities and horrors of war-torn Europe. Such an attitude might be considered a posture if it were not for the circumstances in which these existentialist writers worked.

The appeal of existentialism was its marriage of thought and action, its analysis of modern anxiety, and its willingness to express its ideas through the media of plays, novels, films, and newspaper polemics. After the close of the war in 1945, there was a veritable explosion of existentialist theater (Samuel Beckett, Harold Pinter, Jean Genet, Eugène Ionesco) and existentialist fiction (Albert Camus, Sartre, Beauvoir) in Europe (see Reading 23.1 on p. 822). In the United States, themes of existentialism were taken up eagerly by intellectuals and writers who were attracted to its emphasis on anxiety and alienation.

CULTURE AND SOCIETY

Writers in the Existentialist Tradition

Søren Kierkegaard (1813–1855)—Danish
Fyodor Dostoyevsky (1821–1881)—Russian
Friedrich Nietzsche (1844–1900)—German
Miguel de Unamuno (1864–1936)—Spanish
Nicholas Berdyaev (1874–1948)—Russian
Rainer Maria Rilke (1875–1926)—Czech/German
Martin Buber (1878–1965)—Austrian/Israeli
Jacques Maritain (1882–1973)—French
Karl Jaspers (1883–1969)—German
Franz Kafka (1883–1924)—Czech/German
José Ortega y Gasset (1883–1955)—Spanish
Martin Heidegger (1889–1976)—German
Jean-Paul Sartre (1905–1980)—French
Albert Camus (1913–1960)—French

CULTURE AND SOCIETY

Liberation

If we understand *liberation* in the deep social sense as freedom *to* realize one's full human potential as well as freedom *from* oppressive structures, we would then have to say that the desire for, and realization of, liberating freedom is one of the hallmarks of modern world culture. This was especially true in the second half of the 20th century.

Liberation has come for millions both from the totalitarian regimes of fascism, Nazism, and Marxism as well as freedom from the colonial powers in areas as diverse as India and Africa. These liberation movements have their mirror image in the struggle for civil rights for people of color, for women, and for exploited social minorities, as well as in struggles to end poverty, hunger, and the exploitation of children.

What energizes these quite different movements for freedom and liberation? A partial answer is to be found in the power of mass communication to let people know that they are victims of oppression. There is also the power of certain fundamental ideas derived, in the West, from Greek philosophical thought and biblical prophetism, which crystallized in the Enlightenment that held forth the promise of the right to "life, liberty, and the pursuit of happiness."

The struggle for social and political liberation has involved many communities, with some spokespersons standing out both because of their personal bravery and the power of their convictions. We think immediately of Mohandas Gandhi in India; Martin Luther King Jr. in the United States; Desmond Tutu and Nelson Mandela in Africa; Lech Walesa and Vaclav Havel in Eastern Europe; as well as the many unnamed people who put their lives on the line to live free.

The United States of the 21st century has seen continued struggles for racial justice, which in many instances has taken the form of protesting the shooting of unarmed black men by police. Discrimination against the LGBT (lesbian-gay-bisexual-transgender) community also came into the foreground during the latter 20th century and early 21st century. Lesbians and gay males have in particular fought for marriage equality, and in 2015 the U.S. Supreme Court struck down all local laws and regulations preventing lesbians and gay males from getting married—in any state.

◄ **23.2** George Segal, *Gay Liberation*, inaugurated in Greenwich Village in 1992. Bronze, covered in white laquer; life-sized. Christopher Park, Greenwich Village, New York. Commissioned by a patron, the piece commemorates the Stonewall riots in Greenwich Village in which members of the gay community engaged in violent protests against a raid on the Stonewall Inn by New York police. The spontaneous events were seen as a catalyst for LGBT rights.

READING 23.1 JEAN-PAUL SARTRE

From "Existentialism Is a Humanism"

Atheistic existentialism, of which I am a representative, declares with greater consistency that if God does not exist there is at least one being whose existence comes before its essence, a being which exists before it can be defined by any conception of it. That being is man or, as Heidegger [the German philosopher] has it, the human reality. What do we mean by saying that existence precedes essence? We mean that man first of all exists, encounters himself, surges up in the world—and defines himself afterwards. If man as the existentialist sees him is not definable, it is because to begin with he is nothing. He will not be anything until later, and then he will be what he makes of himself. Thus, there is no human nature, because there is no God to have a conception of it. Man simply is. Not that he is simply what he conceives himself to be, but he is what he wills, and as he conceives himself after already existing–as he wills to be after that leap towards existence.

Man is nothing else but that which he makes of himself. That is the first principle of existentialism. And this is what people call its "subjectivity," using the word as a reproach against us. But what do we mean to say by this, but that man is of a greater dignity than a stone or a table? For we mean to say that man primarily exists—that man is, before all else, something which propels itself towards a future and is aware that it is doing so. Man is, indeed, a project which possesses a subjective life, instead of being a kind of moss, or a fungus or a cauliflower. Before that projection of the self nothing exists; not even in the heaven of intelligence: man will only attain existence when he is what he purposes to be. Not, however, what he may wish to be. For what we usually understand by wishing or willing is a conscious decision taken—much more often than not—after we have made ourselves what we are. I may wish to join a party, to write a book or to marry—but in such a case what is usually called my will is probably a manifestation of a prior and more spontaneous decision. If, however, it is true that existence is prior to essence, man is responsible for what he is. Thus, the first effect of existentialism is that it puts every man in possession of himself as he is, and places the entire responsibility for his existence squarely upon his own shoulders. And, when we say that man is responsible for himself, we do not mean that he is responsible only for his own individuality, but that he is responsible for all men.

THE BEAT GENERATION The so-called Beat writers of the 1950s embraced a style of existentialism filtered through the mesh of jazz and the African American experience. Beat writers such as Jack Kerouac (1922–1969), William S. Burroughs (1914–1997), and Allen Ginsberg (1926–1997) embraced the existentialist idea of alienation even though they rejected the austere tone of their European counterparts. Their sense of alienation was united with the idea of experience heightened by ecstasy of a musical, sexual, or chemical origin. The Beats, at least in that sense, were the progenitors of the 1960s hippies.

Jack Kerouac's *On the Road* could be said to follow in the tradition of Homer's *The Odyssey*. It illuminates the inner geography of the mind as well as the contours and peoples of the lands it navigates. *On the Road*, published in 1957, is a landmark of the Beat Generation, following young, rootless people as they traverse—against a background of drugs, jazz, and poetry—the nation's highways and byways in the era before the social and cultural turmoil of the 1960s:

READING 23.2 JACK KEROUAC

From *On the Road*

We were all delighted, we all realized we were leaving confusion and nonsense behind and performing our one noble function of the time, move. (part 2, ch. 6)

I woke up as the sun was reddening; and that was the one distinct time in my life, the strangest moment of all, when I didn't know who I was—I was far away from home, haunted and tired with travel, in a cheap hotel room I'd never seen, hearing the hiss of steam outside, and the creak of the old wood of the hotel, and footsteps upstairs, and all the sad sounds, and I looked at the cracked high ceiling and really didn't know who I was for about fifteen strange seconds. (part 1, ch. 3)

LA is the loneliest and most brutal of American cities; New York gets god-awful cold in the winter but there's a feeling of wacky comradeship somewhere in some streets. (part 1, ch. 13)

Isn't it true that you start your life a sweet child believing in everything under your father's roof? Then comes the day of the Laodiceans,[2] when you know you are wretched and miserable and poor and blind and naked, and with the visage of a gruesome, grieving ghost you go shuddering through nightmare life. (part 1, ch. 13)

Whither goest thou, America, in thy shiny car in the night? (part 2, ch. 3)

So in America when the sun goes down and I sit on the old broken-down river pier watching the long, long skies over New Jersey and sense all that raw land that rolls in one unbelievable huge bulge over to the West Coast, and all that road going, and all the people dreaming in the immensity of it…and tonight the stars'll be out, and don't you know that God is Pooh Bear? The evening star must be drooping and shedding her sparkler dims on the prairie, which is just before the coming of complete night that blesses the earth, darkens all rivers, cups the peaks and folds the final shore in, and nobody, nobody knows what's going to happen to anybody besides the forlorn rags of growing old…. (part 5)

2. Literally, inhabitants of ancient Laodicea, but referring to Laodiceans' indifference to religion.

ALBERT CAMUS The existentialist ethic remained alive mainly through the novels of Albert Camus (1913–1960). In works like *The Stranger* (1942), *The Plague* (1947), and *The Fall* (1956), Camus—who disliked being called an existentialist—continued to impress his readers with heroes who fought the ultimate **absurdity** of the world with lucidity and dedication, and without illusion.

Today, existentialism is mainly a historical moment in the postwar culture of Europe and America. Its importance, however, resides in its capacity to formulate some of the most important ideas of modernity: the absence of religious faith, the continuous search for meaning, the dignity of the individual, and the concern for human subjectivity.

VISUAL ARTS

Being an artist now means to question the nature of art.

—JOSEPH KOSUTH

There is a saying, once thought to be a Chinese curse, which reads, "May you live in interesting times." Whatever its origin, it captures the value of stimulation and novelty, even at the expense, perhaps, of tranquility. When it comes to contemporary art, we live in nothing if not interesting times. Louise Bourgeois, who was born in 1911 and continued to work avidly until her death at age 98, noted that "there are no settled ways," there is "no fixed approach." Never before in history have artists experimented so freely with so many media, such different styles, such a wealth of content. Never before in history have works of art been so accessible to so many people. Go to Google Images, and the world of art and artists is a mouse click away.

In this section, we discuss the visual arts that have appeared since the end of World War II—the art of recent times and of today.

Postwar Expressionism: Existentialism in the Visual Arts

One of the early effects of the Second World War on the arts was to bring existentialism to them. Europe was devastated by the war to a much greater degree than the United States, which had been protected by two oceans. Cynicism and atheism were abundant, with many arguing that the explanations for how bad things could happen to good people had run their course and were now in the

gutter. The artist Alberto Giacometti rode the wave of postwar pessimism.

ALBERTO GIACOMETTI The Swiss sculptor Alberto Giacometti (1901–1966) was a friend of Sartre and made many drawings of him. Sartre returned the favor by writing about Giacometti, as in "La recherche de l'absolu"—"The Search for the Absolute"—an undertaking that must meet with failure for an existentialist, since nothing is certain in life in that philosophy.

It has also been remarked that there are no casual or disinterested viewers of Giacometti's work and that its rawness touches, well, raw nerves. Such is the case with *Man Pointing No. 5* (**Fig. 23.3**). The man is something of a stick figure roughed up with the harsh kneading of the sculptor's fingers. The figure is unnaturally elongated and skeletal, shedding the imagined odors of death and destruction. The figure is at the very least alienated and alone, pointing, perhaps, at the severe abstraction of the postwar world.

The New York School

At mid-20th century, experiments in earlier nonobjective painting, the colorful distortions of Expressionism and geometric abstraction of Cubism, automatist processes of Surrealism, and a host of other influences—including Zen Buddhism and psychoanalysis—were palpable in the developing styles of New York City artists. From this crucible, **Abstract Expressionism** emerged. Like art movements perceived as radical, critics reacted to it with both intrigue and skepticism. Writing in the *New Yorker* in 1945, Robert M. Coates commented:

[A] new school of painting is developing in this country. It is small as yet, no bigger than a baby's fist, but it is noticeable if you get around to the galleries much. It partakes a little of Surrealism and still more of Expressionism, and although its main current is still muddy and its direction obscure, one can make out bits of Hans Arp and Joan Miró floating in it, together with large chunks of Picasso and occasional

◀ **23.3** Alberto Giacometti, *Man Pointing No. 5*, 1947. Bronze, 70½" × 40¾" × 16⅜" (179 × 103.4 × 41.5 cm). Museum of Modern Art, New York, New York. The sculpture, heavily kneaded by the artist, appears to capture the existential anxieties following World War II.

fragments of [African American] sculptors. It is more emotional than logical in expression, and you may not like it (I don't either, entirely), but it can't escape attention.[3]

Spontaneity, gestural brushstrokes, nonobjective imagery, and fields of intense color characterize Abstract Expressionism. Many canvases are quite large, seeming, at any proximity, to envelop the viewer in the artist's distinct pictorial world. Some lines and shapes seem to reference East Asian calligraphy, but their rendering is expansive and muscular compared with the gentle, circumscribed brushstrokes of Chinese and Japanese artists.

For some Abstract Expressionists, such as Jackson Pollock and Willem de Kooning, the gestural application of paint emerged as the most important aspect of their work.

JACKSON POLLOCK

Pollock's talent is volcanic. It has fire. It is unpredictable. It is undisciplined. It spills itself out in a mineral prodigality not yet crystallized. It is lavish, explosive, untidy.... What we need is more young men who paint from inner compulsion without an ear to what the critic or spectator may feel—painters who will risk spoiling a canvas to say something in their own way. Pollock is one.[4]

3. Robert M. Coates, "The Art Galleries," *New Yorker* (May 26, 1945): 68.
4. Clement Greenberg, quoted in the introduction to the catalog *Jackson Pollock*, Art of This Century Gallery, New York, November 9–27, 1943.

Jackson Pollock (1912–1956) is probably the best known of the Abstract Expressionists. Photographs or motion pictures of the artist energetically dripping and splashing paint across his huge canvases are familiar to many people. Pollock would walk across the surface of the canvas as if controlled by primitive impulses and unconscious ideas. Accident became a prime compositional element in his painting. Art critic Harold Rosenberg coined the term **action painting** in 1951 to describe the outcome of such a process—a painting whose surface implies a strong sense of activity, as created by the signs of brushing, dripping, or splattering of paint.

Born in Cody, Wyoming, Pollock went to New York to study with Thomas Hart Benton at the Art Students League. The 1943 quote from Clement Greenberg that begins this section shows the impact that Pollock made at an early exhibition of his work. His paintings of this era frequently depicted actual or implied figures that were reminiscent of the abstractions of Picasso and, at times, of Expressionists and Surrealists.

Aside from their own value as works of art, Pollock's drip paintings of the late 1940s and early 1950s made several innovations that would be mirrored and developed in the work of other Abstract Expressionists. Foremost among these was the use of an overall gestural pattern barely contained by the limits of the canvas. In *One: Number 31* (**Fig. 23.4**), the surface is an unsectioned, unified field. Overlapping skeins of paint create dynamic webs that project from the picture plane, creating an illusion of infinite depth. In Pollock's best work, these webs seem to be composed of energy that pushes and pulls the monumental tracery of the surface.

▲ **23.4** Jackson Pollock, *One: Number 31*, 1950, oil and enamel paint on canvas, 8' 10" × 17' 5⅝" (269.5 × 530.8 cm). **The Museum of Modern Art, New York, New York.** Pollock would walk across the surface of the canvas, dripping and splashing paint, as if in the thrall of primitive impulses and unconscious urges. "Accident" is a prime compositional element in his painting.

Pollock was undergoing psycho-analysis when he executed his great drip paintings. He believed strongly in the role of the unconscious mind, of accident and spontaneity, in the creation of art. He was influenced not only by the intellectual impact of the Automatist Surrealists but also by what must have been his impression of walking hand in hand with his own unconscious forces through the realms of artistic expression. When asked about the meaning of such paintings, Pollock would say, "Any attempt on my part to say something about it…could only destroy it."[5]

Before his untimely death in a car crash in 1956, Pollock returned to figural paintings that were heavy in impasto and predominantly black. One wonders what might have emerged if the artist had lived a fuller span of years.

LEE KRASNER Lee Krasner (1908–1984) was one of relatively few women in the mainstream of Abstract Expressionism. Yet, despite her originality and strength as a painter, her work, until fairly recently, took a critical backseat to that of her famous husband—Jackson Pollock. She once noted:

> I was not the average woman married to the average painter. I was married to Jackson Pollock. The context is bigger and even if I was not personally dominated by Pollock, the whole art world was.[6]

Krasner had a burning desire to be a painter from the time she was a teenager and received academic training at some of the best art schools in the country. Like Pollock and the other members of the Abstract Expressionist school, she was exposed to the work of many European émigrés who came to New York in the 1930s and 1940s.

Both Pollock and Krasner experimented with allover compositions around 1945, but the latter's work was smaller in scale and exhibited much more control. Even after 1950, when Krasner's work became much freer and larger, the accidental nature of Pollock's style never took hold in her work. Rather, Krasner's compositions might be termed a synthesis of choice and chance.

Easter Lilies (**Fig. 23.5**) was painted in 1956, the year of Pollock's fatal automobile accident. The jagged shapes and bold

▲ **23.5** Lee Krasner, *Easter Lilies*, 1956. Oil on cotton duck, 48¼" × 60⅛" (122.655 × 152.7 cm). **Private collection.** Whereas Pollock's action paintings have an almost accidental quality to them, Krasner's imagery seems to be more controlled.

black lines against the muddy greens and ochers render the composition dysphoric; yet in the midst of all that is harsh are the recognizable contours of lilies, whose bright whites offer a kind of hope in a sea of anxiety. Krasner once remarked of her work, "My painting is so autobiographical, if anyone can take the trouble to read it."[7]

WILLEM DE KOONING Born in Rotterdam, Holland, Willem de Kooning (1904–1997) immigrated to the United States in 1926, where he joined the forerunners of Abstract Expressionism. Until 1940, de Kooning painted figures and portraits. His first abstractions exhibit Picasso's influence. But, as the 1940s progressed, de Kooning's compositions consistently featured a clash of the organic shapes and harsh, jagged lines, reflecting "the age of anxiety" about which W. H. Auden wrote in his Pulitzer Prize-winning poem by the same name set in 1940s New York City.

De Kooning is perhaps best known for his series of paintings of women that began in 1950. In contrast to the appealing

5. Jackson Pollock, quoted in Sidney Janis, *Abstract and Surrealist Art in America* (New York: Reynal & Hitchcock, 1944), p. 112.
6. Lee Krasner, quoted in Roberta Brandes Gratz, "Daily Close-Up—After Pollock," *New York Post*, December 6, 1973.

7. Lee Krasner, quoted in Cindy Nemser, "A Conversation with Lee Krasner," *Arts Magazine* (April 1973): 48.

▲ **23.6** Willem de Kooning, *Two Women's Torsos*, 1952. Pastel drawing, 18⅞" × 24". The Art Institute of Chicago, Chicago, Illinois.

figurative works of an earlier day, many of his abstracted women are frankly overpowering and repellent. Faces are frequently resolved into skull-like masks reminiscent of ancient fertility figures; they assault the viewer from a loosely brushed backdrop of tumultuous color. Perhaps they portray what was a major psychoanalytic dilemma during the 1950s—how women could be at once seductive, alluring, and castrating.

The subjects of *Two Women's Torsos* (**Fig. 23.6**) are among the more suggestive of the series. Richly curved pastel breasts swell from a sea of spontaneous brushstrokes that here and there violently obscure the imagery. The result is a freewheeling eroticism.

JOAN MITCHELL The intense physicality of action painting had the effect of masculinizing the Abstract Expressionist movement, and artist statements at the time did little to dispel that notion. Pollock, for example, famously referred to his canvas as an arena. The "boys' club" image was underscored by appearances. About the same time that Joan Mitchell (1925–1992) painted one of her many untitled works (**Fig. 23.7**), 28 artists considered the leading figures in New York painting were brought together for a photograph; only one was a woman—a painter named Hedda Sterne—whose work, though gestural, was much less aggressive in character than that of her male colleagues.

◀ **23.7** Joan Mitchell, *Untitled*, 1957. Oil on canvas 94⅛" × 87⅝" (239.1 × 222.6 cm). Embracing all-over painting with the expansiveness and power of this untitled painting, Mitchell, as did virtually all of the Abstract Expressionists, worked on a large scale. She emphasized materials and process but kept subject matter central to her paintings. Trying to paint a feeling as precisely as possible, she often described her paintings as "memories of feelings" or "memories of feelings of or about landscapes."

Mitchell did not pose in the photograph, but she is widely considered to have been the most important woman to work in the gestural idiom of Abstract Expressionism of the 1950s. Her sweeping brushstrokes, liberal use of color, and intense, raw energy create a sense of urgency and mood of turbulence.

MARK ROTHKO For some Abstract Expressionists such as Mark Rothko and Helen Frankenthaler, the creation of pulsating fields of color was more important than the gestural quality of the brushstroke. Their canvases are so large that they seem to envelop the viewer with color, the subtle modulations of which create a vibrating or resonating effect.

Mark Rothko (1903–1970) painted lone figures in urban settings in the 1930s and biomorphic Surrealistic canvases throughout the early 1940s. Later in that decade, he began to paint the large, floating, hazy-edged color fields for which he is renowned. During the 1950s, the **color fields** consistently assumed the form of rectangles floating above one another in an atmosphere defined by subtle variations in tone and brushwork. They alternately loom in front of and recede from the picture plane, as in *Magenta, Black, Green on Orange (No. 3/No. 13)* (**Fig. 23.8**). The large scale of these canvases absorbs the viewer in color, and the often blurred edges of the rectangles have a vibratory effect on the eyes.

Early in his career, Rothko favored a broad palette ranging from pale to vibrant and highly saturated colors. During the 1960s, however, his works grew somber. Reds that earlier had been intense, warm, and sensuous were now awash in deep blacks and browns and took on the appearance of worn cloth. Oranges and yellows were replaced by grays and black. Light that earlier had been reflected was now trapped in his canvases. Despite public acclaim, Rothko experienced depression during his last years, and his paintings of that period may reflect this.

HELEN FRANKENTHALER Helen Frankenthaler (1928–2011) was described by fellow artist Kenneth Noland as a "bridge between Pollock and what was possible." Frankenthaler's approach was less about extending the inner world of the artist into the outer through gesture and more about exploring the connection between color and surface—indeed, the literal integration of the two. By pooling and spreading expanses of diluted paint on unprimed canvas in her "soak stain" technique, Frankenthaler's translucent veils of color seeped into the fibers of the canvas, softening the edges of the colorful floating shapes. Intermittent flowing lines, splotches, and splatters of paint keep our eyes attuned to the decorative surface. In paintings such as *The Bay* (see **Fig. 23.9** on p. 828), the canvas and image are literally one.

▶ **23.8** Mark Rothko, *Magenta, Black, Green on Orange (No. 3/No. 13)*, 1949. Oil on canvas, 85⅜" × 65" (216.5 × 164.8 cm). **Museum of Modern Art, New York, New York.** When one sits or stands in front of works such as this one, the subtle differences in color create something of a pulsating effect.

◀ **23.9** Helen Frankenthaler, *The Bay*, 1963. Acrylic on canvas, 80¾" × 81¾" (205.1 × 207.7 cm). Detroit Institute of Arts, Detroit, Michigan. © 2016 Helen Frankenthaler Foundation, Inc./Artists Rights Society (ARS), New York. Before applying her paints, Frankenthaler thinned them to the consistency of washes.

Constructed Sculpture and Assemblage

True experimentation in the medium of sculpture came with the advent of the 20th century, and contemporary sculptors owe much to the trail-blazing predecessors who embraced unorthodox materials and processes. Constructed sculpture was added to the lexicon of technique as artists came to often build large-scale works from pieces of wood or welded shapes of steel. Components of constructed sculpture may include materials such as rods, bars, tubes, planks, dowels, blocks, fabric, wire, thread, glass, plastic, and machined geometric solids. As with many contemporary painters, sculptors were eager to emphasize surfaces and explored varied ways to add to them the artist's gesture. Also, as with Abstract Expressionist paintings, many of their works bore little or no resemblance to objects in the visible world.

Assemblage refers to works that are constructed, but from found objects.

DAVID SMITH American artist David Smith (1906–1965) moved away from figurative sculpture in the 1940s. His works of the 1950s were compositions of linear steel that crossed back and forth as they swept through space. Many sculptors of massive works create the designs but then farm out their execution to assistants or to foundries. Smith, however, took pride in constructing his own metal sculptures. Even though his shapes are geometrically pure (**Fig. 23.10**), his loving burnishing of their highly reflective surfaces grants them the overall gestural quality found in Abstract Expressionist paintings.

ALEXANDER CALDER Trained as a mechanical engineer, Alexander Calder (1898–1976) made **mobiles** that move with currents of air. They are among the most popular examples of

◀ **23.10** David Smith, *Cubi XIX*, 1964. Stainless steel, 112¾" × 58¼" × 40" (286.4 × 148 × 101.6 cm). Tate Gallery, London, United Kingdom. Smith burnished the steel to give it a gestural quality.

sculpture in the 20th century. Viewers generally enjoy them for their simple shapes, pure colors, and predictable seriation in size, and, incidentally, tend to watch for a while to see whether and how they will move. One does not view a Calder mobile and suspect that deep meanings lie within the work. *The Star* (**Fig. 23.11**) is composed of petal-like pieces of different sizes and colors that are cantilevered from metal rods in such a way that they can rotate horizontally—in orbits—in the breeze. However, the center of gravity remains stable, so that the entire sculpture is hung from a single point. The composition changes according to air currents and the perspective of the observer. The combinations of movements are for all practical purposes infinite, so that the observer will never see the work in quite the same way.

▲ **23.11** Alexander Calder, *The Star*, 1960. Polychrome sheet metal and steel wire, 35¾" × 53¾" × 17⅝" (90.8 × 136.5 × 44.8 cm). Art Museum at the University of Kentucky, Lexington, Kentucky. Calder's mobiles are designed to adjust to currents of air.

LOUISE NEVELSON The Russian-born American sculptor Louise Nevelson (1899–1988) made wood assemblages of recognizable found objects, integrating them in novel combinations that take on meanings of their own—meanings that are more than the sum of their parts. *Royal Tide IV* (**Fig. 23.12**) is a compartmentalized assemblage of rough-cut geometric shapes and lathed wooden pieces, including posts and finials, barrel staves, and chair slats—the pieces of a personal or collective past, of lonely introspective journeys amid the cobwebs of Victorian attics. Even though some of the objects are familiar and recognizable, Nevelson's unifying coat of paint de-emphasizes their distinct identities.

▼ **23.12** Louise Nevelson, *Royal Tide IV*, 1960. Wood with gold-spray technique, 127" × 175 ½" × 21 ½" (323 × 446 × 55 cm). Museum Ludwig, Cologne, Germany. Nevelson's assemblages often conjure up a sense of a shared cultural past.

JUDY PFAFF Described by the *New York Times* art critic, Roberta Smith, as a "collagist in space," Judy Pfaff's (b. 1946) sculptures and installations are constructed with all manner of materials and objects. *Said the Spider to the Fly* (see **Fig. 23.13** on p. 830) seems to tumble from the wall into the gallery space, drawing the viewer into a thicket of wood, wire, and paper flowers. Appropriating the opening line of an early 19th-century poem by the same title—"Will you walk into my parlour? Said the Spider to the Fly"—Pfaff

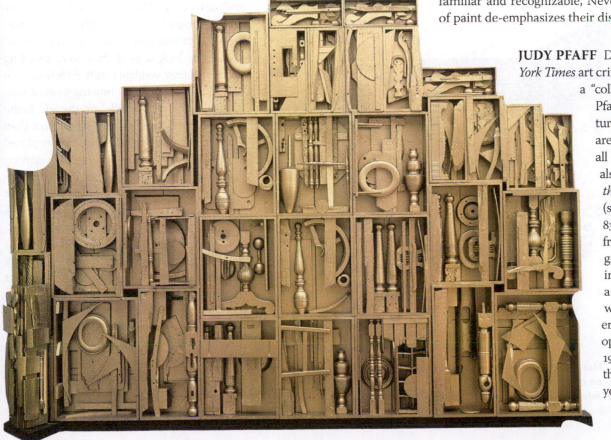

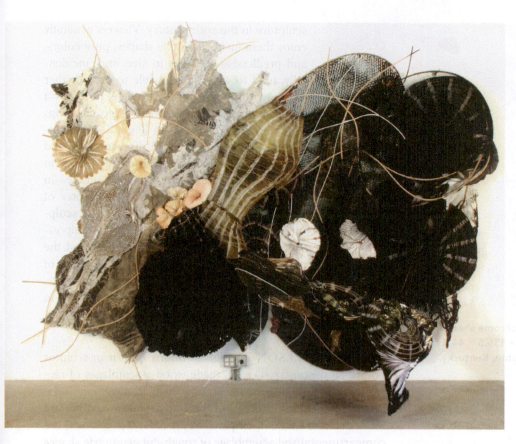

▲ **23.13** Judy Pfaff, *Said the Spider to the Fly* (2010). Paper, wood, wire and rod, artificial flowers, 128" × 162" × 48". The work extends four feet from the gallery wall.

▲ **23.14** Frank Stella, *Mas o Menos* (*More or Less*), 1964. Metallic powder in acrylic emulsion on canvas, 118" × 164 ½" (300 × 418 cm). Musée National d'Art Moderne, Centre Georges Pompidou, Paris, France. In this work, Stella sought repetition of a single formal element of art: the line.

juxtaposes seductive shapes and textures with a forbidding, sinister blackness to contemporize a classic cautionary tale.

Minimal Art

Helen Frankenthaler removed the brushstroke from abstract art, but another group of artists sought to reduce their ideas to their simplest forms. They created geometric shapes or progressions of shapes or lines using minimal numbers of formal elements—for example, the minimum amounts of colors and textures. Nor did they attempt to represent objects. Their school of art is called **Minimalism**.

FRANK STELLA Over the course of his career, Frank Stella (b. 1936) has produced drawings, paintings, sculptures, and architectural enclosures with a sculptural quality. However, he is largely credited as a key founder of the Minimalist school. His *Mas o Menos* (**Fig. 23.14**), which is Spanish for "more or less," is one of many works that represent no object in the real world and repeat basic lines—here, pinstripes arranged into geometric patterns. Stella restricts his palette to a single color. The design of the work tends to "push and pull," however, in that there are figure–ground reversals. When you continue to gaze at this particular work, "walls" that once looked as if they were receding from you may suddenly shift direction such that they appear to be moving toward you. Consider the two "panels" on the left. Is the vertical axis between them farther back than the "edges," or is it closer to the picture plane? Either interpretation is possible, as is viewing the picture as completely flat. We noted Pollock's response to questions about abstract paintings; Stella's remark on his own work was, "What you see is what you see."

Except for the fact that *Mas o Menos* is abstract, it is difficult to imagine work farther removed from that of the Abstract Expressionists. There is no gestural brushwork. There is no sense of existential anxiety; discipline replaces the feeling that primitive impulses might be rising to the surface of consciousness.

DONALD JUDD Sculptor Donald Judd (1928–1994) brought Minimalism into three dimensions. He chose shapes and materials that were pure and simple, mounted on walls or set on

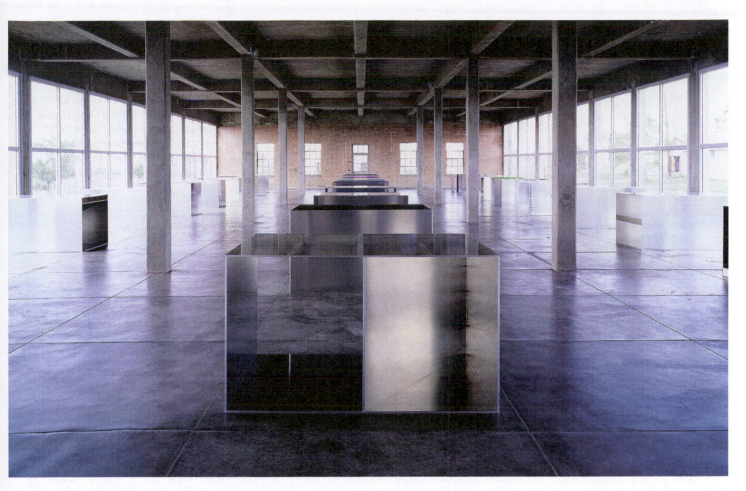

▲ **23.15** Donald Judd, *100 Untitled works in Mill Aluminum*, 1982–1983. Marfa, Texas. Machined aluminum boxes housed in an abandoned building (renovated by Judd) on the former U.S. Army base Fort D. A. Russell. Minimalists sought a purity in their art by reducing the number of formal elements such as color and texture in their work.

the floor in a steady, evenly spaced pattern. The installation *100 Untitled works in Mill Aluminum* (**Fig. 23.15**) features 100 identical metal boxes housed in two former military artillery sheds. Although they are absolutely identical, the impression is somewhat more varied because Judd opened one or more panels, not necessarily the corresponding ones. As light streams through the windows and reflects off the surfaces, the boxes cast shadows of various lengths on the floor and on each other.

Judd's shapes and materials are fabricated in factories from industrial or nontraditional materials. Because skilled workers (and not the artist) created Minimalist works according to the artist's specifications, the traditional relationship between the idea of art and its literal creation—as we shall see in Conceptual Art—is subverted.

Conceptual Art

We noted Joseph Kosuth's statement that being an artist in our times means challenging what is meant by *art*. Traditionally speaking, an artist has been expected to master his or her craft, be it painting, sculpting, architecture, filmmaking—whatever is the chosen medium. Yet we also noted that many painters forgo the brushstroke; Frankenthaler poured paint on canvas. Some artists have used found objects; Duchamp took a urinal, flopped it over on its back, and labeled it *Fountain*, and the art world generally concedes that it is art. Michelangelo wrote that he conceptualized the figures in blocks of stone and used the chisel to release them. But where, then, in Michelangelo lies the art? In the artist's mind or in the carved product? The **Conceptual Art** movement, which began in the 1960s, asserts that art does in fact lie in the mind of the artist; the visible or audible or palpable product is merely an expression of the idea. Artist Sol LeWitt expressed his views on Conceptual Art as we see in Reading 23.3 on page 832.

JOSEPH KOSUTH The charge Kosuth (b. 1945) gave to himself to change the meaning of art led to the creation of works such as *One and Three Hammers* (1965) and *One and Three*

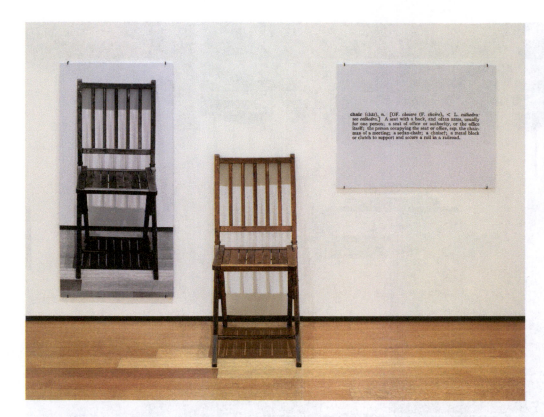

◀ **23.16** Joseph Kosuth, *One and Three Chairs*, 1965. Wooden folding chair, mounted photograph of a chair, and mounted photographic enlargement of the dictionary definition of "chair"; chair: 32⅜" × 14⅞" × 20⅞" (82 × 37.8 × 53 cm); photographic panel: 36" × 24⅛" (91.5 × 61.1 cm); text panel: 24" × 24⅛" (61 × 61.1 cm). Museum of Modern Art, New York, New York. Kosuth sought to communicate the concept of "chairness" from his mind to the viewer as directly as possible.

Chairs (1965; **Fig. 23.16**). Each of these works has three parts: the object itself, a photograph of the object, and the dictionary definition of the object. The artist displays what he considers to be the concept of "chairness" as it exists in his mind. It is not in the execution of the art that the art exists. We see no exquisite drawing or painting. We do not even have a found object that is converted into art; the chair is a chair. The photograph is unremarkable. The definition is…the definition. (As Stella remarked: "What you see is what you see.")

READING 23.3 SOL LEWITT

From "Paragraphs on Conceptual Art"

I will refer to the kind of art in which I am involved as conceptual art. In conceptual art the idea or concept is the most important aspect of the work. When an artist uses a conceptual form of art, it means that all of the planning and decisions are made beforehand and the execution is a perfunctory affair. The idea becomes a machine that makes the art. This kind of art is not theoretical or illustrative of theories; it is intuitive, it is involved with all types of mental processes and it is purposeless. It is usually free from the dependence on the skill of the artist as a craftsman. It is the objective of the artist who is concerned with conceptual art to make his work mentally interesting to the spectator, and therefore usually he would want it to become emotionally dry. There is no reason to suppose, however, that the conceptual artist is out to bore the viewer. It is only the expectation of an emotional kick, to which one conditioned to expressionist art is accustomed, that would deter the viewer from perceiving this art.

BARBARA KRUGER Barbara Kruger's (b. 1945) installation of graphic text on the walls and ceiling of the Guild Hall in East Hampton, New York—*Money Makes Money and a Rich Man's Jokes Are Always Funny* and *You Want It. You Need It. You Buy It. You Forget It* (**Fig. 23.17**)—is very different from the works of Kosuth and LeWitt, yet it also prioritizes the idea of the work over the object, emphasizing the artist's thinking and often de-emphasizing traditional artistic techniques. Much of Kruger's work has been political, emphasizing issues relating to feminism and power. The visual aspect of Kruger's text in *Money Makes Money* relates to the billboards, magazines, and commercial advertising that saturate our cultural landscape, and reminds us of the constant media bombardment in our lives. Conceptually, the installation compels us to think about the impersonal information systems of our era and the degree to which we are affected by their subliminal messages. In this piece, Kruger asks the viewer to think about the cult of materialism and the adage "Money talks." The scale of the type and almost claustrophobic installation make confronting ourselves, our morals, and our way of life inescapable.

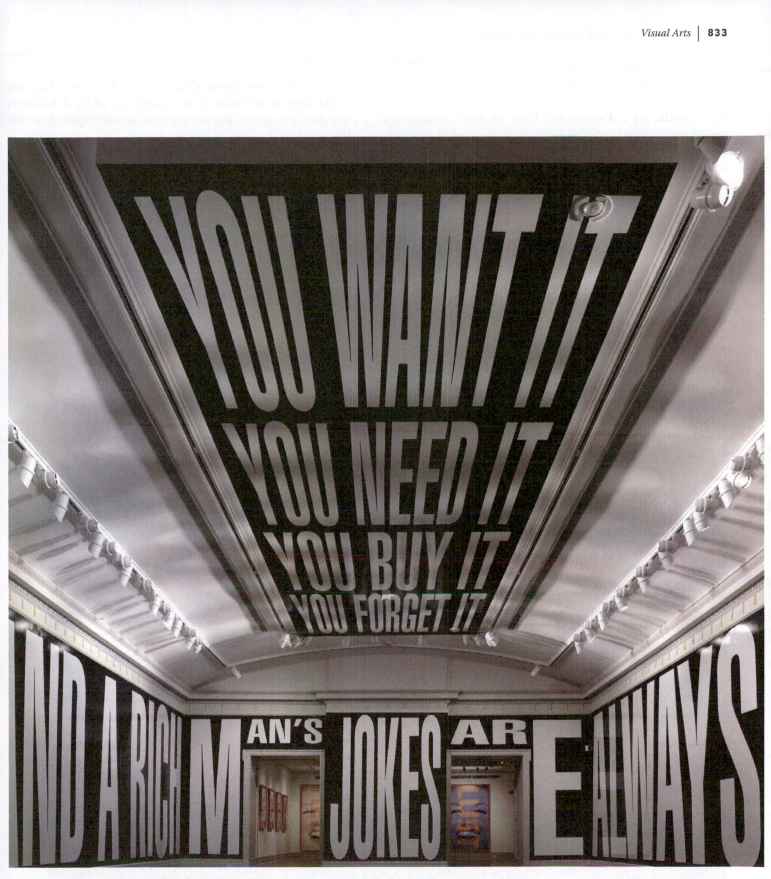

▲ **23.17** Barbara Kruger, *Untitled ("Money makes money and a rich man's jokes are always funny")* and *Untitled ("You want it You need it You buy it You forget it"),* details of 2010 installation titled "Plenty" at the Guild Hall, East Hampton, New York. Acrylic ink on adhesive vinyl, dimensions variable. Kruger confronts viewers with the importance of money in their lives and the way that the social prominence of a person with money can be exaggerated.

Site-Specific Art

Site-specific art is distinguished from art that is created in a studio with no particular spatial context in mind. A site-specific artwork is produced in or for one location and—in theory, at least—is not to be relocated. The work is in and of its site, and often the content and meaning of the work are inextricably bound to it. By this description, the history of art is full of examples of site-specific art, such as the sculptural decoration on the Parthenon (see Figs. 3.4 and 3.5) and Michelangelo's Sistine Chapel ceiling (see Figs. 13.13 and 13.14). But the term *site-specific* came into use in the latter part of the 20th century as a blanket category for art that was created for or in a specific location. That location might be a museum or gallery, a public space, or a site in the natural landscape.

ROBERT SMITHSON Robert Smithson's (1938–1973) *Spiral Jetty* (**Fig. 23.18**) is an example of a type of site-specific art called **land art**. Land art is created or marked by an artist within natural surroundings. Sometimes large amounts of earth or land are shaped into sculptural forms. These works can be temporary or permanent and include great trenches and drawings in the desert, bulldozed configurations of earth and rock, and delicately constructed compositions of ice, twigs, and leaves. What such works have in common is the artist's use of local materials to create pieces that are unified with, or contrapuntal to, the landscape.

Spiral Jetty is composed of basalt and earth bulldozed into a spiral formation in Utah's Great Salt Lake. The spiral shape of the jetty was inspired by a whirlpool, as well as by the configuration of salt deposits that accumulate on rocks bordering the lake. After its creation, the jetty lay submerged underwater for many years. With a prolonged drought, the spiral began to reemerge in 1999, and depending on the water levels of the lake, it now comes and goes.

MAYA YING LIN

It terrified me to have an idea that was solely mine to be no longer a part of my mind, but totally public.

—Maya Ying Lin

This was Chinese–American artist Maya Ying Lin's (b. 1959) reaction to winning the competition—out of 1421 entries—to design the Vietnam Veterans Memorial on the National Mall. When we walk the mall, we are awed by the grand obelisk

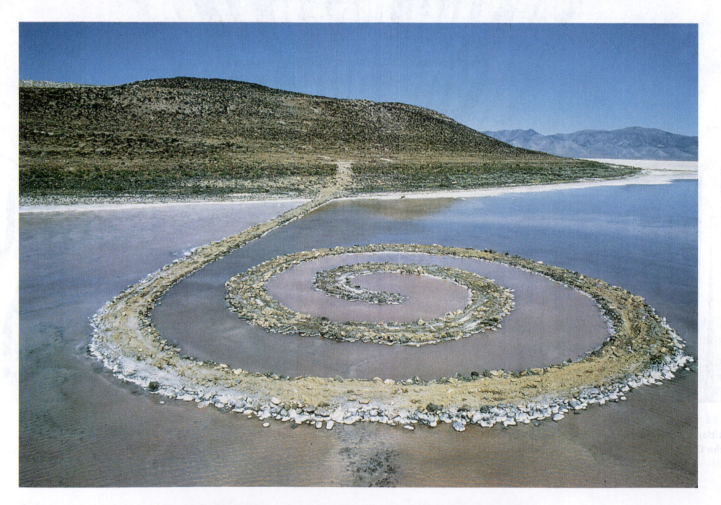

▲ **23.18** Robert Smithson, *Spiral Jetty,* 1970. Black rocks, salt, earth, water, and algae, 1500' × 15' (457.2 × 4.6 m). Great Salt Lake, Utah. Scale is one of the powerful elements in *Spiral Jetty*. It can be easily seen from an airplane flying at 35,000 feet.

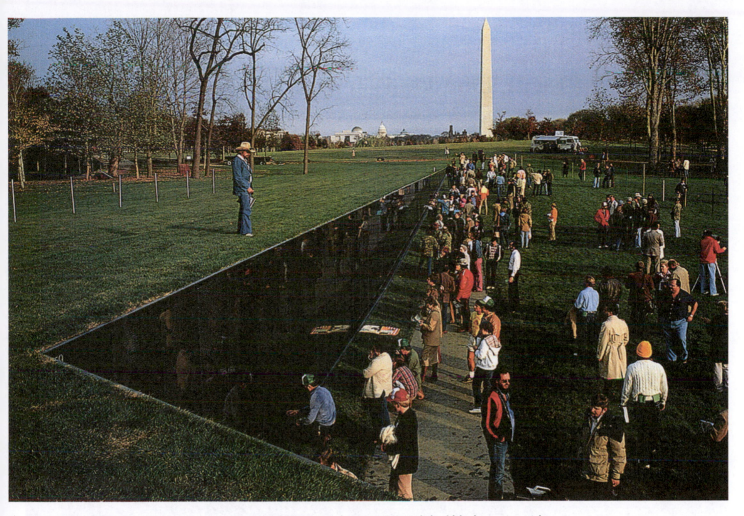

▲ **23.19** Maya Ying Lin, **Vietnam Veterans Memorial,** 1982. Washington, DC. Polished black granite with names inscribed, 492' (150 m) long. Visitors leave flowers and notes and make rubbings of the names of their loved ones.

that is the Washington Monument. We are comforted by the stately columns and familiar shapes of the Lincoln and Jefferson Memorials. But many people have not known how to respond to Lin's monument, in the form of two 200-foot-long black granite walls that form a V as they recede into the ground of their two-acre site (**Fig. 23.19**). There is no label—only the names of 58,000 victims chiseled into the silent walls. In order to read the names, we must descend gradually into the earth and then just as gradually work our way back up. This progress is perhaps symbolic of the nation's involvement in Vietnam.

The eloquently simple design of the memorial stirs controversy, as did the war it commemorates. Architecture critic Paul Gapp of the *Chicago Tribune* argued, "The so-called memorial is bizarre…neither a building nor sculpture." One Vietnam veteran had called for a statue of an officer offering a fallen soldier to heaven. The public expects a certain heroic quality in its monuments to commemorate those fallen in battle, but Lin's work is antiheroic and antitriumphal. Whereas most war monuments speak of giving up our loved ones to a cause, her monument speaks only of giving up our loved ones.

Another viewer observed:

As we descend along the path that hugs the harsh black granite, we enter the very earth that, in another place, has accepted the bodies of our sons and daughters. Each name is carved not only in the stone, but by virtue of its highly polished surface, in our own reflection, in our physical substance. We are not observers, we are participants. We touch, we write [letters to our loved ones], we leave parts of ourselves behind. This is a woman's vision—to commune, to interact, to collaborate with the piece to fulfill its expressive potential.[8]

8. Lois Fichner-Rathus, "A Woman's Vision of the War," *New York Times,* August 18, 1991.

COMPARE + CONTRAST

Heizer's *Rift #1* with Libeskind's Jewish Museum

In 1967, Michael Heizer (b. 1944) took to the bottom of a dry lake bed for *Rift #1* (**Fig. 23.20**), one piece in his land art series called *Nine Nevada Depressions*. Almost three decades later,

Daniel Libeskind (b. 1946) used a startlingly similar shape for his extension of the Berlin Museum dedicated to the Holocaust and Jewish art and life (**Fig. 23.21**). Libeskind's

▼ **23.20** Michael Heizer, *Rift #1*, 1968, first of *Nine Nevada Depressions*, 1968–1972. Displacement of 1.5 tons of earth, 518' 5" × 14' 9" × 9' 10" (158 × 4.5 × 3 m). Massacre Dry Lake, Nevada. Photograph by Michael Heizer.

▲ **23.21** **Daniel Libeskind, Jewish Museum Berlin, 1989–1996. Extension of the Berlin Museum, Berlin, Germany. Reinforced concrete with zinc façade.** The extension of the Berlin Museum is the zinc structure with the zig-zag shape on the left side of this aerial photograph.

zigzag design was derived mathematically by plotting the Berlin addresses of Jewish writers, artists, and composers who were killed during the Holocaust. The building's jagged shape reads as a painful rift in the continuity of the neighborhood in which it stands; it is punctuated by voids that symbolize the absence of Jewish people and culture in Berlin.

Heizer's *Rift* consists of a displacement of local materials such that the normalcy of the landscape is interrupted. For Heizer, the process is perhaps less about symbolism than it is about artistic elements. His depressions play with the

relative scale of humans and nature; he is as much interested in the disintegration of his piece by natural processes over time as he is with the initial creative act. Heizer's jagged "scar" on the earth faded over time and then disappeared. How did Libeskind use this shape to try to ensure that the story of the Jews of Berlin would not fade or disappear? Is there something inherent in these shapes in contrast to their surroundings that suggests a certain symbolism or elicits a certain emotional response? How much do content and context influence our analysis of works with such visual congruities?

◀ **23.22** Christo and Jeanne-Claude, *The Gates, Central Park, New York, 1979–2005.* 7503 vinyl "gates," each hung with a panel of deep saffron-colored nylon fabric, along **23 miles (37 km) of pathways.** A serene view of *The Gates* after a snowfall.

CHRISTO AND JEANNE-CLAUDE As if intentionally timed to shake New York City out of its winter doldrums, 7503 sensuous saffron panels were gradually released from the tops of 16-foot-tall gates along 23 miles of footpaths throughout Central Park. It was the morning of February 12, 2005—a date that marked the end of artists Christo (b. 1935) and Jeanne-Claude's (1935–2009) 26-year odyssey to bring a major project to their adopted city. For a brief 16 days, the billowy nylon fabric fluttered and snapped, obscuring and framing New Yorkers' favorite park perspectives (**Fig. 23.22**). The park's majestic plan of ups and downs, of lazy loops and serpentine curves (as originally designed by Frederick Law Olmsted and Calvert Vaux), was being seen or reseen for the first time as visitors—participants—wove their walks according to the patterns of the gates. The artists have said that "the temporary quality of [our] projects is an aesthetic decision"; that it "endows the works of art with a feeling of urgency to be seen."[9]

As with all of Christo and Jeanne-Claude's works of environmental art, every aspect of the *Gates* project was financed by the artists. The project required more than 1 million square feet of vinyl and 5300 tons of steel. Hundreds of paid volunteers assembled, installed, maintained, and removed the work, and most of the materials were recycled. The estimated cost of the project—borne by the artists alone—was $20 million. The artists finance

their environmental sculptures—which have included *Wrapped Reichstag, Berlin, 1971–1995; Surrounded Islands, Biscayne Bay, Greater Miami, Florida, 1980–1983; Running Fence, Sonoma and Marin Counties, California, 1972–1976;* and others—by selling preparatory drawings and early works by Christo.

Pop Art

If one were asked to choose the most surprising, controversial, and also exasperating contemporary art movement, one might select **Pop Art**. The term *Pop* was coined by the English critic Lawrence Alloway in 1954 to refer to the universal images of "popular culture," such as movie posters, billboards, magazine and newspaper photographs, and advertisements. Pop Art, by its selection of commonplace and familiar subjects—subjects that are already too much with us—also challenges commonplace conceptions about the meaning of art.

Whereas many artists have strived to portray the beautiful, Pop Art intentionally depicts the mundane. Whereas many artists represent the noble, stirring, or monstrous, Pop Art renders the commonplace, the boring. Whereas other forms of art often elevate their subjects, Pop Art is often matter-of-fact. In fact, one tenet of Pop Art is that the work should be so objective that it does not show the "personal signature" of the artist. This maxim contrasts starkly, for example, with the highly personalized gestural brushstrokes found in Abstract Expressionism.

9. The City of New York, Christo and Jeanne-Claude in Their Own Words. (2007). http://www.nyc.gov/html/thegates/html/qanda.html.

◄ **23.23** Richard Hamilton, *Just What Is It That Makes Today's Homes So Different, So Appealing?*, 1956. Collage, 10¼" × 9¼" (26 × 23.5 cm). Kunsthalle Tübingen, Tübingen, Germany. The objects in this tiny collage make it very much a time capsule of its day.

RICHARD HAMILTON Despite the widespread view that Pop Art developed purely in the United States, it actually originated during the 1950s in England. British artist Richard Hamilton (1922–2011), one of its creators, had been influenced by Marcel Duchamp's idea that the mission of art should be to destroy the normal meanings and functions of art.

Hamilton's tiny collage *Just What Is It That Makes Today's Homes So Different, So Appealing?* (**Fig. 23.23**) is one of the earliest and most revealing Pop Art works. It functions as a veritable time capsule for the 1950s, a decade during which the speedy advance of technology found many buying pieces of the American dream. What is that dream? Comic books, TVs, movies, and tape recorders; canned hams and TV dinners; enviable physiques, Tootsie Pops, vacuum cleaners that finally

CONNECTIONS Robert Rauschenberg once said that the objective of the Pop artist was to work "in the gap between art and life." In 1992, more than three decades after Pop Art hit the art world, Richard Hamilton "remodeled" his collage interior, *Just What Is It That Makes Today's Homes So Different, So Appealing?* (see Fig. 23.23). His remake of the 1956 piece posed again the question that is the title of his groundbreaking work and reaffirmed the relevance of Rauschenberg's quote.

One of the most engaging aspects of Hamilton's iconic work was its self-awareness. It announced, boldly and astutely, that the late 1950s had become an era in which personal values and self-identity were shaped by a culture of desire—the offspring of technology and advertising. Looking at Hamilton's revision, the adage "the more things change, the more they remain the same" comes to mind.

What is it that makes Hamilton's "new home" (**Fig. 23.24**) so

▲ **23.24** Richard Hamilton, *Just what is it that makes today's homes so different?* 1992. Digital print on paper, 176 × 267 mm. Tate Gallery, London.

different, so appealing—and so revelatory of life and culture in the 1990s? The view out the window in the original collage showed a theater marquis advertising Al Jolson in *The Jazz Singer*, the first feature length film to synchronize dialogue with film footage. The film marked a major advance in the development of moviemaking. In Hamilton's 1990s version, the views out the windows are a window on world events—including scenes from the Gulf war of 1991 that might have been seen in televised coverage by anyone around the world tuned into CNN. The painting on the wall with letters spelling out AIDS replaces a poster of a comic-strip romance series; it also subverts a well-known pop image by Robert Indiana in which the letters of the word LOVE occupy the same grid compartments. The cratered moon surface on the pre-moon-landing ceiling of the 1956 collage is replaced with a hanging Jupiter chandelier, paying homage to the visit to the planet of the spacecraft *Ulysses* in 1992.

The most telling social message comes across in the revised male and female roles. In Hamilton's 1992 digital collage, the male body-builder holding the Tootsie-Pop barbell is replaced with a female counterpart holding a school-crossing paddle reading "STOP (rather than POP) CHILDREN"—perhaps a reference to reproductive choice. The male figure, rather than glorifying his body, sits hunched over his work in front of a computer screen, surrounded by keyboards and telephones, under the watchful bust portrait of the conservative British Prime Minister Margaret Thatcher, the arch-symbol of financial deregulation that contributed to the boom-era of the 1990s.

let the "lady of the house" clean all the stairs at once. It is easy to read satire and irony into Hamilton's work, but his placement of these objects within the parameters of art encourages us to truly *see* them instead of just coexisting with them.

ROBERT RAUSCHENBERG American Pop artist Robert Rauschenberg (1925–2008) studied in Paris and then with Josef Albers and others at the famous Black Mountain College in North Carolina. Before developing his own Pop Art style, Rauschenberg experimented with loosely and broadly brushed Abstract Expressionist canvases. He is best known, however, for introducing a construction referred to as the **combine painting**, in which stuffed animals, bottles, articles of clothing and furniture, and scraps of photographs are attached to the canvas.

Rauschenberg's *Bed* (**Fig. 23.25**) is a paint-splashed quilt and pillow, mounted upright on a wall as any painting might be. Here the artist toys with the traditional relationships between materials, form, and content. The content of the work is actually its support; rather than a canvas on a stretcher, the quilt and pillow are the materials on which the painter has dripped and splashed his pigments. Perhaps even more outrageous is Rauschenberg's famous 1959 work *Monogram*, in which a stuffed goat—with an automobile tire wrapped around its middle—is mounted on a horizontal base that consists of scraps of photos and prints and loose, gestural painting.

JASPER JOHNS Jasper Johns (b. 1930) was Rauschenberg's classmate at Black Mountain College, and their appearance on the New York art scene was simultaneous. His early work also integrated the overall gestural brushwork of the Abstract Expressionists with the use of found objects, but unlike Rauschenberg, Johns soon made the object central to his compositions. His works frequently portray familiar objects, such as numbers, maps, color charts, targets, and flags, integrated into a unified field by thick gestural brushwork.

One "tenet" of Pop Art is that imagery is to be presented objectively, that the personal signature of the artist is to be eliminated. That principle must be modified if we are to include within Pop the works of Rauschenberg, Johns, and others, for many of them immediately betray their devotion to expressionistic brushwork. Johns's *Three Flags* (**Fig. 23.26**) was painted with encaustic (a combination of liquid wax and

◀ **23.25** Robert Rauschenberg, *Bed*, 1955. **Combine painting: oil and pencil on pillow, quilt, and sheet on wood supports, 75 ¼" × 31 ½" × 6 ½" (191.1 × 80 × 20.3 cm). Museum of Modern Art, New York, New York.** The gestural brushwork and the drips provide some of the "personal signature" of the artist.

◀ **23.26** Jasper Johns, *Three Flags*, 1958. Encaustic on canvas, 30⅞" × 45½" × 5" (78.4 × 115.6 × 12.7 cm). **Whitney Museum of American Art, New York, New York.** Unlike an actual flag, the painting has a pronounced surface texture, reinforcing the fact that it is not an attempt to create the illusion of a real flag.

pigment) and newsprint on three canvases of increasing size that are superimposed on one another. The result yields a distinct surface texture that informs the viewer that she or he is not looking at a painting and not at actual machine-made flags. The work requires the viewer to take a new look at a most familiar object.

ANDY WARHOL Andy Warhol (1928–1987) once earned a living designing packages and Christmas cards. Today he epitomizes the Pop artist in the public mind. Just as Campbell's soups represent bland, boring nourishment, Andy Warhol's appropriation of hackneyed portraits of celebrities (**Fig. 23.27**), his Brillo boxes, and his Coca-Cola bottles elicit comments that

◀ **23.27** Andy Warhol, *Marilyn Diptych*, 1962. Synthetic polymer paint and silk-screen ink on canvas, 6' 10" × 57" (209.2 × 144.8 cm). Image © Tate, London 2015. Many of Warhol's works churn out repeated images of ordinary objects or hackneyed images of celebrities, commenting on our consumer culture.

contemporary art has become bland and boring and that there is nothing much to be said about it. Warhol also evoked contempt here and there for his underground movies, which have portrayed sleep and explicit eroticism (*Blue Movie*) with equal disinterest. Even his shooting (from which he recovered) by a disenchanted actress seemed to evoke yawns and a "What can you expect?" reaction from the public.

Warhol painted and printed much more than industrial products. During the 1960s, he reproduced multiple photographs of disasters from newspapers. He executed a series of portraits of public figures such as Marilyn Monroe and Jackie Kennedy in the 1960s. Marilyn Monroe and Jacqueline Kennedy were both tortured American personas whose images became overused and ubiquitous in the 1960s. Monroe, the movie star, was the nation's first "blonde bombshell," married, sequentially, to such popular figures as the playwright Arthur Miller and the New York Yankees baseball "hero" Joe DiMaggio. The White House, occupied by Jack and Jackie Kennedy and their children, became widely known as Camelot, the legendary dwelling place of King Arthur of Britain. The Kennedy family, especially in the early 1960s, was as close as the modern United States came to having its own royal family. President Kennedy was assassinated in Dallas, Texas, in November 1963. Warhol turned to portraits of political leaders such as Mao Zedong in the 1970s. Although his silk screens, at least in their technique, met the Pop Art objective of obscuring the personal signature of the artist, his compositions and expressionistic brushing of areas of his paintings achieved an individual stamp.

CLAES OLDENBURG Claes Oldenburg (b. 1929) is a Swedish American artist best known for his oversized sculptures in public places, such as the 45-foot-tall *Clothespin* in Philadelphia and the 19-foot-tall *Typewriter Eraser, Scale X* in the sculpture garden of the National Gallery of Art in Washington, DC. The scale of these ordinary objects is responsible for their impact. Other works by Oldenburg owe their impact to their subversion of our senses, such as *Soft Bathtub* and *Soft Toilet* (**Fig. 23.28**). We know these objects to be hard, cold, and unmovable, but Oldenburg constructs them with vinyl stitching and stuffs them with kapok, a silky natural fiber.

Photorealism

Photorealism, or the rendering of subjects with sharp, photographic precision, is firmly rooted in the long realistic tradition in the arts. But as a movement that first gained major recognition during the early 1970s, it also owes some of its impetus to Pop Art's objective portrayal of familiar images. Photorealism is also in part a reaction to the expressionistic and abstract movements of the 20th century. That is, Photorealism permits artists to do something that is very new to the eye even while they are doing something very old.

AUDREY FLACK Audrey Flack (b. 1931) was born in New York and studied at the High School of Music and Art, at Cooper Union, and at Yale University's Graduate School. During the 1950s, she showed figure paintings that were largely ignored, in part because of the popularity of Abstract Expressionism and in part because women artists, in general, did not receive the critical attention that their male colleagues received. Yet, throughout these years, Flack persisted in a sharply realistic or trompe l'oeil style. The technical precision of a painting such as *Jolie Madame* (**Fig. 23.29**) was achieved by projecting a color slide onto a blank canvas, drawing over the image, and then rendering the nuances of surfaces using a combination of controlled airbrushing and layers of primary colors in transparent glazes. Flack is fascinated by the ways in which a wide variety of contrasting textures reflect light. Some of her still life compositions offer meaning, however, beyond their dazzling surfaces. In *Jolie Madame*, the array of elaborate adornments bring into focus the questionable premium placed by society on a certain standard of beauty; the inclusion of such things as a compote of ripe fruit, a perfectly

◀ **23.28** Claes Oldenburg, *Soft Toilet*, 1966. Wood, vinyl, kapok fibers, wire, and Plexiglass on metal stand and painted wood base, 57" × 28¾" × 28" (144.9 × 70.2 × 71.3 cm). Whitney Museum of American Art, New York, New York. We know toilets to be cold, hard, and unbendable. *Soft Toilet* defeats all these expectations.

◀ **23.29** Audrey Flack, *Jolie Madame*, 1973. Oil over acrylic on canvas, 71 ½" × 95 ¾" (181.5 × 243 cm). National Gallery of Australia, Canberra, Australia. The artist's juxtaposition of objects such as the jewels, porcelain, fruit, and fresh-cut flower encourage the viewer to meditate on the fragility of life and its transitory nature.

cut, long-stemmed rose, and a pocket-watch, symbolize the transitory nature of that beauty.

Art, Identity, and Social Consciousness

Art has always reflected the society in which it was created, but today the individual would appear to be paramount, and artists are just as likely to use art to express who they are as people, as women, or as members of various ethnic groups, and how they react to the societies in which they find themselves.

YOKO ONO Yoko Ono (b. 1933) is perhaps most familiar to us as the wife of the Beatles singer-songwriter John Lennon, although she already had an established career as an influential conceptual and performance artist before they met. Concurrent with the emergence of conceptualism, **performance art** emphasizes action rather than the creation of an art object, public spaces rather museum settings, the impermanent over the permanent, and often, audience participation over passive spectatorship. Most of the pioneering work in performance art is memorialized only in still photographs, if at all. It is not until relatively recently that performance pieces have been consistently videotaped or digitally recorded.

Ono's participatory work, *Cut Piece*, in fact, is considered one of the earliest feminine artworks. First staged in Tokyo in 1964, Ono walked to the center of a stage in a black dress, knelt down, placed scissors next to her on the floor, and uttered one word to the audience: "Cut." People ascended the stage and did so in turn, cutting away pieces of her clothing right down to her skin. As the blades of the scissors moved closer to her body, the act grew more and more threatening. Critics came to view this piece—in which Ono tackled the perception of the body as an object and its use as a medium—as one that was groundbreaking in its melding of performance, conceptual, and feminist art.

Ono and Lennon collaborated on a number of performance pieces, the most famous of which were part of their late 1960s peace (in Vietnam) campaign. *Bagism* (**Fig. 23.30**) is intended to erase distinctions among individuals, and, in so doing, erase prejudice concerning gender, race, or class and foster tolerance.

▶ **23.30** Yoko Ono and John Lennon in a Bagism way in 1969.

▶ **23.31** Judy Chicago, *The Dinner Party*, 1974–1979. Painted porcelain, textile, and needlework, 576" × 576" × 576" × 36" (1463 × 1463 × 1463 × 91.44 cm). Brooklyn Museum of Art, Brooklyn, New York. Each of the plates expresses something about one of the invited women as an individual.

careers of its participants, the exhibition exalted women's ways of working.

Chicago has since become renowned for her installation *The Dinner Party* (**Fig. 23.31**), in which the lines between life and death, between place and time, are temporarily dissolved. The idea for this multimedia work, which was constructed to honor and immortalize history's notable women, revolves around a fantastic dinner party, where the guests of honor meet before place settings designed to reflect their personalities and accomplishments. Chicago and numerous other female artists have invested much energy in alerting the public to the significant role of women in the arts and society.

GUERRILLA GIRLS During the 1980s, something of a backlash against inclusion of women and ethnic minorities in the arts could be observed.[10] For example, a 1981 London exhibition, *The New Spirit in Painting*, included no women artists. A 1982 Berlin exhibition, *Zeitgeist*, represented 40 artists, but only one was a woman. The 1984 inaugural exhibition of the Museum of Modern Art's remodeled galleries, *An International Survey of Recent Painting and Sculpture*, showed the works of 165 artists, only 14 of whom were women. The New York exhibition *The Expressionist Image: American Art from Pollock to Today* included the works of 24 artists, only 2 of whom were women. And so it went.

To combat this disturbing trend, an anonymous group of women artists banded together as the Guerrilla Girls. The group appeared in public with gorilla masks and proclaimed themselves to be the "conscience of the art world." They mounted posters on buildings in Manhattan's SoHo district, one of the most active centers in the art world today. They took out ads of protest.

Figure 23.32 shows one of the Guerrilla Girls' posters. This particular poster sardonically notes the "advantages" of being a woman artist in an art world that, despite the "liberating" trends of the postfeminist era, continues to be dominated by men. It also calls attention to the blatant injustice of the relative price tags on works by women and men. Note that at this writing, the inequity persists.

ROBERT MAPPLETHORPE Photographer Robert Mapplethorpe (1946–1989) created many black-and-white images of people struggling in a world that was hostile toward them because of their sexual identity. He grabbed that world by the throat and shook it. He used his photographic skills to shoot not only his acquaintances and friends—artists, musicians, and socialites—but also the first winner of the Women's World Pro Bodybuilding Championship, Lisa Lyon; pornographic film stars; and people from the S&M (sadism and masochism)

JUDY CHICAGO AND MIRIAM SCHAPIRO In 1970, a Midwestern artist named Judy Gerowitz (b. 1939)—who would soon call herself Judy Chicago—initiated a **feminist** studio art course at Fresno State College in California. One year later, she collaborated with artist Miriam Schapiro (1923–2015) on a feminist art program at the California Institute of the Arts in Valencia. Their interests and efforts culminated in another California project—a communal installation in Hollywood called Womanhouse. Teaming up with students from the University of California, Chicago and Schapiro refurbished each room of a dilapidated mansion in a theme built around women's experiences: The Kitchen, by Robin Weltsch, was covered with breast-shaped eggs; Menstruation Bathroom, by Chicago, included the waste products of female menstruation cycles in a sterile white environment. Womanhouse called attention to women artists, their wants, their needs. In some ways, it was an expression of anger toward the injustice of art-world politics that many women artists experienced—lack of attention by critics, curators, and historians, along with pressure to work in canonical styles. It announced to the world, through shock and exaggeration, that men's subjects are not necessarily of interest to women; that women's experiences are significant. And perhaps of most importance, particularly in light of the subsequent

10. Whitney Chadwick, *Women, Art, and Society* (London: Thames and Hudson, 1990).

WHEN RACISM & SEXISM ARE NO LONGER FASHIONABLE, WHAT WILL YOUR ART COLLECTION BE WORTH?

The art market won't bestow mega-buck prices on the work of a few white males forever. For the 17.7 million you just spent on a single Jasper Johns painting, you could have bought at least one work by all of these women and artists of color:

Berenice Abbott	Elaine de Kooning	Dorothea Lange	Sarah Peale
Anni Albers	Lavinia Fontana	Marie Laurencin	Ljubova Popova
Sofonisba Anguisolla	Meta Warwick Fuller	Edmonia Lewis	Olga Rosanova
Diane Arbus	Artemisia Gentileschi	Judith Leyster	Nellie Mae Rowe
Vanessa Bell	Marguérite Gérard	Barbara Longhi	Rachel Ruysch
Isabel Bishop	Natalia Goncharova	Dora Maar	Kay Sage
Rosa Bonheur	Kate Greenaway	Lee Miller	Augusta Savage
Elizabeth Bougereau	Barbara Hepworth	Lisette Model	Vavara Stepanova
Margaret Bourke-White	Eva Hesse	Paula Modersohn-Becker	Florine Stettheimer
Romaine Brooks	Hannah Hoch	Tina Modotti	Sophie Taeuber-Arp
Julia Margaret Cameron	Anna Huntingdon	Berthe Morisot	Alma Thomas
Emily Carr	May Howard Jackson	Grandma Moses	Marietta Robusti Tintoretto
Rosalba Carriera	Frida Kahlo	Gabriele Münter	Suzanne Valadon
Mary Cassatt	Angelica Kauffmann	Alice Neel	Remedios Varo
Constance Marie Charpentier	Hilma af Klimt	Louise Nevelson	Elizabeth Vigée Le Brun
Imogen Cunningham	Kathe Kollwitz	Georgia O'Keeffe	Laura Wheeling Waring
Sonia Delaunay	Lee Krasner	Meret Oppenheim	

Information courtesy of Christie's, Sotheby's, Mayer's International Auction Records and Leonard's Annual Price Index of Auctions

Please send $ and comments to: **GUERRILLA GIRLS** CONSCIENCE OF THE ART WORLD
Box 1056 Cooper Sta. NY, NY 10276

◀ **23.32** Guerrilla Girls, *When Racism & Sexism Are No Longer Fashionable, What Will Your Art Collection Be Worth?* 1989. Poster, 17" × 22" (43.2 × 55.9 cm). You will find many of the women artists listed on the poster in this book.

underground. Many of these latter photographs were sexually explicit, and there were debates as to whether the government, through the National Endowment for the Arts, should be helping to support exhibitions that certain members of Congress felt were "obscene."

Figure 23.33 shows a gay couple, black and white, shot in black and white. The artist shows them with shaved heads so that even a slight similarity in hair color has been eliminated. Although different, the couple are very much together—the white man resting against the black man's back, the black man apparently pleased with the contact. Genital organs are not shown, but the men seem to be at their most raw and basic. Although the figures are still, there is a diagonal line of intensity rising from the lower right into the center of the composition.

Mapplethorpe was diagnosed with AIDS in 1986 and died three years later.

▶ **23.33** Robert Mapplethorpe, *Ken Moody and Robert Sherman*, 1984. Platinum print, edition of 10, 19½" × 19⅝" (49.5 × 49.9 cm). Solomon R. Guggenheim Museum, New York, New York. Some of Mapplethorpe's photographs drew the country's attention to elements of what it was like to be gay and living in the United States at the end of the millennium.

◀ **23.34** Romare Bearden, *The Dove*, 1964. Cut-and-pasted paper, gouache, pencil, and colored pencil on cardboard, 13⅜" × 18¾" (33.8 × 47.5 cm). Museum of Modern Art, New York, New York. The artist experimented with various styles and media, but his collages have been some of his best-known work.

ROMARE BEARDEN Some critics have noted that Abstract Expressionism was essentially the province of an exclusive group of white male artists. Few, if any, women artists or artists of color were counted among the household names associated with the movement. But others adopted the idiom of Abstract Expressionism, and scholars and curators have rediscovered their work.

The African American artist Romare Bearden (1911–1988), like many in the New York School, began painting as a Works Progress Administration artist and studied at the Art Students League. After military service during World War II, he left for Paris to study philosophy on the GI Bill. During the late 1940s and 1950s, he swapped his Social Realist style for a version of Abstract Expressionism, but in the early 1960s, he defined the signature artistic vocabulary, combining painting and collage, that would become characteristic of his mature style. Bearden's work began to include references to African life and culture that continued throughout his career.

A work such as *The Dove* (**Fig. 23.34**) represents a synthesis of Cubism and Abstract Expressionism, constructed through the lens of African American experience. We are drawn into a Harlem street scene composed of clipped, irregularly shaped fragments of photographs—varying in scale and density—pasted onto a regimented backdrop that feels almost like a Cubist grid. The imagery spreads across the field uniformly, with no particular focal point—much the way Abstract Expressionists created their allover compositions. As in viewing a Pollock painting, we experience the tension between surface and depth: the overlapping lines in *One: Number 31* (Fig. 23.4) draw us into the compressed space of the painting and then fix our eyes again on the surface. In *The Dove*, the clarity of some images in relation to others, and the shifts and subversions of

scale, lead our eyes to believe that some figures are near and some are distant. Shape and scale shifting creates a similar tension between surface and depth. Works like *The Dove* reflect Bearden's desire to capture flashes of memory that read like a scrapbook of consciousness and experience particular to his own life and times—from his childhood in North Carolina to his life and work in Harlem. The writer and literary critic Ralph Ellison wrote of Bearden's art:

> Bearden's meaning is identical with his method. His combination of technique is in itself eloquent of the sharp breaks, leaps in consciousness, distortions, paradoxes, reversals, telescoping of time and surreal blending of styles, values, hopes and dreams which characterize much of Negro American history.[11]

FAITH RINGGOLD Faith Ringgold was born in New York City's Harlem neighborhood in 1930 and educated in the public schools of New York City. Raised with a social conscience, she painted murals and other works inspired by the civil-rights movement in the 1960s, and a decade later took to feminist themes after her exclusion from an all-male exhibition at New York's School of Visual Arts. Ringgold's mother, a fashion designer, was always sewing, the artist recalls, and at this time the artist turned to sewing and related techniques—needlepoint, beading, braided ribbon, and sewn fabric—to produce soft sculptures.

11. Ralph Ellison, introduction to *Romare Bearden: Paintings and Projections* (The Art Gallery of the State University of New York at Albany, Albany, New York, 1968).

◀ **23.35** Faith Ringgold, *Tar Beach*, 1988. Acrylic on canvas, bordered with printed, painted, quilted, and pieced cloth, 74⅝" × 68½" (189.5 × 174 cm). Solomon R. Guggenheim Museum, New York, New York. Why do you think this quilt is titled *Tar Beach*?

Ringgold has become known for her narrative quilts, such as *Tar Beach* (**Fig. 23.35**), which combine traditions common to African Americans and women—storytelling and quilting. Here Ringgold tells the story of life and dreams on a tar-covered rooftop. *Tar Beach* is a painted patchwork quilt that stitches together the artist's memories of family, friends, and feelings while growing up in Harlem. Ringgold is noted for her use of materials and techniques associated with women's traditions as well as her use of narrative or storytelling, a strong tradition in African American families. A large, painted square with images of Ringgold, her brother, her parents, and her neighbors dominates the quilt and is framed with brightly patterned pieces of fabric. Along the top and bottom are inserts crowded with Ringgold's written description of her experiences. This wonderfully innocent and joyful monologue begins:

> I will always remember when the stars fell down around me and lifted me up above the George Washington Bridge.

ANSELM KIEFER Anselm Kiefer (b. 1945) is a German painter and sculptor who is wracked with feelings of horror and guilt concerning the Holocaust. Kiefer synthesizes an expressionistic painterly style with strong abstract elements in a narrative form of painting that makes multivalent references to German history and culture. The casual observer cannot hope to decipher Kiefer's paintings; they are highly intellectual, obscure, and idiosyncratic. But, at the same time, they are overpowering in their scale, their larger-than-life subjects, and their textural, encrusted surfaces.

Dein Goldenes Haar, Margarethe (see **Fig. 23.36** on p. 848) serves as an excellent example of the artist's formal and literary concerns. The title of the work, and others of this series, refers to the poem "Death Fugue" by Holocaust survivor Paul Celan, which describes the destruction of European Jews through the images of a golden-haired German woman named Margarethe and a dark-haired Jewish woman named Shulamith (see Reading 23.4 on p. 848). Against a pale gray-blue background, Kiefer uses actual straw to suggest the hair of the German woman, contrasting it with thick black paint that lies charred on the upper canvas, to symbolize the hair of her unfortunate counterpart. Between them a German tank presides over this human destruction, isolated against a wasteland of its own creation. Kiefer here, as often, scrawls his titles or other words across the

◀ **22.36 Anselm Kiefer,** *Dein Goldenes Haar, Margarethe* **("Your Golden Hair, Margarete"), 1981. Mixed media on paper, 14" × 18 ¾" (35.6 × 47.6 cm).** In the center of the piece, a German tank appears to separate the golden hair from the darker, incinerated hair in the distance (at the top of the work).

The photographer and video artist Shirin Neshat (b. 1957) came to the United States from Iran as a teenager, before the shah, or monarch, was removed from power in 1979, and returned in 1990 to witness a nation transformed by the rule of Islamic clergy. She was particularly concerned about how life had changed for Iranian women, who now had limited opportunities outside the home and were veiled behind black chadors. **Figure 23.37** is one of a series called *Women of Allah*, in which guns or flowers are frequently juxtaposed with vulnerable though rebellious faces and hands that emerge from beneath the veil. The exposed flesh is overwritten with sensual or political texts by Iranian women in the Farsi language. Although the calligraphic writing is visually beautiful and elegant, there is no mistaking its purpose as one of resistance. The photos are unlikely to be seen and "decoded" by the eyes of Iranians living in Iran, but the message of the artist to the world outside is clear.

canvas surface, sometimes veiling them with his textured materials. The materials function as content; they become symbols to which we must respond emotionally and intellectually.

READING 23.4 PAUL CELAN

From "Death Fugue," lines 27–34

Black milk of daybreak we drink you at night
we drink you at noon death comes as a master from Germany
we drink you at nightfall and morning we drink you and drink you
a master from Germany death comes with eyes that are blue
with a bullet of lead he will hit in the mark he will hit you
a man in the house your golden hair Margarete
he hunts us down with his dogs in the sky he gives us a grave
he plays with the serpents and dreams death comes as a
 master from Germany

SHIRIN NESHAT

I see my work as a pictorial excursus on the topic of feminism and contemporary Islam—a discussion that puts certain myths and realities under the microscope and comes to the conclusion that these are much more complex than many of us had thought.

—SHIRIN NESHAT

▶ **23.37 Shirin Neshat,** *Allegiance with Wakefulness,* **1994. Black-and-white RC print and ink (photo taken by Cynthia Preston).** The artist's feet are inscribed with militant messages in Farsi.

ARCHITECTURE

After World War II, architecture moved in many directions. Some of these were technological advances that allowed architects to literally achieve greater heights, as in the skyscraper, and to create more sculptural forms, as in Le Corbusier's Chapel of Notre-Dame-du-Haut. Millions of U.S. soldiers returned to their homes and established new families, giving birth not only to what we now call the baby boomers but also to vast housing tracts like Levittown that dotted suburbs that had earlier been farms, small towns, or wilderness. All these and more were examples of modern architecture.

Modern Architecture

Modern architecture rejected the ideals and principles of Classical tradition in favor of the experimental forms of expression that characterized many styles of art and literature from the 1860s to the 1970s. *Modernism* also refers to approaches that are ahead of their time. *Modern* suggests, in general, an approach that overturns the past; by that definition, every era of artists doing something completely new can be considered modern in their time.

Modernism is a concept of art making built on the urge to depict contemporary life and events rather than history. Modernism was a response to industrialization, urbanization, and the growth of capitalism and democracy. Modern architects, like modern artists, felt free to explore new styles inspired by technology and science, psychology, politics, economics, and social consciousness.

As we see in the differences among Wright's Guggenheim Museum, Le Corbusier's Notre-Dame-du-Haut, and Mies's Seagram Building (designed in collaboration with Philip Johnson), Modernism in architecture never comprised just one style. Rather, it serves as an umbrella term that encompasses many architectural visions.

FRANK LLOYD WRIGHT One of the most influential U.S. architects of the 20th century was Frank Lloyd Wright (1869–1959), a disciple of Louis Sullivan (1856–1924). Sullivan had built the first skyscrapers in the United States in the last decade of the 19th century. Like Sullivan, Wright championed an architecture that produced buildings designed for their specific function, with an eye focused on the natural environment in which the building

was to be placed and with a sensitivity to what the building should "say"—as we saw in Wright's house "Fallingwater" (see Fig. 22.20). "Form ever follows function" was Sullivan's famous aphorism for this belief. For Wright and his disciples, there was something ludicrous about designing a post office to look like a Greek temple and then building it in the center of a Midwestern U.S. city. Wright wanted an *organic* architecture—an architecture that grew out of its location rather than being superimposed on it.

For decades Wright designed private homes, college campuses, industrial buildings, and churches that reflected this basic philosophy. In the postwar period, Wright finished his Solomon R. Guggenheim Museum (**Fig. 23.38**), initially conceived in 1943.

This building is a capsule summary of Wright's architectural ideals. Wright was interested in the flow of space rather than its obstruction ("Democracy needs something basically better than a box"), so the Guggenheim Museum's interior is designed to eliminate as many corners and angles as possible. It is essentially one large room with an airy central core—a long, simple spiraling ramp six stories high, cantilevered from supporting walls. A museumgoer can walk down the ramp and view an exhibition without encountering a wall or partition. The viewing of the art is a continuously unwinding experience. But there have been critics: some argue that the building and not the art becomes the exhibition; others complain about the problems of setting horizontal and vertical works of art in a continuously slanting space.

But the overall shape of the building abundantly demonstrates the possibilities inherent in reinforced concrete—a building material that became available in the 20th century. In reinforced concrete, or **ferroconcrete**, steel rods or steel mesh are inserted into concrete slabs at the points of greatest stress before they harden. Alternately, the concrete can be formed around the steel.

▶ **23.38** **Frank Lloyd Wright, Solomon R. Guggenheim Museum, 1943–1959. New York, New York.** The structure of the building is made of reinforced concrete, and the outer surface is finished with sprayed concrete (gunite).

Ferroconcrete has many of the advantages of stone and steel, without some of the disadvantages. The steel rods increase the tensile strength of concrete, making it less susceptible to tearing or pulling apart. The concrete, in turn, prevents the steel from rusting. Reinforced concrete can span greater distances than stone, and it supports more weight than steel. It can assume curved shapes that would be unthinkable in steel or concrete alone. Curved slabs take the forms of eggshells, bubbles, seashells, and other organic shapes. The surface of the building is also made of concrete—sprayed concrete, also known as *gunite*.

The Guggenheim Museum, with its soft curves and cylindrical forms, stands in contrast to the boxy angles and corners of most of the buildings found in New York City. The museum takes on the quality of sculpture.

LE CORBUSIER The Swiss architect Charles-Édouard Jeanneret, known as Le Corbusier (1887–1965), argued that buildings should be lifted off the ground by reinforced concrete pylons; have walls that do not support the structure, thereby allowing the architect to freely form the façade; have an open floor plan (as few walls as possible); and, when possible, have a roof garden to compensate for the vegetation lost to the building. His Chapel of Notre-Dame-du-Haut (**Fig. 23.39**) follows some of these principles. The roof is supported by concrete columns and not the wall, for example, such that it seems to float above the walls—as happens in many cathedrals with clerestories. But there is no roof garden.

The design is an example of what has been referred to as the "new brutalism," deriving from the French *brut*, meaning "rough, uncut, or raw." The steel web is spun, and the concrete is cast in place, leaving the marks of the wooden forms on its surface. The white walls, dark roof, and white towers are decorated

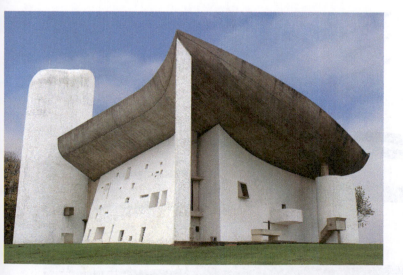

▲ **23.39** Le Corbusier, Chapel of Notre-Dame-du-Haut, 1950–1954. Concrete and stone structure. Ronchamp, France. The roof is supported by columns so that the architect was able to punch windows into the walls at will.

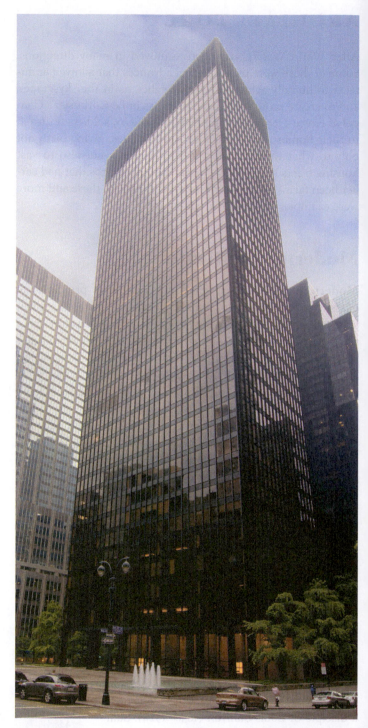

▲ **23.40** Ludwig Mies van der Rohe and Philip Johnson, Seagram Building, 1958. New York, New York. The building reaches the height of the modern aesthetic.

only by the texture of the curving reinforced concrete slabs. In places, the walls are incredibly thick. Windows of various shapes and sizes expand from small slits and rectangles to form mysterious light tunnels; they draw the observer outward more than they actually light the interior. The massive voids of the window apertures recall the huge stone blocks of prehistoric religious structures.

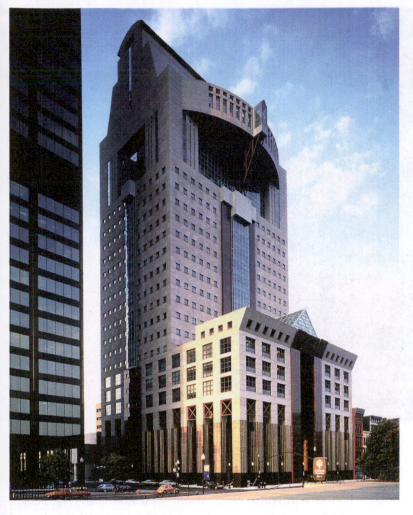

◀ **23.41** Michael Graves, Humana Building, 1985. Louisville, Kentucky.

steel-cage rectangular solids was threatening to bury the nation's cities in boredom. Said art critic John Perrault, "We are sick to death of cold plazas and monotonous 'curtain wall' skyscrapers."

In response—or in revolt—by the end of the 1970s, architects continued to create steel-cage structures but drew freely from past styles of ornamentation, including classical columns, pediments, friezes, and a variety of elements we might find in ancient Egypt, Greece, or Rome. The architectural movement was termed **Postmodernism**; the idea was to once more "warm up" buildings, to link them to the architectural past, to a Main Street of the heart or mind—some sort of mass architectural nostalgia. Postmodernist structures rejected the formal simplicity and immaculate finish of Modernist architecture in favor of whimsical shapes, colors, and patterns. Postmodern architects revived the concept of the decorative in architecture, a practice that was completely antithetical to the purity of Modernism in the 20th century.

MICHAEL GRAVES Michael Graves's (1934–2015) Humana Building (**Fig. 23.41**) looks to ancient Egypt for its historic reference. Tall, tightly arranged pillars (as in an Egyptian **hypostyle** hall) and a grid of square windows lighten the otherwise heavy rectangular solids, which seem to anchor the building firmly to the ground. The overall impression recalls the great pylons, or gateways, of Egyptian temple complexes such as the one at Karnak. The office building is set behind the entry in such a way that the overall contour mimics the block-like seated body position in ancient statuary. The curved shape at the top of the front elevation, "adorned" with a projecting rectangle, recalls a pharaonic headdress.

RENZO PIANO AND RICHARD ROGERS The architects of the Georges Pompidou National Center for Arts and Culture in Paris (see **Fig. 23.42** on p. 852) were an Italian, Renzo Piano (b. 1937), and a Briton, Richard Rogers (b. 1933). This genesis, perhaps, is one of the reasons that many Parisians were initially critical of the building, which differs from modern architecture in that it wears its skeleton on the outside. Staid modern buildings, such as the Seagram Building, have a central service core that carries heating and air-conditioning ducts, electricity, and water—and, of course, elevators and stairways. The various pipes that cover these utilities are coded with different colors to enable workers and repair people to readily locate them. The pipes are also coded in—or rather, on—the Pompidou Center, but they are part of the façade of the building and allowed the architects to splash the building with color. Even the elevator is on the outside—a transparent conveyer that delivers a grand view of the city as it delivers its occupants to the upper floors.

LUDWIG MIES VAN DER ROHE AND PHILIP JOHNSON The Seagram Building (**Fig. 23.40**), the U.S. headquarters for the Canadian distiller Joseph E. Seagram & Sons, was built across Park Avenue from its equally famous and equally Modernist neighbor, Lever House. Designed by Ludwig Mies van der Rohe and Philip Johnson, it is another signature example of the Modernist credo, "form ever follows function." There is no ornamentation. The vertical I beams of bronze-coated steel form a perfectly regular pattern across the elevations of the structure and emphasize its upward reach. Mies, who abhorred irregularity, even specified that the window coverings for the building be uniform, so that from the outside, the windows would never look chaotic or messy. The sharp-edged columns at the entry-level plaza complement the stark grid of the building but also define a softer, transitional space—with trees and fountains—between the chaos of the surrounding city and the austere serenity of the building's interior.

Postmodern Architecture

By the mid-1970s, the clean Modernist look of buildings such as the Seagram Building was overwhelming the cityscape. Architectural critics began to argue that a national proliferation of

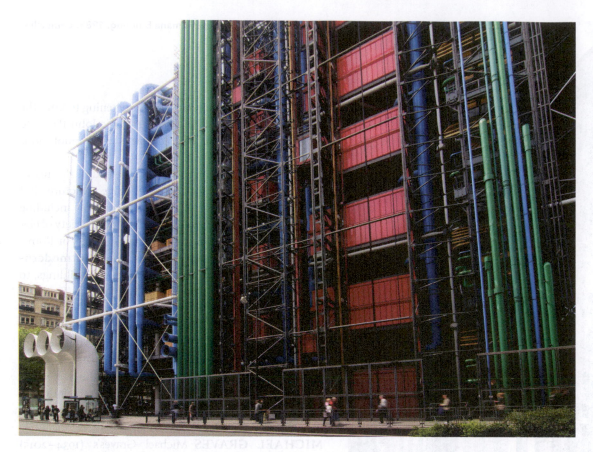

◀ **23.42** **Renzo Piano and Richard Rogers, Georges Pompidou National Center for Arts and Culture, 1977. Paris, France.** Different utilities—water, heating and cooling, electricity—are color coded.

Deconstructivist Architecture

What we have known as modern architecture is no longer modern, at least not in the sense of relating to the present. It's not even Postmodern, if we want to pigeonhole style. As we move forward in the third millennium, the world of architecture seems enthralled by a movement called **Deconstructivism**.

The Deconstructivist movement originated in the 1960s with the ideas of the French philosopher Jacques Derrida. He argued, in part, that literary texts can be read in different ways and that it is absurd to believe that there can be only one proper interpretation. Similarly, in Deconstructivist architectural design, the whole is less important than the parts. In fact, buildings are meant to be seen in bits and pieces. The familiar elements of traditional architecture are taken apart, discarded, or disguised so that what remains sometimes seems randomly assembled.

Deconstructivist architects deny the modern maxim that form should follow function. Instead, they tend to reduce their structures to purer geometric or sculptural forms made possible by contemporary materials, and they make liberal use of color to express emotion.

FRANK GEHRY The Guggenheim museums have always been on the cutting edge of design, beginning with Frank Lloyd Wright's monument on New York City's Fifth Avenue. Canadian-born architect Frank Gehry (b. 1929) designed the no-less-remarkable Guggenheim Museum Bilbao (**Fig. 23.43**), which brings thousands of tourists each year to that industrial Spanish city. Gehry is now designing yet another Guggenheim museum, for Abu Dhabi in the United Arab Emirates. He refers to the Bilbao Guggenheim as a "metallic flower." Others have found the billowing, curvilinear shapes to be reminiscent of ships, linking the machine-tooled structure that is perched on the water's edge to the history of Bilbao as an international seaport. It is as if free-floating geometric shapes have collided on this site, bending them this way and that, such that if the collision had occurred on another day, they might have assumed a different configuration.

Gehry was commissioned to design the Ray and Maria Stata Center at the Massachusetts Institute of Technology, a building that would house classrooms, research facilities, an auditorium, fitness facilities, and a childcare center. His Deconstructivist design solution again features fragmentation and sculptural shapes (**Fig. 23.44**). Here, as in Bilbao, we have a collision of forms; but here they are more rectilinear, and it appears as if a block of row houses somehow collapsed inward or on each other. The Stata Center is a **green building**, meaning that its design is consistent with principles of conservation such as using recirculating storm water, using as much airflow as possible to reduce the use of fossil fuels for heating and cooling, providing operable windows for natural ventilation, reusing construction waste from other projects, and even designing the landscaping to use rainwater.

▲ **23.43** **Frank Gehry, Guggenheim Museum Bilbao, 1997. Bilbao, Spain.** The museum has made Bilbao into a tourist destination. In the foreground, we see one of American sculptor Louise Bourgeois's *Spiders*.

◄ **23.44** **Frank Gehry, Ray and Maria Stata Center for Computer, Information, and Intelligence Sciences, 2005. Massachusetts Institute of Technology, Cambridge, Massachusetts.** Although visitors are most impressed with the building's appearance, it also functions as a green (energy-saving) building. It collects and recycles rainwater; it uses air-conditioning exactly where and when it's needed; and it was even partially constructed from recycled building materials.

▲ **23.45** Santiago Calatrava, World Trade Center Transportation Hub, 2016. New York, New York.
The ribbed windows drench the platform 60 feet below in natural light.

SANTIAGO CALATRAVA Spanish architect Santiago Calatrava's (b. 1951) architecture seems to be going up everywhere: a symphony center in Atlanta; a museum in Milwaukee; 30 bridges, including three that will span the Trinity River in Dallas; a transportation hub for the World Trade Center site that opened in 2016 (**Fig. 23.45**); and a residential tower composed of 12 cubes cantilevered from a concrete core overlooking the East River in New York City. *Time* magazine named Calatrava one of the 100 most influential people of 2005, and the American Institute of Architects awarded him their coveted gold medal in the same year. As we see in the transportation hub, Calatrava—also a sculptor and a painter—has erased the lines between architecture and sculpture.

Eero Saarinen's TWA Terminal at New York's JFK Airport has been said to look like a bird in flight. So does Calatrava's transportation hub (although it also looks something like the plated back of a stegosaurus), but most of the hub is underground. It has a body of glass and steel at street level, and two canopies that extend upward, creating the impression of wings. The practical purpose to the design is to flood the train platform 60 feet below with natural light. Calatrava remarked that the building materials are steel, glass, and light.

VIDEO

Video technology was invented for television, which debuted to the masses in 1939 at the New York World's Fair in Flushing Meadows, Queens. Over about 75 years, television has radically altered U.S. culture at home and placed it before the world. One of your authors recently stopped at a rest area in Egypt between Alexandria and Cairo and observed a young Muslim woman in a hijab (headscarf) and blue jeans watching *Desperate Housewives* in Arabic on a large flat-panel display in the lobby. Television provides many of the images that reflect and create our common contemporary culture—from "reality" programming like *Keeping Up with the Kardashians, Real Housewives of* (fill in your favorite location), and *So You Think You Can Dance* to scripted shows such as *Homeland, True Detective, House of Cards*, and *Orange Is the New Black*. Children spend as many hours in front of a TV set as they do in school, and congressional committees debate effects such as childhood obesity and the impact of televised violence.

Television has also flooded our screens with live coverage of disasters, and the effect has been to change history. Millions watched live and in horror as John F. Kennedy was assassinated

in 1963 and the space shuttle *Challenger* exploded in 1986. It has been suggested that TV footage of the Vietnam War contributed to that war's unpopularity and the United States' pullout from the country in 1975. So-called "gulf potatoes"[12] seemed to be addicted to the coverage of the Gulf War, the nation's first real televised war—which began with CNN's live description of fighter-bombers over Baghdad in 1991. In 2001, viewers watched the destruction of the World Trade Center live—whether from the suburbs of New York or from Los Angeles or Beijing—and in January 2011, the world witnessed protests leading to revolution in Egypt. Viewers become, so to speak, a community connected by broadcasting, cable, and Wi-Fi.

Video art as a medium, distinguished from the commercial efforts of the television establishment, was introduced in the 1960s.

12. A play on the term *couch potato*.

BILL VIOLA Bill Viola's (b. 1951) *The Crossing* (**Fig. 23.46**) is a video and sound installation that engulfs the senses and aims to transport the viewer into a spiritual realm. In this piece, the artist simultaneously projects two video channels onto separate 13-foot-high screens or on the back and front of the same screen.

On one side of the screen, a human form slowly approaches from a great distance through a dark space. The figure gradually becomes more distinct, and we soon recognize a man walking straight toward us, all the time becoming larger. When his body almost fills the frame, he stops moving and stands still, staring directly at the viewer in silence. A small votive flame appears at his feet. Suddenly, brilliant orange flames rise up and quickly spread across the floor and up onto his body. A loud roaring sound fills the space as his form rapidly becomes completely engulfed by a violent raging fire. The fire soon subsides until only a few small flickering flames remain on a charred floor. The figure of the man is gone. The image returns to black and the cycle repeats.

▲ **23.46** Bill Viola, *The Crossing*, 1996. Video/sound installation, edition number 1 of 3, 16:00 minutes. Two channels of color video projections from opposite sides of a large dark gallery onto two large back-to-back screens suspended from the ceiling and mounted to the floor; four channels of amplified stereo sound, four speakers. Room dimensions: 4.9 × 8.4 × 17.4 m. Performer: Phil Esposito. Photo: Kira Perov. Solomon R. Guggenheim Museum, New York, New York. Two large back-to-back projection screens stand in the middle of the room, their bottom edges resting on the floor. Two video projectors mounted at opposite ends of the room project images onto the front and back sides of the screen simultaneously, showing a single action involving a human, culminating in a violent annihilation by the opposing natural forces of fire and water.

On the other side, we again see a dark human form approaching. He slowly moves toward us out of the shadows, in the same manner as the other figure. Finally, he too stops and stares, motionless and silent. Suddenly, a stream of silver-blue water begins pouring onto his head, sending luminous trails of splashing droplets off in all directions. The stream quickly turns into a raging torrent as a massive amount of water cascades from above, completely inundating the man as a loud roaring sound fills the space. The falling water soon begins to subside, and it trails off, leaving a few droplets falling on a wet floor. The figure of the man is gone. The image then returns to black and the cycle repeats.

The two complementary actions appear simultaneously on the two sides of the screen, and the viewer must move around the space to see both images. The image sequences are timed to play in perfect synchronization, with the approach and the culminating conflagration and deluge occurring simultaneously, energizing the space with a violent raging crescendo of intense images and roaring sound. The two traditional natural elements of fire and water appear here not only in their destructive aspects, but manifest their cathartic, purifying, transformative, and regenerative capacities as well. In this way, self-annihilation becomes a necessary means to transcendence and liberation.

Critics speak about the spiritual nature of Viola's work, but it is also about the here-and-now reality of the viewer's sensory experience elicited by the encounter with the work.

PIPILOTTI RIST Pipilotti Rist (b. 1962) is a Swiss video-performance artist whose most common subject is her own nude body afloat in an endless sea. Her work has been projected in venues as diverse as New York's Times Square and the Baroque ceiling of an Italian church (the Chiesa di San Stae) during the 2005 Venice Biennale, an international art exhibition. The first artist to adapt a music-video aesthetic, she creates videos that are saturated with psychedelic color and play against a soundtrack of her own music (she created the all-women band Les Reines Prochaines—The Next Queens). Rist's installations are sensuous and joyous; the "walls liquefy and wash over the people like a psychic Jacuzzi, in order to set them afloat."[13] New York's Museum of Modern Art commissioned Rist to produce a site-specific installation that bathed several walls of the second-floor atrium of the museum in 25-foot-high images (**Fig. 23.47**). At any one time, scores of viewers could be seen walking through the space, sitting on the floor beneath the projections, or lounging on a cushioned island designed by the artist.

MATTHEW BARNEY Michael Kimmelman, the *New York Times* film critic, considers Matthew Barney (b. 1967) to be "the most important American artist of his generation."[14] Contemporary artists continue to challenge the use of traditional mediums, and Barney is no exception, having fashioned dumbbells of tapioca pudding and an exercise bench of petroleum jelly. But Barney is best known for his *Cremaster* series of five films. The characters in the films include nymphs, satyrs, and other legendary figures who are, or are not, what they seem to be. The narratives, enhanced with eclectic soundtracks, circle around various ritual masculine athletic challenges and a good

13. Pipilotti Rist in *Art Now*, ed. Uta Grosenick (Cologne, Germany: Taschen, 2005), p. 442.
14. Michael Kimmelman, "The Importance of Matthew Barney," *The New York Times Magazine* (October 10, 1999).

◀ **23.47** Pipilotti Rist, installation view from *Pour Your Body Out (7354 Cubic Meters)*, 2008. Multichannel video (color, sound), projector enclosures, circular seating element, carpet. Museum of Modern Art, New York, New York. Rist designed the seating herself to assure that viewers would have optimal vantage points.

deal of symbolic pagan pageantry. Much of *Cremaster 2* takes place in the wide-open spaces of the Wild West, accompanied by folk songs, the singing of the Mormon Tabernacle Choir, and other music. One scene transports the viewer to the 1893 World's International Exhibition, in which the novelist Norman Mailer (1923–2007) impersonates the escape artist Harry Houdini (**Fig. 23.48**), standing next to the artist in the guise of a bizarrely attired Gary Gilmore.

Mailer was the author of *The Naked and the Dead* (1948), a positively reviewed novel, based on his military experiences in World War II, that made him famous. The book showed how officers sometimes used foot soldiers as pawns in something of a game when they were bored; it was made into a movie in 1958. Mailer had also written a book, *The Executioner's Song*, about convicted murderer Gary Gilmore, who was executed by a firing squad in 1977. Along with writers such as Tom Wolfe, Joan Didion, and Truman Capote, Mailer was an originator of **creative nonfiction**, or new journalism, a genre that related true stories with the artifice of fiction. In any event, Gilmore, unlike Houdini, did not escape.

At the beginning of *The Naked and the Dead* (Reading 23.5), U.S. troops are in the Pacific, being shipped from island to island to fight Japanese troops:

▲ **23.48** Matthew Barney, *CREMASTER 2*, 1999, Production still.
In this scene, Barney (right) appears with the novelist Norman Mailer.

READING 23.5 NORMAN MAILER

From *The Naked and the Dead*, chapter 1

Nobody could sleep. When morning came, assault craft would be lowered and a first wave of troops would ride through the surf and charge ashore on the beach at Anopopei. All over the ship, all through the convoy, there was a knowledge that in a few hours some of them were going to be dead.

A soldier lies flat on his bunk, closes his eyes, and remains wide-awake. All about him, like the soughing of surf, he hears the murmurs of men dozing fitfully. "I won't do it, I won't do it," someone cries out of a dream, and the soldier opens his eyes and gazes slowly about the hold, his vision becoming lost in the intricate tangle of hammocks and naked bodies and dangling equipment. He decides he wants to go to the head, and cursing a little, he wriggles up to a sitting position, his legs hanging over the bunk, the steel pipe of the hammock above cutting across his hunched back. He sighs, reaches for his shoes, which he has tied to a stanchion, and slowly puts them on. His bunk is the fourth in a tier of five, and he climbs down uncertainly in the half-darkness, afraid of stepping on one of the men in the hammocks below him. On the floor he picks his way through a tangle of bags and packs, stumbles once over a rifle, and makes his way to the bulkhead door. He passes through another hold whose aisle is just as cluttered, and finally reaches the head.

SOME TRENDS IN CONTEMPORARY LITERATURE

By the end of World War II, literary figures who had defined the Modernist temperament, including T. S. Eliot and James Joyce, were dead or already past their best work. Their passionate search for meaning in an alienated world, however, still inspired the work of others. The great Modernist themes received attention from other voices in other media. The Swedish filmmaker Ingmar Bergman (1918–2007) began a series of classic films starting with his black-and-white *Wild Strawberries* in 1957, which explored the loss of religious faith and the demands of modern despair. The enigmatic Irish playwright Samuel Beckett (1906–1989)—who lived in France and wrote in French and English—produced plays like *Waiting for Godot* (1952), absurdist literature that explores a world beyond logic, decency, and the certainty of language.

SAMUEL BECKETT *Waiting for Godot*, for all its apparent simplicity, is maddeningly difficult to interpret. Beckett places two characters, Vladimir and Estragon, at an unnamed and barren crossroads, where they wait for Godot. Their patient wait is interrupted by antic encounters with two other characters. In the two acts, each representing one day, a young boy announces that Godot will arrive the next day. At the end of the

play, Vladimir and Estragon decide to wait for Godot, although they toy momentarily with the idea of splitting up or committing suicide if Godot does not come to save them.

The language of *Godot* is laced with biblical allusions and religious puns. Is Godot God? And does the play illuminate the nature of an absurd world without final significance? Beckett does not say and critics do not agree, although they are in accord with the judgment that *Waiting for Godot* is a classic—if cryptic—statement about language, human relations, and the ultimate significance of the world.

ELIE WIESEL Gradually, as the war receded in time, other voices relating the horrors of the war experience began to be heard. The most compelling atrocity of the war period, the extermination in the Nazi concentration camps of 6 million Jews and countless other dissidents and enemies, has resulted in many attempts to tell the world that story. The most significant voice of the survivors of the event is the Romania-born Elie Wiesel (b. 1928), a survivor of the camps. Wiesel describes himself as a "teller of tales." He feels a duty, beyond the normal duty of art, to keep alive the memory of the near extermination of his people. Wiesel's autobiographical memoir and arguably his greatest work, *Night* (1960), recounts his own years in the camps. It is a terribly moving book. One theme is the loss of Wiesel's faith in God as he witnesses the horrors of the camp and thinks that God is allowing his "chosen" people to be exterminated:

READING 23.6 ELIE WIESEL

From *Night*

Ten thousand men had come to attend the solemn service, heads of the blocks, Kapos, functionaries of death.

"Bless the Eternal...."

The voice of the officiant[15] had just made itself heard. I thought at first it was the wind.

"Blessed be the Name of the Eternal!"

Thousands of voices repeated the benediction; thousands of men prostrated themselves like trees before a tempest.

"Blessed be the Name of the Eternal!"

Why, but why should I bless Him? In every fiber I rebelled. Because He had had thousands of children burned in His pits? Because He kept six crematories working night and day, on Sundays and feast days? Because in His great might He had created Auschwitz, Birkenau, Buna, and so many factories of death? How could I say to Him: "Blessed art Thou, Eternal, Master of the Universe, Who chose us from among the races to be tortured day and night, to see our fathers, our mothers, our brothers, end in the crematory? Praised be Thy Holy Name, Thou Who hast chosen us to be butchered on Thine altar?"

...

Never shall I forget that night, the first night in camp, which has turned my life into one long night, seven times cursed and

seven times sealed. Never shall I forget that smoke. Never shall I forget the little faces of the children, whose bodies I saw turned into wreaths of smoke beneath a silent blue sky.

Never shall I forget those flames which consumed my Faith forever.

Never shall I forget that nocturnal silence which deprived me, for all eternity, of the desire to live. Never shall I forget those moments which murdered my God and my soul and turned my dreams to dust. Never shall I forget these things, even if I am condemned to live as long as God Himself. Never.

American Literature

In the United States, an entirely new generation of writers defined the nature of the American experience. Arthur Miller's play *Death of a Salesman* (1949) explored the failure of the American dream in the person of its tragic hero Willie Loman, an ordinary man defeated by life. J. D. Salinger's *The Catcher in the Rye* (1951) documented the bewildering coming of age of an American adolescent in so compelling a manner that it was, for a time, a cult book for the young. Southern writers like Eudora Welty, William Styron, Walker Percy, and Flannery O'Connor continued the meditations of William Faulkner about an area of the United States that has tasted defeat in a way no other region has. Poets like Wallace Stevens, Theodore Roethke, William Carlos Williams, and Marianne Moore continued to celebrate the beauties and terrors of both nature and people.

Existentialism was well suited to the postwar mood. One aspect of existentialism's ethos was its insistence on protest and human dissatisfaction. That element of existential protest has been very much a part of the postwar scene. The civil-rights movement of the late 1950s and early 1960s became a paradigm for other protests, such as those against the Vietnam War; in favor of the rights of women; and for the rights of the dispossessed, the underprivileged, or the victims of discrimination. The literature of protest has been an integral part of this cry for human rights.

JOHN UPDIKE John Updike (1932–2009) wrote novels, poems, and short stories. His best-known books are about a former high-school basketball star, Harry "Rabbit" Angstrom, who, at 6 feet 3 inches, stands above (most of) the crowd and spends the remainder of his life adjusting to the fact that his glory days have vanished into his past—as will all of our glories (and other endeavors). The first of the series, *Rabbit, Run* (1960), begins as seen in Reading 23.7 with a group of youngsters playing basketball. They are concerned about the tall stranger watching them, but the alienated Harry Angstrom is no threat. For much of the novel, he drives aimlessly through suburban and rural Pennsylvania, as if seeking clues to his future. Updike meticulously lists the songs and commercials on the radio as Rabbit drives, and drives. There are four novels in the Rabbit

15. One who officiates at a religious ceremony.

series. In one of them, which takes place during the height of the civil-rights movement, Rabbit becomes involved with an African American family. In another, he becomes strangely wealthy via ownership of a Toyota dealership, which is an ironic commentary on the United States' new relationship with the rest of the globe and the key role that former enemies play in daily U.S. life. After all, the country has also imported hundreds of thousands—if not millions—of Volkswagens and Mercedes Benzes from Germany.

READING 23.7 JOHN UPDIKE

From *Rabbit, Run*

Boys are playing basketball around a telephone pole with a backboard bolted to it. Legs, shouts. The scrape and snap of Keds on loose alley pebbles seems to catapult their voices high into the moist March air blue above the wires. Rabbit Angstrom, coming up the alley in a business suit, stops and watches, though he's twenty-six and six three. So tall, he seems an unlikely rabbit, but the breadth of white face, the pallor of his blue irises, and a nervous flutter under his brief nose as he stabs a cigarette into his mouth partially explain the nickname, which was given to him when he too was a boy. He stands there thinking, the kids keep coming, they keep crowding you up.

His standing there makes the real boys feel strange. Eyeballs slide. They're doing this for themselves, not as a show for some adult walking around town in a double-breasted cocoa suit. It seems funny to them, an adult walking up the alley at all. Where's his car? The cigarette makes it more sinister still. Is this one of those going to offer them cigarettes or money to go out in back of the ice plant with him? They've heard of such things but are not too frightened; there are six of them and one of him.

EDWARD ALBEE The playwright Edward Albee (b. 1928) is best known for his plays *The Zoo Story* (1958), *The Sandbox* (1959), and *Who's Afraid of Virginia Woolf?* (1962), in the latter of which a learned couple sings the title to the tune of "Who's Afraid of the Big, Bad Wolf?" It was made into a wonderful 1966 movie starring Elizabeth Taylor and Richard Burton (**Fig. 23.49**), who had recently starred together in *Cleopatra*. One of the cultural subplots is that the story finds the Technicolor royalty of ancient Egypt and Rome in a black-and-white, claustrophobic New England college town. Burton is a burned-out professor (George) in the history department; his wife (Martha, as played by Taylor) derides him for, after many years, still being a "bog" in the history department rather than being *the* department (that is, the department chair). In the scene, she nicknames him "boggy." The battling, puffy couple have a young couple—a new professor and his wife—over for dinner. "Having for dinner" can be construed in different ways, as Martha winds up sleeping with the young professor, played by George Segal, while her husband shows angst and the young wife, played by Sandy Dennis, remains vacant and clueless. George and Martha pretend to have a child, upon whose description they seem confused—for example, referring to him as a "blond eyed, blue haired" child. Unlike George and Martha Washington, this George and this Martha will never be parents of a nation, or of a child. But after the inevitable blowup, we discover that this is just a typical evening in the life of George and Martha.

AFRICAN AMERICAN LITERATURE

First and foremost, one can trace African Americans' struggle for dignity and full equality through the literature they produced, especially in the period after World War I. The great pioneers were those writers who are grouped loosely under the name of the Harlem Renaissance (discussed in Chapter 22). By refusing the stereotype of the Negro, they crafted an eloquent literature demanding humanity and unqualified justice. The work of these writers presaged the powerful torrent of African American fiction chronicling racial injustice in America. Richard Wright's *Native*

◄ **23.49** Ernest Lehman, still from *Who's Afraid of Virginia Woolf?*, 1966, from the play by Edward Albee, 1962. Martha (Elizabeth Taylor) is stuck with George (Richard Burton), a professor at a college in a New England college town. They regularly destroy one another verbally. Alcohol, sex, and existential angst play their roles, and we eventually discover that the mutual assured destruction pact is something of a game that keeps the couple entertained and moving (sideways?)—an almost daily occurrence.

Son (1940) has become an American classic. James Baldwin's *Go Tell It on the Mountain* (1953) fused vivid memories of African American Harlem, jazz, and the intense religion of African American churches into a searing portrait of growing up African American. Alice Walker explored her Southern roots in the explosively powerful *The Color Purple* (1982).

RALPH ELLISON Ralph Ellison (1914–1994), born in Oklahoma City, was the grandson of slaves. His father died when he was three, and his mother supported the family as a housekeeper, janitor, and home health aide. Young Ellison loved music and aspired to be a composer of classical music. Early writings were for outlets such as "The Negro Quarterly" and "The New Republic."

His novel *Invisible Man* (1952) established Ellison as an important writer, leading to his teaching at colleges and universities such as Bard College, The University of Chicago, and Yale University. The novel tells of a college-educated black man who fights to survive in a society that degrades him as less than human due to the color of his skin—rendering him "invisible." He finds himself buffeted through a life of unfruitful sexual liaisons and violence (see Reading 23.8), leading to hiding out underground. Writing about his misadventures turns out to be cathartic, and he reemerges psychologically with a new appreciation for life.

READING 23.8 RALPH ELLISON

From *Invisible Man*

One night I accidentally bumped into a man, and perhaps because of the near darkness he saw me and called me an insulting name. I sprang at him, seized his coat lapels and demanded that he apologize. He was a tall blond man, and as my face came close to his he looked insolently out of his blue eyes and cursed me, his breath hot in my face as he struggled. I pulled his chin down sharp upon the crown of my head, butting him as I had seen the West Indians do, and I felt his flesh tear and the blood gush out, and I yelled, "Apologize! Apologize!" But he continued to curse and struggle, and I butted him again and again until he went down heavily, on his knees, profusely bleeding. I kicked him repeatedly, in a frenzy because he still uttered insults though his lips were frothy with blood. Oh yes, I kicked him! And in my outrage I got out my knife and prepared to slit his throat, right there beneath the lamplight in the deserted street, holding him by the collar with one hand, and opening the knife with my teeth—when it occurred to me that the man had not *seen* me, actually; that he, as far as he knew, was in the midst of a waking nightmare! And I stopped the blade, slicing the air as I pushed him *away*, letting him fall back to the street. I stared at him hard as the lights of a car stabbed through the darkness. He lay there, moaning on the asphalt; a man almost killed by a phantom. It unnerved

me. I was both disgusted and ashamed. I was like a drunken man myself, wavering about on weakened legs. Then I was amused. Something in this man's thick head had sprung out and beaten him within an inch of his life. I began to laugh at this crazy discovery. Would he have awakened at the point of death? Would Death himself have freed him for wakeful living? But I didn't linger. I ran away into the dark, laughing so hard I feared I might rupture myself. The next day I saw his picture in the *Daily News*, beneath a caption stating that he had been "mugged." Poor fool, poor blind fool, I thought with sincere compassion, mugged by an invisible man!

African American women writers, important voices in contemporary literature, have explored the interwoven issues of race and gender inequality in poetry, fiction, and biography.

GWENDOLYN BROOKS Gwendolyn Brooks (1917–2000), who was tied to the writers of the Harlem Renaissance, was the first African American woman to win a Pulitzer Prize for poetry (1950). Her life in inner-city Chicago—and encounters with racial prejudice—is reflected in her work:

READING 23.9 GWENDOLYN BROOKS

"The Last Quatrain of the Ballad of Emmett Till"

AFTER THE MURDER,
AFTER THE BURIAL

Emmett's mother is a pretty-faced thing;
 the tint of pulled taffy.
She sits in a red room,
 drinking black coffee.
She kisses her killed boy.
 And she is sorry.
Chaos in windy grays
through a red prairie.

MAYA ANGELOU One of the most widely known figures in contemporary African American literature, Maya Angelou (1928–2014), had a multifaceted career that included novels, poetry, and dramatic literature. She was also a producer, director, and outspoken civil rights advocate. *I Know Why the Caged Bird Sings* (1969) is the first in a series of autobiographical works in which she unflinchingly explores the realities of the African American experience, including the double-edged sword of being black *and* being female, the bitter inequities of social justice and opportunity, and the psychological and physical consequences of captivity—both real and imagined:

READING 23.10 MAYA ANGELOU

From *I Know Why the Caged Bird Sings*

The Black female is assaulted in her tender years by all those common forces of nature at the same time that she is caught in the tripartite crossfire of masculine prejudice, white illogical hate and Black lack of power.

The fact that the adult American Negro female emerges a formidable character is often met with amazement, distaste and even belligerence. It is seldom accepted as an inevitable outcome of the struggle won by survivors and deserves respect if not enthusiastic acceptance (ch. 34).

A recurrent theme in I Know Why the Caged Bird Sings *is Angelou's perception of difference, beginning, as a very young child, with her observations of white and black people. These visual impressions are poeticized in her now-adult voice:*

A light shade had been pulled down between the Black community and all things white, but one could see through it enough to develop a fear-admiration-contempt for the white "things"—white folks' cars and white glistening houses and their children and their women. But above all, their wealth that allowed them to waste was the most enviable (ch. 8).

A sense of alienation—or displacement—that can accompany "difference" is powerfully described in the opening pages of the book:

If growing up is painful for the Southern Black girl, being aware of her displacement is the rust on the razor that threatens the throat.

It is an unnecessary insult (Prologue).

"I Know Why the Cage Bird Sings" is also the title of a poem by Angelou in which the African American condition is symbolized in the juxtaposition of the caged and the free bird. Similarly, in the book, Angelou poignantly connects her own emerging voice (she did not speak for five years after being abused and raped as a young child) to those of her black poet-ancestors whose voices were stifled, silent, mute:

Oh, Black known and unknown poets, how often have your auctioned pains sustained us? Who will compute the lonely nights made less lonely by your songs, or by the empty pots made less tragic by your tales?

If we were a people much given to revealing secrets, we might raise monuments and sacrifice to the memories of our poets, but slavery cured us of that weakness. (ch. 23)

TONI MORRISON Toni Morrison (b. 1931) has written several novels about the African American experience and was awarded the Nobel Prize in Literature in 1993. Her recent novel, *Home* (2012), tells of an African American man's return to the segregated United States after serving in the Korean War. In *The Bluest Eye* (1970), Morrison's first novel, Claudia MacTeer relates the events in the year prior to her friend's rape by her father and the loss of her baby. No marigolds bloomed that year, Claudia tells us. In Reading 23.11, Claudia relates her experience when given a blue-eyed, blond-haired doll for Christmas:

READING 23.11 TONI MORRISON

From *The Bluest Eye*, chapter 1

It had begun with Christmas and the gift of dolls. The big, the special, the loving gift was always a big, blue-eyed Baby Doll. From the clucking sounds of adults I knew that the doll represented what they thought was my fondest wish. I was bemused with the thing itself, and the way it looked. What was I supposed to do with it? Pretend I was its mother?...Picture books were full of little girls sleeping with their dolls. Raggedy Ann dolls usually, but they were out of the question. I was physically revolted and secretly frightened of those round moronic eyes, the pancake face, and orangeworms hair.

The other dolls, which were supposed to bring me great pleasure, succeeded in doing quite the opposite. When I took it to bed, its hard unyielding limbs resisted my flesh—the tapered fingertips on those dimpled hands scratched. If, in sleep, I turned, the bone-cold head collided with my own. It was a most uncomfortable, patently aggressive sleeping companion. To hold it was no more rewarding. The starched gauze or lace on the cotton dress irritated any embrace. I had only one desire: to dismember it. To see of what it was made, to discover the dearness, to find the beauty, the desirability that had escaped me, but apparently only me. Adults, older girls, shops, magazines, newspapers, window signs—all the world had agreed that a blue-eyed, yellow-haired, pink-skinned doll was what every girl child treasured. "Here," they said, "this is beautiful, and if you are on this day 'worthy' you may have it." I fingered the face, wondering at the single-stroke eyebrows; picked at the pearly teeth stuck like two piano keys between red bowline lips. Traced the turned-up nose, poked the glassy blue eyeballs, twisted the yellow hair. I could not love it. But I could examine it to see what it was that all the world said was lovable. Break off the tiny fingers, bend the flat feet, loosen the hair, twist the head around, and the thing made one sound—a sound they said was the sweet and plaintive cry "Mama," but which sounded to me like the bleat of a dying lamb, or, more precisely, our icebox door opening on rusty hinges in July. Remove the cold and stupid eyeball, it would bleat still, "Ahhhhhh," take off the head, shake out the sawdust, crack the back against the brass bed rail, it would bleat still. The gauze back would slit, and I could see the disk with six holes, the secret of the sound. A mere metal roundness.

Feminist Perspectives

A brief consideration of literature by women cannot begin to scratch the surface of the myriad ways that women writers have internalized and voiced feminism's ideological and sociopolitical positions. Contemporary heirs to the feminism inspired by foremothers such as Mary Wollstonecraft, Jane Austen, and Virginia Woolf have approached gender and gender issues from a number of perspectives. These include content—representing female experience from a female's point of view—and style—what feminist critic Elaine Showalter defines as "the inscription of the feminine body and female in language and text."[16]

The scope and variety of feminist perspectives is but merely suggested in two literary works by contemporaries and friends, Sylvia Plath (1932–1963) and Anne Sexton (1928–1974). Both used the imagery of traditional gender roles to examine the restraints of their positions. Plath wrote poetry and prose; Sexton wrote only poetry.

SYLVIA PLATH Plath's autobiographical novel, *The Bell Jar*, was written in the post World War II era of conservatism

16. Elaine Showalter, "Feminist Criticism in the Wilderness," *Critical Inquiry* (1981), reprinted in David Lodge, ed., *Modern Criticism and Theory* (London, New York: Longman, 1988), pp. 331–353, 335.

during which women's roles, opportunities, and sexuality were circumscribed. Grappling with the construction of identity as a writer, Plath sheds light on the tenuous interrelatedness of personal goals and the preordained societal expectations of women, daughters, wives, and mothers. Such anxieties are at the center of the novel, as is Plath's awareness of and unqualified description of the mental illness she suffered—what she described as "owl's talons clenching my heart." Plath attempted suicide, perhaps numerous times, before she succeeded on a February morning in 1963. Reading 23.12 from *The Bell Jar* documents her first attempt to do so by taking prescribed sleeping pills that had been hidden from her by her mother.

ANNE SEXTON Like some of Sylvia Plath's writing, Anne Sexton's work is described by critics as "confessional"; that is, it reveals intimate personal details about the author's life. Sexton, a Pulitzer Prize winner for poetry, wrote about her own mental illness (she, too, committed suicide) as well as her relationship with her husband and children. Her poem "In Celebration of My Uterus" (Reading 23.13) not only raises the physical, psychological, and female identity issues attached to her anticipated hysterectomy but is also a rallying cry for all women, in Sexton's words, to follow her "in celebration of the woman I am and of the soul of the woman I am" and to affirm their own identities.

READING 23.12 SYLVIA PLATH

From *The Bell Jar*

I knew just how to go about it.

The minute the car tires crunched off down the drive and the sound of the motor faded, I jumped out of bed and hurried into my white blouse and green figured skirt and black raincoat. The raincoat felt damp still, from the day before, but that would soon cease to matter.

I went downstairs and picked up a pale blue envelope from the dining room table and scrawled on the back, in large, painstaking letters: *I am going for a long walk.*

I propped the message where my mother would see it the minute she came in.

Then I laughed.

I had forgotten the most important thing.

I ran upstairs and dragged a chair into my mother's closet. Then I climbed up and reached for the small green strongbox on the top shelf. I could have torn the metal cover off with my bare hands, the lock was so feeble, but I wanted to do things in a calm, orderly way.

I pulled out my mother's upper right-hand bureau drawer and slipped the blue jewelry box from its hiding place under the scented Irish linen handkerchiefs. I unpinned the little key from the dark velvet. Then I unlocked the strongbox and took out the bottle of new pills. There were more than I had hoped.

There were at least fifty....

I pinned the key back in the jewelry box...put the jewelry box back in the drawer under the handkerchiefs, returned the strongbox to the closet shelf....

Then I went downstairs and into the kitchen. I turned on the tap and poured myself a tall glass of water. Then I took the glass of water and the bottle of pills and went down into the cellar.

A dim, undersea light filtered through the slits of the cellar windows. Behind the oil burner, a dark gap showed in the wall at about shoulder height and ran back under the breezeway, out of sight....

It took me a good while to heft my body into the gap, but at last, after many tries, I managed it, and crouched at the mouth of the darkness, like a troll.

...The dark felt thick as velvet. I reached for the glass and bottle, and carefully, on my knees, with bent head, crawled to the farthest wall.

Cobwebs touched my face with the softness of moths. Wrapping my black coat round me like my own sweet shadow, I unscrewed the bottle of pills and started taking them swiftly, between gulps of water, one by one by one.

At first nothing happened, but as I approached the bottom of the bottle, red and blue lights began to flash before my eyes. The bottle slid from my fingers and I lay down.

The silence drew off, baring the pebbles and shells and all the tatty wreckage of my life. Then, at the rim of vision, it gathered itself, and in one sweeping tide, rushed me to sleep.

READING 23.13 ANNE SEXTON

In Celebration of My Uterus

Everyone in me is a bird.
I am beating all my wings.
They wanted to cut you out
but they will not.
They said you were immeasurably empty
but you are not.
They said you were sick unto dying
but they were wrong.
You are singing like a school girl.
You are not torn.

Sweet weight,
in celebration of the woman I am
and of the soul of the woman I am
and of the central creature and its delight
I sing for you. I dare to live.
Hello, spirit. Hello, cup.
Fasten, cover. Cover that does contain.
Hello to the soil of the fields.
Welcome, roots.

Each cell has a life.
There is enough here to please a nation.
It is enough that the populace own these goods.
Any person, any commonwealth would say of it,
"It is good this year that we may plant again
and think forward to a harvest.
A blight had been forecast and has been cast out."
Many women are singing together of this:
one is in a shoe factory cursing the machine,
one is at the aquarium tending a seal,

one is dull at the wheel of her Ford,
one is at the toll gate collecting,
one is tying the cord of a calf in Arizona,
one is straddling a cello in Russia,
one is shifting pots on the stove in Egypt,
one is painting her bedroom walls moon color,
one is dying but remembering a breakfast,
one is stretching on her mat in Thailand,
one is wiping the ass of her child,
one is staring out the window of a train
in the middle of Wyoming and one is
anywhere and some are everywhere and all
seem to be singing, although some can not
sing a note.

Sweet weight,
in celebration of the woman I am
let me carry a ten-foot scarf,
let me drum for the nineteen-year-olds,
let me carry bowls for the offering
(if that is my part).
Let me study the cardiovascular tissue,
let me examine the angular distance of meteors,
let me suck on the stems of flowers
(if that is my part).
Let me make certain tribal figures
(if that is my part).
For this thing the body needs
let me sing
for the supper,
for the kissing,
for the correct
yes.

MUSIC

After World War II, many avant-garde composers moved toward greater and greater complexity of musical organization, coupled with an increasing use of new kinds of sound. At the same time, other musicians, disturbed by their colleagues' obsessive concern for order, have tried to introduce an element of chance—even chaos—into the creation of a work of music. In taking these directions, modern "classical" or "serious" musicians seem, at least superficially, to have made virtually a complete break with past traditions. Furthermore, much of their work seems remote from our actual experience. Developments in painting or architecture are visible around us in one form or another on a daily basis, and modern writers deal with problems that affect us in our own lives. Many creative musicians, however, have withdrawn to the scientific laboratory, where they construct their pieces with the aid of machines and in accordance with mathematical principles.

Popular music, on the other hand, seems to be anything but remote. Rock operas, musicals, rock and roll, hip-hop, and rap speak to listeners of their social and financial concerns of the day. Musicians are as likely to come from "the 'hood" as the academy. As in the past, the success of all these new forms of music will be judged by generations to come.

STRUCTURALISM The principle of precise musical organization had already become important in 20th-century music with the serialism of Arnold Schönberg. Schönberg's ordering of pitch (the melodic and harmonic element of music) in rigidly maintained 12-tone rows has been extended by recent composers to other elements. Pierre Boulez (b. 1925), for example, constructed rows of 12-note durations (the length of time each note sounds), 12 levels of volume, and 12 ways of striking the keys for works like his Second Piano Sonata (1948) and Structures for two pianos (1952). In this music, every element (pitch, length of notes, volume, and attack) is totally ordered and controlled by the composer in accordance

GO LISTEN!
PIERRE BOULEZ
"Piano Sonata No. 2"

with his predetermined rows, because none of the 12 components of each row can be repeated until all the other 11 have occurred.

Structuralism eliminates any sense of traditional melody, harmony, or counterpoint, along with the emotions they evoke. Instead, the composer aims to create a pure and abstract musical structure that deliberately avoids any kind of subjective emotional expression. There remains, however, one element in these piano works that even Boulez cannot totally control: the human element. All of the composer's instructions, however precise, have to be interpreted and executed by performers, and as long as composers depend on performers to interpret their works, they cannot avoid a measure of subjectivity. Different pianists will inevitably produce different results, and even the same pianist will not produce identical performances on every occasion.

ELECTRONIC MUSIC In order to solve this "problem," some composers in the 1950s began to turn to electronic music, whose sounds are produced not by conventional musical instruments but by an electronic oscillator, a machine that produces pure sound waves. A composer could order the sounds by means of a computer and then transfer these to recording tape for playback. The process of manipulating electronic sound has been simplified by the *synthesizer* (an electronic instrument that can produce just about any kind of sound effect). In combination with a computer, the synthesizer can be used for either original electronic works or the creation of electronic versions of traditional music, as in the popular *Switched-On Bach* recordings of the 1960s.

From its earliest days, electronic music alarmed many listeners by its apparent lack of humanity. The whistles, clicks, and hisses that characterize it may be eerily appropriate to the mysteries of the Space Age but have little to do with traditional musical expression. Composers of electronic music have had considerable difficulty inventing formal structures for organizing the vast range of sounds available to them. In addition, there still exists no universally agreed-on system of writing down electronic compositions, most of which exist only on tape. It is probably significant that even Karlheinz Stockhausen (1928–2007), one of the leading figures in electronic music, tended to combine electronic sounds with conventional musical instruments. His *Mixtur* (1964), for example, was written for five orchestras, electronic equipment, and loudspeakers. During a performance, the sounds produced by the orchestral instruments are electronically altered and simultaneously mixed with the instrumental sound and prerecorded music. In this way, an element of live participation has been reintroduced.

For all its radical innovations, however, *Mixtur* at least maintains the basic premise of music in the Western tradition: that composers can communicate with their listeners by predetermining (composing) their works according to an intellectual set of rules. The laws of Baroque counterpoint, Classical sonata form, or Stockhausen's ordering and altering of sound patterns all represent systems that have enabled composers to plan and create musical works. One of the most revolutionary of all recent developments, however, has been the invention of **aleatoric music**. The name is derived from the Latin word *alea* (a dice game) and is applied to music in which an important role is played by the element of chance.

JOHN CAGE AND ALEATORIC MUSIC One of the leading exponents of this genre of music was the American composer John Cage (1912–1992), who had been much influenced by Zen philosophy. Adopting the Zen attitude that one must go beyond logic in life, Cage argued that music should reflect the random chaos of the world around us and not seek to impose order on it. His Concert for Piano and Orchestra (1958) has a piano part consisting of 84 different "sound events," of which some, all, or none are to be played in any random order. The orchestral accompaniment consists of separate pages of music, of which some, all, or none can be played by any (or no) instrument, in any order and combination. Clearly, every performance of the Concert is going to be a unique event, largely dependent on pure chance for its actual sound. In other pieces, Cage instructed the performers to determine the sequence of events by even more random methods, including the tossing of coins.

GO LISTEN!
JOHN CAGE
"Piano Sonata II"

Works like these are more interesting for the questions they ask about the nature of music than for any intrinsic value of their own. Cage partly reacted against what he regarded as the excessive organization and rigidity of composers like Boulez and Stockhausen, but at the same time, he also raised some important considerations: What is the function of the artist in the modern world? What is the relationship between creator and performer? And what part, if any, should the listeners play in the creation of a piece of music? Need it always be a passive part? If Cage's own answers to questions such as these may not satisfy everyone, he at least posed the problems in an intriguing form.

The New Minimalists

A very different solution to the search for a musical style has been proposed by a younger generation of U.S. composers.

STEVE REICH Steve Reich (b. 1936) was one of the first Western musicians to build lengthy pieces out of the multiple repetitions of simple chords and rhythms. Critics sometimes assume that the purpose of these repetitions is to achieve a hypnotic effect by inducing a kind of trance state. Reich stated that his aim is, in fact, the reverse: a state of heightened concentration.

In *The Desert Music*, a composition for chorus and instruments completed in 1983, Reich's choice of texts is helpful to an understanding of his music. The work's central section consists of a setting of words by the U.S. poet William Carlos Williams (1883–1963) to music.

The piece begins with the pulsing of a series of broken chords, which is sustained in various ways, chiefly by tuned mallets. This pulsation, together with a wordless choral vocalization, gives the work a rhythmic complexity and richness of sound that is at times reminiscent of some African or Balinese music.

GO LISTEN!
STEVE REICH
"The Desert Music, Third Movement"

PHILIP GLASS The works of Philip Glass (b. 1937) are even more openly influenced by non-Western music. Glass studied the Indian tabla drums for a time; he is also interested in West African music and has worked with Ravi Shankar, the great Indian sitar virtuoso. Many of Glass's compositions are based on combinations of rhythmic structures derived from classical Indian music. They are built up into repeating modules, the effect of which has been likened by unsympathetic listeners to a needle stuck in a record groove.

Length plays an important part in Glass's operas, for which he has collaborated with the U.S. dramatist Robert Wilson. Wilson, like Glass, is interested in "apparent motionlessness and endless durations during which dreams are dreamed and significant matters are understood."[17] Together they produced three massive stage works in the years between 1975 and 1985: *Einstein on the Beach*, *Satyagraha*, and *Akhnaten*. The performances involve a team of collaborators including directors, designers, and choreographers; the results have the quality of a theatrical "happening." Although a description of the works makes them sound remote and difficult, performances of them have been extremely successful. Even New York's Metropolitan Opera, not famous for an adventurous nature in selecting repertory, was sold out for two performances of *Einstein on the Beach*. Clearly, whatever its theoretical origins, the music of Glass reaches a wide public.

GO LISTEN!
PHILIP GLASS
"Music in 12 Parts"

Traditional Approaches to Modern Music

Not all composers have abandoned the traditional means of musical expression. Musicians like Benjamin Britten (1913–1976) and Dmitri Shostakovich (1906–1975) demonstrated that an innovative approach to the traditional elements of melody, harmony, and rhythm can still produce exciting and moving results, and neither can be accused of losing touch with the modern world. Britten's *War Requiem* (1962) is an eloquent plea for an end to the violence of contemporary life, whereas Shostakovich's entire musical output reflects his uneasy relationship with Soviet authority. His Symphony No. 13 (1962) includes settings of poems by the Soviet poet Yevgeny Yevtushenko on anti-Semitism in the Soviet Union and earned him unpopularity in Soviet artistic and political circles.

GO LISTEN!
DMITRI SHOSTAKOVICH
"Symphony #13 (Babi Yar) II Humour"

Both Britten and Shostakovich did not hesitate to write recognizable "tunes" in their music. In his Symphony No. 15 (1971), the last he wrote, Shostakovich even quoted themes from Rossini's *William Tell Overture* (the familiar *Lone Ranger* theme) and from Wagner. The work is at the same time easy to listen to and deeply serious. Like much of Shostakovich's music, it is concerned with the nature of death (a subject also explored in his Symphony No. 14). Throughout its four movements, Shostakovich's sense of rhythm is much in evidence, as is his feeling for orchestral color, in which he demonstrates that the resources of a traditional symphony orchestra are far from exhausted. The mysterious dying close of Symphony No. 15 is especially striking in its use of familiar ingredients—repeating rhythmic patterns, simple melodic phrases—to achieve an unusual effect.

If Shostakovich demonstrated that a musical form as old-fashioned as the symphony can still be used to create masterpieces, Britten did the same for opera. His first great success, *Peter Grimes* (1945), employed traditional operatic devices like arias, trios, and choruses to depict the tragic fate of its protagonist, a man whose alienation from society leads to his persecution at the hands of his fellow citizens. In other works, Britten followed the example of many of his illustrious predecessors in turning to earlier literary masterpieces for inspiration. *A Midsummer Night's Dream* (1960) is a setting of Shakespeare's play, while *Death in Venice* (1973) is based on the story by Thomas Mann. In all of his operas, Britten writes music that is easy to listen to (and, equally important, not impossible to sing), but he never condescends to his audience. Each work deals with a recognizable area of human experience and presents it in a valid musical and dramatic form.

Modern Approaches to Traditional Music Genres

Benjamin Britten's *Peter Grimes* was written in 1945, but the story takes place almost a century earlier. One of the characteristics, however, of contemporary opera is its currency, with many subjects inspired by recent or relatively recent events. *Nixon in China*, for example, by composer John Adams, is based on the U.S. president's historic visit to China in 1972, an overture intended to break the diplomatic logjam in relations between the United States and Communist countries. The score for Adams's opera makes references to the minimalist music of Philip Glass but also to that of classical 19th-century composers Wagner and Strauss. Adams has also written operas on the subject of the making of the first atomic bomb (*Dr. Atomic*) and the 1985 murder of the disabled U.S. senior citizen Leon Klinghoffer after Palestinian terrorists hijacked the cruise ship on which he was vacationing (*The Death of Klinghoffer*).

17. Anthony DeCurtis, ed. *Blues & Chaos: The Music Writing of Robert Palmer* (New York: Simon & Schuster, 2009), p. 414.

ROCK OPERA In the 1960s, a number of rock musicians created a new genre—rock opera—that merged contemporary sound and songwriting with more-or-less traditional operatic structure. The first of these to be billed from the start as a rock opera was *Tommy* (1969) by Pete Townshend and The Who. Drawing on conventions of classical opera, *Tommy* has essentially no spoken dialogue, although some spoken lines are scattered throughout the piece. Two years later, *Jesus Christ Superstar* by Andrew Lloyd Webber opened on Broadway, a rock opera that is sung through completely—without spoken words. Webber's opera, with lyrics by Tim Rice, is a loosely constructed story that posits the emerging celebrity of Jesus Christ and its psychological impact on Him. Relationships between Jesus and Judas and Jesus and Mary Magdalene are presented as more complex than the Bible would have us believe, empha-

GO LISTEN!
ANDREW LLOYD WEBBER

"Superstar" from *Jesus Christ Superstar*

sizing the human nature of these larger-than-life figures. *Jesus Christ Superstar* was also a trailblazer in the contemporizing of familiar stories for opera and stage musicals.

Contemporary rock opera composers also have paid homage to beloved operatic repertory. *Miss Saigon* (1989, music by Claude-Michel Schönberg and Alain Boublil, with lyrics by Boublil and Richard Maltby, Jr.) brought the more current event of the Vietnam War to the story line of Giacomo Puccini's *Madame Butterfly,* in which an overseas marriage between an American lieutenant and a naïve and hopeful Japanese girl ends in tragedy when he returns to the States and embarks on another, more conventional life without her. The main characters in *Madame Butterfly* are replaced with an American G.I. and a young Vietnamese orphan-girl whom he meets in a nightclub where bar girls compete for the dubious title of "Miss Saigon," the "prize" of a Marine, and the dream of being taken away from the war-ravaged country to a better life in America. The musical number, "The Heat Is On in Saigon," is sung by the soldiers and bar girls in the steamy, sexually charged atmosphere of the club. It contrasts dramatically in tone with "The Movie in My Mind" in which the contest winner, Gigi, leads the bar girls in a sorrowful song that reflects their (likely unfulfilled) fantasies about life as it would be in America in the arms of a "strong G.I."

GO LISTEN!
CLAUDE-MICHEL SCHÖNBERG

"The Heat Is On in Saigon" from *Miss Saigon*

Operatic structure and style have also made their way into works written for the musical theatre; *Porgy and Bess* is a good example of a work that opened on Broadway but is now considered part of contemporary opera repertory. Broadway musicals such as *The Phantom of the Opera* (also by Andrew Lloyd Webber), *Evita* (by Webber, with lyrics by Tim Rice), or *Sweeney Todd: The Demon Barber of Fleet Street* (by Steven Sondheim, with a libretto by Hugh Wheeler) employ a number of conventions typical of traditional opera.

MUSICALS *The Phantom of the Opera*, although operatic in feel and tone, was staged as a work of musical theater—a book musical—with songs, dance, and acting. Musical theater performers are often referred to as "triple threats" for their superior skills in all of these disciplines. Combining music and theater as we know it goes back at least to the 19th century with lyricists and composers such as Gilbert and Sullivan, but the book musical, written from the outset to combine the disciplines with a dramatic story, exploded as an art form distinguishable from opera in the 20th century.

MUSICALS AND SOCIAL CONSCIOUSNESS The variety of book musicals would seem endless, and consideration of each type—operatic musicals, musical plays, musical comedies, and more—would fill more space than this discussion allows. An interesting subcategory for our purposes, however, is what we may describe as the "socially conscious" musical—a musical that addresses contemporary themes and social issues. *South Pacific*, by the renowned musical theater partners Richard Rodgers (music) and Oscar Hammerstein (lyrics), premiered in 1949, just four years after the Japanese surrender to the Allies in August 1945. Based on James A. Michener's 1947 novel, *Tales of the South Pacific*, the centerpiece of the musical is the love affair between an American nurse (Nellie Forbush) stationed on a naval base in the South Pacific and a French plantation owner (Emile de Becque) who, as is ultimately revealed, is a widower and father of two mixed-race children. The subject of contemporary racial views and prejudice is a powerful subtext in the narrative, further highlighted by a secondary story line featuring a love interest between an island girl (Liat) and an American lieutenant (Joseph Cable). As both de Becque and Cable become entangled in the consequences of racial prejudice, de Becque asks Cable why Americans hold these views. Cable answers that they are not inborn but, rather, they are learned. In his musical number, "You've Got to Be Carefully Taught," Cable tells the Frenchman that children are taught by adults "to hate and fear."

GO LISTEN!
RODGERS AND HAMMERSTEIN

Matthew Morrison, "You've Got to Be Carefully Taught" from *South Pacific*

In *West Side Story* (1957, music by Leonard Bernstein, lyrics by Steven Sondheim, book by Arthur Laurents), ethnic prejudice and social problems take center stage in a musical that contemporizes Shakespeare's story of Romeo and Juliet and the tragic impact of their feuding families on the two young lovers. New York City's Upper West Side neighborhood in the mid-1950s is the backdrop for a gang rivalry between the Jets (white boys from the working class) and the Sharks (young Puerto Rican immigrants). As in *Romeo and Juliet*, a young man (Tony) who belongs to one group, the Jets, falls in love with the sister of the leader of the Sharks (Maria). Conflict escalates between the gangs and, in the heat of a moment, one murder leads to another; Tony is guilty of killing Maria's brother. The musical numbers convey many dimensions of ethnic suspicion and blind hatred on both sides, but the tragic trajectory of the story is mitigated by some songs that cloak social issues in more comedic terms. One of these, "Gee Officer Krupke," sung by the Jets, is a mock-plea to a beat-cop and the juvenile courts to spare young hoodlums like them by pointing to the sociological circumstances that give rise to their behavior.

Hair: The American Tribal Love-Rock Musical (music by Galt McDermot), which opened in an Off-Broadway theater in 1967 and a year later moved to Broadway to become a sensation, tells the story of a group of long-haired hippies who personify hallmarks of the so-called counterculture of the 1960s: sexual freedom, use of illegal drugs, anti-Vietnam War sentiment, and social liberalism. *Hair*, like *West Side Story*, was set in the present. It was intended to cast light on the big divide between pro- and anti-war

GO LISTEN!
GALT MACDERMONT
"Hair" from Hair

factions within the U.S. citizenry, between "establishment" and "anti-establishment" views on patriotism, authority, and other societal principles. Both musicals, one could say, were intended to promote tolerance and to effect social change.

So, too, with *Rent* (1996, music and lyrics by Jonathan Larson), a rock musical based on another Puccini opera, *La Boheme*, which premiered in 1896 (100 years before the opening of *Rent*). Puccini's opera told the story of nearly starving artists—bohemians—living in a Parisian garret and the untimely death of one of the artist's girlfriends from tuberculosis. At the time that Puccini was writing, tuberculosis was referred to as the Great White Plague, ravaging the populations of inner cities that were prone to crowding and unsanitary conditions. *Rent* finds its analogy in a struggling artist community living in New York City's Lower East Side and the HIV/AIDS epidemic among homosexuals and drug users in the late 1980s and early 1990s. Just as death from tuberculosis in the 19th century seemed almost unavoidable, HIV/AIDS among these societal groups "at the end of the millennium" seemed inevitable. In Larson's adaptation of the Puccini opera, the lead male character, Roger, is living with the disease and has become depressed and isolated in the wake of the suicide of his girlfriend after learning that they were both infected. A musician and composer, Roger's state of mind has had a paralyzing effect on his ability to continue to write songs. His desperation to leave his mark, even as he faces the harsh reality of impending death, is the subject of the musical number, "One Song Glory." Groundbreaking in its focus on people living with and dying from HIV/AIDS, *Rent* was the recipient of numerous Tony Awards and the Pulitzer Prize for Drama.

GO LISTEN!
JONATHAN LARSON
"One Song Glory" from Rent

▲ **23.50** Elvis Presley, stage performance in the 1956 movie, *Love Me Tender.*

CONNECTIONS On January 20, 1958, Elvis Presley, the "King of Rock and Roll"—and arguably the most significant icon of popular culture in the 20th century—reported for induction into the United States Army, two years after being declared 1-A (eligible) by the Memphis, Tennessee, draft board. His fans dubbed the day "Black Monday."

Presley served as a regular soldier for two years, even though he was offered the opportunity to enlist in Special Services—an opportunity that would have enabled him to complete his tour of duty performing for troops.

Popular Music

ROCK AND ROLL Rock and roll, the egalitarian American genre of music that evolved in the 1930s and 1940s, exploded on the cultural and entertainment scene in the mid-1950s. The music was young, sexual, and wildly popular. Its influence was felt in movies, in radio and television, in dance and contemporary language. Disc jockeys spun rock and roll vinyl records on the radio, and Dick Clark's TV show *American Bandstand* had teenagers dancing on camera to its rhythms. The movie *Blackboard Jungle* (1954) featured what was arguably the first true rock and roll song, "Rock Around the Clock." The same year, Elvis Presley's first hit, "I'm All Right Mama," became an overnight sensation.

The stylistic roots of rock and roll were multicultural, with a heavy emphasis on African and African American musical traditions. It combined a black church gospel style, the blues, boogie-woogie piano, Southern country elements, and European-based folk tunes. To learn and absorb this synthesis, Elvis visited black segregated barrooms and dance halls in Mississippi before he recorded his first songs. Sam Phillips, an early Presley supporter, remarked that in the young musician he found "a white man with the Negro sound and the Negro feel."[18] Rock and roll's basic sound features a blues rhythm against the constant background beat of a snare drum.

GO LISTEN!
ELVIS PRESLEY

"Heartbreak Hotel"

Other typical instruments include two electric guitars, a bass guitar, and drum set, often along with a piano and saxophone. The driving visceral rhythms appealed to the young and rebellious and quickly spread all over the world.

Elvis Presley was the first real star of rock and roll music. He was a larger-than-life figure who, in addition to being a teen idol and international phenomenon, was a driving force behind the "loosening up" of the postwar generation. In addition to his contributions to the contemporary music scene (his recordings consistently performed at the top of the charts), Presley starred in a long list of films in which he also sang rock and roll tunes.

In the egalitarian spirit of rock and roll, many women singers made the hit parade. Willa Mae (Big Mama) Thornton recorded the old African American blues tune, "Hound Dog," in 1952, which was a success on the rhythm and blues charts three years before the Elvis Presley version became a rock and roll hit. Many "girls" groups (as they were called then) contributed to rock and roll. The first black girls' group to become a success was the Chantels. With Arlene Smith as the lead singer, they recorded the top hit, "Maybe" in 1958. Teenagers were also swinging to the songs "Be My Baby" and "Walking in the Rain" by Ronnie Spector and the Ronettes in the early 1960s. Their producer was the legendary Phil Spector, who invented the "big wall of sound," an echo chamber effect that made his recordings unique. These early rock and roll tunes could be heard over European, Asian, and African radio shortly after being recorded in the United States. Rock and roll was among the first examples of American mass culture to have an international impact.

ROCK MUSIC Rock and roll was the foundation of rock music, a genre that took on many and widely different styles starting in the 1960s. One of the most—if not *the* most—versatile, influential, and commercially successful bands in history—The Beatles—was formed in the English port city of Liverpool in 1960. Nicknamed the "Fab Four," they became international stars in just a few short years. Their popularity was so universal that the word *Beatlemania* was coined to describe the phenomenon; sales of their music to date have been estimated at over $1 billion.

The Beatles drew heavily on rock and roll for their earliest tunes, along with jazz, blues, and folk music. Their first worldwide smash hit was "I Want to Hold Your Hand," cowritten by John Lennon and Paul McCartney. The song was also included on the album *Meet the Beatles*, which was released to the American market and ultimately sold more copies than the single. Along with several other tunes (including "She Loves You," "I Saw Her Standing There," and "All My Loving"), "I Want to Hold Your Hand" was sung before a live audience on American television's *The Ed Sullivan Show* on Sunday night, February 9th, 1964. Over 73 million viewers tuned in to see the group's first live U.S. performance—45.3% of homes with TV sets. The success of The Beatles in this country paved the way for what was called the "British Invasion," bringing rock bands like The Bee Gees, The Dave Clark Five, The Moody Blues, The Rolling Stones, and The Who to radio Billboard Charts and the lucrative American market.

Critical reviews of *The Ed Sullivan Show* performance were mixed, with some predicting that The Beatles would be here today and gone tomorrow. The group stayed together until 1969 and, over the course of almost a decade, their music and lyrics, affected by the 1960s counterculture, became more experimental. References to other pop music styles, eastern music, psychedelic rock, and even classical music pervaded their compositions and yielded continuously unexpected results. A good example of their ingenious synthesizing is "Back in the U.S.S.R.," written by McCartney as a tongue-in-cheek homage to the American rock band, The Beach Boys, and their song, "California Girls," by Brian Wilson. Written in the middle of the Cold War when little was known about life and culture within the Soviet Union, McCartney fantasizes a parallel between the girls The Beach Boys sang about and their counterparts in the Communist state.

GO LISTEN!
THE BEATLES

"I Want to Hold Your Hand"

GO LISTEN!
THE BEATLES

"Back in the U.S.S.R."

18. Jon Garelick, "Sam Phillips: Rock's Visionary," *Boston Phoenix*, August 8–14, 2003.

The Beach Boys, called "America's Band," hailed from Southern California and while they, like most contemporary rock bands, were influenced by the British Invasion, their songs could not have been more uniquely American—or even more specifically, Californian. Tunes like "Surfin' USA," "Surfer Girl," and "California Girls" glamorized the California youth culture—cars, surfing, "endless summers." The band's close vocal harmonies became their signature style, which gained international popularity quickly. By the mid-1960s, however, The Beach Boys—like The Beatles—had moved on to more complex arrangements with experimental instrumentation. "Good Vibrations," one of their most familiar songs, was a trailblazer in psychedelic rock, a genre inspired by the sensations of mind-altering, hallucinogenic drugs like LSD that had become part of the 1960s counterculture.

GO LISTEN!
THE BEACH BOYS
"California Girls"

HIP-HOP AND RAP The word *rap* came into usage in the African American community in the 1960s and referred to talking or conversation. Today, rapping denotes a music genre that melds speech, poetry, and song. It is typically connected to the urban scene and often has sociopolitical content. Rap began loosely in the early 1980s with pieces that featured a certain "flow," or rhythms, rhyme schemes, and enunciation. The genre has expanded to include many, many variations and has spawned a host of rappers with unique musical perspectives.

Rap is a central element in the African American hip-hop subculture that originated in block parties in the Bronx, New York, in the 1970s. Elements of hip-hop also include beatboxing (a vocal technique that reproduces the sounds of percussion instruments), breakdancing (a style of street dance), and graffiti. One of the most acclaimed and influential acts to hit the hip-hop scene in the 1980s was Run-D.M.C.—a group of three musicians from Hollis, Queens, New York. Inducted into the Rock and Roll Hall of Fame in 2009, Run-D.M.C. is widely viewed as having created the sound of hip-hop music, along with the style: the fedora hat, gold name plates, Cazal glasses, and white, laceless Adidas brand sneakers. Their international hit, "Walk This Way," which was a cover for a song written by Steven Tyler and Joe Perry of the hard rock group Aerosmith, was groundbreaking in its interfacing of hip-hop musical style with rock.

GO LISTEN!
RUN-D.M.C.
"Walk This Way"

POP MUSIC AND THE MUSIC VIDEO The combination of music and moving images has a lengthy history ranging from music shorts (one- or two-reel musical films running under half an hour) that date back to the early 20th century to feature-length films in which a music track was sprinkled with dialogue sequences that loosely framed a story. Two early examples of music feature films are *A Hard Day's Night* (1964) and *Help!* (1965)—both starring The Beatles. Critics have traced the music video as we know it to these films.

▲ **23.51 Michael Jackson (center) in still from *Thriller*, 1983. Music video directed by John Landis.** Michael Jackson's innovative and elaborate music video of his performance of the song of the same name set the standard for music videos for a generation to come.

Music videos as marketing tools and art forms unto themselves hit their stride with the launch of MTV (music television) in 1981. Recording artists like Madonna created and starred in music videos, some of which, like her *Immaculate Collection*, featured a whole album of songs that was also sold as a VHS tape. Arguably the most well-known and influential music video is Michael Jackson's *Thriller* (**Fig. 23.51**). The big budget, iconic choreography, cinematography, and running time (almost 14 minutes) set standards in the industry for generations of recording artists.

GO LISTEN!
MICHAEL JACKSON
"Thriller"

A NOTE ON THE POSTMODERN SENSIBILITY

In the past generation, some critics have been insisting, with varying degrees of acceptance, that much of contemporary art has moved beyond the Modernist preoccupation with alienation, myth, fragmentation of time, and the interior states of the self. The most debated questions now are: What exactly followed Modernism that makes it distinctively Postmodern? Does it have a shaping spirit? What do the artists in the various media hold in common that permits them to be considered representative Postmodernists?

Some critics see the Postmodernists as those who push the Modernist worldview to its extreme limit. This is hardly a satisfactory definition, because rather than define a new sensibility, it merely elasticizes the definition of Modern to include more of the same. While Postmodernism must build on what Modernism has accomplished, it must also find its own voice.

It is impossible to create art today as if Cubism or Abstract Expressionism had never existed, just as it is impossible to compose music as if Stravinsky had never lived. Nor can we live life—or even look at it—as if relativity, atomic weapons, and Freudian explorations of the unconscious were not part of our intellectual and social climate. If the humanities are to be a genuine part of the human enterprise, they must surely incorporate their past without being a prisoner of it, reflect its present, and point to the future. In fact, most of the great achievements in the humanities have done precisely that; they have mastered the tradition and then expanded it.

It may well be that the key word to describe the contemporary situation in the arts is *pluralism*: a diversity of influences, ideas, and movements spawned by an age of instant communication and ever-growing technology. In an age when more people than ever before buy books (although many in electronic format); see films; watch television; go to plays and concerts; surf the Internet; and listen to radios and MP3 players, what we seem to be seeing is the curious puzzle the Greek philosophers wrote about millennia ago—the relationship of unity and diversity in the observable world: we are one, but we are also many.

GLOSSARY

Abstract Expressionism (p. 823) A style of painting and sculpture of the 1950s and 1960s in which artists expressionistically distorted abstract images with loose, gestural brushwork.

Absurdity (p. 823) The condition of existing in a meaningless and irrational world.

Action painting (p. 824) A contemporary method of painting characterized by implied motion in the brushstroke and splattered and dripped paint on the canvas.

Aleatoric music (p. 864) Music whose composition comprises an element of chance.

Color field (p. 827) A method of painting in which the visual elements of art, such as line, space, and color, and principles of design are used to suggest that areas of color stretch beyond the canvas to infinity; figure and ground are given equal emphasis.

Combine painting (p. 840) A contemporary style of painting that attaches other media, such as found objects, to the canvas.

Conceptual art (p. 831) Art that seeks to communicate a concept or idea to the viewer, not necessarily involving the creation of an actual art object such as a painting or piece of sculpture.

Creative nonfiction (p. 857) A genre of writing that relates true stories as though they were works of fiction, lending drama to the plots and characters.

Deconstructivism (p. 852) A Postmodern approach to the design of buildings that disassembles and reassembles the basic elements of architecture, challenging the view that there is one correct way to approach architecture; the focus is on the creation of forms that may appear abstract, disharmonious, and disconnected from the functions of the building.

Existentialism (p. 820) A philosophy that emphasizes the uniqueness and isolation of the individual in a hostile or indifferent universe, regards human existence as inexplicable, and stresses freedom of choice and responsibility for the consequences of one's actions.

Feminist (p. 844) Relating to the doctrine that advocates that women have social, political, and other rights that equal those of men; a person who holds such a view.

Ferroconcrete (p. 849) Concrete reinforced with steel rods or mesh.

Green building (p. 852) A building that is designed to conserve materials and energy.

Hypostyle (p. 851) In architecture, a structure with a roof supported by rows of piers or columns.

Land art (p. 834) Site-specific work that is created or marked by an artist within natural surroundings.

Minimalism (p. 830) A 20-century style of nonrepresentational art in which visual elements are simplified and reduced to their essential properties. Also a style of 20th-century music.

Mobile (p. 828) A sculpture that is suspended in midair by wire or string, and made of delicately balanced parts such as rods and sheets of metal, and so constructed that the parts can move independently when stirred by a gust of air.

Modern architecture (p. 849) Architecture that rejects Classical ornamentation in favor of experimental forms of expression.

Performance art (p. 843) An art form that typically features a live presentation of political or topical themes to onlookers or audience participants and that may incorporate the arts of acting, music, poetry, dance, and painting.

Photorealism (p. 842) The rendering of subjects in art with sharp, photographic precision.

Pop Art (p. 838) An art style originating in the 1960s that uses ("appropriates") commercial and popular images and themes as its subject matter.

Postmodernism (p. 851) A contemporary style of architecture that arose as a reaction to Modernism and that returned to ornamentation drawn from Classical and historical sources.

Site-specific art (p. 834) Art that is produced in or for one location and is not intended to be relocated.

Structuralist (p. 864) In music, a composer who uses precise musical organization.

THE BIG PICTURE THE CONTEMPORARY CONTOUR

Language and Literature

- Mailer published *The Naked and the Dead* in 1948.
- Playwright Arthur Miller staged *Death of a Salesman* in 1949.
- Kerouac published *On the Road* in the 1950s.
- Camus published *The Stranger*, *The Plague*, and *The Fall* in the 1940s and 1950s.
- Beckett wrote *Waiting for Godot* in 1952.
- Wiesel published his autobiographical account of the Holocaust, *Night*, in 1960.
- Updike published his "Rabbit" novels beginning in 1960 with *Rabbit, Run.*
- Ellison (*Invisible Man*), Baldwin (*Go Tell It on the Mountain*), Walker (*The Color Purple*), Angelou ("Caged Bird"), and Morrison (*The Bluest Eye*) wrote about African American experiences.
- Rich, Plath, and Sexton wrote from feminist perspectives.

Art, Architecture, and Music

- Giacometti created works of art revealing existentialist angst in the 1940s and 1950s.
- Boulez composed structuralist music in the late 1940s and early 1950s.
- The artists of the New York School—foremost among them, Jackson Pollock—emphasized gesture in the creation of Abstract Expressionist works in the 1940s and 1950s.
- Other Abstract Expressionists such as Rothko and Frankenthaler emphasized the color field.
- Electronic music developed in the 1950s.
- Schools of art such as Minimalism, Conceptual Art, site-specific art, and Pop Art developed in the 1950s and 1960s.
- Cage composed aleatoric music.
- The first rock operas (*Tommy*) and rock musicals (*Hair*) were written in the late 1960s.
- Photorealism developed in the 1970s.
- Feminist art developed in the 1970s and continues today.
- Other artists, including Bearden and Ringgold, communicated their reactions to their African American experience.
- Sculptors after World War II followed various directions, including abstract and figurative art.
- Modern architecture had its heyday in the 1950s and 1960s, followed by Postmodern architecture in the 1970s and 1980s, and then Deconstructivism.
- Shostakovich continued to compose symphonies through 1971.
- Glass composed operas in the 1970s and 1980s.
- Reich composed *The Desert Music* in 1983.
- Video art has been undergoing development in recent decades.

Philosophy and Religion

- Sartre delivered his address "Existentialism Is a Humanism" in October 1945.
- The Beat movement infused U.S. writers in the 1950s.
- Deconstructivism became a guiding philosophy among many architects of today.

Glossary
With Pronunciation

12-bar blues A form of blues in which a fixed series of chords, 12 bars (or measures) in length, is restated continuously throughout the piece.

Abstract Expressionism A style of painting and sculpture of the 1950s and 1960s in which artists expressionistically distorted abstract images with loose, gestural brushwork.

Absurdity The condition of existing in a meaningless and irrational world.

Action painting A contemporary method of painting characterized by implied motion in the brushstroke and splattered and dripped paint on the canvas.

Adagio Slow, as in a passage or piece of music.

Aleatoric music Music whose composition comprises an element of chance.

Allegro In music, a quick, lively tempo.

Anabaptist A member of a radical 16th-century reform movement that viewed baptism solely as a witness to the believer's faith; therefore, Anabaptists denied the usefulness of baptism at birth and baptized people mature enough to understand their declaration of faith.

Analytic Cubism The early phase of Cubism (1909–1912), during which objects were dissected or analyzed in a visual information-gathering process and then reconstructed on the canvas.

Anime A Japanese style of animation characterized by colorful graphics and adult themes.

Animism A belief in spiritual beings; a belief that natural objects (such as plants, animals, or the sun) or natural events (such as wind, thunder, and rain) possess spiritual qualities or spiritual beings.

Anthem The English term for a *motet*; a choral work having a sacred or moralizing text; more generally, a song of praise.

Antithesis An idea or pattern of behavior that is the direct opposite of another (the **thesis**).

Apartheid In South Africa, the rigid former policy of segregation of the white and nonwhite populations.

Aria A solo song in an opera, oratorio, or cantata, which often gives the singer a chance to display technical skill.

Atonal Referring to music that does not conform to the tonal character of European Classical music.

Automatist Surrealism A form of **Surrealism** in which the artist or writer freely associates to the task at hand in the belief that the work is being produced by the unconscious mind.

Ayre A simple song for one voice accompanied by other voices or by instruments.

Baldacchino An ornamental canopy for an altar, supported by four columns and often decorated with statuary.

Baroque A 17th-century European style characterized by ornamentation, curved lines, irregularity of form, dramatic lighting and color, and exaggerated gestures.

Bauhaus A school of design established in Germany by Walter Gropius based on functionalism and employing techniques and materials used in manufacturing.

Bel canto An Italian term for opera that is defined by "beautiful singing."

Belle époque French for "beautiful era"; a term applied to a period in French history characterized by peace and flourishing of the arts, usually dated as beginning in 1890 and ending with World War I in 1914.

Blank verse Unrhymed **iambic pentameter**.

Blue note A melody note bent a half step down.

Bolshevik A member of a left-wing party that adopted the Communist concepts of Marx and Lenin.

Bushido The behavioral or moral code of the samurai; a Japanese counterpart to chivalry.

Calligraphy Decorative handwriting, particularly as produced with a brush or a pen.

Cantata A short oratorio composed of sections of declamatory recitative and lyrical arias.

Chanson A French word meaning song, often used to refer to a song that is free in form and expressive in nature.

Chiaroscuro From the Italian for "light–dark"; an artistic technique in which subtle gradations of value create the illusion of rounded, three-dimensional forms in space; also called *modeling*.

China A translucent ceramic material; porcelain ware.

Chorale prelude A variation on a chorale that uses familiar songs as the basis for improvisation.

Chorale variations Instrumental music consisting of a set of variations upon melodies taken from a familiar hymn or sacred song.

Classic period In Mesoamerica, the period between 300 ce and 900 ce, characterized by the height of various civilizations, especially the Maya.

Classical A term for music written during the 17th and 18th centuries; more generally, referring to serious music as opposed to popular music.

Codex A bundle of manuscript pages that are stitched together in a manner resembling a modern book.

Collage An assemblage of two-dimensional objects to create an image; a work of art in which materials such as paper, cloth,

and wood are pasted to a two-dimensional surface, such as a wooden panel or canvas.

Colonialism A political system in which one nation has control or governing influence over another nation; also known as *imperialism*.

Color field A method of painting in which the visual elements of art, such as line, space, and color, and principles of design are used to suggest that areas of color stretch beyond the canvas to infinity; figure and ground are given equal emphasis.

Combine painting A contemporary style of painting that attaches other media, such as found objects, to the canvas.

Communion A Christian **sacrament** in which consecrated bread and wine are consumed as memorials to the death of Christ or in the belief that one is consuming the body and blood of Christ.

Conceptual art Art that seeks to communicate a concept or idea to the viewer, not necessarily involving the creation of an actual art object such as a painting or piece of sculpture.

Concerto grosso An orchestral composition in which the musical material is passed from a small group of soloists to the full orchestra and back again.

Counter-Reformation The effort of the Catholic Church to counter the popularity of Protestantism by reaffirming basic values but also supporting a proliferation of highly ornamented Baroque churches.

Counterpoint In music, the relationship between two or more voices that are harmonically interdependent.

Couplet A pair of rhyming lines of poetry.

Creative nonfiction A genre of writing that relates true stories as though they were works of fiction, lending drama to the plots and characters.

Cross-rhythm A traditional African musical method in which the pattern of accents of a measure of music is contradicted by the pattern in a subsequent measure; also termed *cross-beat*.

Cubism A 20th-century style of painting developed by Picasso and Braque that emphasizes the two-dimensionality of the

canvas, characterized by multiple views of an object and the reduction of form to cube-like essentials.

Curia The tribunals and assemblies through which the pope governed the church.

Dada A post–World War I movement that sought to use art to destroy art, thereby underscoring the paradoxes and absurdities of modern life.

Daguerreotype A 19th-century form of photography in which a thin sheet of chemically treated, silver-plated copper is placed in a camera obscura and exposed to a narrow beam of light.

De Stijl An early-20th-century art movement that emphasized the use of basic forms, particularly cubes, horizontals, and verticals; also called *Neo-Plasticism*.

Deconstructivism A Postmodern approach to the design of buildings that disassembles and reassembles the basic elements of architecture, challenging the view that there is one correct way to approach architecture; the focus is on the creation of forms that may appear abstract, disharmonious, and disconnected from the functions of the building.

Der Blaue Reiter German for The Blue Rider; a 20th-century German Expressionist movement that focused on the contrasts between, and combinations of, abstract form and pure color.

Die Brücke German for The Bridge; a short-lived German Expressionist movement characterized by boldly colored landscapes and cityscapes and by violent portraits.

Dies Irae A medieval Latin hymn describing Judgment Day, used in some Roman Catholic requiems for the dead. (Latin for "day of wrath.")

Dynamism The Futurist view that force or energy is the basic principle that underlies all events, including everything we see. Objects are depicted as if in constant motion, appearing and disappearing before our eyes.

Engraving An image created by cutting into or corroding with acid the surface of a metal plate or wooden block, such that a

number of prints of the image can be made by pressing paper or paper-like materials against the plate or block.

Enlightenment A philosophical movement of the late 17th and 18th centuries that challenged tradition, stressed reason over blind faith or obedience, and encouraged scientific thought.

Ensemble A group of musicians, actors, or dancers who perform together.

Ephemera Items not of lasting significance that are meant to be discarded.

Epiphany A sudden realization of the meaning or nature of something.

Existentialism A philosophy that emphasizes the uniqueness and isolation of the individual in a hostile or indifferent universe, regards human existence as inexplicable, and stresses freedom of choice and responsibility for the consequences of one's actions.

Expressionism A modern school of art in which an emotional impact is achieved through agitated brushwork, intense coloration, and violent, hallucinatory imagery.

Fascism A radical authoritarian national political ideology.

Fauvism From the French *fauve* for "wild beast"; an early-20th-century style of art characterized by the juxtaposition of areas of bright colors that are often unrelated to the objects they represent and by distorted linear perspective.

Feminist Relating to the doctrine that advocates that women have social, political, and other rights that equal those of men; a person who holds such a view.

Ferroconcrete Concrete reinforced with steel rods or mesh.

Figurative art Art that represents forms in the real world, especially human and animal forms.

Free love A social movement that originally sought to separate the state from matters such as sex, marriage, birth control, and adultery; more generally, sexual activity without legal sanction.

Free verse Poetry without rhyme or a consistent meter pattern.

Fugue A musical piece in which a single theme is passed from voice to voice or instrument to instrument (generally four in number), repeating the principal theme in different pitches.

Futurism An early-20th-century style of art that portrayed modern machines and the dynamic character of modern life and science.

Galleon A ship with three or more masts used as a trader or warship from the 15th through 18th centuries.

Geoglyph A large design produced on or in the ground, as by compiling stones or scraping into the earth.

Gesamtkunstwerk An artistic creation that combines several mediums, such as music, drama, dance, and spectacle, as in the operas of Wagner. (German for "total artwork.")

Gikuyu In Kikuyu beliefs, the male primordial parent; the father of the Kikuyu people.

Glaze In ceramics, a coating; a coating of transparent or colored material applied to the surface of a ceramic piece before it is fired in a kiln.

Gothic novel A kind of novel that shares Romantic roots with tales of horror, as in the novels *Frankenstein* and *Dracula*.

Green building A building that is designed to conserve materials and energy.

Ground In drama, an open area in front of the stage.

Groundling The name given an audience member at a dramatic event who stands in the pit or ground rather than being seated (because admission is generally less expensive).

Haiku Three-lined Japanese verse, with a syllable structure of 5-7-5, which usually juxtaposes images, often drawn from nature, to achieve deeper meaning.

Harlem Renaissance A renewal and flourishing of African American literary, artistic, and musical culture following World War I in the Harlem section of New York City.

Harpsichord A keyboard instrument; a forerunner of the modern piano.

Heliography A 19th-century form of photography in which bitumen, or asphalt residue, is placed on a pewter plate to render the plate sensitive to light.

Horizon line In linear perspective, the imaginary line (frequently where the earth seems to meet the sky) along which converging lines meet; this spot is known as the vanishing point.

Huaben Chinese short stories of the Ming dynasty.

Hybridity In the arts, the mixing of the traditions of different cultures to create new blends and new connections.

Hyperbole Poetic exaggeration.

Hypostyle In architecture, a structure with a roof supported by rows of piers or columns.

Iambic pentameter A poetic metrical scheme with five feet, each of which consists of an unaccented syllable followed by an accented syllable.

Iambic tetrameter A poetic metrical scheme with four feet, each of which consists of an unaccented syllable followed by an accented syllable.

Iconoclastic Having to do with the destruction or removal of sacred religious images.

Iconography A set of conventional meanings attached to images; as an artistic approach, representation or illustration that uses the visual conventions and symbols of a culture. Also, the study of visual symbols and their meaning (often religious).

Illusionistic Surrealism A form of **Surrealism** that renders the irrational content, absurd juxtapositions, and changing forms of dreams in a manner that blurs the distinctions between the real and the imaginary.

Impressionism A late-19th-century artistic style characterized by the attempt to capture the fleeting effects of light through painting in short strokes of pure color.

Indentured servant A person who is placed under a contract to work for another person for a period of time, often in exchange for travel expenses or an apprenticeship.

Induction A kind of reasoning that constructs or evaluates propositions or ideas on the basis of observations of occurrences of the propositions; arriving at conclusions on the basis of examples.

Indulgence According to Roman Catholicism, removal or remission of the punishment that is due in purgatory for sins; the forgiving of sin upon repentance.

Intermezzo In music, an interlude.

Jazz A musical style born of a mix of African and European musical traditions at the beginning of the 20th century.

Kabuki A type of drama begun during the Edo period of Japan that was based on real-life events.

Kantor Music director, as at a school.

Khipu Inka methods of recording information using fiber and knots.

Kiva A large circular room that serves as a ceremonial center in an Ancestral Puebloan community.

Kora A traditional African string instrument that is plucked; 11 strings are plucked by one hand, and 10 strings by the other hand.

Lacquer A hard, durable finish for furniture and other objects that is created from the sap of the sumac tree.

Laissez-faire French for "let it be"; in economics, permitting the market to determine prices.

Land art Site-specific work that is created or marked by an artist within natural surroundings.

Largo Slow, as in a passage or piece of music.

Leitmotiv A leading motif; a recurring theme or idea in a literary, artistic, or musical work.

Lens A transparent object with two opposite surfaces, at least one of which is curved, used to magnify or focus rays of light.

Lieder German art songs. (The German word for "songs" [singular *lied*]).

Linear perspective A system of organizing space in two-dimensional media in which lines that are in reality parallel and

horizontal are represented as converging diagonals; the method is based on foreshortening, in which the space between the lines grows smaller until it disappears, just as objects appear to grow smaller as they become more distant.

Logogram A sign or glyph that expresses meaning.

Madrigal A song for two or three voices unaccompanied by instrumental music.

Mannerism A style of art characterized by distortion and elongation of figures; a sense of flattened space rather than depth; a lack of a defined focal point; and the use of clashing pastel colors.

Materialism In philosophy, the view that everything that exists is either made of matter or—in the case of the mind, for example—depends on matter for its existence.

Mazurka A traditional Polish dance similar to a polka.

Mesoamerica Literally, "middle America," referring to present-day Mexico, Guatemala, Honduras, Belize, and parts of Costa Rica and El Salvador.

Mestizo A term used in Spain and conquered American nations to describe a person of combined European and Native American descent. In the Spanish *casta* (caste) system, mestizos received more favorable treatment than people who were fully Native American.

Metaphor A figure of speech in which a word or phrase denoting one kind of object or idea is used in the place of another to suggest a similarity between them, as in "She was swimming in money."

Metaphysical Pertaining to a group of British lyric poets who used unusual similes or metaphors.

Minaret A tall, slender tower attached to a mosque, from which a *muezzin* or crier summons people to prayer.

Minimalism A 20-century style of nonrepresentational art in which visual elements are simplified and reduced to their essential properties. Also a style of 20th-century music.

Minuet A slow, stately dance for groups of couples.

Mobile A sculpture that is suspended in midair by wire or string, and made of delicately balanced parts such as rods and sheets of metal, and so constructed that the parts can move independently when stirred by a gust of air.

Modern architecture Architecture that rejects Classical ornamentation in favor of experimental forms of expression.

Modulation In music, the shift to a new key.

Monody From the Greek *monoidia*, meaning an ode for one voice or one actor; in early opera, a single declamatory vocal line with accompaniment.

Montage The sharp juxtaposition of scenes by film cutting and editing.

Movement A self-contained section of a larger musical work; the Classical symphony, for example, has four distinct movements.

Mughal A Muslim dynasty in India, founded by the Afghan chieftain Babur in the 16th century.

Mumbi In Kikuyu beliefs, the female primordial parent; the mother of the Kikuyu people.

National Socialism A right-wing, **fascist**, anti-Semitic, and anti-Communist movement that developed in 20th century Germany; also known as *Nazism*.

Natural selection The means by which organisms with genetic characteristics and traits that make them better adjusted to their environment tend to survive, reach maturity, reproduce, and increase in number, such that they are more likely to transmit those adaptive traits to future generations.

Naturalistic style Frank Lloyd Wright's architectural style, in which a building's form is integrated with its site.

Neo-Classicism An 18th-century revival of Classical Greek and Roman art and architectural styles, generally characterized by simplicity and straight lines.

Neue Sachlichkeit A cynical, socially critical art movement that arose in

Germany in the aftermath of World War I. It frequently employed a harsh realism to protest war.

Nocturne A short piano piece in which a melancholy melody floats over a murmuring accompaniment.

Noh A type of Japanese drama in which actors wear wooden masks.

Nonobjective Referring to art that does not represent or intend to represent any natural or actual object, figure, or scene.

Omnipotent All-powerful.

Omniscient All-knowing.

Opera A dramatic performance in which the text is sung rather than spoken.

Oratorio A sacred drama performed without action, scenery, or costume, generally in a church or concert hall.

Orthogonal In linear perspective, a line pointing to the vanishing point.

Overglaze The outer layer or **glaze** on a ceramic piece; a decoration applied over a glaze.

Patronage In the arts, the act of providing support for artistic endeavors.

Pediment In architecture, any triangular shape surrounded by *cornices*, especially one that surmounts the *entablature* of the *portico facade* of a Greek temple.

Performance art An art form that typically features a live presentation of political or topical themes to onlookers or audience participants and that may incorporate the arts of acting, music, poetry, dance, and painting.

Personification The representation of a thing or idea in art or literature as a person, as in referring to a ship or car as "she."

Philologist A person who studies the history of language in written sources; a scholar of the changes in language over time.

Photorealism The rendering of subjects in art with sharp, photographic precision.

Photosensitive Responsive to light.

Picaresque Of a form of fiction having an engaging, roguish hero who is involved in a series of humorous or satirical experiences.

Pietà In artistic tradition, a representation of the dead Christ, held by his mother, the Virgin Mary (from the Latin word for "pity").

Pit In drama, an open area in front of the stage.

Pointillism A systematic method of applying minute dots of discrete pigments to the canvas; the dots are intended to be "mixed" by the eye when viewed.

Polonaise A traditional Polish dance that is marchlike and stately.

Polyphony Music with two or more independent melodies that harmonize or are sounded together.

Pop Art An art style originating in the 1960s that uses ("appropriates") commercial and popular images and themes as its subject matter.

Popol Vuh The bible or Council Book of the Maya.

Portico A roofed entryway, like a front porch, with columns or a colonnade.

Postclassic period In Mesoamerica, the period between 900 ce and the Spanish conquest of 1521, characterized by the decline of some civilizations but the rise and fall of the Aztec civilization.

Postimpressionism A late-19th-century artistic style that relied on the gains made by Impressionists in terms of the use of color and spontaneous brushwork but employed these elements as expressive devices. The Postimpressionists rejected the essentially decorative aspects of Impressionist subject matter.

Postmodernism A contemporary style of architecture that arose as a reaction to Modernism and that returned to ornamentation drawn from Classical and historical sources.

Preclassic period In Mezoamerica, the period between 2000 bce and 300 ce, characterized by the rise of civilizations and rulers.

Predestination God's foreordaining of everything that will happen, and with Calvinism, including the predetermination of salvation.

Prelude In music, a brief instrumental composition; a piece that precedes a more important movement.

Program music Music that describes elaborate programs or plots.

Prohibition The period in the United States from 1920 to 1933, during which the 18th Amendment prohibited the manufacture or sale of alcoholic beverages.

Propaganda The presentation of a point of view with the intention to persuade and convince.

Psychoanalytic theory Sigmund Freud's theory of personality, which assumes the presence of unconscious conflict and the mental structures of the id, ego, and superego.

Quatrain A verse of poetry with four lines.

Ragtime A syncopated (off-beat) musical style popular between about 1899 and 1917. A forerunner of jazz.

Rajput A member of a Hindu people claiming descent from the warrior caste during the Indian Heroic Age.

Realism A movement in art directed toward the accurate representation of real, existing things.

Recitative The free declaration of a vocal line, with only a simple instrumental accompaniment for support.

Rococo An 18th-century style of painting and of interior design that featured lavish ornamentation. Rococo painting was characterized by light colors, wit, and playfulness. Rococo interiors had ornamental mirrors, small sculptures and reliefs, wall paintings, and elegant furnishings.

Romanticism An intellectual and artistic movement that began in Europe in the late 18th century and emphasized rejection of Classical (and Neo-Classical) forms and attitudes, interest in nature, the individual's emotions and imagination, and revolt against social and political rules and traditions.

Sacrament A visible sign of inward grace, especially a Christian rite believed to symbolize or confer grace.

Samurai Japanese professional warriors in medieval times.

Sarcophagus A coffin; usually cut or carved from stone, although Etruscan sarcophagi were made of terra-cotta.

Satyagraha Nonviolent civil disobedience.

Scatting The singing of improvised syllables that have no literal meaning.

Scherzo A fast-moving, lighthearted piece of music (Italian for "joke").

Shaman A person deemed capable of communicating with good and evil spirits. Shamans often enter trance states during a ritual and sometimes practice healing.

Simile A figure of speech in which the words *like* or *as* are used to describe a person or thing by comparing it with something else, as in "He ran like the wind."

Site-specific art Art that is produced in or for one location and is not intended to be relocated.

Slavery A social system or practice in which one person is the property of, and wholly subject to the will of, another person.

Social realism An art movement largely of the 1930s in which visual artists sought to draw attention to the plight of working class and poor people, often tinged with satire and social protest.

Soliloquy A passage in a play spoken directly to the audience, unheard by other characters, and often used to explain the speaker's motives.

Sonata A kind of short piece of instrumental music.

Sonata form A musical form having three sections: exposition (in which the main theme or themes are stated), development, and recapitulation (repetition) of the theme or themes.

Sonnet A 14-line poem usually broken into an octave (a group of eight lines) and a sestet (a group of six lines); rhyme schemes can vary.

Sprechstimme Arnold Schönberg's term for "speaking voice," that is, speaking words at specific pitches.

Stream of consciousness A literary technique that is characterized by an uncensored flow of thoughts and images,

which may not always appear to have a coherent structure.

Structuralist In music, a composer who uses precise musical organization.

Sturm und Drang German for "storm and stress"; the German manifestation of Romanticism, which emphasized originality, imagination, and emotion.

Style galant A style of elegant, lighthearted music that was popular in France during the early part of the 18th century.

Surrealism A 20th-century style of art and literature whose content and imagery is believed to stem from unconscious, irrational sources and therefore takes on fantastic forms, although often rendered with extraordinary realism.

Syllabogram A sign or glyph that denotes sounds.

Synthesis In Hegelian philosophy, the reconciliation of mutually exclusive propositions—the thesis and the antithesis; more generally, the combining of separate substances or ideas into a single unified object or concept.

Synthetic Cubism The second phase of Cubism, which emphasized the form of the object and constructing rather than disintegrating that form.

Synthetism Paul Gauguin's theory of art, which advocated the use of broad areas of unnatural color and "primitive" or symbolic subject matter.

Tenebrism A style of painting in which the artist goes rapidly from highlighting to deep shadow, using very little modeling.

Terza rima A poetic form in which a poem is divided into sets of three lines (*tercets*) with the rhyme scheme *aba, bcb, cdc*, and so on.

Thesis An academic proposition; a proposition to be debated and proved or disproved (plural *theses*).

Toccata A free-form rhapsody composed for an instrument with a keyboard, often combing extreme technical complexity and dramatic expression.

Tonality The sum of melodic and harmonic relationships between the tones of a scale or a musical system.

Tone poem Richard Strauss's term for a program symphony (see program music).

Transcendentalism A 19th-century New England literary movement that sought the divine in nature. More generally, the view that there is an order of truth that goes beyond what we can perceive by means of the senses and that it unites the world.

Trompe l'oeil Literally, French for "fool the eye." In works of art, trompe l'oeil can raise the question as to what is real and what is illusory.

Twelve-tone technique A musical method that uses the 12 notes of the chromatic scale—on the piano, all of the black and white notes in a single octave—carefully arranged in a row or series; also called *serialism*.

Übermensch Nietzsche's term for a person who exercises the will to power (plural *Übermenschen*).

Underglaze A decoration applied to the surface of a ceramic piece before it is glazed.

Urdu The literary language of Pakistan; similar to Hindi when spoken, but written in the Arabic alphabet and influenced by Persian.

Virginal An early keyboard instrument small enough to be held in the lap of the player.

Vocal harmony A traditional musical method in which consonant notes are sung along with the main melody.

Yahoo In *Gulliver's Travels*, a crude, filthy, and savage creature, obsessed with finding "pretty stones" by digging in mud—Swift's satire of the materialistic and elite British.

Photo Credits

CHAPTER 13 13.1 akg-images/Andrea Jemolo; 13.2 The Trustees of the British Museum/Art Resource, NY; 13.2A Réunion des Musées Nationaux/Art Resource, NY; 13.2B ©Cengage Learning; 13.3 Alinari/Art Resource, NY; 13.4 Rmn-Grand Palais/Art Resource, NY; 13.5 Bildagentur-Online/Alamy; 13.6 Erich Lessing/Art Resource, NY; 13.7 National Gallery, London/Art Resource, NY; 13.8A Scala/Art Resource, NY; 13.8B © Cengage Learning; 13.8C Iran/Persia/Italy: Ptolemy viewed from the back holding a terrestrial sphere. He is facing Zoroaster who holds a celestial sphere. Detail from "The School of Athens," Raphael (Raffaello Sanzio), 1509–1510/Pictures from History/Bridgeman Images; 13.9 Araldo de Luca/CORBIS; 13.10 Bettmann/Getty Images; 13.11 Arte & Immagini srl/Fine Art Premium/Corbis; 13.12 Scala/Art Resource, NY; 13.13 Jon Arnold Images/Alamy Stock Photo; 13.14 Bracchietti-Zigrosi/Vatican Museums; 13.15 Scala/Art Resource; 13.16 Scala/Art Resource, NY; 13.17 Tips Images/Tips Italia Srl a socio unico/Alamy; 13.18A Artwork by Cecilia Cunningham/Cengage Learning; 13.18B Artwork by Cecilia Cunningham/Cengage Learning; 13.19 Jonathan Poore/Cengage Learning; 13.20 British Museum, London, Great Britain; 13.21 Alinari Archives/Fine Art/Corbis; 13.22 Marka/SuperStock; 13.23 Dea Picture Library/De Agostini Editore/Age Fotostock; 13.24 Scala/Art Resource, NY; 13.25 National Gallery, London/Art Resource, NY; 13.26 Scala/Art Resource, NY; 13.27 © The Art Gallery Collection/Alamy; 13.28 Scala/Art Resource, NY; 13.29 © 2006 Fred S. Kleiner; 13.30 Scala/Art Resource, NY; 13.31 RMN-Grand Palais/Art Resource, NY; 13.32 Portrait of a Lady (oil on canvas), Tintoretto, Jacopo Robusti (1518–94) (after)/Worcester Art Museum, Massachusetts, USA/Bridgeman Images; 13.33 Rmn-Grand Palais/Art Resource, NY; 13.34 Scala/Ministero per i Beni e le Attività culturali/Art Resource, NY.

CHAPTER 14 14.1 Geraint Lewis/Alamy; 14.2 Scala/Ministero per i Beni e le Attività culturali/Art Resource, NY; 14.3 akg-images; 14.4 Courtesy of the National Library of Medicine, Bethesda, Maryland; 14.5 bpk, Berlin/Art Resource, NY; 14.6 The Metropolitan Museum of Art/Art Resource, NY; 14.7 The Trustees of The British Museum/Art Resource, NY; 14.8 The Art Archive at Art Resource, NY; 14.9 bpk, Berlin/Alte Pinakothek, Munich/Art Resource, NY; 14.10 The Art Archive at Art Resource, NY; 14.11 Erich Lessing/Art Resource, NY; 14.12 Erich Lessing/Art Resource; 14.13 National Gallery, London/Art Resource, NY; 14.14 RMN-Grand Palais/Art Resource, NY; 14.15 ©Jonathan Poore/Cengage Learning; 14.16 ©Jonathan Poore/Cengage Learning; 14.17 RMN-Grand Palais/Art Resource, NY; 14.18 V&A Images, London/Art Resource, NY; 14.19 SuperStock; 14.20 Monastery of San Lorenzo de El Escorial (St. Lawrence of El Escorial), (UNESCO World Heritage List, 1984), Madrid, Spain, 16th century/De Agostini Picture Library/C. Sappa/Bridgeman Images; p. 477

© Lois Fichner-Rathus 14.21 Hemis/SierpinskiJacques/hemis.fr/Alamy; 14.22 The Gallery Collection/Corbis; 14.23 Lebrecht Music & Arts/The Image Works; 14.24 Andrea Pistolesi/The Image Bank/Getty Images; 14.25 Eduard Gruetzner/AKG-images.

CHAPTER 15 15.1 Ecstasy of St. Teresa (marble) (detail), Bernini, Gian Lorenzo (1598–1680)/Santa Maria della Vittoria, Rome, Italy/Alinari/Bridgeman Images; 15.2 Cengage Learning; 15.3 ©Jonathan Poore/Cengage Learning; 15.4 Alinari Archives/Fine Art/Corbis; 15.05A A. H. Baldwin & Sons Ltd., London; 15.5B A. H. Baldwin & Sons Ltd., London; 15.6 Joseph Martin/akg-images; 15.07 Scala/Art Resource, NY; 15.8 The Cornaro Chapel,detail of the altar with 'The Ecstasy of St. Teresa' (photo), Bernini, Gian Lorenzo (1598–1680)/Santa Maria della Vittoria, Rome, Italy/Bridgeman Images; 15.9 Jonathan Poore/Cengage Learning; 15.10 ©Jonathan Poore/Cengage Learning; 15.11 Scala/Art Resource, NY; 15.12 Scala/Art Resource, NY; 15.13 Scala/Art Resource, NY; 15.14 Alinari/Art Resource, NY; p. 510 Cengage Learning; 15.15 The Gallery Collection/Corbis; 15.16 Rape of the Daughters of Leucippus (oil on canvas), Rubens, Peter Paul (1577–1640)/Alte Pinakothek, Munich, Germany/Bridgeman Images; 15.17 The Art Archive at Art Resource, NY; 15.18 Erich Lessing/Art Resource, NY; 15.19 Erich Lessing/Art Resource, NY; 15.20 Erich Lessing/Art Resource, NY; 15.21 SuperStock; 15.22 The Pierpont Morgan Library/Art Resource, NY; 15.23 Erich Lessing/Art Resource, NY; 15.24 Susanna and the Elders, 1647 (oil on mahogany panel), Rembrandt Harmensz. van Rijn (1606–69)/Gemaldegalerie, Staatliche Museen zu Berlin, Germany/Bridgeman Images; 15.25 Susannah and the Elders, 1610 (oil on canvas)/Gentileschi, Artemisia (1597–c.1651)/SUPERSTOCK INC./Private Collection/Bridgeman Images; 15.26 The Metropolitan Museum of Art/Art Resource, NY; 15.27 The Metropolitan Museum of Art/Art Resource, NY; 15.28 The Metropolitan Museum of Art. Image source: Art Resource, NY; 15.29 Yann Arthus/Getty Images; 15.30 Massimo Listri/Fine Art/Corbis; p. 525 Image/Alamy; 15.31 Angelo Hornak/Fine Art/Corbis; 15.32 Anthony F. Kersting/AKG-images; 15.33 Self Portrait, c.1680 (oil on canvas), Smith, Thomas (d.1691)/Worcester Art Museum, Massachusetts, USA/Bridgeman Images; 15.34 Francis G. Mayer/Fine Art Value/Corbis; 15.35 Scala/Art Resource, NY; 15.36 NASA.

CHAPTER 16 16.1 Medicea Laurenziana Library, Florence; 16.2 Album/Oronoz/Album/SuperStock; 16.3 Aerialarchives.com/Alamy; 16.4A Archivio J. Lange/DeA Picture Library/The Art Archive; 16.4B © Lois Fichner-Rathus; 16.5 Top Photo Corporation/Thinkstock; 16.6 François Guénet/akg-images; 16.7 Yann Arthus-Bertrand/CORBIS; 16.8 Reconstruction by Heather Hurst and Leonard Ashby, copyright Bonampak Documentation Project, Yale University; 16.9 Image copyright © The Metropolitan Museum of Art. Image source: Art Resource, NY; 16.10 © Spencer A. Rathus; 16.11 Roger Cracknell 01/Classic/Alamy; 16.12 Gianni Dagli Orti/Fine Art/Corbis; 16.13 HIP/Art Resource, NY; p.558 Gianni Dagli Orti/Fine Art/Corbis; 16.14 © 2011 Banco de México Trust. Licensed by Artist's RIghts Society (ARS), NY. Dirk Bakker, photographer for the Detroit Institute of Arts/The Bridgeman Art Library; 16.15A © 2011 Banco de México Trust. Licensed by Artist's RIghts Society (ARS), NY. Photo © Schalkwijk/Art Resource, NY; 16.15B © Spencer A. Rathus; 16.16 George Steinmetz/Latitude/Corbis; 16.17 Kate S. Buckingham Endowment/Art Institute of Chicago; 16.18 The Michael C. Rockefeller Memorial Collection, Purchase, Nelson A. Rockefeller Gift, 1967/The Metropolitan Museum of Art/Art Resource, NY; 16.19 Cengage Learning; 16.20 De Agostini Picture Library/Getty Images; 16.21 Smithsonian Institution; 16.22 The Metropolitan Museum of Art/Art Resource; 16.23 HIP/Art Resource, NY; 16.24 The Seven Moais (Restored in 1960 by Archaeologist William Mulloy) of Ahu Akivi are the Only Moai to Face the Ocean, Rapa Nui (Easter Island), Chile (photo)/UNIVERSAL IMAGES GROUP/Bridgeman Images; 16.25 Phoebe A. Hearst Museum of Anthropology; 16.26 Image # 4481, American Museum of Natural History, Library; 16.27 Blanket, Chilkat Tribe (wool & cedar bark)/American School (19th century)/Private Collection/Bridgeman Images; 16.28 Mark Newman/Media Bakery; 16.29 Photo © National Museum of Women in the Arts.

CHAPTER 17 17.1 ©Subodh Gupta. Courtesy of the artist.; 17.2 Prisma Bildagentur AG/Alamy; 17.3 V&A Images, London/Art Resource, NY; 17.4 Tony Waltham/Robert Harding Picture Library; 17.5 The Brooklyn Museum of Art, 87.234.6; 17.6 Courtesy CSU Archives/The Everett Collection, Inc.; 17.7 Everett Collection Inc./Alamy; 17.8 Ragamala Series, 1960 (oil on canvas), Husain, Maqbool Fida ('M.F.') (1915–2011)/Private Collection/Photo © Christie's Images/Bridgeman Images; 17.9 Shahzia Sikander. Photograph: Sheldan C. Collins, courtesy Whitney Museum of American Art; 17.10 ©Subodh Gupta. Courtesy of the artist.; 17.11 The Metropolitan Museum of Art. Image source: Art Resource, NY; 17.12 Victoria & Albert Museum/Art Resource, NY; 17.13 The Nelson-Atkins Museum of Art, Kansas City, Missouri. Purchase: William Rockhill Nelson Trust, 48-16; 17.14 Best View Stock/Getty Images; 17.15 RMN-Grand Palais/Art Resource, NY; 17.16 The Metropolitan Museum of Art. Image source: Art Resource, NY; 17.17 "Women hold up half of heaven, and, cutting through rivers and mountains, change to a new attitude", propaganda poster from the Chinese Cultural Revolution, 1970 (colour litho), Chinese School, (20th century)/Private Collection/Bridgeman Images; 17.18 Shanghai Chinese Painting Academy; 17.19 The Luo Brothers. Image courtesy of the artists.; 17.20 Prisma Bildagentur AG/Alamy; 17.21 The forest of pines (ink on paper), Tohaku, Hasegawa (1539–1610)/Tokyo

National Museum, Japan/The Bridgeman Art Library International; **17.22** Réunion des Musées Nationaux/Art Resource, NY; **17.23** [2000.472] Sharf Collection, Museum of Fine Arts, Boston; **17.24** Agencja Fotograficzna Caro/Alamy; **17.25** Center for Creative Photography, University of Arizona; **17.26** Osaka City Museum of Modern Art; **17.27** AF archive/Alamy; **17.28** AF archive/Alamy; **17.29** Courtesy Tomio Koyama Gallery, Tokyo. © 2001 Takashi Murakami/Kaikai Kiki Co., Ltd.

CHAPTER 18 **18.1** Jean-Dominique Lajoux; **18.2** Ramon Manent/The Art Archive at Art Resource, NY; **18.3** Sandro Vannini/Encyclopedia/Corbis; **18.4** Andre Held/akg-images; **18.5** The Trustees of the British Museum/Art Resource, NY; **18.6** Robert Harding Picture Library/SuperStock; **18.7** Werner Forman/Art Resource, NY; **18.8** British Library Board/Robana/Art Resource, NY; **18.9** Granger, NYC—All rights reserved.; **18.10** Werner Forman Archive/AGE Fotostock; **18.11** Charles Lenars/Documentary Value/Corbis; **18.12** © Wendy Stone/Corbis; **18.13** Egungun Masquerade Costume, Yoruba Culture, Benin (mixed media), African, (20th century)/Indianapolis Museum of Art, USA/Gift of the Alliance of the Indianapolis Museum of Art/Bridgeman Images; **18.14** Elisofon Photographic Archives, National Museum of African Art, Smithsonian Institution, Washington DC; **18.15** Image copyright © The Metropolitan Museum of Art. Image source: Art Resource, NY; **18.16** Digital Image © The Museum of Modern Art/Licensed by SCALA/Art Resource, NY; **18.17** Faith Ringgold © 1973; **18.18** Image copyright © The Metropolitan Museum of Art. Image source: Art Resource, NY; **18.19** © CNAC/MNAM/Dist. RMN-Grand Palais/Art Resource, NY; **18.20** Image copyright © The Metropolitan Museum of Art. Image source: Art Resource, NY; **18.21** Claude Postel/Fine Art Value/Corbis; **18.22** Wangechi Mutu. Courtesy of the artist.; **18.23** Image copyright © The Metropolitan Museum of Art. Image source: Art Resource, NY.

CHAPTER 19 **19.1** Erich Lessing/Art Resource, NY; **19.2** Scala/Art Resource, NY; **19.3** The Swing (Les Hasards heureux de L'Escarpolette), 1767 (oil on canvas), Fragonard, Jean-Honore (1732-1806)/© Wallace Collection, London, UK/Bridgeman Images; **19.4** Erich Lessing/Art Resource, NY; **19.5** Scala/Art Resource, NY; **19.6** © Jonathan Poore/Cengage Learning; **19.7** Erich Lessing/Art Resource, NY; **19.8** Mary Countess Howe, c.1760 (oil on canvas)/Gainsborough, Thomas (1727-88)/Historic England Archive/The Iveagh Bequest, Kenwood House, London, UK/Bridgeman Images; **19.9** Lord Heathfield (1717-90) Governor of Gibraltar during the siege of 1779-83, 1787 (oil on canvas)/Reynolds, Joshua (1723-92)/National Gallery, London, UK/Bridgeman Images; **19.10** National Gallery, London//Art Resource, NY; **19.11** The Granger Collection, NYC; **19.12** Erich Lessing/Art Resource, NY; **19.13** Derek Bayes/Lebrecht Music & Arts; **19.14** Gianni Dagli Orti/The Art Archive at Art Resource, NY; **19.15** Napoleon Crossing the Alps on 20th May 1800, 1803 (oil on canvas) (see 184124 for detail), David, Jacques Louis (1748-1825) (workshop of)/Château de Versailles, France/Bridgeman Images; **19.16** Kehinde Wiley. Courtesy of Sean Kelly Gallery, New York, Roberts & Tilton, Culver City, California, Rhona Hoffman Gallery, Chicago and Galerie Daniel Templon, Paris. Digital image courtesy of the artist. Used by permission.; **19.17** © Jonathan Poore/Cengage Learning; **19.18** Interior of the Pantheon, Rome, c.1734 (oil on canvas)/Pannini or Panini, Giovanni Paolo (1691/2-1765)/National Gallery of Art, Washington DC, USA/Bridgeman Images; **19.19** Edwin Remsberg/Alamy; **19.20** © Cengage Learning; **19.21** Antiques & Collectables/Alamy; **19.22** George Washington, 1796 (oil on canvas), Stuart, Gilbert (1755-1828)/Museum of Fine Arts, Boston, Massachusetts, USA/William Francis Warden Fund, John H. and Ernestine A. Payne Fund, Commonwealth Cultural Preservation Trust. Jointly owned by the Museum of Fine Arts, Boston, and the National Portrait Gallery, Washington D.C./Bridgeman Images.

CHAPTER 20 **20.1** © Jonathan Poore/Cengage Learning; **20.2** Hervé Champollion/AKG Images; **20.3** Library of Congress Prints and Photographs Division; **20.4** Sarin Images/Granger, NYC—All rights reserved.; **20.5** Fine Art Images/AGE Fotostock; **20.6** RMN-Grand Palais/Art Resource, NY; **20.7** IMAGE ASSET MANAGEMEN/AGE Fotostock; **20.8** Fitzwilliam Museum, Cambridge/Art Resource, NY; **20.9** Alfredo Dagli Orti/The Art Archive at Art Resource, NY; **20.10** Sylvia Sleigh.; **20.11** V&A Images, London/Art Resource, NY; **20.12** Scala/Art Resource, NY; **20.13** Image Asset Management/World History Archive/AGE Fotostock; **20.14** Erich Lessing/Art Resource, NY; **20.15** Erich Lessing/Art Resource, NY; **20.16** RMN-Grand Palais/Art Resource, NY; **20.17** Fine Art Images/AGE Fotostock; **20.18** British Library/akg-images; **20.19** IMAGE ASSET MANAGEMEN/AGE Fotostock; **20.20** Fine Art Images/AGE Fotostock; **20.21** Bpk, Berlin/Art Resource, NY; **20.22** "The Tyger," plate 41 from "Songs of Experience," 1794 (relief etching with w/c), Blake, William (1757-1827)/Yale Center for British Art, Paul Mellon Collection, USA/Bridgeman Images; **20.23** V&A Images, London/Art Resource, NY; **20.24** Ronald Grant Archive/Alamy; **20.25** Fine Art Images/AGE Fotostock; **20.26** Anne-Christine Poujoulat/AFP/Getty Images; **20.27** Erich Lessing/Art Resource, NY; **20.28** The Stomach of the Legislature, the Ministerial Benches of 1834 (litho) (b/w photo), Daumier, Honore (1808-79)/Bibliotheque Nationale, Paris, France/Bridgeman Images; **20.29** The Metropolitan Museum of Art/Art Resource, NY; **20.30** Tomas Abad/AGE Fotostock; **20.31** SuperStock; **20.32** Olga Bogatyrenko/Shutterstock; **20.33** Renaud Visage/AGE Fotostock; **20.34** Louis Daguerre/Time & Life Pictures/Getty Images; **20.35** The Print Collector/Alamy; **20.36** Pictorial Press Ltd/Alamy; **20.37** Library of Congress, Prints & Photographs Division [LC-B8171-7942].

CHAPTER 21 **21.1** SuperStock/SuperStock; **21.2** Library of Congress Prints and Photographs Division (LC-USZ62-62880); **21.3** Nymphs and Satyr, 1873 (oil on canvas), Bouguereau, William-Adolphe (1825-1905)/Sterling and Francine Clark Art Institute, Williamstown, Massachusetts, USA/Bridgeman Images; **21.4** Erich Lessing/Art Resource, NY; **21.5** SuperStock/SuperStock; **21.6** Dea Picture Library/De Agostini Editore/Age Fotostock; **21.7** marka/jarach/AGE Fotostock; **21.8** Fine Art Images/AGE Fotostock; **21.9** CNAC/MNAM/Dist. Réunion des Musées Nationaux/Art Resource, NY; **21.10** ©Peter Willi/Getty Images; **21.11** The Metropolitan Museum of Art/Art Resource, NY; **21.12** Alfredo Dagli Orti/The Art Archive at Art Resource, NY; **21.13** IMAGE ASSET MANAGEMEN/AGE Fotostock; **21.14** Portrait of a Young Lady (oil on canvas), Morisot, Berthe (1841-95)/Musee Fabre, Montpellier, France/Bridgeman Images; **21.15** The Rehearsal, c.1877 (oil on canvas), Degas, Edgar (1834-1917)/Burrell Collection, Glasgow, Scotland/© Culture and Sport Glasgow (Museums)/Bridgeman Images; **21.16** Erich Lessing/Art Resource, NY; **21.17** National Gallery of Art, Washington DC, USA/Index/The Bridgeman Art Library; **21.18** James Abbott McNeill Whistler/The Gallery Collection/Fine Art Premium/Corbis; **21.19** Portrait of Dr. Samuel D. Gross, 1875 (oil on canvas), Eakins, Thomas Cowperthwait (1844-1916)/Philadelphia Museum of Art, Pennsylvania, PA, USA/Bridgeman Images; **21.20** Photography © The Art Institute of Chicago, 1928.610; **21.21** Sunday Afternoon on the Island of La Grande Jatte, 1884-86 (oil on canvas), Seurat, Georges Pierre (1859-91)/The Art Institute of Chicago, IL, USA/The Bridgeman Art Library; **21.22** Francis G. Mayer/Paul Cezanne/Fine Art/Corbis; **21.23** The Philadelphia Museum of Art/Art Resource, NY; **21.24** Digital Image © The Museum of Modern Art/Licensed by Scala/Art Resource, NY; **21.25** Yale University Art Gallery/Art Resource, NY; **21.26** Vision of the Sermon (Jacob Wrestling with the Angel) 1888 (oil on canvas), Gauguin, Paul (1848-1903)/© Scottish National Gallery, Edinburgh/Bridgeman Images; **21.27** Vanni Archive/Art Resource, NY; **21.28** Erich Lessing/Art Resource, NY; **21.29** Archives H. Matisse. © 2013 Succession H. Matisse/Artists Rights Society (ARS), New York.; **21.30** ©Universal History Archive/UIG/Getty Images; **21.31** © The Museum of Modern Art/Licensed by SCALA/Art Resource, NY; **21.32** 2011 Artists Rights Society (ARS), New York/ADAGP, Paris. Photo: © Solomon R. Guggenheim Museum; **21.33** ©2013 Artists Rights Society (ARS), New York/VG Bild-Kunst, Bonn; **21.34** Russell Gordon/Danita Delimont, Agent/Alamy; **21.35** Tomas Abad/AGE Fotostock; **21.36** © 2015 Estate of Pablo Picasso/Artists Rights Society (ARS), New York; Digital Image The Museum of Modern Art/Licensed by SCALA/Art Resource, NY; **21.37** Erich Lessing/Art Resource, NY; **21.38** CNAC/MNAM/Dist. RMN-Grand Palais/Art Resource, NY; **21.39** Digital Image © The Museum of Modern Art/Licensed by SCALA/Art Resource, NY; **21.41** Jonathan Poore/Cengage Learning; **21.42** © Jonathan Poore/Cengage Learning; **21.43A** ART on FILE/Terra/Corbis; **21.43B** © Cengage Learning; **21.44A** Bildarchiv Monheim/AKG Images; **21.44B** © Lois Fichner-Rathus; **21.44C** © Lois Fichner-Rathus; **21.45A** © Lois Fichner-Rathus; **21.45B** © Lois Fichner-Rathus; **21.46** Coll/Lebrecht/The Image Works; **21.47** Novosti/Topham/The Image Works; **21.48** Portrait of Emile Zola, Hervé Lewandowski, Oil on canvas, 146.5 x 114 cm. Réunion des Musées Nationaux/Art Resource, Inc.

CHAPTER 22 **22.1** Erich Lessing/Art Resource, NY; **22.2** Erich Lessing/Art Resource, NY; **22.3** The Dream, 1921 (oil on canvas)/Beckmann, Max (1884-1950)/SAINT LOUIS ART MUSEUM/Saint Louis Art Museum, Missouri, USA/Bridgeman Images; **22.4** 2013 Georgia O'Keeffe Museum/Artists Rights Society (ARS), New York.; **22.5** The Philadelphia Museum of Art/Art Resource, NY; **22.6** Courtesy Whitney Museum of American Art, New York, New York; **22.7** Aaron Douglas. Courtesy of the Aaron and Alta Sawyer Douglas Foundation; **22.8** Photo: The Jacob and Gwendolyn Lawrence Foundation/Art Resource, NY; **22.9** Digital Image © The Museum of Modern Art/Licensed by SCALA/Art Resource, NY; **22.10** Rmn-Grand Palais/Art Resource, NY; **22.11** L.H.O.O.Q., 1919 (colour litho), Duchamp, Marcel (1887-1968)/Private Collection/Bridgeman Images; **22.12** Banque d'Images, ADAGP/Art Resource, NY; **22.13** Digital

Literary Credits

This page constitutes an extension of the copyright page. We have made every effort to trace the ownership of all copyrighted material and to secure permission from copyright holders. In the event of any question arising as to the use of any material, we will be pleased to make the necessary corrections in future printings. We thank the following artists, authors, publishers, and agents for permission to use the material indicated.

CHAPTER 13 Page 418: Michelangelo Buonarroti, *Michelangelo: A Record of His Life as Told in His Own Letters and Papers* (trans. Robert W. Carden). Boston & New York: Houghton Mifflin Company, 1913, p. 201. **Page 428:** W.G. Clark, W. A. Wright, & E. Dowden. *The Complete Works of William Shakespeare Arranged in Their Chronological Order.* Chicago: Morrill, Higgins & Co., 1892. **Page 445:** W.G. Clark, W. A. Wright, & E. Dowden. *The Complete Works of William Shakespeare Arranged in Their Chronological Order.* Chicago: Morrill, Higgins & Co., 1892. **MindTap Voices Feature:** Herbert Von Einem. *Michelangelo.* London: Methuen and Company, Ltd, 1973.

CHAPTER 14 Pages 486–487: Salve Deus Rex Judaeorum, written by Aemilia Lanyer. London: 1611. **MindTap Voices Feature:** Letter by Katherine Zell reprinted from *Women of the Reformation in Germany and Italy* by Roland H. Bainton.

CHAPTER 15 Page 495: On-page footnote: St. Teresa of Avila, *The Life of St. Teresa, Written by Herself,* trans. David Lewis, 5th ed. Ed. Benedict Zimmerman (New York: Benziger Brothers, 1916), 266–267. **MindTap Voices Feature:** By Giambattista Passeri, trans. Rudolf and Margot Wittkower, in their book *Born Under Saturn: The Character and Conduct of Artists* (New York: New York Review of Books, 1963), 142.

CHAPTER 17 Page 580: M. K. Gandhi, *Non-Violent Resistance* (Satyagraha). New York: Schocken Books, 1961. **MindTap Voices Feature:** Jonathan D. Spence, *Emperor of China: Self-Portrait of K'ang-Hsi* (Copyright © by Jonathan D. Spence, 1974). New York: Vintage Books, a division of Random House, 1988.

CHAPTER 18 Page 610: From *Unbowed: A Memoir* by Wangari Muta Maathai, copyright © 2006 by Wangari Muta Maathai. Used by permission of Alfred A. Knopf, a division of Random House, Inc. Any third party use of this material, outside of this publication, is prohibited. Interested parties must apply directly to Random House, Inc. for permission. Published in the UK by William Heinemann and reprinted by permission of The Random House Group Limited. **MindTap Voices Feature:** E. Jefferson Murphy, *History of African Civilization.* New York: Crowell, 1972, p. 110.

CHAPTER 19 Page 656: P. B. Shelley, "Ode to the West Wind." In Francis T. Palgrave (Ed.). *The Golden Treasury: Of the Best Songs and Lyrical Poems in the English Language.* London: Macmillan, 1875. **Page 658:** Robert Charles Sands, "Original Busts and Portraits of Washington." In *The Atlantic Magazine,* Volume 1. May–October, 1824 (pp. 435–436). New York: E. Bliss & E. White, 1824. **MindTap Voices Feature:** *The Letters of Horace Walpole, Earl of Orford,* ed. John Wright, vol. 3 (Philadelphia: Lea and Blanchard, 1842), 430.

CHAPTER 20 Page 666: M. & J. Mathews (Eds.). Charles Baudelaire. *The Flowers of Evil.* New Directions Publishing Corporation, 1955. **Page 674:** Linda Nochlin, *Women, Art, and Power and Other Essays.* Harper and Row, 1988, pp. 1–2. Copyright 1988 Linda Nochlin. **Pages 690–692:** Charles Armitage Brown, "Life of John Keats" in Hyder E. Rollins, ed. *The Keats Circle: Letters and Papers 1816–78,* Second Edition. Harvard, 1965, ii. 656. **Pages 692–693:** H. Buxton Forman, ed. *The Poetical Works by Percy Bysshe Shelly,* Vol. I, Third Edition. London: Reeves & Turner, 1892, p. 105. **Page 695:** http://www.ringnebula.com/Beet/Letters/Anderson_vI_letter51.htm **Page 704:** W. G. Clark, W. A. Wright, & E. Dowden. *The Complete Works of William Shakespeare Arranged in Their Chronological Order.* Chicago: Morrill, Higgins & Co., 1892. **Page 708:** Ralph Waldo Emerson, "Nature," in Nature: Addresses and Lectures (Boston: James Munroe, 1849), 7–8.

CHAPTER 21 MindTap Voices Feature: From *Letters of Composers: An Anthology, 1603–1945,* ed. Gertrude Norman and Miriam Lubell Shrige (New York: Alfred A. Knopf, 1946), 301–302.

CHAPTER 22 Page 789: http://www.poetryfoundation.org/poem/175779. **MindTap Voices Feature:** Virginia Woolf, *A Writer's Diary; Being Extracts from the Diary of Virginia Woolf.* (Edited by Leonard Woolf.) San Diego: A Harvest Book—Harcourt, Inc., 1953, p. 349.

READING SELECTIONS

CHAPTER 13 Reading 13.1: Jean Paul Richter. (Ed. & trans.). *The Literary Works of Leonardo da Vinci.* 2 vols. London: S. Low, Marston, Searle & Rivington, 1883. **Reading 13.2:** Lorna de' Lucchi, trans. *An Anthology of Italian Poems 13th–19th Century.* New York: Alfred A. Knopf, 1922, p. 127. **Reading 13.3:** Source: Translations from Dante, Petrarch, Michael Angelo, and Vitoria Colonna. London, Kegan Paul & Co.: 1879, p. 317. **Reading 13.4:** "On Women" from *The Book of the Courtier* by Baldesar Castiglione, translated by George Bull (Penguin Classics, 1967). Copyright © George Bull, 1967. **Reading 13.5:** "On Women" from *The Book of the Courtier* by Baldesar Castiglione, translated by George Bull (Penguin Classics, 1967). Copyright © George Bull, 1967. Reprinted by permission of the publisher Penguin Books, Ltd. **Reading 13.6:** Veronica Franco, *Poems and Selected Letters.* Edited and translated by Ann Rosalind Jones and Margaret F. Rosenthal. Chicago: The University of Chicago Press, 1998. pp. 38–39. Reprinted by permission of University of Chicago Press. **Reading 13.7:** Ann Rosalind Jones and Margaret F. Rosenthal, trans. *Veronica Franco, Poems and Selected Letters.* Chicago: The University of Chicago Press, 1998, pp. 38–39. **Reading 13.8:** From *The Autobiography of Benvenuto Cellini,* translated by George Bull (Penguin Classics,

1956). Copyright George Bull, 1956. Reprinted by permission of Penguin Books, Ltd.

CHAPTER 14 Reading 14.1: Source: *Works of Martin Luther,* trans. and ed. Adolph Spaeth et al. (Philadelphia: A. J. Holman Company, 1915), vol.1, 29–38. **Reading 14.2:** "John Calvin: On Predestination." Modern History Sourcebook, Paul Halsall, Fordham University, June 1998. Internet http://legacy.fordham.edu/halsall/mod/calvin-predest.asp. Text scanned and modernized by Jerome S. Arkenberg. Source: The Library of Original Sources (Milwaukee: University Research Extension Co., 1907), vol. 5: 9th to 16th Centuries, 141–150. **Reading 14.3:** Alphonso Gerald Newcomer, Alice Ebba Andrews, & Howard Judson Hall (Eds.). From the Sermon "Sinners in the Hands of an Angry God." *Three Centuries of American Poetry and Prose.* Chicago and New York: Scott, Foresman and Company (1917), pp. 94–95. **Reading 14.4:** Theodore G. Tappert, *The Book of Concord.* Philadelphia: Muhlenberg (1959), pp. 107–108. **Reading 14.5:** W.G. Clark, W. A. Wright, & E. Dowden. *The Complete Works of William Shakespeare Arranged in Their Chronological Order.* Chicago: Morrill, Higgins & Co., 1892. **Reading 14.6:** Excerpt from The Complete Essays of Montaigne, translated by Donald Frame. Copyright © 1957, 1958 by the Board of Trustees of the Leland Stanford Jr. University; renewed 1971, 1976. All rights reserved. With the permission of Stanford University Press, www.sup.org. **Reading 14.7:** Excerpt from *The Complete Essays of Montaigne,* translated by Donald Frame. Copyright © 1957, 1958 by the Board of Trustees of the Leland Stanford Jr. University; renewed 1971, 1976. All rights reserved. With the permission of Stanford University Press, www.sup.org. **Reading 14.8:** Wyatt, "Whoso list to hunt?" *Poet's Corner,* by Bob Blair, Jon Lachelt, Nelson Miller, and Steve Spanoudis, http://www.theotherpages.org/poems/wyatt01.html. **Reading 14.9:** Edmund Spenser, "Amoretti." In John Matthews Manly (Ed.). *English Poetry: 1170–1892.* Boston: Ginn & Co. (1907), p. 90. **Reading 14.10:** Thomas Dibdin. *A Metrical History of England,* Vol. II. London: Joseph Hartnell, 1813, p. 90. **Reading 14.11:** A.H. Bullen, ed. *The Works of Christopher Marlow,* Volume the First. London: John C. Nimmo, 1885, pp. 275–276. **Reading 14.12:** Christopher Marlowe, "Passionate Shepherd." Available from Poets.org (Academy of American Poets), at https://www.poets.org/poetsorg/poem/passionate-shepherd-his-love. **Reading 14.13:** W.G. Clark, W. A. Wright, & E. Dowden. *The Complete Works of William Shakespeare Arranged in Their Chronological Order.* Chicago: Morrill, Higgins & Co., 1892. **Reading 14.14:** W.G. Clark, W. A. Wright, & E. Dowden. *The Complete Works of William Shakespeare Arranged in Their Chronological Order.* Chicago: Morrill, Higgins & Co., 1892. **Reading 14.15:** W.G. Clark, W. A. Wright, & E. Dowden. *The Complete Works of William Shakespeare Arranged in Their Chronological Order.* Chicago: Morrill, Higgins & Co., 1892. **Reading**

14.16: W.G. Clark, W. A. Wright, & E. Dowden. *The Complete Works of William Shakespeare Arranged in Their Chronological Order.* Chicago: Morrill, Higgins & Co., 1892. **Reading 14.17:** W.G. Clark, W. A. Wright, & E. Dowden. *The Complete Works of William Shakespeare Arranged in Their Chronological Order.* Chicago: Morrill, Higgins & Co., 1892. **Reading 14.18:** W.G. Clark, W. A. Wright, & E. Dowden. *The Complete Works of William Shakespeare Arranged in Their Chronological Order.* Chicago: Morrill, Higgins & Co., 1892. **Reading 14.19:** W.G. Clark, W. A. Wright, & E. Dowden. *The Complete Works of William Shakespeare Arranged in Their Chronological Order.* Chicago: Morrill, Higgins & Co., 1892. **Reading 14.20:** W.G. Clark, W. A. Wright, & E. Dowden. *The Complete Works of William Shakespeare Arranged in Their Chronological Order.* Chicago: Morrill, Higgins & Co., 1892. **Reading 14.21:** W.G. Clark, W. A. Wright, & E. Dowden. *The Complete Works of William Shakespeare Arranged in Their Chronological Order.* Chicago: Morrill, Higgins & Co., 1892. **Reading 14.22:** W.G. Clark, W. A. Wright, & E. Dowden. *The Complete Works of William Shakespeare Arranged in Their Chronological Order.* Chicago: Morrill, Higgins & Co., 1892. **Reading 14.23:** W.G. Clark, W. A. Wright, & E. Dowden. *The Complete Works of William Shakespeare Arranged in Their Chronological Order.* Chicago: Morrill, Higgins & Co., 1892. **Reading 14.24:** W.G. Clark, W. A. Wright, & E. Dowden. *The Complete Works of William Shakespeare Arranged in Their Chronological Order.* Chicago: Morrill, Higgins & Co., 1892.

CHAPTER 15 Reading 15.1: John Vietch, trans., *The Method, Meditations and Philosophy of Descartes,* London: M. Walter Dunne, 1901, pp. 171–172. **Reading 15.2:** Hobbes's *Leviathan,* Harrington's *Oceana,* Famous Pamphlets. London: George Routledge and Sons, 1889, p. 64. **Reading 15.3:** John Locke, *An Essay Concerning Human Understanding,* Thirtieth Edition, London: William Tegg & Co., 1849, p. 10. **Reading 15.4:** Molière, *Tartuffe,* trans. Richard Wilbur, in *Molière's* The Misanthrope *and* Tartuffe (Orlando: Harcourt, 1965), 244–45. **Reading 15.5:** Cervantes, *The Adventures of Don Quixote,* trans. J. M. Cohen, 1947. Reprint London: CRW, 2008, 565–66. Translation © 2006 by Executors of the Estate of J. M. Cohen. **Reading 15.6:** John Donne *Selected Poems,* Henry King Elegies, etc., Izaak Walton Verse-Remains. J.R. Tutin, 1904, p. 9. **Reading 15.7:** Samuel Johnson, ed., *The Works of the English Poets, From Chaucer to Cowper,* Volume VI, London: J. Johnson, 1810, p. 560. **Reading 15.8:** G. A. Aitken, ed. *The Poems of Andrew Marvell.* New York: Charles Scribner's Sons, 1898, pp. 56–57. **Reading 15.9:** Charles W Eliot, ed., *The Complete Poems of John Milton,* Volume 4, The Harvard Classics, New York: PF Collier & Son, 1909, pp. 90–91. **Reading 15.10:** Charles W. Eliot, ed., *The Complete Poems of John Milton,* Volume 4, The Harvard Classics, New York: PF Collier & Son, 1909, p. 92. **Reading 15.11:** John Winthrop. "A City upon a Hill," excerpted from "A Modell of Christian Charity," 1630. Collections of the Massachusetts Historical Society (Boston, 1838, 3rd series 7:31-48.) **Reading 15.12:** *The Poems of Mrs. Anne Bradstreet (1612–1672): Together with her Prose Remains. The Duodecimos,* 1897, p. 17. **Reading 15.13:** *The Poems of Mrs. Anne Bradstreet (1612–1672): Together with her Prose Remains. The Duodecimos,* 1897, p. 271.

CHAPTER 16 Reading 16.1: Miguel León-Portilla and Earl Shorris, *The Language of Kings.* New York:

W. W. Norton & Company, Inc., 2001, p. 204. **Reading 16.2:** Bernal Diaz del Castillo, *The Discovery and Conquest of Mexico, 1517–1521* (trans. Alfred Percival Maudslay). London: RoutledgeCurzon, first printed for the Hakluyt Society, 1908, pp. 271–273. **Reading 16.3:** Miguel Leon-Portilla. *The Broken Spears: The Aztec Account of the Conquest of Mexico.* Beacon Press, 1962, 1990. **Reading 16.4:** Miguel León-Portilla, *Fifteen Poets of the Aztec World,* pp. 90–91. **Reading 16.5:** Romances de los señores de Nueva España, fol. 35r; from Miguel León-Portilla, *Fifteen Poets of the Aztec World,* p. 83.

CHAPTER 17 Reading 17.1: "Memoirs of Zehir-ed-Din Muhammed Babur, Emperor of Hindustan" written by himself, in John Leyden and William Erskine, trans. Chaghatai Turki. London: Oxford University Press, 1921. **Reading 17.2:** Munshi Permchand, *The Shroud,* 1936. **Reading 17.3:** Krishna Dutta and Andrew Robinson, ed. *Selected Letters Of Rabindranath Tagore.* London: University of Cambridge Oriental Publications Series, 1997. **Reading 17.4:** Arthur Waley, trans. *Chin P'ing Mei: The Adventurous History of His Men and His Six Wives.* New York: G.P. Putnam's Sons, 1940, p.429. **Reading 17.5:** Excerpt from *Monkey* by Wu Cheng-En, translated by Arthur Waley. **Reading 17.6:** Witter Bynner (trans.). *The Jade Mountain: A Chinese Anthology.* New York: Alfred A. Knopf, 1929. Used by permission of The Witter Bynner Foundation for Poetry. **Reading 17.7:** Witter Bynner (trans.). *The Jade Mountain: A Chinese Anthology.* New York: Alfred A. Knopf, 1929. Used by permission of The Witter Bynner Foundation for Poetry. **Reading 17.8:** Arthur Waley, trans. Murasaki Shikibu. *The Tale of Genji.* by Rutland: Tuttle Publishing, 2010. **Reading 17.9:** Matsuo Basho. *Furu ike ya.* 1686.

CHAPTER 18 Reading 18.1: Harriet Beecher Stowe, *The Ministers Wooing.* New York: Derby and Jackson, 1859. **Reading 18.2:** Alan Paton, *Cry, the Beloved Country,* 1948. New York: Charles Scribner's Sons. 1948, p. 16. **Reading 18.3:** Nelson Mandela. *Long Walk to Freedom.* Little, Brown and Company, 1994. **Reading 18.4:** A. Thébia-Melsan, ed. *Aimé Césaire, pour regarder le siècle en face,* Paris: Maisonneuve & Larose, 2000. **Reading 18.5:** Haberland, Eike, ed. *Leo Frobenius An Anthology.* Wiesbaden, Germany: F. Steiner, 1973. **Reading 18.6:** Daniel P. Kunene, trans. Thomas Mofolo. Chaka. Portsmouth: Heinemann Educational Publishers, 1981. **Reading 18.7:** William Butler Yeats. "The Second Coming," 1919. First printed in *The Dial* (November, 1920). **Reading 18.8:** Chinua Achebe. *Things Fall Apart.* New York: Random House, 1994.

CHAPTER 19 Reading 19.1: Joseph B Seabury, ed. *Pope's Essay on Man and Essay on Criticism.* New York: Silver, Burdett and Company, 1900, p. 18. **Reading 19.2:** Joseph B. Seabury, ed. *Pope's Essay on Man and Essay on Criticism.* New York: Silver, Burdett and Company, 1900, p. 26. **Reading 19.3:** Thomas Roscoe, ed., *The Works of Jonathan Swift,* Vol. V, New York: Derby & Jackson 1861, pp. 16–17. **Reading 19.4:** Allan Cunningham, ed. *The Complete Works of Robert Burns.* Boston: Phillips, Sampson, and Company, 1853, pp. 105–106. **Reading 19.5:** Mary Wollstonecraft. *A Vindication of the Rights of Woman: with Strictures on Political and Moral Subjects,* 3rd ed. London: J. Johnson, 1796. **Reading 19.6:** Mary Wollstonecraft. *A Vindication of the Rights of Woman: with Strictures on Political and Moral Subjects,* 3rd ed. London:

J. Johnson, 1796. **Reading 19.7:** Book I, Section 4, "Slavery" in *The Social Contract or Principles of Political Right,* by Jean Jacques Rousseau (1762), G. D. H. Cole, trans., Philosophy and Theology: Rousseau's Social Contract. London: J.M. Dent and Sons, 1913, pp. 1–13. **Reading 19.8:** Haskell M. Block, ed. *Candide and Other Writings* by Voltaire, 1956 (Random House, Inc.). **Reading 19.9:** John Hal Stewart. *Documentary Survey of the French Revolution.* New York: Macmillan, 1951, pp. 113–115. **Reading 19.10:** Declaration of Independence, 1776. Library of Congress, Washington, DC. **Reading 19.11:** The Bill of Rights, 1789. Library of Congress, Washington, DC.

CHAPTER 20 Reading 20.1: Karl Marx and Friedrich Engels. *Manifesto of the Communist Party.* translated and edited by Fredrick Engels. Chicago: Charles H. Kerr & Company, 1906. **Reading 20.2:** Charles Darwin. *On the Origin of Species by Means of Natural Selection.* London: John Murray, 1859, p. 466–468. **Reading 20.3:** Anna Swanwick, trans. Goethe's *Faust.* London: George Bell and Sons, 1905, p. 23. **Reading 20.4:** Anna Swanwick, trans. Goethe's *Faust.* London: George Bell and Sons, 1905, p. 122. **Reading 20.5:** William Wordsworth, *Lyrical Ballads with Pastoral and other Poems,* Vol. I, Third Edition, London: T. N. Longman and O. Rees, 1800, pp. vii-viii. **Reading 20.6:** William Blake, *Songs of Innocence and Songs of Experience,* London: William Blake, 1789. **Reading 20.7:** William Blake, *Songs of Innocence and Songs of Experience,* London: William Blake, 1794. **Reading 20.8:** William Wordsworth. "Tintern Abbey," "Ode to Duty," "Ode on Intimations of Immortality," "The Happy Warrior," "Resolution and Independence," and "On The Power of Sound." London: W & R Chambers, 1892, pp. 5-6. **Reading 20.9:** William Wordsworth, *Poems, in Two Volumes,* Vol. II, London: Longman, Hurst, Rees, and Orme, 1807, p. 44. **Reading 20.10:** Samuel Taylor Coleridge. *The Rime of the Ancient Mariner.* M. A. Eaton, ed. Boston: Educational Publishing Company, 1906, pp. 21–23. **Reading 20.11:** Samuel Taylor Coleridge. *The Rime of the Ancient Mariner.* M.A. Eaton, ed. Boston: Educational Publishing Company, 1906, pp 30–31. **Reading 20.12:** Henry Lytton Bulwer, ed., *The Complete Works of Lord Byron.* Paris: A. and W. Galignani and Co., 1841, p. 254. **Reading 20.13:** Henry Lytton Bulwer, ed., *The Complete Works of Lord Byron.* Paris: A. and W. Galignani and Co., 1841, p. 142. **Reading 20.14:** Henry Lytton Bulwer, ed., *The Complete Works of Lord Byron.* Paris: A. and W. Galignani and Co., 1841, p. 142. **Reading 20.15:** H. Buxton Forman, ed. *The Poetical Works by Percy Bysshe Shelly,* Vol. I, Third Edition. London: Reeves & Turner, 1892, p. 250. **Reading 20.16:** H. Buxton Forman, ed. *The Poetical Works by Percy Bysshe Shelly,* Vol. I, Third Edition. London: Reeves & Turner, 1892, p. 528. **Reading 20.17:** Harry Buxton Forman, ed. *The Poetical Works of John Keats.* London: Reeves & Turner, 1884, pp 269-271. **Reading 20.18:** Jane Austen. *Plan of a Novel According to Hints from Various Quarters.* Oxford: The Clarendon Press, 1926. **Reading 20.19:** Mary Wollstonecraft Shelley, *Frankenstein; or, The Modern Prometheus.* London: Lackington, Hughes, Harding, Mavor, & Jones, 1818. **Reading 20.20:** Victor Hugo, *Les Miserables,* Isabel F. Hapgood, trans., Digireads.com Publishing, 2011, p. 24. **Reading 20.21:** Gustave Flaubert, *Madame Bovary,* Eleanor Marx-Aveling, trans., London: W. W. Gibbings, 1892, p. 70. **Reading 20.22:** "Father Goriot" in Ellen Marriage, trans. *The Works of Honoré de Balzac,* Philadelphia, Avil Publishing Company,

1901, p. 12. **Reading 20.23:** George Sand. *Lelia*. Maria Espinosa, trans. Bloomington: Indiana University Press, 1978. **Reading 20.24:** George Sand. *Lelia*. Maria Espinosa, trans. Bloomington: Indiana University Press, 1978. **Reading 20.25:** Charles Dickens. *A Tale of Two Cities*. London: James Nisbet & Co., Limited, 1902, pp. 448–449. **Reading 20.26:** Charles Dickens. *Oliver Twist*. Vol. I. London: Richard Bentley, 1838, pp. 1–3. **Reading 20.27:** Ralph Waldo Emerson, "Self-Reliance," *Essays, First Series*, Boston: James Munroe and Company, 1850. **Reading 20.28:** Henry D. Thoreau. *Walden; or, Life in the Woods*. Boston: Ticknor and Fields, 1854. **Reading 20.29:** Edgar Allan Poe. *The Raven and Other Poems*. New York: Wiley and Putnam, 1845. **Reading 20.30:** Walt Whitman's "Song of Myself," in *Leaves of Grass* (Boston: James R. Osgood and Co., 1881–1882), 29–33. **Reading 20.31A:** *The Poems of Emily Dickinson*, edited by Thomas H. Johnson, Cambridge, Mass.: The Belknap Press of Harvard University Press, Copyright © 1951, 1955 by the President and Fellows of Harvard College. Copyright © renewed 1979, 1983 by the President and Fellows of Harvard College. Copyright © 1914, 1918, 1919, 1924, 1929, 1930, 1932, 1935, 1937, 1942, by Martha Dickinson Bianchi. Copyright © 1952, 1957, 1958, 1963, 1965, by Mary L. Hampson. **Reading 20.31B:** *The Poems of Emily Dickinson*, edited by Thomas H. Johnson, Cambridge, Mass.: The Belknap Press of Harvard University Press, Copyright © 1951, 1955 by the President and Fellows of Harvard College. Copyright © renewed 1979, 1983 by the President and Fellows of Harvard College. Copyright © 1914, 1918, 1919, 1924, 1929, 1930, 1932, 1935, 1937, 1942, by Martha Dickinson Bianchi. Copyright © 1952, 1957, 1958, 1963, 1965, by Mary L. Hampson. **Reading 20.32:** Nathaniel Hawthorne. *The Scarlet Letter: A Romance*. Boston: Ticknor, Reed, and Fields, 1850. **Reading 20.33:** Herman Melville, *Moby-Dick; or, The Whale*, New York: Harper & Brothers, 1851.

CHAPTER 21 **Reading 21.1:** Gertrude Stein, *The Autobiography of Alice B. Toklas*. New York: Random House, Inc., 1933. **Reading 21.2:** W. S. Gilbert & A. Sullivan. *The Lass That Loved a Sailor*. 1878. **Reading 21.3:** Marcel Proust. *Remembrance of Things Past*. Vol. 1, "Swann's Way" and "Within a Budding Grove." The definitive French Pléiade edition translated by C.K. Scott Moncrieff and Terence Kilmartin. New York: Vintage, 1982. **Reading 21.4:** Mark Twain. *Roughing It*. Hartford: American Publishing Company, 1872. **Reading 21.5:** Mark Twain. *The Mysterious Stranger*. New York: Harper & Brothers, 1916. **Reading 21.6:** Émile Zola, *The Ladies' Delight*, trans. Robin Buss (London: Penguin, 2001). Au Bonher des Dames was originally published in 1883. **Reading 21.7:** Oscar Wilde. *The Picture of Dorian Gray*. Leipzig: Bernhard Tauchnitz, 1891. **Reading 21.8:** Mona Caird. "Marriage." *Westminster Review* 130 (August 1888): 188–201. **Reading 21.9:** Fredrick Lawrence Knowles, ed. *A Yearbook of Famous Lyrics: Selections from the British and American Poets, Arranged for Daily Reading or Memorizing*. Boston: Dana Estes & Company, 1901, p. 335. **Reading 21.10:** Rudyard Kipling. *Ballads and Barrack-Room Ballads*. New York: The Macmillan Company, 1897. **Reading 21.11:** Rudyard Kipling. *Songs from Books*. Garden City: Doubleday, Page & Company, 1912. **Reading 21.12:** Henrick Isben. "A Doll's House" in Eva Le Gallienne, Trans. *Six Plays*. New York: International Creative Management, Inc. 1957. **Reading 21.13:** Kate Chopin. "The Dream of an Hour" in *Vogue* magazine, December 6, 1894.

CHAPTER 22 **Reading 22.1:** Rupert Brooke, "The Soldier" in George E. Woodberry. *The Collected Poems of Rupert Brooke*. New York: John Lane Company, 191. **Reading 22.2:** http://www.poetryfoundation.org/poem/176849. **Reading 22.3:** From Virginia Woolf. *A Room of One's Own*. New York: Harcourt, Brace and Company, 1929. **Reading 22.4:** Ernest Hemingway. *Men Without Women*. New York: Charles Scribners Sons, 1927. **Reading 22.5:** James Joyce. *Ulysses*. Mineola: Dover Publications, 2002. **Reading 22.6:** "Before the Law" from *The Complete Stories* by Franz Kafka, edited by Nahum N. Glatzer, copyright © 1946, 1947, 1948, 1949, 1954, 1958, 1971 by Schocken Books, an imprint of the Knopf Doubleday Group, a division of Random House LLC. In the UK, from *Collected Stories* by Franz Kafka, Published by Vintage. Reprinted by permission of Schocken Books, an imprint of the Knopf Doubleday Publishing Group, a division of Penguin Random House LLC, The Random House Group Limited, and of A M Heath & Co. Ltd. Authors' Agents. All rights reserved. Any third party use of this material, outside of this publication, is prohibited. Interested parties must apply directly to Penguin Random House LLC for permission. **Reading 22.7:** Aldous Huxley, *Brave New World*. New York: HarperCollins Publishers, 1932, 1946. **Reading 22.8:** Sinclair Lewis. *Babbitt*. New York: Harcourt, Brace and Company, 1922. **Reading 22.9:** Sinclair Lewis. *Babbitt*. New York: Harcourt, Brace and Company, 1922. **Reading 22.10:** "I, Too" from *The Collected Poems Of Langston Hughes* by Langston Hughes, edited by Arnold Rampersad with David Roessel, Associate Editor, copyright © 1994 by the Estate of Langston Hughes. Used by permission of Harold Ober Associates Incorporated and Alfred A. Knopf, an imprint of the Knopf Doubleday Publishing Group, a division of Penguin Random House LLC. All rights reserved. Any third party use of this material, outside of this publication, is prohibited. Interested parties must apply directly to Penguin Random House LLC for permission. **Reading 22.10:** "I, Too" from *The Collected Poems Of Langston Hughes* by Langston Hughes, edited by Arnold Rampersad with David Roessel, Associate Editor, copyright © 1994 by the Estate of Langston Hughes. Used by permission of Harold Ober Associates Incorporated and Alfred A. Knopf, an imprint of the Knopf Doubleday Publishing Group, a division of Penguin Random House LLC. All rights reserved. Any third party use of this material, outside of this publication, is prohibited. Interested parties must apply directly to Penguin Random House LLC for permission. **Reading 22.11:** A. A. Brill, trans. and ed. *The Basic Writings of Sigmund Freud (Psychopathology of Everyday Life, the Interpretation of Dreams, and Three Contributions To the Theory of Sex)*. Originally published: New York: Modern Library, 1938.

CHAPTER 23 **Reading 23.1:** Jean-Paul Sartre, *Existentialism and Humanism*. Methuen Publishing Ltd, 1952. **Reading 23.2:** Jack Kerouac. *On the Road*. New York: Viking Press, 1957. **Reading 23.3:** © *Artforum*, June 1967, "Paragraphs on Conceptual Art," by Sol LeWitt. **Reading 23.4:** By Paul Celan, translated by Christopher Middleton, and published by HarperCollins in *The Poetry of Our Own World*, edited by Jeffrey Pain. © 2000 by Christopher Middleton. Retrieved at: https://www.poets.org/poetsorg/poem/fugue-death. **Reading 23.5:** Norman Mailer, *The Naked and the Dead*. New York: Rinehart and Company, 1948, p. 3. **Reading 23.6:** Stella Rodway, trans. Elie Wiesel, *Night*. New York: Bantam Books, 1987. **Reading 23.7:** John Updike. *Rabbit, Run*. New York: Alfred A. Knopf (Random House), 1960. **Reading 23.8:** Ralph Ellison, *Invisible Man*. New York: Vintage Books, 1952, pp. 4–5. **Reading 23.9:** Reprinted By Consent of Brooks Permissions. **Reading 23.10:** Maya Angelou. *I Know Why the Caged Bird Sings*. New York: Random House, 1969. **Reading 23.11:** Toni Morrison. *The Bluest Eye*. New York: Alfred A. Knopf, 1993. **Reading 23.12:** Sylvia Plath, *The Bell Jar*. New York: Harper Perennial, 1971, pp. 167–169. **Reading 23.13:** "In Celebration of My Uterus" from *Love Poems* by Anne Sexton. Copyright © 1967, 1968, 1969 by Anne Sexton. Reprinted by permission of Houghton Mifflin Harcourt Publishing Company and Sterling Lord Literistic. All rights reserved. **Reading 23.13:** "In Celebration of My Uterus" from *Love Poems* by Anne Sexton. Copyright © 1967, 1968, 1969 by Anne Sexton. Reprinted by permission of Houghton Mifflin Harcourt Publishing Company and Sterling Lord Literistic. All rights reserved.

Index

Pages marked in italics indicate illustrations.